WHISTLER

STANLEY WEINTRAUB

WHISTLER
A Biography

T·T TRUMAN TALLEY BOOKS / E. P. DUTTON / NEW YORK

This paperback edition of Whistler
first published in 1988 by E. P. Dutton

Copyright © 1974 by Stanley Weintraub

*Published in the United States by
Truman Talley Books • E. P. Dutton,
a division of NAL Penguin Inc.,
2 Park Avenue, New York, N.Y. 10016.*

*Published simultaneously in Canada
by Fitzhenry and Whiteside, Limited, Toronto.*

Library of Congress Catalog Card Number: 88-71871

ISBN: 0-525-48432-9

Designed by Jacques Chazaud

1 3 5 7 9 10 8 6 4 2

First published in hardcover in 1974 by Weybright & Talley.

For Rodelle

Contents

Contents

ILLUSTRATIONS

"How long do you take to knock off one of your pictures?"
"Oh, I knock off one possibly in a couple of days—one day to do the work, and another to finish it."
"And that was the labour for which you asked two hundred guineas?"
"No; it was for the knowledge gained through a lifetime."

Whistler to the Attorney General at the Ruskin libel trial in November 1878

Prologue

ON the afternoon of Wednesday, July 22, 1903, Jonathan Sturges, Princeton '85, returned by hansom cab to Long's Hotel in New Bond Street, London, where he lived. Broad-shouldered and handsome from the waist up, he had been crippled and stunted since infancy, and could hardly walk without a stick for support. His friend Jimmy Whistler had given him a silver-headed ebony one after Sturges had admired the slender four-foot wand which was as much symbol of Whistler's bellicosity as the butterfly signature to which the artist often added an anatomically incongruous sting.

Raised upon a folded blanket, with the glass top of the cab up and the lower doors closed, his silk hat on his head and gloves in his hand, Sturges seemed not to notice that it was an overcast day with a persistent drizzle. Nor did he seem ready to alight from the hansom when the driver pulled open the doors. There was, instead, a puzzling pause; then Sturges signalled to the hotel porter, who rushed forward to the curb and helped Sturges drag himself down. When he took the burly porter's arm and, strangely stickless, hobbled into the hotel, it was the first time anyone there had seen him accept assistance. In the lobby he shifted a shaking hand to the arm of a waiting friend, who noticed that Sturges's coat was soaking wet and that under the sodden hat his face was pale.

Settled in his rooms, Sturges had a brandy-and-soda brought to him; and after a sip or two he confided, "It was dreadful; no one could have imagined such a thing."

A few years before, when one of his long-time adversaries died, Whistler had lamented that he hardly had a close enemy left in London. This had been demonstrated that day first at Chelsea Old Church, and then at the graveyard at Chiswick where Whistler had been buried and Sturges had paid his final respects. Police were at hand to restrain the crowd, but there was no crowd. The small squat-steepled church by the Thames where Whistler had dutifully taken his mother a generation earlier had been less than half full, and few followed, by cab and carriage,

to the graveside, where a clergyman mumbled rapidly through the service. Barely a dozen old friends had remained, and with them several women—including the two sisters of his late wife and an elderly lady who kept in the background and was suspected to be his loyal but cast-off model and mistress of thirty-six years before, Jo. With her was a tall man who was not her child but Whistler's, "an infidelity to Jo," as he had once put it.

There were only two wreaths, one a gilded laurel creation that Whistler would have deplored, and a single primrose for each official mourner to drop into the grave after the coffin was lowered. When it came to Sturges's turn, he had limped forward on the rain-slicked stone path. Suddenly his ebony prop slipped from his grasp and fell into the grave. Someone clutched at Sturges, and an attendant was about to step down onto the coffin to retrieve the stick when Sturges ordered him to leave it where it lay.

"Heigh-ho," said Sturges in a tone abruptly charged with levity. "It would have amused the old boy very much!"

Later, at a memorial dinner for James Abbott McNeill Whistler, there was an academic oration and subsequent eulogies, several from men who had badgered and belittled the artist in his lifetime. "Somehow," an estranged disciple, William Rothenstein, felt, "the many speeches rang false. For praise comes from equals, flattery from inferiors. I remembered a story of some Spaniard who, instead of presiding at a meeting, sent his stick to be laid in his place. I felt that Whistler's stick was, spiritually, present."

Sturges took another sip of his brandy-and-soda and thought about the incident at the grave. Whistler had given him the stick and, in an action that seemed characteristic of a man not publicly celebrated for generous deeds, had taken it back.

I

Born in Exile

"DETERMINED that no mendacious scamp shall tell the foolish truths about me when centuries have gone by, and anxiety no longer pulls at the pen of the 'pupil' who would sell the soul of his Master," Whistler began in a fragment of memoir he never continued, "I now proceed to take the wind out of such speculation by immediately furnishing myself the fiction of my own biography which shall remain—and is—the story of my life." But he went a little further. "To begin with," he added, "I am not an Englishman." Nor was he recognizably an American, a Russian, or a Frenchman, although he was born in Massachusetts, was raised in Russia, and had learned his art in France. He disliked the English while spending most of his life in England and in his fading years even became a Jacobite and a pro-Boer. Technically he remained an American citizen, which at the least was a convenience enabling his belated Yankee patrons to import his work into the United States free of duty; and he always considered himself a West Point man, although in his nostalgic pride he ignored the embarrassing fact that he had been expelled.

Being an American in Europe—an American who never returned home—emphasized for Whistler his sense of belligerent alienation, of the artist as purposeful exile. Even as artist he was an outsider among his

peers, dedicating his *The Gentle Art of Making Enemies* with defensive pride to "the rare Few, who, early in Life, have rid Themselves of the Friendship of the Many." It was Whistler's self-portrait. For only a few brief clusters of years in his life was he something other than the complete expatriate, although there seemed available always the compensatory loyalty of his disciples, his mistresses, his mother.

Whistler's mother forever sits before us in bleak contentment in the painting her son titled *Arrangement in Grey and Black*. The result has been to overshadow a distinguished father, George Washington Whistler, one of fifteen children of a British soldier who surrendered at Saratoga, went home to marry, then returned to America to enlist in the army of the infant nation. George Whistler continued the military tradition. In 1814, when he was fourteen, and the war with Britain begun in 1812 was dragging to a stalemated conclusion, he entered the new Military Academy at West Point. Good at drawing and at draftsmanship, he excelled in the Academy's specialty, engineering. Under the General Survey Act of 1824, Congress authorized the supply of Army engineers for many state and private internal improvement programs, from canals to railroads, and George Whistler as a young officer not only led a surveying team which helped establish the boundary between the United States and Canada but began working as a consulting engineer in planning the development of railroads—the biggest new industry in America.

Major Whistler married twice. His first wife, Mary Swift, daughter of the Surgeon at West Point, had died after bearing three children;* his second wife was Anna McNeill, sister of his Academy classmate and railroad building associate William McNeill. Both men soon resigned their commissions, Whistler in 1833, in order to make commercial use of their expertise as civil engineers, and it was while George Washington Whistler was supervising engineer of a locomotive works in Lowell, Massachusetts, that the first child of his second wife was born on July 11, 1834. On November 9, 1834 he was christened James Abbott, the middle name gradually disappearing from use as Whistler in adulthood adopted his mother's family name and became in the process a Scotsman and a Southerner. (While his father's forebears were Irish and English, his mother's, McNeills of North Carolina, had been Stuart supporters who came to America in 1746, after the Battle of Culloden.)

"I have read," he wrote in his autobiographical fragment, "that I was

* George William and Deborah survived; Joseph died in childhood.

born in Pomfret, Connecticut, in Boston, and even in Lowell! But my people were Southerners . . . and if there were any truths in this strange Northern cradle of their sons they would have lived it down in silence. My dear good Mother as a Christian would have seen [to] it. For my part, though for a moment attached by the drollery of [birth] down East without a drop of Yankee blood in my veins, upon the whole it won't do. . . . No, the time has gone by when a man shall be born without being consulted. . . . Meanwhile I have chosen Baltimore—I was born then in Baltimore." Still, Lowell, Massachusetts it was, although by the time Jimmy was three, his life pattern of rootlessness had begun, the family moving to Stonington, on the eastern edge of Connecticut, where Major Whistler was supervising the construction of a railroad to Providence in Rhode Island. It was a brief but happy interlude, for Anna's sister, Mrs George Palmer, resided in Stonington nearby. To oversee his operations the Major had a horse-drawn carriage bolted onto train wheels, and on Sundays the family was permitted to use the new trackage to drive to Westerly, nearby in Rhode Island, to go to church.

Sunday, for the young Whistler boys, began on Saturday afternoon, when their Sunday clothes were inspected, their pockets emptied of anything which might distract from the solemnity of the seventh day, their toys put away until Monday, and their heads washed in preparation for church. In the rigid New England atmosphere in which Jimmy Whistler was raised the emphasis on gravity and decorum was a fact of everyday life; it was only when Anna's passion for prayers and piety was translated intact to alien surroundings that it was to appear extreme.

When Major Whistler became chief engineer of the Western Railroad of Massachusetts in 1840, the family moved again, this time to a house on Chestnut Street in Springfield. There a fourth son, Charles, was born in 1841 (William and Kirk had been born in Connecticut), and there in 1842 Kirk died. The year saw still more massive dislocations in the Whistlers' lives. In the summer of 1842 a mission sent to England and America by Czar Nicholas I to locate someone to supervise construction of a 420-mile Moscow–St Petersburg railroad fastened upon Major Whistler. The salary offered was $12,000 a year. In 1842 a major-general received, in pay and allowances, only a third as much.

Whistler left his family behind, to follow the next year after he had arrived and made arrangements for housing. They sailed from Boston aboard the steamer *Acadia* in mid-August 1843—Anna, her two step-children, her three young sons and her Irish maid Mary. To the

family brought up under Anna's puritanical regimen the voyage was one of spellbinding excitement, although the usual lengthy grace was said, even when at mealtimes the pitching of the ship would distract from prayers by causing the dishes to slide along the table. And even at sea the Sabbath was strictly kept.

Diversions were few. Icebergs appeared in the northernmost arc of the voyage, each in Anna Whistler's journal "like a huge tent of snow," and two days from port little Charles celebrated his second birthday. At six in the morning of August 29, 1843 they docked in Liverpool, then went north to Preston, in Lancashire, where two half-sisters of Mrs Whistler lived. The next leg of the trip, to Hamburg, took them first to London. Nine-year-old Jimmy's first experience of the river he was to celebrate as an artist, was a view by lamplight in the predawn mist, as boatmen rowed the family and its belongings out to the *John Bull*, lying in the quiet Thames.

From Hamburg they took carriages to Lubeck and Travemunde, where the steamer *Alexandra* was to take them to Russia, the last lap. Three days from harbor, Charles, the baby of the family, suddenly became ill and died. It was a saddened family that arrived by the packet up the Neva to the English Quay at St Petersburg. There Major Whistler met them and took them to their house in the Galernaya district.

Much of the city lay in mud and poverty, but the Whistlers lived like nobility and saw mainly the semi-oriental splendor of the Winter Palace and its gardens, and the handsome offices and mansions of the swollen bureaucracy. Major Whistler's status fit his authority and salary. In addition to the trackage to be laid he was to carry out a three-million-dollar contract arranged with a Philadelphia-Baltimore combine to tool up for production the Russian railroad workshops. The work between two cities more than four hundred miles apart kept Whistler away a great deal, and the household remained mother-dominated. With the onion-shaped domes of St Petersburg's cathedrals and palaces constantly in view, and a corps of obsequious Russian servants hovering about, Anna nevertheless carried on a home life as American as she could manage. On Sundays reading was limited to prayers and the King James Bible. American dishes appeared regularly, including her favorite, buckwheat cakes, a recipe her famous son later would patriotically impose upon his breakfast guests. A cow was stabled in the courtyard to supply fresh milk. The American holidays were celebrated in traditional fashion, even to fireworks on the Fourth of July.

They saw few Englishmen and fewer Americans, and Jimmy and William had at first a Swedish tutor and learned fluent French—the Court language—with the result that when the boys were invited to a military fête, and had their glasses filled with champagne, they cried out automatically, *"Santé à l'Empereur!"* The pomp and parades encouraged a swagger in Jimmy and an aristocratic outlook he liked to identify with the pre-Civil War American South, rather than Czarist St Petersburg. At one military review, which they watched from the Prince of Oldenburg's palace, Jimmy put on what had become his usual display for the Russian officers, after a glittering inspection of eighty thousand troops by the Czar. Of her son that day Anna wrote in her journal:

> I do not like to make comparisons for Jemie's eagerness to attain all his desires for information and his fearlessness often make him offend us because we love him too tenaciously to be reconciled to his appearing less amiable than he really is. The officers, however, seemed to find amusement in his remarks in French or English. . . . They were soon informed of his military ardour and that he hoped to serve his country. England? No, indeed! Russia, then? No, no, America, of course.

Jimmy's first experience with fireworks on a grand scale, and of amusement gardens, both of which he afterwards painted from London experiences of them, came in St Petersburg. The gardens of the Pavloski, "a fairy scene at seven o'clock," were hung with lamps, and pulsated with music and the sounds of singing and dancing, while fireworks celebrated important royal occasions, as when the sky over St Petersburg was set aglow on May 30, 1846 to welcome the Czarina back to the city. It was the occasion, too, for a demonstration of gallantry which meant much to Mrs Whistler, for Jimmy led her—at the reckless hour of ten-thirty—along the Nevsky in the family's carriage "just to take a peep" at the festivities. "The throng was almost out of control when the Czarina's retinue came into sight," Mrs Whistler wrote in her diary:

> I was terrified lest the poles of their carriages should run into our backs, or that the horses might take fright or bite us, we were so close, but Jemie laughed heartily and aloud at my timidity. He behaved like a man, shielding me with his arm, and, I must confess, brilliant as the spectacle was, *my* greatest pleasure was derived from the conduct of my dear and manly boy.

The Whistlers spent their first summer in Russia away from St Petersburg, in a *dacha* three-and-a-half miles from the city. Although arranged for the boys' health, it also improved Mrs Whistler's morale, for both Russian and English gentlefolk summered in villas along the Peterhof road. Here Deborah had a German tutor, and the boys their Swedish tutor; and to remind them of home the Major read months-old copies of the Stonington *Weekly News* aloud to the family while Anna sewed—until it was time for Bible reading and bedtime prayers in the half-light of the northern summer nights. In the mornings Jimmy practiced the piano for a half-hour and read aloud to his mother from the Bible, the mannerisms of his later speech and writing reflecting the babble of foreign tongues in which he grew up and his enforced immersion in Scripture. After four months the family returned to St Petersburg, but to a less pretentious house.

The new home looked across the Neva to Vasilievsky Island, dominated by the Imperial Academy of Fine Arts, ornate, odiferous, and in need of repairs, and poor in everything but copies of classical statuary and a marble bust of Nicholas I. Still, it loomed invitingly for a boy who wanted to draw, and Jimmy had been encouraged by the example of Sir William Allen, a Scottish painter then at the Russian court. In June 1844, Sir William had taken tea and bread and butter at the Whistlers', impressing the young artist with his talk of a commission he had from the Czar to execute an epic canvas illustrating Peter the Great teaching his *mujiks* how to build ships. Sir William could not have left without first being asked to admire Jimmy's pencil sketch of Aunt Alicia as well as other attempts. After Jimmy and Willie had said their good-nights the artist told Anna Whistler, "Your little boy has uncommon genius, but do not urge him beyond his inclination."

It was only an amusement for him, Mrs Whistler insisted proudly; but Jimmy persisted in producing pencil and pen-and-ink drawings, around some of which he drew his own frames before sending them off to relatives. Any surface would do for his caricatures and drawings, and for his copies of pictures and prints, and a Russian grammar survives in which he drew three pen-and-ink sketches and another in pencil. He learned little Russian, but the book had its uses. Despite Sir William's warning, Jimmy's inclination toward art needed no urging and would have heeded no curbing.

Jimmy Whistler was always more impressed with his own work than that of those he was asked to admire. His mother once took him to Peter

the Great's famous palace and gardens, the Peterhof, where she lauded the Czar's own bird paintings. Jimmy laughed at them, preferring instead a statue of Samson tearing open the jaws of the lion, out of which a fountain jetted water a hundred feet. When, however, he was in bed with one of several attacks of rheumatic fever he experienced in Russia, his mother gave him a book of illustrations which did impress him enough to cause him to maintain thereafter that Hogarth was the greatest English artist. "If I had not been ill, Mother," he confided, "perhaps no one would have thought of showing them to me."

The Peterhof was only one of many buildings laden with art available to Jimmy in the St Petersburg area. There were the exhibitions at the Academy, and also at the Hermitage, then and still one of the great museums, where he could see the works of Velasquez, and of the Flemish painters, both which would influence him later; and near the Whistlers' summer villa was Catherine the Great's country palace, the Tsarskoe Selo, with a curious Chinese salon designed in oriental simplicity by Charles Cameron, a Scot who had never been to China. Whether any of the art young Whistler saw in Russia influenced him directly is questionable. His letters and notes and early drawings provide no positive evidence. What may have influenced him more directly was "the grayish dreaminess, the blue dimness of the northern days." It was not only the fog-shrouded Thames twilight which drained the brightest colors from his canvases, or blurred their detail.

With the Imperial Academy so enticingly nearby, it was inevitable that the family would make efforts to place Jimmy there, and in April 1845, when he was ten, he began drawing lessons at the Academy, in the second level of four, where the work was "heads from nature" (under instructors Vistelius and Voivov) and the pupils awesomely older. Very little else at the Academy was done from nature, for the traditional practice was to draw from plaster casts of classical works. To help Jimmy keep up with the older boys the family engaged an Academy student named Karitzky, who was in the highest grade, to tutor him on Saturdays.

He worried that he was not good enough for his class, and revered Karitzky because he was on an unattainable level; yet when Jimmy had his first-year examinations on March 2, 1846 he emerged first in a class of forty-six. Meanwhile the desultory lessons in French and English from Monsieur Lamartine (a German) continued for both boys, and Anna continued her practice of having each recite a verse from the Psalms before breakfast, going herself to her Bible and tracts even more often

than heretofore, as she worried over her own condition; she was again pregnant and feared for herself, in the hands of Russian medicine. The baby arrived with no difficulty, and on schedule, but lived only fourteen months.

In the autumn of 1846, Major Whistler placed the boys in a boarding school, Monsieur Jourdan's, in St Petersburg. Both needed the discipline. They wore uniforms of cap, grey trousers, and black jacket, and had to have their hair cropped. Jimmy, Anna noted in her journal from her sons' letters home, "found the new suit too tight for his drawing lesson, so he sacrificed vanity to comfort, and was not diverted from his two hours' drawing by the other boys' frolics, which argues well for his determination to improve, as he promised his father." Having to write his French lesson over twenty-five times was not nearly as serious a punishment to him as being denied his drawing hour. The experiment of M. Jourdan's did not last long. The boys came home for the Russian Christmas holidays early in January 1847 "drooping from the close confinement," Anna thought. They seemed at first to recover quickly, skating daily on the Neva, Jimmy crossing on the ice to his beloved Academy to draw with the students. By the end of January he was in bed with rheumatic fever, his chief amusement during the two months of his convalescence his pencil and paper, and a book of Hogarth's engravings. Neither Jimmy nor Willie ever returned to boarding school in Russia.

Soon after Jimmy's recovery he went with his family to the first royal inspection of the railroad, an oft-postponed event which took place on March 23, 1847. Although Nicholas had been eager to have the line built, since other civilized countries had railroads, he made little effort to understand what had to be done once his commissioners had picked their engineer; and when Major Whistler had come to him with a map of the country to ask about his preferences as to where the trackage should be laid, the Czar had taken a ruler and drawn a straight line from St Petersburg to Moscow. Now, however, he appeared impressed with the work already accomplished, and at a *levée* the next day Nicholas hung an ornate decoration suspended from a scarlet ribbon around the Major's neck, identifying it as the Order of St Anne.

In other ways, too, life was going well for the Major. In particular, he had cause to celebrate the success of his daughter's summering in England the previous year, for she had met a promising young man. A correspondence had ensued, and in the summer of 1847 the whole family embarked for London, to remain until after Deborah's marriage, on

October 10. Jimmy, now thirteen, was in the wedding party at Preston. Francis Seymour Haden, Deborah's husband, a physician and amateur artist, was twenty-nine, rich, and handsome, and equally adept with scalpel and brush. Young Whistler was impressed, but afterwards confided that when they first met he resented the way Haden patted him on the shoulder, "just like a school teacher."

Winter had set in by the time the Whistlers' ship returned to Cronstadt, and the port was nearly icebound. For the boys it was time for schooling again, this time with a new tutor, Monsieur Biber; and Jimmy was encouraged to continue with his drawing under Karitzky. Then, after the spring thaw, Jimmy had another attack of rheumatic fever, and before he had recovered a cholera epidemic broke out in the city. Anna Whistler noted in her diary, "It is raging terribly and my heart fails me at the very name." One son had already died, she recalled, in "this unwholesome city founded on a bog." Her husband agreed that, although he could not leave his work again, the family should not remain. Anna and the boys sailed early in July on the *Camilla*, Jimmy now well enough to try "taking the portrait of a Hindoo in the servants' quarters forward."

In London the family visited the Hadens at their Knightsbridge town house, 62 Sloane Street, and went to the seaside, Jimmy with sketchbook. In Russia cholera raged all along the railroad. Whistler urged his wife to return when cold weather helped abate the epidemic. He was ailing himself, he wrote, but nothing so serious as cholera, although the symptoms sounded alarmingly similar. Reluctantly Anna returned, but only with Willie, for Jimmy's health, she was sure, could not stand another Russian winter. He remained instead, first at a boarding school near Bristol, then—in January 1849—with the Hadens, observing his brother-in-law's etching techniques, going to the galleries, attending Mr Leslie's lectures on painting at the Royal Academy (which included praise of Hogarth), and reading Mrs Jameson's *Memoirs of the Early Italian Painters*. Haden had given him a Fuseli print, and he had made friends with Sir William Boxall, a Royal Academician whom Major Whistler had engaged the previous year to do a portrait of his son. The only dreary element was his lessons from a clergyman, which gave satisfaction only to Anna Whistler. To his father on January 24, Jimmy wrote enthusiastically,

Have you been to any exhibition at the [St Petersburg] Academy lately? I wish you would tell me all about it (if you have) in your

next. Did I mention in my last, that Mr Boxall is going to take me to Hampton Court, where Raphael's cartoons are? I shall tell you what I think of them then. Fancy being so near the works of the greatest artist that ever was! I wish you could go with me! And Karitzky, too, how much we should enjoy it! I hope, Dear Father, you will not object to my choice, viz: a painter, for I wish to be one so *very* much and I don't see why I should not, many others have done so before. I hope you will say *"Yes"* in your next, and that Dear Mother will not object to it. . . .

Anna Whistler responded disappointingly:

And now, Jamie, for your future calling! It is quite natural that you should think of all others, you should prefer the profession of an Artist, your father did so before you. I have often congratulated myself his talents were more usefully applied and I judge that you will experience how much greater your advantage, if fancy sketches, studies, etc., are meant for your hours of leisure. I have hoped you would be guided by your dear father and become either an architect or engineer. . . .

Work on the railroad was nearly over for Major Whistler at about the time he had begun to recover, in mid-winter, from what must certainly have been a touch of cholera. The Czar pressed new duties upon him—he wanted the naval repair depot at Cronstadt enlarged, a new bridge built over the Neva, an arsenal and new fortifications constructed and an iron roof for the Riding House at St Petersburg. The Major agreed only to stay until his contract expired later in the year. In the meantime he badly needed a rest, and in a warmer climate.

When the winter weather moderated enough to permit navigation in the Baltic, he planned to recuperate elsewhere. Instead he grew worse. The Czar's own physician diagnosed the problem as a rheumatic heart, overtaxed by the autumn cholera. By March, George Whistler was bedridden, and none of the remedies prescribed—from leeches to laudanum—did anything but further weaken him. Once Anna realized her husband would not recover, she turned to her staunch religious faith for support and faced the inevitable grimly but unbroken. On April 9, just before dawn, he died, and the Czar impulsively sent an emissary to offer burial in Russia and education for the Major's sons at the school for Court pages, an opportunity and an honor for the widow should she remain in

the country. All she wanted, however, was permission to take the body to America for burial; and the Czar provided his private barge for the journey down the Neva to the Baltic. On the nineteenth of May, which would have been the Major's forty-ninth birthday, Anna Whistler and Willie sailed from Russia. In London Sir William Boxall's portrait of Jimmy, which the Major had never seen, was being exhibited at the Royal Academy in Trafalgar Square.

II

West Point

ETURNING to America Mrs Whistler and young William made a stopover in England to pick up Jimmy, who was staying with the Hadens in Sloane Street; and in London they went to the Royal Academy to view the portrait of Jimmy. Later Sir William Boxall's canvas would be the only work of art other than his own which Whistler would hang on the walls of the many houses and studios he occupied. The boys went on with Aunt Alicia to Preston, travelled north to visit Edinburgh and Glasgow and returned to their mother in Liverpool, where the remnants of the family—less than half the number that had sailed for Russia—embarked on the steamer *America* on July 29, 1849.

Twelve days at sea provided Anna Whistler with more than enough time to meditate upon her drastically changed circumstances and come to terms with them. "How wisely, how mercifully," she wrote in her journal, "has my heavenly Conductor led me on, blessing every means for the restoration of my health, and on the wide sea has caused an interest to be awakened in the arrival at our haven which I could not bring myself to think of while in London." And she made certain that her sons were uplifted by constant reminders of their father's virtues:

> Once while sitting at the stern musing & weeping in selfish
> indulgence . . . I involuntarily thought, "Ah had my beloved

husband been here with me, how unalloyed my delight in admiring to him this emerald and crystal road upon the smooth summer sea, every hour taking us twelve miles nearer to our dear native land together!" Suddenly his gentle patient accents sounded from my faithful memory, "I do not wish to suffer less, only for patience to bear what God orders for me." . . . To talk to Jemie of his father's example is a benefit to us both. . . .

On August 9 the ship docked in New York. The family took another boat down the harbor to Stonington, Connecticut, to stay with Aunt Kate Palmer until they could find a new home.

The family income, including widow's pension, was $1500 a year, hardly poverty level in 1849, but it meant living in reduced circumstances for a family used to princely comforts. Frugality was a way of life Anna Whistler seized with a Puritan zeal, which evidenced how long her nature had been denied its New England instincts. Piety and respectability did not require poverty, but a touch of it made self-denial simpler.

In Pomfret, deep inland in the northeastern corner of the state, was a school, Christ Church Hall, whose principal, the Rev Dr Roswell Park, had been an Academy-educated engineer before he became a parson. Anna Whistler found a farmhouse nearby. Willie and Jimmy became day boys at Christ Church Hall, and before leaving for school each morning had the Bible read to them by their mother, after which each recited to her his required verse. After school and on weekends and holidays—even Christmas Day—there were chores to do which in St Petersburg had been done by servants. Wood had to be cut and carried, and the chickens and the pig had to be fed. When it snowed a path had to be shovelled to the pen—and it seemed to snow almost daily the first winter in Connecticut, creating problems unknown in the harsher climate of Russia.

At school Whistler—now nearly sixteen—carried the books of one of the girls, and made fun of the precise and authoritarian Dr Park one day by coming to school nearly lost inside an exaggeratedly high collar and tie which mimicked the principal's. Titterings filled the classroom, but Dr Park suppressed his wrath, and bided his time, going after Jimmy with a ferule for a later and more trifling cause of offence. To escape the unexpected flailing of the stick Whistler dashed to the girls' side of the hall, where he was trapped; and while on the floor, where he had thrown himself to ward off a wild swing, was soundly whacked, to everyone's amusement, perhaps even his own. After that he resorted mainly to

flouting discipline via his caricatures, and commenting on the books he had to read by illustrating them on the flyleaves and in the margins.

In his second and final year at Christ Church Hall, Whistler continued to show no vocation for the ministry, his mother's current hope. A career in art, she continued to believe, was out of the question for a young man of good family. The United States had no need for art, and such little of it as it required could be imported from Europe. But Jimmy had inherited a profession which Anna Whistler could reluctantly accept, although she had misgivings about the military life, and privately hoped she could divert him from art to architecture, a respectable and practical occupation. In her diary she noted that her son was "full of thoughts of going to West Point and many influential friends are helping him get in," yet she found herself "wishing he would bend his talents to architecture, but leaving the decision to God, who will I trust overrule all for the final good of James." The decision was partly financial—an appointment to West Point was an all-expenses-paid college scholarship in engineering as well as in military tactics—and partly inexorable family tradition. It had been the profession of his father and grandfather.

Early in 1851 General Joseph Swift took the son of his old Academy classmate to West Point to make the appropriate preliminary inquiries and introductions, a problem being that young Whistler—only four inches above five feet—might be thought too small to become an effective officer. Since half-brother George Whistler knew veteran politician Daniel Webster of Massachusetts, the appointment was solicited through that agency. In a letter dated February 19, George wrote to enlist the sympathy of the former Senator, then President Millard Fillmore's Secretary of State, referring to Major George Washington Whistler's career and services. The rest was a formality. The entrance examinations were nothing for which one needed the services of a crammer, a cadet-to-be at that time having little else to do but appear before the rigid-faced members of the Academic Board in the Library building, write down a few lines read at him from a book and read aloud a page himself, and answer several questions dealing with fractions and decimals.

In the spring of 1851 James Abbott* Whistler was certified a cadet at large, news he greeted by becoming so seriously ill that for four weeks he lay abed while Anna Whistler "trembled lest I must resign my darling to death (the angel messengers to believers in the Lord)."

* He added the McNeill while at West Point.

On July 1, 1851, ten days before his birthday, he became a plebe. The Government would now invest $690.86 a year to educate him, including $24 monthly pay received in credits at the Academy commissary. The routine began with reveille at 5:00 a.m. and ended seventeen hours later, but for young Whistler the discipline at the Point seemed almost a relaxation from the stern maternity he had known for seventeen years.

To be closer by, Anna Whistler (with Willie) moved to Scarsdale, New York, but fortunately for Jimmy there were few home furloughs for plebes. He quickly developed the habit of taking brief ones in other directions, wandering off alone and off-limits, and acquiring demerits for absences and lateness. His manner became one of eccentricity, breezy contempt for discipline, and studied indolence, all of it practiced with a defiant charm. During study hours he would pass the time sketching, sitting in barracks at an iron table at which another cadet opposite him would be busy at his books, the two separated by an oil lamp. As the evening wore on, Whistler would be found asleep, his head supported by one hand. When the half-past nine drum sounded, warning that study hour ended at ten, Whistler was quick to pull down his bedcovers. Later, however, he was ready for action of a non-scholarly variety, once surprised in barracks by an inspecting officer who found a deck of cards laid hurriedly aside. The cadets knew that the offence was serious, and considered asking that the report read "cards in possession," a lesser infraction, rather than "playing cards," as they had not been caught in the act. "No," said Whistler, "we had been playing," and the delinquent cadets lost a furlough.

Except for his truthfulness and sense of honor, he was a poor plebe, regularly acquiring demerits for his indiscipline. He rebelled against almost every aspect of institutional life. Barracks regulations required that cadets wear low-quarter uniform shoes, that they be arranged under the foot of the bedstead with their toes in line, and that they be neatly blacked. Boots were not "uniform," and therefore prohibited; however Whistler had acquired a pair for his unauthorized nocturnal expeditions, and not only failed to hide them but even displayed them at the foot of his iron bedstead. They were more accessible that way, for once lights were out he might feel the urge for buckwheat cakes, oysters, or roast turkey—or for porter, hard cider, or hot flip (egg, beaten in ale, then heated)—at Benny Havens's, a tavern incongruously located at Buttermilk Falls,* two miles from the Point. Cadet food was bad, and basically

* Afterwards Highland Falls.

beef—sliced cold or smoked for breakfast and supper; boiled, roasted, or baked for dinner; and supplemented by beef soup, boiled potatoes, boiled pudding, boiled fish, stale bread and strong coffee. Upon entering the mess room, cadets took their places and remained standing until their officer cried, "Take seats." Only then could the plebes march in to occupy their separate tables at the far end of the hall. After the command "Cadets rise!" at the end of the meal the upperclassmen were marched off to their quarters; then at the command, "Candidates rise!" Whistler and his fellow plebes would file out, often hooted at contemptuously wherever they went, the upperclassmen taunting, *"Plebs! Plebs!"*

Inevitably an inspecting officer reported him for having boots in his possession, for boots not blacked, and for boots not in position. The demerits were considerable and Whistler could not resist the opportunity to write an unsolicited explanation to the commandant on the subject of his appalling record, now made worse by three new citations, and concluding, "But, in this case, as it is adding but a little to the whole, what boots it?" For this he was reported anew for writing an improper excuse, adding yet another demerit to a total that kept him on the brink of dismissal.

The commandant after his first year at the Point, Colonel Robert E. Lee, found Whistler one of his sorest trials. Whistler's scholarship remained indifferent and there was no aspect of drill or discipline he failed to flout. He was vain about his curly black hair, and tried to cajole Old Joe, the black barber at the Academy, into letting the locks remain longer than proper at the required once-a-month haircut. But Old Joe was more difficult to get by than the officers, gesticulating with his scissors and asking, "Mr Whistler, do you want me to cut your hair according to regulations or not?" Still, he managed to look like a foreign cadet—perhaps a Frenchman—dark-ringleted, nearsighted, small, and thoroughly unmilitary in manner.

Later in life, Whistler was fond of telling West Point stories about himself, many of them true. The cadets were ordered out early one morning on a surveying exercise, one story went. It was cold and raw, the incentive for Whistler, when he came to a deep ditch, to sneak back unperceived to barracks and a warm bed. At morning roll-call he failed to answer to his name and was put on report as absent without the knowledge or permission of the instructor. Summoned before the instructor, he asked, "Have I your permission to speak?" Permission being granted, Whistler took the offensive. "You have reported me, sir,"

he said, "for being absent from parade without the knowledge or permission of my instructor. Well, now, if I was absent without your knowledge or permission, how did you know I was absent?" At a history lesson where the recently fought war with Mexico was being studied, he confessed to not knowing an apparently significant date. "What!" said the examiner, "you do not know the date of the battle of Buena Vista? Suppose you were to go out to dinner, and the company began to talk of the Mexican War, and you, a West Point man, were asked the date of the battle, what would you do?"

"Do?" said Whistler. "Why, I should refuse to associate with people who could talk of such things at dinner!"

In his first semiannual examination, in January, 1852, in a class of seventy-nine, he survived better than one might have expected. He was thirty-sixth in algebra, forty-second in English, and fortieth in general merit. At the examination in June for the fifty-nine fourth-classmen who had completed the year he was forty-second in academic standing—ninth in French, forty-first in English, and a faltering forty-seventh in mathematics (geometry and trigonometry). A portent of problems to come was his demerit total: 190. Ten more, and there would have been no second year.

Whistler's horsemanship was no better than his scholarship. Once, in the girder-arched Riding Hall, an engineering marvel nearly twice the length of a twentieth-century football field, after he slid over his horse's head, Major Sackett, the cavalry instructor, called out sarcastically, "Mr Whistler, aren't you a little ahead of the squad?" After his first hard fall he lay for a moment without any sign of life, and the dragoon soldiers, assuming serious injury, rushed to him and began picking him up; but Whistler ordered them to put him down. Major Fitz John Porter, the instructor, called out from his own horse, "Mr Whistler, are you hurt?" Brushing off the sawdust, Whistler retorted, "No Major! But I do not understand how any man can keep a horse for his own amusement." And Whistler never kept his own horse.

At the end of his second year at the Academy, Whistler hung on, both undistinguished and unhappy, except when at his drawing classes. By June 1853 he was thirty-seventh in mathematics but had plunged to thirteenth in French, and was thirty-second in general merit, a position due in part to his first in drawing, and his having been safely at home on sick leave from May 30 to August 28, taking the examinations on his return. As a result he also had only 168 demerits. Away from the Point,

he accumulated no such regular infractions against the Blue Book as laughing and talking in the ranks, lateness and absence from parade, and "long hair." Among other advantages of absence was that he missed Major Garnett's order, after a cadet was found drunk and out of bounds before reveille, to have the instructors of infantry tactics inspect all quarters for liquor and other contraband, "taking each piece of clothing separately out of the lockers, tearing all the bedding apart and checking it, and also shaking everything out of the clothes-bags." But he also missed the annual fireworks on the plain, on the mid-June evening when graduates celebrated their last night at the Point; and he missed most of the prank-punctuated period under canvas at the Academy's "Camp Jefferson Davis" which, during the summer, relieved the routine of barracks life and eased—but did not end—the three daily drills.

Anna Whistler, having little idea of the situation, wrote a friend in September 1853, "I observe your kind interest in my cadet at West Point, and my prayer is that he may enlist under the banner of the Captain of our Salvation."

The only captain of Whistler's salvation at the Point was a professor who was not only not a captain but held no military rank, Robert W. Weir (1803–1889), who had instructed Grant and Lee in the mysteries of drawing, and had painted an already famous mural, *The Embarkation of the Pilgrims*, for the rotunda of the Capitol in Washington. It was only in the year of Whistler's admission to the Academy that the infant technology of photography was becoming a practical possibility and the techniques of preparing maps and sketches of terrain retained a significant place in the military curriculum. The Academy employed an experienced artist to teach its cadets. Drawing was part of the curriculum from the second year, and proved Whistler's opportunity to improve his academic standing. His first assignment, a cadet in his class recalled, was copying "topographical conventional signs," the symbols used in maps. Then came topography, including such aspects as "warped surfaces" and "shades and shadows and perspective," with pencil-sketchings of figures not beginning until January.

Weir was impressed by the delicacy of Whistler's work, and gave him special attention—once, at least, too much attention. During a figure-drawing session, when Whistler was busy on a pen-and-ink sketch, and Weir walked about from desk to desk, examining the work in progress, he noticed Whistler's peasant girl and walked back to ink his own brush, preparatory to improving the drawing. Seeing him approaching again,

Whistler raised his hands to protect his paper and cried out, "Oh, don't, sir, don't! You'll spoil it!"

So nearsighted that it seems surprising he passed the entrance physical examination, Whistler had developed a compensatory drawing technique which other cadets found curious. He

> would first fix his eyes near a portion of the model, and then proceed to copy it upon his drawing board. He never drew any outline of the work he was copying. He seemed to work at random, and in this instance he displayed one of his favorite tricks, which was to draw first, say a face, from the model, then a foot, then the body, skipping from one part of the picture to another, apparently without keeping any relation of the parts. But when the picture was completed, all the parts seemed to fit in together like a mosaic. And it was a complicated piece of work.

Weir's assistant disapproved of the freedom Whistler had to draw as he pleased, and once paused in his rounds of student desks to watch carefully as Whistler, using watercolors, was copying freely from a picture of a crowded cathedral interior. Behind the tonsured head of a monk Whistler was painting a shadow. Puzzling over it unsuccessfully, the lieutenant finally said, loudly enough so that every other cadet could hear him, "Your work, sir, is faulty in principle. What is the meaning of that shadow? There is none in the model, and you should know better, for by no principle of light and shade could any shadow be there. Why, there is nothing to cast it." Without any indication that he had heard, Whistler proceeded with his picture, filling his brush and with one sweep of it threw a cowl over the head of the monk. He had painted its shadow *first*. The lieutenant walked quietly away.

Unwilling to let discipline smother obvious talent, Weir gave Whistler the run of his studio—or painting room, as he called it—an extension to his rambling granite and sandstone house at its west side overlooking the Hudson, with a large north window and high ceiling. To the cadet it was a new world. He had been in magnificent museums in London and St Petersburg but he had never been in a great working studio. Its walls were covered with paintings, framed and unframed, from floor to ceiling, although the lowest ones were hidden by stacked canvases and vacant frames of all sizes. At one side was an ornately carved oak cabinet; facing it was a cabinet made by a local carpenter to hold etchings and prints; and on every available surface stood plaster casts, wooden

manikins and bottles of oil and varnish. Rusting bits of armor and old halberds and swords hung on the walls or leaned against them, while in the cleared center of the room stood a high, old-fashioned easel (with a rod along the top for a curtain should the artist wish to conceal, then dramatically reveal, the painting beneath), a model stand, a pair of Elizabethan turned chairs Weir had used in his Capitol mural, and a favorite, much-used swivel chair.

The studio might have been in Paris, but Weir, who had studied on the Continent, was nevertheless a proper Yankee. He had sixteen children, and his second wife called him "Mr Weir." He refused to let one of his daughters study art even after she was a grown woman; it was unfitting for a female. A stern Episcopalian (and ex-Presbyterian), Weir rigidly kept the Second Commandment. No work, games or amusements were permitted on Sunday, and even Sabbath reading had to be chosen with the Lord's Day in mind. And daily the family assembled in the painting room for morning and evening prayers. Except for the other uses to which the painting room was put, it might have been any of the homes over which Anna Whistler presided, but Cadet Whistler knew it only for the delicious rubbish and litter of the working artist.

Some of Whistler's drawings done at the Point—milkmaids, a man dispensing alms, scenes from Dickens, Dumas and Victor Hugo—suggest that Weir often encouraged his pupil to do extra work of a nonmilitary nature; and Whistler also regularly did quick sketches of cadet life inspired by his acute sense of the ridiculous. The autograph book of his classmate Thomas Wilson (afterwards a Civil War general) attracted four such sketches including one of apparently intoxicated cadets entitled "Christmas comes but once a year." A pen-and-ink satire in a cadet's notebook was captioned, "Merit its own reward/or/The best man leads the squad," and another, less subtle, drawing was inscribed, "Position of a Soldier: annihilation of the Bowels." The surviving West Point sketches, on scraps of paper and in blank spaces and leaves of notebooks and textbooks, suggest that Whistler's compulsion to draw must have generated hundreds of such exercises. "In the recitation-room, at church, and almost anywhere," his classmate George D. Ruggles recalled, "the ridiculous incidents of a situation would strike him, and he would sketch, in a second or two, cartoons full of character and displaying the utmost nicety of appreciation of its ludicrous points." One, on the theme of the Academy regulation that "cadets should understand the honor and responsibility of a soldier on post," recorded, in four panels, the reaction

of a cadet to the monotony of two hours on post. In the first ("First Half Hour"), the young cadet, smart and stiff as the rifle on his shoulder, stands next to a tree. In the second half hour, tired and bored, he leans against the tree, his rifle propping him up. In the third half hour he sits drowsily at the foot of the tree, his rifle on the ground. In the "Last half hour!" the cadet is flat on his back, asleep.

He would draw on anything—camp stools and tent flaps were among his earliest canvases—and heads were his favorite subject. He caricatured pompous officers, proud upperclassmen, and frightened plebes; and for the cover of the sheet music of the Academy's "Song of the Graduates" (1852) he drew a newly graduated second lieutenant and a plebe parting with a handclasp against a romantic backdrop of Hudson riverscape.

This title page was the first Whistler to be lithographed, and its professionalism may owe something to an experienced hand at the printer's; but his real affection for the Point owes nothing to anyone. Whistler loved the Academy, and spoke of it with unfeigned affection all his life, however unreceptive he was to its narrow discipline. The pomp of morning and evening parades, with music and a drum major; the tight-fitting tunics and trousers that trussed one into a military swagger; the fireworks of artillery practice on the plain and the lobbing of mortar shells into the ravine; walks along the cedar-lined bank looking out over the Hudson, or up among the boulders to Cro' Nest, with its breathtaking river view from the summit; afternoons in the studied clutter of Weir's studio and the casual barracks camaraderie and conspiracies for furtive nights out—these weighed substantially in the scale when balanced against the rule book and a regimen of military engineering. His soul rebelled against orthodoxy; yet in June 1854 he was barely twelve months away from the beginning of a career predicated upon a routine that might take him from rank to rank and post to post until the twilight of dignified retirement.

Whistler's own farewell to the Point came abruptly, during the June examinations at the end of his third year, after he had already been placed thirty-ninth in philosophy. Called up for examination in chemistry, he was asked to discuss the properties of silicon. His regular instructor was away and, as temporary replacement, the class received Lieutenant Caleb Huse, who had often complained of Whistler's long hair and the arrogant manner in which he called attention to it by languidly combing it at his desk with extended fingers. "I am required to discuss the subject of silicon," Whistler began. "Silicon is a gas. . . ."

"That will do, Mr Whistler," said Huse, who promptly failed him in chemistry. Afterwards Whistler would say, "Had silicon been a gas, I would have been a major general," but this failed to take into account that in the same month—June 1854—he had risen eighteen demerits above the allowable annual limit of two hundred—grounds for automatic expulsion. Upon being pronounced deficient in studies and conduct by the Academic Board, and recommended for dismissal, he appealed to the Superintendent, Col. Lee,* who wrote on the petition, summing up three years of unsoldierly irresponsibility, "I can therefore do nothing more in indulgence. I can only regret that one so capable of doing well should have so neglected himself and must suffer the penalty."

On June 16, Whistler was discharged—but not yet dismayed, as he insisted much later. "The Professor would not agree with me that silicon was a gas, but declared it was a metal, and as we could come to no agreement on the matter, it was suggested—all in the most courteous and correct West Point way—that perhaps I had better leave the Academy. Well, you know, it was not a moment for the return of the prodigal to his family or any slaying of fatted calves. I had to work and I went to Washington and called at once on Jefferson Davis, who was the Secretary of War, a West Point man like myself." Davis had known the cadet's father, and had once himself been dismissed from the Point—for being discovered drinking beer at Benny Havens's in 1825—and reinstated, both factors likely to cause him to view the matter with sympathy; but the elaborate petition turned down by Lee had already received his own negative endorsement as well. Still, he listened, for this was no ordinary cadet.

"He was most charming, and I—well—from my Russian cradle, I had an idea of things and the interview was in every way correct, conducted on both sides with the utmost dignity and elegance. I explained my unfortunate difference with the Professor of Chemistry, represented that the question was one of no vital importance, while on all really important questions, I had carried off more than the necessary marks. My explanation made, I suggested that I should be reinstated at West Point, in which case, so far as I was concerned, silicon should remain a metal. The Secretary, courteous to the end, promised to consider the matter, and named a day for a second interview."

Unsure that charm and old school tie were enough, Whistler

* Who had never acquired a single demerit in four years at the Academy.

prudently went on to the Navy Department and called on the Secretary, James C. Dobbin—"also a Southerner," Whistler added. To Dobbin he brazenly suggested a direct appointment to Annapolis as a midshipman. "The Secretary objected that I was too old. In the confidence of youth, I suggested that age should be no objection. I could be entered at the Naval Academy and the three years at West Point could count at Annapolis. The Secretary was interested, for he too had a sense of things. He regretted, with gravity, the impossibility. But something impressed him, for later he reserved one of six appointments he had to make in the Marines, and offered it to me. In the meantime I had returned to the Secretary of War who had decided that my wishes in the matter of West Point could not be met. West Point discipline had to be preserved, and if one cadet could be reinstated, a dozen others who had tumbled out after me, would have to be reinstated too."

Whistler's career at West Point had ended. All he had left besides his memories were his drawing professor's parting blessings and predictions of a brilliant future—as something other than an officer in the United States Army.

III

Washington

THE problem of Whistler's future became a family problem, and the solution was a family one. He would be packed off to Baltimore, to the Winans Locomotive Works, where his half-brother George—married to Julia Winans—was now a partner and superintendent. Through the late summer and early autumn Whistler lived with George and reluctantly reported for work as an apprentice draftsman. "But Jem never really worked," a fellow apprentice, Frederick Miles, remembered. "He spent much of his several short stays and two long ones in Baltimore loitering about the drawing-office and shops, and at my drawing-desk. . . . We all had boards with paper, carefully stretched, which Jem would cover with sketches, to our great disgust, obliging us to stretch fresh ones. . . . He would also ruin all our best pencils, sketching not only on the paper, but also on the smoothly finished backs of the drawing-boards, which, I think, he preferred to the drawing side." Yet they indulged him like a privileged lunatic. "We kept some of the sketches for a long time. I had a beauty—a cavalier in a dungeon cell, with one small window high up."

It must have been with relief that the partners in the works learned, early in November, that Whistler had found a new job. The Secretary of War, Jefferson Davis, had told him, at his final futile interview, that if he

would call on Captain Benham, an official of the Coast Survey in Washington—and a friend of his father's—a post might be found for him there. Benham administered the drawing department, in one of several houses the Survey occupied across the street from the Capitol building. There charts were drawn and reproduced—often composites of maps (with markings of shoals and notations of individual soundings), views of harbors, prominent landmarks, and other navigational aids. Production was from etched copper plates—sheets coated with an acid-resisting ground, then drawn upon—incised into—with a sharp tool, after which the finished drawing was "bitten-in" to the exposed lines on the plate with acid.

On November 7 he reported for work as a draftsman, a young man of twenty who did not look as short as he actually was because he was also so slender, with a Scotch cap set forward over a mass of dark curly hair, a new mustache, and a blue-and-green plaid cape draped dapperly over his shoulders. He was assigned a room on the third floor, and as he was shown about, the corps of cartographers and clerks buzzed that this was the man who had been dismissed from West Point for failing to obey the rules, but who was reputed to be overflowing with artistic talent. An immediate celebrity, he set about vindicating both reputations.

After an abbreviated two-day course in engraving and etching he was given a copper plate, some maps and drawings of Boston Bay, and instructions to demonstrate with etcher's needle what he had learned of the technique. The result was a small maplike fragment of coastline, two views of the entrance to the Bay, and six small vignettes, one the head of an old woman, and two of which may be fanciful self-portraits. It was an augury of what violations of instructions were to come; yet the work was finely accomplished, and Whistler was kept on at $1.50 a day—an amount which barely kept him in gloves, he later complained.

Whistler lived less fashionably than he dressed. He lodged in a furnished room in a two-stories-and-attic brick building on the northeast corner of Twelfth and E Streets, N.W.—the sort of quarters renting then for no more than ten dollars a month, with breakfast. The hours at the Coast Survey were an undemanding nine to three, but he was rarely on time when he was there at all, and usually emerged from his bed too late even for breakfast.

He seldom drew at his room, but drew on it instead, the landlord once complaining about it when he came vainly to collect an arrears in rent. "Now, now, never mind!" Whistler assured him; "I'll not charge

you anything for the decorations." Decorations appeared, too, on the bare white wall along the stairs leading down to the office of Superintendent Alexander Dallas Bache—pencil sketches of soldiers fencing, soldiers on parade, at rest, in action; and also an assortment of heads, Whistler frequently stopping on the way up or down to improve his drawings. Now and then he did a drawing in watercolors or in crayons at the office; John Ross Key, a survey draftsman, remembered one illustrating the scene in *Pickwick Papers* where the Cobbler's friend, visiting him in debtor's prison, finds him lying on a blanket under a table, and the Cobbler explains that he was used to a four-poster bed, and could not sleep without one. Whistler as a youth, his artist friend—and enemy—of later years, Walter Sickert, wrote, was "Dickens-mad. A little of Cruikshank, a little of the exquisitely gracious and immortal 'Phiz', had crept unconsciously into the ideals of Whistler. . . ."

As a Survey draftsman he was impatient with map-drawing; and brought one of his large slouch hats to leave on a peg in the office in case one of his superiors came looking for him. Sitting under another hat, in a nearby tavern, would be Whistler. If all the tales about Whistler in Washington were true, he must have spent more time on duty at the Survey—at least technically on duty—than the official records credit him with, for his accomplishments were legendary, although generally inappropriate. One story describes his attempting to add interest to a coastal scene by drawing in sea serpents, mermaids, and smiling whales, and Whistler himself loved to tell the story of another, smaller, drawing. Captain Benham would make inspections of the work his draftsmen were doing by scrutiny of the copper plates with the magnifying glass which was standard equipment at each desk. Whistler etched a little devil on his glass, and when Benham came by, stretched back out of the way, to watch the reaction. "He saw Captain Benham give a jump. The Captain said nothing. He pocketed the glass, and that was all Whistler heard of it until many years afterward, when, one day, an old gentleman appeared at his studio in Paris, and by way of introduction took from his watch-chain a tiny magnifying glass, and asked Whistler to look through it—'and,' he said, 'well, we recognised each other perfectly.' "

When it was clear that cartography bored Whistler, Benham suggested that he might etch the inset views of the headlands and entrances to harbors often used to fill the otherwise vacant spaces on charts; but if any were accomplished, they are without his name. Except for his instructional copperplate etching, the only other one in the Survey

files is a sketch of Anacapa Island in the Santa Barbara Channel, off the California coast, with a view from the south of the eastern extremity of the island. Two graceful flights of seagulls contribute interest but have no topographical value. Reprimanded for the addition, Whistler declared, "Surely the birds don't detract from the sketch. Anacapa Island couldn't look as blank as that map did before I added the birds." But Benham warned him about wasting the Government's copper and reminded him that the Survey was not an art school. Still, the plate was a thoroughly professional piece of work, proving that if Whistler had wanted a career with the Coast Survey, he could have remained there as long as his accomplished contemporary Augustus Lindenkohl, who with the rank of Assistant, prepared studies of the Hudson River canyon and the Gulf Stream, and devised the first transverse polyconic projection of the United States. In 1898, forty-three years later, Lindenkohl was still at his desk in the Survey offices. Captain Benham, he recalled then, once

took occasion to tell me that he felt great interest in the young man, not only on account of his talents, but also on account of his father, who was his particular friend, a graduate of West Point, and a distinguished civil engineer; and he furthermore told me that he would be highly pleased if I could induce Whistler to be more regular in his attendance. "Call at his lodgings on your way to the office," he said, "and see if you can't bring him along."

Accordingly, one morning I called at Whistler's lodgings at half past eight. No doubt, he felt somewhat astonished at this early intrusion, but received me with the greatest *bonhomie*, invited me to make myself at home and promised to make all possible haste to comply with my wishes. Nevertheless he proceeded with the greatest deliberation to rise from his couch and put himself into shape for the street and prepare his breakfast, which consisted of a cup of strong coffee brewed in a steamtight French machine, which was then a novelty; and he also insisted upon treating me with a cup of coffee. We made no extra haste on our way to the office, which we reached about half past ten—an hour and a half after time. I did not repeat the experiment.

In the evenings Whistler often played billiards at a room on the corner of Thirteenth Street and Pennsylvania Avenue, but was too nearsighted to play well. Each time he would lose a game he would plunk

down his quarter with the remark, "Here goes my breakfast!" It was a meal he seldom ate, yet not as a result of billiard losses. Instead, he boarded at a nearby restaurant and confectionery run by a Mr and Mrs Gautier, whom he had charmed into extra attentions for himself and his friends, and when not at the billiard room after dark seemed to disappear into a world unknown to his draftsmen colleagues and billiard-playing acquaintances.

Family friends in Washington bureaucracy and diplomacy and Baltimore business had made it easy for him to live on the fringes of fashionable society. He knew people at legations and ministries, and was especially familiar at the Russian Embassy. The Russian Minister, Edward de Stoeckl, who had known his father in St Petersburg, was particularly kind to him, and Whistler, eager to reciprocate, audaciously invited de Stoeckl to dinner.

> The invitation was accepted, and Whistler said he would call in a carriage at the appointed time. As they were driving off Whistler asked the Minister if he would object to his stopping at a store on the way. . . . After stopping, Whistler returned to the carriage with several paper bundles and resumed his very entertaining conversation. Presently he asked the Minister if he would mind stopping a moment at the market. . . . More paper parcels were added to the collection.
>
> They then drove to a lodging house, and Whistler, taking his paper bundles, conducted the Minister to a room in the attic, where he invited him to a seat . . . in a cozy corner. . . . He pulled out a gas stove and the necessary saucepans, and cooked and served an excellent dinner, with an appropriate accompaniment of wines of approved vintage, coffee, and cigars. During the whole proceedings, Whistler kept up a running conversation of wit, humor, and comment on his proceedings, telling the Minister by way of explanation that he had not the money to give him a handsome entertainment as he would like to, and, as the next best thing, gave something of his own device. At the conclusion of the affairs he sent his guest home in a carriage.

The Minister, during his duties in America, may have been entertained more lavishly elsewhere, but certainly not more memorably.

Whistler "was fond of balls," a young man then an attaché at the British Embassy recalled. "He was rather hard up, I take it, for I

remember that he pinned back the skirt of a frock-coat to make it pass as a dress-coat at evening parties." The Englishman was Henry Labouchere, later an editor and M.P.—and friend, in the days when the combative Whistler had few real ones. Fluent in French, witty in his own tongue, sophisticated in manner and adept in the ballroom, Whistler was an attractive young man to invite; but it was a side of him remote from most of his friends, who knew of no women in his life and assumed that his mornings in bed had no relationship to his night life. Still, there was a side of his life his Survey colleagues did not know, for he had a circle of artist friends and young women he painted, and one of his bohemian companions urged him to a career as a painter with predictions of fame, fortune, and females.

Whatever work Whistler did at the Coast Survey was done late in the day, and in January and February of 1855 he was generally not there at all. "I was not late," he explained once; "the office opened too early." One Survey entry reads, typically, "Two days absent and two days deducted from monthly pay, for time lost by not coming to the office." In January he was credited with only six and a half days of work and in February only six. Even the most tolerant admirer of his genius—or loyal friend of his late father—had to draw the line, and although it is unclear whether Whistler resigned or was dismissed, by February 12 he was again jobless. But he had attended—in his fashion—one of the most demanding schools of etching there was, and had learned the basic principles of printmaking. The monotonous, mechanical, precise work was not Whistler's style, yet he would be professionally indebted to it for the rest of his life.

Whatever finally convinced Whistler to gamble entirely on art as a career, it was not success with women or failure at the Survey, for he had apparently made a bargain with his family before taking the Coast Survey job that he would keep it for a year, then go abroad for study. His mother's puritanism surfaced despairingly in a letter to him in Washington exhorting him to acquire "habits of frugality, industry and order, for without these you can never flourish as an artist." The letter was dated the day after he left the Survey for good. Only three months of the promised year had elapsed.

IV

To Paris

NEITHER the years at West Point nor the months at the Coast Survey were wasted, for they reinforced in the young Whistler the revolt from authority which had begun in his reaction from his mother's puritanism. All that family pressure to direct his destiny into respectable professions had accomplished was to focus his ideas for his own future more directly onto Art; and the abortive apprenticeships had given him a sort of art education—drawing at the Academy, draftsmanship at the locomotive works, printmaking at the Survey.

His family background could not easily confine him to America. The Whistlers' wanderings and his own predilections had led him more and more into the bohemian way of life. There was no fertile soil in which a bohemian could mature in America; and the profession of Art had itself few roots there.

Even at the Survey Whistler spoke enthusiastically of Paris while he sketched passersby from the office windows, taking great interest in the arrangements and folds of their clothes. And his master, Weir, he knew, had been lured back to America, to teach at the Point, from work and study in Italy. Few American artists at that time had moved permanently to Europe, but many longed to go there to acquire a patina of continental sophistication as well as to learn from the originals of which they had

only seen bad copies. It was part of the strategy of professional competition as well: even six months of study and exhibition abroad might help sell paintings at home.

In America the artist had suffered not only from the absence of an artistic tradition, but from the puritanical dogma that art had to be practical and moral. Nathaniel Hawthorne, writing of the artist's life in *The Marble Faun*, complained that people in his time were "as good as born in their clothes, and there is practically not a nude human being in existence. An artist, therefore . . . cannot sculpture nudity with a pure heart, if only because he is compelled to steal guilty glimpses at hired models." American patrons paid for effort and intricacy, and found their money's worth in the folds of drapery rather than the feel of inspiration, and a German painter complained that American clients would ask only how long it took to paint a painting, and then compute the price by the number of days. "Invention and years of study," he objected, "go for nothing with these people." Whistler would find such philistinism not restricted to the New World.

The initiated spoke romantically of apprenticeship in a European garret, "the only fit abode for the artist and the poet. . . . No great work of art was ever executed in a palace." Europe was cheap, it was claimed, yet the contention was exaggerated, Margaret Fuller warning in the 1850s that the artist needed a thousand dollars a year for life abroad, however bohemian, and that rich American patrons, having "read essays on the uses of adversity in developing genius . . . are not sufficiently afraid to administer a dose of adversity beyond what the forces of the patient can bear." But Paris, Rome, Florence and Düsseldorf possessed picturesque and exotic artists' communities in which life, it was reported, was happy and satisfying, a life of professional growth and boisterous brotherhood, with no equivalent in Boston or Baltimore.

"Artist life in Paris," a young American painter wrote in 1855, in a letter published in a New York newspaper, "is a strange mixture of sense and folly, study and play." In a sentence it was the theme of a novel about the Latin Quarter, Henri Murger's *Scènes de la vie de Bohème*. Published in 1848, it was an instant success, ending the wretched side of the author's own bohemian life; by Whistler's West Point period a few years later it was already known across the Atlantic. He apparently delighted in its humor and color, and while still in America "knew Murger by heart." "It seemed to him," an early biographer suggests, "the ideal life. To have an apartment in the Quartier Latin, to be impecunious but cheerful, to strike

up friendships with eccentric characters, each a genius as yet unrecognized, to be intimate with models, to be familiar with waiters at cafés, and, behind and beyond all this, to burn with an unquenchable devotion for art—such seemed to Whistler, as it has seemed to many young men, to be the only existence worthy of novel natures."

In the sketches Rodolphe (a writer), Marcel (a painter), Schaunard (a musician) and Colline (a philosopher) find feminine consolation in Left Bank *grisettes* but—until the end—little alleviation of their chronic poverty. Their struggles for publicity and for commissions, take place against a background of stoic gaiety and unrelenting optimism—the armor of the legendary bohemian artist. In his preface, however, Murger cautioned that Bohemia was not all of the artistic life but only a stage in it—"the preface to the Academy, the Hôtel Dieu, or the Morgue." The fortunate who emerged successfully from Bohemia might afterwards recall—"amidst their calm and prosperous glory"—and "perhaps with regret, the time when . . . they had no other fortune in the sunshine of their twenty years than courage, which is the virtue of the young, and hope, which is the wealth of the poor."

Murger had several axioms for the ambitious. There was nothing worse than to be an unknown bohemian, one of "the great family of poor artists, fatally condemned to the law of incognito, because they cannot or do not know how to obtain a scrap of publicity." These were "obstinate dreamers," not professionals, "waiting for pedestals to come of their own accord and place themselves under them." Bohemia, he warned, could be a *cul-de-sac*. One could stay there too long, leaving behind sometimes "a work which the world admires later on and which it would no doubt have applauded sooner if it had not remained invisible. In artistic struggles it is almost the same as in war; the whole of the glory falls to the leaders; the army shares as its reward the few lines in a despatch . . . and one epitaph serves for twenty thousand dead."

It was the sentimental untalented who had created "the ridiculous race of the unappreciated, the whining poets whose muse has always red eyes and ill-combed locks, and all the mediocrities of impotence who, doomed to non-publication, call the muse a harsh stepmother, and art an executioner." For a determined few it could be different:

> All truly powerful minds have their word to say, and, indeed,
> utter it sooner or later. Genius and talent are not unforeseen
> accidents in humanity; they have a cause for existence, and for

that very reason cannot always remain in obscurity, for, if the crowd does not come to seek them, they know how to reach it. . . .

To arrive at their goal, which is a settled one, all roads serve, and the Bohemians know how to profit by even the accidents of the route. . . . Their daily existence is a work of genius, a daily problem which they always succeed in solving by the aid of audacious mathematics. . . . They know how to practice abstinence with all the virtue of an anchorite, but if a slice of fortune falls into their hands you will see them at once mounted on the most ruinous fancies, loving the youngest and prettiest, drinking the oldest and best, and never finding sufficient windows to throw their money out of. . . .

For Whistler, already convinced of his eventual vocation, Murger's book must have been a creed to live by, or at least to aspire to. Whether by accident or design, his career as an artist would follow—not always successfully—the paths *La Vie de Bohème* had laid out. He resisted his half-brother's efforts to return him to the locomotive works in Baltimore, and insisted that the only drawing he would do would be in an *atelier* in Paris. Clearly, he would be a jobless bohemian in America, or an art student in France. Mrs Whistler capitulated, and George Whistler promised an allowance of $350 a year, to be mailed quarterly, as long as Jimmy pursued his studies, then paid his fare as far as London.

In Scarsdale Anna Whistler confided her misgivings to a friend, James Gamble. Willie was in college and more respectable, but in some ways nearly as much of a disappointment as Jimmy. "Dear friend," she wrote Gamble on September 20, 1855, "unite with me in prayers for these precious lads, that every change to them may be sanctified. Willie read aloud the tract you sent him, but not as though he were convinced. We can only sow the good seed and wait the Lord's blessing upon it." Liberated, Jimmy left for England, his mother writing afterward to Gamble, "How many lessons has a widowed mother to 'Be still and know it is the Lord', that faith may be exercised. What can I do now for my Jemie but pray, believing! The Lord may draw him nearer to himself in his absence from me. He benefited by spending six weeks with his sister in London, for her winning counsels so affectionately impressed him, and her husband, an amateur artist, was a most capable advisor."

Life in Knightsbridge was plush and sedate, and Seymour Haden an

eager listener to his brother-in-law's accounts of etching techniques at the Coastal Survey. The quarterly seventeen pounds ten went far, too, while he was a guest at 62 Sloane Street; but for Whistler it was a limbo. On November 3 he unpacked his suit of white duck, incongruous in a London autumn, donned his favorite wide-brimmed and beribboned hat (it looked right for an artist) and bought a first-class ticket to Paris by way of Le Havre. He was twenty-one.

V

Bohemian in Paris

A T a station en route to Paris Whistler's train stopped long enough
to permit him to stroll the platform, smoking. A burly, untidy,
blackbearded young Irishman was also on the platform, a
medical student named John O'Leary, and to continue their conversation
Whistler forewent his first-class accommodation to join O'Leary in his
third-class carriage. Both were going to Paris, and both knew no one
there, nor any place to stay. Impulsively they decided to share rooms.
Since *La Vie de Bohème* indicated that art students lived in the Quartier
Latin and often went to the Théâtre de l'Odéon, Whistler explained to a
cabman on arrival that the two wanted lodgings near the Odéon. *"Je
connais ça,"* the cabman said, and took them to the Hôtel Corneille, an
immense, dilapidated pile on the semirural and tumbledown south bank
of the Seine, still untouched by the broad avenues and other bold
transformations by which the Second Empire had been altering the map
of Paris.

According to one of his earliest friends in the city, Tom Armstrong,
Whistler went upstairs with the *concierge* to inspect the rooms. When he
found two which seemed reasonable, he shouted down the stairwell for
O'Leary to bring up their trunks. Soon he heard footsteps, and then loud
curses and howls, and looking down saw O'Leary sitting on a stair

bewailing an accident which had befallen his trunk—which was only a rickety wooden box tied up with rope. It had fallen and come to pieces in the process, and sovereigns were rolling down the stairs, for John O'Leary had put his money in loosely among his clothes. "Ah well," he cried out, "if it's been laking like that all the way along it's sorra a few of them'll be left for me."

The new lodgings were a pair of bedrooms with connecting door, but the door remained open only briefly, for O'Leary was *"très matinal le soir,"* unable to get up early enough to do the rounds in the hospital of La Charité. He decided to leave the Corneille to live closer to La Charité. The move failed: after three months he had not once arrived in the wards by seven; and he transferred to rooms opposite La Pitié. There Whistler lost sight of him, too busy with his own new friends in Paris.

George Whistler had wanted him to go to the more formal École des Beaux-Arts, but on November 9 he began attending morning classes at the École Impériale et Spéciale de Dessin, and soon evening classes as well, a regime which lasted until he met Tom Armstrong, T. R. Lamont, Edward Poynter and George Du Maurier, who were studying elsewhere. Lamont was the first English friend he made. When Seymour Haden kept his promise to Whistler to come to Paris for the *Exposition Universelle,* his novelist friend, W. M. Thackeray, came over too, and invited Whistler to dinner. Whistler had already pawned his dress suit and had to borrow one from Lamont. He also needed new gloves, which he acquired on credit, he told Armstrong, by making love to the salesgirl. Proper footgear was a more difficult problem, solved, according to Whistler's story, by patrolling the hotel corridors until someone left outside his own door for polishing a pair of patent leather shoes which fitted, although their borrower afterwards complained of their shape. By the next morning they had been returned, completing a tale in the tradition of Schaunard and Marcel.

As in Washington, Whistler enjoyed the double life of bohemian and *bon vivant,* enjoying the company of artists who lived up to the traditions of Murger's book and going, when he could extract invitations, to Embassy receptions or similar functions. When in difficulties—usually over unpaid bills but sometimes over alleged rowdiness—he would announce to the *commissaire* at the police desk, *"Je suis américain,"* and claim the protection of the flag, in particular that of the American Minister, John Young Mason. "Whistler thought nothing of knocking up Judge Mason," Armstrong remembered, "when he wanted the

American Eagle to back him up. I cannot swear the Minister came himself, though I think he did on one occasion, but at any rate he lost no time in sending a secretary or attaché." It was not the expected reaction of a bohemian artist: Whistler had acquired aristocratic reflexes amidst the privilege of St Petersburg and the punctiliousness of West Point.

One of Whistler's favorite stories from *La Vie de Bohème* was about the eviction of Schaunard from his rooms and his replacement by the equally penniless Marcel, whose furniture existed only on splendidly painted screens. Whistler had a friend, he claimed, who did not even have screens, and possessed nothing but his bed, which his landlord could not legally seize; but with charcoal he had drawn a roomful of exquisite pieces of furniture on his walls. Whistler changed lodgings often, usually because he overspent his allowance; but his most significant move was his change of *ateliers,* joining the Rue de Vaugirard studio of Charles Gabriel Gleyre in June 1856, after some desultory months of trying to find a focus for his work. In the *atelier* system students began drawing and painting from live models at once, less experienced students receiving advice from more veteran habitués. The master, a painter whose private studio was elsewhere, supplied the model (the sexes changing from week to week) and visited occasionally to observe the work and comment on it, charging a fee per student for the facilities and pocketing the profits. Gleyre, a Swiss who had taken over the profitable *atelier* of Paul Delaroche, and fancied himself a disciple of Ingres, took no money for himself, his students only paying the costs of studio and model. Believing that skill in drawing was the artist's most important equipment, he emphasized line at the expense of color, and told his students that black was the basis of tone, a lesson Whistler learned well, although he came infrequently.

What the *atelier* was like, and the life of the students who inhabited it, was described nearly forty years later in Du Maurier's novel, *Trilby,* and given some allowance for sentiment and romance, the description was close to reality. There was, for example, an initiation ceremony, and in *Trilby* Little Billee is strapped to a ladder and carried bumpily through the neighborhood in a procession, knowing that if he cries out he will be put under the pump. In reality, not only might the new arrival be crucified *à l'échelle,* but the ladder placed against a convenient wall in a busy street to expose the apprentice to public laughter. Whistler, according to Val Prinsep, a Gleyre student several years later, was placed *à l'échelle,* but Whistler himself (as his pride would have dictated) denied it. "There was not even the usual tormenting of the *nouveau.* If a man were a decent

fellow, and would sing his song, and take a little chaff, he had no trouble." The song would follow a repast of cakes and wine which the novice was required to provide for the *atelier,* neither practice which Whistler found offensive, since he enjoyed both a bottle and a song, and had a repertoire of Southern slave ballads he had apparently acquired in Washington or Baltimore.

Although the atmosphere in the loosely supervised studios was coarse and disgusting to the fastidious Whistler, he could remember few unpleasant incidents at the *atelier Gleyre*—one "when a student, who had already been there some time, seemed too pleased with himself, too certain he was going to be made *massier.** And one morning when I came to the studio late, I found them all working very hard, the unpopular one among them, and there at the end of the room, on the model's stand was an enormous catafalque, a wonderful construction, the unpopular one's name on it in big letters. No one said a word. But that killed him. He was never again seen in the place." When in high spirits, students would sit astride their chairs backwards and gallop around the model, sometimes singing obscene songs, sometimes intoning the *Marseillaise,* which during the Empire was forbidden. Du Maurier illustrated the gallop respectably with a male model in the circle in *Trilby* but was more explicit about the affair to his *Punch* colleagues a decade later, telling "tales of Whistler and his *vie de Bohême* in Paris, and of the nude model fingering his fair friend while the students made hobby horses of their chairs. . . ."

The students drew or painted every day except Sunday, from eight to noon, then again for two hours each afternoon except Saturday, when the *atelier* was swept and cleaned. The room had nothing in it but about fifty low chairs with backs, easels and drawing boards and a platform for the model, with a stove nearby, since modeling was usually from the life, whatever the weather outside. The bare walls were covered with caricatures and the colorful scrapings of numberless palettes, and the atmosphere, especially on warm days, was heavy with a fog of tobacco, to which Whistler contributed, and sour with the sweat of the unwashed. Whistler, interested in what was happening in art and unconvinced that he needed the austere regimen of daily attendance, often slept until eleven, then frequented the parks and cafés, where he argued about academic art and the *avant-garde* experiments of new masters he had not met, like Courbet, with the young artists out on their own or from other

* Student-in-charge.

ateliers. He also went to the museums and galleries, to learn and to earn, for he had discovered that one way to survive between remittances from Baltimore was to copy—on commission—classics in the Louvre or the Luxembourg.

Although for a time Whistler shared rooms with two Englishmen, Poynter and Lamont, when Armstrong in the autumn of 1856 rented a studio at 53 Rue Notre Dame des Champs, a quiet, tree-lined street of neat two-storied houses, and invited his friends to share the lease and the space, Whistler declined. It was too conventionally English for him, and Armstrong enlisted only Poynter and Lamont, along with Du Maurier, who worked there but lived with his mother and sister in the Faubourg Poissonière. Whistler found a French bank clerk named Aubert with whom to share lodgings, an arrangement which worked well since Aubert cared little about art and saw little of Whistler. But the arrangement foundered on economics, for the bank clerk took home few principles of frugality, and Whistler had none.

Since Whistler lived from remittance to remittance, his style of living would deteriorate progressively as the distance grew from receipt of the previous draft. Frederick B. Miles, an acquaintance of the family, brought one cheque personally in May, 1857, and could not find Whistler at his last known address, discovering him instead by tramping the galleries until, at the *Musée Luxembourg,* he accidentally backed into a copyist's easel, heard a muttered *damn,* and discovered Whistler

> painting busily. He took me to his quarters in a little back street, up ten flights of stairs—a tiny room with a brick floor, a cot bed, a chair on which there was a basin and pitcher. . . . We sat on the cot and talked as cheerfully as in a palace. "Now," said Whistler, "I shall move downstairs, and begin all over—furnish my room comfortably. You see, I have just eaten my washstand and borrowed a little, hoping the draft would arrive. [I] have been living for some time on my wardrobe. You are just in time; don't know what I should have done, but it often happens this way! I first eat a wardrobe, then move up a flight or two, but seldom get so high as this before a draft comes!"

Solvent again, he took Miles to meet some of his friends and gave him dinner at an elegant restaurant, then led him the next day to the little Crémerie Bachimont to show him where he usually ate when funds were low.

One of the great culinary events of 1857 for Whistler and his friends took place not in a restaurant but in Lamont's cramped, third-floor lodgings, in a building already condemned for demolition by the city authorities, just before the long-planned move to the Notre Dame des Champs studio—a gala Christmas dinner conceived by Tom Armstrong and composed of all the foods they had dreamed of in bad times. Armstrong had been ill with rheumatic fever in the fall, which he blamed on working in the rain, and while flat on his back thought of the meals he owed his palate, and wondered whether a Christmas turkey should be boiled, as in England, or roasted, as in France. Even more English, he decided, would be a leg of mutton—boiled. With the aid of his friends, ingredients unobtainable in Paris were ordered from London—a plum pudding, whisky, English beer and a Stilton cheese—and French liqueurs and other local delicacies: "truffled *galantines* of turkey, tongues, hams, *rillettes de Tours, pâtés de foie gras, fromage d'Italie* (which has nothing to do with cheese), *saucissons d'Arles et de Lyon,* with and without garlic, cold jellies peppery and salt . . . sweet jellies, and cakes, and sweetmeats, and confections of all kinds, from the famous pastry-cook at the corner of the Rue Castiglione."

By Christmas Eve the hamper from London had not yet arrived, but the group, not yet ready to give way to panic, walked through a cold and moonlit Paris to midnight Mass at the Madeleine. The next morning there was still no hamper, and by Christmas afternoon the friends, hungry and anxious, called at the depot to find that the hamper had been held by customs because of the two illegal bottles of whisky. Confiscation of the whisky was the price of release, and by six o'clock they had hauled the hamper to Lamont's studio and replaced the whisky at considerable expense with a French equivalent from a shop in the Rue de Rivoli. With only Lamont's landlady to help, they set about cooking their dinner, frying sausages, preparing stuffing, mixing salads, concocting a punch. By ten o'clock they were able to sit down to eat, drink and sing. Armstrong, still weak and recuperating, held out until six in the morning, when his companions put him to sleep in Lamont's bed, and kept going themselves until eight. A week later, on New Year's Eve, Lamont, Armstrong, Poynter and Du Maurier took possession of their new quarters. Whistler compromised his independence by appearing there whenever he craved English companionship, Du Maurier once commemorating his presence by drawing a sketch of Whistler on the wall, "then a fainter one, and then merely a note of interrogation."

As well as Lamont's few pieces of his own furniture moved from the condemned flat and two inefficient stoves, they had a rented piano on which all of them would occasionally thump favorite tunes, Du Maurier singing French songs in a tenor voice in which he took just pride, Lamont ("the Laird" of *Trilby*) Scottish folk songs, Poynter fragments of operatic arias and Whistler what Armstrong called "nigger songs, songs of the old times before slavery was abolished. . . . He used to take a stick or an umbrella and, holding it in his left hand like a banjo, twiddled on it with the finger and thumb of the right hand while he pattered grotesque rhymes founded on the supposed adventures of Scripture characters. These were said to be camp-meeting hymns, and perhaps they were originally to some extent, but they must have been amplified and made more grotesque by white folks." From minstrel shows which mocked and mimicked plantation life among the blacks, Whistler would sing such songs as "Jordan Am a Hard Road to Travel."

A studio favorite was a burlesque entitled "De History ob de World":

> De World was made in six days,
> And finished on de seventh.
> According to de contract should have been de eleventh;
> But the masons dey fell sick,
> And de joiners wouldn't work,
> And so dey thought de cheapest way
> Was to fill it up with dirt.

And Whistler would plunk at his walking stick or umbrella and call for the refrain:

> Walk in, walk in, walk in, say
> Walk in de back parlor and hear de banjo play.

Whistler's attitude toward his friends' more strenuous amusements, such as boxing and fencing, appeared in a sketch Du Maurier made in 1857, "Ye Societie of our Ladye in the Fields," in which the inhabitants of the studio appear in characteristic postures, Whistler is shown seated, hat still covering his long hair, his feet propped high on the mantelpiece. He preferred the other side of their extracurricular activities, also described (but with propriety) in *Trilby*, the hobnobbing "with models, male and female, students of law and medicine, painters and sculptors, workmen and blanchisseuses and grisettes," who were not only "good company" but upon whom one could practice one's French. "And the evening was

innocently wound up with billiards, cards, or dominoes, at the Café du Luxembourg opposite; or at the Théâtre de Luxembourg, in the Rue de Madame, to see funny farces with screamingly droll Englishmen in them; or, still better, at the Jardin Bullier . . . to see the students dance the cancan . . . or, best of all, at the Théâtre de l'Odéon, to see Fechter and Madame Doche in the *Dame aux Camélias*."

Although Whistler's irregular appearances at Gleyre's and air of doing no visible work seemed at odds with his ambitions, he sometimes appeared over-serious to his friends at the studio, once trying to kindle their enthusiasm for a project in which each of the five would choose his own subject and produce an etching—although only Whistler had real etching experience. A print by each of the five would go to "some literary person in England" who would build a story around the illustrations to be signed by "Plawd," a name composed from the first letters of Poynter, Lamont, Armstrong, Whistler and Du Maurier. "We were very vague about the prospective writer of the text," Armstrong recalled, "who was spoken of as the 'literary bloke'." Only three plates were actually accomplished, an interior with female figures by Whistler, a facetious self-portrait with fictitious wife and son by Du Maurier, and a turreted French castle by Poynter, from the upper part of which a beam or gallows projected, a skeleton dangling from it. Nothing came of the idea, which was impractical from the start, but it belies, as other evidence does as well, the malicious "idle apprentice" description which Du Maurier in later years put into the serial (*Harper's*) version of *Trilby*, in the character of Joe Sibley, a description not of Whistler in Paris but of an acerbic later Whistler as seen through the pen of a friend who had fallen out:

> Then there was Joe Sibley, the idle apprentice, the king of bohemia, *le roi des truands,* to whom everything was forgiven, as to François Villon, *"à cause de ses gentillesses."*
>
> Always in debt, like Svengali; like Svengali, vain, witty, and a most exquisite and original artist; and also eccentric in his attire (though clean), so that people would stare at him as he walked along—which he adored! But (unlike Svengali) he was genial, caressing, sympathetic, charming; the most irresistible friend in the world as long as his friendship lasted—but that was not forever!
>
> The moment his friendship left off, his enmity began at once. Sometimes this enmity would take the simple and straightforward

form of trying to punch his ex-friend's head; and when the ex-friend was too big, he would get some new friend to help him. And much bad blood would be caused in this way—though very little was spilt. And all this bad blood was not made better by the funny things he went on saying through life about the unlucky one who had managed to offend him—things that stuck forever! His bark was worse than his bite—he was better with his tongue than with his fists—a dangerous joker! But when he met another joker face to face, even an inferior joker—with a rougher wit, a coarser thrust, a louder laugh, a tougher hide—he would just collapse, like a pricked bladder!

In Paris Whistler's English friends were eager for his company, delighted by his wit, certain of his genius—and ready to overlook his eccentricities. He was never as idle as the canard in *Trilby* suggests; yet a reputation for not working up to his abilities followed him, Poynter (with whom he had also fallen out) remarking at a private showing of Whistler's work late in both their lives, "A genius, but the devil wouldn't work!" And recalling their days as students he added, even later, "—if he could be called a student, who, to my knowledge, during the two or three years when I was associated with him, devoted hardly as many weeks to study."

For Whistler, there was always the comfortable refuge of 62 Sloane Street, where his portrait by Boxall hung in the dining room. He crossed the Channel whenever the emotional or material need arose, usually bringing a friend, and often borrowing the funds for the fare. In the summer of 1857 he went there en route to the Art Treasures Exhibition in Manchester. Before the Exhibition Whistler and his friends (including Manet) had admired the Velasquez *Infanta Margaret* in the Louvre and Whistler did a study in chalk based upon the Velasquez *Thirteen Cavaliers* there;* but at Manchester there were fourteen portraits by, or attributed to, the Spanish master. It was a great event in Whistler's life. When the tonal qualities of his best work were later compared to Velasquez it would be no accident.

Another artistic confrontation had already occurred, again with unforeseen repercussions. Felix Bracquemond was working in the Louvre on a preliminary drawing for his etching after Holbein's *Erasmus* when he first met Whistler. Afterwards he came upon a book of woodcuts by

* The *Cavaliers*, misattributed to Velasquez, was really by Mazo.

Hokusai among rejected prints in the shop of Auguste Delâtre that both he and Whistler frequented. The discovery of Japan was another incident in Whistler's education. He may not have acquired the kind of schooling Edward Poynter thought was important, but he was schooling himself, often unaware, and often in spite of himself.

Intermittently Whistler rebelled against the commercial, informal education into which he had been introduced at the Louvre and the Luxembourg, across the rickety Pont des Arts from the Left Bank. But he needed money more than he valued his pride, and reluctantly copied a classic or two. The less fortunate students were forced to turn the drudgery into a minor industry, copying religious pictures to sell cheaply to churches, and there were shops in the Rue Bonaparte where canvases could be obtained with the outlines of the most popular pictures already printed on them. A completed canvas—and some were as much as six feet long—brought a badly needed seven francs. Whistler's own first commissions came when a former Stonington resident, Captain Williams, visited Paris and

> got me to paint his portrait, and then gave me a commission to copy as many pictures as I chose for twenty-five dollars a piece, and I copied a picture . . . of a snow scene, with a horse and a soldier standing by it and another in the snow at his feet; a second of St. Luke, with his halo and draperies; a third of a woman holding up a child toward a barred window and a man seen looking through the bars; and a fourth of an inundation. I have no doubt I made something very interesting out of them. There were very wonderful things [in them] even then, the beginnings of harmonies and purple schemes. I suppose it must have been intuitive. Then for another Stonington man, I painted—I copied—Ingres' *Angelica* chained to the rock. Probably all these are still at Stonington and are shown as wonderful things by Whistler!

Armstrong also recalled Whistler's unenthusiastic copying at the Luxembourg of a group from Couture's *Decadence des Romains*, and remembered that the nude *Angelica*, chained by her hands to a large rock in raging waters "was not a bit like that of Ingres, for it was done in a thin, transparent manner, with no impasto and hardly enough paint to cover the canvas. . . ." When he reproached Whistler for skimping on the paint he was told that the price his friend would be paid "would not

run to more than good linseed oil"—although Whistler was getting one hundred francs each for the copies. One day in the Luxembourg, another painter recalled, a number of students had crowded their easels about a famous picture. Whistler

> would paint a bit, and then rush back to contemplate what he had done. In one of these mad backward rushes he struck a step-ladder, on the top of which was a painter. Over went step-ladder, painter, and all, and the painter, trying to save himself, seized the top of his own canvas and another, pulling them over, easels and all. One knocked down another, and there was a great crash. Whistler was in the midst, and his loud voice was heard, as he sat on the floor, his head protruding through a big canvas that had fallen on him, using expressions of a vigorous type. He was seized by the guardian, because, as Whistler was making the most noise, he assumed that the whole fuss was due to him. This was quite correct; but all the painters coming to his rescue, telling the guardian that it was all an accident, he let Whistler off.

Mrs Whistler heard about her son from Deborah Haden following each of his visits to London, writing to a friend in January, 1857, "I hear of my student in Paris . . . and [he is] doing well." American friends visiting France also reported to her on his condition, as did an English acquaintance of the Hadens, who lived in Paris and entreated Whistler to spend his Sundays at her house and accompany her to the English Church, which, according to his mother, whose moral influence over her "Jemie" could cross oceans, he did "sometimes." When the friend died in 1858 he was "tenderly affected," his mother noted; but given his interest in a completely different kind of woman, it is safer to assume that for Whistler it was more a release. Even so, with his mother at a safe distance, he could afford to think of her affectionately. Once in Paris he mentioned her, and Lamont exclaimed, "Your mother? Who would have thought of *you* having a mother, Jimmy?" "Yes, indeed, I have a mother," said the artist, who would paint her a dozen years later. "And a very pretty bit of color she is, I can tell you."

VI

The French Set

A BETTER companion than painter was Ernest Delaunoy, one of the "no-shirt" Frenchmen whose company Whistler enjoyed although their lives were more squalid than bohemian. Delaunoy, who often shared the proceeds of Whistler's pawned belongings, had little luck selling his hack reproductions, although his American friend professed admiration for them. One was a favorite subject for students, Paolo Veronese's *Marriage Feast at Cana*,* which Delaunoy had copied on a large canvas—so large that he had to enlist a friend to help carry it about to prospective buyers. Crossing the Seine, they offered it for five hundred francs to dealers on the fashionable Right Bank. Then they carried it back and offered it for two hundred and fifty to smaller dealers on the Left Bank. Failing there too, they trudged over the bridge again and suggested a reduction to one hundred and twenty-five. When no one snatched at the bargain, they wearily crossed again and asked seventy-five francs, but had to re-cross to offer it desperately for twenty-five, then return to the opposite bank to ask ten. While crossing the Pont des Arts yet again, searching for someone who might take it for five, they changed

* Populated with over 130 characters, the *Marriage* is the largest canvas on display at the Louvre.

their minds, and, swinging the clumsy canvas, heaved it over the side. Suddenly the picture had been noticed. Pedestrians on the bridge shouted, omnibuses and cabs on both banks stopped, police ran to the scene, boats put out to the rescue—and the artists disappeared into the crowd, pleased with themselves but still without a sou.

For Ernest Delaunoy nothing ever seemed to go right; thus when, in the late summer of 1858, he and Whistler decided to make a tour of northern France, Luxembourg, and the Rhineland, Whistler should have expected something to go awry. Courting trouble, they set out unprepared, departing from Paris in linen suits, Whistler with his broad-brimmed hat and patent-leather shoes, and Delaunoy with hat and walking stick. Almost their only baggage was their drawing equipment, Whistler weighed down with a knapsack of wax-covered copperplates on which he intended to etch directly from the scene rather than make preliminary pencil impressions. They had little money, but expected hospitality once the train had deposited them at the foot of the Vosges, where a friend, Dabo, lived. The town inspired one of Whistler's finest early plates. Struck by its deserted aspect at evening, he scratched a view of bleak houses fading into darkness, with a tall street lamp illuminating the foreground. Then he wrapped it up, unbitten, and put it back in his knapsack for the journey to Strasbourg and then by boat on the Rhine to Cologne, from whence they expected to continue to Amsterdam.

At Cologne their funds gave out. "What is to be done?" asked Ernest, who as Whistler put it had

nothing in prospect anywhere, [and] took the situation gloomily. "Order breakfast," I said, which we did. Then I wrote for money to everybody—to a fellow student, a Chilean I had asked to look after my letters in Paris—to Seymour Haden—to Amsterdam where I thought letters had been forwarded by mistake. We waited. Every day, we went to the Post Office, and every day the officials said, *"Nichts, Nichts!"* until finally we got to be known, I with my long hair, Ernest with his brown holland suit and straw hat now fearfully out of season. The boys of the town would be in wait to follow us to the Post Office, and hardly would we get to the door before the official would shake his head and cry out *"Nichts, Nichts!"* and all the crowd would yell *"Nichts! Nichts!"* At last, to escape attention we spent the day sitting on the ramparts outside the town.

[49]

Desperate, Whistler went back to the hotel, packed his only baggage—his copperplates—in his knapsack and carried it down to Herr Schmitz, the proprietor, whose daughter Gretchen he had etched. He was without a sou, he explained to Schmitz, but would leave the sack of plates—"to be kept with the greatest care as the work of a distinguished artist"—as security for the hotel bill. "But what is to be done with copperplates?" asked the proprietor. Whistler explained that once back in Paris he would forward what he owed for the fortnight's lodging and Herr Schmitz would return the knapsack. "He was a good sort," Whistler recalled, "for he agreed, and even gave us the last breakfast I asked for. . . ." When they set off, with no baggage but sketchpad and pencils, their only money—he afterwards told Deborah Haden—was the two groschens "which Lina, the pretty little servant girl had the evening before in a sudden and unexpected gush of sympathy thrust into my hand and immediately burst into tears. . . ."

Whistler's letter to his sister immediately after the trip, enlivened by a drawing of Ernest and Jimmy setting out for Paris with straw hats and walking sticks, another of a pair of ragged patent-leather shoes, and a third of a makeshift straw bed, attests to the reliability of his later accounts, for even to Deborah he wrote of how

> the real honest hard miseries of the pilgrimage would have effaced all poetry and romance from any minds but our own . . . how we walked until *I actually could not* make one *step* more—how the first night I made a portrait in pencil . . . for a plate of soup for Ernest and myself—how we slept on straw and were thankful—how my wretched Parisian shoes got rid of a portion of their soles and a great part of their upper leather . . . how I was unable to move out of the way of a mob of hooting Prussian children such as the Prophet Elijah would certainly have set all the wolves in his power upon, how we were weary and miserable, how I *for a glass of milk,* had to make the portrait of one of my tormentors, the ugly son of the woman who took our only two groschen for a bed which she made on the floor with an armful of straw. . . .

Everybody in Paris, he added, thought that they were dead, "and my *entrée* at the Café Voltaire on Sunday was one of the most triumphant. *Comment!*" The real triumph was the redemption of his copperplates from Cologne, which he effected with Haden's money, and it was to "Mon vieil

Ami, Seymour Haden," in November 1858, that he dedicated the first printing of *Twelve Etchings from Nature*, known popularly as *The French Set*. He had accomplished enough to make a printing worthwhile—understated village streets, landscapes, people, and interiors which at their best captured the feel of his subject with minimal details. Ironically his work from the beginning would be in complete contrast to his life, for beneath the flamboyant, extroverted exterior was an artistic personality which sought essences rather than surfaces.

For the title-etching Whistler had drawn a self-portrait, the artist seated, hunched over a sketchpad, his broad-brimmed hat and long hair throwing deep shadows over his face, while around him curious German children watch him draw. (Ernest had posed for the plate by donning Whistler's hat and sitting out in the street, quickly attracting a crowd. Afterwards Whistler inserted his own head and hair.)

Luckily, Whistler knew the right printer to strike off the bitten copperplates, Auguste Delâtre, who had a shop in the Rue St Jacques which was a rendezvous for Parisian printmakers. Delâtre was a craftsman of great skill, able to pry the subtleties out of a copperplate, and Whistler observed all the technicalities of the process with great fascination. It was not merely that this was his first set of etchings: he was interested to learn how to conduct the operation himself, something he later did, or at the least oversaw. Afterwards, when the young sculptor Charles Drouet and Whistler were looking over copies of Rembrandt's etchings together in Drouet's rooms, the Frenchman, impressed by the results of Delâtre's work, told Whistler that he was the greatest etcher since Rembrandt, and pointed out where he saw similarities in their technique. Whistler could not dissemble how moved he was by the thought. *"Si vous le pensez, mon cher,"* he told Drouet, *"ça me donne grand plaisir."*

The printing was expensive, and Whistler sought sales help from his brother-in-law in London, who had connections in the English art world. He also drew his mother into merchandizing *The French Set*, as a letter she wrote a friend early in December indicates:

> On Saturday I was so delighted to get a letter from Jemie dated Sloane St., Nov. 14th, where he says he expects to stay all winter. His sister and brother write me they are exerting all their energies to make him prefer London for his work to Paris. I shall try to interest all friends to become subscribers to a set of etching views of France and Germany, Jemie's first complete work of the

kind! Twelve single sheets (Mr Haden, who has superior artistic judgment and taste, thinks them of rare beauty!) at two guineas, the set to be bound as a drawing room album or framed as separate pictures, as subscribers may prefer. . . . You may imagine my trembling anxiety, my earnest prayers that God may bless the endeavors of my pious daughter and her good husband to settle Jemie's versatile genius at this crisis. Mr Haden warrants him 25 subscribers at two guineas each in London, and depends upon my interesting 25 in Jemie's native land to subscribe. . . . Praise God and bless His holy name for all His tender mercies towards the widow and the fatherless!

One of the set of twelve, that of a seated, sad-eyed deceptively wistful young girl with a shawl and somewhat untidy hair, would have worried Mrs Whistler had she known that "Fumette" had been her son's Parisian mistress. On the Left Bank the *grisette* was still almost all that Murger had attributed to her. She worked at whatever she could, sometimes modeled besides, and in off-hours often shared the bed as well as the temporary prosperity of a student-lover. She went with him on Sunday outings to the countryside, or to cheap theaters, guarded him jealously from other *grisettes,* and with bleak realism had no expectations of becoming a bride. Tom Armstrong, who knew "Fumette"—her real name was Héloïse—recalled that "she used to go about bareheaded and carrying a little basket containing the crochet work she was in the habit of doing, and a volume of Alfred de Musset's poems. This little pose added to the interest excited by her flowing locks and large eyes. She was a chatterbox, and at times regaled us with songs, rather spoken than sung, for she had not much voice . . .":

> Would you know, yes, know
> How artists love? They invoke
> Love with such artistry,
> They are such artistic folk
> That they go off saying:
> "Won't you come to my place, Mademoiselle?
> I'll do your portrait."

In later verses, Armstrong remembered, "the amatory peculiarities of soldiers, lawyers, doctors, and others were sung about." But Héloïse herself was not as gentle as her song or her portrait, although Whistler

managed to live with her for two tempestuous years in lodgings in a "hotel" in the Rue St Sulpice.

Known as *la Tigresse* in the Latin Quarter because of her violent temper, Héloïse proved her nickname when, in a fit of jealousy after Whistler had been absent longer than she expected, she tore up all his drawings she could find. When he returned and saw the pieces piled high on the table, Whistler broke down and wept, then left to submerge his despair in drink, taking with him his friends Henri Oulevey and John Lambert. After imbibing too much kirsch he tipsily insisted that his companions go with him to an all-night restaurant. Both refused, since they were out of funds, but Oulevey, realizing that further argument was useless, fortified himself with some of Whistler's kirsch—"to be in the right frame of mind," he told the Pennells—and the three went off, not to the restaurant, Oulevey and Lambert discovered, but to pry sufficient francs from Whistler's Baltimore friend George Lucas.

It was after one in the morning, but Whistler dragged his friends to Lucas's apartment, demanded that the concierge let him in, and while Oulevey and Lambert huddled out of sight in the shadows, banged on the door until Lucas opened the door—on the chain. He was angry, and refused to believe Whistler's thick-tongued story that he had been locked out of his own lodgings until he had paid the rent, and did not have a sou. It was obvious, even to the very sleepy Lucas peering through the partly opened door, that if Whistler was without a sou it was due to drink.

Defeated, but not dissuaded from the expedition to the restaurant, Whistler dragged his companions to the Halles and on the twelve sous that he had left ordered beer for three; then, complimenting the *patron* on his cuisine, he suggested that they each be served *un petit souper fin*. But, added Whistler, although their credit was good, it was not their practice to pay when served. It was not the practice of the restaurant to be paid at any other time, said the *patron,* unmoved by the earlier praise, and the companions shuffled out to another restaurant, where, Whistler suggested, they should say nothing about payment until they had eaten. The stratagem succeeded, Whistler all the while working himself into wild agitation about the treasonable behavior of Lucas. He would challenge Lucas to a duel, and Oulevey and Lambert would be his seconds. The two friends were too sleepy to argue, and soon all three fell asleep at the table, as Oulevey realized when he awakened and saw that morning had come as well as the bill. Prudently, he went back to sleep.

At his second awakening Oulevey found that Whistler had been up before them, had gone out to tap another American painter-friend for funds, and had a pocketful of francs. But the friend had taken advantage of him, he complained, insisting that Whistler remain long enough to look at his pictures. On the way home they passed the Café de France, where they saw Lucas in a corner having his breakfast chocolate. But Whistler had already forgotten the duel.

What Whistler had not forgotten was *la Tigresse,** whose unpredictability had become discomforting. They drifted apart, leaving Whistler with two etchings of her and his memories. (She went off to live with a musician and much later turned up in Argentina.) Whistler consoled himself with another mistress, a more elegant *cocotte* named Finette who danced the cancan at the Bal Bullier and was described by Whistler's friend Theodore Duret as "a creole of easy virtue." She survives, too, in an etching, dated 1859, in which she appears, cool and sophisticated, in a floor-length dress, a simple hat over curls which coil down to her shoulders. Later she danced as Madame Finette in London music halls, but by then Whistler had made other domestic arrangements.

Not all of Whistler's favorite females were beddable. One was old, seamed of face, and nearly blind. She huddled on the steps at the entrance to the Luxembourg, selling matches and flowers. Whistler longed to do her portrait, and she posed for him so often that he was chaffed about her in the Quarter. Brazenly, he met the taunts when Lalouette, the restaurateur, invited his clients to spend a day in the country at his expense, and Whistler—who owed him money—brought *La Mère Gerard*. She went off in a carriage with him, grew jollier as the day wore on, and spent part of the afternoon again sitting to him. The portrait was a success—such a success that Whistler thought it was too good to give her, and after a delay he presented her with a copy. As poor as her sight was, she nevertheless could tell the difference and was furious. And unforgetful. Later, when after a long absence Whistler returned with Lamont to the Luxembourg steps and asked her whether she had had any news of her little American, she answered, without looking up, that she had heard he was dead, adding that it was one scoundrel less—*"Encore une espèce de canaille de moins!"* Whistler laughed in his inimitable high-pitched way, and there was a reunion (and Du Maurier acquired another tale for *Trilby*).

* Reminiscences of Whistler's friends include references to Héloïse also as *La Panthère* and as *La petite lionne.*

Another sensitive portrait of the period was that of an old man with a pipe in his mouth, whom Whistler had found in the Halles. His curious hat and worn face intrigued Whistler, who gave him forty sous to come to the studio to be painted. Very well, said the man, but he could not leave his *voiture*. The artist wondered how someone so poor could keep a carriage. When the old man pointed out his vehicle Whistler understood, but off they went anyway, the painter accompanying the pushcart of *pots-de-chambre*, which was left in the courtyard below his studio. For several hours Whistler painted, while the vendor of chamber-pots smoked his pipe and sang comic songs, and Whistler joined in. The portrait is now in the Louvre.

In the Louvre on October 7, 1858, just before Whistler had gone to London with the etchings Delâtre had pulled, he stopped by a young man working on yet another copy of Veronese's *The Marriage Feast at Cana* and warmly admired the work. Had he known that Henri Fantin-Latour had sold four previous copies of the painting he might have been less appreciative of the copyist's flair. When Fantin put down his brushes they continued their talk that evening at the Café Molière, the meeting place for a circle which included Alphonse Legros, Carolus-Duran, Zacharie Astruc—who had a splendid beard and was later etched by Whistler—and Edouard Manet. Soon Whistler was considering Fantin and Legros, with himself, as a *Société des Trois*, and although café talk among the larger group was of their adopted master, Gustave Courbet, Whistler fast assumed the leadership of his more intimate sub-group, afterwards writing to Fantin of the importance to him of their "long evening chats" and of "that real exchange of sympathies which we can't find with others."

With Fantin and Legros, Whistler put aside the carefully cultivated *persona* of the dapper, devil-may-care eccentric he adopted among his English companions, and talked seriously of art and frankly of their roles as artists. With them he could also practice the camaraderie he saw among Armstrong, Du Maurier, and Poynter. One cold morning he discovered Fantin working in bed in his poorly heated room in the Rue Feron. Finding a scrap of paper, he quickly sketched him, huddled in his overcoat under the bedclothes, scarf wound about his neck and concealing all of his face but his nose, a top hat perched atop his bushy hair and tipped down over his forehead. *"Fantin au lit à la poursuite de ses études sous des difficultés,"* he wrote in a corner; and it was true that Fantin-Latour was pursuing his studies with difficulty, for part of the sketch showed his drawing board, at which one hand, emerging from an overcoat sleeve, was

struggling. It was a scene in the best traditions of *La Vie de Bohème*, and would have pleased Murger. It is now in the Louvre.

Although Courbet exemplified to Whistler's new friends the revolutionary spirit, they worshipped other gods as well. Whistler discovered Théophile Gautier, who wrote fiction and criticism and, in the preface to his novel *Mademoiselle de Maupin* (1836) insisted that the artist had no business deferring to morality in his search for beauty, while in his *Émaux et Camées* (1852) he declared for the impersonality of art—the artist had to eschew the inculcating of doctrine and concentrate on attaining perfection of form. The point was not lost on Whistler, nor were Gautier's famous *transpositions d'art* in which he experimented with registering the impressions of one medium via another, transcribing paintings into words. And Whistler discovered Baudelaire, whose collection of poems, *Les Fleurs du Mal* (1857) had been the subject of a famous trial for obscenity, the result of which had been that six poems were banned. But Baudelaire in his preface had praised Gautier, and had declared his belief that it was the artist's task not to record nature or idealize nature but to make art out of nature. From Fantin in particular, Whistler profited by learning the lessons imparted at Lecoq de Boisbaudran's *atelier,* where students were taught to cultivate visual memory by looking at street scenes out of the studio windows, then returning to their drawing boards to reproduce what they had seen. And in summer, Fantin told Whistler, students were taken to the country on moonlit nights so that de Boisbaudran could spread out a white cloth before them in a field and demonstrate the different values of white in varying intensities of light.

To the Molière circle Whistler brought his *French Set*, which was warmly admired, and which ensured that when he returned from his trip to London he would have a place at the table. The group would move eventually to the Café Guerbois, but the discussions would continue and their impact would be reflected in Whistler's work.

Just as necessary to Whistler in 1858 as his English and French artist friends was the Haden home in London, which permitted him yet a third world, where there was comfort in abundance and an avuncular, although often difficult, proprietor who presented no bills for bed or breakfast, and not only admired his work as an artist but was so stimulated by it that he sometimes let his medical practice slide in order to lock himself in an upstairs room to work on his own etchings. For Whistler another room had more interest—the Hadens' music room, with its grand piano and its

round table at which the family read by lamplight. Whistler even sketched his sister Deborah reading by lamplight and Haden, impressed, rushed upstairs to do his own *A Lady Reading*.

It was a good time for Whistler. While at Sloane Street in November he began a large canvas he had been thinking about for some time, posing Deborah Haden and her daughter in a manner suggesting Vermeer's *Concert*, which he could have seen then in London. Like similar paintings by seventeenth-century Dutch masters, *At the Piano* was a tranquil and austerely set domestic subject, mother seated at the piano, daughter standing; and, in the manner of his new friend Fantin, Whistler used the bottoms of picture frames in the background to structure and add severity to the painting. It foreshadowed his future work—the prototype of his most characteristic later canvases. Later Degas would say, "In our beginnings Fantin, Whistler and I were all on the same road, the road from Holland. Go and see at the exhibition at the Quai Malaquais a small picture, a *scène de toilette* by Fantin; we could have signed it, Whistler and I."

Wintering in England foreshadowed other developments as well. He was getting to like London and was exploring areas of London south of Knightsbridge in search of subjects. A mile south of the corner of Hans and Sloane Streets was the Thames, in which direction he and Haden went out on sketching expeditions together. The same Greenwich Pensioner appears in both their plates in the same attitude, and "Greenwich Park 1859" appears in Whistler's hand over Haden's signature in one plate. *Sub Tegmine* appears to be a joint etching done at the same time, the landscape Haden's and the Pensioner reclining in the partial shadow of a tree Whistler's. Similarly *Trees in the Park* was a joint effort incised in Kensington Gardens, Haden apparently responsible for the trees and Whistler the girl standing among them.* Later, when they sketched the Thames together, they would continue to see different rivers, Haden doing romantic riparian scenes, Whistler the raw wharves; and to fulfil their opposing needs, Haden would go upriver to Fulham and Richmond to find unspoiled riverscapes, while Whistler went downstream to Wapping and Rotherhithe.

When Whistler returned to Paris early in the new year it was with a new confidence in his art—and with *At the Piano*, which was so praised by

* Many years afterward, long after the two men had quarreled, a proof of an early Whistler etching was sold at auction and warmly competed for because Whistler had inscribed on it: "Legs not by me, but a fatuous addition by a General Practitioner."

his friends that he decided to submit it to the Salon of 1859. It was rejected by the jury, as were paintings by the other two members of the *Société des Trois*, as well as one by another of the Café Molière circle, Theodule Ribot. It meant that the group would not become immediately fashionable; but instead, via a hastily improvised substitute showing, they become symbols of artistic independence. The rejected Ribot was a friend of François Bonvin, who operated the Atelier Flamand at 189 Rue St Jacques and liked work suggesting a Flemish influence. Indignant at the rebuff, he offered his studio for an exhibition of the rejected pictures. Whereas works by the unknowns might have been overlooked among the many at the Salon, here they were the focus of *avant-garde* attention, seeming more defiant than their creators intended. Even Courbet, thought of then as the archrealist and political rebel, was there. "I recall very well," Fantin wrote afterwards, "that Courbet was struck with Whistler's picture." It was the tentative beginning of a curious master-disciple relationship, for Courbet then had little but rebellion to teach Whistler. Later they struck artistic—and other—sparks off each other.

Whatever had been salvaged by the Rue St Jacques exhibition, the Salon had still rejected *At the Piano*. In Paris Whistler felt like a student; the city had been, in effect, his school. In London he could be on his own as an artist. In May, putting on one of his wide-brimmed hats, screwing in his single eyeglass and collecting his few belongings, he took the boat train to London. He owed Lalouette 3000 francs, which he promised faithfully to pay. Eventually he did.

VII

La Tamise

WITH Whistler from Paris came *At the Piano*, which he offered to the Hadens if they would provide the wall space. Haden did; "but I had no particular satisfaction in that," Whistler recalled. "Haden just then was playing the authority on art and he could never look at it without pointing out its faults—and telling me that it would never get into the Academy—that was certain." Still, Whistler's friends were invited to Knightsbridge, Haden writing directions to Fantin himself. "Come, come, come," Whistler himself urged Fantin, writing in French, "just come to me at once! Here you will find all you need to continue in the vein and with the abundance that has begun for you. No idea, theory or any other nonsense must prevent you from coming here immediately. . . . Let my lucky star influence you just a little bit. You know I have always assured you that something would come your way. Well, it is England, my dear fellow, that greets young artists with open arms."

Fantin came, and Haden condescendingly but kindly commissioned from him copies of the inevitable *Marriage Feast at Cana* and other classics. Legros came, too, escaping all he had inherited from his father—his debts. He was, Whistler said, "in so deplorable a condition that it needed, well, you know, God or a lesser person to pull him out of

it." Even Delaunoy came, and it says much for the artistically intolerant Seymour Haden that he was hospitable to the émigrés from Bohemia who had little experience of clean sheets or clean shirts.

Delaunoy's brief stay was a minor disaster. He not only feared baths and had no dress clothes for dinner but was afraid to expose his shabby boots before the servants, and shuffled about in slippers. Fantin bought appropriate clothes to pass respectably at table, enjoyed the roast beef and champagne and the prospective patrons who could be met among those newly rich. But he went home anyway, to return in 1861.

Legros remained. Even before he had arrived, Haden had generously bought one of his oils, *L'Angelus*, according to Whistler "a little interior of a church with kneeling figures of women." Convinced that Legros had bungled the perspective of the floor, Haden had tinkered with it in his studio upstairs, then mounted it in a "gorgeous frame" and hung it in the drawing room. He even left it there, although becoming "just a bit restive" when Legros arrived in London. On his first visit the artist "was fearfully impressed with the frame, having been used to see himself in any shabby old frame that came his way." Soon, however, Legros' eyes moved from the dazzling frame to the painting, and the "desecration" was discovered—"the brother-in-law's crime," as Whistler described it to Fantin, who was already back in France. What should he do? Legros asked Whistler. " 'Run off with it,' I suggested. We got it down, called a four-wheeler, and carried it away. . . ." By then Whistler had acquired studio space of his own, where the two attacked Haden's improvements with turpentine, knife and razor. As soon as the doctor missed his painting he guessed what had happened to it but said nothing, eventually turning up at the studio to find *L'Angelus* on an easel, his additions gone. "Ah," he said, after a long pause, "so you have wiped it all out. Well, do it better." *"Oui,"* said Legros; and there was nothing more either cared to say about it. The episode intensified the burgeoning antagonism between Haden and his young brother-in-law.

Hospitality gave Haden no proprietary rights over the direction of his art, Whistler felt; and rather than endanger his independence he began a withdrawal from Knightsbridge. "The artists cluster round Newman Street," a London guidebook of the 1850s noted, and there Whistler rented a first-floor back-room studio at No 70, across Oxford Street from Soho. Although the Thames was his chosen subject, that sector of Chelsea below Sloane Street where the Royal Hospital and the Physic Garden extended along the river (the Embankment was yet unbuilt), and

where the reedy flats of Battersea lay on the far bank, did not have the immediate lure of the ugly wharves of Wapping, downstream, where he found additional cheap lodgings. Still relatively new to dockside, but curious about everything, Whistler asked questions of everyone, and with his strange American-Russian-French pronunciations of the Queen's English, his swarthy complexion, mustache, and mop of black curly hair too long to be hidden by his improbable hats, and his single, glinting eyeglass, he was assumed to be a foreigner, an impression reinforced at the inn when he asked the maid-of-all-work what she ate for breakfast. "Bloaters," she said. "What are bloaters?" he asked. "Why, 'errings, you bloomin' green'orn!"

Whistler territory was there—the lower Thames, below London Bridge, where ocean-going vessels docked in the Pool and above a clutter of wharves, barges, factories and warehouses loomed a tangle of masts and rigging. The grimy urban residue of the industrial revolution, aesthetically offensive to most of his contemporaries, Whistler found happily suited to his interests as an etcher and a realist, as in *Black Lion Wharf*, one of the earliest etchings, with a ramshackle background of docks and decaying buildings. *The Pool*, a related etching, was equally realistic. In the right middle-ground was a houseboat, on the deck of which stood a woman in a white dress. One might ponder her role, for Victorian art at its most commercial often comprised a pictorial anecdote. It was an approach Whistler rejected. The woman in white was not mysterious, she belonged to the design. .

Gradually the Englishmen he knew in Paris drifted back across the Channel to begin work in London, and to the acquaintances Whistler had made through the Hadens he added those made through Armstrong and Poynter, Du Maurier and the brothers Ionides. Aleco Ionides was the most curious of the lot, more patron than painter although the same age as the others. He had wanted a taste of the artists' life and his family, wealthy Anglo-Greek merchants with a handsome home on fashionable Tulse Hill in Lambeth, provided it. Back in London, he and Lucas Ionides provided their Left Bank companions with an entry into society.

Whistler had also found friends in the Junior Etching Club, to which he was proposed for membership on July 6, 1859 and elected in November. It provided a connection with *Punch* illustrator Charles Keene—another member—but Whistler, who liked Keene, did not like the concept of etching as illustration, and when asked to contribute a plate on the subject of "Black-eyed Susan" to a proposed collection of

national and patriotic songs could not bring himself to do it. Instead, he would return to what he referred to in his letters to Fantin as *la Tamise* and draw the stolid longshoremen, in the process often getting stranded in the mud, or cut off by the tide, or hampered by the failing twilight he would later bend to his purposes in his painting.

A season of etching, and of examining what was being shown in the galleries and done in the studios, convinced Whistler to offer *At the Piano* to the Royal Academy for its 1860 show—if he could extricate it from Sloane Street. He had gone back to Paris in the winter of 1859–60 and done some desultory drawing, rediscovering that the competition for attention there was keen and realizing that he had better opportunities against a far weaker field in London. One of his etchings then may have proved another point as well—his *Île de la Cité*, an uninspired view of the Seine and its bridges done in December 1859. It was abandoned in a not quite finished state. *La Tamise* was his subject, and he would work where it was.

English painting was at the apogee of the sentimental academic subject picture. Victorian religiosity and humanitarian idealism encouraged production of the overloaded anecdote, exemplified by almost any picture accepted at the R.A. during Whistler's early years in Europe. A typical example, *The Last Day in the Old Home*, exhibited at the R.A. in 1862, depicted a profligate and financially ruined husband in the lushly paneled and portrait-hung drawing room of a stately home, his champagne glass unfeelingly raised and another in the hand of the young son he is already debauching, his neglected wife and daughter sitting helplessly by, his expensive furnishings already tagged for sale, his aged mother, handkerchief to her eyes, off to one side negotiating with the auctioneer's agent for the sale of the house and contents.

Whistler could not sympathize with such framed three-volume novels. He was at first puzzled by the curious stillness in the upper reaches of the London art world at one particular time of year.

> Artists locked themselves up in their studios—opened the doors only on the chain; if they met each other on the street they barely spoke. Models went round with an air of mystery. When I asked one where she had been posing, she said, "To Frith and Watts and Tadema." "Golly! what a crew!" I said. "And that's just what they says when I told 'em I was a-posing to you!" Then I found out the mystery; it was the moment of painting the Royal

Academy picture. Each man was afraid his subject might be stolen. It was the era of the subject. And, at last, on Varnishing Day, there was the subject in all its glory—wonderful! The British subject! . . . And in the Academy there you saw him: the familiar model—the soldier or the Italian—and there he sat, hands on knees, head bent, brows knit, eyes staring; in a corner, angels and cogwheels and things; close to him his wife, cold, ragged, and baby in her arms; he had failed! The story was told; it was clear as day—amazing! The British subject! What!"

In an unexpected decision, the usually predictable hanging committee of the Royal Academy accepted what the Paris Salon had excluded, along with five Whistler etchings—several of the Thames and one of the bearded Zacharie Astruc. The etchings were exhibited in what Thackeray called the "little, dingy octagon closet," the Octagon Room, off the passage which connected the two principal picture galleries and "dark as a cellar," Walter Crane remembered. But *At the Piano* was well hung, and attracted attention. Few of the elect had ever heard of the young artist, yet John Millais generously told him, on discovering who he was, "What! Mr Whistler! I am happy to know—I never flatter, but I will say that your picture is the finest piece of colour that has been on the walls of the Royal Academy for many years." Awed by the success, George Du Maurier, recently returned to London, wrote his mother, "I have seen his picture, out and out the finest thing in the Academy. I have seen his etchings, which are the finest I *ever* saw." And Sir Charles Eastlake, director of the National Gallery and a former president of the Academy, escorted the Duchess of Sutherland to get a closer look at *At the Piano,* saying, "There, Ma'am, that's the finest piece of painting in the Royal Academy." Whistler's euphoria ended with the press notices, which were mixed. The *Daily Telegraph*'s critic described "an eccentric, uncouth, smudgy, phantom-like picture of a lady at the pianoforte, with a ghostly looking child in a white frock looking on," while the critic on the *Athenaeum* more prudently suggested that "despite a recklessly bold manner and sketchiness of the wildest and roughest kind," the picture possessed "a genuine feeling for colour and a splendid power of composition and design. . . ." Innocent in commerce, Whistler was pleasantly baffled by a letter from John Phillip, an Academy artist, admiring *At the Piano* and asking its price. In his youth and inexperience, Whistler answered, he did not know about such things, and would leave

the question of price to the purchaser. "Spanish" Phillip, a recently elected R.A. long resident in Spain and an admirer of Velasquezand Murillo, sent £30.* Since he had only given the painting to Haden "in a way," Whistler felt no qualms about parting with it for a price, the first but not the last time he would act upon his unorthodox views about the ownership of art.

Had he struck a blow for rebellion in his Academy success? He may have thought he had found a better battlefield than Paris upon which to campaign for his aesthetic concepts. Certainly his letters to friends in France indicated as much. But—to his short-term advantage—*At the Piano* probably had succeeded as the subject picture Whistler had not painted. "The family that plays together stays together."

Eleven Thames copperplates are dated 1859. They were his major effort for months. Another attempt at a major canvas was something for which Whistler was unready until well into the next year. When he worked steadily along the docks, from Greenwich to Westminster, he lived across the Thames at Rotherhithe, and in June 1860 let his Newman Street lodgings for ten shillings a week, unfurnished. Hardly sumptuous, it was, according to Armstrong, "long and narrow, with a window at one end looking out to the back, and about the middle of it a string was fixed across from wall to wall. Over this hung a piece of silk drapery about the size of two pocket handkerchiefs. This was supposed to separate the parlour from the bedroom."

For the fastidious Du Maurier, the tiny, dark room at 70 Newman Street had the advantage of its relationship to Whistler. "He is a wonder, and a darling," he wrote worshipfully to his mother, "—and we are immense chums, though I see less of him now for he is working hard and in secret down in Rotherhithe, among a beastly set of cads and every possible annoyance and misery, doing one of the greatest *chefs d'oeuvres*— no difficulty discourages him." When Du Maurier actually began visiting Whistler's dockside lodgings, however, and spent evenings at Thamesside "free-and-easies," where laborers and sailors lifted their pints and entertained themselves with song (a scene he put into *Trilby*) he was as happy as his host.

The "secret" work Whistler had been doing—"Hush! don't tell Courbet!" he wrote Fantin—was a painting. In the first excitement of inspiration, with nothing else at hand on which to try out his concept, he had pulled out his passport and sketched the design on a blank page. The

* Forty years later it sold for almost one hundred times that amount.

canvas, to be called *Wapping*, would have three figures at a corner table on the balcony of a dockside inn against a crowded background of Thames shipping and Wapping warehouses, a portion of the scheme Whistler considered triumphantly as "like an etching and . . . difficult beyond belief." Du Maurier thought the unfinished canvas was already "perfectly gorgeous," and would refer to it carefully as "the picture." Whistler knew, however, that he was having serious problems with the painting, especially with the figures in the foreground, describing the situation in a drawing and a long letter in French to Fantin. From right to left on the balcony were a sailor, another man (it would be, finally, Legros), and a young Irishwoman—and the model was "jolly difficult to paint." She was painted in deep décolletage, the low-cut bodice causing Whistler's friends to warn that it could never be an Academy picture, Whistler defiantly answering that if it were rejected for immodesty he would open the bodice more and more every year until he was elected to the Academy and hung it himself. He had already repainted the woman's head three times and was still dissatisfied, but worried about redoing it further and possibly losing its freshness. But the woman herself fascinated him, especially her coppery-red hair and her remoteness. (Her hair, he confided to Fantin, was "the most beautiful that you have ever seen.") He wanted to keep painting her, and was entertaining ideas of keeping her in yet another sense. But how could she be so aloof, when she earned her shillings sitting to artists, and was even willing to do so in the dank dockside atmosphere of Rotherhithe? The problem absorbed him.

A frequent visitor to watch Whistler work was Serjeant Thomas, a lawyer who also had a print shop at 39 Old Bond Street. John Millais and Holman Hunt had already benefited from his sponsorship, before they were well-known, and Thomas's visits, going downriver by boat, were to examine the commercial possibilities of an investment in Whistler. Impressed by the Thames plates, he offered Whistler half-profits if he could have exclusive selling rights, with the Thomas firm standing the costs of printing and advertising. Consenting, Whistler agreed, too, to prepare an invitation card for publicity, adapting his etching of Millbank, looking across the Thames to the warehouse-crowded foreground south of stark pilings, high and dry at low tide. Curved round a corner of the card was the information that "The Works of James Whistler—Etchings and Dry Points, are on View at E. Thomas' Publisher. . . ."

When work was in progress he would go evenings to Bond Street to acid-bathe his plates, accept a glass of the Serjeant's favorite port, and

observe the preparations, now and then exclaiming "Excellent! Very good indeed!"—and no one knew whether he meant the vintage or the copperplate. Even Delâtre was imported from Paris as needed to print the etchings, and all augured well. No one, it would be said later, could pull Whistler's etchings better than Delâtre, unless it were Whistler himself. And he was learning.

When the artists' quarter lured Whistler back, or he was planning an assault upon Tulse Hill, or another society home patronizing artists, he often stayed the night at Newman Street. He was "the pet of the set," Du Maurier reported, enviously. "Jemmy was adored," and was *"in love"* with the charming married sister of Aleco and Lucas Ionides, Aglaia Coronio—"which he has no business to be." Jimmy had no business even to be in love with the unmarried girls in the clan. His diminished status in the world left him with *entrée* as courtier but nothing more.

Unconcerned or unaware of the decorous flirtations going on around him, "Old Ionides," the family patriarch, bought Whistler's etchings, commissioned via Luke a portrait of his son, for which Luke sat at Newman Street, and listened to Whistler's songs and stories, and Du Maurier's finer tenor. Du Maurier, in turn, would take Whistler to the well-to-do Wightwicks, whose beautiful daughter Emma would later marry Du Maurier; but old Wightwick, his future son-in-law reported, "couldn't stand" Whistler, "tried to shut him up, failed and went to bed sulky and sick with a cigarette Jimmy made him smoke." Afterwards they went to Newman Street to sleep, where they "spent 48 hours during which he talked nearly the whole time. He is in my opinion the grandest genius I ever met, a giant—considered besides, as a 'wit,' greater than either [Theodore] Hook or Sydney Smith, by those who have met those swells." Whistler's prowess in the drawing room continued to amaze him several months later, Du Maurier noting in October, 1860, "Jemmy's *bons mots* which are plentiful are the finest things I have ever heard; and nothing that I ever read of in Dickens or anywhere can equal his *amazing power of anecdote.*"

Entrée into the artistic side of society kept Whistler leading a double—or even triple—life. The Wightwicks bravely invited him back, and he flirted harmlessly with Emma, although the invitation was clearly a means of decorously inviting Du Maurier. He met John Ruskin and Dante Gabriel Rossetti, Edward Burne-Jones and Laurence Alma-Tadema, and although few of his social contacts were owed to the Hadens

he remained sufficiently *persona grata* to return there to try to follow up his Academy success by beginning a new series of sittings with Deborah and Annie while continuing his trips to Rotherhithe.

The new canvas again utilized the music room, but Whistler worked hard to avoid the appearance of repeating himself. Tom Armstrong looked in and admired how he had handled Annie, this time seated; but Frederick Leighton, Du Maurier wrote Armstrong, "told him it was out of harmony, and the last time I saw him he was in complete despair, couldn't put it in again—hope it's all right now." Still aiming for color contrast rather than story value, he had placed Annie Haden, again in white, seated in the middle-ground reading, her mother only visible via her reflection in a mantelpiece mirror to the left, while filling the right side of the picture with the standing—and almost two-dimensionally silhouetted—figure of the visiting Miss Boot, in black riding habit from hat to heels. The impact is curious, for the massively black Miss Boot is almost surreal amidst the chintz-curtained and picture-hung fussiness of the quiet nineteenth-century room. An air of uneasiness invades the Victorian serenity. (Later he would retrospectively retitle the canvas by reducing the original title to a subtitle. It became *Harmony in Green and Rose: The Music Room.*

As 1860 became 1861 Whistler continued to lead several lives, exhausting his friends and his models and working simultaneously and intensively at a variety of projects. Working on *The Music Room* returned him regularly to the Hadens, where he and Du Maurier spent Christmas Day, 1860, and where he had not long before put Annie Haden to interminable sittings, until one day she was so tired that she wept. Full of remorse, Whistler had comforted her with a tenderness he seldom evinced, then before they sat again went out to buy her a Russian leather writing case as a peace offering.

There was always one subject he could return to for which sittings could be accomplished without tears—the murky Thames, leaden under a leaden winter sky, but exciting on the rare days when patches of ice formed around anchored ships, and slabs of ice floated downstream and were sent bobbing upstream again on the powerful tides. At the Rotherhithe dockside he found a subject so right that he could sketch the essentials outdoors in the chill, then paint it in three days—a large sailing vessel moored amid the ice, the background a hazy silhouette of buildings and smoking factory chimneys foreshadowing his later evocations of the

river. As with his etchings, *The Thames in Ice* was a discovery of the atmospheric qualities of a setting, the work of a realist moving away from realism.

Pleased with the canvas, he brought it to Knightsbridge, where Seymour Haden saw it and offered to buy it. Whistler, somewhat embarrassed over selling *At the Piano* almost off Haden's wall, told his brother-in-law that he could have it at any price he thought reasonable. Ten pounds, Haden said: three pounds for each of the three days it took to paint it, and a pound over. Chagrined, Whistler accepted the ten-pound note rather than wrangle over the price in the presence of his sister. "I did what she wanted," he later said, "to please her." He titled it *The Twenty-Fifth of December, 1860, on the Thames*, a day he and Du Maurier had spent by the fireside and the dining table with the Hadens in Sloane Street.

Soon after New Year's Day Du Maurier and Whistler teamed up with the Ionides clan to put on playlets after Sunday dinners at Tulse Hill, one of many done in an era before mechanical entertainment usurped relations between people; and just as Aubrey Beardsley would write the skits and design the hand-drawn programs for at-homes a generation later, Du Maurier contributed such deathless dramas as "The Thumping Legacy," his January 14 vehicle for Whistler and himself as well as Luke and Aleco—and Aglaia Coronio. The actors played in Greek costumes provided by the Ionides, fluffed their lines to everyone's amusement and nearly collapsed themselves when Du Maurier said, rather than "I would arrest you," as written, "I would eat you," and Whistler extemporized, "Are you quite sure you wouldn't throw me up?" Laurence Alma-Tadema, although in the audience rather than in the play, came clad appropriately—considering his predilection for painting classical tableaux —as an ancient Roman, in toga and crowned with flowers, but determinedly retaining his eyeglass. "Amazing!" Whistler said, "with his bare feet and St John's wooden eye!"

"I did my part stunningly," Du Maurier wrote his mother. "Jimmy was magnificent, but unfortunately got awfully drunk at supper and misbehaved himself in many ways." Whistler was having woman trouble, but it would soon be settled—almost settled—by the copper-haired Irish girl who was still sitting to him for *Wapping*.

If Whistler had worried over whether he could afford either a marriage or a mistress, London-style, rather than Left Bank, his successes

were leaving him, temporarily at least, in unusual solvency. His *French Set* had brought him £200, and an outright sale of the plates brought him an additional £100 in the spring of 1861, while Thomas was selling Thames etchings for a then-considerable £1 and £2 per proof, of which he divided the proceeds with Whistler, who complained that they were selling slowly. With no new canvas quite ready, he had offered *La Mère Gerard*, of Left Bank days, to the Academy, which had accepted it, although it was of no special distinction—an index, perhaps, of the level of Academy work in 1861. The *Athenaeum* nevertheless praised it as "fine" and "powerful-toned," while the *Daily Telegraph*, although noting its "evidence of genius and study," complained of "mud and clay" on Whistler's palette and suggested that it would be "far fitter hung over the stove in the studio than exhibited at the Royal Academy."

Fantin arrived from France to keep Whistler even busier early in the summer, and he exhausted himself with introductions for his friend. The Edwardses, rich patrons from Hampton Court, had a boat with which they often met Whistler and Fantin at the nearest railway station, and Whistler did several plates of the upper Thames from it; but either *la Tamise* had turned unfriendly or Whistler was finally reaping the results of overwork as well as exposure, for he again came down with rheumatic fever. "I have just heard a report that Jimmy Whistler is *dying*," Du Maurier wrote to his young aunt, "and although I do not believe it I am terribly perturbed in my mind, and am going to see him." The report proved only partially correct: Whistler was very sick, and took several months to recover fully; and the illness had several significant repercussions. He took a crucial trip to France, to convalesce, and he took with him a mistress.

Earlier, when he had been at an at-home theatrical at the Majors—cousins of the Ionides clan, with two attractive sisters—a curious incident had occurred. "I must tell you a funny thing he [Whistler] said to Rosa Major," Du Maurier reported to his worldly mother. "At their theatrical, he wore her pork-pie hat (that was the evening that he got so drunk); afterwards, it appears, Rosa M. found that somebody had spat in the hat and didn't wear it any more; and the other day she gave it to him, saying that he might have it as it had been spit in, and thinking that he would be much ashamed, but he took the hat quite delighted, and said:—'By jove, Miss Rosa, if that's the way things are to be obtained in your family I only regret I didn't spit in your hand!' (If Miss Rosa knew whose head her hat adorns at present, she would have kept it in spite of

the spit.)" In September Whistler had gone to Paris, and with him had gone Joanna Hiffernan, the splendid red-haired model for his *Wapping* canvas. She was now much more than a model.

VIII

Jo

THE ascent of Joanna Hiffernan from model to mistress was more a transition to a marriage without benefit of clergy. Jo had become a necessary part of Whistler's existence. Her parents were satisfied with the relationship, Patrick Hiffernan, a hard-drinking bohemian and typical stage-Irishman, referring to Whistler as "me son-in-law." Reciprocating the affection, Whistler apparently got along with both parents, an undated 1862 letter from Du Maurier to Armstrong reporting, "Jimmy came to town just for a day . . . the reason of his visit was the death of his *Mother-in-law:* about which he was quite sentimental and very much afraid that the bereaved widower—Joe's Papa, who is an impulsive and passionate Irishman—will do something to disgrace Joe's sisters."

Jo was as intelligent as she was beautiful, and before long was Whistler's bookkeeper as well as housekeeper, manager of his tangled affairs and model for his best work of the period, sometime painter herself and agent for his paintings. Even before he had left with her for France, all his friends knew of Jo, and many had met her at the Thames-side inn where they shared rooms while *Wapping* was being painted. Afterwards she would be the foster-mother of Whistler's son John, the product of an uncalculated risk Whistler took with a willing model, and described lightly as "an infidelity to Jo." John Charles Hanson's mother was a

housemaid, Louisa, quickly abandoned; Jo dutifully was the surrogate mother even when the father proved neglectful. Among her many attributes was loyalty, and she demonstrated more of it than Whistler deserved.

In Brittany with Jo in September 1861, Whistler recuperated by the sea. They went on to Paris when the late autumn weather began to worsen, and rented a studio in the Boulevard des Batignolles, where Whistler, with Jo sitting to him, began a canvas deliberately aimed at challenging the Academy and the Salon. He had probably read Gautier's poem *"Symphonie en blanc majeur,"* and having already painted Annie Haden twice in white determined to emphasize whiteness. Even his Breton painting, in which he depicted a peasant girl asleep among the rocks at low tide, and had first thought of calling *Alone*—and did at first title *Alone with the Tide*—is unmistakable evidence of the hold of subject painting (or at least of the commercial pressure for "story") that he felt operative in Academy and Salon juries. This time he deliberately eschewed the temptation, or at least most of it. All the furniture was removed from the end of the studio where Jo would pose, and the wall hung with a white cloth, beneath which Jo stood on a brownish-white wolfskin rug. There would be no subject or story, but there would be the theme of whiteness. When he left with Jo for a brief return trip to London in February he was still struggling with it.

Whistler had been engaged in an angry correspondence with Serjeant Thomas about the slow sale of his etchings, and wanted more control over his own work, although he had originally signed a seven-year agreement. Whistler even engaged a shrewd lawyer, and according to Tom Armstrong carried copies of his correspondence with Thomas in his pockets to read gleefully to friends because he thought they were clever and amusing. The exchange had become more bitter; then it ceased. Thomas had died; his sons were now handling his affairs. Whistler thought he could manage them, and returned from Paris to see, suddenly appearing early one Sunday morning in Du Maurier's Newman Street studio, sitting on the edge of the bed and recounting his adventures in France at great length. "I wrote to the old scoundrel," he said of Thomas, "and he died in answer by return of post—the very best thing he could do!" Then Whistler went on to describe his seacoast picture and "the woman in white," and Du Maurier reported it vividly to Tom Armstrong: "Red-haired party, life-size, in a beautiful white cambric dress standing against a window which filters the light through a transparent white muslin curtain—but the figure receives a strong light from the right and

therefore the picture barring the red hair is one gorgeous mass of brilliant white. My notion is that it must be a marvellously brilliant thing—you can fancy how he described it."

That evening Whistler, again alone, turned up at the rooms of Tom Jeckell, where a number of his artist acquaintances had gathered. Henry Stacy Marks, the art critic of the *Spectator*, was there, and teased Whistler—who he knew had no fondness for the brilliantly lit riverscapes of J. M. W. Turner—because Seymour Haden had just hung a swirling Turner watercolor at Sloane Street. Whistler dismissed Turner, but expressed great disgust at the fuss Haden had made about a proper frame, turning the discussion somehow into an attack on Turner for being so particular about being mounted, rather than on Haden for the hanging. "Particular!" scoffed Marks about Turner, "why he'd leave his pictures in his court yard to be pissed àgainst!" "Well," said Whistler, satisfied that he had been right about Turner all along, "that accounts for some of the damned peculiarities we're obliged to swallow!" Much later, when he was asked by a lady to help her determine whether a picture she wanted to buy was a genuine or a sham Turner, Whistler refused, observing, "But, after all, isn't the distinction a very subtle one?"

On the following afternoon Whistler brought Jo to Du Maurier's studio, "got up like a duchess, without crinoline—the mere *making up* of her bonnet by Madame somebody or other in Paris had cost 50 fr. . . . —They have both gone back to Paris." Du Maurier's own sexual starvation gnawed as he thought of Jimmy Whistler flaunting his Jo. Referring to another artist whose relationship to his models was a good deal more remote, he added to Armstrong, ". . . fancy a fellow wanting to get into the good graces & something else of some woman, & remaining at home to study her peculiarities. . . . Our friend Jimmy would be down on his knees directly he saw her & pulling up her petticoat etc." Possession of Jo did not make the cocky, abrasive Whistler any the better loved by his friends.

Working to exhaustion through the winter in an attempt to make the deadline for submission of *The White Girl* to the Academy, Whistler, back in Paris, made his own early breakfasts, attacked the canvas by eight each morning, and ended, dissatisfied, and with what Du Maurier called "painter's colic." The aggravation was not only over the painting, for in an excess of friendship Whistler had invited the incorrigibly bohemian Ernest Delaunoy to share their Boulevard des Batignolles quarters. Jo and Ernest bickered constantly, with Whistler, too much the loyal comrade to

evict the impossible Ernest, taking out his frustrations in a fight with a hackney coachman. Drouet visited to watch the progress of the painting, as did Courbet, for whom Whistler, proud of Jo's beautiful hair, drew it down over her shoulders as she stood for him, the better to display it.

With the painting done by early spring, and Whistler eager to offer it to the Academy hanging committee, he and Jo had an excuse to extricate themselves from Ernest. Jo, writing from London, reported the impact *The White Girl* was already having on Whistler's friends. It was "a fresh sensation—for and against. Some stupid painters don't understand it at all while Millais for instance thinks it splendid, more like Titian and those of old Seville than anything he has seen—but Jim says for all that, perhaps the duffers may refuse it altogether." Jo went with Whistler everywhere except to such houses as Haden's, although Whistler continued to use 62 Sloane Street as his professional address. It was a respectable location, and he would always attempt to have it both ways—to enjoy the boons of Bohemia and the blessings of respectability.

Taking no chances, Whistler submitted not only *The White Girl* and an etching of *Rotherhithe,* but *Alone with the Tide* and—borrowed from Haden, and faithfully promised back—*The Thames in Ice.* And, because his stay in Paris had left him short of money, he offered wood blocks of a commercial variety to the pictorial weeklies. Two appeared as illustrations to *The First Sermon,* published in *Good Words*—a girl crouching by a fire, near a man seated at a table with his hand on a lute, and a seated girl at a writing desk. The work compromised his principles, but purity of principle was uncertain even in his paintings done at the time, and literary illustration was fashionable, remunerative, and often then of high quality. No one denigrated Burne-Jones, Tenniel, and Simeon Solomon for illustrating Dickens's novels, Tennyson's poems, or other lesser works which today survive only as vehicles for their better-remembered illustrators.

Even a volume published by Day and Son that year, *Passages from Modern English Poets,* had two etchings by Whistler (and one by Millais), done for the Junior Etching Club. But *The Angler (The Punt)* and *A River Scene (Sketching),* both Thames scenes, illustrated the contents only coincidentally, and a later critic writing on English illustration in the 1860s noted that "in these the master-hand is recognisable at a glance, although the authorship of the rest can only be discovered by the index." For *Once a Week* Whistler contributed four wood blocks, each bringing

him a necessary £9. One, *The Relief Fund in Lancashire*—a strong and characteristic sketch—curiously appeared without the work it was to illustrate, for Tennyson became ill and his address on the famine in Lancashire never happened. One of them Du Maurier described as "first rate," adding about other Whistlerian activities, "Jimmy . . . is in his furnitures somewhere with Joe, *qui devient de plus en plus insupportable et grande dame* I am told. His pictures have met with no mention as yet I believe but they look glorious."

Where Whistler was then living—in furnished lodgings—was a small two-story brick house at 7A Queen's Road,* just beyond the Royal Hospital for sick and pensioned servicemen in Chelsea. It was not a location guaranteed to give Jo delusions of grandeur, but Whistler's prospects, at least, looked good, and she was sharing them. They continued to look good even when the expected news came that *The White Girl* had been rejected by the Academy, for Whistler's other submissions were accepted. He garnered a good press, although he complained to George Lucas that the two canvases accepted were "stuck in as bad a place as possible." The *Athenaeum* even compared the *Rotherhithe* etching to Rembrandt, a comparison increasingly made but with no impact upon Whistler's sales. John Millais was already earning £3000 a year, eight hundred of it, Du Maurier wrote his mother enviously, from magazine wood blocks. "On the other hand there is Jimmy, almost the greatest genius of the day, with scarcely any big enough here to rank by him, who isn't making a *sou,* and borrowed a shilling from me yesterday." The pattern would be repeated all through Jo's life with Whistler.

When money ran desperately low, which was often, Jo would be seen, as "Mrs Abbott," in Bond Street, where to sympathetic but nevertheless careful art dealers she brought small drawings, watercolors and prints for which she was prepared to accept shillings where Whistler in his pride would have asked vainly for pounds. (Some were her own, and if the dealer was not quick to perceive the difference, Jo was even less quick about disabusing him.) Genius was not its own reward, although on occasion a drawing could be bartered for something at the grocer's. When even that was impossible Jo resorted to extreme measures, once stopping Ford Madox Brown in the hall as he arrived for a party to beg him to go to the poulterer's and purchase a pound of butter. "The bread was cut but

* Now Royal Hospital Road.

there was nothing to put upon it. There was no money in the house, the poulterer had cut off his credit, and Mrs Whistler said she dare not send her husband for he would certainly punch that tradesman's head."

Nevertheless, Whistler was getting recognition. An international exhibition at the South Kensington Museum included *Thames Warehouses* and *Black Lion Wharf*, bringing him accolades as "the most admirable etcher of the day." Then Matthew Morgan opened a gallery at 14 Berners Street, just off Oxford Street and close to Newman Street, advertising his aim of "placing before the public the works of young artists who may not have access to the ordinary galleries." It was not quite true of Whistler and some of the others displayed, but it was an opportunity of showing the rejected portrait of Jo, which appeared there in June in the company of works by Frith, Poynter, Egg and Maclise. "Nothing daunted," he wrote to Lucas, "I am now exhibiting the White Child at another exposition where she shows herself proudly to all London! That is, to all London who goes to see her. She looks grandly in her frame and . . . in the catalogue of this exhibition is marked:

'Rejected at the Academy'

What do you say to that! Isn't that the way to fight em!"

Unfortunately, Morgan labeled the painting *The Woman in White*, suggesting a literary relationship which had never occurred to Whistler. The *Athenaeum* then criticized the painter for failing to live up to the story his picture promised. It was both "able" and "bizarre," said the *Athenaeum*'s critic, and justifiably rejected by the Academy. "It is one of the most incomplete paintings we have ever met with. A woman in a quaint morning dress of white, with her hair about her shoulders, stands alone in a background of nothing in particular. . . . The face is well done, but it is not that of Mr. Wilkie Collins' *Woman in White*."

The result was the painter's debut in the press, his first of many letters to the editor in his curious, sometimes almost foreign, prose published in the *Athenaeum* on July 5, 1862:

62 Sloane Street, July 1, 1862.

May I beg to correct an erroneous impression likely to be confirmed in your last number? The Proprietors of the Berners Street Gallery have, without my sanction, called my picture "The Woman in White." I had no intention whatever of illustrating Mr. Wilkie Collins' novel; it so happens, indeed, that I have

never read it. My painting simply represents a girl dressed in white, standing in front of a white curtain. —I am, &c.,

James Whistler

The novel, which had been recently and immensely successful, was about a beautiful and mysterious young woman, reputedly mad, who dressed entirely in white. Story-conscious critics saw a mysterious air and disturbing gaze (perhaps madness?) in Whistler's figure. Even Courbet had called it *"une apparation du spiritisme."*

In France he seemed to be at least partly understood. At Martinet's Gallery in Paris his Thames etchings were on display that summer, and Baudelaire in the *Revue Anecdotique* and later in *Le Boulevard* praised *"jeune artiste americain, M. Whistler,"* for his sensitivity to the atmospheric effects of the waterfront in "etchings that are as subtle and as lively as improvisation . . . ; a wonderful jumble of rigging, yardarms, and cordage; a chaos of fog, furnaces and spiraling smoke; the profound and complex poetry of a vast city." Yet the artist, unsatisfied, complained to Fantin, "Baudelaire waxes poetical about the Thames but says nothing about my etchings themselves."

For solace in his professional frustrations, nevertheless, there was always the responsive Thames. One of his new acquaintances even provided him with an intriguing new perspective of it. Walter Severn, a civil servant and amateur painter, and his younger brother Arthur, an aspiring painter just returned from Rome, lived in Manchester Buildings, on the north bank just below Westminster Bridge. At high tide the river washed against the walls of the house, and covered part of the pilings which still surrounded the piers of the newly completed bridge. "It was the piles, with their rich colour and delightful confusion that took his fancy," Arthur Severn remembered, "not the bridge, which hardly showed. He would look steadily at a pile for some time, then mix up the colour, then holding his brush quite at the end . . . make a downward stroke and the pile was done." It would be Whistler's *The Last of Old Westminster*, to be sent to the Academy the next year.

When it seemed as if the only funds Whistler could count on were from the magazine work he despised, old Alexander Ionides appeared as *deus ex machina* and commissioned new work. Whistler, reported Du Maurier, would "start for Venice with Joe on the proceeds." The socials in Holland Park and Campden Hill often had the results which

exhibitions failed to accomplish. Much of Victorian social life was exclusively male—clubs and bachelor parties at which real business never seemed to rise to the surface. Nevertheless, beneath the conviviality, connections were made, and had their results. Veteran professionals in the arts and letters like Thackeray and Trollope, aspiring ones like Severn, and rising ones like Whistler would turn up, each as interested in the moneyed consumers of culture as in each other, yet eager to swap professional gossip. One of the most looked-forward-to invitations of this sort in the early 1860s would come from Arthur Lewis, an amateur painter and musician as well as a keen huntsman and whip, who lived in what Du Maurier described as the "bachelor's paradise" of Moray Lodge, a house on Campden Hill where on Saturday evenings he gave parties announced by an elaborately designed card announcing "Music at 8.30; Oysters at 11." Here a group of amateur singers, including *Punch* illustrator Charles Keene, would sing part-songs, glees and madrigals in Lewis's large billiard room, where the carefully covered surface of the billiard table held pipes, jars of tobacco, cigars, tankards and bottles. At the end of the serious part of the concert a lavish buffet featuring oysters was unveiled, and humorous songs, recitations and conversations in corners filled the remainder of the evening.

At one Moray Lodge party three men talking in a group were pointed out to Arthur Severn as the Prince of Wales, the Duke of Sutherland, and Poole, the fashionable tailor. The editor of *Punch* was usually there with such of his staff as Leech and Tenniel, and Millais, Frith, Holman Hunt, Augustus Egg and Anthony Trollope were regular guests. Toward the end of the evening, if he were present, everyone would call for Whistler. He would pretend reluctance; then he would be seized and hoisted to a high stool, where he assumed a comic grimace, slowly adjusted his eyeglass and surveyed his audience, which only yelled the more that he begin. When there was, finally, silence, using his thin, expressive hands for emphasis, he would sing songs in *argot* French, imitating what he had heard in Parisian cabarets, and his favorite "plantation" songs. The War between the States had been underway in America, and there was much sympathy with the Southern cause in England; but Whistler's Southern songs took no sides, although he did personally, his brother William serving as a young medical officer in Lee's Confederate army.

To his friends Whistler had been talking about a sketching journey to Venice with Jo once the exhibition—and social—season was over. It failed to materialize. He had been ignoring his complaints for some months, but

apparently was suffering from white lead poisoning, the result of his prolonged work, in an airless Paris studio, on *The White Girl*, now aggravated by additional painting. Dr Arthur Chapman, whom Whistler had met earlier in Paris, advised a trip to the Pyrénees, and Whistler accepted the suggestion as an opportunity finally to go to Madrid, on a pilgrimage to the country of Velasquez. Enthusiastically, he wrote to Fantin, urging that he join Jo and him, and when Fantin answered that he could not, Whistler promised him a detailed account of all the important pictures in the Prado, especially those by his adopted master. But Jo, too, was ill, "very full of coughs" and requiring the "mild air of the South," he wrote to Lucas. The mountain air had to be foregone.

They went to Guethary, on the coast between Biarritz and St Jean-de-Luz. Although they remained there until late in the autumn, and Whistler began a number of canvases, he completed only one, frustrated by his experiments in trying, while using paint sketchily, to capture the immediate impression of a scene with as few details as possible. To Fantin he explained, "In any case, these pictures painted out of doors after nature, *en plein air,* cannot be anything else than large sketches; a bit of floating drapery, a wave, a cloud; it's there for a moment, then it disappears and the true tone has to be caught in flight just as one shoots a flying bird. But the public demands a finished product."

One of the problems, he explained to Fantin, was working in unfamiliar territory. It was difficult to get adjusted, and it was more difficult to find local models, who then only posed after "a great deal of coaxing." But with Jo available as model, he began a painting representing her "quite clear and in rose" in a group with an old woman in black and a sailor in a red shirt, with a background of "waves that are superb (in nature); breakers so solid that they seem carved in stone." It was to be a "drawing room" painting, he told Lucas when he was so confident of completing it that he wrote to Paris to order for it "a very pretty frame, highly finished, brilliant and rich, deep also, and rather broad." But the weeks went by with little real accomplishment. "I am almost demoralized by these lost days—and these weeks which pass by," he complained to Fantin. "Now I am compelled to abandon my picture until next year. I will leave my canvas here and return to finish it. Yes, *mon cher,* you are right—painting after nature, this ought to be done at home." It was true that *la Tamise* was home, and not the Bay of Biscay, but the breakers "carved in stone" had their impact—one wave he painted and a second which nearly put an end to his painting altogether, as he described vividly to Fantin:

The sea here is terrible. I was carried away by a strong current which dragged me towards those breakers in question, and if it had not been for my model in the red shirt I should have left my canvas unfinished. Because I should have been stone dead. The sea was enormous. The sun was setting, all lent itself to the occasion, and I saw the land getting further and further away. A wave fifteen feet high engulfed me, I drank a ton of salt water, passed through it, to be swallowed up in a second twenty feet high, in which I turned round like a Catherine-wheel and was overwhelmed by a third. I swam and swam, and the more I swam the less I approached. Ah my dear Fantin, to feel one's useless efforts and lookers-on to be saying, "But this gentleman is amusing himself; he must be jolly strong." I cried, I howled in despair, I disappeared three, four times. At last they understood. A brave railway employee ran and was twice rolled over on the beach. The bathing-attendant, my model, heard the call and arrived at a gallop, jumped into the sea like a Newfoundland, succeeded in catching my hand and the two pulled me out.

The other wave—"a sea piece of deep tone," he called it in a letter to Lucas—he caught on canvas in *The Blue Wave: Biarritz,* which anticipated Courbet in depicting a broken wave and was a mood-piece rather than an attempt at realism. It was more successful than his reservations to Fantin suggested; yet his expedition to the Basses-Pyrénées had been in part in order to continue on to Madrid.

The pilgrimage to the Prado continued as far as Fuenterrabia, across the Spanish frontier. "Ah, my dear Fantin," he exclaimed, "a splendid country! . . . It was the most extraordinary thing to see the complete change in customs, faces, houses, in everything, by simply crossing a small river, the Bidassoa. A matter of twenty minutes! . . . The houses covered with green balconies, as in bad paintings, each filled with dark-skinned maidens eating chocolate all day long. Comic-opera Spaniards in the streets, and others who look natural in a beret and red blouse. And children—the town swarming with them, wild and looking like little Turks."

From the frontier Whistler promised Fantin that he would take notes and describe every Velasquez work he could see. Yet he would not dare attempt the sacrilege of copying a Velasquez, for such work was "of that glorious type which does not allow itself to be copied. Ah, my dear one,

how he must have worked!" But Jo found the climate increasingly disagreeable, and longed for the familiar fogs of London. The remainder of the trip was abandoned. "I am delaying my visit to Spain until next year," Whistler wrote Fantin, "and you will come with me. . . . It will be a sacred pilgrimage for us, and nothing should hinder us from making it. . . . Thus let us give each other our hands and swear to it." *

Instead of continuing, Whistler and Jo returned to Paris, where Whistler went about his framing activities—he had had his Westminster Bridge picture forwarded from London, and retrieved *The Blue Wave* from Guethary—and sent Jo back to London, to set up housekeeping again. By late December he was back in England, complaining of rheumatism and the after-effects of his near-drowning, and keeping to his bed.

The trip to France had hardly restored him to robust health, but remaining under his blankets would neither pay his bills nor help him move to the permanent quarters in London he and Jo had determined they needed. "Jimmy and Joe are as thick as ever," Du Maurier cynically wrote Tom Armstrong. "Jim is going to retire from the world altogether and work hard. As a beginning he is getting up some private theatricals at the Greeks'. . . ." Whatever one thought of it as a way of obtaining commissions, it worked. £300 in orders from the Greeks were in hand by February, 1863, and Whistler and Jo leased 7 Lindsey Row, overlooking the Thames near Old Battersea Bridge.

* Years later, in one of his last letters to Fantin, Whistler would write, "Madrid, not yet."

IX

Salon des Refusés

F ROM the little house on Lindsey Row (now 101 Cheyne Walk),
next to the faded but once splendid Lindsey House, Whistler could
sit on the sill, see Battersea Church and the irregular outline of the
factory chimneys on the opposite bank of the Thames, and paint the
passing river traffic. But his mind was elsewhere: he was still striving for
an Academy success as well as a Salon acceptance, and had new work for
the Academy to consider. For the biennial Salon he would defiantly offer
The White Girl. He went to Paris himself, carrying the rolled-up canvas,
and in Fantin's studio had it framed for the Salon before he left with
Legros for Holland, where his etchings were exhibited at The Hague and
would win a gold medal.

The most interesting place in Paris for artists in 1862 was the shop of
Madame de Soye, at 220 Rue de Rivoli. It offered oriental objects of art,
with little distinction between nationalities and cultures, although it went
by the name of *La Porte Chinoise*. Its wares demonstrated the new interest
in oriental culture in the West which followed Commodore Perry's
expedition of 1853–54. Whistler was a customer, and would augment his
collection of fans, Ukiyo-e prints and blue-and-white porcelain. Whistler
had apparently known Japanese woodcuts as early as 1856, from
Bracquemond's accidental find in Delâtre's shop, but the real impact upon

him of oriental art seems to have occurred after his 1862 trip to the continent. Even the house on Lindsey Row in retrospect would take on an Eastern aspect, its spare interior simplicity as much, however, indebted to Holland and Puritan New England as the Japan which Whistler's acquisitions of Orientalia would suggest to visitors. Matting covered portions of the bare floors, and here and there a Whistler etching would adorn otherwise bare walls. Rare highlights of color would appear in the starkly furnished rooms, and even in the artist's studio, its walls pale yellow to pick up the light, there was an absence of clutter—only a chair, a bench, a screen, an easel and a small table to hold a palette. All the places in which he would live would reflect the same severity. He no more tried to be modish in his home than he did for Salon or Academy hanging committees.

Before he left London he had sent to the Academy *The Last of Old Westminster*—finally finished and removed from the Severn sitting-room*—and six prints, including one of Jo asleep (*Weary*), her long hair a halo. It might have been better had both not been accepted, since Whistler's canvas was hung (in Du Maurier's description) "down on the ground," and he swore to no effect that he would take a penknife and cut it out of the frame. Other young painters had better luck. Val Prinsep's portrait of his unhandsome but socially prominent mother was hung "right on the line," and Frederick Walker's *Lost Path* (a girl lost in a snowstorm), his first oil, was "right at the top in the North room." Thus Whistler had to place his bets for recognition upon Paris.

Nine hundred and eighty-eight canvases were accepted for the 1863 Salon. Nearly three thousand were rejected. In London Whistler's work, while generally tolerated, suffered the fate of being badly hung and usually misunderstood. In Paris the Hanging Committee, the old enemy of originality, refused him altogether, along with works by Manet, Fantin-Latour, Legros, Bracquemond, Vollon, Harpignies, Pissarro, Cazin and others Whistler admired, and at the Café de Bade, where a group of young artists met every evening from five-thirty to seven, the protests rang. Within the week the Parisian intelligentsia had complained so loudly about the mediocrity of the chosen canvases and the merit of the works the Salon had refused, that seeking a way to demonstrate his liberalism, the Emperor Napoleon III, on April 22, suddenly appeared at the *Palais de l'Industrie*, accompanied only by his equerry, and demanded

* It was sold almost immediately to John Cavafy, an Ionides kinsman.

to be shown both the accepted and the rejected pictures. The staff of M. de Nieuwerkerke, who presided over the Hanging Committee, apoplectic with anxiety, hurried about and found some forty representative canvases. The Emperor looked them over and went back to the Tuileries, from which he sent for de Nieuwerkerke, who was apparently terrified and in hiding. When he could not be found the Emperor summoned a Salon subordinate and ordered him to reconvene the Committee and reconsider the rejected paintings. The official pleaded that such a proceeding would cause the Committee to resign in a body and destroy the Salon's prestige, and that its conservatism was a bulwark against subversive elements in society which would only be encouraged by the sanction of radical works. The Emperor agreed that the Committee should not be given the opportunity to resign; instead the public would be given the opportunity to see all the works submitted, the rejected as well as the accepted, and all in the same *Palais de l'Industrie*, although in different rooms.

Two days later the Emperor's decision was published in the *Moniteur*, and on April 28 a second notice announced that "the exhibition of rejected works" would open a fortnight after the official Salon, on May 15, and that artists who did not want their works so exhibited had to reclaim their canvases before May 7 or be automatically furnished hanging space. After the first celebrations in the studios, Parisian painters began to look more soberly at the alternatives, especially when the conservative press began to refer to the "Salon of daubs." Accepting the exhibition space might put one on the Hanging Committee's list for eventual—and perhaps perpetual—revenge. Rejecting the chance, however, was implicit support of the Salon's condemnation. The former risk seemed more grave than the latter to hundreds of painters, who thronged the *Palais de l'Industrie* to remove their work; Whistler instead worried from Amsterdam that Martinet—to whom he had entrusted his canvas in event of rejection—would reclaim it for his own gallery. "This matter of the Salon of the Rejected is charming!" he wrote to Fantin. "I must surely leave my painting there! And you yours also. It would be foolish to withdraw them to put them at Martinet's." He would return to Paris in a few weeks to see everything, he added; but he did not. Both he and Jo were there via *The White Girl*, but the old spell of Paris was nearly gone.

Panic had reduced the number of exhibitors in the "Counter-Salon," already beginning to be known as the *"Salon des Refusés,"* and the Salon hierarchy, alert to undermine the Emperor's intentions, encouraged the hesitant to withdraw rather than be "submerged in a mass of nonentities."

Shrewdly, too, the authorities carefully hung the worst canvases on the line, and printed no catalogue; and when the Marquis de Laqueuille, editor of the *Beaux-Arts*, offered to publish a catalogue at his own expense, he could not get a list of the contributors and their canvases from de Nieuwerkerke. After he managed, anyway, to compile a catalogue on his own, he was prevented from selling it in the *Palais de l'Industrie*. Yet the harassments only made the event more anticipated, seven thousand tickets being sold in the first few hours after the official opening, with curious crowds milling about the dozen exhibition rooms along with the critics, and arguing loudly about the merits of each work.

Napoleon III's political instincts proved wrong. The public, instinctively conservative, saw only a "Salon of Pariahs," a "Clown's Exhibition," a brazen attempt on the part of the inferior to set themselves up against the established values of such formidable artists and arbiters of taste as Meissonier, Picot, Robert-Fleury and Flandin. Even the Empress Eugénie, no prude in her private life, found Manet's *Déjeuner sur l'herbe* immodest, and the Emperor had to confess that a picture of two fully clothed gentlemen (too well-dressed to be artists) picnicking with a naked woman (their model?) lent a disquieting atmosphere to the *Salon des Refusés*.* Why hadn't he been shown it when he asked to look at sample canvases? And why hadn't he been shown the equally disquieting *Le Fille blanche*?

Whistler's painting proved a *succès pour rire*. Émile Zola's novel *L'Oeuvre* (1886) communicates the atmosphere vividly:

> It was all very well set out; the setting quite as luxurious as that provided for the accepted pictures: tall, antique tapestry, hangings in the doorways, exhibition panels covered with green serge, red velvet cushions on the benches, white cotton screens stretched under the skylights, and, at the first glance down the long succession of rooms, it looked very much like the official Salon, with the same gold frames, the same patches of colour for the pictures. But what was not immediately obvious, was the predominant liveliness of the atmosphere, the feeling of youth and brightness. The crowd, already dense, was growing every

* Manet had adapted a portion of Marcantonio Raimondi's crowded engraving of a lost Raphael *Judgment of Paris*. The crowds offended by the unclothed woman sitting unconcernedly with her friends would not have given the canvas a second glance had Manet also shown the morning-coated and grey-trousered men in classical Parnassian nudity.

minute, for visitors were flocking away from the official Salon, goaded by curiosity, eager to judge the judges, convinced from the outset that they were going to enjoy themselves and see some extremely amusing things. It was hot; there was a fine dust rising from the floor; by four o'clock the place would be stifling.

In *L'Oeuvre* the "Woman in White" was "a curious vision, but seen by the eye of a great artist," while to popular opinion Whistler's canvas and its companions were such a source of innocent fun that

the women had stopped stifling their merriment with their handkerchiefs, and the men, completely unrestrained, were holding their sides and roaring with laughter. It was the contagious hilarity of a crowd bent on amusement, gradually working itself up to the point where it would laugh loudly at nothing and be just as convulsed by beautiful things as by ugly ones. . . . The "Woman in White" . . . was rarely without her group of grinning admirers digging each other in the ribs and going off into fits of helpless mirth. Every picture had its peculiar attraction; people would call to each other to come and look at this or that, and pithy remarks were heard on every lip.

For the English *Fine Arts Quarterly* Philip Hamerton wrote, "The hangers must have thought her particularly ugly, for they have given her a sort of place of honour, before an opening through which all pass, so that nobody misses her. I watched several parties. . . . They all stopped instantly, struck with amazement. This for two or three seconds, then they always looked at each other and laughed. Here, for once, I have the happiness to be quite of the popular way of thinking." Fantin saw it differently, writing to Whistler, "Now you are famous. Your picture is very well hung. You have won a great success. We find the whites excellent; they are really superb, and at a distance (that's the real test) they look first class. Courbet calls your picture an apparition, with a spiritual content (this annoys him); he says it's good. . . . Baudelaire finds it charming, charming, exquisite, absolutely delicate, as he says. Legros, Manet, Bracquemond, de Balleroy and myself; we all think it's admirable." Another French critic, Paul Mantz, called it a *Symphonie du Blanc*, and Whistler afterwards changed its title to *Symphony in White, No. 1*, the first of the musical terms he would use to emphasize the abstract elements in his work.

To Fantin he wrote that he longed to be there and hear what was being said in the Café de Bade; but instead, in Holland, he searched for interesting old paper for printing and blue-and-white china for his house in Lindsey Row, and he etched Amsterdam scenes. Then he went back to London. Twelve of his prints had been bought for the Print Room of the British Museum, and his funds from the Greeks had not run out; yet he knew that the £60 he had spent on fine china was a dangerous extravagance.

Legros was then living in Lindsey Row with Whistler and Jo, and the two painters were planning an exhibition which would include Fantin-Latour. "We are comprising more than ever the Society of the Three," he wrote to Fantin ebulliently. "We are going to become rich and quickly. . . . For each to support the two others is to support himself; we are all egotists and all quite different, but I am faithful to the words of the Society. . . ." Fantin's own loyalties to the "Three" were less fixed; yet his newest canvas, in a way a celebration of his expectations for his circle, would include Whistler and Legros. Eugène Delacroix had died in August, and Fantin, Manet, and Baudelaire had been among the few mourners who had followed the coffin to the cemetery. Delacroix had been academic and old-fashioned in his own work but hospitable to the new in art, and Fantin, feeling that it was a scandal that so few mourned the loss, decided to paint, in the tradition of Franz Hals, a *Hommage à Delacroix*—himself and a group of his friends—gathered about Delacroix's self-portrait: Manet, Whistler, Legros, Bracquemond, Baudelaire, Champfleury, Duranty, Cordier and Balleroy. Four had been rejected at the Salon. Not until the next spring, with submission time for the new Salon near, did Whistler hurry over to Paris to sit for his place in it, frock-coated and elegant with his gloves folded over the head of his cane, a confident smile creasing his lips. He was the only non-Frenchman in the group.* The Hanging Committee accepted the barely-dry canvas, and Whistler thus appeared in the 1864 Salon—on Fantin's canvas. There was no new *Salon des Refusés*.

Pleased with his success, Fantin planned yet another and more daring group portrait, *Verité: Le Toast*. A tribute to realism in art in which he was emboldened by the scandalous *Déjeuner* of Manet, it featured Whistler—at his own request—incongruously in Japanese costume and

* Dante Gabriel Rossetti was supposed to be in the picture and Whistler had even written to Fantin, "Reserve two good places," but Rossetti never managed to go to Paris for a sitting.

with flowers in his hand (to emphasize his new Eastern interests), Manet toasting a nude, winged female who represented Truth, and a group of soberly dressed artists. Prudently, Fantin dismembered it after the 1865 Salon, separately framing the head of Whistler; but Whistler began sketching his own ideas for such a canvas, ten feet by six or seven, to be set in his studio, "porcelains and all," and composed of groupings of his models and friends as well as a self-portrait. Jo and another model would be in Japanese draperies, while Fantin and Albert Moore—who would soon replace Legros in the Society of Three—would be in ordinary clothes. It would be, he wrote to Fantin, an apotheosis of everything shocking to Academicians. It went no farther than two small studies of the artist in his studio, brush in hand, and two models—Jo lounging on a divan, the other holding a fan.

To pose for the *Hommage* canvas which had started it all required a journey to Fantin's studio. Because of unexpected disarray in his domestic arrangements, Whistler had been unable to get to Paris any sooner. Legros had been spending more time at Lindsey Row than pleased Jo, especially after the long jaunt of the two artists together through Holland; and Whistler's loyalties were put to the test. By November, 1863, Du Maurier was writing to Armstrong, "Jimmy and Legros are going to part company, on account (I believe) of the exceeding hatred with which the latter has managed to inspire the fiery Joe: one never sees anything of Jimmy now. . . ." Legros moved out, and the relationship cooled; but the final breach did not occur till several years later, the subject supposedly money Whistler claimed was long owed him.

The real cause was women, William Michael Rossetti informed the Pennells many years later. The final breach occurred in the office of Luke Ionides, when Legros and Whistler, already on strained relations, by chance appeared in Luke Ionides' office the same afternoon. From another room Ionides heard Legros say to Whistler, "You lie!" Whistler knocked him down and Ionides rushed in to separate the pair. Afterwards friends tried to patch up the quarrel, which by then had been aggravated by a commission Legros thought should have gone to him but went instead, at Whistler's suggestion, to Fantin. Whistler dismissed the suggestion that he apologize to Legros. "A man gives you the lie to your face and you naturally strike him." They never spoke to each other again.

After the eviction of Legros there was a new complication. Anna Whistler was eager to leave the United States and be near her son and stepdaughter, now that—after Gettysburg—there seemed no likelihood

that the Confederacy would prevail. Her sympathies lay with it and she lived for a time in Richmond, from whence her son William would leave as well upon the defeat of the South.

Willie was a military surgeon with a Southern unit, unable to be with his young wife when she died in March, 1863. But Anna Whistler had been there at her side, and soon afterwards determined to slip through to the North and thence across the Atlantic to the rest of her family. By autumn she was en route to England, ill throughout the voyage and for the first four weeks she spent in London, but serene in her feeling that she had done the right thing. With Deborah Haden living in relative splendor in Knightsbridge and Jimmy Whistler in modest fashion in far less splendid Chelsea, the move of Anna Mathilda Whistler to 7 Lindsey Row seems curious on the face of it. Yet Deborah was only a stepdaughter, and her warm correspondence over many years did not include an invitation to live at 62 Sloane Street, where Mrs Whistler knew she would be guest rather than chatelaine. Jimmy was an authentic son, and in her Scotch Presbyterian fashion Anna Whistler was going to save her firstborn son from himself.

Jo loyally moved out into lodgings, nevertheless remaining nearby as model and mistress. As a woman she was a chattel. As a mistress her status was no better. Whether or not she had shared bed and board with Whistler, as a woman of low-class origin Jo knew not to expect marriage with a man who by comparison was a blueblood. She accepted the inevitable.

Anna Whistler, fifty-six, frail, and failing in sight, was not so blind as to misunderstand the relationship, but she wisely chose what she wished to see and acknowledge, even after a quarrel about Jo at the Hadens in February, 1864. Haden, waxing newly indignant over Whistler's improper behavior, led him up four flights of stairs to lecture him in his private workroom, then turned him out of the house, pursuing him down the stairs and scolding him all the way. But as Whistler found the front door closing on him he discovered he had left his hat behind. "Jimmy came in again," Du Maurier reported, "got his hat and went and said goodbye to his mother and sister." Wearily, he asked Haden, "And now, have we got to go all through this again?"

"It appears," Du Maurier detailed to Armstrong, "he had told Haden that he (Haden) was no better than (Jim)! *Hinc illae assaultae et batteres,* for it positively amounted to that. . . . I've not mentioned it to any but you; it's a deuced unfortunate thing and there is little chance of ever a

raccommodement." Although Victorian morality so often involved the hypocrisy of surface behavior, Whistler's brother-in-law had not ignored Jo's existence: he had in the past only denied her admission as a guest under his roof. "The best of it is," Du Maurier noted, "that Haden has dined there [at Lindsey Row], painted there,* treating Joe like an equal; travelled with them and so forth, and now that Joe is turned into lodgings to make place for Jim's mother, and Jim is living in respectability, Haden turns round on him and won't let Mrs H. go to see her mother in a house which had once been polluted by Joe's presence. Droll, eh? I wonder Jim cannot agree with Haden, knowing him so well—I always get along capitally with him. I say with a deferential air and rather timidly: Mr Haden, doesn't it occur to you that snow in reality, is of a fine jet black colour? And he answers heartily in the affirmative—but by jove, he won't stand bullying or chaff."

Whistler and Jo were having an awkward time adjusting to the revised relationship, yet Du Maurier put the blame on Jo's jealousy, and found his own recent wedded bliss with Emma an improvement over bonds lacking benefit of clergy. Whistler, he thought, was, as a result of it all, "in mortal fear of Joe," and "utterly miserable," and had grown "spiteful and cynical *et pas amusant du tout.* I fancy the Joe is an awful tie."

For Anna Whistler Lindsey Row was sufficiently respectable. She wrote her sister Kate that the house was very commodious, "with delightful parlors and bedrooms, an excellent kitchen, laundry, pantries, etc." The area's romantic past excited her as well, and she added that it had once been "the court end of London as far back as Henry the 8th," and "the residence of Courtiers," and "what tales the old walls could tell." Some of the more recent tales would have been about Whistler and Jo, but Anna Whistler's presence in the studio portion of the house was not encouraged.† Once she made the mistake of going to the studio uninvited and discovered the maid standing to Whistler in the nude. It was a shock, although she might have consoled herself with the fact that the maid was standing; and afterwards she visited only on invitation, usually to take trays of lunch and tea when a prospective purchaser or a model was present, or when her son worked alone.

* A Haden plate, *Battersea Reach*, bears in its first state the inscription "Old Chelsea, Seymour Haden, 1863, out of Whistler's window." Another dated 1863 is entitled *Whistler's House, Old Chelsea.*

† "I am never admitted there, not anyone else but his models," Anna Whistler wrote her friend James Gamble on June 7, 1864.

On Sundays Whistler would escort his mother to square-topped Chelsea Old Church, a short walk away, and leave her at the door. But she was happy nevertheless. "I think in the small Churches there is a more Evangelic spirit," she wrote an American friend, and "So I find it under Rev. Davies." Soon Whistler was showing her off to his friends and patrons, and she was flourishing. Although Whistler regretted the inconvenience to Jo, after ten years' absence he found that he truly loved his mother in his own fashion and settled comfortably into the new domestic arrangements, while expecting Jo to remain to him what she had always been. Just as Jo—as *The White Girl*—had been denied respectable exhibition space in the Salon and had to settle for something less, even in Chelsea, she found, there was for her a *Salon des Refusés*.

X

Tudor House

WHY Whistler had moved to Lindsey Row becomes clear from a London map of 1863. It was on the unfashionable, Battersea Bridge edge of Chelsea, which made the rent cheap, while still providing an uncluttered view of the Thames from the window. At the Royal Hospital corner of Chelsea the paved Thames Embankment already supported a wide road intended to run between Vauxhall and Battersea Bridges, and it had gone as far as the Hospital and the new (1858) Chelsea Bridge before being halted by the high cost of construction. But where it had already gone the roadway had cut off access to the river. Seven Lindsey Row was on the near side of the wooden and elderly Battersea Bridge. It was, despite the name, a continuation of Cheyne Walk to the west, and within walking distance of the large, curious "Tudor House" of Dante Gabriel Rossetti at 16 Cheyne Walk.

"Jimmy and the Rossetti lot, i.e., Swinburne, George Meredith, & Sandys," Du Maurier had written to Tom Armstrong in October 1863, "are as thick as thieves"; and he freely quoted a Fontaine fable about the animals living amongst themselves as cousins, their union

> ". . . si douce et presque fraternelle
> Enveloppe tous les voisons."

"Their noble contempt for everybody but themselves," he complained, "envelops me I know . . . but I think they are best left to themselves like all Societies for mutual admiration of which one is not a member." Unlike the rest of Whistler's friendships, the one with Rossetti lasted. When he died in 1882, Whistler said of him, simply, "Rossetti was a king." Even later, when he wrote some scraps of autobiography, he observed, again invoking a royal metaphor, that Rossetti was "a Prince among his fellows. Well do I remember with strong affection the barbaric court in which he reigned with joyous simple ingenuous superiority as he throned it in Chelsea."

Whistler discovered a bizarre, bohemian atmosphere in Tudor House unlike anything else he had ever experienced. Swinburne and Meredith both lived there for a time, and John Millais, Ford Madox Brown and other Pre-Raphaelite visitors, a curious Anglo-Portuguese art connoisseur and confidence man named Charles Augustus Howell, and a menagerie of exotic animals. Rossetti's friends, if not painters themselves, were at least on the fringes of art. His brother William Michael was a critic, and Thackeray and Swinburne more than occasional writers on the subject, in the fashion of Baudelaire and his generation across the Channel. Thackeray, who could draw as well as write, could be acerbic in print about his painter contemporaries, once writing about a Landseer portrait of Nell Gwynn that it was "too refined . . . Nelly never was such a hypocrite as to look as modest as that." Meredith even modeled for a famous painting, Henry Wallis's *The Death of Chatterton*, which was painted in the attic in Gray's Inn where the despairing young poet had poisoned himself, and was exhibited at the Royal Academy in 1856. Whistler could abet the literary relationships, and through Fantin-Latour on a trip to Paris was able to arrange a meeting between Swinburne and Baudelaire, as well as between Swinburne and Manet, and the poet reciprocated by identifying Whistler to Ruskin as "the first critic who so far overpraised my verse as to rank it above his own painting." Rossetti, too, was attracted to Whistler, perhaps seeing Pre-Raphaelite tendencies in the contemplative, almost other-worldly *White Girl*; and as a connoisseur of women Rossetti found Whistler's own connections useful. It was through Whistler, for example, that he discovered "the Greeks."

"Rossetti's first appearance at the Tulse Hill house," Tom Armstrong recalled, "was on one summer Sunday, when a cab-load, such a cab-load was perhaps never seen except at an Irish funeral, set out from Chelsea: Whistler, Rossetti, Du Maurier, Legros, Radley and myself were in or on

it. It seems to me that there were others in that four-wheeler, Poynter perhaps, but I am not sure, and I want to be accurate. The occasion was a memorable one. Then for the first time was revealed to this artistic circle the beauty of two girls, relations or connections of the Ionides family, and daughters of the Consul-General for Greece in London, Mr Spartali. We were all *à genoux* before them and, of course, burned with a desire to try and paint them."

Christine Spartali, elegant, voluptuous and "spiritual" in the Pre-Raphaelite sense, was already known as a Rossetti type in the mold of William Morris's wife Jane, the Movement's *grande dame*. Whistler longed to paint her, finally combining his new oriental interests with his *White Girl* style while using her as model. "Jimmy has painted, or nearly painted," Du Maurier reported to Armstrong early in 1864, "a chinese woman which Gambart has bought for £100—I hear it's very fine." It was Miss Spartali, in a Japanese robe, a portrait Whistler entitled *La Princesse du Pays de la Porcelaine*. He had first tried out his concept with another model, using oils on a small wood panel, but had quickly discarded her, and had not completed the kimono or the background on the preliminary version when Miss Spartali had offered to pose for a large portrait.

The sisters went to Lindsey Row for the sittings. Whistler carefully prepared in advance a rug and screen in place in the studio, and had small preparatory studies in oil and pastel before him. But after twice-a-week sittings during the winter of 1863–64 the portrait seemed far away from completion, each sitting adding little to the canvas. Whistler would gaze at his model, look at the picture from a distance, dash to it and give it a stroke with his brush, then move away. From half-past ten until nearly two the process continued; then Mrs Whistler provided lunch in the studio—sometimes including raw tomatoes, American style, and canned apricots and cream; and at least once there was roast pheasant with champagne. Then the sitting—or, rather, standing, since Miss Spartali was not allowed to rest—continued until four, when sitter and companion were released.

When Christine Spartali fell ill, Whistler used a model for the gown, and when she recovered enough to permit Whistler to do a pencil drawing of her head, few further sittings were necessary. Yet the outcome was less than Whistler had hoped. Although Christine and her sister Marie wanted their father to purchase it, the elder Spartali did not care for it. When another prospect complained that the signature was too large,

Rossetti took it into his studio and soon found a buyer for it, the London art dealer Ernest Gambart.

Rossetti's help in selling the portrait had an unexpected benefit. The bold scrawl of a signature, he had told Whistler as the canvas stood unsold, would not do; and he suggested something more discreet—a symbol like the potter's mark on a blue-and-white vase, or initials such as the "P.R.B." once used by the members of the Pre-Raphaelite Brotherhood. Whistler owned more than enough initials, and dropping *Abbott* in favor of *McNeill* used a "J.M.W." which he gradually shaped into the famous butterfly. Eventually it replaced his initials altogether, even in his correspondence; but the first canvas to receive the butterfly is unknown: earlier purchasers of his work sometimes asked him to apply the ideograph *ex post facto*. He did.

The relationship with Rossetti, Du Maurier thought, augured well for Whistler. "Whistler is getting on very well now," he wrote his mother in April 1864, "wonderfully so considering that he is the great genius and innovator, the sort of fellow who dies [neglected] in a hospital, while centuries after him has a statue put up." Du Maurier had been to a bachelor party with Rossetti, Whistler, and Swinburne at the home of the amiable and gentle young artist Simeon Solomon. "Such a strange evening," Du Maurier wrote; "Rossetti is the head of the prœ-raphaelites, for Millais and Hunt have seceded; spoilt so to speak by their immense popularity;* whereas Rossetti never exhibits and is comparatively unknown; this strange contempt for fame is rather grand. . . . As for Swinburne, he is without exception the most extraordinary man not that I ever met only, but that I ever read or heard of; for three hours he spouted his poetry to us, and it was of a power, beauty and originality unequalled. Everything after seems tame, but the little beast will never I think be acknowledged for he has an utterly perverted moral sense, and ranks Lucrezia Borgia with Jesus Christ; indeed says she's far greater, and very little of his poetry is fit for publication."

Swinburne seemed at home amid the curiosities Rossetti collected in Tudor House. A wispy carrot-colored mustache and thin beard attested to

* At the height of his fame John Millais earned between £20,000 and £40,000 a year and was reputed to have sold his *North-West Passage* for 4,700 guineas; Holman Hunt, who was advised by Charles Dickens what to charge for his work, probably received the highest price then paid to a living English artist for an easel picture when he sold a second copy of his famous religious anecdote *The Light of the World* to Charles Booth for 12,000 guineas. Booth presented it to St Paul's.

the frailty of his masculinity more than his ballads about cruel and beautiful women. Still, he enjoyed being in the proximity of the lusty Pre-Raphaelites and worshipped their women from a respectful distance—Rossetti's plump cockney Fanny, Whistler's red-haired Irish Jo and Sandys' dusky gypsy Kiomo. Then—or after a particularly stimulating bachelor party—fortified with whisky and a dip into his collection of de Sade, he would put on his top hat and frock coat and find his way to a discreet house in St John's Wood where he paid two "golden-haired and rouge-cheeked" women to whip him. Whistler knew of Swinburne's foibles and fetishes, since the poet made little secret of his love for the literature of flagellation; but both loved French literature and art, and admired each other's work, Swinburne saluting Whistler in his letters as *mon père*.

In Swinburne, the delicate son of a British admiral, Mrs Whistler found someone to mother, although if she knew of his sadistic predilections she might have treated him with less exemplary sweetness. She read her Bible, however, and not Swinburne's privately distributed *Whippingham Papers*, and ignored the haze of whisky which surrounded him as a manly frailty to be foreborne. At one gathering in Whistler's studio, Lord Redesdale remembered, all the men were busily smoking, but the artist had neglected to provide anything to drink. Swinburne sat there with increasing impatience, then stood silent and rigid, and finally screamed into the thickening haze, *"Moi, je ne fume jamais, mais je bois!"* But no one seemed to hear his plea, and nothing alcoholic arrived. Nevertheless, once at Lindsey Row Swinburne was overtaken by a convulsive fit, either epileptic or alcoholic, and Mrs Whistler nursed him with tender solicitude, keeping him there until he was well enough for the rigors of Tudor House. Once, too, at Lindsey Row, when he was sitting at her feet, she addressed him as "Mr Swinburne," and he appealed to her, "Mrs Whistler, what has happened? It used to be Algernon!" "You have not been to see us for a long while, you know," she said. "If you come as you did, it will be Algernon again." And it was.

George Meredith's stay at 16 Cheyne Walk was more brief, as Rossetti concealed an imperious presence beneath his brooding eyes and baggy clothes. Rossetti had given a dinner on April 30, 1863 for several of his patrons, including a Newcastle lead merchant, during which Meredith, turning his wit almost entirely upon ridicule of Rossetti's pictures, had been in unusually brilliant form. Mortified by such a scene in the presence of people who bought his work, the painter decided to ask

Meredith to reside elsewhere. Two months later Meredith was still paying his share of the rent and had no idea he was so out of favor, but he had indiscreetly mentioned some difference of his with Rossetti to a cabman—perhaps the dinner—and the cabman afterwards conveyed both Rossetti and the tale. The last supper had begun in typical Tudor House fashion, with Swinburne declaiming between dishes from *Leaves of Grass* while the pet wombat nibbled at Rossetti's cigars, and Whistler and Howell oblivious to both. But Rossetti was indignant. Meredith had been living with him practically as a guest, but if he could gossip to cabmen he was no gentleman—and for emphasis slapped a serving spoon into the dish of meat in front of him, the hot gravy splashing into Whistler's face. Meredith took his bags and his leave.

Although Meredith recalled that "merry bouts between us were frequent," Whistler sourly could summon up only a few of them; but Meredith was at the least a good listener, and remembered tales of the unwashed Ernest Delaunoy all his life. As a raconteur, Whistler found him wanting, as he would "sit back, his head sunk in his chest, his eyes closed, looking like a stupid Buddha in a second-rate temple, and paying not the slightest attention to the rest of us. Then he would suddenly come to, heave himself like a mountain about to deliver itself of a mouse, and get off some pompous epigram apropos of nothing."

Swinburne, however, could even deliver himself of a poem in praise of a Whistler picture, and the artist was delighted. The occasion was *The Little White Girl* (afterwards prefaced by the title *Symphony in White, No. 2*), for which Jo again posed. In the winter of 1864 Mrs Whistler had gone to Torquay for her health, and Jo moved back briefly to Lindsey Row. In *The Little White Girl*, Jo, standing and dressed in white, holds a Japanese fan, while on the mantel behind her is a blue vase. Above the mantel is a mirror, in which her wistful expression is reflected, another Whistler bow in the direction of seventeenth-century Dutch painters, whose gentle domestic settings used mirrors and frames to provide a sense of spaciousness and geometrical arrangement. Swinburne was enchanted by it, although its tranquility was seemingly alien to his nature, and wrote a poem, "Before the Mirror," in which he found story values which the artist regularly claimed to eschew:

> Come snow, come wind or thunder,
> High up in air,
> I watch my face, and wonder
> At my bright hair. . . .

Whistler, who reciprocated by doing an etching of Swinburne, thought the poem was a "rare and graceful tribute," and "a noble recognition of work by the production of a nobler one," while Swinburne countered by writing Ruskin that "whatever merit my song may have, it is not so complete in beauty, in tenderness and significance, in exquisite execution and delicate strength, as Whistler's picture. . . . " He was going to take Burne-Jones the following Sunday to Whistler's studio, and urged Ruskin to accompany them. "Whistler (as any artist worthy of his rank must be) is of course desirous to meet you, and to let you see his immediate work. As (I think) he has never met you, his desire to have it out with you face to face must spring simply from knowledge and appreciation of your own works."

Whistler actually had Swinburne's poem printed on gold paper and pasted to the frame, and when *The Little White Girl* was shown at the Royal Academy in 1865, he had two stanzas printed in the exhibition catalogue. To Whistler Swinburne explained the Pre-Raphaelite inspiration of his verses, "entirely and only suggested to me by the picture, where I found the metaphor of the rose, and the notion of sad and glad mystery in the face languidly contemplative of its own phantom and all other things seen by their phantoms." "Gabriel," he also noted, "praises them highly."

Whistler admired the stocky and unprepossessing yet magnetic Rossetti even more than his Tudor House boarder. He wrote of him as *"un grand artiste"* to Fantin-Latour, but seemed to have preferred him as a person. "A charming fellow, the only white man in that crowd of painters," he told the Pennells; "not an artist, you know, but charming and a gentleman." When Rossetti framed a picture he had painted, then wrote a sonnet on the subject and read it to his friend Jimmy, Whistler's advice was to "take out the picture and frame the sonnet." Privately, Rossetti had low opinions of the work of Whistler's Parisian friends, among whom he included "a man named Manet," whose pictures were "for the most part mere scrawls." He would not have French art in his house, but for the canvases of Legros; thus Whistler's break with Legros was a source of acute discomfort for Rossetti, who liked them both, and realized he could never have them in the house together again. "I could imagine myself in a moment of exasperation, committing such an assault upon a friend," he confided to his brother William; "but if so I should the next moment kneel down with shame and compunction and implore his pardon." Called upon by a contrite Whistler to be a mediator, Rossetti

wrote to him deprecating his "rowdyism on this and other occasions," and declining the assignment; but they continued to be friends, the gentle Rossetti afterwards careful whom he invited to Tudor House when Whistler was expected. One letter to Anderson Rose, the loyal and patient solicitor for both men, invited him to dinner but added that because he was also inviting Thomas Hughes (author of *Tom Brown's School Days*), who was such a quiet man, he would not have Whistler at the table.* Rossetti's bachelor gatherings were nevertheless seldom quiet ones, especially when Swinburne was present and would read an obscene or satiric skit, as his *Fille du Policeman*, in which Queen Victoria has a twin sister who is ravished by the *Bishop de Londres*, or would read extracts from de Sade's *Justine* while his listeners screamed with laughter and Swinburne excited himself to the brink of a fit.

Visiting Tudor House was one of the more unusual experiences in Victorian London. Rossetti had a passion for exotic things and exotic behavior, this aspect of his personality becoming more extreme after the chloral-overdose death of his model-mistress-wife Elizabeth Siddall, his sonnets to whom he remorsefully placed, in manuscript, in her coffin in February, 1862, not long before he first met Whistler. There were always other interesting women around Rossetti, but the gloom persisted, and on moving to Cheyne Walk in October, 1862 he decided to rid his mind of morbid thoughts by collecting exotic animals. There was a raccoon who liked raw eggs, and a pet wombat who died of eating too many of Rossetti's cigars, but before the tragedy, Whistler remembered, it was allowed on the dinner table while the men had coffee and cigars. There were also peacocks, which roamed the house except when fastidious guests were expected, when they were let out into the garden: and there was a gazelle, who fought with a peacock, "until," Whistler remembered, "the peacock was left standing desolate with its tail apart strewed upon the ground." Even more self-destructive were the quarrels of Rossetti's two kangaroos, mother and son, which apparently killed each other. Another time Rossetti gave a party, Ellen Terry recalled, to celebrate the awakening of his white dormice from winter hibernation. "They're awake now," he announced, "but how quiet they are! How full of innocent repose!" Then prodding them encouragingly, he said, "Wake up!" But they were dead.

* Yet Hughes in 1863 had been a founder member, with Whistler, of the Arts Club at 7 Hanover Square, which also included Charles Dickens, Monckton Milnes (Lord Houghton), and Edward Godwin.

Most interesting of all was the zebu, which Whistler christened a "Bull of Bashan," bought in April, 1864 by Rossetti for £20 at the Crémorne amusement gardens upstream from Chelsea, "brought home by two men, led through the hall, out into the garden at the back, and its rope fastened to a stake." Rossetti was assured that it was quite tame and would only cost "about 2s 6d. a week for keep." At least the former was accurate, and Rossetti, Whistler recalled, "used to come and talk to it. One day the bull got so excited it pulled up the stake and made for Rossetti, who went running round the garden, tearing round round and round a tree, a little fat person with coat tails flying, until, at last he managed to rush up the garden stairs and slam the door. . . . Then he called his man and ordered him to go and tie up the bull, and the man, who had looked out for the rest of the menagerie, who had gone about the house with peacocks and other creatures under his arm, rescued armadillos, captured monkeys from the tops of chimneys, struck when it came to tying up a Bull of Bashan on the rampage, and gave a month's warning."

One of the many paradoxes about Rossetti was his willingness to collect creatures which had the freedom of the house, including the dinner table, while he simultaneously acquired rare Orientalia, especially fragile seventeenth- and eighteenth-century blue-and-white porcelain. In the latter love he had a formidable rival in Whistler. To Whistler's chagrin he sometimes found his friend bidding against him and raising the prices for both of them, at the firm of Farmer and Rogers in Regent Street, whose manager, Lazenby Liberty, sensing the wave of the future, soon opened his own shop on the opposite side of the street. When it came to Nankin blue-and-white, Rossetti, whose resources—and zeal— were greater than Whistler's, would not be outdone. According to one story which appears in various versions (but here retold in a version current in Whistler's lifetime), an unnamed friend of the poet, who collected old china, once invited a number of people to supper in order to exhibit a valuable plate he had just purchased. Among the guests was Rossetti, who made an excuse to stay the night and left early the next day. Soon after his departure it was discovered that the priceless plate was missing; but its owner said nothing, instead contriving soon afterwards to get invited to dine and sleep at Tudor House. In the middle of the night he got up and prowled the cupboards for his treasure, finding it eventually under a pile of clothes at the bottom of a wardrobe, wrapped in paper.

Substituting an ordinary dinner plate from the kitchen, he took his property home in the morning. Sometime afterwards Rossetti called on him greatly excited. "I never saw anything like it!" he exclaimed. "I'm simply surrounded by a set of confounded thieves. What do you think? You know that plate of yours? Gone, my dear fellow! Stolen, and a common piece of crockery left in its place!"

The obsession could cause peculiar difficulties for Rossetti's or Whistler's hosts. The first time Rossetti dined at the home of Whistler's friend Albert Moore he was served soup. "I say, what a stunning plate!" he cried, and forgetting its contents turned it over to look for its mark. The flood that followed came as a complete surprise. Yet for Whistler and Rossetti, collecting blue-and-white satisfied more than an aesthetic or acquisitive craze. Years later Whistler would even observe, when Western troops were suffering unexpected reverses in China, "Better to lose whole armies of Europeans than harm one blue pot!" Both he and Rossetti used their purchases as props in their pictures, and were in the vanguard of the boom which Du Maurier would satirize in *Punch* in 1880, where the cartoon's Aesthetic Bridegroom, admiring a blue-and-white wedding gift, breathes, "It is quite consummate, is it not?" And the Intense Bride, cradling the object in her hands cries passionately, "It is, indeed! Oh, Algernon, let us live up to it!" By 1880 both men were out of the competition. Rossetti sold his collection in 1872. Whistler's creditors seized his in 1879.

Another attraction of Tudor House to Whistler was that Jo was welcomed there; and on Mrs Whistler's absences Jo would entertain Rossetti and Fanny Cornforth at Lindsey Row, where Jo would sometimes officiate at séances. In 1852 the first American medium to get extensive press coverage had arrived in London and almost immediately manifestations of rapping were recorded all over England, ladies even sending out invitations to "Tea and Table-Turning." Queen Victoria herself was alleged to have attempted communication with Prince Albert's shade, having, even earlier, awarded to one Georgina Eagle a medal for "Meritorious and Extraordinary Clairvoyance"; and from the Court down, interest in occult phenomena burgeoned.

"We often had table-turning at Jimmy's," Luke Ionides remembered, "but no very important results. He had an idea that Jo was a bit of a medium; certainly, the raps were more frequent when she was at the table, but I cannot recall any message worth repeating. Jimmy believed in

it more or less. One day when Rossetti joined us, the latter broke up the séance after a time by saying, "You'd better stop that, otherwise you will all go mad."

One day when Whistler was about to leave the studio with a model, he later told Mortimer Menpes, a disciple, he suddenly asked her to place her hands upon a table and use her will power. She did, and soon there was a knocking and rapping seemingly emanating from the table. "Gentle spirit," Whistler inquired tentatively, "is it good?" There were more noises, identified as indicating that the spirit was saying, "No, it is bad." "Gentle spirit," said Whistler then, "don't come again!" And to make sure he removed the table. The model was Jo.

Rossetti encouraged Jo's experiments in spirit-rapping at his own house as well; however Whistler's memories were of Lindsey Row. "One day, I and the White Girl went into her room and just the two of us alone tried the same experiment, and a cousin from the South talked to me and told me the most wonderful things. Again by holding a lacquer box, a beautiful Japanese box, one of the many wonderful things in the Chelsea house, between us, we had the same sort of manifestations. But it is a study, really, that would engross a man's whole lifetime, and I have my painting to engross me. [Do] I believe? Yes." It was a generation of growing unbelief in the traditional forms, and of the popularity of such mediums as Browning dramatized in "Mr. Sludge, 'the Medium' ":

> One does see somewhat when one shuts one's eyes
> If only spots and streaks; tables do tip
> In the oddest way of themselves: and pens, good Lord,
> Who knows if you drive them, or they drive you?

Whistler thought there might, nevertheless, be something in it. "The silliness, as a rule, of the spirit's performance? They may seem silly now, but wasn't the beginning of some of the wonderful electrical contrivances we have the mere dancing of little paper dolls on a table? The darkness that is always necessary? Why not? Everyone knows, there are certain chemicals that act only in the darkness. Why should it not be the same with the spirits? How can we understand the conditions that rule them? For myself, I have no doubt—the very fact that man, beginning with the savage, has always believed in them is proof enough."

The Whistler-Rossetti friendship reached its peak in the middle 1860s, and would persist for another decade. Ford Madox Ford wrote a half century later that the Tudor House circle, he discovered, had gone

beyond Rossetti's taking in Whistler's pictures to try to sell them. "Looking through some old papers the other day I came upon a circular that [Ford] Madox Brown had printed, drawing the attention of all his own patrons to the merits of Whistler's etchings and begging them in the most urgent terms to make purchases because Whistler was 'a great genius.' " The influence of Pre-Raphaelitism on Whistler, and Whistler's own ideas on Rossetti and his circle went beyond commerce, spreading to books and book design, furniture, wallpaper, house interiors and clothes, Whistler's "Japonism" encouraging a necessary simplicity in palette as a balance to the Brotherhood's preoccupation with medievalism, detail, and excess. Afterwards there was no bitter falling-out, as it was difficult to be an enemy of Rossetti's. Even the patrons whose money he took but whose canvases he never delivered were seldom moved to anger. Here, perhaps, in his moral anarchism, was Rossetti's most significant impact upon Whistler—not in the art-for-art's-sake doctrines the younger artist had been adopting independently, or in the mood-portraits and oriental decoration characteristic of Whistler at the time. Rossetti believed, or at least lived as if he believed, that the chief justification of a businessman's existence was to make possible the existence of artists, and his Tudor House dinners for his patrons, at which Whistler listened and learned, made the point without equivocation.

It was an attitude polar to the traditional relationship between artist and patron, especially the reciprocity with which Whistler, enlarging on Rossetti's example, not only accepted the hospitality of his patrons but returned it at ritual breakfasts and dinners. Patrons could be fed, and feasted upon. They could be guaranteed nothing else, except, perhaps, the attention of the artist. Bernard Shaw, who knew the later Whistler, as well as Rossetti's reputation, may have borrowed this philosophy for his Louis Dubedat, the rogue-artist of *The Doctor's Dilemma*, who fails to feel conscience-stricken about not delivering a painting because he had "nearly all the money" from the patron in advance. Whenever in later years this attitude would dictate Whistler's own practice, he would explain it in terms of the claims of art over its ostensible owners, but possibly it was the ghost of Rossetti.

XI

A Portuguese Person Named Howell

"ONCE in a while," Whistler remembered modestly, "I would take my gaiety, my sunniness, to Ford Madox Brown's receptions. And there were always the most wonderful people—the Blinds,* Swinburne, anarchists, poets, musicians, all kinds and sorts, and in an inner room Rossetti and Mrs. Morris sitting side by side, being worshipped, and, fluttering around them, Howell with a broad red ribbon across his shirt front, a Portuguese decoration hereditary in his family." In 1865 Howell's friends might still have believed his sensational reminiscences and his exotic pedigree—in any case his conversation was so lively that "dear little Owl" in 1866 was offered £200 by Ruskin to live nearby Burne-Jones in Fulham to help him through a period of depression. Burne-Jones remained as melancholy as ever, but Howell became Ruskin's bagman for his deeds of benevolence, although before long it was clear to everyone but the innocent Ruskin that his chief beneficiary was Howell.

Howell was always his own chief beneficiary. "Criminally speaking," said Whistler, "the Portugee was an artist." A pirate among the

* Mathilde Blind was a poetess in the Pre-Raphaelite circle and author of an early study of George Eliot.

Pre-Raphaelites, he had a gift for fraud, and could buy, sell or steal anything. "I hear, my dear Burnand," Whistler once wrote to the comic dramatist and future editor of *Punch*, "that you have fallen under the fascinations of the modern Macaire! *—otherwise Bobadil el Chico! alias 'the Owl'—known to you as Charles Augustus Howell." One of Rossetti's many limericks memorialized him:

> There's a Portuguese person named Howell,
> Who lays on his lies with a trowel;
> When I goggle my eyes,
> And start with surprise,
> 'Tis at the monstrous big lies told by Howell.

Rossetti nevertheless utilized Howell's formidable talents as factotum. The price was high, for he stole whatever he could, but he got high prices for whatever he did not steal, and his conversation, endlessly filled with schemes and stories, was so entertaining that one ignored its essential untruth. Howell encouraged Rossetti's collecting mania, buying and selling not only the English antiques which cluttered Tudor House, but Japanese screens, fans, and prints, and Chinese pottery and porcelain, selling some of the Orientalia twice, with Whistler sometimes the recipient and sometimes the victim.

He was half-Portuguese, born to an English father in Oporto, and quick-witted enough to talk his way into a minor post in the Portuguese Embassy in Rome before he was out of his teens. Soon he was in London, living on his light-fingeredness and his supple tongue. He dealt in anything and his dealings always became so deliberately complicated and confused that one scarcely knew whose money and whose property was whose at the end of a transaction. What belonged to others became his in no time. Rossetti's assistant Treffry Dunn told how they looked through a book of Rossetti's drawings and among the pencil and chalk sketches of many famous people came upon a beautiful face, delicately drawn and shaded in pencil, with a background of pale gold. "Howell, with an adroitness which was remarkable, shifted it from the book into his own pocket and neither I nor Rossetti ever saw it again."

Among Howell's exploits were the secret sale of items filched from Whistler's wastebaskets, from voided checks to discarded letters; the

* Robert Macaire was a character in *L'Auberge des Adrets*, a French comedy of 1823, the epitome of the clever and audacious rogue; Captain Bobadil was the boastful but cowardly soldier in Ben Jonson's *Every Man in His Humour* (1598).

invention of dramatic flogging scenes for Swinburne's delectation; the persuading of Rossetti to exhume his wife's body seven years after her death to recover the manuscript poems buried with her (and Howell even superintended the job) and the looking after of Whistler's son John when Whistler did not. Once Lord Redesdale rebuked Whistler for permitting himself to be seen walking down Bond Street with Howell, advising him, "My dear Whistler, even you cannot brave the people [any] longer. Howell, you know, is a robber." "Well, my dear Mitford," said Whistler, "so was Barabbas!"

There were times when Whistler needed what he defined as a Barabbas. Once, when he was more than usually hard up, he and his friends were discussing the construction of the Brompton Oratory, in South Kensington, and Whistler dashed off a sketch of his ideas for the church. It was a passing thought, and the sketch was tossed aside and forgotten. But not by Howell, who retrieved the scrap and carried it to Attenborough, the pawnbroker. When he came back it was with more money than any of the group had ever received for a pawned piece of work. Unredeemed, the sketch was forgotten until Whistler chanced by Attenborough's and discovered it in the window, with a large price tag and described as Michelangelo's first drawing for St. Peter's.

One summer in Chelsea, Whistler recalled, he was looking out of his window and saw Howell passing, with his mistress, a minor artist called Rosa Corder. He shouted out to them, and they came in. "It was astounding with Howell, he was like a great Portuguese cock of the poultry yard: Hens were always clucking about him—his wife 'Kitty,' and Miss Alice Chambers, and Rosa Corder. Well, they came in and I rang, and tea and ice and all sorts of wonderful things came up. . . ." Howell could not resist an entrepreneurial opportunity. "Why you have etched many plates, haven't you? You must get them out, you must print them, you must let me see to them—there's gold waiting. And you have the press."

Whistler confessed that he did have his own press, but it was rusty after not being used for a time. Howell would hear of no difficulties. He would fix it; he would even pull the prints. "And there was no escape. And the next morning, there we all were, Rosa Corder too, and Howell pulling at the wheel, and there were basins of water and paper being damped, and prints being dried, and then Howell was grinding more ink, and with the plates under my fingers, I felt all the love for it come back." In the afternoons Howell would solicit the print-sellers in Pall Mall, "and

there were orders flying about, and cheques—it was all so amazing. . . ."

Howell, of course, pocketed his commission, and then some. One evening they left a pile of eleven prints, just pulled. The next morning there were only five. "It's very strange," said Howell, "we must have a search. No one could have taken them but me, and that you know is impossible!"

A letter to William Rossetti dated February 18, 1869 indicates what Howell planned to do with the etchings he would deal with legitimately:

> I have bought Whistler's etchings and am going to publish the "Thames" (12 plates) at once. Publisher F. S. Ellis.
>
> Will you write me a nice preface? and perhaps two or three lines describing each plate? Some of the places being done away with (I think) by the Embankment, and each plate being of importance as a local record of Old London, etc., etc. What can you charge me for this, and when can I have it. If you say yes I will scrape up a set of the etchings and send them to you for reference and give you a month to write the thing in.

When Whistler wanted some proofs of his etchings he went to the printer but came back empty-handed, being told that the transaction was being accomplished through Howell, and that Howell had left orders not to give anything to anyone without written instructions. Whistler was furious and rushed off to his friend, who was full of sympathy and professed anger at the printer. "Very stupid of them!" "How foolish of them!" "Of course, my dear fellow, you are entitled to as many of your own proofs as you want. I will write a letter to them at once; you shall post it."

He scribbled off a note and read it aloud: "Give Mr Whistler the proofs he desires.—Yours very truly, C.A.H." With a flourish he tucked it into an envelope, addressed and stamped it, and Whistler posted it on his way home.

The next morning he went for his proofs, and when he was again refused them explained heatedly that there was a letter from Howell authorizing him to collect his own work. "We did have a letter from Mr Howell today, but it hardly gave us those instructions," he was told. "I am certain it did," Whistler insisted. "He read it to me. Let me see it."

The letter was produced but at arm's length from Whistler, who snatched at it and read, "Of course you will not give Mr Whistler the proofs he desires." The artist put the note in his pocket, flourished his

cane at the shop assistant who had been left holding the envelope, and strode off to find the letter-writer.

"What does this mean, Howell?" he raged, confronting him with the double-dealing note. "Oh, my dear fellow, how stupid of me," Howell apologized. He had intended, he explained, to put a period after *not*. "To separate sentences, my dear man. I am so sorry. A million apologies."

Although they went to the printer's together, Whistler still did not get all the proofs he wanted. "Some have been mislaid," said Howell. Yet the friendship persisted. Howell was useful.

The end of the relationship occurred some years later, after Howell lent his good offices in the matter of an ornate Chinese cabinet Whistler was selling to a friend, Sidney Morse. Since Howell was temporarily short of funds he took the cabinet home instead, and called in a pawnbroker named Chapman who agreed to lend £3 on it. Because Howell wanted the money immediately, although it was a weekend, he offered the pawnbroker the pagoda-shaped top of the cabinet as earnest of good faith, and promised delivery of the larger and less portable section on Monday. Chapman carried it away.

Then Morse called for his cabinet. Howell explained with regret that the top had met with a small accident and had been sent to a cabinetmaker for repairs. He was persuasive enough to get Morse to pay the amount due and take possession of the lower half, which he carried home in a cab. Then the pawnbroker was told the identical story about his missing half; but each part-owner was reassured that without his section the cabinet was of no use to anyone else. Before long the affair of Whistler's cabinet was in the hands of solicitors, although Whistler had received no money. The exchanges of letters lasted three years:

> Dear Sir—I am so sorry you took the cabinet away without examining it. I have written about the alleged missing headpiece, but, of course, I cannot say that it was ever during Mr. Whistler's ownership in any other condition. Yours etc.
>
> (Howell's solicitor to Morse)

> Dear Mr. Howell,
> I understand that you have the top of the cabinet I purchased from Mr. Whistler, and are kindly having it repaired for me. As some of the pieces are with me, perhaps you would kindly direct your man to see me about it.
>
> (Morse to Howell)

It is really too bad that you should be put to so much trouble. As to Mr. Whistler, I have not seen him for some two months. Mr. Howell I see frequently, and I have written him very strongly on the matter this evening. I expect it rests with him more than with Mr. Whistler.

(Howell's solicitor to Morse)

Mr. Howell is with me. It seems he has to-day been about the cabinet. Mr. Howell feels that Mr. Whistler has given him a great deal of trouble in a matter in which he has not the slightest interest.

(Howell's solicitor to Morse)

What is all this mystery relating to the top of the Cabinet I purchased from Mr. Whistler? The cabinetmaker in Bloomsbury, who had it in hand for repair, tells me that "you took it away from his shop some six or eight months back." Please send down the top to me without any further delay.

(Morse to Howell)

Accidentally, Whistler discovered the top in Chapman's pawnshop, paid the principal and three years' interest on the £3 Howell had borrowed, and reunited the halves of the cabinet.

This is *too too* charming of you! Quite too too. And every piece fits in, and the Cabinet is itself again. I am most curious to know where it turned up at last. . . .

(Morse to Whistler)

Received from Mr. Whistler £4 10s od. for the top of cabinet acquired by me under the following circumstances:

Mr. Howell called upon me on Saturday (about 30 August 1878), and took me with him to Bloomsbury to see a cabinet that he wished me to advance money upon. After examining the cabinet, I agreed to lend him £3 on account upon it as it stood; and, accompanied by Mr. Howell, I drove to my house (where I paid him £3) taking with me the top of the cabinet only—believing that I had thus secured the whole, for as Mr. Howell pointed out, the bottom would of course be worthless to anyone else without the top . . . and as the entire cabinet could not have been carried on the cab without great risk, it was arranged that I should send on the Monday for the remaining part.

I sent—and have often since sent—in vain. I need scarcely say that from that day to this I have seen no more of the cabinet.

I make this circumstantial statement at the request of Mr. Whistler, to whom the cabinet really belonged all the time, and to whom this accidental visit to my shop has restored the missing portion.

Thus by continually promising the bottom to the one who had the top, and the top to the one who had the bottom—and ingeniously dwelling on the supposed truth that either part was valueless without the other, Mr. Howell has for three years worked his brilliant idea of dividing the cabinet between us!

(Chapman to Morse)

Even then Whistler felt that he could not do without Howell; but with good humor and mock solemnity printed whatever correspondence he could gather about his friend's exploit and published a pamphlet, *The Owl and the Cabinet*, in which, he said, he had Howell "on toast." He also told the story at—seemingly—every dinner table in London. Howell thought the punishment more severe than the crime, and the friendship stretched thin. Years later, he died under circumstances as strange as his life. He was found in a gutter near a Chelsea public house, with throat slit and a half-sovereign between his clenched teeth.

Among the Whistler canvases Howell had not sold in his lifetime were eight or nine discovered in the office of someone with whom they had been left as security for unpaid bills. "Why," said Whistler on seeing one propped against a wall, "there's the portrait I did of myself." It had disappeared for twenty-five years. When Howell's personal effects were auctioned at Christie's, and a list published, Whistler identified the real owners: "That was Rossetti's—that's mine—that's Swinburne's. . . ." One item, Whistler's portrait of Rosa Corder, he described as "I firmly believe, the only thing Howell ever paid for in his life. I was amazed when I got the cheque, and I only remembered some months afterwards that he had paid me out of my own money which I had lent him the week before." But although Howell's price was often high, he would be loyal and available when Whistler needed him most for nearly twenty years. Once, for example, he took twenty shillings out of his pocket to give Whistler, and his remaining half-crown came out with it. "I might as well have that, too," said Whistler. Howell noted the transaction in his

diary on returning from Chelsea to Fulham, adding, "I walked home, damn him." Few artists were as fortunate as Whistler in having Barabbas as agent and factotum, in the guise of a Portuguese person named Howell.

XII

London to Valparaiso

NEIGHBORS of Whistler in Lindsey Row pointed him out, when he sat seated on his window sill sketching, as "the Japanese artist." Not only did he have a houseful of oriental artifacts, but would even pose models in Japanese dress against a backdrop of the Thames and the Battersea bankside. "Are you interested in old china?" his mother wrote a friend in America:

> This artistic abode of my son is ornamented by a very rare collection of Japanese and Chinese. He considers the paintings upon them the finest specimens of art, and his companions (artists), who resort here for an evening's relaxation occasionally, get enthusiastic as they handle and examine the curious figures portrayed. Some of the pieces are more than two centuries old. He has also a Japanese book of paintings, unique in their estimation. You will not wonder that Jemie's inspirations should be (under such influences) of the same cast. He is finishing at his studio a very beautiful picture for which he is to be paid one hundred guineas without the frame, that is always separate. I'll try to describe this inspiration to you. A girl seated, as if intent upon painting a beautiful jar which she rests upon her lap—a quiet and easy attitude. . . .

She went on to describe the painting Whistler first referred to as his Chinese Woman, and now known as *Purple and Rose: The Lange Lijzen of the Six Marks*. *Lange Lijzen* ("Long Elizas") was the Delft term for the tall decorative figures on the 17th-century Chinese vase, while the "six marks" referred to the potter's identifying "signature." Cluttered with oriental curios, the canvas was as Victorian as it was experimental; but Whistler was already working on paintings that would go beyond *The Lange Lijzen* in imposing an Eastern simplicity and stylization upon his models and his materials. In the process Jo and Mrs Whistler could hardly escape each other, for he used his mistress, more than anyone else, as his model, and turned his mother's "withdrawing room," where she had her "bright fire" and wrote her letters, into—in her words—"more than half studio." It was there that he displayed his blue pots, his fans and screens and Japanese prints; and he set up an easel among them as a second studio. He also started and left unfinished dozens of canvases, dissatisfied with the way his conceptions were being realized, and seldom returned to complete them. "Jemie is not a rapid painter," his mother explained, "for his conceptions are so nice; he takes out and puts over and oft until his genius is satisfied."

That February of 1864, despite his oriental experiments, he could not resist the river. The temperature had dipped, and ice floated down the Thames, tempting Whistler to sketch the scene from the open window while his mother, too curious to escape to another fireplace, shivered. One early 1864 drawing sold to "Old Ionides" took in Old Battersea Bridge, which had a special hold on him, but inevitably he returned before he finished these to the Eastern canvases which had been commissioned by the knights of commerce whose prosperity was crucial to the progress of his art. The *Lange Lijzen*, for example, would go to James Leathart of Newcastle. Another canvas his mother described as "portraying a group in Oriental costume on a balcony, [with] a tea equipage of old China; they look out upon a river, with a town in the distance." Tom Armstrong came by one evening just as Whistler was removing all the painting he had done on it "in a hard day's work," and suggested that he might have left it, at the least, until the next morning. "No," said Whistler, "if I had left it till tomorrow I might have persuaded myself that it was good enough to leave permanently." It would be called *Variations in Flesh-Colour and Gold: The Balcony*, and placed brightly dressed models against a backdrop of the Thames, and of factories dimly seen on the opposite bank.

Moody and uncertain of himself despite the cocky air he affected among his friends, Whistler confided only to Fantin-Latour his doubts about the direction in which he was going. What was the purpose of arranging Japanese fans on English shelves, and kimonoed ladies on Chelsea balconies? "I am horribly depressed at the moment," he wrote. "It's always the same—work that's so hard and uncertain. I am *so slow*. When will I achieve a more rapid way of painting[?]—when I say that, I mean to say something different; you will understand what I'm driving at. I produce so little, because I rub out so much. Oh! Fantin, I know so little. Things don't go so quickly."

Not only was he unhappy with his two newest small Thames paintings, but with his inadequacies in general as a technician. To make the incongruous—by conventional standards—come off was not so simple. Still, by the spring of 1864 he was pleased enough with his first completed oriental-inspired canvas, *The Lange Lijzen*, to chance sending it to the Royal Academy for the spring competition, and with it would go *Wapping*, which had dissatisfied him but which he had now hung in his drawing room while he decided whether to offer it to the Paris Salon or render it acceptable to the Academy. It was "the finest painting he has done . . ." Mrs. Whistler thought. "The Thames and so much of its life—shipping, steamers, coal heavers, passengers going ashore, all so true to the peculiar tone of London and its river scenes. It is so improved by his perseverance to perfect it! A group on the inn balcony has yet to have the finishing touches." Both were submitted to the Academy and both accepted, the critic of the *Athenaeum* describing *Wapping* (with Jo's *décolletage* now discreetly lifted) as an "incomparable view of the Lower Pool of London," and while praising *The Lange Lijzen* for its "superb colouring" and "beautiful harmonies," called the drawing itself "preposterously incorrect." But Anna Whistler, reading *The Times*, could feel justified in her opinions about *Wapping*. "If Velasquez had painted our river," said its critic, "he would have painted it something in this style." She may also have had something to do with its eventual sale, for it was bought by George Whistler's Baltimore brother-in-law, Tom Winans.

In her first months in London Anna Whistler was pleased with her progress in reforming and redirecting her son's way of life. That she was nevertheless a realist can be seen by reading between the lines of a letter:

> While his genius soars upon the wings of ambition, the everyday
> realities are being regulated by his mother, for with all the bright

hopes he is ever buoyed up, but as yet his income is very precarious.

I am thankful to observe that I can and do influence him. The artistic circle in which he is only too popular is visionary and unreal, tho so fascinating! God answered my prayers for his welfare, by leading me here. All those most truly interested in him remark upon the improvement in his home and health. The dear fellow studies as far as he can my comforts, as I do all his interests, practically—it is so much better for him generally to spend his evenings *tête-à-tête* with me, tho I do not interfere with hospitality in a rational way, but I do all I can to render his home as his father's was. My being in deep mourning and in feeble health excuses my accepting invitations to dine with his friends. I like some of the families in which he is intimate and I have promised to go to them when the birds sing and the flowers bloom in the fields. . . .

On the surface everything had changed; beneath, nothing. Just as beneath the oriental accessories on Whistler's canvases Jo remained the central figure in his art, so beneath the well-regulated life his mother laid out for him on Lindsey Row he lived another one apart. In the meantime Anna Whistler liked to think that she had merged the roles of wife and mother in herself.

One way Whistler could be alone with Jo outside the studio was to leave London; and he took her to Trouville and Deauville in Normandy, two resorts made fashionable by the presence of the Duc de Morny and the Empress Eugénie. In the summer of 1865 the social attraction was a robust forty-six-year-old former peasant named Gustave Courbet, whose work Whistler had long admired, who considered himself in political opposition to the Second Empire and would later go to prison after being on the barricades in 1871, but who, in the summer of 1865, was the guest of the Duc de Choiseul, whose dogs he painted. Whistler was more interested in his seascapes and dunescapes, which Courbet painted with a vigorously wielded palette knife. It was suddenly the rage to have one's portrait done by the artist, for whom visiting Hungarian and French countesses sat. "My fame has doubled," he wrote to his parents, adding, with some small exaggeration, "and I have become acquainted with everybody who might be of use to me. I have received more than two thousand ladies in my studio, all of whom wish me to paint their

portraits. . . . I have bathed in the sea eighty times. Only six days ago we bathed with the painter Whistler who is here with me; he is an Englishman who is my pupil."

Whistler was neither an Englishman nor Courbet's pupil, but he was an admirer, and Courbet reciprocated by admiring "the beauty of a superb red-headed girl whose portrait I have started"—Whistler's Jo. For Courbet and Whistler, Jo would clown about to draw them out of painterly talk of "space" and "horizon" and in the evening she would sing Irish songs with a verve she did not feel in London.. At least once they stole off at midnight from the hotel casino to the beach, and went out into the icy, moonlit breakers; while during the days from August through November they would eat their fill of shrimp salads with fresh butter, and steaming cutlets, then go out, Jo's hair streaming in the wind, to paint the sky and the sea. In *Harmony in Blue and Silver: Trouville*, Whistler paid his homage to Courbet, although his suggestion of space is more silken in its muted distances and high horizon. In the foreground is a note of reality—a stocky bearded figure in a sun helmet, looking out to sea. Courbet.

As a student in Paris, Whistler had been under the spell of Courbet's rough-hewn portraits and rugged pugnacity, and may have anticipated in his own early seascapes the work Courbet was doing at Trouville, although the Frenchman privately would say, condescendingly, "He has talent, little Whistler does, but he always makes the sky too low, or the horizon too high." "A stupid painter out there," Whistler told Val Prinsep about an objection to his painting a distant boat as a blur, "complained that I had not made out what kind of ship it was; but I said to him, 'To me it is not a ship but a tone.' " Whistler was making the most of his shortsightedness.

About Jo, Courbet had only superlatives. Whistler had done, several years before, a drypoint of her he called *Weary*, tracing on his copperplate the outlines of her voluminous skirt, her tight bodice and puffed sleeves, and especially her tired face against a background of loose, lush hair, as she once lay back, exhausted, in an overstuffed chair. Using his stubby drypoint needle with such sensitivity he had given new life to the medium. Unlike the graver, the needle scratched the plate without removing the metal, deflecting it instead up out of the grooves into rough flanking ridges which would trap enough ink to record them as a furry blur. Before the 1850s drypointing was good only for a few—rarely more than a dozen—reproductions, because each impression wore down the

delicate ridges. But as a student in Paris, Whistler had learned about the new technique of electroplating with iron to reinforce the blurry accent and increase the number of possible drypoint impressions. In Paris, Courbet, too, had been fascinated by Jo's cascade of red hair; finally in Trouville he was able to pose her, producing *La Belle Irlandaise* (*The Woman with the Mirror*) and three other versions probably finished the next year. What she—and his paintings of her—meant to him, Courbet explained to Whistler in a letter dated February 14, 1877, breaking a long silence that had been Whistler's doing. Nostalgically Courbet recalled their summer together with Jo at Trouville and added that he still had, and would never sell, his portrait of her. On the last day of that year he died, and in his studio a friend that day found a painting called *Anglaise aux Cheveux d'or*. English or Irish, the girl with the golden hair was Jo.

While Whistler painted at Trouville, his brother Willie was settling down in London. He had remained through the Civil War as a surgeon on the Confederate side, Anna Whistler staunchly defending a "struggling South" which—to her—was "not fighting for Slavery, but in defense of its homes." Until the last year of the war only one of his letters had got through the Northern blockade. In the last month of the war—April, 1865—Willie himself slipped through the Union lines with dispatches for England and somehow managed to sail with them from New York to Liverpool. With Richmond fallen and the war over, and his mother in England, he stayed. Before Trouville, Whistler and Willie, reunited, had taken their mother briefly to Germany to consult an oculist about Mrs Whistler's failing vision. Late in November, when he returned from France with Jo, Whistler found the urge to leave England again overwhelming.

The guilt he had felt as a West Point man who had remained an ocean away from the battle had been reinforced by the presence in London of his brother, a mild medical college graduate who had shown courage under fire at Spotsylvania and other places mentioned in dispatches from across the Atlantic. Still, the desire to go off to fight in a minor foreign war to recover his diminished self-esteem would not have been enough to push even the volatile Whistler into an overseas adventure. But Anna Whistler, it is said, wrote a letter to some Southern cousins in which she described a bitter scene with her son in which, encouraged by the Hadens, she had attacked the liaison with Jo which had continued even while mother and son lived respectably together, a relationship which had even brought Jo back into her house when Mrs Whistler was away, and

included not only nights, but months—as at Trouville—apart with Jo. Anna Whistler knew the risks of bringing up the unmentionable subject, but her son's career as a respectable artist was at stake. Whistler flung himself out of the house. He was ripe for a quixotic gesture.

"It was a moment," he told the Pennells, "when many of the adventurers the war had made of many Southerners were knocking about London hunting for something to do, and, I hardly knew how, but the something resolved itself into an expedition to go out to help the Chileans, and, I cannot say why, the Peruvians, too. Anyhow, there were South Americans to be helped against the Spaniards. Some of these people came to me as a West Point man, and asked me to join, and it was all done in an afternoon."

Whistler's arrangements may well have taken no more than an afternoon. On January 31, 1866, in the offices of his solicitor J. Anderson Rose on Salisbury Street, off the Strand, he made his will, a one-page document which bequeathed his entire estate to "Joanna Hiffernan of No. 7 Lindsey Row aforesaid Spinster . . ." and named Rose and Dante Rossetti as executors. Supplementing it he made out a power of attorney giving Jo the right to dispose "of pictures in his possession and any he might send from abroad," and to draw on his precarious account at the Bank of London. There was no mention anywhere of Whistler's mother.

On the evening of the same day Whistler left on the boat train to Southampton; Swinburne—who thought his friend was going to California—was among the well-wishers seeing Whistler off.

Sailing to Panama, Whistler and his fellow-adventurers then had to cross the canal-less isthmus and secure another vessel south to Chile. The journey was "all very awful," he recalled, but they arrived in time for the little action there was. What had actually happened was that in Spain's last hostile action against her former colonies a naval squadron rounded Cape Horn, sailed into the Pacific, seized the guano-laden Chincha islands off Peru and demanded payment of the debts to Spain which the struggling nation had incurred while still a colony. Chile made common cause with her northern neighbor and mobilized her fleet, bringing upon herself the token bombardment of Valparaiso on March 31, 1866.

As Whistler told the story, "I found myself at Valparaiso, and in Santiago, and I called on the President or whoever the person in authority was. After that came the bombardment. There was the beautiful bay with its curving shores, the town of Valparaiso on one side, on the other the long line of hills. And there, just at the entrance of the bay, was the

Spanish fleet, and in between, the English fleet and the French fleet and the American fleet and the Russian fleet, and all the other fleets. And when the morning came, with great circles and sweeps, they sailed out into the open sea, until the Spanish fleet alone remained."

The remainder of the story was a scene out of Joseph Conrad. The Spanish fleet "drew up right in front of the town, and bang went a shell, and the bombardment began. The Chileans didn't begin to defend themselves. The people all got out of the way, and I and the officials rode to the opposite hills where we could look on. The Spanish fleet conducted the performance in the most gentlemanly fashion; they just set fire to a few of the houses, and once, with some sense of fun, sent a shell whizzing over toward our hills. And then I knew what a panic was." Presumably Whistler and his party had horses, and one wonders whether his poor record at the Academy as a horseman was the result of lack of incentive, for according to his version of the affair "I and the officials turned and rode as hard as we could, anyhow, anywhere. The riding was splendid and I, as a West Point man, was head of the procession. By noon the performance was over. The Spanish fleet sailed again into position, the other fleets sailed in, sailors landed to help put out the fires, and I and the officials rode back into Valparaiso. All the little girls of the town had turned out, waiting for us, and, as we rode in, called us 'Cowards!' The *Henriquetta,* the ship fitted up in London, did not appear until long after, and then we breakfasted, and that was the end of it."

After the Battle of Callao in May, 1866 hostilities ceased altogether, although the war officially dragged on until a treaty was signed in 1871. For Whistler and his party there was nothing to do but wait for a way home. Their impact upon Chilean and Peruvian independence had been nil, but the handful of seascapes which were the major result of Whistler's presence there were among his finest work. While he awaited the ship that would take him on the first leg of his return voyage he had met a Mr McQueen, who offered him the hospitality of his club, and from a window there early one evening Whistler painted a lyrical impression of Valparaiso harbor. Sailing ships with furled sails thrust their spiky forms into the haze and throw delicate impressions upon the still waters of the harbor, their lights glowing through the dusk. It was the first of what he would later call his nocturnes.

Collectively the Valparaiso canvases showed interest in neither geography nor war, demonstrating the appeal of Japan rather than the technique of Courbet, with an impression of sky and water, the effects of

fading light on the atmosphere, and decorative devices of oriental art such as a sprig or branch in the foreground and an Eastern-looking signature. In each he experimented with muted light, whether dusk or dawn, one afterwards called, perhaps ironically, *The Morning after the Revolution. Valparaiso.* There is no sign of a fight.

Whether or not Whistler felt he had gone on a fool's errand, he had matured one aspect of his style so completely that more than a century later certain qualities of atmosphere at dusk would be described as *Whistlerian* and summon up a mood in a word. But en route home he was irritable and belligerent, and annoyed at a Haitian negro "who made himself—well—obnoxious to me, by nothing in particular except his swagger and his color. And, one day, I kicked him across the deck to the top of the companion way and there sat a lady who proved an obstacle for a moment." However Whistler picked up his victim, dropped him down on the steps below her, then booted him further down.

The ship's captain confined him to his quarters for the remainder of the voyage, in the tussle giving Whistler a black eye; however that only restrained him temporarily. When he got out of the boat train in London he unaccountably thrashed a total stranger at the station.

At Lindsey Row, Mrs Whistler had remained patiently and without apparent rancor, wondering only—as she wrote a friend—whether it was the Lord's admonishment that she had no "continuing abode on earth." Friends came to spend the day in chatting or in "trimming a bonnet," and Deborah visited. Fortunately there was Major George Washington Whistler's pension.

While Whistler had been away, life had been more difficult for Jo. Although she was shrewd in business matters and a careful manager of Whistler's money, there was no business in Whistlers, new or old, and soon there was no money. By May she was appealing to Anderson Rose to lend her £10 on the security of "any one of Mr Whistler's Sea Views now at Mr Rossetti's." She had not been able to find a buyer for any of them. By summer she was forced to sell some of Whistler's etched copper plates, while Rose diplomatically put off creditors. By the time Whistler returned, she had gone off briefly to France to pose again for Courbet. Her journey was a good deal more predictable than Whistler's Valparaiso adventure. Courbet, on the surface a stocky, gentle peasant with eyes like a heifer, was a master portraitist and lavish admirer of Jo—his "superb redhead." And Jo's chief business, from which Whistler's absence had

deprived her, was as a model. By the time Whistler had begun the slow voyage back, Jo was at Courbet's Rue Hautfeuille studio in Paris.

Khalil Bey, who had been Turkish ambassador to Russia, had been told by the critic Sainte-Beuve about Courbet's lush canvases of luscious nudes, especially the *Venus and Psyche (The Awakening)*, painted several years before. The description was so alluring that he visited the artist prepared to buy it on the spot, but since it was already sold, Courbet promised him its "sequel" for 20,000 francs when it was completed. Khalil Bey knew it would be worth waiting for. Courbet's nudes were notorious. Napoleon III was said to have horsewhipped *The Bathers* of 1858 at the opening of the Salon. And Courbet loved especially to paint sleeping nudes, with their hair floating in waves and curls down the pale flesh.

The "sequel" was *Paresse et Luxure (Sloth and Lewdness)*, later circumspectly retitled *Le Sommeil (Sleep)*. His friend Charles Baudelaire had just published (as *Flotsam*, 1866) the poems banned from the 1861 edition of his notorious *Fleurs du Mal*, one of them, "Women Accursed," about the lesbian lovers Delphine and Hippolyta, "beauty robust" and "beauty frail," stretched "on scented downy cushions, dazed in sense," the head of one resting upon the breast of the other after "bleak and sterile raptures." In the original edition, in another poem, "Tresses," Baudelaire had celebrated the erotic quality of a woman's hair in a litany of "O locks . . . this fragrant forest . . . heavy tresses . . . cool shadowy tent . . . on the down of tresses rich and curled I swoon. . . . " Courbet combined the two flowers of evil. On his canvas the two "lost women" are on a couch asleep with the exhaustion of passion spent, their limbs intertwined in a contrast of fair and amber flesh, their heads a contrast of copper and ebony hair. The fair-skinned model, who seems to be recognizable in several other Courbet nudes done the same year, was Jo.

Whistler's own artistic treatment of Jo had always been within the implicit rules of Pre-Raphaelite imagery, where the mistress was idealized in a manner remote from sensuality. Mid-Victorian artists of the Rossetti cult, whatever they practiced between the sheets, "frequently painted the beloved, who usually had red hair, as a languid and, indeed, rather asexual creature, the very diminution of whose physical appeal made her (at any rate in their eyes) particularly alluring and desirable just because she was remote—an unspotted flower in a rank world." Nothing could have

been farther from the Baudelairean canvas for which Jo posed for Courbet.

When Whistler returned in November he arranged through Anderson Rose for the lease of 2 Lindsey Row (now 96 Cheyne Walk), one of the sections of Lindsey House. Jo and he seemed to resume the old relationship, together but apart, and in a December letter to Charles Lucas in Paris he included a "Jo tells me to send her kindest regards to yourself and Madame. . . . " The old ways in London resumed, Whistler (now with his brother) spending evenings at Rossetti's with Sandys, Jeckell, Howell, and Swinburne, and Swinburne unsurprisingly getting very drunk. But by the end of December Whistler and Willie were in Paris together, and thereafter Jo disappears from his life. Did the scandal of *Paresse et Luxure,* and Jo's posing for it for Courbet in his absence, have anything to do with it? Whistler could not help but have heard about the painting in Paris, for it was already notorious.* He not only knew the *Fleurs du Mal,* but his friend Swinburne, always attracted to the perverse, had introduced it to the English public in a *Spectator* review in 1862. What is clear is that Whistler's already violent conduct became even more aggressive after his return from Valparaiso, and utterly hostile to the recently revered Courbet and everything in art which Courbet exemplified. "I was told that Jo never had anything of his," Luke Ionides remembered of her parting with Whistler. Model though she was for some of his most memorable paintings and etchings, she left without a token of her presence in his life, and Whistler seldom mentioned her afterwards. But she would raise his son.

* After Baudelaire such representations in art were increasingly acceptable in France, Swinburne happily writing to a friend in 1869 about "a Sapphic group" sculpted by James Pradier "of two girls in the very act—one has her tongue up *où vous savez,* her head and massive hair buried, plunging, diving between the other's thighs. It was the sculptor's last work before he left this world of vulgar copulation for the Lesbian Hades. May we be found as fit to depart—and may our last works be like his."

XIII

Uncertainty

W HISTLER's sudden repudiation of Courbet was so violent that the psychological implications may be as significant as the artistic. Was he repudiating Courbet for his disloyalty as well as for his heavy, earthy realism? "Courbet and his influence was disgusting," he wrote Fantin-Latour in 1867; ". . . all that he represented was bad for me." The letter comes through as a cry of anguish as well as an artistic statement. In his Valparaiso canvases he had come to Impressionism before anything similar had been shown by Manet, Degas, Monet, Renoir—or Courbet. But after Valparaiso he abandoned the technique, apparently in an even stronger reaction against Courbet. "I must tell you," he wrote impulsively to Fantin, "that I am now much more exacting and hard to please than when I threw everything slap-dash onto the canvas, knowing that instinct and beautiful color would pull me through. . . . Ah, my dear Fantin, what an education I am giving myself! or rather, what a terrible lack of education I feel! With my own natural gifts, what a painter I should be now if, vain and content with these qualities, I had not turned my nose up at everything else!" Now he had nothing but regret for his weakness, and rage when he thought of the "damned realism" of Courbet which had appealed to his "painter's vanity" although it had mocked at tradition. Only ignorance had caused

him to accept so readily the cry of "Vive la Nature!" It was too easy—"one had only to open one's eyes and paint what was before one"—but it had been a personal misfortune. His work, he confessed, had been that of "a young rascal who swelled with vanity at being able to show other painters splendid talents, qualities which demanded only a strict education to make a master of their possessor." But he had become only "a corrupted schoolboy" under Courbet, although he insisted it was not the man nor his works which now repelled him, and that he had always been "rich in qualities" which Courbet did not possess. "Ah, my friend . . . our little group was a vicious society. Had I only been a student of Ingres! I do not say that out of ecstasy before his paintings. I have only lukewarm feelings toward them and find several of his paintings which we saw together of a rather questionable style, not at all Greek as claimed but very terribly French."

Why then reject Courbet for Ingres? To Fantin he explained that it was a philosophical change. "Drawing, by God! Color is vice, although it can be one of the finest virtues. When controlled by a firm hand, well guided by her master, Drawing, Color is then like a splendid woman with a mate worthy of her—her lover but also her master—the most magnificent mistress possible. . . . But when united with uncertainty, with a weak drawing, timid, deficient, easily satisfied, Color becomes a bold whore, makes fun of her little fellow, isn't it so? —And gallivants as she pleases, taking the thing lightly as long as everything is pleasing to her, treating her poor companion like a simpleton who is bothering her—which, moreover, is true, too. The result is visible: a chaos of drunkenness, cheats, regrets, things left unfinished! All right now, enough!"

It was an education, he continued, spelling out his suffering, that he had been painfully undergoing for more than a year. "The most magnificent mistress possible . . . united with uncertainty. . . ." He may have been discussing Art, but the images vividly evoked the estranged Jo. And Whistler was becoming more estranged and combative, although he held a housewarming at 2 Lindsey Row on February 5, 1867, and invited his friends. Somehow he had staved off his creditors and had furnished his new home as if he could afford it. "There are some fine old fixtures," W. M. Rossetti wrote in his diary, "such as doors, fireplaces and . . . many delightful Japaneseisms. Saw for the first time his pagoda cabinet. He has two or three sea-pieces new to me: one, on which he particularly lays stress, larger than the others, a very grey unbroken sea,

also a very clever vivacious portrait of himself begun." Yet he was not eager to spend much time at Lindsey Row, in March making a second trip across the Channel to exhibit four paintings in the Paris International Exposition at the Champs de Mars, one of them a Valparaiso canvas, *Twilight on the Ocean.** The others were *Old Battersea Bridge* and two of Jo, *The White Girl* and *Wapping*.

Even the exhibition provoked his combativeness, however, for he suddenly insisted on being hung "on the American line! so that England may no longer lay claim to his brilliant reputation etc . . . etc. . . ." He was hung as he wanted to be, with the Americans, and one Paris critic wrote of him, "M. Whistler seems to me the only American really worthy of attention; he is our old acquaintance of the *Salon des Refusés* of 1863, where his *'Fille blanche'* had a *succès d'engouement.* He is truly an American, as understood by the motto, 'time is money.' M. Whistler so well knows the value of time that he scarcely stops at the small points of execution; the impression [is] seized as it flies and fixed as soon as possible in swift strokes, with a galloping brush—such is the artist and such, too, is the man." Although hung with his countrymen, however, Whistler's four paintings were badly positioned, and he was annoyed enough to consider making a formal demand for the withdrawal of his pictures. Instead, he used up his truculence in other ways. One day in Paris that spring, as he walked through a narrow street, a workman accidentally spilled some wet plaster on him. Whistler went after him, swinging, and had to be escorted by the police to a magistrate, where he claimed the protection of the American Minister and was released. A few days later he came upon Seymour Haden in the same district, and accused his brother-in-law of everything short of murder. Both began swinging at each other, Haden with his larger size and longer reach managing to lock Whistler's head under his arm and with his free fist to punch his brother-in-law in the face until Whistler wriggled free and pushed Haden through the window of a café. Back he went before the same magistrate, this time unprotected by the American Minister. *"Connu!"* said the magistrate. Whistler this time paid a fine and was released.

Haden, outraged, went immediately on his return to the Burlington Fine Arts Club, of which they were both members, and threatened to resign unless Whistler were expelled. (Then he sued Whistler separately for slander.) There was a meeting of the Committee, at which Whistler

* Afterwards retitled *Crepuscule in Flesh Colour and Green* (Tate Gallery).

expected both Rossettis to move a preventive counterproposal which would explain rather than expel. In that vein, W. M. Rossetti drew up a statement for Whistler which concluded, "The world is understood to contain some gentlemen besides English gentlemen: some codes of social honour besides the English and some communities in wh. practices such as that of duelling or the summary castigation of any form of personal insolence are not yet obsolete. This may or may not be unfortunate or censurable, but a fact it is & it is also a fact that I happen to be a Virginian, a cadet of the military Academy at West Point, & for many years a resident in France."

When W. M. moved his resolution, however, D. G., who was innocent of any knowledge about procedure at public meetings, did nothing, and the motion lost for want of a second. By a vote of nineteen to eight Haden was upheld, the Committee alarmed about reports that Whistler had committed "seven (or even nine)" assaults since he had returned from Chile. After the vote the Rossetti brothers submitted their resignations on a matter of principle—that the Club had no right to interfere in the private affairs of its members or institute "inquisitional proceedings" at which the accused was offered no hearing. From Paris Whistler protested to Dante Gabriel against his "friendship weak in faith." His friend replied in a carefully worded letter that he had done all that could be expected. Whistler was unsoothed.

Several years later, when Whistler's combativeness was under better control, he undertook to defend a friend from a club expulsion. Appearing at the Arts Club for Swinburne, who was accused of drunkenness, Whistler bluntly told the Committee, "You accuse him of drunkenness—Well, that's his defense." According to Ezra Pound, Whistler also declared to the Committee, "You ought to be proud that there is in London a club where the greatest poet of your time *can* get drunk if he wants to, otherwise he might lie in the gutter." In any event, there was an exchange of concessions and Swinburne was not asked to resign from the Arts Club until yet another incident.

The Burlington Club affair was the breaking point in Whistler's relationship with Haden. Each had interfered in the other's life so often that nothing was now left but raw vindictiveness, Anna Whistler writing to a friend the following year that her stepdaughter's home was now closed to her. "I took a cab last Thursday to meet dear Debo at our mutual friend Eliza's.* . . . You know we are not permitted to meet in

* Eliza Smith lived in Westminster.

either of our homes. . . . Annie Haden's birthday . . . no doubt was duly celebrated at 62 Sloane St. as usual but the 13th of this month is also the anniversary of Jemie's expulsion from the Burlington Club by Annie's *father* & my banishment from Debo's family circle in consequence."

For Anna Whistler the emotional disturbances generated by the family quarrels often affected her vision, and although Willie visited to apply some German eye medicine, her handwriting became shaky. For Jimmy the outbursts themselves were symptoms of profound inner conflicts. The newly furnished house in Lindsey Row notwithstanding, his domestic life was in tatters and his artistic outlook was confused. In 1867 he had submitted his work successfully to both the Royal Academy and the Salon as well as to the International Exposition, but he had simultaneously rejected most of his own former work as unsatisfactory and derivative. He wanted to be himself, but had not found a self he liked. The arrogance had always been a mask for uncertainty, but never more than in 1867.

Reappraising his work, he could see a new direction in one of the canvases he had submitted to the Salon, *Symphony in White, No. 3*, his last portrait of Jo. It had been his link to a young painter he had already suggested to Fantin as Legros' replacement in their curious Society of Three. Albert Moore was twenty-five years old in 1865 when Whistler admired his painting *The Marble Seat* in the Academy exhibition which displayed *The Little White Girl* and *Old Battersea Bridge*. Immediately he thought of including Moore in the painting he was planning of a gathering of his artist-friends in his studio; and Swinburne soon agreed that Moore's work was to painters "what the verse of Théophile Gautier is to the poets: the faultless and secure expression of an exclusive worship of things beautiful." Rossetti thought he was "a dull dog," yet Moore's pseudoclassical groups of languorous women in clinging and semitransparent diaphanous draperies should have appealed to that admirer of the sensual and the antique. Moore's "five o'clock tea antiquity" (a term applied to Alma-Tadema, who like Leighton was influenced by Moore) was deliberately decorative and without subject, but his contemporaries added story and defrosted the cold carnality. It was the ideal way to sell nudes to nineteenth-century buyers, for naked or near-naked females in Roman or Greek settings satisfied the market for mildly erotic art without outraging Victorian taste.

That Moore was interested, rather, in drapery and arrangement of figures pleased Whistler, and that Moore—whose inspiration was the

Parthenon frieze—stubbornly persisted in using his models as a decorative mechanism only increased Whistler's admiration. Prospective patrons found Moore puzzling to deal with. One invited him to breakfast to discuss the commissioning of a canvas, Moore being given a free hand as to price and choice of subject. After considerable time had passed Moore advised that he had prepared a sketch, and was invited again to breakfast, where he produced it. "What do you call it?" inquired the patron. "I do not call it anything," said Moore, "but you can call it what you like." He had hoped to display a picture such as *Boadicea Addressing Her Troops, The Finding of the Body of Harold*, or *Socrates Swallowing the Hemlock*; but Moore was not disposed to humor him, and the picture was never painted.

He was clearly Whistler's kind of man, and partly under his influence Whistler produced his *Symphony in White, No. 3*, which Du Maurier had seen in progress along with a trove of seascapes at a then-rare (for him) dinner at Lindsey Row. He had "eaten the salt of James, the James that whistleth!" he wrote to Armstrong. "We are friends. I marvel much at the cunning work his fingers have woven on the stretched cloth. The two damsels in snowy samite! and many a scape of sand & sea & sky which he hath lately wrought on some distant coast—I know not where." Despite Du Maurier's rhapsody, the third *Symphony in White* probably was no longer what he had seen in 1865, and had undergone improvements along the lines of Whistler's new classical predilections, for the artist had boldly painted over the final numeral to re-date it 1867, a suggestion that he had painted over even more. The result, Walter Sickert said later, was "badly composed, badly drawn, badly painted, the low-water mark of the old manner before the birth of the new."

In his infatuation with drapery Whistler would not have considered the painting as in the old manner. As a signal of change it was the first of Whistler's works to bear a musical title from the start, and when it appeared at the Academy, Philip Hamerton in the *Saturday Review* (June 1, 1867) criticized the accuracy of the title, as if Whistler had meant to restrict his range of color entirely to shades of white. It was "not precisely a symphony in white," he carped. "One lady has a yellowish dress and brown hair and a bit of blue ribbon, the other has a red fan, and there are flowers and green leaves. There is a girl in white on a white sofa, but even this girl has reddish hair; and of course there is the flesh colour of the complexions."

Furious, Whistler fought back in a letter the editor would not print,

examining the "profound prattle": "*Bon Dieu!* did this wise person expect white hair and chalked faces? And does he then, in his astounding ignorance, believe that a symphony in F contains no other note, but shall be a continual repetition of F.F.F. Fool!" Since the quality of the R.A. 1867 show was low, Whistler was especially offended. He had gone to the Academy with Swinburne and found little to praise, pointing out a sea scene by J. C. Hook, for whom he seldom had a favorable word, as one of the better canvases.

Since Valparaiso Whistler had abandoned seascapes himself. Instead, under Moore's influence he produced a series of small nude or slightly draped figures done on brown paper with pastel colors or very thin paint. More disastrously, because of their scale, he had begun, late in 1866, on commission from Liverpool shipowner (and Rossetti patron) Frederick Leyland, a group of related canvases which attempted to blend his own borrowings from the Japanese with Moore's pseudoclassicism. One large composition, apparently to be a *Symphony in White, No. 4*, was inspired by Greek terra-cotta statuettes in the British Museum, and exists in an unfinished version in oils known as *Three Figures: Pink and Grey*, a second oil, and a series of pastel and pen-and-ink studies. In his uncertainty over the poses and the placement of his figures, and their relationship to their draperies and their setting, Whistler wasted hundreds of hours of model's wages in discovering that he was neither meant to be an Alma-Tadema nor a Moore. The *"Six Projects"* all failed. Swinburne was nevertheless enraptured by them. They evidenced "the love of beauty for the very beauty's sake, the faith and trust in it as in a god indeed." He had noted Whistler's profound reaction from realism, and had put the best face he could upon it. But Whistler's worship of Greece was a wrong turning, whatever the practical exercise in composition and design.* In his suddenly acute sense of incapacity—his letter to Fantin about Courbet including a self-analysis as a "debauched schoolboy"—he felt the need for remedying his defects in drawing the human form, not heavily like Courbet, but with grace as well as with sufficient anatomical accuracy to satisfy himself.

Even before Anna Whistler returned to America in June 1867, to visit friends and relatives and to sell her property at Stonington, Whistler,

* He had long rankled at criticism accusing him (as in Sydney Colvin's words in 1867) of "neglect of form . . . contempt of executive finish, the apparently slurring method by which he achieves exactly as much as he wishes, and attempts no more. . . ."

uneasy at 2 Lindsey Row and now without Jo, moved in with architect Frederick Jameson, who had bought his *Crepuscule in Opal: Trouville*, spending seven months at 62 Great Russell Street, in Bloomsbury, a two-room flat on a second floor above a pharmacy where the three long front windows of the studio looked out over the British Museum. Burne-Jones had once lived there, when he was first married, and in the converted Adam sitting room, with its frieze and oversized marble fireplace, Whistler worked on his Greco-Japanese canvases and had his models come to pose. Yet at Lindsey Row he had a large new second-story rear studio, freshly painted in light grey, with his prints and Japanese hangings for inspiration, and newly decorated rooms in which to entertain. Like all the places in which Whistler lived, however, 2 Lindsey Row was always in a state of near-completion, however simple its furnishings and decoration. The drawing room had been unpainted until the day of his inaugural dinner party, when he sent for the neighboring Greaves brothers, who considered themselves as disciples, to help him. "It will never be dry in time!" one of them worried. "What matter?" said Whistler; "it will be beautiful." By evening, after frenzied activity, it was a study in flesh-color, pale yellow and white, and reports were that some gowns and coats were equally acquainted with those colors before the end of the evening. But for more than a year after Whistler moved in, 2 Lindsey Row was quiet and often deserted except for his two servants.

The months in Great Russell Street were unproductive, Jameson recalling that Whistler would finish "large portions" of several canvases, "but they never satisfied him, and were shaven down to the bed-rock mercilessly." And he would talk frankly to Jameson about his awareness of his defects in drawing. According to T. R. Way, Albert Moore came to see one finished canvas of three draped, nearly nude females, about which Whistler was pleased with his scheme of whites, pinks, and blues. But Moore criticized "some tone or colour," and by the next day Whistler had scraped out the picture. Only drawings, pastel studies, and unfinished canvases remain.

Even after his mother's return, Whistler found excuses to work away from Lindsey Row, often at the Speke Hall estate of patron Frederick Leyland, near Liverpool, Anna Whistler rationalizing his absences as "practicing the greatest self-sacrifice, if he may but finish such large & more difficult paintings to satisfy his own difficult standards of Art by the first of April, for the Exhibition . . . ," especially since the "persecutions" of Seymour Haden were creating barriers to her son's acceptance.

To James Gamble of Scarsdale, visiting her in London, she described Jimmy's filial devotion, for when in town he returned two evenings a week for a late dinner and to see how "Mother is taking care of herself." But the Lindsey Row studio remained vacant for months at a time, and Whistler did not appear to even miss the sprawl of Battersea Reach.

For several years he completed nothing and had nothing to exhibit at the Academy, and when Philip Hamerton wrote to him in 1868, when he was working on his book *Etchings and Etchers*, to borrow some examples of his work, Whistler was uncooperative. "I wonder whether you would object to lend me a set of proofs for a few weeks. As the book is already advanced I should be glad of an early reply. My opinion of your work is, on the whole, so favourable that your reputation could only gain by your affording me the opportunity of speaking of your work at length." It did not take a long memory to recall Hamerton's remarks about *Symphony in White, No. 3.* Whistler ignored the request, although in 1868 he was regularly broke and needed useful publicity. It was almost as if he did not want to promote or sell his work, a letter to Luke Ionides, who had offered to call with some ladies who wanted to see Whistler's output, agreeing without enthusiasm to show them "what little there is to interest them" at Lindsey Row. Meanwhile he borrowed money from Ionides regularly, and often did not even have the money for a stamp, blaming the lateness of the hour for being unable to buy one and having to send the begging letter postage-due.

One day, when Ionides called on him without warning, Whistler asked if he had any money with him. Ionides confessed to having only twelve and sixpence. "That's enough for my purpose," said Whistler, in a flash of his dormant old self, "Let's go out and buy two chairs and some bottles of wine. I'm expecting a moneyed guest tonight and you're going to dine with us." * They went off and bought two chairs at two shillings each, four bottles of claret, and four sticks of sealing wax, in blue, green, yellow and red. Back at Lindsey Row they sealed the corks of the bottles, each with a different color.

At dinner, after the soup, Whistler said gravely to the maid, "Go down and bring a bottle with a yellow seal." After the next dish he ordered a bottle with a red seal, and others after the following courses. "Whether the fact that the 'moneyed guest,' Mr, afterwards Sir, Thomas

* The place of the chairs in the tale is puzzling, since 2 Lindsey Row was not reduced to that extremity, but Ionides in 1924 was remembering events nearly sixty years before.

Sutherland, bought a picture for a hundred pounds, was a result of the supposed different wines," Ionides wondered, "I do not know!" But Sutherland was an early patron of Whistler and the tale does fit the point in Whistler's life when his mother was away in America, Jo was gone, and little was going well.

Whether in Chelsea or Bloomsbury, none of the *"Six Projects,"* even the nearest-to-completion of them, the *Three Figures: Pink and Grey,* which Whistler expected to be of Academy pitch, were ever finished. Yet the *cul-de-sac* of his inspiration from Moore left him with no ill-will; in fact he was so concerned with the continuing resemblance of his work to Moore's as late as 1870, when he was working on yet other canvases for the patient Leyland, that he wrote to Moore with real concern that although he admired his friend's "beautiful sketches . . . more than the production of any living man" it struck him that one of his own sketches "was in motive not unlike your yellow one—of course I don't mean in scheme of colour but in general sentiment of movement and in the place of sky, the sea, and shore, etc." And he suggested that Moore and a friendly arbitrator visit his studio to view a similar work. Moore came with the mutual friend Whistler suggested, Billy Nesfield, an art collector and the fat, jolly partner of Richard Norman Shaw, the architect.

Whistler had seen much of Nesfield, for after taking boxing lessons from a professional who had a place, according to Tom Armstrong, "behind the Quadrant in Regent Street," he often looked for sparring partners rather than for the public brawls which came, in any event, spontaneously enough. Nesfield was usually accommodating, but one night Whistler turned up at his friend's chambers in Argyle Street late at night and insisted on a round with the gloves. "Nesfield got up and admitted him, but he owed him a grudge for the disturbance, and he paid out for it. Nesfield had not so long a reach as Jimmy, but he was very powerful, and at the end of the bout he sent his disturber away with his shirt covered with blood." But Whistler, the architect told Armstrong, "took his punishment very well and cheerily."

Nesfield proved equally accommodating in the curious controversy Whistler had insisted upon with Moore, concluding diplomatically that each painter had learned something from the other, Whistler in Moore's use of female drapery and "hard study of Greek work." But he saw "no harm in both painting in a similar way as the effect and treatment are so wide apart." Their work would grow even more widely apart, although

Moore would often go with Whistler on painting trips down the Thames, and each would remain vocal in admiration of the other.

When Moore became reclusive, and out of fashion, long stretches of time would pass between meetings, but once, encouraged by Graham Robertson, who had studied with his friend, Whistler went with the younger painter to Moore's home, where nothing seemed ever to be done in the way of dusting, mending, papering, house-painting or white-washing. They found Moore alone in his huge studio, solemnly wielding his brushes, surrounded by large open jugs each holding a cone of rolled-up brown paper. Fascinated by the sight, but remembering Moore's dislike at being questioned, Whistler nudged Robertson and asked, "What are the jugs for?"

"I don't know."

"Ask him."

"*You* ask him: you've known him longer."

"You're his pupil. You *might* ask him."

Robertston took a deep breath. "What are the jugs for?" he inquired.

"The drips," said Moore.

"The drips?" Whistler whispered to Robertson, wondering about a new painting technique. "What drips? *Ask* him."

As his question trailed off, a fat bubble of water oozed from the ceiling and fell with a plop into one of the containers. The roof leaked. It had probably leaked for months, or even years, but patiently Moore set his easel among the pots and worked under conditions which would have been impossible for the fastidious Whistler.

Only in the *Symphony in White, No. 3*, at the beginning of their relationship, a work which in itself was a less successful outgrowth of Whistler's earlier experiments in white, was Moore's influence evident in a completed canvas. But Moore's sympathy and method were there when Whistler needed to turn to someone, and he never forgot it, although there are reports of coolness between them that arose when, at a dinner hosted by old Dowdeswell the art dealer at the Café Royal, Moore told the others that he had suffered a misfortune in his efforts at painting a group of flying figures. In order to get movement in the draperies appropriate to flight had used fans and bellows, which proved effective although the model came down with pneumonia and died. "Ha! ha!" laughed Whistler. "And this is how you make consumption!" Moore was furious, and the old friendship faded almost entirely. If one were to judge

from their display of each other's work, there was never any close comradeship; Whistler invariably hung only advertisements for himself on his own walls, and Moore made no ostentatious display of his gift nocturne, *Trafalgar Square—Snow*. According to Graham Robertson it spent much of its existence leaning face against a studio wall, until, late in Moore's life, he furnished it for an exhibit, indicating that he or Whistler remembered that he had it. In any case, Whistler understood, and at Moore's death in 1893 Whistler observed in a typical tilt at his adopted land, "Poor fellow! The greatest artist that, in the century, England might have cared for and called her own—how sad for him to live there—how mad to die in that land of important ignorance and Beadledom."

XIV

Nocturnes

I N Whistler's day at the old Dudley Gallery, Tom Armstrong recalled, there was once an empty frame hanging on the wall, with a back of grey board. Some wag, with charcoal, drew a horizon from end to end within the frame. With one or two spots judiciously placed, he thought, and perhaps a butterfly, it could have looked like a Whistler from across the room. Whistler bristled at such suggestions. It might better have been said that he painted the blur of twilight on the Thames because he was nearsighted. Defective in distance vision, he saw contours where others could pick out details. Yet his nocturnes, prefigured in the Valparaiso canvases, were deliberate experiments in painting the night, done after he was convinced that the failure of his figures in classical drapery was absolute. Darkness needed no figures, but yielded up its own.

One summer night in the 1890s, Whistler took Sidney Starr, a dinner guest, for a walk along the Thames in the direction of his former home in Lindsey Row, and the artist talked of his paintings executed from those windows. Then, indicating Battersea Reach bathed in the near-darkness, Whistler asked, "Starr, now please point out the detail which Burne-Jones said my nocturnes lack; of course you can see it now. . . ." The bitter sarcasm was not lost on Starr, who knew what Whistler had gone through in the seventies, when he was perfecting the genre that he would

make completely his. At first he called his night riverscapes "moon-lights," even when no such light was palpable; and when he saw the poetic but realistic harbor scenes of his Chelsea neighbor John Atkinson Grimshaw (1836–1893), such as *Liverpool Quay by Moonlight* (1887) he was happy that he had found the evocative word *nocturne,* one of his many debts to his patron Frederick Leyland. "I can't thank you too much for the name Nocturne as the title for my moonlights," he wrote to Leyland in the seventies. "You have no idea what an irritation it proves to the critics and consequent pleasure to me; besides, it is really so charming and does so poetically say all I want to say and *no more* than I wish."

That he painted with new confidence was clear from a letter to George Lucas in Paris, early in 1873, urging him to look at a Whistler exhibition at the Durand-Ruel Gallery in the Rue Lafitte and "tell me how you like them. They are not merely canvases having interest in themselves alone, but are intended to indicate slightly to 'those whom it may concern' something of my theory in art. It is the science of color which I believe I have almost entirely penetrated and reduced to a system." He had another object in mind, too. "Go and see and also fight any battles for me about them with the painter fellows you may find opposed to them—of whom by the way there will doubtless be many. Write me what you may hear and in short as I am not there to see, tell me what effect my work produces, if any. . . . By the names of the pictures also I point out something of what I mean in my theory of painting."

But Whistler's penchant for impressionistic and musical titles got him into difficulty even when he deliberately eschewed them, a critic's pun that his *Yacht Race* was a *Symphony in B sharp* turning up in the catalogue of Durand-Ruel's French Gallery (in London) in 1875. "I am convinced that you will not willingly have done anything of this kind to annoy me," Whistler—then ill and confined to his bed—wrote to the manager, Charles Deschamps, in one of his less acerbic moments. "It was probably proposed by someone at the club and thought rather a good thing, and [you thought] that I would be pleased with it . . . but you see, the names I give to my pictures really do mean to indicate seriously the kind of work I am about. . . . I never joke with my own work *myself* and I cannot let it be supposed that I should do so." Deschamps answered apologetically that he found "the silly title in question" written on the back of the canvas, an anonymous practical joke he had accepted as genuine. Understanding but nevertheless pained, Whistler published a

retraction in the *Athenaeum* which admitted the fake title to have been a "brilliant parody" as well as a "senseless pun." Then he went back to painting.

Returning to the river more often than had been his wont, Whistler employed his neighbors Walter and Henry Greaves as boatmen as well as general factotums. They helped in the studio, served meals to models and visitors, ran errands, and listened raptly when the artist wanted an audience. They took to dressing like Whistler, in dark, wide-brimmed, low-crowned hats, and brightly colored ties and gloves. They even took to painting—not only the walls of Whistler's dining room but canvases which in Walter's case, at least, had intimations of the Master.

In the evenings they sometimes visited the drawing classes in Limerston Street conducted by a Frenchman, Victor Barthe, where, when Whistler came, he was the principal attraction, bringing with him not only his own informal pupils but often his own model. He and the Greaveses would sit down as three, Whistler making small drawings in chalk on brown paper, his satellites on each side of him looking not at the nude model but at Whistler's paper, then copying what they saw, never going beyond the Master. And when Whistler would put down his chalk to roll a cigarette, they would; and when he would puff at it, the brothers would.

One day in 1874, once the model rested, a lanky sheep-faced young man of twenty-two new to Barthe's, George Moore, picked his way through the easels, struggling to the edge of the crowd that had gathered about Whistler, and sniffed at the brown-paper slips that seemed to him so "empty and casual." "I must have disguised my feelings very well," Moore recalled, for he asked me to come to see him; any Sunday morning, he said, I should find him at 96 Cheyne Walk. The very next Sunday I went there, but there were few pictures in the studio. . . ." One was "a girl in a white dress, dreaming by the chimney-piece, the almost Rossettian face reflected in the mirror," and while Moore read the Swinburne verses printed on the frame Whistler "discoursed to his friends on the beauty of Oriental art." But Whistler's own practice of Eastern painting seemed to Moore to mean "two or three lines and a couple of dots," and when he asked another visitor how this could be interpreted as good drawing, "He gave me a hurried explanation, and returned to Whistler, who laughed boisterously while rattling iced drinks from glass to glass; and I think I despised and hated him. . . ."

The next time at Barthe's Moore defiantly offered his friendship to a

younger celebrity in the group, Oliver Madox Brown, son of the great Pre-Raphaelite, a strange, nineteen-year-old genius with a long, fat body and broad, beaked face, who painted as brilliantly as he wrote, but who would be cheated of fame, in a few months, by typhoid. "Nolly" Brown was working on a novel, and Moore begged him to bring his manuscript to Limerston Street and read from it during the rests. "He promised to do so, and the following day when Mary Lewis left the pose and wrapped herself in a shawl (a shapely little girl she was, Whistler's model; she used to go over and talk to him during the rests), Oliver began to read." Whistler and his following made no move to join the group, nor did Mary Lewis leave her place. Instead, she "sat like one entranced, her shawl slipping from her, and I remember her listening at last quite naked. And when the quarter of an hour had gone by we begged Oliver to go on reading, forgetful of Whistler, who sat in a corner looking as cross as an armful of cats. At last, M. Barthe was obliged to intervene, and Mary resumed the pose. *'Après tout, je ne veux pas que mon atelier devienne un cours de littérature,'* he muttered." But at the end of the sitting she remained to hear how the story ended, and Whistler left in further fury. But he had company. The brothers Greaves were loyal, never forgetting that, except for their relationship with Whistler, they were watermen on Battersea Reach.

Most mornings at home when the weather was good, Whistler would go out from seven to eight for a row on the river with the Greaves brothers, then join his mother for breakfast or—taking advantage of the tide upstream—visit Howell in Putney for an even later breakfast. Afterwards, in Chelsea, he painted or sketched through the day, stopping for a meal only if someone were sitting for him, and then only reluctantly and late. Sometimes after seven he would join his mother for dinner, and two or three evenings a week he would remain with her for the evening, reading or sketching, until she retired, which was always early enough for Whistler to go out again. Such nights could be spent on the Thames, Walter and Harry Greaves rowing him about in the stillness until he came to a view he liked, when he would order them to stop, and in black and white chalk on brown paper he would sometimes sketch, by feeling rather than by sight, the location of lights, bridges, buildings and riverbank.

As in his early London etchings, Whistler was, without formulating it as a philosophy of art, the poet of the grimy industrial landscape that had altered the Thames riverfront. When he actually drew in the failing

dusk it was a matter for some wonder by observers, one of whom asked how it were possible. "As the light fades and the shadows deepen," he explained, "all the petty and exacting details vanish; everything trivial disappears, and I see things as they are, in great, strong masses. The buttons are lost, but the garment remains; the sitter is lost but the shadow remains; the shadow is lost but the picture remains. And that, night cannot efface from the painter's imagination."

The next day he would transfer the more successful of his brown-paper images to a panel of mahogany from the boatyard or an absorbent canvas, using quantities of pigment (mixed on the palette) so heavily cut with linseed oil or turpentine that they could be washed onto the canvas like watercolor—his "sauce," Whistler called it. As additional tones were spread, the canvas had to be put on the floor to keep the "sauce" in place, the shimmering effect eventually arrived at resulting from the many thin layers of tone which imparted the nuances he wanted, but at the price of an extreme simplification of subject and background. For the suggestions of lights and shoreline he would reshape his brushes over a lighted candle, melting the glue in the base of each brush and pressing the bristles into the shape he wanted. Then, with flicks of color, lanterns and harbor lights would emerge, and soft shadows suggesting silhouettes of buildings and shore, bridges and barges, currents and wakes, even people. Unless Whistler thought the effect too experimental or unsuccessful to be seen in public, the canvas on its stretcher would be propped against a garden wall to dry in the sun.

It was his synthesis of the reticent, simplified Japanese method, and much thought had gone into it, not only on the evidence of the Valparaiso paintings, but on the evidence as well of his later words to Fantin-Latour, thanking him for a gift of two flower still lifes. "It seems to me," he wrote, "that color ought to be, as it were, embroidered on the canvas, that is to say, the same color ought to appear in the picture continually here and there, in the same way that a thread appears in an embroidery, and so should all the others, more or less according to their importance; in this way the whole will form a harmony. Look how well the Japanese understood this. They never strive for contrast; on the contrary, they seek repetition."

Neither Whistler nor the Japanese could paint the night *at night.* When Whistler went out without notepaper he recorded his impressions for the morning by a peculiar feat of memory recalling the teachings of Lecoq de Boisbaudran at his *atelier* in the 1850s. Thomas Way, the

lithographer, remembered how, strolling by the Thames at night, Whistler would stop, stare, then turn his back on the scene and test himself, "The sky is lighter than the water, the houses darkest. There are eight houses, the second is lowest, the fifth the highest; the tone of all is the same. The first has two lighted windows, one above the other; the second has four." If he faltered he was corrected until he had it right; then he would go off with a brisk good night and visions of a new nocturne. Way remembered, too, that once, after they had left the Lindsey Row studio and were walking along the road toward the gardens of the Royal Hospital, Whistler suddenly stopped, "and pointing to a group of buildings in the distance, an old public house at the corner of a road, with windows and shops showing golden lights through the gathering mist of twilight, said, 'Look!' " Way turned, and realized that although his friend was fascinated with the scene, he had neither sketchpad nor paper, and offered his own notebook. "No, no, be quiet," said Whistler, who was taking in the scene. Finally he walked back a few yards and turned his back, saying, "Now see if I have learned it." And he described the setting as if he had memorized a poem, then walked on again with Way, who tried to interest him in yet another scene; but Whistler put the idea aside, saying, "No, no, one thing at a time." In a few days, when Way returned again to Lindsey Row the first scene was there on the easel, completed.*

For Whistler a nocturne was a night piece, not a river piece, and some of his new canvases were of Chelsea after dark, the *Nocturne* (first *Harmony*) *in Grey and Gold: Chelsea Snow* evoking impressions of a lighted public house window, lanterns and lighted windows, a patch of snow, the dark silhouette of a figure, a suggestion of a tree. But the prevailing impression was of glowing light and gathering dusk—or grey and gold—except for critics who saw a story in the traveler reaching friendly warmth. Whistler wrote to *The World* of his frustration that the English could not consider a work of art for itself, apart from any supposed story. His Chelsea canvas illustrated his meaning: "a snow scene with a single black figure and a lighted tavern. I care nothing for the past, present, or future of the black figure, placed there because black was wanted at that

* Degas apparently learned the method from one of de Boisbaudran's pupils. Once he and the sculptor Bartholomé arrived at a friend's country house after chatting together throughout the journey, and during the visit Degas reconstituted from memory several of the landscapes he had observed while travelling. Bartholomé was amazed as the scenes reappeared "as if they were before his eyes," although Degas, he recalled, "did not stop once to look at them" as they had passed.

spot. All I know is that my combination of grey and gold is the basis of the picture. Now this is precisely what my friends cannot grasp." Give it a Dickensian "story" title, he was told, and he could get for it "a round harmony of golden guineas." He would not.

Most of the nocturnes utilized the Thames in some fashion, while the language of music furnished the titles. There was *Harmony in Grey: Chelsea Ice; Variations in Violet and Green* (the river at twilight); *Nocturne in Blue and Green: Chelsea*. Sometimes there was a silhouetted figure in the foreground, and the Japanese floral devices that showed it was a transitional piece. In every case realism was unimportant. Walter Greaves once complained that the chimneys were not painted straight. "But they are Whistler's," said the painter. Most people, he objected, liked "the sort of day when, if you look across the river, you can count the wires in the canary bird's cage on the other side." They also liked the equivalent in their nights. He once went out on the river when a friend had observed that the stars were fine. "Not bad," said Whistler, "but there are too many of them." For his nocturnes he preferred the harsh light of nature—even starlight—veiled, eventually creating a sense of space and atmosphere identified with him. A lady told him that she had observed on a trip up the Thames patches of haze which were like a series of Whistlers. "Yes, madam," he agreed, "Nature is creeping up."

Whistler's protégés were creeping up as well. In his *Nocturne in Blue and Gold: Old Battersea Bridge*, a section of the old wooden span loomed ghostlike in the foreground, while a bent and solitary waterman beneath—again the lonely silhouette—could be seen at the tip of a passing barge. Later Walter, the more talented of the Greaves brothers, would paint his own nocturnes and portraits in the Whistler mode, even predating his *Passing Under Old Battersea Bridge* by ten years to leave the *ex post facto* appearance that he had anticipated Whistler. (In the process Greaves mistakenly put the new Albert Bridge in the background.) Although he was a talented primitive painter—as his *Hammersmith Bridge on Boat Race Day* later proved—he felt so committed to copying his master that he copied everything, including Whistler's color harmonies. Copying old masters in the Louvre was one thing, but copying one's own master so blatantly cheapened the product—"it not only would be unfair to yourselves, but to my inventions too," Whistler wrote vexedly to Walter Greaves:

> Don't you see Walter you know how I continually invent—
> and invention you know is the cream of the whole affair and so

easy to destroy the freshness of it. And you know that the whole system of arrangements and harmonies which I most certainly invented, I brought you up in; so that it is only natural that I should expect my pupil to perceive all harmony in the same way: he must do it—for I have shown him that everything outside of that is wrong. . . .

Now look, suppose you were to see any other fellows doing my moonlights. How vexed you would be. You see I invented them. Never in the history of art had they been done. Well nothing more natural than that you two should do them—and quite right that the traditions of the studio should go on through the pupils—but still, for instance, it would be absurd now to paint another "White Girl." Don't you know what I mean? . . .

Ever affectionately your friend. . . .

That Walter Greaves never took the broad hint is obvious not only from the canvases which have survived him but from other letters in which Whistler made such observations as "Of course it is quite natural for you to see Nature as I have made her known to you." Before the inevitable break, however, the Greaves family and the Whistlers—mother and son—were on such warm terms of friendship that it would have been difficult to decide which had adopted the other.

The Greaveses tolerated Anna Whistler's proselytizing, and she was sure that when her son went off for an evening there, often to supper and music in the parlor, he was safe from bohemian influences. Sometimes, however, he went there only to secure boatmen for a trip to the Putney home of the raffish Howell, and sometimes on an evening Whistler, accompanied by one or more of the Greaves family, would walk the quarter-mile up the narrow neck of land that led from Lindsey Row to Cremorne Gardens. The twelve acres comprising the pleasure gardens of Cremorne had once been a stately mansion and park—Cremorne House. By the 1830s, its heirs, having known bad times, had turned the property over to commerce, and it had become first and unsuccessfully a sporting club, then an amusement park, with pagoda-shaped bandstand and open-air dancing platform lit by gas lamps, a Venus fountain, entertainment ranging from balloon ascents to circus, marionette theatre and bowling alley—like Vauxhall Gardens, a London Prater or Tivoli, at a shilling admission for fifteen hours of fun.

Sometimes when the tide was right, Whistler would go out by boat

with the Greaves brothers to observe the lights of Cremorne glittering through the oaks and elms, and to await the nightly fireworks spectacle of rockets and catherine wheels. From the pleasure gardens, recollected by daylight, came the *Nocturne in Blue and Silver: Cremorne Lights, Nocturne in Black and Gold: The Fire Wheel,* and *Nocturne in Black and Gold: The Falling Rocket.*

Although Whistler became the poet of Cremorne as Thomas Rowlandson three-quarters of a century earlier had been the poet of Vauxhall Gardens, his etchings and canvases of colorful, strolling figures in Cremorne are far less remembered than the nocturnes. There Whistler was the European Hiroshige. The last Japanese master in the tradition of Haronobu, Utamaro, and Hokusai, Hiroshige sought after the effects of rain and twilight in his landscapes, and produced a memorable color woodcut, "Spring Fireworks over Edo," in a stylized flatness that suggested some of Whistler's experiments. But the impressionism of his nocturnes owed nothing to any tradition, and it often took a feat of imagination to elicit subtleties of story or topography from them. Nowhere else was Whistler's insistence on the abstractly decorative qualities of a setting, or the revolutionary aspects of his art, better exemplified; and nowhere else was his work more influential among artists who worked in other media. Poets would later find them expressing moods they sought in their own poetry, and composers would later evoke shimmering Whistlerian effects in their music. The bejeweled London night evoked Whistlerian words from Lord Alfred Douglas:

> See what a mass of gems the city wears
> Upon her broad live bosom! row on row
> Rubies and emeralds and amethysts glow.
> See! that huge circle like a necklace, stares
> With thousands of bold eyes to heaven, and dares
> The golden stars to dim the lamps below. . . .

In *London Nights* and in *Silhouettes* Arthur Symons, also in the '90s, when Whistler's art was most influential upon writers, would write verses in a similar vein, of

> . . . blackness broken in twain
> By the sudden finger of streets . . .

and of

> . . . the Embankment with its lights,
> The pavement glittering with fallen rain,
> The magic and mystery that is night's. . . .

And reviewers would recognize that "in their richness of suggestion and their felicity of presentment they remind one of the work of Mr Whistler. Perhaps this is how, if he chose verse as the medium for his expression, he might appeal to our mental eye."

W. E. Henley would even dedicate a poem to Whistler, one which attempted to describe the melancholy and mystery he saw imaged in nocturnes like *Blue and Gold: Old Battersea Bridge*, where

> Under a stagnant sky,
> Gloom out of gloom uncoiling into gloom,
> The River, jaded and forlorn,
> Welters and wanders wearily—wretchedly—on;
> . . . In and out among the ribs
> Of the old skeleton bridge . . .

Nothing better demonstrated the transitory aspect of the floating world Whistler evoked and captured in a way which altered men's vision* than the fate of Cremorne Gardens itself. By 1877 protests about noise and rowdiness from the increasing population around the Gardens in Chelsea and Fulham forced the closing of Cremorne, which lives on almost entirely, from crowd scenes and dancers to fireworks and riverscape, in Whistler's pictures. A generation later it had crumbled into the Thames mud, weeds and the trees of the old park leaving barely a trace of the pleasure gardens. For Whistler himself the nocturnes it inspired were a mixed blessing. He created dozens of them, many unsalable in his lifetime because they were so remote from the tradition which appealed to Victorian connoisseurs.

When first exhibited, the nocturnes created as much mirth as misunderstanding. One journal referred to "the blue and black smudges which purport to depict the 'Thames at night,'" while another complained that "A dark bluish surface, with dots on it, and the faintest adumbrations of shape under the darkness, is gravely called a Nocturne in Black and Gold." Another complained of "Whistler's meaningless canvases," with which the artist would have contentedly agreed. Frederick Wedmore judged that Whistler's reputation was "imperilled by original

* "The German [Richard] Muther and the French Gustave Geffroy tell us, independently of one another, that on crossing the Channel at night, when they came upon the English coast, and saw the points of light piercing the mist and the gloom, they exclaimed: 'A Whistler!' The same sort of expression must have been provoked by these views of the Thames." (Theodore Duret, *Whistler*, 1904)

absurdity," while Philip Hamerton reacted, "I think Mr. Wedmore takes the Nocturnes and Arrangements too seriously. They are merely first beginnings of pictures, differing from ordinary first beginnings in having no composition. The great originality was in venturing to exhibit them." Fortunately in the seventies Whistler had a second string to his bow: he painted people, although he would seldom call the result produced by the traditional name of portrait. Neither would the critics.

XV

Patrons and Portraits

T HE nocturne captured a fleeting vision. Portraits were a captive
subject: the sitter could come back again and again, even in the
same garments. And patrons paid for portraits, often in advance,
while Whistler's unsold night pieces rested against a wall in the drawing
room at Lindsey House. The message was clear: if the artist wanted to
experiment he had to earn the opportunity in a trade where both cheap
workmen and fashionable Academicians abounded. Some painters con-
cerned about the servile aspects of portraiture philosophized that they
penetrated character or extracted spiritual qualities; others looked back
into the great galleries and defended the inherent dignity of their calling.
Whistler saw opportunities for *harmonies* and *arrangements,* and for checks
representing golden guineas.

While Leyland was still willing to let Whistler experiment for his
guineas, a wealthy Glasgow member of Parliament, William Graham,
who had commissioned neither a harmony nor an arrangement, but a *Blue
Girl*, a portrait of his fifteen-year-old Maggie, had little success in getting
delivery. The sittings were prolonged; Maggie Graham complained of
fatigue and illness, and eventually refused to sit further. Whistler nursed
his annoyance through what was left of the day, then late in the evening
decided that the back of the canvas was a good surface for something else.

Although it was stained through from the abortive *Blue Girl* on the other side, he began preparing it for use. Early the next day he surprised his mother by telling her that he wanted her to pose for him, that he had long wanted to do her portrait. It was his revenge upon Maggie Graham, and much else besides, for Whistler had begun a portrait of his mother—possibly as a peace offering after the Valparaiso adventure—sometime in 1867, intending the canvas for the Salon. Apparently he had abandoned it when it was far along, for he had even written to Fantin-Latour of his intentions to have *Le portrait de la mère* photographed. Now he returned to his most obvious portrait subject.

Uncomplainingly stoic despite the certain earlier disappointment, Mrs Whistler sat silently, dressed in black as always, on a straight-backed chair, in front of an etching of *Black Lion Wharf*, while a portrait in profile took shape, dreaming as the old and sedentary do, except when interrupted by her son's loud anger with himself for not getting everything as perfect as he wanted. With each expostulation she stiffened but remained silent, remembering, "I silently lifted my heart that it might be cast down in the Lake at the Lord's will." The number of times that was necessary may have contributed to the tight-lipped, Puritan austerity of her figure, her hands clutching a white handkerchief in her lap. Still, Anna Whistler was confident in the outcome, although the work, she thought, involved deferring remunerative assignments. "Jemie had no nervous fears in painting his mother's portrait," she wrote a friend, "for it was to please himself & not to be paid for in other coin!" Fortunately there was his mother's pension, and his advances from Leyland.

One afternoon as the picture progressed Whistler saw his mother wilt and cry for a pause, and he apologized for his obtuseness and offered to take her for a bit of river air. Near Lindsey Row was a landing for the two-penny pleasure boats which cruised the Thames. "He was charmed with the life on the Thames. He took out his pencil & tablets as we sat side by side on the little steamer [and] were a half-hour or more benefitting by the sunshine and breezes." At the Westminster landing they disembarked, walked through St James Park, then hailed a hansom cab for the shilling ride in the still-warm air back home. Before Battersea Reach the late afternoon sun shimmered on the water, and after a pause to admire it, Whistler—forgetting the portrait—rushed inside to capture the scene, putting his easel before a drawing room window and painting until the moon came up, his mother watching fascinated, and even encouraging him to do a moonlight impression of the Thames. Lest such feelings be

thought frivolous in Stonington or Scarsdale she added, "God has given the talent and it cannot be wrong to appreciate it."

The *Arrangement in Grey and Black, No. 1* conveyed a tenderness and serenity which belied past tensions between mother and son. When it was completed both knew that each other's expectations had been exceeded. In the use of a seated figure in profile, the spare setting and the verticals and horizontals of picture frame, Whistler had harked back to his portrait of his sister-in-law in *At the Piano*, and Deborah, who—certainly without her husband's knowledge—came over from Sloane Street to see it, was lavish with compliments. Friends came to Lindsey Row to praise the likeness, but Whistler insisted (as he would continue to do), "To me it is interesting as a picture of my mother; but can or ought the public to care about the identity of the portrait? It must stand or fall on its merits as an arrangement." Few among the faithful listened. Solicitor John Anderson Rose, beset by Whistler's creditors, but "who seems to have given me his own Mother's place since she died," Anna Whistler wrote, "was charmed and came four times. He says when it is exhibited next spring he shall go every day to see it." Rossetti, stirring from Tudor House despite his increasing insomnia, melancholy and dependence on chloral, had long been close to his own mother, and understood the sensitivity of the portrait, telling Whistler that it "must make you happy for life," while Swinburne, whose aged mother Lady Jane patiently suffered his scandalous London life and his annual pilgrimage to see her at Leigh House in Bradford-on-Avon, spoke of its "intense pathos . . . and tender depth of expression."

Because the portrait had long been contemplated, and even begun in a false start, it had finally gone quickly and without frustration. Rather than continue to think of it as destined for Paris and the Salon, Whistler seems to have realized that it had more important uses. First, he would take it to the Leylands at Speke Hall, their establishment near Liverpool, to prove to his most important patrons that he could complete a portrait, and that the result would be worth their patience; but he told his mother as he packed to go to Speke Hall that he was crating it to take with him because he could not let it out of his sight. He probably meant it, for a complex of reasons. In any event, she was deeply moved.

The Leyland household, especially the ladies, were charmed, and Whistler wrote to his mother every detail of their appreciative comments. Frederick Leyland himself agreed that the canvas must not be hidden in

the guest room but placed on the large wall of the main banquet room between the still-unfinished *Arrangement in Black* of the master of the house and a portrait by Velasquez. "You bear the comparison very well, my darling Mother," he wrote her, "with the masterpieces on each side of you."

Whistler had been getting on capitally with the Leylands despite the unfinished canvas, and had spent the late summer and most of the autumn of 1870 at Speke Hall, a visit even more extended than the year before. Leyland, Whistler's mother wrote, with no exaggeration, was "not only a prosperous man in Liverpool but a very cultivated gentleman of taste." Totally unlike Whistler in almost every way, he had accomplished enough in his forty years (he was three years older than his court artist) seemingly to be able to finance the entire Pre-Raphaelite movement. Beginning with Rossetti, whose seediness and bohemianism did not put him off, and who talked him into buying pictures from his needier friends, he behaved more generously to many artists than they deserved.

Reputedly the son of a woman who had sold pies in the streets of Liverpool, he had risen from apprentice in the shipping firm of Bibby, Sons, & Co., to managing director and in 1873 would be owner of his own steamship fleet, The Leyland Line. On his desk was a card file he insisted on having brought up to date each morning detailing the position of each ship he controlled and how much cargo space was available. He was equally in command of his facts about advances to painters, and what he had paid for delivered canvases, prices he always paid without haggling. No patron could have been more patient. In 1864 he had commissioned a painting from Rossetti for 450 guineas. Five years later it was delivered—*Lilith*—and afterwards ruined by Rossetti's insistence on repainting. He was the second owner of *La Princesse du Pays de la Porcelaine*, and so pleased with it that he commissioned portraits of himself and his wife—the first for £400, all of it advanced years before there was a canvas to show for it. But the *Mother* demonstrated that Whistler could paint a portrait to rival anything by anyone Leyland knew, and the advances and the hospitality continued with Whistler expected to paint portraits not only of his hosts but also of their four children.

Early in 1872 Mrs Whistler thanked the "One source of help on which I rely for the continued success of either of my dear boys" for the preservation of her portrait. It had been in one of three boxes of canvases returning with Whistler from Liverpool, in a luggage car which caught

fire. "The flames had reached the case in which my portrait was, but in time to be discovered," she wrote James Gamble; "the lid was burnt, a side of the frame scorched, yet the painting uninjured."

On Easter Tuesday back in London, Whistler had friends in to wish the portrait well before it went that evening to the Academy, along with a nocturne. His mother, in an armchair in her "Japanese bedroom" (she was recovering from a cold and had been attended by Willie Whistler), listened to the praises of admirers. On April 20 she wrote to her American friends about the "cheering report" on the picture, and that it had been considered "a fine work" and was "well hung." She had not been told that it had first been rejected.

"I hear that Whistler has had the portrait of his mother turned out," Madox Brown wrote to George Rae. "If so, it is a shame, because I saw the picture and know it to be good and beautiful, though, I suppose, not to the taste of Messrs. Ansdell and Dobson." Richard Ansdell, a bird-and-animal painter who was a watered-down Landseer, and William Dobson, a painter of scriptural subjects then best known for his *Tobias and the Angel* and *The Good Shepherd,* had led the faction which had consigned the canvas to the room in the cellar where pictures denied hanging space awaited retrieval by their senders. Belatedly, Sir William Boxall found out what had happened. Years before he had met Major Whistler, visiting London from St Petersburg, who had commissioned a portrait of his young son, which Boxall had submitted to, and hung at, the Academy. Now seventy-two and full of honors, he demanded, as a member of the Council of the R.A., to see the rejected portrait of Major Whistler's widow, done by the boy he had painted. Resentfully, the Hanging Committee brought it back for view, and Sir William, impressed, threatened to resign and remove his own picture if the portrait were not hung.

The threat worked, and the portrait was grudgingly and badly hung, along with the nocturne, and poorly received by the press. "The canvas is large, and much of it vacant," the *Times*'s critic wrote. "A dim, cold light fills the room, where the flat, grey wall is only broken by a solitary picture in black and white. . . . And here in this solemn chamber sits the lady in mournful garb. The picture has found few admirers among the thousands who seek to while away the hours at Burlington House, and for this result the painter has only to thank himself." According to the *Examiner* it was "not a picture, and we fail to discover any *object* that the artist can have in view in restricting himself almost entirely to black and grey." Whistler's

"experiments" were not pictures, and certainly not Art. In this the Academicians and the critics agreed. The artist, who understood how the acceptance had come about, never again would send a picture to the Academy. At the very point when he seemed to have found himself again as an artist, the dinosaur faction of the R.A. and in the press had forced him to renew his role as rebel.

Capitalizing on the impact of his *Mother* portrait at Speke Hall, Whistler did an *F. R. Leyland's Mother* etching in addition to etchings of the Leyland girls and of the house and surroundings. The four Leyland children worshiped Whistler, but although the girls were not frustrated by the long hours of posing which ended in a rubbed-out canvas or disappointingly tentative sketches in charcoal and pastel,* Leyland's son, after three sittings, lounging in a chair with a big hat pushed back on his head and his long legs stretched out, refused to pose again.

Frances Leyland often used the more-than-willing Whistler as an escort about London, especially after her busy husband acquired a town house at 23 Queen's Gate in 1869. Once at the opera the attendant who took their wraps and Whistler's hat leaned over to whisper to him, "I beg your pardon, Sir, but there is a white feather in your hair, just on top." It was Whistler's white forelock, of which he was inordinately proud, checking it often when he passed any sort of reflecting surface to make sure it was combed out to be more visible. (After Valparaiso it had appeared mysteriously, and Whistler accepted it as a natural asset.)

When in London Frances Leyland sometimes posed for Whistler in his Chelsea studio, and attended dinners and Sunday breakfasts (not yet a Whistler ritual) at Lindsey Row. For one large dinner party she even offered her butler, and in the afternoon came over with her sister to see that everything was in order, and even hung up white muslin curtains at the windows for him. The host himself prepared individual longhand menus for each place, each in French, and signed with his butterfly, so that guests would have a free—and original—Whistler to take home, perhaps to whet the appetite for a more substantial Whistler. And the dinners (he later was forced to retreat to the less expensive but no less flamboyant Sunday breakfasts) featured an impressive array of courses, an 1873 example going through *Consommé à la Royale, Truite Saumonée Hollandaise, Aspic de foie gras, Filet de Boeuf à la Marsaillaise,* and *Babas au*

* One was posed against a dark panelled wall in a black riding habit, with silk hat; another in a white muslin dress with many flounces; the youngest in a ruffled blue dress, against a blue background.

Rhum to *Crème Oncle Tom* and *Ananas à la Crème*. The food came on blue-and-white china, goldfish swam in a blue-and-white bowl on the table, and the talk was of books and art, Whistler less interested in fashionable French and English authors than in his compatriots Mark Twain and Bret Harte.

At the dinner at which Florence Leyland assisted, Whistler had Leyland take in a daughter of the singer Grisi, because he knew his patron loved music and spent hours at his own piano; but all she wanted to talk about were the romantic novels of Ouida. Partly for diplomatic reasons and partly because he was infatuated with Frances Leyland, Whistler took her in himself, after she coolly prevented a disaster when she caught a young woman neither of them liked nearsightedly mistaking an antique porcelain Japanese bath with water-lilies for a divan and was lowering herself into it.

People talked about her and Whistler, gossip—apparently abetted by Dante Rossetti—going so far as to suggest that she might leave her husband and run off with him; and Whistler controlled the speculation while continuing to see her as often as he could first by keeping his mother in the background and then by arranging an engagement with Mrs Leyland's youngest sister which no one in the Leyland family seems to have accepted seriously, and which eventually faded when Whistler found consolation in Chelsea. Whether or not Frances Leyland was in love with him, she unquestionably encouraged his proximity, and was more than patient about the repeated sittings for her portrait in London and at Speke Hall. Whistler's letters to her seem more feverish in feeling than mere flowery words from artist to patroness. After one Christmas stay in London he wrote, carefully, "It is natural enough that utter desolation should set in now that you all have taken your departure and everything like life has gone with you—and desolation it accordingly is." He confided his ambitions to her, that he was known in art circles as "an unreliable fellow," but that he now felt a power in his hands which would bring him artistic successes as well as frustrations to his enemies; and he sought her sympathy when he spelled out his plans.

That he never finally conquered her remoteness—although he made his availability for an affair obvious—seems evidenced by his portrait of her, standing in a loose, flowing gown of pink and white chiffon, with her back to the artist and her face in profile, elegant and somewhat severe. The pose was one natural to her, she said many years later; it was one she took while talking. Whether because of Whistler's chronic lack of

confidence in his work or his desire to keep the relationship going, he rubbed out the picture again and again. Even when it looked as if it were finally finished, she would discover the next morning that the results of the previous day's posing had disappeared from the canvas. Finally, to paint the drape of the gown correctly and finish the portrait, he took both the canvas and the gown back to London with him and sought a model to stand in it, reporting to Mrs Leyland that he had "at last found a beautiful creature to replace the 'perfect woman'—though I fear I shall never absolutely believe any other (model, of course—'common people') her equal. . . ." It was Maud Franklin, who, like Frances Leyland, was slim of figure, elegant of carriage, and with splendid auburn hair. Soon, with good reason but without benefit of clergy, she would be calling herself "Mrs Whistler."

Before Maud Franklin could establish herself at 2 Lindsey Row the aged chatelaine who was the authentic Mrs Whistler had to absent herself, and in 1873-74 the time was not yet. Instead, Frances Leyland visited as well as posed for Whistler in Chelsea and entertained him and stood for him at Speke Hall. When their relationship was young she even traveled with him to see his son John, who was being cared for as a small boy by a woman "somewhere in the country, and Whistler seemed quite fond of him, taking him in his arms." And she saw John later as well, when he was older and Jo—still "Mrs Abbott"—was again mothering him. To John, Jo was "Aunty," and sometimes he would come to the Lindsey Row studio—Mrs Leyland remembered him as a lad in a sailor suit—to tell Whistler that "Aunty" needed some money. The raffish blend of bohemian and Beau Brummel in Whistler fascinated Frances Leyland, who sought the *frisson* of decorous flirtation and even regretted in later years, she told Elizabeth Pennell, that Whistler could not have married her—it would have been better for him, she thought. As it was, the decade-long relationship was frustrating yet curiously satisfying for both. By the time it was over, Whistler needed more than the occasional services of a compliant model: he needed a Maud. And in Mrs Leyland's pink-and-white gown he had already found, in Maud, a surrogate Florence Leyland.

The record of Whistler at Speke Hall is considerable. He did etchings and drypoints of Mrs Leyland and her children, of the house, the woods and coast nearby, Leyland's shipping in Liverpool harbor. He did preliminary sketches and oils for his pictures. And he finally finished—almost finished—the portraits of Frederick and Frances Leyland. For

Leyland he had set himself the task of depicting a full-length figure—the first male portrait he had attempted—dressed in black yet against a black background, a pure *Arrangement in Black.* Black on black, life-size and from head to foot, could result in a figure so vaguely defined and spectral that everything but Leyland's face, hands and ruffled shirt would flatten and fade into the background. The effort at first foundered, and although Whistler had begun it in the late 1860s it was not completed until shortly before his one-man show of 1874.

Like many Victorian patrons, Leyland not only wanted his portrait as a reaching-out for the immortality art offered where commerce could not, except as it provided the guineas for the grand gesture; he wanted the immediate recognition of his place in the world by the exhibition of that portrait in the Royal Academy. Whistler had at first promised it for the 1869 show, although he had not yet emerged from the period of his lowest confidence in himself as an artist. The previous Christmas he had, in his usual cocky way, written to Leyland for more money, for it was, he explained, that festive season when it was so difficult to do battle with the enemy of Yuletide joy, poverty, and his ammunition was exhausted. This time he wanted the balance due for his portrait, "which is steadily progressing—and depend upon me for its completion as soon as possible."

Leyland sent fifty guineas, but when Easter approached the picture had only sustained more rubbings-out, and Whistler, unable any longer to keep up the confident air, panicked. It could not be sent to the Academy in its spectral condition, and Whistler appealed to his mother, a favorite at Speke Hall, for a way out of his dilemma. "Leyland must be written to, but I cannot do it. You can, dear Mother, for me, & I am sure you will try to relieve my mind that far. Say to him I feel it right to put again in his hand the £400 he advanced as the price of the first picture. I dare say George will lend me that amt. which I feel in honor bound to refund. Say to Leyland that on my return to Chelsea, I will finish the two pictures he has ordered, before I begin any others, only beg him to believe I have not failed to do so before now from lack of endeavor to gratify his wish and my own. I cannot even shew him the first in its present state."

George Whistler, partner in the Winans locomotive enterprises and Jimmy's half-brother, had sold the uncompleted portion of the Winans railroad contract with the Russian government back to the czar for a substantial sum and left Russia with his family early in 1869; but when he arrived in England ill, instead of returning to America he had taken a place in Brighton to recuperate. Jimmy saw a way out of his difficulties

via a loan from him, if necessary, but very likely expected the indulgent Leyland to be unable to make any harsh demands via Anna Whistler. "You may judge, dear Mr Leyland, how painful is this task to me, for tho my experience of blighted hopes in this world has taught me to expect disappointment, I yet tremble as my Sons encounter it, for they have not the faith in God which is my support." He had earned the divine rebuke, she went on, for working on Sunday in defiance of the Fourth Commandment, work which had proved of no avail. "I am only comforted," she went on, "by believing that tho our present chastening is grievous, its results will be for our rejoicing in God our Savior."

Leyland clearly could not disappoint the godly Anna Whistler, and carried the advance on his carefully kept books until the painting was done in 1873. But it was not until the Pall Mall one-man show of June, 1874 had been in progress for a week that Whistler collected his final £210 for his portrait—on display there—of Mrs Leyland. That he never had to beg a loan from the ailing George Whistler was fortunate. George, who had invited his mother and brothers to Christmas dinner in Brighton, died suddenly on December 23, 1869. Jimmy Whistler remained on his own, and cut down on his entertaining until new commissions came in.

The problem with the portrait of Leyland had always been, Whistler decided, less the placing of a black image on a black background, than the placement of Leyland's long legs. He could not get the stance, with one foot forward, right hand on hip, convincingly. Finally he employed a male model, not to stand in Leyland's evening clothes, as Maud did for Frances Leyland's gown, but in the nude. Somehow he was going to get the legs right. Although he then had to paint trousers over the bare legs, the gamble worked. The result was the closest he had yet got to Velasquez.

Whistler was having problems completing other portraits as well. London banker W. C. Alexander had been one of the few admirers of the *Mother* at Burlington House, and had bought the nocturne Whistler exhibited there. Then he commissioned Whistler to paint his four daughters, Mary, Cecily, Helen and Grace, and arranged for Whistler to meet the children. The plan was to paint them beginning with the eldest, Mary, then ten; but when her mother brought her to Lindsey Row in the family victoria, Whistler made some polite flourishes with his pencil, then wrote to Mrs Alexander asking her to bring instead the "little fair daughter instead of her elder sister," explaining that he could begin the project "with more freshness at this very fair arrangement I propose to

myself than at any other." For Cecily, not yet nine, he conceived a *Harmony in Grey and Green*, meticulously preparing the setting and advising her mother on the fabric for the dress and all the accessories from hat to shoes. And to get the fabric right Whistler consulted his own mother, the two of them writing a joint letter on August 26, 1872 to Mrs Alexander, Anna Whistler beginning by regretting the "additional trouble" her son was making, then explaining that "his fancy is for a rather clearer muslin than the pattern enclosed in your note. I think Swiss Book muslin will be right, that the arms may be seen through it. . . ."

There Whistler took the pen to suggest instead "fine Indian Muslin—which is beautiful in color," and drew a map of the Leicester Square area to locate the "sort of second-hand shop called Akeds" which carried it. If she had to resort to "the usual fine muslin of which ladies' evening dresses are made," he insisted that it be well bleached—"of course not an atom of blue." A pastel sketch of Cecily which still hung in Aubrey House—the Campden Hill, Kensington house to which the Alexanders soon moved—a century later shows that Whistler from the beginning knew exactly what he wanted, from the starched, frilly dress and the broad, feathered felt hat dangling at Cecily's side to the butterflies and flowers behind her. Again the background of his portrait had a flat, linear—almost Japanese—quality, and Whistler added to it not only his now-familiar butterfly mark but two flitting butterflies and a spray of daisies, light touches which suggest nothing of the relentless regimen of sittings which probably turned Cecily Alexander's earlier smile into a hint of a pout.

"I was the first victim," she told the Pennells, "and I'm afraid that I considered myself a victim all through the sittings, or rather standings, as he never let me change my position, and I believe I sometimes used to stand for hours at a time." She would tire and sometimes dissolve in tears, with Whistler so absorbed that he noticed nothing. Instead, he would stand back from the canvas, dart in close, then dart back again to look at the canvas as it was reflected in a mirror on the mantel. "Although he was rather inhuman about letting me stand on for hours and hours . . . he was most kind in other ways. If a blessed black fog came up from the river, and I was allowed to get down, he never made any objection to my poking about among his paints, and I even put charcoal eyes to some of his sketches of portraits done in coloured chalks on brown paper, and he also promised to paint my doll, but this promise was never kept."

Whistler's mother hovered nearby, but never came into the studio,

she recalled. Lunch hour with Mrs Whistler would come, and a servant would announce it, but Whistler would paint on, "and despair filled my soul, and I believe it was generally teatime before we went to those lunches, at which we had hot biscuits and tinned peaches, and other unwholesome things. . . ." Perhaps the tinned peaches were responsible, for the Alexanders began sending Anna Whistler "delicious fruits, [and] hot-house grapes and peaches," which she found "so thoughtful." And they invited her to their home for a weekend, sending their carriage for her on Saturday afternoon and returning her on Monday morning. She seldom left Chelsea, which made "attending their church and also the Lord's table with them" a rare experience. There was no one with whom to share her surfeit of piety at Lindsey Row.

After seventy sittings Whistler pronounced the picture complete and sent for Miss Mary Alexander, prescribing to her mother a milliner who sold wonderful picture hats and proposing that the portrait be painted at their new house in Campden Hill so that he could keep in mind its projected effect in the drawing room where it was to hang. But *Agnes Mary, Miss Alexander*, full of mysterious effects only half accomplished, remained an unfinished portrait of a girl in riding habit, drawing on her gloves. Mary had caught scarlet fever while she was being painted, and Whistler never returned to the canvas. Portraits of other members of the family went only as far as sketches in chalk, pen and ink, and even oils, yet Whistler remained friends with the Alexanders, and when he would visit Aubrey House he would immediately screw in his eyeglass, pause before the nocturne in the hall to murmur "beautiful . . . beautiful" and then make for the *Harmony in Grey and Green*.*

While the *Miss Alexander* was still in the studio, journalists who knew that Whistler's door was usually open turned up to examine it, Walter Greaves (who, with his brother, often showed visitors the studio) letting in Tom Taylor of the *Times*. To Sidney Starr, Whistler reported that Taylor said "Ah, yes, um," then observed that the upright line in the paneling of the wall was wrong, and that the portrait would be improved without it. "Of course," he added, "it's a matter of taste." Whistler's retort earned him no credits for his next show. "I thought that perhaps for once you were going to get away without having said anything foolish; but remember, so that you may not make the mistake again, it's

* W. C. Alexander bequeathed it to the National Gallery after refusing an offer of £10,000 for it in 1913 from Charles Freer. *Agnes Mary* in its unfinished state hangs in the Tate Gallery.

not a matter of taste at all, it's a matter of knowledge. Good-bye." The result was that Whistler made the gossip columns more than the art columns, except when there was something unfavorable to say. Literary critics and young writers were more welcome guests, Edmund Gosse (introduced by W. M. Rossetti) remembering "the bare room with little in it but the easel, and . . . the small, alert, nervous man with keen eyes and beautiful hands who sat before it, looking at his canvas, never moving but looking steadily for twenty minutes or half an hour, perhaps, and then, [all] of a sudden, dashing at it, giving it one touch, and saying, 'There, well, I think that will do for today!' "

On one of Cecily Alexander's twice-a-week visits, escorted from the family carriage to No. 2 Lindsey Row by her mother, she had passed a stooped, bearded man going down the studio staircase at the back and out the door. "Who is that?" he had asked the maid. "Miss Alexander, who is sitting to Mr Whistler." Thomas Carlyle shook his head. "Puir lassie! Puir lassie!" He knew the ordeal, and, old and weary, might not have gone through with it as far as he did had he had any idea of Whistler's painstaking method of portraiture. A Chelsea neighbor, he had been lured there by a friend, Madame Emilie Venturi, who had bought the nocturne *Harmony in Grey: Chelsea in Ice*, and admired the *Arrangement in Grey and Black.* "Carlyle saw the *Mother,*" Whistler told the Pennells, "and seemed to feel in it a certain fitness of things. . . . He liked the simplicity of it, the old lady sitting with her hands in her lap—and said he would be painted." To intimates, the moody Scot had often referred to the dapper, arrogant Whistler as "The Creature," and used other terms of undisguised contempt, once telling William Allingham that Whistler was "the most absurd creature on the face of the earth." That he was willing to sit was the first triumph of the *Mother.* And Whistler, realizing it, began drawing preliminary studies for his *Carlyle,* which would adopt a parallel approach—the same colors and a profile figure, and no romantic clutter of bookshelves and papers to emphasize the philosopher and historian.

Sitting down for the first time, Carlyle had said, "An' now, mon, fire away!" But Whistler in his perfectionism first made a pen-and-ink study, an oil sketch on the back of an abandoned nocturne, a small oil study of the head and shoulders, and another of the profile figure. Enjoying Whistler's ready wit and fund of anecdotes, Carlyle at the beginning looked forward to his sittings and added stories of his own, once describing his earlier sittings to other artists. "There was Mr Watts, a mon of note. And I went to his studio, and there was much meestification,

and screens were drawn round the easel, and curtains were drawn, and I was not allowed to see anything. And then, at last, the screens were put aside and there I was: And I looked. And Mr Watts, a great mon, he said to me, 'How do you like it?' And then I turned to Mr Watts, and I said, 'Mon, I would have ye know I am in the hobit of wurin' clean lunen!' " *

The sittings dragged on, with Whistler dissatisfied with what he had done, and Carlyle increasingly restive on his hard, straight chair. William Allingham noted in his diary, "If C. makes signs of changing his position, W. screams out in an agonised tone: 'For God's sake, don't move!' C. afterwards said that all W.'s anxiety seemed to be to get the *coat* painted to ideal perfection; the face went for little. He had begun by asking for two or three sittings, but managed to get a great many. At last C. flatly rebelled. . . ." For a long time he had not realized that Whistler was merely doing preliminary studies. Then he was not allowed to see the principal canvas. "At last, when he let me look at it," Carlyle grumpily reported, "I said, 'Oh, yes! I see, that is the mouth and that's the nose': but I was told that all that was [only] the beard, and that the face was somewhere up there." And Whistler would gesture vaguely.

For Carlyle, in the summer of 1873, enough was enough. He let Whistler finish the face, and a model—the father of painter Phil Morris—was engaged to sit in Carlyle's long black coat. Nevertheless the result was worth the effort for both men. For the world Carlyle is, visually, the figure in Whistler's *Arrangement in Grey and Black, No. 2*, gloved right hand on his walking stick, his famous broad, slouch hat on his knee, long black coat bulged out at the chest, its tails reaching the floor, and above, tired eyes looking out over the craggy, worn face. It became one of Whistler's best-known works and eventually the first to be purchased for a public gallery; yet for nearly twenty years Whistler would exhibit it often and have to pawn it even more often.

Whistler refused to let the Academy judge his *Carlyle*. When it was exhibited a decade later at the Loan Exhibition of Scottish Portraits it created so much of an impression that Whistler tried to interest the curator of the British National Portrait Gallery in purchasing it for the nation. Sir George Scharfe dismissed the suggestion with a "Dear! Dear! and is *this* what painting has come to!" A story has it that Whistler answered, scathingly, "No, it hasn't," but all that he wanted remembered

* "A portrait," said Watts, in an attack upon the Whistler method, "should have in it something of the monumental; it is a summary of the life of a person, not the record of accidental position or arrangement of lights and shadows."

afterward was that Scharfe turned away from the portrait with rebuke in his eye, and vanished.

Soon after the completion of the *Carlyle*, Whistler arranged for a one-man show at Henry Graves's Flemish Gallery at 48 Pall Mall, a retrospective which would include a sampling of his work up to and including the *Carlyle* and such of his portrait work for Leyland as he had already completed, altogether thirteen well-spaced oils and fifty etchings. Even the gallery became a Whistler "arrangement" —grey walls, palms, flowers, and blue-and-white pots. He designed the invitation card for the private view on June 6, 1874, and his mother and the Greaves brothers addressed all the invitations, including replicas of the Whistler butterfly.

Of his friends, Swinburne was enthusiastic even before he arrived at the private view, writing to urge others to attend and adding, "I have seen at least some of the things to be exhibited—and I assure you in my poor opinion they are second only—*if* second to anything—to the very greatest works of the age." Rossetti, as a rival for the patronage to which he had introduced Whistler, had other ideas, writing suspiciously to Madox Brown, "I see Whistler is getting up an exhibition! I think I twig the motive power. He must have finished the Leyland portraits, and persuaded L. that they were sure to be hung badly if sent to the R.A.—whereupon L., rather than see himself hoisted, paid bang out for an independent show of them. I have no doubt at this juncture it will send Whistler sky-high, and Leyland will probably buy no one else any more! I believe Leyland's picture will set the fashion in frills and buckles."

Rossetti was both right and wrong. The long-worked-over portraits of Frederick and Frances Leyland were included (as *Arrangement in Black* and *Symphony in Flesh Colour and Pink*), with F. R. Leyland, known in his time as the only man of his generation to wear the frilled shirts of time past, complete to his ruffles. But his idiosyncratic taste in shirts set the fashion in 1874 no more than Whistler's style in portraiture. For Whistler it was a calculated risk that failed. Most critics ignored the opening, and those who did not were polite at best and unflattering at worst, suggesting that he had failed to fulfil the promise of his earlier work. Eccentric titles beginning with "Nocturne" or "Arrangement," and Whistler's flat surfaces and muted tones were too untraditional to be acceptable, although one critic noticed a "Velasquez touch." Bad or good, Whistler scissored out every notice for his file.

XVI

Portraits and
Non-Portraits

"WHISTLER called yesterday and carried me off to his exhibition, which is now closed but not yet dismantled," Dante Rossetti wrote to Madox Brown in August, 1874. "I thought three pictures—his mother, *Carlyle*, and the banker's little daughter—very fine works indeed in their own way. The others were not equal to these, but the head of Leyland is very like him, and the figure of Mrs. L. a graceful design, though I cannot see that it is at all a likeness." He was obviously relieved. The Pall Mall show had not carried the day in a way that would have monopolized patronage for Whistler. Yet the show had not driven commissions away, and with Leyland's payment for the portrait of his wife and 600 guineas he had received for another Pall Mall portrait he was suddenly—and briefly—out of serious debt. The year before he had been asked by the wealthy Louis Huth, who had bought his *Symphony in White, No. 3*, to paint his wife, and the work was underway at the same time that Mrs Leyland had been posing at Lindsey Row, the women often meeting as one came and the other went. Florence Leyland even admired the black velvet dress in which Mrs Huth posed, and Whistler had flattered her out of wanting to duplicate it. Louis Huth was an admirer of Velasquez, and Whistler provided him with a canvas after the master, a tall, striking figure emerging from the shadows. Watts had

painted her without making her stand for hours, Mrs Huth had complained. "And still, you know, you come to me!" he answered, unconcerned. She did, but like Frances Leyland was glad to have a model pose for the finishing touches on the dress, and Whistler was even more glad to get the highest fee he had ever collected for a single picture.

While Mrs Huth became the lucrative *Arrangement in Black, No. 2*, actor Henry Irving would become *Arrangement in Black, No. 3*; but the financial benefits of the Irving canvas proved nil. Whistler had been interested in painting Irving for several years—his Hamlet in 1874 had been a spectacular success—and had sketched him during his performances, even going to rehearsals with Mrs Edward Compton, wife of the actor-manager, and swapping jokes with her as activities on the stage progressed. Finally Irving, who had been watching them, was convinced they were laughing at his acting, and ordered Compton to send Whistler and his wife to the back of the pit. At another rehearsal Whistler, sketching from the stalls, asked Compton to take off his top hat to improve the view. Compton swept it off, revealing a mass of brilliant white curls. "For goodness' sake, Colonel," cried Whistler. "Put your hat on again."

Mrs Compton was an old friend, as was her mother, the theatre manageress Isabel Bateman, who would have Whistler as well as his mother for dinner. For the severe Anna Whistler she announced simple fare and eschewed formal dress, Whistler protesting, "Oh but NO, my dear Mrs Bateman—'plain dinner with nothing to tempt you· to exceed'—This is all very well to write to the Mother! 'and no *tail coat!* and *no* ceremony—and to be packed off early—at any hour her prudence suggests' . . . ah but I don't like it. Certainly not—I wish to be tempted and should exceed of course—and I like tail coats and prefer ceremony— and dinner—*not* plain—and I will stay downstairs with Mr Bateman and I won't go home till morning—if he pleases!" *

Under Mrs Bateman's management in the spring of 1876, Henry Irving was performing as Philip of Spain in Tennyson's *Queen Mary*. Whistler, spurred by memories of his favorite Velasquez portrait, the *Philip IV*, persuaded Irving to be painted in the costume he had worn. By early May it seemed nearly ready, although Whistler was continually harassed by creditors seeking long-overdue payments while Irving stood

* The note teased. Whistler was ill and unable to come the next evening, and his mother was "really poorly." For Anna Whistler this was increasingly her condition in 1874-75.

shivering in the unheated studio. It was an effective Philip II but, to the actor, neither completed nor a successful Henry Irving, and he refused to buy it or sit for it any longer, although Whistler offered it to him for a token sum.

Another measure of Whistler's unsuccess in painting men (he seemed never able to get the legs right) was the portrait of the great Pablo Sarasate, holding his violin under his arm and looming out of the darkness as if onstage. He had not been able to sell it to Sarasate or anyone else.* "None of Whistler's paintings were finished," contended Walter Sickert, a later disciple-turned-apostate. "They were left off—which is another thing—sometimes by force of circumstances, sometimes because he could do nothing more to them. He had an exquisite gift for painting, and a touching and romantic enthusiasm, and too much taste for a creator. . . . A master is a craftsman who knows how to begin, how to continue, how to end. That is just what Whistler did not. The half-dozen life-size canvases on which his reputation in that kind rests were a small percentage of similar works, on a similar scale, which he was unable to pull off."

By 1876 Whistler was again very hard up. His life at Lindsey Row required more money than his pictures were bringing him, and his mother's small income was no longer available to augment it. In August, 1875, when she was nearly seventy-one, she had been ordered by her doctors—including Dr Willie—to leave the fog and damp of London. The excitement of the Pall Mall exhibition had first sent her to her bed with a "sudden prostration of strength," and a prescription of rest and port wine, to which she had added her own home remedy of "strong bark and quinine," had not affected her general debility. There was even a turn for the worse in February, 1875, and when the crisis had passed Dr Willie prescribed sun, warmth, and sea air, and Anna Whistler was moved to Talbot House in Hastings, on the Channel coast. Into 2 Lindsey Row would move Maud Franklin.

Sharing Whistler's bed and board in the mid-seventies was no sinecure. Maud posed for his pictures and managed the shambles of his business affairs and the house at Lindsey Row, a life of constant dunning by bailiffs, of unfinished and unsaleable pictures, of frequent quarrels caused by two quick tempers taut with recurrent financial strain. His

* Only in 1896 was it finally sold, to the Carnegie Art Institute in Pittsburgh, for five thousand dollars—the first of his pictures to be purchased by a public gallery in America.

finances were bedevilled by his inability to finish much of his work, most seriously his commissions. Seldom was the nervous energy of genius so numbed by feelings of technical inadequacy. In May 1876, for example, after work on the Irving portrait ceased, Sir Henry Cole of the South Kensington Museum ordered a nearly life-size picture of himself. It was begun strongly but never finished. Other portraits were similarly begun, one of Lady Redesdale, in a full-length Chinese blue silk, nearly completed, for a fee set at 200 guineas, and one of Lord Redesdale, in a Van Dyck costume. But for an unpaid debt of thirty pounds bailiffs were suddenly in possession at Lindsey Row, and Whistler in anger slashed the canvases, even tearing several nocturnes off their stretchers and slashing them as well.

A creative torment was at work, with the bailiffs only the excuse. He was regularly self-tortured by his lack of figure-drawing skill, when the problem may have been more his inability to reconcile in every portrait his desire to encompass in a powerful abstract design a revelation of character, an accurate likeness and a sense of spontaneity. It was important for him, said one of his later sitters, Theodore Duret, to make his portraits look effortless. "One of his principal anxieties . . . was to preserve . . . the appearance of having been produced without effort. . . . Therefore that with which his detractors have reproached him, the painting of sketches only, was not with him the consequence of absence of effort, but came from his very conception of a work of art, and was on the contrary the result of persistent attention and additional labor." As Whistler himself put it, "A picture is finished when all trace of the means used to bring about the end has disappeared. To say of a picture, as is often said in its praise, that it shows great and earnest labour, is to say that it is incomplete and unfit for view."

Some of the mature portraits of the 1870s were permitted to survive. Whistler, who loved the theatre and the music hall, was attracted by the eleven-year-old dancer Connie Gilchrist, a Gaiety Theatre star as "the skipping girl," and asked her to pose for him, hoping to repeat the success of his Cecily Alexander. But he wanted to paint her as she appeared on the stage, dancing with a skipping rope, and posed her that way in his studio. It was a rare Whistlerian attempt to capture a figure in movement, and Whistler failed to recognize the artificiality of the result, although prospective purchasers did. *Harmony in Yellow and Gold: The Gold Girl, Connie Gilchrist*, was not rubbed out with the rag which

terrified tired sitters, nor was it slashed. But neither was it sold, and Whistler abandoned another he started of her in repose.

Arrangement in Black and Brown: Rosa Corder survived because it was purchased. Miss Corder, with whom Whistler probably had dallied himself, although she was recognized as Howell's mistress, knew how to survive in a man's world. She exuded sexual appeal, and knew it, and, in her mid-twenties, had no interest in marriage although considerable interest in men. With a house in the city, set up by Howell, and a studio at Newmarket, where she painted famous racehorses, she knew everyone worth knowing in artistic circles, and moved boldly about Victorian London, including Howell's home at Fulham, where his complaisant wife Kate welcomed her; and she even visited Howell's seafront villas at Selsey Bill, near Portsmouth, where Whistler had painted a beachscape which dramatically abstracted pictorial space.

Rosa Corder had been a pupil of Rossetti's briefly in the summer of 1874, and also spent time in Whistler's studio, if not also in his bed; but Howell was her chief tutor. Daughter of a Hackney merchant, she was nevertheless self-liberated and made her own way, giving Howell the idea that she could support their liaison handily—and with something left over, besides—by turning out Rossetti copies, often complete to his signature. Howell arranged for a room in Bond Street where—until found out—she could quietly produce "Rossetti heads" and copies of "objectionable drawings" by Henry Fuseli, who in Blake's time had fashioned satanic seminudes.

Howell wanted a full-length portrait of Rosa Corder, and offered £100. Whistler never expected to be paid but liked the idea, and stood her in a doorway with the darkness of a shuttered room behind her, her firm body clothed in black and turned away from him, her face in profile, left hand on hip, a dark plumed hat in her right hand. After forty sessions she looked—in the portrait—sophisticated and desirable, but felt wan with fatigue, twice having fainted after having held a pose too long. When she saw that Whistler intended to toy even more with the canvas—and thus with her—and felt as an artist that it had been worked over to the point of diminishing returns, she refused to go on. Defeated, Whistler declared the portrait done. The *Arrangement in Black and Brown* became that rare Whistler canvas, a portrait abandoned completed.

While the work had been proceeding, Howell had suggested a portrait of Disraeli as a companion piece to the *Carlyle*, for which he had

sold the engraving rights to Graves, the print-seller in Pall Mall. Graves agreed to pay a thousand pounds for the picture and the copyright, but Whistler never managed to get Disraeli to sit for him and considered the deal dead. When the *Rosa Corder* was judged finished, Whistler met the happy Howell for supper at her establishment in Southampton Row. Gazing at the completed portrait in his most sentimental mood, and realizing that Whistler had captured her charm, Howell said, "You have never believed me in all this; you have never had the least confidence; you did not think I was going to pay you, but here!" And he threw down a roll of banknotes, which Whistler quickly pocketed, later discovering when he counted it that he had been paid only seventy pounds.

Two years later, passing by Graves's shop one day after a long absence, he stopped in to chat with the old man, who was very glad to see him. In fact, said Graves, he was wondering when Whistler proposed to pay back the two hundred pounds. "What two hundred pounds?" Whistler wondered, and discovered that he had been paid for the *Rosa Corder* from the advance Graves had paid Howell for the abortive Disraeli portrait. Howell had not only underpaid Whistler out of Whistler's own unearned pounds, but had pocketed the change.

Whistler's steadiest model in the mid-seventies was Maud Franklin, who soon after his mother moved to Hastings began calling herself "Mrs Whistler." Whistler generally introduced her as "Madame," a sophisticated euphemism which meant nothing in particular but had a married ring to it. Slim and graceful, with sharp but not unattractive features almost stereotypically English,* she posed in a tight-waisted gown for one portrait Whistler unaccountably afterwards called *Arrangement in Black and White, No. 1: The Young American.* Another for which she modeled had an even more curious title, given Whistler's fulminations at subject pictures: *Arrangement in Yellow and Grey: Effie Deans.* At the bottom of the canvas Whistler later added, for the purchaser, the line about the character in Scott's *The Heart of Midlothian* which had inspired the pose—"She sunk her head upon her hand and remained seemingly unconscious as a statue." It was the only composition on a literary theme Whistler ever completed, and only two others were ever attempted, an *Ariel* and an *Annabel Lee.* The painting from Poe had been commissioned, and even paid for, by William Graham, but Whistler rubbed it down in

* The minor American artist John M. Alexander, who first met Maud a decade later, described her as "not pretty, with prominent teeth, a real British type."

dissatisfaction and in 1877 gave Graham as a substitute the *Nocturne in Blue and Gold.*

Maud posed for a third major portrait at the time, the full-length *Arrangement in Black and Brown: The Fur Jacket.* A suggestion of melancholy crosses her face, a sign, perhaps, of problems faced and problems already sure to come. He exhibited nocturnes in the few London galleries which would have him, and Ralph Thomas issued from 36 Soho Square the first catalogue of Whistler's etchings—fifty copies privately printed, of which only twenty-five were for sale. The size of the printing may have been an indication of the extent of public interest.

A self-portrait of the artist in grey painting coat and with brushes in his hand was the frontispiece of the catalogue, etched from the oil not by Whistler but by Percy Thomas. As with other works, Whistler completed few of them; but he was a compulsive self-portraitist. His great predecessor as etcher and painter, Rembrandt, in his twenties would contort his face in a candle-lit mirror to try out ways of sketching pity or fear, would imitate—and draw—poses he saw in portraits by Titian or Raphael, and would flaunt his vanity in period costumes and copy himself down; for he was vain and wanted to put himself on record as an attractive man, and he was his handiest and most adaptable model.

Whistler paraded his ego while practicing his craft, making it a sort of secret vice, frugally painting a barge and water over the beginnings of one self-portrait, and abandoning others to the refuse pile. Yet dozens survive in a variety of media and moods. Lithographer Thomas Way once questioned him about the authenticity of a black-and-white portrait of himself on brown paper, characteristic of the nocturne period, which his father owned, and Whistler's reply was that he was not in the habit of collecting the works of his contemporaries, but that at one period of his life he had made a practice of making a drawing of himself each night before going to bed—"though I finally destroyed most of them."

There was, however, one work of a contemporary he did keep in his drawing room in the seventies, a terra-cotta bust by Sir Joseph Edgar Boehm—of Whistler. Vanity—or reassurance? The self-portraits in oil, chalk, pencil, pen-and-ink, and drypoint suggest both, as does his behavior at one of his Sunday morning breakfasts, when a party of ladies and gentlemen gathered in his studio after the ritual meal, prepared to go off on an excursion together, as planned. Whistler had an idea which pleased him more, and posing one of the flattered ladies, began a full-length portrait of her, while the other members of the party shifted

restlessly from foot to foot and eventually wanted to know when the expedition would get underway. "By Jove," said Whistler, exasperated, "it's not before everyone that I would paint a picture!" He needed to paint, and when frustrated could paint himself, or summon the Greaves brothers and go out to draw his beloved Thames, quiescent in the dawn or ablaze at dark with the reflection of rockets and catherine wheels off Cremorne.

XVII

Patrons and Peacocks

"MY dear Artist son's summer," Anna Whistler wrote in 1876, "has been spent in decorating a spacious dining-room for Mr. Leyland. It is indeed quite an original design! A great undertaking, painting walls and ceiling as he would do a picture in oils. By the desire of Mr. Leyland Jemie staid in the home, beginning work at 7 in the morning, and I know how reluctantly he would break off to dress for 8 o'clock dinner. Imagine him on ladders and scaffoldings using his palette and studio brushes! No wonder he looks so thin, tho he is so elastic in spirit. . . . "

Whistler had been to Hastings to visit her, telling her of his grand design and pencilling out for her what the "Peacock Room" would be like when completed. He had also sent her a piece from the latest issue of *The Academy* with a report on it, and Deborah Haden had seen him at work there, writing to her stepmother that the room was already "beautiful beyond her language to describe." When it was completed, Whistler told his mother, he would go off to Venice to do a set of twelve etchings which had been commissioned. After all his setbacks, the situation seemed almost too good to be true.

"Why don't you give yourself the delight in life of building a fine gallery for big pictures?" Dante Rossetti had suggested to Leyland just

after Christmas in 1871. "What a jolly thing that would be!" It would have, of course, large walls awaiting more Rossetti commissions, he must have thought, and played on Leyland's realization that he had more money than he could easily spend. "I know I'd do it if I were you, for what is life worth if one doesn't get the most of such indulgences as one most enjoys?" Leyland, whose ambitions resembled those of a Venetian or Florentine merchant prince, and who was buying works by Botticelli, Filippo Lippi and Crivelli as well as by Rossetti, Millais, Madox Brown, Burne-Jones, Moore and Whistler, eventually saw the need for a more expansive London setting for the fruits of his patronage. By 1876 he had moved from Queen's Gate to an outwardly undistinguished but roomy twenty-year-old town house at 49 Prince's Gate, Kensington, and had employed Norman Shaw for the interior reconstruction. In addition, he bought for his wide entrance hall staircase a splendid gilt-bronze balustrade saved from the demolition of Northumberland House at Charing Cross, and on the pillar from which the balustrade sprang, he planned to stand a statuary group from the prow of a Venetian galley—two female figures of gilded wood, one seated and the other waving an oriflamme. If the rest of the interior lived up to that promise it would be a remarkable house.

However unprepossessing 49 Prince's Gate was externally, Leyland had the materials to turn any decorator in the Victorian tradition of overstuffed clutter into a genius—Beauvais tapestry; Indian, German, Tyrolese and Italian inlaid cabinets; Renaissance bronzes; Chippendale and Louis XVI furniture; oriental rugs and porcelain; Genoese velvets; a grand piano and antique harpsichord. Further, one feature of the house had remarkable attractiveness for a collector of paintings. The three living rooms were interconnecting, and when the folding screens of walnut and brass which separated them were fully opened, they created a salon ninety-four feet long. Potentially it was a gallery.

Having bought blue-and-white china from the Oxford Street shop of Murray Marks, and approved of the way Shaw had designed the interior, Leyland found no anomaly in putting the architect to work on a house full of porcelain and pots; and Shaw—on the advice of Marks—employed Thomas Jeckell, who had done a Japanese-paneled billiard room for Alexander Ionides to design the room for the porcelain. For Leyland, Jeckell had to work with three initial stipulations. He had to find a way to display Leyland's porcelain; he had to focus attention on the only painting intended for the room, Whistler's *Princess from the Land of Porcelain;* and

he had to use floral-embossed Cordovan leather which Leyland had acquired at great expense for the walls. There was no way that Spanish leather could be reconciled with oriental pots, but Jeckell—or Shaw—compounded the problem by designing a Jacobean pendant ceiling in which each pendant served as a gas fitting. It was utilitarian, but, said architect E. W. Godwin, who happened to drop in, "To speak most tenderly, it was at the best a trifle mixed." The Leylands apparently understood the failure, and called on Whistler for help.

No. 2 Lindsey Row had been one of Whistler's few recognized artistic successes. He had decorated it in severe but impeccable taste, and it was inevitable that Florence Leyland, who knew the house well, should consult Whistler. "Jeckell writes to know," she confided, "what colour to do the doors and windows in the dining room. . . . I wish you would give him your ideas." Whistler gave even more. He painted some of the panels of the staircase and consulted not Jeckell but himself. The *Princess* was already reserved for the position over the mantel in the dining room, and space left at the oppposite end of the room for a painting commissioned a decade earlier by Leyland but not yet completed to Whistler's satisfaction, the Moore-influenced *Three Figures: Pink and Grey.* To Leyland he complained that the room had an oppressive feeling to it, not merely the panelled, pendant ceiling but also the dark leather on the walls, relieved only by small red flowers. Besides, he urged, the red flowers on the leather and the red border on the rug clashed with the *Princess.* A touch of color here and there, to lighten the leather, and the removal of the border of the rug—if not the rug itself—would bring the room more into harmony with his picture. Bewildered by Whistler's aesthetic subtleties, and eager to get the job completed so that he could entertain in his house, Leyland agreed to the altering of the carpet and the touching-up of the leather.

The results were disastrous. Somewhat stunned, Leyland watched the red border cut from his rug, and a sampling of the flowers on the embossed leather painted over with yellow and gold. The results, Whistler confessed to him, were disappointing. The untreated leather looked yellowy, and more gilt would be needed. And of course Jeckell's carved walnut shelves would have to be harmonized with the treatment of the leather. Leyland objected that Jeckell might be annoyed at his work being improved without his consent, but Whistler countered that Jeckell had asked for his advice on color before and had been sufficiently unsure about colors in the dining room to write to Mrs Leyland about it. All that

Leyland was certain about was that the room, after Whistler's sample daubs, could not be left as it was.

Concluding a hasty gentleman's agreement about remuneration, mentioning, he thought, a figure of about £500, he left for Liverpool. Not only was the London season over, and his wife eager to return to Speke Hall for the summer, but he was busy arranging for the launching of the Leyland Line into the increasingly profitable North Atlantic shipping routes, a task which, fortunately for Whistler, kept Leyland away for months. Had they harbored any doubts about Whistler's salvage operation at Prince's Gate the increasingly manic mail they received from him would have sent them down to London on the next train.

In the innocence of the creative afflatus, Whistler had posted a copy of a review of his work that appeared in the *Academy* that September to Liverpool. There were as yet no peacocks, an afterthought* developed out of unused designs for W. C. Alexander's house, but the article observed that the leather had already been lost under liberal application of gold paint. Critical jargon may have obscured the reality of the transformation, for the *Academy* spoke of the pattern of the leather having been "modified and enriched by the introduction of a fair primrose tint into the flowers patterned upon the deep ground of gold." With delight Whistler added an euphoric accompanying letter:

> *Mon cher Baron—Je suis content de moi!* The dining room is really alive with beauty—brilliant and gorgeous while at the same time delicate and refined to the last degree—
>
> I have *enfin* managed to carry out thoroughly the plan of decoration I had formed—and I assure you, you can have no more idea of the ensemble in its perfection, gathered from what you last saw on the walls, that you could have of a complete opera judging from a third finger exercise!—*Voila*—But don't come up yet—I have not yet quite done—and you mustn't see it til the last touch is on. . . .

* The peacock motif was pervasive among the Pre-Raphaelites and their followers, Dante Gabriel Rossetti even harboring real ones at Tudor House. Yet they appeared even earlier in the rococo interior of the Royal Pavilion at Brighton, designed by John Nash in a "Hindoo style" for George IV (then Prince Regent) in 1815. Wallpaper designed by Godwin, and a fresco by Moore, both several years before Whistler's, as well as Whistler's own plans for the Alexander dining room, included peacocks and preceded the Prince's Gate work. Later (1891) the young Beardsley was enraptured by a visit to the Peacock Room, and the exotic bird was pervasive in his first major commissions, the illustrations for Wilde's *Salome* and the *Morte d'Arthur.*

There is no room in London like it *mon cher*—and Mrs Eustace Smith is wiped out utterly!—What do you think of the article in the *Academy?* There will be a little letter of mine in next week that Tommy [Jeckell] may have his full share of praise as is right.

The *mélange* of cockiness and magnanimity suggested to Leyland that more was going on than the modest rectifications he had authorized, while a keeping-up-with-the-neighbors attitude was hardly a part of the shipowner's personality. Mrs Smith, also of Prince's Gate, had commissioned Tom Armstrong and the architect George Aitchison to decorate her house, and Walter Crane to paint a frieze of white cockatoos in her boudoir—the cockatoos possibly causing Whistler to resurrect the abortive Alexander peacocks. The *Academy* letter may have had an intent other than its deep bow to Jeckell, for the last thing Whistler wanted was his presence on the premises to see what had been done to his design. But how little was left of it was obvious from Whistler's emphasis upon the shelving, described as by "the distinguished architect . . . whose delicate subtlety of feeling we see in perfection in the fairy-like railing of Holland Park. If there be any quality whatever in my decoration, it is doubtless due to the inspiration I may have received from the graceful proportions and lovely lines about me."

Again he put off a trip to Hastings, writing instead:

My Own Darling Mother,

I must not wait any longer that I may tell you what I have longed to do, the completion of this famous dining room. How I have worked. There must still be another week of it, or even two, before I can leave it, and say *I am content*. It is a *noble* work, though, Mother, and one we may be proud of, so very beautiful! and so entirely new, and original, as you can well fancy it would be, for at least *that* quality is recognized in your son.

Willie has told you of the visit of the Princess Louise to the "Peacock Palace," in Princes Gate, and her delight in the "gorgeous loveliness" of the work. Also the Marquis of Westminster . . . and everybody else. I know you will be pleased that this testimony of worth should be offered after so much labor, therefore I tell you. The mere visits of Princes, and Dukes, we well know is no *voucher* for the *quality* of a work of art, for they are simply curious people, generally better *mannered* than

others about them, but able to look with the same satisfaction upon a *bad* thing, as a good one. Still they are *charming* people, and show *real* delight in this beautiful room, keep up the buzz of publicity most pleasantly in London society, and this is well, and I hope good may result.

I am tired, but well, I am happy to say. Good night, dearest Mother, it is late, and I must get to my work again tomorrow. Tell "Sis" she may come with Annie, at half past four or five, P.M. any day to 49 Princes Gate, to see the room.

<div style="text-align:right">Your loving son,
Jamie</div>

His work had turned feverish with enthusiasm and with anxiety to both get the job done and entertain the invited guests and curious sightseers who came while Whistler held open house. Patrons Lionel Robinson and Sir Thomas Sutherland, with whom he was to have gone to Venice, started belatedly without him; and the Greaves brothers hauled in more pails of Antwerp blue and books of gold leaf—charged to Leyland's account—with which to smother the stubborn Spanish leather. They laid on the gold, Walter Greaves remembered, until their hair and faces were gilded, and they and the room were a shimmer of gold and blue. "I have worked like a nigger and really in the way of decoration done something gorgeous!" he wrote Alan Cole. "You must immediately upon your return go round to Prince's Gate 49, and say that I wish you to look over the dining-room. The family are all away. . . . I suppose I really must complete the thing this week, and still have some lovely Peacocks to go on the shutters—you will be immensely pleased. . . . " On September 20 he noted in his diary, "To see Peacock Room. Peacock feather devices—blues and golds—extremely new and original."

The work on the pendant ceiling, and on the peacocks, and peacocks' eyes and peacocks' feathers, took longer and absorbed more paint and gilt than Whistler expected. A month later when Cole was back to see the room, it was still "developing." On the same day, he met Edward Poynter, long unsympathetic to Whistler, yet who spoke highly of the decoration in a way which implied he had seen it. On November 10 Cole was back yet again, and found Whistler "quite mad with excitement," and on November 20 he brought the Prince of Teck* to see the room. Old Sir Henry Cole, his father, hurried over from the South Kensington Museum

* Husband of Victoria's daughter Princess Mary.

to examine the progress of the painting, and exclaimed that Whistler's work was as careful as Mulready's. William Mulready painted in a sludge of mawkishness. Whistler could not have been pleased.

Since Whistler was doing some parts over again several times as new ideas came to him which rendered already painted panels pallid in comparison, he began getting up earlier and leaving Prince's Gate later. Exaggerating his lack of plan for the room he told the Pennells, "I just painted as I went on, without design or sketch—it grew as I painted. And towards the end I reached such a point of perfection—putting in every touch with such freedom—that when I came round to the corner where I had started, why, I had to paint part of it over again, or the difference would have been too marked. And the harmony in blue and gold developing, you know, I forgot everything in my joy in it!" And he did forget time, although not his designs, since several preliminary or contemporary studies exist, one or more of them possibly made to accompany a letter to the Leylands or to his mother. "I am still labouring and painting in London!" he wrote to Mrs Leyland, who had expected him at Speke Hall. "The dining room has proved a Herculean task. . . . Think of the rate at which I work when I tell you that the other morning I was called at quarter to six, and that it was a quarter to nine at night as I left Prince's Gate!" At night, he recalled later, he was fit for nothing but bed, "so full were my eyes of sleep and peacock feathers."

The Peacock Room became a public entertainment. Artist Louise Jopling came to look one morning, and Whistler gave her "a lesson in decoration, and I was allowed to paint on one corner of the celebrated room." Mrs Marie Spartali Stillman took tea with Whistler while Henry and Walter Greaves worked on ladders above them or prepared picnic lunches from food they had brought to the empty mansion; and when Lady Ritchie, whom Whistler as an art student had known in Paris, arrived, she found him in a painter's smock, in a room that was "like a dream . . . full of lovely lights and tints, and romantic, dazzling effects." He put down his brushes and talked of the old days. "I used to ask you to dance," he said, "but you liked talking best." "No, indeed," Lady Ritchie corrected, "I liked dancing best," whereupon Whistler whirled her around the room amid the ladders and paint pots. Yet the dozens who came were not enough. He was drunk with enthusiasm over his masterpiece-in-progress, and wanted it to provide for him the public recognition which he had been given only sparingly and grudgingly in the past. A modest 5″

x 7½″ broadside, printed for him by Thomas Way, remedied that for people who had not read the *Academy* or moved in artistic circles:

"HARMONY IN BLUE AND GOLD
THE PEACOCK ROOM."

The Peacock is taken as a means of carrying out this arrangement.

A pattern, invented from the Eye of the Peacock, is seen in the ceiling spreading from the lamps. Between them is a pattern devised from the breastfeathers.

These two patterns are repeated throughout the room.

In the cove, the Eye will be seen running along beneath the small breastwork or throatfeathers.

On the lowest shelf the Eye is again seen, and on the shelf above—these patterns are combined: the Eye, the Breastfeathers, and the Throat.

Beginning again from the blue floor, on the dado is the breastwork, BLUE ON GOLD, *while above, on the Blue wall, the pattern is reversed,* GOLD ON BLUE.

Above the breastwork on the dado the Eye is again found, also reversed, that is GOLD ON BLUE, *as hitherto* BLUE AND GOLD.

The arrangement is completed by the Blue Peacocks on the Gold shutters, and finally the Gold Peacocks on the Blue wall.

The invitation, since that is what it was, by inference, although it did not mention Leyland or his house, could be picked up in such London shops as that of Lazenby Liberty; and the curious came, including an American correspondent who recorded, with some apparent sartorial exaggerations:

A very slim spare figure extended on a mattress in the middle of the floor: beside him an enormous palette, paints, half a dozen long bamboo fish-poles on a line with their butts close at hand, and a very large pair of binocular glasses. Mr. Whistler dressed wholly in black velvet, with knickerbocker pantaloons stopping just below the knees, black silk stockings, and low pointed shoes, with black silk ties more than six inches wide and diamond buckles, was flat on his back, fishing-rod in hand and an enormous eyeglass in one eye, diligently putting some finishing

touches on the ceiling, his brush being on the other end of the fish-pole. Occasionally he would pick up his double glasses, like some astronomer peering at the moon, and having gained a near and better view of the effect, he would again agitate the paint-brush at the other end of the long pole. "Now wouldn't I be a fool," said he, "to risk myself on a scaffolding and nearly twist my head off my shoulders trying to look upward, when I can overcome the difficulty and annihilate space so easily thus?"—and he gave a wave of his fish-pole.

A second notice then appeared in the London press, in the *Morning Post,* on December 8, and Whistler was worried that Leyland would see it and hurry down from Liverpool. Yet he made light of his concern to critic J. Comyns Carr. "Leyland, you see, Carr, is utterly ignorant of art. He's only a millionaire, and that a thing should be costly is the only proof that he has of its value. Well, let him spend his money on doing the thing as I tell him it has got to be done. I'll see that it doesn't cost too little!" And he burst into a cackle of laughter that seemed mischievous to Carr, but was unreasonably malicious to a man who had clearly been a prince among patrons—almost as if he were already certain of a quarrel.

Before Christmas he wrote to Mrs Leyland that the dining room "will be finished this week," and that it was "something quite wonderful" about which he took great pride. "Tell Freddie that I think it will be a large sum but even then [it] barely pays for the work." Early in the new year the room was about done. There were gold peacocks on a blue ground, blue peacocks on a gold ground and peacocks' eyes and feathers in gold and blue on the walls, ceiling and shutters, as well as two splendid peacocks on the wall facing the *Princess,* where originally there was to have been a Whistler picture. It was the most astonishing feat of decoration in England, and he wanted a private view which would confirm that and finally establish his reputation, warning Leyland brusquely to stay at Speke—"These people are coming not to see you or your house: they are coming to see the work of the Master, and you, being a sensitive man, may naturally feel a little out in the cold."

Whistler received the critics on February 9, 1877, as Master of the Peacock Room if not all of 49 Prince's Gate. Before then at least one uninvited guest had quietly appeared, the artist whose work Whistler had been called in to harmonize. No evidence of his labor remained. Tom Jeckell stumbled home in grief and was found later babbling incoherently

of fruit and flowers and peacocks while feverishly working at gilding the floor of his bedroom. He was taken to an asylum, where he died four years later without recovering his reason. Meanwhile Whistler had his success. The usually unsympathetic *Times,* on February 15, 1877, was full of praise:

A PEACOCK ROOM.—A singular experiment in decoration had just been carried out by Mr. Whistler, well known as a painter, and even more distinguished as an etcher. An apartment in the house of Mr. Leyland at Prince's-gate has been decorated throughout in blue and gold, the ornamentation being entirely derived from the beautiful plumage of the peacock displayed in various forms, the whole intended by Mr. Whistler to be what, in his peculiar pictorial nomenclature, he calls "Harmony in blue and gold." . . . Mr. Whistler, explaining his design, says a pattern has been invented from the eye of the peacock's feather, combined with one derived from the breast feathers. These two patterns, either in blue or gold, are repeated throughout the room. They are spread from the lamps over the ceiling, and in the cove of the cornice the eye of the feather is seen running along beneath the small breast feathers. From the cornice to the dado the wall is painted a flat blue, and on the end wall is a large design of two great peacocks fighting, all painted in gold, and with flashing eyes of real diamond and ruby. . . . The whole interior is so fanciful and fantastic, and at the same so ingenious and original in motive as to be completely Japanesque. When the room is furnished, as it is intended to be, with the vases and other pretty ornaments, which it may be presumed will not be restricted to blue and gold only, but will enrich this "harmony" with every beautiful modulation of colour and form, and when the blue carpet covers the floor, the last touch of finish will be put to this very novel piece of decoration which, besides its originality, has great interest in being throughout the work of the artist's own hand without the adventitious aid of the stenciller, and marked with artistic feeling and individuality in the design and the execution.

Whistler's friend, the architect E. W. Godwin, wrote a piece, correcting some of the *Times*'s slips, for the *Architect. Punch,* always hostile to Whistler, was characteristically snide. But the *Standard, Pall Mall Gazette* and *Examiner* echoed the *Times*'s praise, while *London*

described "a paradise of peacocks, and a blending of Occidental audacity and Oriental taste . . . [with] all the beauty that bizarrerie can give—all that, and something more." The *Observer* praised Leyland's taste for permitting the unconventional work, while the *Academy* praised Whistler's "immense zeal and spirit" and his "salient triumph of artistic novelty." The Peacock Room, it admitted, was "too uniformly gorgeous for some tastes, but singularly captivating and complete," and added that "to say that the room is unique were to say little: it will long remain to the eye and mind a type of what artistic enterprise and conception *sui generis* can effect, in combination with opulence."

When Whistler, amid his euphoria, was told what had happened to Tom Jeckell he smiled, Mortimer Menpes reported, and said, "To be sure, that is the effect I have upon people." Jeckell's brother, a brass founder, had a less mild reaction to the proceedings, and wrote to Whistler. A draft of a reply exists, in which Whistler regretted that the press had not mentioned Jeckell more, and offered to write to the *Architect* and the *Builder* to confirm Jeckell's share in the work. "Your brother Tom was one of my most intimate comrades," he explained, "and in the sorrow that has come upon him no one has been more grieved than myself." Jeckell always cared for his artistic judgment, he insisted, while promising to send a copy of a letter to prove on what close artistic terms they were. Further, "Tom was absent and never saw the room until the whole color scheme was nearly complete, and I had begun to gild on my own responsibility his lovely columns feeling sure that by this means the beautiful carving would for the first time be fully brought out. . . ." And so he took his brushes in hand "feeling sure that Tom would be pleased, as he finally was. . . ." Was he suggesting that when Jeckell went home from the Peacock Room and began madly gilding his floors it was in ecstatic imitation of Whistler?

Leyland was hardly less angry. Jeckell's work had been destroyed, but Leyland's room had been "ruined" without his consent, and at a tremendous cost in gold leaf for which he had to pay the bills; while Whistler had turned his house for months into a personal salon. Besides, his blue-and-white collection would be almost invisible amidst the blaze of peacocks' feathers. "Ah," said Whistler, unrepentant, "you should be grateful to me. I have made you famous. My work will live when you are forgotten. Still, perchance, in the dim ages to come, you may be remembered as the proprietor of the Peacock Room." What had he done with the Spanish leather which had cost so many hundreds of pounds,

Leyland demanded, although he well knew what had been done with it. "Your Spanish leather," said Whistler, uncowed, "is beneath my peacocks; and an excellent ground, too, it formed to paint them on." Controlling his fury Leyland asked what the proper fee would be to get the painter out of his house, and Whistler suggested two thousand guineas, although he owed at least half that amount in advances on undelivered paintings, and had piled up more bills for Leyland in his progress through the Peacock Room. Leyland is reported to have consulted with Rossetti, who advised him not to pay anything. But when he returned to find Whistler still working, he offered him a thousand pounds, although unordered merchandise is traditionally exempt from payment. Whistler accepted it, although complaining about not being paid in guineas. Professionals were regularly paid the extra shilling; tradesmen were paid in pounds.

On March 5, Alan Cole was "late at Prince's Gate, with Whistler, consoling him. He trying to finish the peacocks on shutters. With him till 2 a.m., and walked home." Whistler, brooding over the alleged robbery of his shillings, and over Leyland's misunderstanding of his masterpiece, neglected to consider his patron's remarkable generosity over a decade, no less over the payment for the Peacock Room. As Peter Ferriday has put it, "It was, of course, customary for artists to get the shillings, but all things considered the artist had been fortunate to get his pounds. The shillings question was only an excuse to declare war." One can go further than that, for the record of Whistler's sales of canvases and commissions up to that time often showed payments in pounds. But he wanted to treat Leyland differently. The relationship of artist to patron, as he saw it, was at stake.

On the wall panel opposite from the *Princess* Whistler had painted, as the *Times*'s critic had observed, "two great peacocks fighting." Before he left the room altogether he symbolized his quarrel with Leyland by maliciously retouching the broad panel of the two peacocks, creating a rich peacock and a poor peacock, the former covered with gold coins, while under his claws is a pile of silver coins—the unproffered shillings. "You know," he told Cole, "there Leyland will sit at dinner, his back to the *Princess*, and always before him the apotheosis of *l'art et l'argent!*" Gleeful at his malice he wrote to Theodore Child about "the shipbroker's house" that "as you sit at the table you can see your host on the wall! And it is not everyone who may have the joy of dining on roast Peacock any day he likes!!!" He was even less discreet on his last day in the

Peacock Room, when talking to some friends who stopped by to see his handiwork. Leyland's derogatory comments were mentioned, and Whistler said, scornfully, "Well, you know, what can you expect from a parvenu?" Frances Leyland had come to town unexpectedly and had let herself in with her own key. The dining room door was open, and Whistler's remark floated by as she passed. Whether or not she ordered him from the house is uncertain. What is certain is that the next time he arrived at Prince's Gate the servants' instructions were not to admit him. The Leylands were never at home to him at Prince's Gate again. As far as Leyland's lifetime was concerned, Whistler had seen the last of the Peacock Room.

XVIII

From Leyland to Ruskin

IN 1879 an unemployed young Irishman, resident in London only three years, and who spent his evenings at free public meetings or in wandering the artists' sectors off the King's Road or the Embankment, wrote his first novel, set partly in the gallerylike Richmond mansion of the wealthy art patron Halket Grosvenor. Ambitious and utterly unknown at twenty-three, the author acquired his ideas of aesthetic art—and no artistic movement was ever as social as the Aesthetic Movement—from the Sunday evening at-homes of the one family associated with it which he had the courage to attend, the Lawsons. "When I lived at Victoria Grove [in Fulham]," he wrote, years afterward, "the Lawsons: father, mother, Malcolm, and two sisters, lived in one of the handsome old houses in Cheyne Walk, Chelsea. Cecil and another brother, being married, boarded out. Malcolm was a musician; and the sisters sang. One, a soprano, dark, quick, plump and bright, sang joyously. The other, a contralto, sang with heartbreaking intensity of expression, which she deepened by dressing esthetically, as it was called then, meaning in the Rossettian taste; . . . so that when she sang . . . she produced a picture as well as a tone poem." Only the landscape artist brother is important in the novel: "Cecil, who had just acquired a position by the few masterpieces [of his] which remain to us, was very

much 'in the movement' at the old Grosvenor Gallery, then new, and passing through the sensational vogue achieved by its revelations of Burne-Jones and Whistler."

The leading roles were transparent. The Cyril Scott of the novel (Cecil Lawson was a transplanted Scot) combined admirer and Master, as a conversation at Grosvenor's house suggested:

> "I believe he empties several cans of paint on a canvas, and then looks for a landscape in the result, as we look for pictures in the fire. At least that is what it looks like to me. Atmospheric art is rubbish."
>
> "I have been shewn some of these new harmony paintings" said the old gentleman; "and they seemed to me not unlike certain places which I have seen."
>
> "But they are not like pictures" said Lady Geraldine.
>
> "No" said the other, catching with some relief at this: "that is quite true. Theyre not."
>
> "Well" said she, "people go to galleries to see pictures, and not fogs and lobster salads." *

The conversation could have been held at the Grosvenor Gallery, whose founder, the banker Sir Coutts Lindsay, was clearly the inspiration for the wealthy patron of the arts named for his gallery in *Immaturity*, a novel so unlike its contemporaries that Bernard Shaw had to wait fifty years to find it a publisher. Intent upon establishing an *avant-garde* rival to the stolid Academy, Sir Coutts and Lady Lindsay spared no guineas in decorating the new gallery for its opening in May, 1877. At the height of his reputation as a decorator when he held open house at Prince's Gate, Whistler was not only invited to exhibit, but to do a frieze, described by Walter Crane as representing "the phases of the moon on the coved ceiling of the West Gallery . . . with stars on a subdued blue ground, the moon and stars being brought out in silver, the frieze being divided into panels by the supports of the glass roof." That Whistler found the time to do the work on schedule is indicative of his manic energy in 1876–77, some of which in the spring of 1877 he was expending on his quarrel with Leyland. "My dear Jim," Leyland's son wrote him affectionately that April, "—Good-bye old fellow—any time you're passing call in—I leave Town this evening, & ain't time to call. Hope you'll be on better terms with 49 Prince's Gate when I return."

* See p. 213 for an indication of the source of the "fog and lobster salad" image.

The optimism was unfounded, for recriminatory letters passed back and forth between Leyland and Whistler during the entire first season of the Grosvenor Gallery, which ended that July. Whistler at first threatened to publish the correspondence, but Leyland's half of it was clearly too embarrassing for such a risk. Whistler had gone so far in the unauthorized scheme before he was caught, Leyland wrote, that he had no choice but to let it be completed, and the unrealistic price asked was prompted only by vanity. Further, the outraged shipowner charged, "Five months ago your insolence was so intolerable that my wife ordered you out of the house. . . . The fact is [that] your vanity has completely blinded you to all the usages of civilized life, and your swaggering assertion has made you an unbearable nuisance to everyone who comes in contact with you." Leyland had even more palpable hits. If nothing else could induce in Whistler a more modest appraisal of his own abilities, he wrote, certainly his complete failure to produce any serious work for so many years should have done so. It was an exaggeration, as Leyland knew, but his proof was the thousand guineas Whistler had received from him for undelivered pictures. Although the portraits of Frederick and Frances Leyland had been reborrowed for exhibition purposes, even so they were not quite finished. The newspaper puffs about the Peacock Room were a humiliation to him, having connected his name "with that of a man who had degenerated into nothing but an artistic Barnum."

Whistler responded by offering to return the pictures, yet withheld them anyway, while contradicting another of Leyland's charges with "Mrs. Leyland never ordered me out of her house—never uttered a discourteous word to me in her life." Frances Leyland had had no choice but to order him out, but despite his decade of unfulfilled promises and the questionable ethics of his Prince's Gate activities, the Leylands—excluding Frederick—liked Whistler in the way one becomes attached to a swaggering, friendly pirate. Still, they were forbidden to see him, and resorted to deceit quickly discovered by Leyland.

Throughout the summer the countercharges flew, Leyland returning one of Whistler's defenses of the Peacock Room with the suggestion that he carry the letter around with him in his pocket, for "An advertizement of this kind is of such importance in the absence of (or incapacity to produce) any serious work that I feel it would be an unkindness to deprive you of the advantage of it." Whistler replied that he was regularly sickened by the thought that he had provided his most exquisite creation "for such a man to live in." Leyland even threatened Whistler with a

whipping if he tried to see the Leyland ladies, and Whistler rejected the idea that he might ignore old friends, concluding, with a reference to Leyland's propensity for ruffled shirts, "Your last incarnation with a horsewhip, I leave to you to work out—Whom the Gods intend to be ridiculous they furnish with a frill."

Verity and Sons, designers and manufacturers of lamps and candelabra, became involved when Leyland had them send their bill for Peacock Room work directly to Whistler, and promptly Whistler declared that it was a poor joke perpetrated at their expense. They would have to resort to the law, he wrote. "Mr. Leyland refused to pay me my price for the decorations in his house and I should have been pained had he deviated from this simple course when he found himself face to face with your account."

Eventually Theodore Watts, Swinburne's good friend, attempted to mediate the Leyland-Whistler dispute, and was ordered to keep out of it. "He promised me a whipping and sends me his gas bill!!" Whistler wrote recklessly. "*Mon cher* these things are not done every day! . . . And now Maecenas careering from Counting House to County Court, with Commercial Enterprise in his eye and writs and gas bills in his pocket—and the Painter impoverished by his 'Patron,' pleading for mercy—are we to be robbed of this tableau because, rash man you are pleased to interfere?"

Leyland had wanted the work due him besides, and Whistler added to Watts that he would not deliver as much as an etching, drawing or sketch. Watts refused to take no for an answer, and Whistler explained—by now it was February 2, 1878—that he would not rob Leyland "of any real right," but had not returned the portraits because Leyland had, in his letters, disparaged their artistic value. Besides, he insisted, "Whereas I do not acknowledge that a picture once bought merely belongs to the man who pays the money, but that it is really the property of the whole world, I consider that I have a right to exhibit such picture that its character may be guaranteed by better artists. . . ." After that he would "restore" such pictures to "their chance purchaser." That "their chance purchaser" happened to be the man who commissioned them and paid in advance for them, and that they were portraits of himself and his wife, was irrelevant to Whistler. As for Florence Leyland's portrait, he could offer no hope of delivery, blaming its state on her insufficient sittings and the bar to her ever completing them. It would mean returning 400 guineas to Leyland, which he did not have, but

"directly I am able," he promised, he would repay it, if even by instalments. It was an inglorious conclusion, but Whistler continued to wave the drooping banners of his artistic reputation.

At the Grosvenor Gallery those banners had also fared badly, partly, perhaps, because the sumptuous setting overshadowed most pictures, hung well apart as Whistler liked, but against rich crimson brocades and antique furniture, as Sir Coutts spared no expense. When the pictures were being hung, the proprietor himself had expressed disappointment at the obviously unfinished *Irving* and the strangely vague nocturnes, and at the private view on April 30, 1877, Whistler's work was mostly ignored, the crowds gathering before the offerings of Alma-Tadema, Burne-Jones, Millais, Leighton and Poynter. Whistler's exhibition area, said the *Times*, was "musical with strange Nocturnes," and "reduced" Henry Irving to "a mere arrangement," which in practice meant "an entire absence of details, even details generally considered so important to a full-length portrait as arms and legs." In fact, Mr. Whistler's arrangements suggest to us a choice between materialized spirits and figures in a London fog."

Busy with his feud with Leyland, and with his reserve energies directed toward putting what he had left of his Peacock Room £1000 into plans for a new home and studio in Chelsea, Whistler paid less attention to press comment about the Grosvenor Gallery than to the Sunday afternoon receptions Sir Coutts was hosting there in an effort to bring the moneyed and the artistic worlds together. Strutting like a bantam cock in a dapper frock coat and mirror-polished dancing pumps, Whistler was a magnet for visitors and played his role happily, although with conspicuous unsuccess in selling pictures. One Sunday his old Paris friend Edward Poynter, soon to be President of the Royal Academy, and already carrying himself with appropriate gravity, strode into the Gallery to be received by Lady Lindsay. Seeing what Alice Comyns Carr called the "unaccountably melancholy and aloof expression" Poynter always wore in public, Whistler intercepted him and slapped him on the back, crowing, "Hullo, Poynter. Your face is your fortune, my boy! Ha! Ha!" Poynter clenched his teeth and walked on, but his wife glared at the culprit, and Sir Charles Dilke complained aloud, "I suppose everything is allowed to Velasquez." John Everett Millais, who had liked the work of the apprentice better than that of the self-styled Master, muttered to Archie Wortley as they stood before Whistler's pictures at the Grosvenor, "It's damned clever; it is damned sight too clever!" And then he dragged Wortley on.

An American artist, youngest son of Whistler's old West Point

drawing mentor and former student of academic painter Jean-Léon Gérôme, agreed with the prevailing opinion. Alden Weir reported to his father in the first summer of the Grosvenor Gallery, "Yesterday we saw some of Whistler's work and I was agreeably disappointed. . . . They are fine as far as they go, but are not more than commencements." Before the month was out he had further satisfied his curiosity by visiting Whistler, and was pleased to discover the man as disagreeable as his work. To his brother John he described the experience:

> We then turned our steps towards Whistler's place and were ushered into an eccentric waiting room or parlor where the Chinese art prevailed. Milord enters, thin, slick, frizzled haired and to all appearances a coxcomb. He introduces himself with gracious smiles and after keeping us waiting a full half hour, makes his excuses for not having looked at our cards. . . . The conversation began, he striking an artistic position displaying a pair of howling socks, patent leather boots of exceedingly old fabric and plenty of London assurance. Ah! ha oh! Yes ah-no-ah yes ah ha yesssssss. . . . However, he showed behind all this an observing man, his eye is sharp. . . . We went into his studio where his palette consisted of a mahogany table about three feet in length covered with the demi, semi etc. tones of Whistler, a portrait which he showed us, I thought was well laid on, which he considered finished etc. and so on. I went, however, today to see his etchings and some are really remarkable and many more absolutely bad to me. He sent his compliments to Father and said: "You tell him that I regret he did not send you to me. Ah Pooh! I think nothing of Gérôme." It was below me to reply to such an eccentric remark in his own house. . . .

To his mother and father he was slightly more circumspect, but only slightly, for the distaste was too fresh and his determination to denigrate Whistler's work too strong.

> Yesterday we all went out to visit Turner's house at Chelsea. We afterward went and called on Whistler, whom we found a snob of the first water, a first class specimen of an eccentric man. His house is decorated according to his own taste. The dining room is à la Japanese, with fans stuck on the walls and ceiling, according to his own liking. He showed us some of his nocturnes

in the different minors, rather flat, however of a certain harmony and best seen in a demi obscure room with the light softened by passing through several thicknesses of curtains. His talk was affected and like that of a spoilt child, hair curled, white pantaloons, patent leather boots and a decided pair of blue socks, a one-eyed eye glass and, in escorting us to the boat, he carried a cane about the size of a darning needle. Alas! this is the immortal Whistler who I had imagined a substantial man!

There were also rich Americans in London during the exhibition season. Two of them, Mrs Marian Adams and Mrs Jack Gardner of Boston, were as interested in Lady Lindsay's position as a niece of Baron Rothschild as in her dabbling in art promotion through the creation of a "refuge" for "Pre-Raphaelites," for whom Mrs Adams cared little. To her the Gallery contained "many shocking daubs, with now and then one to redeem the rest." Both were interested in seeing Whistler's portrait of Connie Gilchrist, whom Mrs Adams described as having, in the painting, "a red flannel vest reaching to her hips, a handkerchief, bag and satin boots with high Louis XV heels; [she] is jumping rope with red handles. Any patient at Worcester who perpetrated such a joke would be kept in a cage for life." At Lady Lindsay's Sunday afternoon she was introduced to Whistler, whom she found "more mad away from his paint pots than near them."

"Mrs Jack" came on the arm of Henry James, and enjoyed Whistler's eccentricities. Later she and Whistler became friends, and he did a pastel portrait of her which he called *A Little Note in Yellow*. At the same time she bought his *Violet Note*, a nude sketch of a model, Lyse Vazaeti. The two were alike in size, creating gossip when she showed them that Whistler had painted Mrs Gardner in the nude. Abetting the speculation, she hung the sketches side by side at Fenway Court.

Another who expected "daubs," and found them, was John Ruskin, who despite Swinburne's early lobbying for Whistler was unconverted. Slade Professor of Art at Oxford, he used his pulpit as well as his private fortune to preach reformation of a world degraded by industrialism. His gospel was hard work and simplicity of life, and one of the virtues he saw in the artist for whom he had the greatest missionary zeal—Turner—was hard work. The simple life, in his philosophy, meant returning to an idealized and utopian version of medieval life, pictured often in the canvases of Burne-Jones, whose Arthurian subjects he admired. In his

monthly pamphlet *Fors Clavigera* ("fate bearing a hammer"), a tenpenny hortatory pastoral letter combining advice to the working classes with crotchety diatribes on any subject which occurred to him, he preached "the utmost simplicity of life . . . combined with the highest attainable refinement of temper and thought." He wished someone else would come forward to lead the battle, he declared, but with no one forthcoming, it was "only with extreme effort and chastisement of my indolence that I go on. . . ."

If there was a quality Ruskin did not possess, it was indolence. He pushed himself even harder than he pushed others, and wrote for the masses less than for those who could afford his publications on an encyclopedic variety of things, although his own knowledge had curious gaps. One led to the disaster of his marriage. At the time of the Grosvenor Gallery opening he was fifty-eight. Nearly thirty years had gone by since, as a gifted critic already known for his *Modern Painters*, he had married eighteen-year-old Effie Gray, and, having learned all his anatomy from portraits and statuary, was shocked on their wedding night to discover the existence of pubic hair. Six years later Effie divorced him on grounds of his impotence, and married their friend John Millais, who had found the fact which had disabled Ruskin no disfigurement peculiar to her. Love came to Ruskin lunatic and late, and Rose La Touche, the child he had adored unsatisfactorily since he first met her, when she was ten, died in 1875. By 1877 he was declining into a new period of insanity, yet his mental breakdowns had resulted in only brief respites from publication. Instead he put his hysteria into his writing.

Fors Clavigera, the fulminations of Ruskin's fifties, was the work of a fine mind flashing brilliantly at times but having gone cranky and erratic. Inveighing against the new technique of lithography, since the past was perfect and the future suspect, he advised, "Let no lithographic work come into your house if you can help it." No past master whose work failed to meet his standards of "finish" or morality passed muster. Rembrandt's work was often "licentious." Visiting his friend F. S. Ellis, when he noticed a fine copy of Goya's powerful *Caprichos* he declared that it was hideous and "only fit to be burnt." Ellis, mesmerized by Ruskin's wild stare as he contemplated the book, agreed, putting the volume into the empty grate (for it was August), and Ruskin set it afire, watching over it until it was ashes. "The very best possible elementary instruction . . . in the art of watercolour painting" for young ladies, the Slade

Professor of Art wrote in one of the "Letters to the Workmen of Great Britain," would be to color cheap engravings.

"Of our working classes," he wrote unarguably in the July 2 issue of *Fors*, "comparatively few ever enter a gallery of pictures." A sense of beauty had to be awakened by other means, and most important for most people, he contended, was not municipal purchases of canvases and statuary; "What you can afford to spend for the splendour of your city, buy grass, flowers, sea, and sky with. No art of man is possible without those primal Treasures of the art of God." Yet he was pleased, despite reservations, that Sir Coutts Lindsay, "a gentleman in the true desire to help the artists and better the art of his country," had opened the Grosvenor Gallery. For one thing, Burne-Jones's work, exhibited there, was "simply the only art-work at present produced in England which will be received by the future as 'classic' in its kind." And the portraits by Millais "may be immortal." But the décor of the Gallery was "very injurious to the best pictures it contains, while its glitter unjustly veils the vulgarity of the worst." Sir Coutts had also been too liberal in extending invitations to artists. As early as 1873, in a lecture on Tuscan art delivered at Oxford, Ruskin had noted, "I never saw anything so impudent on the walls of any exhibition in any country as last year in London. It was a daub, professing to be 'a harmony in pink and white' (or some such nonsense); absolute rubbish, and which had taken about a quarter of an hour to scrawl or daub. The price asked was two hundred and fifty guineas." The name of the painter was unmentioned but not unclear.

At the Grosvenor Whistler had exhibited only one painting he marked for sale, his 1875 impression of fireworks at Cremorne, *Nocturne in Black and Gold: The Falling Rocket*. Querulously, Ruskin chastised Sir Coutts for permitting its display. "For Mr. Whistler's own sake, no less than for the protection of the purchaser, Sir Coutts ought not to have admitted works into the gallery in which the ill-educated conceit of the artist so nearly approached the aspect of wilful imposture. I have seen, and heard, much of Cockney impudence before now; but never expected to hear a coxcomb ask two hundred guineas for flinging a pot of paint in the public's face."

Sitting in the Arts Club in Hanover Square on an evening early in July, soon after Ruskin's *Fors* had arrived in the mail, Whistler and his old friend of Paris days, George Boughton, were alone in the smoking room when Boughton chanced on the diatribe. "Although I well knew

how he rather enjoyed adverse criticism and made sport of the writers,"
Boughton recalled, "I hesitated to call attention to this outburst. I shall
never forget the peculiar look on his face as he read it and handed the
paper back to me with never a word of comment, but thinking, furiously
though sadly, all the time."

"It is the most debased style of criticism I have had thrown at me
yet."

"Sounds rather like libel," Boughton suggested.

"Well," said Whistler, "that I shall try to find out"—and he lit a
cigarette and departed to find a lawyer.

Whistler went to Anderson Rose, who had long represented him at
the London bar, mostly for nonpayment of bills. Rose had cleared him in
August, 1873 of failure to appear as a juror (a £5 fine) by presenting an
affidavit to Central Criminal Court that his client was an American
citizen, and even earlier had handled Seymour Haden's sticky suit for
slander when Whistler had accused him of complicity in the death of his
assistant J. R. Traer "through harsh and ungenerous behavior." He had
got Whistler off with a payment of £20 for failing to restore a studio
rented from E. Clifton Griffith to its original condition on expiration of
the lease, and currently had a suit on his hands from Lewis Rodway, a
cheesemaker and poulterer on Fulham Road, for nonpayment of an
eighteen guinea bill, one of many which plagued Whistler in the
seventies. This time Whistler would be plaintiff, claiming £1000 damages
in a writ for libel, issued July 28, 1877, inasmuch as Ruskin had "falsely
and maliciously published" statements regarding Whistler which had
"greatly damaged his reputation as an artist," preventing him from selling
his pictures.

Ruskin was delighted at the prospect, and became almost hysterically
excited about the case although the preliminary arrangements dragged on
through the year. "It's mere nuts and nectar to me the notion of having to
answer for myself in court," he wrote Burne-Jones, "and the whole thing
will enable me to assert some principles of art economy which I've never
got into the public's head by writing, but may get sent all over the world
vividly in a newspaper report or two." Expecting to appear in his own
behalf, Ruskin worked on a memorandum which would constitute his
own statement. His duty as a critic was to recommend artists of merit to
public attention, he wrote, and to prevent artists of no merit from
occupying public attention. Further, his sincere and accurate description

of Whistler and his work was intended to help the artist achieve his promise, such as it might be, while safeguarding the public from unsatisfactory artistic performance:

I have spoken of the plaintiff as ill-educated and conceited—because the very meaning of education in an artist is that he should know his true position with respect to his fellow workmen and ask from the public only a just price for his work. Had the plaintiff known either what good artists gave habitually of labour to their pictures or received contentedly of pay for them, the price he set on his own productions would not have been coxcombry, but dishonesty. I have given him the full credit of his candid conceit and supposed him to imagine his pictures to be really worth what he asked for them. And I did this with the more confidence because the titles he gave them showed a parallel want of education.

The value of a picture, he pontificated further in his draft defense, depended upon the justice and clarity of the ideas therein, contrary to those modern schools "which conceive the object of Art to be ornament rather than edification." It was therefore reasonable for a critic "to require of a young painter that he should show the resource of his mind no less than the dexterity of his fingers," and not libelous "to recommend the spectator to value order in ideas above arrangement in tints, and to rank an attentive draughtsman's work above a speedy plasterer's." Finally, Ruskin penned a thunderbolt calculated to win over the most wavering juror. Whatever the issue of the trial, he would announce from the stand, his intention was to retire from public life because of his health and advancing years.

Reading the draft later, Ruskin's junior counsel, Mr Bowen, noted in his opinion for the defense that such language as Ruskin had drafted was "exceedingly trenchant and contemptuous . . . Mr Ruskin must not be surprised if he loses the verdict. I should rather expect him to do so." Ruskin nevertheless acted as if he had already won, making much of his sudden status as a public figure.

In London Whistler was acquiring his own new notoriety, hoping for crowds around his work at the Grosvenor's second season, and even being lampooned, with his own collaboration, in a comedy at the Gaiety Theatre. In *La Cigale*, a French comedy by Meilhac and Halevy, Degas and Impressionism were satirized, but John Hollingshead, manager of the

Gaiety, assumed that he had better substitute a more familiar local symbol of modernism, and in December, 1877 Whistler was the obvious choice. Thus Marignan, the hero, was transformed in *The Grasshopper* into Pygmalion Flippit, "an Artist of the future," who declares that he is a "Harmonist in colours—in black and white, for example," and that he and his followers "now call ourselves harmonists, and our work harmonies or symphonies, according to colour." Flippit even refers to "my great master, Whistler," hardly another libel since Whistler even consented to having his Chelsea neighbor, Carlo Pellegrini, who drew for *Vanity Fair,* paint a caricature of him for the play, which was wheeled onstage on an easel. Whistler even attended the last rehearsal and approved of the dialogue, an opportunity he might have wished he had had with *Fors Clavigera.* From the offices of the Gaiety, looking out at the stage door, he drew three lithographs of the stage entrance, and, with much solemnity, brewed a drink new to the Gaiety people which he claimed was of American origin, a "Mint Julep."

In one scene Flippit's "dual harmony in red and blue" was presented to a prospective buyer one way up as a desert scene and the opposite side up as a sunset at sea. Whistler was delighted by the burlesque. But in the trial to come the *Nocturne in Black and Gold: The Falling Rocket* would be shown, accidentally, upside down. Life would imitate art, as the Thames fogs had begun to resemble Whistler's nocturnes.

XIX

Whistler v. Ruskin

A<small>T</small> 49 Prince's Gate late in 1878 Frederick Leyland was host at a dinner in his famous Peacock Room which gave him particular pleasure. His guests were the leading artists and art critics in London—Burne-Jones, Poynter, Armstrong, Boughton, Spencer Stanhope, Comyns Carr, Walter Crane, and Val Prinsep—and conversation inevitably turned to the work of the uninvited artist which surrounded them in the room. Crane, committing the worst solecism possible in that company, admitted to liking it. Burne-Jones would allow no merit to Whistler as an artist, or even to his aims. There was only one *right* way of painting, he insisted in an emotional dissertation. The long-delayed libel suit against Ruskin was about to go to trial, with Burne-Jones as chief witness for the defendant, and under the circumstances he could hardly afford to concede any credit to Whistler.

The case had taken more than a year to be heard, a year of declining fortunes for Whistler, who as the preliminaries stretched out, more and more needed a favorable judgment. It was more difficult for him to sell his work or acquire a commission in the glare of ridicule, yet he had made the matter public when the cantankerous criticism, deep in the far-from-best-selling *Fors Clavigera*, if ignored might have quickly been forgotten. The Philistine press led by *Punch* was grateful for the opportunity, but

the weekly *London* led the pack in venom. Ruskin had said, it wrote in its editorial of August 18, 1877, what many Englishmen had thought—that the "Whistleristic principle" of painting had been inspired by the realization that a technique of art "lay dormant" in the cleaning of the palette and the spreading of the "oily coagulations" on a piece of paper:

> We sometimes picture the scene. A piece of newspaper is set to receive the refuse paint; a prophetic glow overspreads the young American features; and on a contemptible patch of the New York *Herald*, glitters the first genuine Whistler.
>
> Mr Whistler's brave attempt to enlighten the Britishers is lost to us. . . . But we can't despair, remembering as we do that the Whistlerian idea arose in the land of progress and Presidents, the land where Barnum blows and Whitman catalogues. . . .

The proceedings were slow in getting underway, although both sides were eager for the confrontation. "It's mere nuts and nectar to me the notion of having to answer for myself in court . . ." Ruskin wrote to Burne-Jones. "*I've* heard nothing of the matter yet, and am only afraid the fellow will be better advised." But Whistler was determined, and Anderson Rose toiled over the brief, adding, altering, cutting—even after news came in February, 1878 that Ruskin was ill and delirious, and that the trial had to be rescheduled. His physician diagnosed "brain-fever," and courtesy demanded that the plaintiff accept the delay.

The postponement meant that another Grosvenor Gallery exhibition would open before the trial, this time without Ruskin's reviewing it. Whistler sent his usual assortment of *Harmonies, Nocturnes* and *Arrangements,* including *Arrangement in Black and White, No. 1: The Young American,* his portrait of Maud. He never explained the curious title.

Henry James liked Burne-Jones's and George Boughton's work better than Whistler's contributions, which were only "pleasant things to have about, so long as one regards them as simple objects—as incidents of furniture or decoration. The spectator's quarrel with them begins when he feels it to be expected of him to regard them as pictures. His manner is very much like that of the French 'Impressionists.' " The *Times* sneered at "two of those vaporous full lengths . . . which it pleases him to call 'arrangements' in blue and green, and white and black, as if the colour of the dress imported more than the face; and as if young ladies had no right to feel aggrieved at being converted into 'arrangements.' He has, besides, one 'Harmony in blue and silver,' the Thames in mist as we infer from

what looks like the clock tower gleaming faintly through the haze; a 'Variation in flesh colour and green,' for which we should suggest the name 'Chelsea China,' as it represents ladies in celestial costumes on a balcony overlooking what looks like the Thames on a dirty day, and two 'Nocturnes' in blue and gold and grey and gold, also views of the river in fog." The large display—perhaps Whistler's way of appearing unperturbed by the forthcoming trial—attracted attention, but not purchasers. Millais had sent only two paintings, described by critic Tom Taylor anonymously in the *Times* as "once more" exhibiting "the highest power of our time in . . . portraiture." One of them showed a Scotch lassie turning down a page in her Bible, the other depicted two girls in identical suits of green, one of them "with her hand on the head of a noble deer-hound." For the *Times* there was no competition. "Mr Whistler has his own abilities, his own aims, and his own admirers, and it is no use denying the one, arguing about the second, or abusing the third," the *Times* suggested. "He has a right to his place among the originals of the time; and it is well he should find room and verge enough in the Grosvenor Gallery."

Whistler's pretrial situation was financially and artistically little short of desperate. The helpful and often heroic Howell, who often acted as intermediary where money was concerned, suddenly made matters even worse by diverting Whistler's dwindling funds to settle his own obligations. Then he owned up in a letter:

22 Feb 1878

My dear Whistler:

I wish you to have in writing this fact—Your cheque for £100—held by Mr Blott—I hold myself entirely responsible for. I gave it to Mr Blott in settlement of an account of mine. You have not received one penny of it, the arrangement being that I could renew it with Mr Blott by paying the necessary interest. I undertake that you shall incur no annoyance whatever. . . .

Before long Blott's lawyer was at Whistler's door, and all Whistler could do was to offer a picture as security for a debt he had thought had been satisfied. After months of haggling Blott accepted the *Carlyle* as hostage, negotiations which had not made Whistler's preparations for the new Grosvenor Gallery exhibition easier. Few *arrangements* seemed worth their weight in paint, forcing Whistler to defend his artistic nomenclature in the press during the Grosvenor show. To *The World* he wrote on May 22

that although "many good people" found *symphonies, arrangements, harmonies* and *nocturnes* to be funny titles and their creator eccentric, he was determined to force viewers to see a picture, not a story, in his work. Yet he understood that without conventional baptism of his pictures there was no market for them:

> But even commercially this stocking of your shop with the goods of another would be indecent—custom alone has made it dignified. Not even the popularity of Dickens should be invoked to lend an adventitious aid to art of another kind from his. I should hold it a vulgar and meretricious trick to excite people about Trotty Veck when, if they really could care for pictorial art at all, they would know that the picture should have its own merit, and not depend upon dramatic, or legendary, or local interest. . . .
>
> Art should be independent of all clap-trap—should stand alone, and appeal to the artistic sense of eye or ear, without confounding this with emotions entirely foreign to it, as devotion, pity, love, patriotism, and the like. All these have no kind of concern with it; and that is why I insist on calling my works "arrangements" and "harmonies".
>
> Take the picture of my mother, exhibited at the Royal Academy as an "Arrangement in Grey and Black". Now that is what it is. To me it is interesting as a picture of my mother; but what can or ought the public to care about the identity of the portrait?
>
> The imitator is a poor kind of creature. If the man who paints only the tree, or flower, or other surface he sees before him were an artist, the king of artists would be the photographer. It is for the artist to do something beyond this: in portrait painting to put on canvas something more than the face the model wears for that one day: to paint the man, in short, as well as his features. . . .

The argument was eloquent but Whistler's sales remained few, and were mainly to friends. Through Howell he sold a *Nocturne in Grey and Gold* to Luke Ionides almost on the eve of the trial, and to Howell or through Howell passed almost everything which left his studio. Chief benefactor, undoubtedly, was the Portugee. Earlier that year he bought from Whistler—for fifty pounds—a large landscape, a sketch for *Miss Alexander* and another for a portrait of Walter Greaves, a Chelsea winter

nocturne, a framed Battersea nocturne and eight unused frames. After paying so little he then would lend additional money to Whistler, who was busy meanwhile pawning paintings and borrowing where he could, even from Anderson Rose, whose expectations of return may have come from the Ruskin lawsuit, if at all. One of Howell's notebook entries read "Lent ten pounds to Whistler, eight pounds to Maud, good girl Maud." More than a dozen years had passed since Jo had done the borrowing. Nothing seemed to have changed, except that Whistler lived more elegantly and owed more money.

Although Whistler looked forward to a personal duel with Ruskin which would end in the triumph of imagination and experiment in art, and confirm the supremacy of the artist over the critic, the repeated delays asked for by Ruskin's counsel made it obvious that if there were to be a trial at all, it would have to be without the presence of Ruskin. He could not be subjected to the strain of appearing in court, it was argued, although he was ostensibly recovered. At fifty-nine (Whistler was fifteen years younger) Ruskin was now aged and easily tired, and worked cautiously only in the mornings, resting through the remainder of the day except for some exercise prescribed by his doctor—an hour of chopping wood. "I think I can draw and write nearly as well as ever," he wrote a friend, "on subjects that do not excite me. . . ." Yet on the morning of the trial he wrote a letter referring to the "comic Whistler lawsuit." It was apparently a subject which left him complacent and undisturbed.

Whistler was far more agitated. Ruskin had left his case in the hands of Burne-Jones, who had retained the prestigious law firm of Walker, Martineau and Co. Whistler had the loyal Anderson Rose working on preparation of the case, with Mr Serjeant Parry as counsel, but neither they nor Whistler had been able to amass a band of respectable artists and critics with whom to impress a jury. Artists were not a brave lot, being at the mercy of critics whose professional loyalty went out to one of their embattled brethren. Charles Keene, whom Whistler admired as his generation's Hogarth, shied away from testifying, writing to a friend on November 24, "Whistler's case against Ruskin comes off, I believe, on Monday. He wants to subpoena me as a witness as to whether he is (as Ruskin says) an impostor or not. I told him I should be glad to record my opinion, but begged him to do without me if he could. They say it will most likely be settled on the point of law without going into evidence, but if the evidence is adduced, it will be the greatest lark that has been

known for a long time in the courts." Whistler had letters from respectable artists speaking favorably of his "moonlights," but none wanted them entered in evidence, and they were never mentioned at the trial.

In the end Whistler came up with one major witness, Frederick Leighton, the newly elected President of the Royal Academy; but even here his luck failed. It had become automatic that the Academy's President would receive a knighthood, and Leighton was summoned to Windsor on the morning the trial began. Even the Queen, it seemed, was on Ruskin's side.

On Monday, November 25, 1878, at the Court of Exchequer in Westminster, in the shadow of the Houses of Parliament, the doors opened at 10:00 a.m. and the 150 seats were quickly filled, and then the aisles. At eleven, the judge, Sir John Walter Huddleston, rapped for silence. It would be the first time Art had gone on trial beneath the high vaulted arches, and both sides recognized an opportunity to make history. For Burne-Jones it was "a national cause." For Whistler it was a matter not only of vindication of his philosophy as an artist but of his survival as an artist.

His chief counsel, Mr Serjeant Parry, opened the case so deferentially that he might have been defending the other side:

> I speak for Mr Whistler, who has followed the profession of an artist for many years, while Mr Ruskin is a gentleman well known to all of us, and holding perhaps the highest position in Europe or America as an art critic. Some of his works are destined to immortality, and it is the more surprising, therefore, that a gentleman holding such a position could traduce another in a way that would lead that other to come into a court of law to ask for damages. The jury, after hearing the case, will come to the conclusion that a great injustice has been done. Mr Whistler . . . is not merely a painter, but has likewise distinguished himself in the capacity of etcher, achieving considerable honours in that department of art. He has been an unwearied worker in his profession, always desiring to succeed, and if he had formed an erroneous opinion, he should not have been treated with contempt and ridicule.

After recapitulating the grounds for the plaintiff's action, Mr Parry went on:

Mr Ruskin pleaded that the alleged libel was privileged as being a fair and *bona fide* criticism upon a painting which the plaintiff had exposed to public view. But the terms in which Mr Ruskin has spoken of the plaintiff are unfair and ungentlemanly, and are calculated to do, and have done him, considerable injury, and it will be for the jury to say what damages the plaintiff is entitled to.

Whistler, dapper as always, was called to the box in his own behalf, and Parry's assistant, Mr Petheram, asked him to tell the jury who he was, and where he was born:

My name is James McNeill Whistler. I am an artist, and was born in St Petersburg, Russia. I lived in that city for twelve or fourteen years.

He could have refuted the "cockney coxcomb" allegation with the Lowell, Massachusetts, truth, but assumed that the twelve men good and true would be more impressed by the Imperial Czarist court. Refuting allegations of lack of education was easier, for the United States Military Academy had added glitter in the post-Civil War world, but he continued, when asked about his education:

I studied in Paris with Du Maurier, Poynter, Armstrong. I was awarded a gold medal at the Hague. I have exhibited at the Royal Academy. My etchings are in the British Museum and Windsor Castle collections. I exhibited eight pictures at the Grosvenor Gallery in the summer of 1877. No pictures are exhibited there save on invitation. I was invited by Sir Coutts Lindsay to exhibit. The first was a *Nocturne in Black and Gold—The Falling Rocket.* The second, a *Nocturne in Blue and Silver.** The third, a *Nocturne in Blue and Gold*, belonging to the Hon Mrs Percy Wyndham. The fourth, a *Nocturne in Blue and Silver*, belonging to Mrs Leyland. The fifth, an *Arrangement in Black—Irving as Philip II of Spain.* The sixth, a *Harmony in Amber and Black.* The seventh, an *Arrangement in Brown.* In addition to these, there was a portrait of Mr Carlyle. That portrait was painted from sittings Mr Carlyle gave me. It has since been engraved, and the artist's proofs were all subscribed for. The Nocturnes, all but two, were sold before

* Later retitled *Blue and Gold—Old Battersea Bridge.*

they went to the Grosvenor Gallery. One of them was sold to the Hon Percy Wyndham for two hundred guineas—the one in *Blue and Gold.* One I sent to Mr Graham in lieu of a former commission, the amount of which was a hundred and fifty guineas. A third one, *Blue and Silver*, I presented to Mrs Leyland. The one that was for sale was in *Black and Gold—The Falling Rocket.*

Since the publication of Mr Ruskin's criticism, have you sold a Nocturne?

Not by any means at the same price as before.

What is your definition of a Nocturne?

I have perhaps meant rather to indicate an artistic interest alone in the work, divesting the picture of any outside anecdotal sort of interest which might have been otherwise attached to it. It is an arrangement of line, form and colour first; and I make use of any incident of it which shall bring about a symmetrical result. Among my works are some night pieces, and I have chosen the word Nocturne because it generalizes and simplifies the whole set of them.

The portraits of Carlyle and Irving were brought into court, together with *The Falling Rocket* and other nocturnes, and set up on easels before the jury, although in the dim light little could be seen other than that they were canvases in frames. *The Falling Rocket* was exhibited upside down, and when the plaintiff pointed out the mistake laughter rippled through the spectators. Another was handed across the court over the heads of several people so that Whistler might identify it as his own work, and in the process an elderly gentleman with a bald head was bumped by it, after which the picture looked as if it might fall out of its frame. Serjeant Parry rose, and as if nothing had happened, although laughter in the courtroom had not faded, asked, "Is that your work, Mr Whistler?"

"Well, it was once," said Whistler, fixing his eyeglass in his eye, "but if it goes much longer in that way, I don't think it will be."

Although Whistler expected further questioning from his counsel to draw out his distinguished clientele prior to Ruskin's attack, and his loss

of commissions and of income following it, neither Parry nor Petheram followed up the artist's recital of famous sitters and patrons, and the curtailment of his sales. Instead, confident that the point had already been made and needed no reiteration, they turned Whistler over to Sir John Holker, the Attorney General, who was appearing for Ruskin.

SIR JOHN: Mr Whistler, you have sent pictures to the Academy which have not been accepted?

WHISTLER: I believe that is the experience of all artists.

SIR JOHN: What is the subject of the *Nocturne in Black and Gold?*

WHISTLER: It is a night piece, and represents the fireworks at Cremorne.

SIR JOHN: Not a view of Cremorne?

WHISTLER: If it were called a view of Cremorne, it would certainly bring about nothing but disappointment on the part of the beholders. [*Laughter*] It is an artistic arrangement.

SIR JOHN: Why do you call Mr Irving an *Arrangement in Black?* [*Laughter*]

Pounding his gavel, the judge interposed, explaining through the general hilarity that the picture, not Mr Irving, was the *Arrangement.*

WHISTLER: All these works are impressions of my own. I make them my study. I suppose them to appeal to none but those who may understand the technical matter.

Not pleased about the banter upon what was at least to him a serious subject, Whistler added that other pictures of his had been placed in the nearby Westminster Palace Hotel, where they could be seen under better lighting conditions, and that he hoped the jury would have that opportunity. Then the cross-examination continued.

SIR JOHN: Is two hundred guineas a pretty good price for an artist of reputation?

WHISTLER: Yes.

SIR JOHN: It is what we who are not artists would call a stiffish price.

WHISTLER: I think it very likely it would be so. [*Laughter*]

SIR JOHN: Artists do not endeavour to get the highest price for their work irrespective of value?

WHISTLER: That is so, and I am glad to see the principle so well established.

SIR JOHN: I suppose you are willing to admit that your pictures exhibit some eccentricities. You have been told that over and over again?

WHISTLER: Yes, very often. [*Laughter*]

SIR JOHN: You send them to the Gallery to invite the admiration of the public?

WHISTLER: That would be such vast absurdity on my part that I don't think I could. [*Laughter*]

SIR JOHN: Did it take much time to paint the *Nocturne in Black and Gold?* How soon did you knock it off? [*Laughter*]

WHISTLER: I beg your pardon. [*Laughter*]

SIR JOHN: I'm afraid I was using a term that applies rather to my own work. [*Laughter*] I should have said, "How long did it take you to paint that picture?"

WHISTLER: Oh, no! Permit me. I am too greatly flattered to think that you apply, to a work of mine, any term you are in the habit of using with reference to your own. Let us say, then, how long did I take to "knock off"—I think that's it—to knock off that Nocturne. Well, as well as I remember, about a day. I may have put a few more touches to it the next day if the painting were not dry. I had better say, then, that I was two days at work on it.

SIR JOHN: The labour of two days, then, is that for which you ask two hundred guineas?

WHISTLER: No. I ask it for the knowledge of a lifetime.

There was warm applause, for the first time in the trial. Judge Huddleston rapped sharply and announced that if such a manifestation of feeling were repeated he would have to clear the courtroom. The Attorney General then continued.

SIR JOHN: You don't approve of criticism?

WHISTLER: I should not disapprove in any way of technical criticism by a man whose life is passed in the practice of the science which he criticizes; but for the opinion of a man whose life is not so passed, I would have as little regard as you would if he expressed an opinion on law.

SIR JOHN: You expect to be criticized?

WHISTLER: Yes, certainly; and I do not expect to be affected by it until it becomes a case of this kind.

The *Nocturne in Blue and Silver* was then introduced as evidence, and the Judge examined it closely, afterwards asking Whistler what it was intended to represent.

WHISTLER: It represents Battersea Bridge by moonlight.

JUDGE: Is this part of the picture at the top Old Battersea Bridge?

WHISTLER: Your lordship is too close at present to the picture to perceive the effect which I intended to produce at a distance. The spectator is supposed to be looking down the river towards London.

JUDGE: The prevailing colour is blue?

WHISTLER: Yes.

JUDGE: Are those figures on the top of the bridge intended for people?

WHISTLER: They are just what you like.

JUDGE: That is a barge beneath?

WHISTLER: Yes, I am very much flattered at your seeing that. The picture is simply a representation of moonlight. My whole scheme was only to bring about a certain harmony of colour.

JUDGE: How long did it take you to paint that picture?

WHISTLER: I completed the work in one day, after having arranged the idea in my mind.

SIR JOHN: After finishing these pictures, do you hang them up on the garden wall to mellow?

WHISTLER: I should grieve to see my paintings mellowed. [*Laughter*] But I do put them in the open air that they may dry as I go on with my work.

The court then adjourned briefly so that the jury could cross the street to see the Whistler paintings on view at the Westminster Palace Hotel. When everyone returned, and Judge Huddleston continued the proceedings, *The Falling Rocket* was again produced, this time right-side-up, and the Attorney General resumed his questioning.

SIR JOHN: You have made the study of art your study of a lifetime. What is the peculiar beauty of that picture?

WHISTLER: It is impossible for me to explain to you the beauty of

harmony in a particular piece of music if you have no ear for music.*

SIR JOHN: Do you not think that anybody looking at the picture might fairly come to the conclusion that it had no particular beauty?

WHISTLER: I have strong evidence that Mr Ruskin did come to that conclusion. [*Laughter*]

SIR JOHN: Do you think it fair that Mr Ruskin should come to that conclusion?

WHISTLER: What might be fair to Mr Ruskin I cannot answer. But I do not think that any artist would come to that conclusion. I have known unbiased people express the opinion that it represents fireworks in a night scene.

SIR JOHN: You offer that picture to the public as one of particular beauty, as a work of art, and which is fairly worth two hundred guineas?

WHISTLER: I offer it as a work which I have conscientiously executed and which I think is worth the money. I would hold my reputation upon this, as I would upon any of my other works.

The arrangement between attorneys was that each side would present three expert witnesses, and when Whistler stepped down in favor of the first, it was with the feeling that he had already won the day without them. He had held his own with England's leading prosecutor, and assumed that the air of amusement which still filled the courtroom was one of sympathy with him.

It was William Michael Rossetti who followed him to the stand. A friend to both sides, he had been subpoenaed the day before when Whistler could not find a replacement for the newly minted knight, Frederick Leighton, and testified reluctantly "in opposition to Ruskin's interest." As an art critic he had admired Ruskin's writings and had written in praise of Whistler's work. He would not go back on either when asked his opinion of the canvases arrayed before the jury.

ROSSETTI: I consider the *Blue and Silver* an artistic and beautiful representation of a pale but bright moonlight. I admire Mr

* Whistler later dramatized this exchange by rewriting it as follows:
 SIR JOHN: Do you think, Mr Whistler, you could make *me* see the beauty of that picture?
 WHISTLER [looking first at *The Falling Rocket*, then at the smug face of the Attorney General]: No. I fear it would be as hopeless as for a musician to pour his notes into the ear of a deaf man. [*Laughter*]

Whistler's pictures, but not without exception. I appreciate the meaning of the titles. *The Falling Rocket* is not one of the pictures I admire.

SIR JOHN: Is it a gem? [*Laughter*]

ROSSETTI: No.

SIR JOHN: Is it an exquisite painting?

ROSSETTI: No.

SIR JOHN: Is it very beautiful?

ROSSETTI: No.

SIR JOHN: Is it eccentric?

ROSSETTI: It is unlike the work of most other painters.

SIR JOHN: Is it a work of art?

ROSSETTI: Yes, it is.

SIR JOHN: Is two hundred guineas a stiffish price for a picture like that?

ROSSETTI [*after a long pause, while laughter bubbled up in the courtroom*]: I think it is the full value of the picture.

Uneasily, Rossetti stepped down, and Albert Moore took his place on the stand. Loyal and outspoken Albert Moore, who like Whistler was sufficiently out of the main stream to be excluded from Royal Academy membership, had once declared that there was not a single R.A. who could do as much as design a button.

SIR JOHN: Mr Moore, in general how would you describe Mr Whistler's pictures?

MOORE: They are the most consummate works of art.

SIR JOHN: The *Nocturne in Black and Gold* . . .

MOORE: Simply marvelous!

SIR JOHN: . . . the so-called *Falling Rocket* . . .

MOORE: No other painter could have succeeded in it as Mr Whistler has done. Exquisite!

SIR JOHN: Is the picture with the fireworks an exquisite work of art?

MOORE: There is a decided beauty in the painting of it.

SIR JOHN: Is there any eccentricity in these pictures?

MOORE: I should call it originality. What would you call eccentricity in a picture? [*Laughter*]

Whistler's last witness in his own inconsequence testified to the

difficulty the painter had experienced in locating distinguished profession-
als to appear for him. William Gorman Wills was a minor Irish
playwright who had written costume vehicles for Henry Irving, and was
an even more minor portrait painter. But he was the only other painter
Whistler could cajole to court—which was more than Queen Victoria
could do when she had asked Wills to paint the royal grandchildren.
(Wills pleaded a prior engagement.) For the third witness Sir John
Holker had the same basic question, and Wills, encouraged by Moore,
went even beyond his example.

> WILLS: I have affirmed that Mr Whistler's works are artistic
> masterpieces. Allow me to go further. They have been
> painted by a man of genius. Mr Whistler looks at nature in a
> poetical light and has a native feeling for colour.

There had been one more witness for Whistler waiting his turn, but
he was not called. Algernon Graves, proprietor of a London shop which
made and sold prints and engravings, had reproduced Whistler's *Carlyle* in
mezzotint, and waited to testify to the popularity of the work. But Sir
John objected that the original had not been listed in the Grosvenor
Gallery catalogue, and Judge Huddleston upheld the contention that there
was no conclusive proof of its having been exhibited there at the time,
although other critics seemed to have seen it. Encouraged, the Attorney
General then submitted to the Court that the plaintiff had not proven his
case; hence there was no case for his client to answer. The response sent
Whistler home for the day almost ready to count the damages as
won.

> JUDGE: No, I cannot deny that Mr Ruskin's criticism, as it stands,
> holds Mr Whistler's work up to ridicule and contempt. So far
> it is libelous, and must, therefore, go to the jury. It is for the
> Attorney-General to prove it fair and honest criticism.

Counsel for the defense opened with a suggestion that Ruskin was
the aggrieved party, prevented from doing his duty. A critic might use
strong language without malice, for without it the incentive to excel
might disappear from the fine arts.

> SIR JOHN: It is my hope, gentlemen of the jury, before this case is
> closed, to convince you that Mr Ruskin's criticism upon the
> plaintiff's pictures was perfectly fair and *bona fide,* and that,

however severe it might have been, there was nothing that could reasonably be complained of. . . .

Rightly or wrongly, Mr Ruskin has not a very high opinion of the days in which we live. He thinks too much consideration is given to money-making, and that the nobility of simplicity is not sufficiently regarded. With regard to artists he upholds a high standard and he requires that the artist should possess something more than a few flashes of genius. He requires a laborious and perfect devotion to art, and he holds that an artist should not only struggle to get money, but also to give full value to the purchaser of his production. It was the ancient code that no piece of work should leave the artist's hands which his diligence or further reflection could improve, and that the artist's fame should be built upon not what he received but upon what he gave.

It was unfortunate, he went on, that Mr Ruskin was still too ill to attend and declare these views in person, but it was not to be wondered at, given such views, that he would not be attracted to Mr Whistler's paintings. "He did subject them to a severe and slashing criticism, and even held them up to contempt; but in doing so he only expressed, as he was entitled to do, his honest opinion." The Attorney General droned on, turning to the plaintiff's exhibits before the court to contend that they were "marked by a strangeness of style and a fantastical extravagance which fully justified the language employed by Mr Ruskin in regard to them." He had much more to say, but the time was already late, and Judge Huddleston adjourned the court for the day.

Resuming his opening statement the next morning, the Attorney General became an art critic.

SIR JOHN: In the present mania for art it has become a kind of fashion among some people to admire the incomprehensible, to look upon the fantastic conceits of an artist like Mr Whistler, his "nocturnes," "symphonies," "arrangements" and "harmonies," with delight and admiration; but the fact was that such productions were not worthy of the name of great works of art. This was not a mania that should be encouraged; and if that was the view of Mr Ruskin, he had a right as an art critic, to fearlessly express it to the public. . . .

Let them examine the *Nocturne in Blue and Silver*, said to represent Battersea Bridge. What was that structure in the middle? Was it a telescope or a fire escape? Was it like Battersea Bridge? What were the figures at the top of the bridge? And if they were horses and carts, how in the name of fortune were they to get off? . . .

If Mr Whistler disliked ridicule, he should not have subjected himself to it by exhibiting publicly such productions. If a man thinks a picture is a daub he has a right to say so, without subjecting himself to the risk of an action.

I will not be able to call Mr Ruskin, as he is far too ill to attend, but if he had been able to appear, he would have given his opinion of Mr Whistler's work in the witness box. Mr Ruskin says, through me, as his counsel, that he does not retract one syllable of his criticism, believing it was right! The libel complained of said, among other things, "I never expected to hear a coxcomb ask two hundred guineas for a flinging a pot of paint in the public's face."

What is a coxcomb? I have looked the word up, and find that it comes from the old idea of the licensed jester who wore a cap and bells with a cock's comb in it, who went about making jests for the amusement of his master and family. If that is the true definition, then Mr Whistler should not complain, because his pictures have afforded a most amusing jest! I don't know when so much amusement has been afforded to the British public as by Mr Whistler's pictures.

I have now finished. Mr Ruskin has lived a long life without being attacked, and no one has ever attempted to control his pen through the medium of a jury. Mr Ruskin does not retract one syllable of his criticism upon Mr Whistler's pictures. He believes he is right. For nearly all his life he has devoted himself to criticism for the sake of the art he loves, and he asks you, gentlemen of the jury, not now to paralyse his hand. If you give a verdict against him, he must cease to write. It will be an evil day for the art of this country if Mr Ruskin is to be prevented from indulging in proper and legitimate criticism, and pointing out what is beautiful and

what is not, and if critics are to be all reduced to a dead level of forced and fulsome adulation.

With the case begun, Sir John bowed to the judge and placed the conduct of the trial and the examination of the defense witnesses in the hands of Charles Bowen, his junior counsel. Bowen's first task was to introduce Burne-Jones. To assist the jury, Bowen read extracts from Ruskin's most fulsome appreciations of Burne-Jones, then let the bearded, dignified artist speak for himself.

BURNE-JONES: I am a painter and have been so for twenty years. I have painted some works which have become known to the public within the last two or three years, including *Days of Creation* and *Venus's Mirror*, both of which were exhibited at the Grosvenor Gallery last year. . . .

I think that nothing but perfect finish ought to be allowed by artists, that they should not be content with anything that falls short of what the age acknowledges as essential to perfect work.

BOWEN: These nocturnes of Mr Whistler's . . . Take the one in blue and silver—*Old Battersea Bridge*—do you see any artistic quality in that nocturne, Mr Jones?

BURNE-JONES: Yes . . . I must speak the truth, you know.

BOWEN: Yes. Well, Mr Jones, what quality do you see in it?

BURNE-JONES: I think the *Nocturne in Blue and Silver* is a work of art, but a very incomplete one; an admirable beginning, but that it in no sense whatever shews the finish of a complete work of art. I am led to the conclusion because while I think the picture has many good qualities—in color, for instance, it is beautiful—it is deficient in form, and form is as essential as color.

BOWEN: Now, take the *Nocturne in Black and Gold—The Falling Rocket*—is that, in your opinion, a work of art?

BURNE-JONES: No, I cannot say that it is. I never saw a picture of night that was successful. This is only one of a thousand failures that artists have made in their efforts to paint the night. The color is even better than the other, but it is more formless, and as to the composition and detail, it has neither.

BOWEN: Is the picture in your judgment worth two hundred guineas?

BURNE-JONES: No, I cannot say it is, seeing how much careful work men do for much less. This is simply a sketch. The day and a half, in which Mr Whistler says it was painted, seems a reasonable time for it.

BOWEN: Do you see any mark of labor in the pictures by Mr Whistler that are under consideration?

BURNE-JONES: Yes, there must have been great labor to produce such work, and great skill also. Mr Whistler gave infinite promise at first, but I do not think he has fulfilled it. I think he has evaded the great difficulty of painting and has not tested his powers by carrying it out. The difficulties in painting increase daily as the work progresses, and that is the reason why so many of us fail. We are none of us perfect. The danger is this, that if unfinished pictures become common, we shall arrive at a stage of mere manufacture, and the art of the country will be degraded.

BOWEN: The word "finish" has been applied here many times as it applies to the art of painting. Here is a painting by the great Italian master Titian. I ask the witness to look at it in order to explain what "finish" is.

Arthur Severn was sitting next to Ruskin's solicitor, with volumes of *Modern Painters* in front of him, looking up passages as he thought they might be needed, and as the canvas by Titian—from Ruskin's own collection—was held before the court he heard one member of the jury, noting the dark coloring and the gold embroidery of the cap and cloak in the portrait and mistaking it for Whistler's notorious *Nocturne*, muttering, "A horrid thing! I entirely agree with Ruskin." Another, overheard by the plaintiff, exclaimed, "Now come, we've had enough of them Whistlers!" Whistler's counsel had other reasons to oppose its being placed in evidence.

PARRY [*rising*]: I object! We do not know that this is a genuine Titian.

JUDGE: You will have to prove that it is Titian.

BOWEN: I shall be able to do that.

JUDGE: That can only be by repute. I do not want to raise a laugh, but there is a well-known case of an "undoubted" Titian being purchased with a view to enabling students and others to find out how to produce his wonderful colors. With

that object the picture was rubbed down, and they found a red surface, beneath which they thought was the secret, but on continuing the rubbing they discovered a full-length portrait of George III in militia uniform. [*Laughter*]

BURNE-JONES: This is a portrait of Doge Andrea Gritti, and I believe it is a real Titian. It is a very perfect sample of the highest finish of ancient art. The flesh is perfect, the modeling of the face is round and good. That is an Arrangement in Flesh and Blood!

PARRY: What is the value of this picture of Titian's?

BURNE-JONES: That is a mere accident of the salesroom.

PARRY: Is it worth one thousand guineas?

BURNE-JONES: It would be worth many thousands to me! But it might have been sold for forty guineas. . . .

JUDGE: You are a friend of Mr Whistler, Mr Burne-Jones, I believe?

BURNE-JONES: I was. I don't suppose he will ever speak to me again after today.

Burne-Jones's opinion of Whistler remained unshaken under cross-examination. The plaintiff was an artist whose powers remained unfulfilled despite his early promise, although he conceded to Whistler "an unrivalled sense of atmosphere."

Next to be called was stocky, red-bearded William Powell Frith, R.A., sixty and full of honors, whose immensely detailed and crowded *Derby Day* canvas, reproduced by the thousands, seemingly hung in every public house in England. Ruskin's counsel had chosen carefully to appeal to the jury. While Burne-Jones would have found rapport with the real gentlemen (if any) among the twelve, Frith was one with the shopkeepers and artisans.

FRITH: I am a Royal Academician and have devoted my life to painting. I am a member of the Academies of various countries. I am author of *The Railway Station*, *Derby Day*, and *The Race for Wealth*.

BOWEN: You have seen Mr Whistler's pictures?

FRITH: I have.

BOWEN: Are the pictures works of art?

FRITH: I should say not. The *Nocturne in Black and Gold* is not a serious work to me. I cannot see anything of the true

representation of water and atmosphere in the painting of Battersea Bridge. There is pretty color which pleases the eye, but there is nothing more. To my thinking, the description of moonlight is not true. The colour does not represent any more than you would get from a bit of wallpaper or silk. The picture is not worth two hundred guineas. Composition and detail are more important matters in a picture. . . .

BOWEN: You attend here very much against your will?

FRITH: Yes, it is a very painful thing to be called to give evidence against a brother artist. I am here on subpoena. I had been previously asked to give evidence, but declined.

PARRY: Is Turner an idol of Mr Ruskin's?

FRITH: Yes, and I think he should be an idol of everybody.

PARRY: Do you know one of Turner's works at Marlborough House called *The Snowstorm?*

FRITH: Yes, I do.

PARRY: Are you aware that it has been described by a critic as a mass of soapsuds and whitewash?

FRITH: I am not.

PARRY: Would you call it a mass of soapsuds and whitewash?

FRITH: I think it very likely I should. [*Laughter*] When I say Turner should be the idol of everybody, I refer to his earlier works, but not to his later ones, which are as insane as the people who admire them. [*Laughter*]

JUDGE: Somebody described one of Turner's pictures as "lobster and salad." [*Laughter*]

FRITH: I have myself heard Turner speak of his own pictures as "salad and mustard." [*Laughter*]

PARRY: Without the lobster? [*Laughter*]

Somehow the case at hand had been lost in the interchange, but Parry recovered to complete the cross-examination, eliciting the information that Frith had not exhibited at the Grosvenor, had read Ruskin, and thought that Whistler had "very great power as an artist." "A decidedly honest man," Whistler reflected afterwards. "I have not heard of him since."

The last witness for the defense had again been very carefully chosen—Tom Taylor, playwright, editor of *Punch* and art critic of the *Times.* What juryman could disagree with *Punch* and the *Times?*

Introducing himself, he confirmed the opinions of Burne-Jones and Frith about *The Falling Rocket* by producing from his ample pockets copies of his newspaper columns, and with the permission of the Court "read again with unction his own criticism," as Whistler described it. The plaintiff was not a serious artist, Taylor concluded, for his work belonged "in the region of chaff. All Mr Whistler's work is unfinished. It is sketchy. He, no doubt, possesses artistic qualities, and he has got an appreciation of qualities of tone, but he is not complete, and all his works are in the nature of sketching. I have expressed, and still adhere to the opinion, that these pictures only come 'one step nearer pictures than a delicately tinted wall-paper.' "

With the case for the defendant concluded, Bowen summed up the evidence on his behalf. All that Ruskin had done, he said, was express a sincere and apparently valid personal critical opinion on Whistler's pictures. To censure him would be to muzzle all honestly held beliefs. Parry closed for the plaintiff.

> PARRY: I submit that the defense has not dared to ask if Mr Whistler deserves to be stigmatized as a "wilful impostor." Even if Mr Ruskin has not been well enough to attend this court, he might have been examined before a commission! No, his decree has gone forth that Mr Whistler's pictures are worthless. He has not supported that by evidence. He has not condescended to give reasons for the view he has taken, he has treated us with contempt, as he treated Mr Whistler. He has said: "I, Mr Ruskin, seated on my throne of art, say what I please and expect all the world to agree with me." Mr Ruskin is great as a writer, but not as a man; as a man he has degraded himself. His tone in writing the article is personal and malicious. Is an imperious autocrat on his throne to issue edicts which shall bring ruin, irretrievable ruin, gentlemen, on a humble, industrious and gifted gentleman?
>
> Mr Ruskin's criticism of Mr Whistler's pictures is almost exclusively in the nature of a personal attack, a pretended criticism of art which is really a criticism upon the man himself, and calculated to injure him. It was written recklessly, and for the purpose of holding him up to ridicule and contempt. Mr Ruskin has gone out of his way to attack Mr Whistler personally and must answer for the conse-

quences of having written a damnatory attack upon the painter. That is what is called pungent criticism—but it is defamatory, and I hope that you, gentlemen of the jury, will mark your disapproval by your verdict.

In the long shadows of the waning afternoon, all that remained was the formal charge to the jury.

JUDGE: There are certain words by Mr Ruskin, about which I should think no one would entertain a doubt: those words amount to a libel. It is of the last importance that a critic should have full latitude to express the judgments he has honestly formed, and for that purpose there is no reason why he should not use ridicule as a weapon; but a critic should confine himself to criticism, and not make it the veil for personal censure, nor allow himself to run into reckless and unfair attacks merely for the love of exercising his power of denunciation. The question for the jury is, did Mr Whistler's ideas of art justify the language used by Mr Ruskin? And the further question is whether the insult offered—if insult there has been—is of such a gross character as to call for substantial damages. Whether it is a case for merely contemptuous damages to the extent of a farthing, or something of that sort, indicating that it is one which ought never to have been brought into court, and in which no pecuniary damage has been sustained; or whether the case is one which calls for damages in some small sum as indicating the opinion of the jury that the offender has gone beyond the strict letter of the law.

It had become so dark by the time Judge Huddleston finished that candles had to be brought in; and by their light the jury filed out to consider a verdict already left in no doubt by the concluding remarks from the bench. Later it was Bernard Shaw's opinion that Whistler's counsel had bungled the case, for damages had to be claimed, and sustained, on the basis of loss to his commercial, not his artistic, reputation. "That sort of thing can be understood by lawyers, and he would have been awarded £1000. But in talking about his Artistic Conscience he could only raise a farthing—that being all conscience is worth in the eyes of the Law."

The jury was out an hour. The verdict was for the plaintiff. The damages assessed were one farthing.

To emphasize his feeling that the case should never have been brought to court, Huddleston refused to assess the guilty party for costs. (Each side would have to pay its own.) Puzzled, Whistler turned to Serjeant Parry to ask, "That's a verdict for me, is it not?" "Yes, nominally," said Parry. "Well," Whistler said, "I suppose a verdict is a verdict." As they gathered up their papers and prepared to leave, George Washburn Smalley, a friend and London correspondent for the New York *Tribune*, came up to offer his sympathy and Whistler, grasping his hand, said to him, "It's a great triumph; tell everybody it's a great triumph!" Untactfully he dissented, and Whistler told the New Englander scornfully, "My dear Smalley, you are just fit to serve on a British jury!"

But it was not a triumph. Costs for each side would be £386.12s.4d. Then there were the attorney's fees. And Whistler was already more deeply in debt than he had ever been before.

Dante Gabriel Rossetti read about the trial in his morning paper, and wrote to author William Davies, "Alas for Jimmy Whistler! What harbour of refuge now, unless to turn Fire-King at Cremorne? And Cremorne itself is no more! A nocturne Andante in the direction of the Sandwich Islands, or some country where tattooing pure and simple is the national School of Art, can now alone avert the long-impending Arrangement in Black on White." Whistler had long flirted with bankruptcy and now might have to flee from his debts, Rossetti suggested. What profited a man that he gain a farthing in order to lose everything else?

The Falling Rocket remained unsold until 1892.

XX

Aftermath

"ROSE my dear old friend!" Whistler wrote the day after the trial, "What shall I say to you that can . . . prove my warmth of feeling and my sense of the splendid way in which you managed and fought my battle for me! Nothing could have been finer. Morally, and in the judgement of all the world—all the world with whom high honor has weight—it is a complete victory! I come home to find my table strewn with letters of congratulation and sympathy. . . ." And he went on to mention the proposal of Comyns Carr that a subscription fund be begun to raise the costs of the trial, and his own hopes that Rose would encourage it as a dignified gesture. It meant more than dignity, for along with the congratulatory letters and the more revealing messages of condolence which Whistler acknowledged were piles of bills from anxious creditors. To Lazenby Liberty he apologized that he had been tremendously absorbed in the trial, and had found his house "covered with letters of congratulation and sympathy. . . ." But what Liberty wanted to know was when Whistler would be paying his bills, and Whistler encouraged him with news of Howell's "great Railway Case." While Whistler had fought to a pyrrhic victory, Howell had won a substantial sum in settlement for property in Fulham taken for a railroad

right-of-way.* Because of it, Whistler reassured Liberty, "I trust myself all so soon to bring you gold."

Ruskin fared better. Arthur Severn returned with the news immediately to Brantwood, arriving in a snowstorm, and described the trial to Ruskin and Joan Severn with great verve, dwelling on the incident in which a Whistler nocturne and its frame nearly parted company atop a spectator's bald head. The critic, too, was receiving letters of congratulation and sympathy, and 118 of his friends and admirers would quickly join to raise the amount of his costs, although it was more a gesture than anything else, given the comfortable state of Ruskin's finances. Burne-Jones first sent (in a letter to Joan Severn) "a fourth part of a half penny stamp which I do in justice think I owe to my blessed oldie for any possible injury I may have done to his cause." Giving testimony was, he felt, "very ugly work, & I trembled a good deal and wasn't very articulate and my tongue clave to the roof of my mouth . . . and I dare say I spluttered and was ridiculous but as I said—I would stand on my head in Pall Mall for him and I did what was pretty much the same."

Having paid the symbolic farthing, Burne-Jones joined the group at the Fine Art Society which was raising the costs, anticipating a course he and William Morris had planned—in event of defeat—to put up whatever damages would be assessed as well. A circular solicited funds in the name of Art:

Whistler *vs.* Ruskin. Mr. Ruskin's costs.

A considerable opinion prevailing that a lifelong, honest endeavor on the part of Mr. Ruskin to further the cause of Art should not be crowned by his being cast in costs to the amount of several hundreds of pounds, the Fine Art Society has agreed to set on foot a subscription to defray his expenses arising out of the late action of Whistler *vs.* Ruskin.

Persons willing to co-operate will oblige by communicating with the Society, 148, New Bond Street, London.

Concerned that Ruskin might in an excess of morality refuse to accept the purse, Burne-Jones wrote to him that "we are determined you shall not pay one penny & you wont baulk us will you? . . ." To another friend he wished "all that trial-thing hadn't been; so much I wish it, and I

* The case was heard in the Sheriff's Court, Red Lion Square, on November 27, 1878, and judgment given for Howell, the sum later fixed at £3,650.

wish Whistler knew that it made me sorry—but he would not believe [it]."

But Whistler had more to worry about than that. He not only had to find the money to pay his costs as well as his counsel; he had to find a way to repair his damaged reputation. Criticism had been put on guard against libel by the verdict but not to such a great extent as Whistler hoped, and in the aftermath of *Whistler vs. Ruskin* it would take a courageous client to purchase a nocturne or commission an arrangement. In a libel suit, ruin faced either defendant or plaintiff, and it was even possible, as Whistler learned, for the victor to emerge more hurt than the vanquished. Whistler lost in every way, while winning his suit. His reputation was not rehabilitated, and the farthing won was suitable for nothing more than an ornament on a key chain—if he then could still afford a key chain.

In an editorial *The Times* had concluded, the day after the trial, "As the jury awarded damages, we conclude that, in their opinion, Mr Ruskin had exceeded the limits of fair criticism; but as the damages were nominal while Mr Whistler proved that the pecuniary loss he had suffered through the defendant's criticism was real, it must be inferred that the jury thought that he did not deserve to be recouped the loss he had sustained." The verdict, it concluded, was "bewildering" yet "a censure on both." Ruskin, it thought, would regard it as a fine for speaking the truth. Whistler would regard it as a fine for painting in his own manner, as "an *Impressioniste*, almost the only one we have on this side of the Channel." And there *The Times* was ready to back the jury, the judge, and Ruskin's attorneys.

As *The Times* also implied, Whistler was done in by the Victorian middle-class taste for exact workmanship. It could come to terms with Pre-Raphaelitism, with its scrupulous exactitude, for the gospel of hard work was applied to everything. Art was the product of honest toil, and if the honest toil did not show, the result was suspect, as was Impressionism, which did not produce a recognizable and edifying image in a workmanlike manner. A verisimilitude that was associated with mirror-image was actually not more true than the impression of the effects of light and atmosphere, however the latter not only did not meet contemporary standards of craftsmanship but also registered an alien mode of vision. Thus in England Whistler was both cause of the growing disassociation between the artist and the public as well as its victim, and

the trial recorded that alienation.* One prospered by pleasing the public, or one survived at best by being true to one's idiom until the public was reconciled to it—the first stage of acceptance. Whistler had read it all years before, in *La Vie de Bohème*.

With the press full of unflattering comment about the libel suit, Whistler set about preparing his side of it for print. Linley Sambourne, a *Punch* caricaturist and friend of Whistler's, had expressed the prevailing view in a cartoon on December 7, in which a bewigged judge awards a curly locked (with one tuft in white) plaintiff with legs made of penny whistles a single oversized farthing. The caption: "Naughty critic, to use bad language! Silly painter, to go to Law about it!" Henry James, writing for the *Nation*, told its readers in America much the same thing:

> The case had a two days' hearing, and it was a singular and most regrettable exhibition. If it had taken place in some Western American town, it would have been called provincial and barbarous; it would have been cited as an incident of a low civilisation. Beneath the stately towers of Westminster it hardly wore a higher aspect.
>
> A British jury of ordinary tax-payers was appealed to decide whether Mr Whistler's pictures belonged to a high order of art, and what degree of "finish" was required to render a picture satisfactory. The painter's singular canvases were handed about in court, and the counsel for the defence, holding one of them up, called upon the jury to pronounce whether it was an "accurate representation" of Battersea Bridge. Witnesses were summoned on either side to testify to the value of Mr Whistler's productions, and Mr Ruskin had the honour of having his estimate of them substantiated by Mr Frith. . . .

Yet James confessed "to thinking it hard to decide what Mr Whistler ought properly to have done," for he understood the artist's resentment at Ruskin's arrogant language, which "quite transgresses the decencies of criticism."

* Intricacy and evidence of effort were crucial to buyers of art on both sides of the ocean, a German-born painter in America complaining to visiting author Captain Marryat that Americans would only ask how long it took to paint a painting, and then divide the price by the number of days. Years of "invention and years of study go for nothing with these people." And Seymour Haden had bought Whistler's *Thames in Ice* on similar terms.

In short order Whistler had taken his tarnished triumph to the press, in a seventeen-page pamphlet dedicated to Albert Moore, *Whistler v. Ruskin: Art and Art Critics*, which began by insisting that the "*fin mot* and spirit" of the trial had been missed, "or perhaps willingly winked at," by the popular journals. The position of Ruskin as an authority on art remained unscathed, as if the title of Slade Professor rendered his writings impervious to criticism. Whistler would reverse that:

> A life passed among pictures makes not a painter—else the policeman in the National Gallery might assert himself. . . . Let not Mr Ruskin flatter himself that more education makes the difference between himself and the policeman when both stand gazing in the Gallery. . . .
>
> Still, quite alone stands Ruskin, whose writing is art, and whose art is unworthy of his writing. To him and his example do we owe the outrage of proffered assistance from the unscientific— the meddling of the immodest—the intrusion of the garrulous. Art, that for ages has hewn its own history in marble, and written its own comments on canvas, shall it suddenly stand still, and stammer and wait for wisdom from the passer-by?—for guidance from the hand that holds neither brush or chisel? Out upon the shallow conceit! What greater sarcasm can Mr Ruskin pass upon himself than that he preaches to young men what he cannot perform! Why, unsatisfied with his own conscious power, should he choose to become the type of incompetence by talking for forty years of what he has never done!
>
> Let him resign his present professorship, to fill the chair of Ethics at the University. As master of English literature, he has a right to his laurels, while, as the populariser of pictures, he remains the Peter Parley of painting.

Ruskin did resign his chair at Oxford, although the event was unrelated to Whistler's thunderbolt. He had said even before the trial that if he lost he would not go on with his professorship, and kept his promise, declaring that he could not hold a position from which he had "no power of expressing judgement without being taxed for it by British Law." The argument was evasive, since the Law had taxed him for a libel in a periodical he issued, not for one issued *ex cathedra* from his Slade chair. Still, Whistler was happy in the one apparent success of the trial: he had unseated Ruskin. To his almost-*alma mater* he proudly sent a copy

of the pamphlet for its library, inscribed, "From an old cadet whose pride
it is to remember his West Point days." And he never relaxed in his
rancor toward the former Slade Professor. Years later, when an old lady
boasted to him at dinner that she was Ruskin's cousin he reassured her,
"Really, madam, you must not let it distress you too much. We all have
our relations of whom we are ashamed."

Whistler had sent a copy of his *Art and Art Critics* to Tom Taylor of
The Times, inscribing it *"Sans rancune."* But Taylor, who had borne
witness against the author, saw rancor in it anyway, writing to Whistler
that he should not have quoted out of context from an article on
Velasquez "in such a way as to give exactly the opposite impression as to
that which the article, taken as a whole, conveys. . . . God help the
artists if ever the criticism of pictures falls into the hands of painters! It
would be a case of vivisection all round." And Taylor sent a copy to *The
World*, which published it, prompting a malicious Whistler reply in the
same paper: "Why squabble . . . ? You *did* print what I quote, you
know, Tom; and it is surely unimportant what more you have written of
the master. That you should have written anything at all is your crime.
No; shrive your naughty soul, and give up Velasquez, and pass your last
days properly in the Home Office. Set your house in order with the
Government for arrears in time and paper, and leave vengeance to the
Lord, who will forgive my 'garbling' Tom Taylor's writing."

Yet another exchange followed, with Taylor in mock-apology: "I
ought to have remembered that your writing, like painting, belongs to the
region of chaff." Then Whistler, pretending that his pen had already
killed Taylor, answered, "Why my dear old Tom, I never *was* serious with
you, even when you were among us." It was a bizarre business for a man
strangling in debt, but Whistler preferred not thinking about the
inevitable. A year later Taylor died, and Whistler mourned, "I have
hardly a warm personal enemy left."

The little pamphlet, described by *Vanity Fair* as "a discord in black
and white," brought the only profit he made from the Ruskin trial beyond
the single farthing. His hope for a subscription to pay his costs quickly
faded, the extent of sympathy with him suggested by the London
Standard on November 30, 1878:

> Of course, Mr Whistler has costs to pay too, and the amount
> he is to receive from Mr Ruskin (one farthing), even if

economically expended, will hardly go far to satisfy the claims of his legal advisers. But he has only to paint, or, as we believe he expresses it, "knock off," three or four "symphonies" or "harmonies"—or perhaps he might try his hand at a Set of Quadrilles in Peacock Blue?—and a week's labor will set all square.

The subscription started by J. P. Heseltine with a check for £25, which opened an account to receive further contributions at the office of *L'Art*, 134 Bond Street, came to nothing. Whistler sent Heseltine one of his pastels. Not even Howell, with all his new railroad settlement money, had rushed to the cause, although he helped (on his usual commission) to sell the nearly unsaleable Whistlers. Yet he did remind Whistler that since he had been "always a great success in court," had he been called as a witness rather than the painters whose testimony did Whistler little good, he could have won the case. "Yes," said Whistler, "and we should all have been in Newgate."

An irony for Whistler was that while his canvases found no buyers, *Art and Art Critics*, designed by the author and issued by Chatto and Windus, rapidly went into a sixth printing and appeared in shop windows which had never before held so much as a Whistler reproduction. It was his first sustained piece of writing, and in its curious rhetoric evidenced an American long abroad, much of it in places where English was not spoken. To Henry James it was "an off-hand, colloquial style, much besprinkled with French—a style which might be called familiar if one encountered anything like it." And James, who admired Whistler's etchings but not his oils, added, "He writes by no means as well as he paints; but his little diatribe against the critics is suggestive, apart from the force of anything that he specifically urges." What it suggested was the reality of critical impact upon a painter's reputation, regardless of the critic's competence. "The Observatory at Greenwich under the direction of an apothecary," James quoted with seeming approval from Whistler, "the College of Physicians with Tennyson as President, and we know what madness is about! But a school of art with an accomplished littérateur at its head disturbs no one, and is actually what the world receives as rational. . . ." In the end, James felt compelled to at least some sympathy with Whistler:

> Mr Whistler winds up by pronouncing Mr Ruskin, of whose writings he has perused, I suspect, an infinitesimally small

number of pages, "the Peter Parley of Painting." This is very far, as I say from exhausting the question; but it is easy to understand the state of mind of a London artist (to go no further) who skims through the critiques in the local journals. There is no scurrility in saying that these are for the most part almost incredibly weak and unskilled; to turn from one of them to a critical *feuilleton* in one of the Parisian journals is like passing from a primitive to a very high civilisation. Even, however, if the reviews of pictures were very much better, the protest of the producer as against the critic would still have a considerable validity.

Few people will deny that the development of criticism in our day has become inordinate, disproportionate, and that much of what is written under that exalted name is very idle and superficial. . . .

The problem, James concluded, was not special to painters. "The whole artistic fraternity is in the same boat—the painters, the architects, the poets, the novelists, the dramatists, the actors, the musicians, the singers." They were essential to civilized life, while criticism was only "an agreeable luxury." But Whistler was finding it a most disagreeable luxury, as it was about to deprive him of the essentials of a civilized life. He and Maud had just moved into an expensive new home, and the new debts as well as the calling up of his old ones by every tradesman in Chelsea with whom he had dealt for a decade seemed about to make his tenancy brief.

The White House, at the lower end of Tite Street, toward the new Embankment, cost more than it should have. Begun before the Ruskin proceedings in an atmosphere of optimism about his prospects, it originated in Whistler's idea of opening an *atelier* for students. He was sure that there was a younger generation eager for his instruction since every younger generation felt less tradition-bound than its elders. For advice he turned to architect Edward William Godwin. Godwin was a fellow member of the Arts Club, a power in the Royal Institute of British Architects, an outspoken champion of Whistler's work, and an admirer of Orientalia himself, and so unpredictable that he once criticized his own designs in the *Building News*. He also had had a long string of amatory successes, before, during and after his liaison with Ellen Terry which had finally ended by mutual disagreement in November 1875. Two months after discarding her and their three young children, he married his "student," Beatrice Philip, the plump and pretty twenty-one-year-old

daughter of a Scottish sculptor, and immediately after the ceremony went off to dine alone at his club. But when he went to consult Whistler about the new house, "Trixie" came along, and for some months was a fixture at Whistler's studio. Maud was displeased, but the prospect of the "White House" lent her reserves of patience.

The site chosen, a few blocks east of Lindsey Row on Tite Street, overlooked to the rear the grounds of the Royal Chelsea Hospital. Upon it Godwin had a contractor erect a simple three-story house faced in white Portland stone and with a green slate roof. Unlike its neighbors it was unornamented to an extreme, Godwin (like Whistler) preferring a Japanese simplicity to Victorian decoration. To indulge the owner, the door and exterior woodwork were painted a "Peacock blue," while unlike the regularity of windows in other Chelsea houses, the 47-foot studio at the top and other rooms below had windows where function, not form, demanded them. The architectural journals complained about the unorthodoxy and starkness of the house, and the Metropolitan Board of Works refused the builder a license until additional ornamentation in the form of moldings, cornices and parapets were written into the plans. Many were later conveniently ignored, but the changes Whistler himself asked for as work progressed delayed completion and sent up the price.

When the Lindsey Row lease was up on June 25, 1878 the White House had already cost more than the two thousand pounds Whistler had stipulated as his maximum, but it was not ready for occupancy. In September Godwin sent him his accounting, and in October, when the impending trial should have occupied him more than anything else, he was even more busy trying to pay, postpone, or circumvent his debts. Godwin had estimated the White House at £1910. His bill, dated September 9, 1878, itemized £920.5s. in "additions." It was still a bargain, Godwin assured Whistler, for it could be sold, he felt, for £3000, not as a house which was a mere dwelling-place, "but as a house plus a work of art—of the original Whistler & Yours very sincerely E. W. Godwin."

In addition, the contractor presented his own bill for overages, Benjamin Ebenezer Nightingale listing alterations totalling £635. "The Nightingale," Whistler is reported to have said, "hath soured his sweet song." After the trial, when it became obvious that payment would be delayed at best, he went to court and had a judgment against Whistler issued, but the indefatigable Howell managed to forestall the contractor temporarily without using any of his own money. Debts were piling up to such an extent that a visitor to the White House might have thought that

its economy in furnishings was a result of past extravagances; but its bare walls (but for a few Whistler prints), its cane furniture, goldfish in bowls, and flowers in vases were part of the plan, although the postponed papering and carpeting had not been part of Whistler's scheme. Everywhere there were packing cases of unpacked china or old silver, draperies, and vacant frames. The White House looked as if Whistler and Maud were either moving in or out, and that aspect of it remained unchanged during their abbreviated tenancy.

While Whistler entertained his friends stylishly he was not at home to creditors, prudently keeping his door on the chain, but even day-to-day existence both before the trial and after required money. Howell helped by buying the copyright of Henry Graves's mezzotints of the *Carlyle* for £80 and six proofs, and turned out dozens of them, although the plate could not stand so large an edition. Still, because Graves was happy with the sales, at Howell's urging he commissioned Whistler in September 1878 to do a portrait of Disraeli (already then Lord Beaconsfield) which could be reproduced in mezzotint. With £1000 at stake Whistler hurried to Hughenden. "If I sit to anyone, it will be to you, Mr Whistler," the artist reported Disraeli as saying as he left him at the gate. But he may never have seen Disraeli, who sat instead to Millais, and Graves—through Howell—commissioned instead engravings of the *Mother* and of the *Rosa Corder*. When even this income was quickly swallowed up a month before the trial Howell bought an unfinished portrait for £10 and a sealskin coat. Alan Cole in his diary for October 16 recorded, "Poor J. turned up depressed—very hard up, and fearful of getting old."

In an undated letter which appears to have been written at about this time Whistler wrote to his mother in Hastings in the same bleak mood, assuming that she would have heard of his troubles from his brother Willie. He thought of her constantly and wanted to visit her to tell her that he loved her and was "always your fond son," but was waiting until he could arrive with the news that his artistic fortunes had improved. But they had not. "It is a long story, my dear Mother, and one of these days you will know how courageous I have been in these past years of tribulation and discouragement." He saw, hopefully, redemption ahead, but in the process communicated as he seldom had to anyone the extent to which he had always been plagued by the self-doubt beneath the Whistler persona. "I believe," he reassured her and himself, "I shall have established for myself a proud reputation in which you will rejoice with me—not because of the worldly glory alone, but because of the joy you

will see in me as I produce lovely works, one after the other without any more of the old agony of doubt and uncertainty." He was now painting at his peak, he insisted, and soon would "owe no man." In the latter prediction he would be quite right, but for the wrong reasons.

In the social world the Ruskin trial had the impact of making Whistler even more interesting at dinner parties, including those of Christina Stewart Rogerson, who considered a day wasted if it did not terminate in a dinner party or a theatre party. Mrs Rogerson was homely, although always startlingly dressed, but she had a clever tongue and one of the best guest lists in London. Henry James met Whistler there—"a queer but entertaining creature"—who did not know that the pieces anonymously criticizing him in the New York *Nation* came from James's hand. Whistler even invited James to one of his Sunday breakfasts in Chelsea, the novelist writing home that his host was "a queer little Londonized Southerner, and paints abominably. But his breakfasts are easy and pleasant, and he has tomatoes and buckwheat cakes. I found there Sir Coutts and Lady Lindsay (the Grosvenor Gallery people)—who are very sociable (and Sir Coutts the handsomest man in England)."

To some breakfast guests style was no substitute for nutriment, the fashionable Italian landscape painter Martini complaining, after one visit, "If 'e imagines that I will always be content to pay two shillings or 'alf a crown for my cab to go down to the Suburban and come 'ome 'ungry 'e is mistaken. One egg, one toast, no more. One flower in Japanese pot and two goldfish in bowl, dat is not food."

With guests at the White House Whistler was his unruffled self. Art dealer Charles Dowdeswell recalled taking the penny steamer to Chelsea one Saturday afternoon to see the house, which he found "a very strange one":

> The front door opened on to the pavement, and on entering one found oneself at once midway upon a flight of stairs,—I was directed to descend, and found myself in a large terracotta coloured room with white woodwork—very plainly furnished and very unusual. There were two long windows about sixteen feet high on one side of the room, looking upon a little bit of garden. They had small square panes of about a foot square. The furniture consisted of a table and some large low chairs and a couch, covered to the ground in terracotta serge. I had expected to find the furniture very severe in design but to my surprise found no

design at all save what was necessary for comfort. Over the couch was an etching. . . .

After a minute, Whistler came in and after a few remarks about the frame, said "Well, I suppose you'd like to see the studio now you're here?" I said I should, whereupon he invited me to follow him up a very narrow staircase (past the front door again) and after his coolly telling me that "he wouldn't keep me long"—and not to "break my neck up the stairs" (a not altogether needless warning) we came to the studio. It appeared to run the whole length of the house and was the top floor. A large canvas of several lightly draped figures was on the easel. A model with a shawl thrown over her was cutting out paper patterns at a table. I asked him what he had done fresh in etching—and he led me to one end of the studio, which was simply covered with beautiful studies in colored chalk upon brown paper, pinned upon the wall. . . .

The reality beneath the placid White House façade was different. In December 1878 Whistler, sending the letter without a stamp because as usual he had money for none, pressed Theodore Watts to send him a check for three guineas for a *Carlyle* print—"tomorrow—like a good fellow—or better still bring it around yourself." Even small sums were urgently needed, Whistler—according to legend—once taking a hansom and driving about to find someone who would lend him a half-crown to pay for it, the fare mounting meanwhile to half a guinea. Another legend of Whistler's post-trial financial chaos had a Chelsea grocer, suddenly concerned by his best customer's failure to collect the anticipated damages, insisting upon payment of bills which had run up to six hundred pounds. Whistler's alleged reply was in character:

How—what—why—why, of course, you have sent these things—most excellent things—and they have been eaten, you know, by most excellent people. Think what a splendid advertisement! And sometimes, you know, the salads are not quite up to the mark; the fruit, you know, not quite fresh. And if you go into these unseemly discussions about the bill—well, you know, I shall have to go into discussions about all this—and think how it would hurt your reputation with all these extraordinary people. I think the best thing is not to refer to the

past—I'll let it go, and in the future we'll have a weekly account—wiser, you know.

The grocer left without anything being paid on his bill, refusing later to clear the account by accepting two nocturnes, one a rare but nonetheless unsaleable *Valparaiso*. Another story had him return to the White House to see delivery men struggling to carry in a grand piano; and when Whistler emerged to say that he was too busy just then to attend to the matter, the grocer assumed that if Whistler could order a grand piano for the new house, everything must be all right. But it was not. Whistler had to do everything in style. If one were insolvent the degree made no difference.

Yet creditors could not be stayed forever with airs of spurious affluence; nor would they be paid in pictures Whistler could not sell himself. Not even the Arts Club, where E. W. Godwin sat on the Council. His dues were long overdue, and Whistler responded to the dunning with the hope that the presentation of a picture might meet the difficulty. The club secretary spurned the offer with "It is not a *Nocturne in purple* or a *Symphony in blue and grey* that we are after, but an *Arrangement in gold and silver*." It was an *Arrangement* Whistler could no longer produce.

XXI

Bankruptcy

WHISTLER owed the Arts Club £30, the North Metropolitan
Permanent Building Society £91.11.3, his contractor Nightin-
gale another £100, merchants Winsor and Newton £48.19.6,
solicitor Anderson Rose £477.8.9, picture and frame dealer Louis
Herrmann £125.1.4. He also owed his fishmonger £97, his greengrocer
£23, his milkman £22, his lamp-oil man £136, his baker £12, his wine
dealer £126, his photographer £14, his tailor £20, his bootmaker £12, his
shirtmaker £27. He had a second mortgage on the White House. He had
over two thousand pounds in unsecured loans outstanding, £1200 of the
total from the now-dead Tom Winans, whose heirs were pressing for
payment. While writs on the familiar blue legal paper poured in,
Whistler maintained his jaunty façade. But to Anderson Rose he wrote on
January 7, 1879, "I cannot even open the enclosed which I meant to hand
you yesterday directly it came—awfully frightened by the look of it—but I
am working hard and hope to get a little money next week that I may be
able to give you perhaps about £40. Meantime please see if you can keep
them off my back. . . ." Another envelope, obviously a writ, was
forwarded unopened "because it is all important that I should not be
disturbed in the work that I am finishing. . . ." Turning out saleable

work then was almost impossible, and his chief task was to mask his terror while delaying the inevitable as long as possible.

Bailiffs had been briefly in possession of his effects before as a result of an aggrieved creditor. Now he was beset by summons-servers, sheriffs and constables. Bailiffs bore formidable looking papers which attached everything he possessed, and would not leave until satisfied by a down payment found by further borrowing. While Whistler shuddered at each footfall of the postman he busied himself with a curious use of the mails to deceive either his mistress or his creditors. At the same time as he was forwarding, unopened, each bill and writ to Rose, he was sending envelopes to George Lucas in Paris addressed to Maud in London, which he asked Lucas to mail so that it would appear that he was writing from Paris. Maud's letters to him were then also forwarded via Paris. If a faked absence helped prevent writs and summonses from being served, the expedient was at best a delaying action. It may be that the only one really deceived was Lucas. "I am sorry to give you all this trouble my dear Lucas," Whistler wrote on January 7, "but pray help us through this petite affair and all will come right."

If Whistler were concealing an amorous involvement it is difficult to see where he found the time or energy for it amid the legal and financial distractions which surrounded him in the aftermath of the Ruskin verdict. But he did not want to reveal his embarrassing financial plight to Lucas, and may have assumed that his suggestion of a concealed *amour* would have moved a long-time resident of Paris to action more than an impending bankruptcy. "Doubtless you have heard of my Ruskin trial," he finally noted in a letter of January 11 forwarding another letter to Maud, "but the details I must give you myself." And as a thank-you he enclosed a copy of his *Art and Art Critics* pamphlet. Soon the deception ran its course and Whistler and Maud faced the prospect of sharing the White House with bailiffs whom no device could keep for long from attaching or auctioning off everything Whistler owned.

Money had to be made, not merely by Howell's device of selling reproduction rights for a *Carlyle*, but by creating new works at a time when portrait commissions were nonexistent. "You know from Willie," he wrote to his mother, "that I have taken up etching again.* . . . Ultimately I hope to get together sufficient [funds] to go to Venice with, and then I might come back in six weeks with a sum [of saleable work]

* He was doing lithographs for Thomas Way.

large enough to pay off nearly everything and find myself out of difficulty at last!" The rest of the world saw a different Whistler, one who lived by the advice he later gave American sculptor Augustus St Gaudens, who had picked him up in a cab in London. St Gaudens was then exulting over the success of his General Sherman statue, and confessed to Whistler that he couldn't help feeling cocky about it. Whistler grabbed the sculptor's knee to emphasize his point and snapped, "That's the way to feel. If you ever feel otherwise never admit it. Never admit it."

Whistler tried not to admit it. One merchant, arriving with a long-overdue bill, found the painter entertaining friends, and was offered a glass of champagne, but no payment. He objected that a man who could not settle his accounts should not indulge in expensive wines. "Oh, don't let that worry you," Whistler reassured him, "I don't pay for that either."

At the Arts Club, where Whistler's dues were far in arrears, he appeared unembarrassed—and often—and once turned on his most carefree manner to shut off an alcoholic scene by Swinburne. It was late, and most members had gone home, when the poet began screaming furiously from the coat-room, while throwing and trampling upon whatever remained hanging there, "My hat—they've stolen my hat!" His carroty hair flew, his arms windmilled, his eyes blazed—but the waiters carefully stood their distance and no one ventured to help him find his hat, not an easy task in the uproar since after eight all gentlemen's hats would have looked alike. Whistler, on his way out, happened to be wearing his topper, and after contemplating the confusion took it off and approached Swinburne. "Isn't this your hat, old chap?" he asked, fitting it onto the poet's disheveled head. Swinburne accepted it with an unintelligible howl, and rushed out into the darkness. After a discreet pause, Whistler, bareheaded, strode satisfied in the direction of Chelsea.

Amid the financial sleight-of-hand Whistler somehow found the courage of necessity and exhibited that spring at the Grosvenor—the *Rosa Corder* (owned by Howell), the *Connie Gilchrist*, two nocturnes, six etchings, and five drawings in chalk. Once he chose the work he hoped to sell he fled with Maud to Paris and presumed upon Lucas's hospitality. According to one probably apocryphal story a bill collector arriving to dun Whistler discovered the Master painting one evening by the light of two large candles held for him by visiting friends, who cautioned the dun not to disturb the painter at his work, but to wait until an appropriate pause. He waited, not at all unwilling to watch a celebrity at his easel. Soon one of the friends passed a candle to him saying, "Hold this for me a minute." He took it, pleased to be of even so small a service to the great

man. "Hold this for me," said the other friend, and the bill collector found himself holding two candles at arm's length while Whistler painted steadily on. Suddenly he stopped and turned. "Don't move," he said; "Hold those candles just like that. I want to find exactly the same light when I return." Then the Master left the room, while the dun continued to hold the candles until his arms began to ache. "Do you think Mr Whistler will be much longer?" he gasped at last. "I don't know," said one of the visitors. "He said he was going to Paris by the night boat."

When Whistler and Maud returned to London early in May they found the façade crumbled. All the possessions Whistler owned but the works at the Grosvenor were about to be auctioned for debt. Notices were tacked up on hoardings about London and on the White House itself:

CHELSEA

Ebonized & gilt Drawing Room Suite
3-ft. LAC JAPAN CABINET
JAPANESE SCREEN
COTTAGE PIANOFORTE
CARVED OAK DAVENPORT
Turkey pile and Persian Carpets.
VERY VALUABLE COLLECTION OF
NANKIN & OTHER CHINA
Fittings of Dining Room, Japanese Camphorwood Cabinet,
MAHOGANY SET OF DINING TABLES
VALUABLE COLLECTION OF
OIL PAINTINGS
Etchings and Drawings,
ETCHING PLATES, Japanese and Chinese Books,
ORNAMENTAL ITEMS, Japanese Bath
THE APPENDAGES OF BED CHAMBERS
100 OZS. of SILVER PLATED ARTICLES
WHICH WILL BE SOLD BY AUCTION, BY MESSRS.

NEWTON

On the Premises of Mr. WHISTLER,
"THE WHITE HOUSE," TITE STREET, CHELSEA.
On TUESDAY, May 13th, 1879

Whistler complained of the tastelessness of using his name, and new placards were printed removing the offending line; but the sale was scheduled nevertheless. Defiantly then, Whistler ordered the bailiffs to remove some of the posters which rain and wind had quickly loosened and which were flapping in the wind, or paste them down firmly. He wanted neither his sleep nor his esthetic sense disturbed. And to underline his contention that the auction was, however authentic, a huge joke, he sent out invitations to a luncheon at the White House, adding as postscript, "You will know the house by the bills of sale stuck up outside."

Inside he was equally defiant. When a bailiff ("the man") wore his hat in the drawing room Whistler fetched his elongated walking stick from the hall and knocked the offending hat off. Too surprised to be angry, the bailiff became docile after that, and even helped wait at table. One morning he urgently asked to see Whistler, who was still shaving, and Whistler had him sent up, asking as he entered, "Now, then, what do you want?"

"I want my money, sir."

"What money?"

"My possession money, sir."

"What? They haven't given it to you?"

"No, sir, it's you that have to give it to me."

"Oh, the deuce I have! If I could afford to keep you, I would do without you."

"Well, I think it's very hard, sir. I have my own family to keep, and my own rent to pay. What is to become of my wife and family if I don't get my wages?"

"Ha! ha! You must ask those who sent you here to answer that question."

"Really, Mr Whistler, I need the money."

"I'll tell you what I advise you to do. Have a man in yourself."

On May 5 Maud wrote the news to Lucas:

I write because the show is so frightfully afire that Whistler can't. The place is full of men in possession & the sale is fixed for the 13th. You had better come over and buy.

This is only a line to thank you. We will send you more particulars soon. . . .

I am very glad to say [Whistler] is in capital spirits, and all

the papers speak exceedingly well of the pictures in the Grosvenor. I have one or two etchings that I shall have much pleasure in sending you as soon as things are a little smoother. . . .

Maud's news was less than correct. Whistler was in capital spirits except when desperately closeted with Anderson Rose; and no newspapers spoke exceedingly well of Whistler's Grosvenor pictures, none of which were sold. But the important thing was to forestall the auction, although bailiffs were already in possession to prevent removal of any property. On May 7, his alternatives gone, Whistler affixed the necessary £1 stamp to a petition to the London Bankruptcy Court:

> The humble petition of James McNeill Whistler
> of The White House Chelsea Embankment in the
> County of Middlesex, Artist
>
> Showeth:
>
> That your Petitioner alleges that he is unable to pay his debts and is desirous of instituting proceedings for the liquidation of his Affairs by Arrangement or Composition with his Creditors and hereby submits to the jurisdiction of this Court in the matter of such proceedings and that your Petitioner estimates the amount of the debts owing by him to his Creditors at £4,500.
>
> Your Petitioner therefore prays that notices conveying such General Meeting or Meetings of his Creditors as may be necessary to be given by him during the course of such proceedings may be sent in the prescribed manner and that such resolution or resolutions as his Creditors may pass in the course of such proceedings and may require registration may be duly registered by the Registrar of the Court. . . .

At one o'clock on the afternoon of May 8 the petition was filed, and on May 9 the Court issued an injunction restraining all creditors from precipitate action "until after June 9th," and appointing James Waddell, Public Accountant, to act as Receiver and take immediate possession. The action had the effect of installing a court-appointed bailiff at Tite Street, but it also prevented the auction and kept a roof over Whistler's head. Newton's sent the Receiver a bill for fifteen guineas with respect to the canceled sale—not the least of a new set of mandatory expenses for

Whistler, for bankruptcy had its legal costs, including official bailiffs at five shillings a day.

Because no new indebtednesses he incurred could cost him anything while under bankruptcy, Whistler managed somehow to continue entertaining at the White House while the evidences of Newton's withdrawn sale posters still pock-marked the walls. Bailiffs in livery assisted with the serving, both at dinner parties and at the famous Sunday breakfasts, which began at 11:45 and featured Anna Whistler's buckwheat cake recipe, prepared, with running commentary on matters in general, by Whistler himself. As the most public evidence of his indifference to being a declared bankrupt he invited the Member of Parliament for his district, Sir Charles Dilke, to Sunday breakfast on May 25, in a note which observed that his presence would "greatly delight some mutual friends and your rooted constituent." How long Whistler would remain a "rooted constituent" was left unsaid.

Since one of the first tasks of the Receiver was to list and secure all Whistler assets, the first task for Whistler was to evade the bailiffs and retrieve whatever property he could. The stories Whistler told about spiriting paintings past bailiffs drugged with too much drink became legendary, the bailiffs numbering three and even seven, and the potion beer spiked with large quantities of snuff. Whatever the means, he did manage to deposit many of his paintings in safekeeping. Some were already—like the *Mother*—elsewhere as security for unpaid loans. Unquestionably at least one of the committee of examiners overseeing the liquidation of Whistler's assets was surprised, while another may have abetted the deception. For the committee was an unusual collection of creditors, named at a meeting to which all whom Whistler owed anything were invited to attend. To anticipate the June 9 deadline it was held on June 4, at the Inns of Court Hotel, High Holborn, with Sir Thomas Sutherland in the chair, and creditors ranging from Frederick Leyland to Chelsea tradesmen in attendance. To the surprise of most of them, Whistler appeared too, and opened the proceedings unhelpfully with a speech attacking his chief creditors, Leyland being labeled as the "quintessence of plutocratic putrefaction."

The creditors resolved that the indebtednesses of Whistler "be liquidated by arrangement and not in Bankruptcy," that James Waddell be Trustee, and that the "Committee of Inspection" consist of Leyland, Way and the ubiquitous Howell, who managed to demonstrate that he

was one of the largest unsecured creditors. The unsecured indebtedness was placed at £4641.9.3, and assets estimated at £1824.9.4. Whistler added other details in a statement—that he possessed among his assets an I.O.U. from a friend for £36.19.4 which he considered worthless; the Connie Gilchrist *Gold Girl* picture at the Grosvenor which he valued immodestly at £500; his *Mother* portrait in the possession of the engraver Josey, which he also valued at £500; and two unfinished pictures at the home of his brother Willie, to which he was unable to give any value.

To check on the actual stock of Whistler work in the studio the examining trio went to Tite Street, and discovered three pictures the artist had not mentioned. In Whistler's view, neither his own belligerence nor his arrogance had done him in: it had all started—and ended—with Leyland, his chief creditor. And the three canvases all caricatured Leyland, who had actually conducted himself with great patience under conditions which would have sent most men seeking vengeance. The three pictures, in which Leyland's frilled shirts were suggested, tried his patience even more. One large one (73½ × 55 inches) entitled *The "Gold Scab": Eruption in Frilthy Lucre,* showed the shipowner as a repulsive reptilian peacock covered with gold coins and sitting on the White House, which he is using as a bench from which to play the piano. The others were equally unfair and bitter. *The Loves of the Lobsters—An Arrangement in Rats* showed two red lobsters amid a black chaos, about which a lady was reputed to have told Whistler when he had a group of friends in to see the three pictures on May 13, "I wonder you did not paint the lobsters making love before they were boiled." "Oh, I never thought of that," said Whistler. The third, *Mount Ararat,* showed Noah's Ark on a hill, with little frilled figures all about. The venomous *Ararat* and *Lobsters* pictures have disappeared, but the *Gold Scab* remains as an example of the perversion of Whistler's talents at the most paranoiac period of his life.

In a way the bankruptcy was a healthy occurrence for him. He could now stop running away from his self-created catastrophes and begin, in his mid-forties, to rebuild his life. With London likely to be a humiliating place, Whistler revived the idea of producing for the Fine Art Society a series of plates of Venice on the model of his successful Thames etchings. When Ernest Brown of the Fine Art Society, which had reproduced four London plates of *Old Battersea Bridge* vintage that year, had visited the White House on business, Whistler took him to the high window of the

studio and showed him the river and the view of Battersea beyond. Then, putting his hand on Brown's shoulder he said, "I am afraid I am going to lose my house!" The strain of keeping the mask up all the time was becoming too much.

A commission for twelve plates to be accomplished during a three-month stay in Venice was worked out, complete to an advance to cover expenses, and Whistler planned happily to leave several days before the sale of the White House. It was an ironic business arrangement. Whistler's sponsor, the Fine Art Society—the mechanism by which he was being extricated from financial and artistic embarrassment—had been treasurer for the committee to pay Ruskin's share of the court costs which had done Whistler in.

From the Receiver he had permission to destroy all unfinished work; but one canvas he returned to and completed, a small portrait of Mrs Lewis Jarvis. It meant more traveling funds. Later, when Whistler's possessions were sold, Jarvis acquired another Whistler—the ornamental Japanese bath.

"Dunn met Jimmy in the street yesterday evening," Rossetti wrote Watts-Dunton on August 29. "He was very spry indeed and announced himself to be in full work." Full work meant plans for Venice and the half-hearted destruction of the copperplates and canvases which by then were back at Tite Street, some unsold, most unfinished. Plates were scratched, pictures smeared with glue or black, or slashed. But many abandoned canvases, rolled up tidily, were left as they were. For his final Sunday breakfast Whistler invited friends to meet Lillie Langtry, daughter of the Dean of the Channel Isle of Jersey, who at twenty-five was the reigning society beauty in London and newest mistress of the Prince of Wales. To Whistler the "Jersey Lily" was the most beautiful woman he had ever seen, perhaps the one thing on which he and Millais agreed, and in 1882 he did an *Arrangement in Yellow* portrait of her. The last breakfast ushered Whistler out of the White House with a flourish of notables. As usual he superintended the buckwheat cakes at the corner fireplace, and drolly ordered waiters about—an unusual number of waiters, and so unusually clumsy that Whistler often jumped up and carried out his orders himself. When everyone had left but George and Phoebe Smalley he accompanied them to the door. It was a clear Sunday afternoon, and the Thames sparkled to the south. "Did you notice my fine waiters?" he asked. "I should like to walk down the Embankment with you, but I must go back. These gentlemen, as you see, will not let me out of their sight."

The waiters, of course, were the ubiquitous bailiffs, out in force because of the impending sale of the White House.

Maud had already been packed off on the Newhaven & Dieppe to Paris. Whistler remained for further farewells. At one seemingly American dinner party early in September, he encountered the visiting Mark Twain as well as Henry James, and Twain was sufficiently impressed with Whistler's talk of pictures to ask his own London publisher, Andrew Chatto, to secure a Whistler etching for a friend of his wife's, Clara Spaulding. But such sales were too little and too late to do Whistler any good.

The final fling was the most ironic. George Boughton, who had been at the Arts Club with Whistler when Ruskin's review arrived, and catastrophically for Whistler had conceived it as a libel, was giving a housewarming costume party at his new Norman Shaw-designed house on Campden Hill on the very night that was to be, because of the outcome of the libel trial, Whistler's last in the White House. Each guest on entering wrote his or her name in a large book with the character each represented opposite. Artistic London turned out in splendor, one guest dressed entirely in black signing himself as Whistler and his character that of Hamlet. But that night he was no melancholy Dane. He drank to the hostess and to—and with—the guests, and was in his merriest mood. Then he went home, where his young son John Charles was waiting. From across Tite Street Carlo Pellegrini looked out his window and watched the pair put a ladder up against the wall of the White House. While John held a candle, Whistler climbed up high enough to paint an inscription on the lintel above the front door: "Except the Lord build the house, they labour in vain that build it. E. W. Godwin, F.S.A., built this one." Then Whistler bid John goodbye and took the boat train to France.

On September 18 the White House and most of its effects were offered at auction. Harry Quilter, the *Times*'s art critic and witness for Ruskin against Whistler, bought the property for £2700. The furniture and art works, in several sales over later months, brought only £449.10.5, the *Gold Girl* hopefully valued at £500 itself going for £63 to Whistler's old friend of Coast Survey days Henry Labouchere, now a London journalist and politician. The other of the two pictures listed by Whistler as his main assets—the *Mother*—had already been claimed for a debt of £454.7.5. It was the only way the artist could protect his painting. In Howell's slippery hands it was a risk, but Whistler had only the alternative of public sale. For a guinea, Thomas Way purchased a hoard

of unfinished canvases which were only rubbish to the auctioneer. Receiver's costs amounted to more than £300, including 186 working days of paid men in possession. Whatever it was worth to Whistler in Venice, he was a discharged debtor.

All that he would be able to do to get even with Ruskin from the distance of Italy was to keep his tongue barbed. He had been dispossessed of his house and reputation, but not of his wit. There was an English artist, John Wharlton Bunney, who survived in Venice by painting views of churches. "Whenever I see Bunney painting in St. Mark's," Whistler would soon be telling friends, "I want to go up and chalk on his back, 'I AM BLIND.'" A Ruskin disciple, Bunney had done illustrations for Ruskin's *The Stones of Venice*.

XXII

Venice

TWO days before the sale of the White House Whistler joined
Maud in Paris, carrying with him little more than several changes
of clothes, a box of copperplates and etching equipment provided
by Thomas Way, and a supply of his favorite brown paper, also furnished
by the faithful printer. At eight on the evening of the eighteenth Lucas
joined Maud to see him off on the Venice train. He would find a place to
stay, and send for her.

At first Whistler settled in a cheap room at the once-splendid Palazzo
Rezzonico on the Grand Canal, wandered about in search of sketching
opportunities, paid a visit to the American consul John Harris, and lived
cheaply on polenta, macaroni, and coffee. The Palazzo was too gloomy a
pile to hold him long. He quickly moved to a room above a shop on the
west side of the Canal, near the Church of the Frari. Then he sent for
Maud, who was escorted to Lyon Station by Lucas on October 18, a
month after Whistler had left the same platform. As far as Dijon she
shared a seat with a priest who spoke English, then rode all night
through the mountains to Turin through cold weather and heavy snow,
for neither of which she was prepared. At Venice Whistler met her. To
Lucas she wrote, with relief, "Oh isn't this a lovely place, and such a
lovely day too."

Whistler was slow getting to work, although he was supposed to accomplish his assignment in three months. While appearing to do little, he was absorbing the unfamiliar, decaying surroundings, the stones of Venice celebrated in a book he probably never read but which had made the critical reputation of his arch-enemy Ruskin. By the time the weather had grown blustery and raw—the coldest winter, he was told, in thirty years—he and Maud were settled into modest housekeeping, with an old newspaper for a tablecloth, and their cooking done sometimes over a spirit lamp in their own room, otherwise by a landlady whom Whistler taught to prepare *polenta à l'Americaine,* over which he poured a thick, sweet syrup, and washed down with thin wine at sixpence a quart. On etching reconnaissances he worked with half-numbed fingers on cold copperplates, then, often with Maud, warmed his hands over cups of coffee at Florian's, the Orientale, or the Quadri, regaling new acquaintances with descriptions of bailiffs and bill collectors being offered champagne at the White House. To Nellie Whistler, Willie's wife, he wrote of the "terribly provoking weather against which I can make very little headway" yet held out hope for "a nice little haul of guineas" on his return. His mother sent him woollen gloves. His clothes began to give out, and when the familiar soft felt hat had developed a rent and was repaired, he ripped the stitches out, quoting the proverb that "a darn is premeditated poverty, but a tear is the accident of a moment."

From Whistler's activities in his first months in Venice one would not have known that it was the city of the Brownings, of George Eliot, of Franz Liszt, of Ouida, of the young John Sargent, of others famous in the arts who could be seen almost daily in the piazzas and cafés. He was working out his humiliation alone, but for a reminder that winter from the Fine Art Society in Bond Street that the etchings commissioned were overdue. First he decided not to respond. Then he wrote indignantly to ask for more money.

Unrecovered from the blows to his ego caused by the public spectacle of his bankruptcy, Whistler showed only flashes of the old self, although he eventually overcompensated in ways which made the pretrial peacock seem a model of humility. At the beginning in Venice, he leaned heavily upon Maud. Once, when he was biting a plate on top of a bureau in his cramped quarters, the acid began to run off, but instead of mopping it up or rescuing his shirts and socks from the drawers he stood helplessly still and shouted, "Maud! Maud!" She was not in at the time, although fortunately a new friend invited to watch the process came to the rescue,

snatching away the contents of the bureau and pouring water onto the acid which had run onto the floor.

To Nellie, Whistler wrote imploring her to find out what was happening to his auctioned canvases, and when someone sent him a cutting from the *Daily News* regretting that Whistler should be etching in Venice when there was a Christmas Day fog so worthy of him at home, he wrote frankly of his feelings to Deborah Haden. "There is but one thing that consoles me in my numbed state here," he explained, "and that is the total darkness you seem to live in over there. Of course if things were as they ought to be . . . I should be *resting* happily in the only city in the world fit to live in, instead of struggling in a sort of Opera Comique country when the audience are absent and the season is over! I said the other night to the horror of the few listeners at the Consul's, where . . . I fancy I am a trial, that an artist's only possible virtue is idleness—and there are so few who are gifted with it. . . . You see so many flooding the place with their vicious work." Like fellow-American Henry James he preferred London with all its fogs and faults to any other place. It was a difficult winter, and he was homesick. He did not like the Italian language; and he claimed that the most humble London cab suited him better than the most splendid gondola. And although in London he never would have dreamed of consulting the American Minister, as he had done as a young man in Paris, while in Venice he regularly sought out the solace of the American flag.

Whistler met many of the large American colony, but to visit the most respectable he left Maud at home. For her it reinforced the desire to be referred to as Mrs Whistler, and she even began signing her letters as Maud Whistler, beginning a rumor that Whistler had indeed married her quietly in a Venetian church. But despite their closeness in sharing privation in the same way as they had shared illusory luxury, there was no marriage, and whatever Maud called herself, Whistler carefully continued to allude to her as *Madame,* and let the listener interpret its meaning. More frail and wan than ever, and more alone than ever before, Madame never spent a social evening with the Consul and "Mother" Harris, where Whistler scintillated. But, as poor as Whistler was, there were public places to which he could take Maud, in particular the national entertainment. Opera at the Fenice and the Goldoni was 2 *lire* for a stall and 4 *lire* for a box at a time when the *lire* was 25 to £1.

One day early in 1880, as the weather warmed, a group of young American painters leaving the Academy of Fine Arts saw the Assistant

Consul and a small, wiry stranger in a wide-brimmed brown hat coming down the steps of the iron bridge which crossed the Grand Canal. "These are all American boys," Grist pointed out, while the canal breezes fluttered Whistler's long black ribbon tie about his eyeglass. "Boys," he said with a wave of his hand as they approached, "let me introduce you to Mr Whistler."

"Whistler is charmed," was the greeting to each one as he shook hands. What instinct prompted him to the overdramatized—or condescending—third-person he never explained, but it was as if the exiled Master were seeking the comfort of homage, whether or not the others accepted it only as eccentricity.

When Otto Bacher's turn came Grist said, "Mr Whistler, this is the boy who etches."

"Ah, indeed! Whistler is quite charmed, and will be glad to see your work."

The "boys" were all under the wing of the uncouth, goodnatured, Frank Duveneck, a self-taught artist who had risen from decorating altars in Cincinnati churches to prize-winning at the Academy in Munich, where he had acquired a flock of younger pupils. But in Germany he had met a plain, New England-born perennial art student two years older than he was, Elizabeth Boott, an expatriate heiress and old friend of Henry James, who induced the smitten Duveneck to return with her to Florence. Thus the "boys" continued their education in Florence, and then Venice, with Duveneck finding that dividing his time between Lizzie Boott and his students left him with little time for the students, half a dozen of whom were living in the Casa Jankovitz, on the Riva, and the others scattered about the area. For Whistler it was an opportunity to have his own instant and informal *atelier,* a realization he came to gradually while the students themselves were independently arriving at the same conclusion about the curious stranger.

Bacher was a particularly important find for Whistler, for he had a small press and German ink superior to the local product. The Master promised to visit. A month later, on a rainy Sunday, he did, and approved, too, of the view from their windows. Soon he came to sketch from them, doing both etchings and pastels, and then decided to move there himself, shipping .his goods in a gondola one morning and taking a furnished room for himself and Maud which had two windows looking out toward the Doge's Palace and the Salute. Below was the shop of Signor Jankovitz, despite his name an Italian mender of watches and compasses.

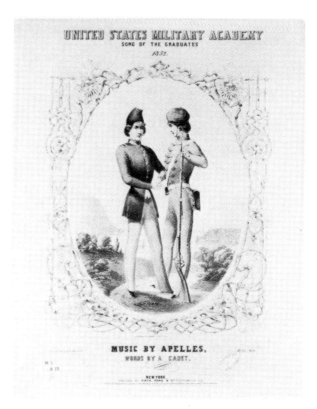

1. Lithograph of the cover of the sheet music for the United States Military Academy "Song of the Graduates," designed by "Cadet Whistler" in 1852. Markings at the bottom are identifying stamps from the Smithsonian Institution. *Courtesy of the Library of Congress.*

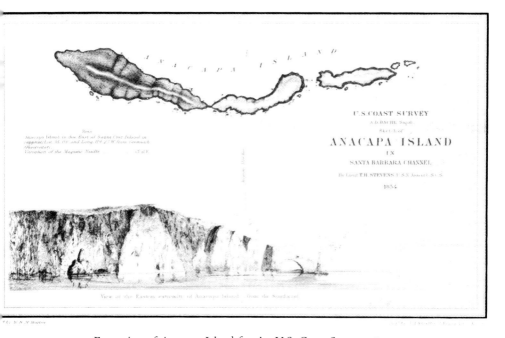

2. Engraving of Anacapa Island for the U.S. Coast Survey, 1854. Signed by "J. A. Whistler, J. Young & C. A. Knight." *Courtesy of the Library of Congress.*

3. *"Fumette"* (Whistler's first
mistress in Paris). Etching, 1859.
*Courtesy Prints Division,
New York Public Library,
Samuel P. Avery Collection.*

4. "Fantin abed, pursuing his studies
with difficulty—14° [C.] cold."
Drawing, dated December 20, 1859.
*Cabinet des Dessins,
Musée du Louvre, Paris.*

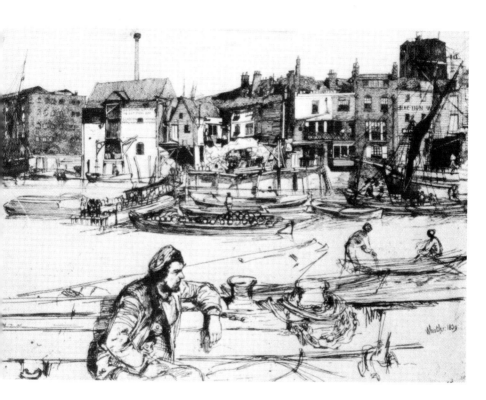

5. *Black Lion Wharf*, third state of
the etching, 1859. From *The
Thames Set. Courtesy of the Library
of Congress.*

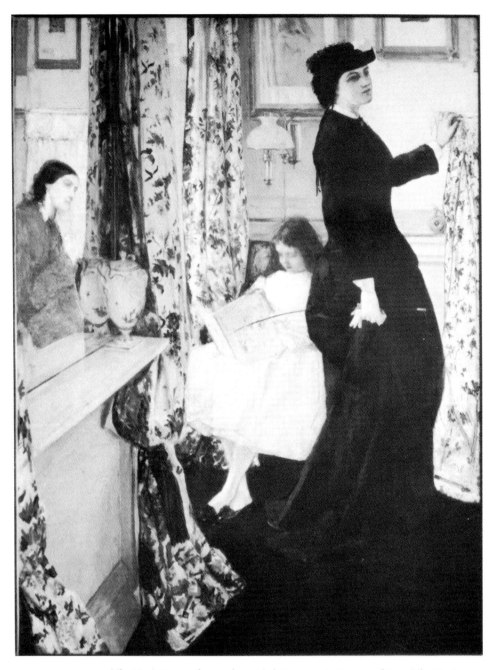

6. *The Music Room*, afterwards retitled *Harmony in Green and Rose: The Music Room*. Oil on canvas, 37⅝ x 27⅞″, 1860. First exhibited 1892 at the Goupil Gallery, after being the property of George Whistler and of Mrs Reveillon, his daughter, who had removed the picture to St Petersburg. The models from right to left are Deborah Haden, Annie Haden, and Miss Boot. *Courtesy of the Smithsonian Institution, Freer Gallery of Art, Washington, D.C.*

7. *The White Girl*. (Afterwards retitled *Symphony in White, No. 1: The White Girl.*) Oil on canvas, 84½ x 42½″. Dated 1862. *Courtesy of the National Gallery of Art, Washington, D.C. (Harris Whittemore Collection).* First exhibited at the Salon des Refusés, 1863. The model is Jo.

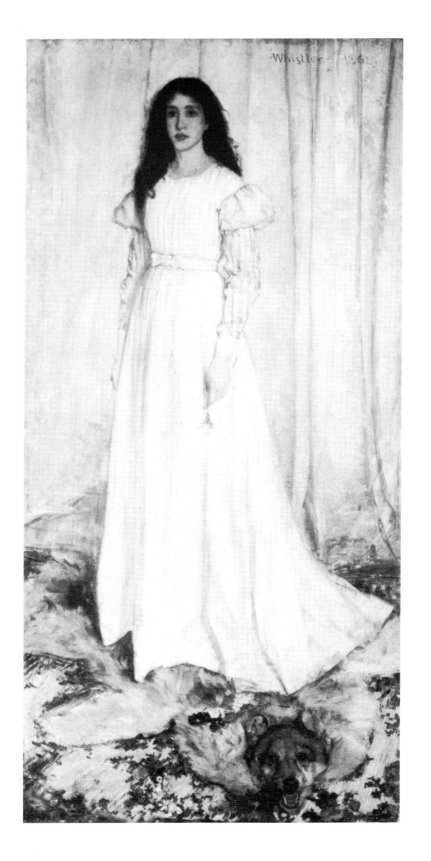

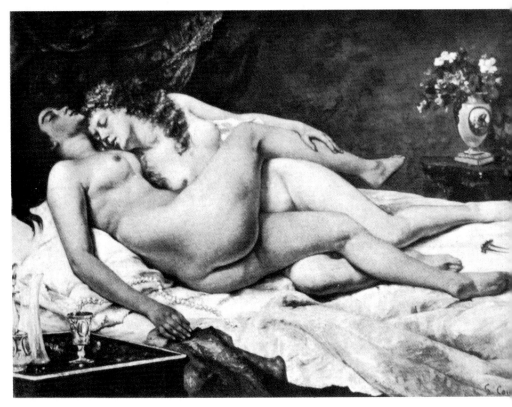

8. Gustave Courbet: *Le Sommeil (Paresse et Luxure)*. Oil on canvas, 1866. *Courtesy the Musée du Petit Palais, Paris*. The upper model is Jo.

9. *Nocturne in Blue and Gold, Valparaiso*. Oil on canvas, dated 1866. *Courtesy of the Smithsonian Institution, Freer Gallery of Art, Washington, D.C.*

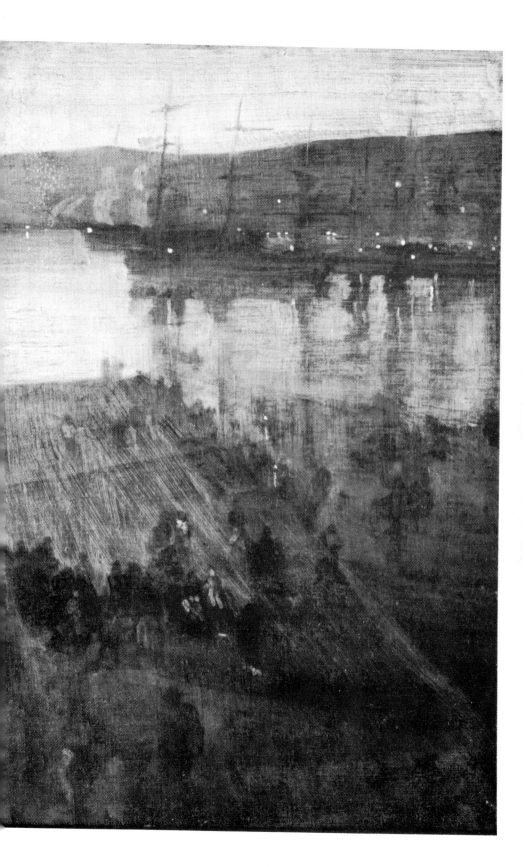

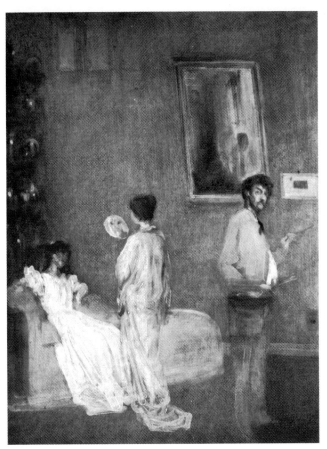

10. *The Artist in His Studio.*
Oil on panel, late 1860s.
$24\frac{3}{4}$ x $18\frac{3}{4}$". *Courtesy of the Art
Institute of Chicago (Friends of
American Art Collection).*

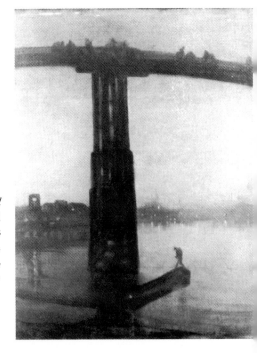

11. *Nocturne in Blue and Gold: Old
Battersea Bridge* (1872–1875). Oil
on canvas. One of the notorious
exhibits in the Ruskin trial.
*Courtesy of the Tate Gallery,
London.*

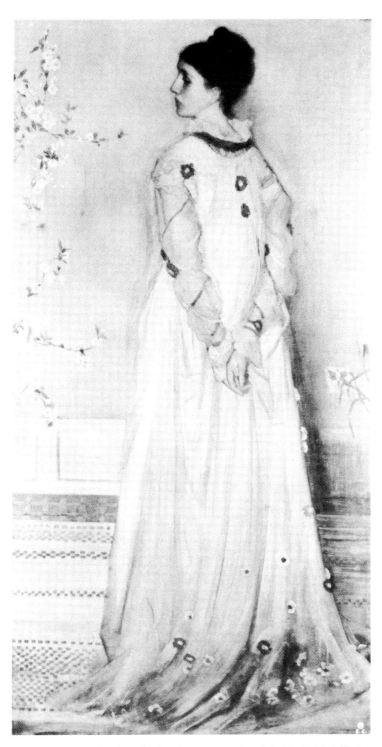

12. *Mrs Frederick Leyland.* Oil on canvas. *Copyright The Frick Collection.*
First exhibited as *Symphony in Flesh Colour and Pink* at
Henry Graves's Flemish Gallery, London, 1874.

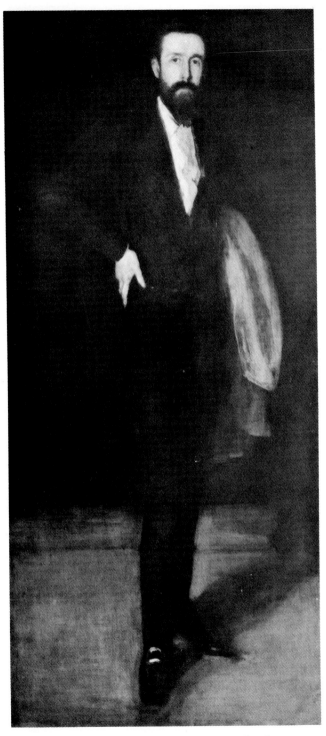

13. *Mr Frederick Leyland.* Oil on canvas. First exhibited as
Arrangement in Black at Henry Graves's Flemish Gallery, London,
1874. *Courtesy of the Smithsonian Institution, Freer Gallery of Art,
Washington, D.C.*

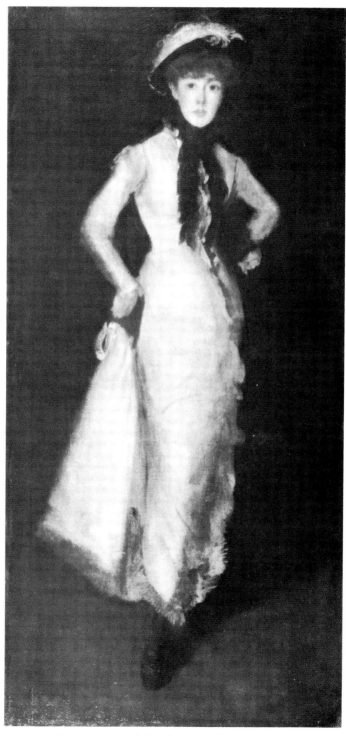

14. *Arrangement in Black and White: The Young American.* Oil on
canvas. First exhibited at the Grosvenor Gallery, 1878. The model,
despite the curious title, is Maud. *Courtesy of the Smithsonian
Institution, Freer Gallery of Art, Washington, D.C.*

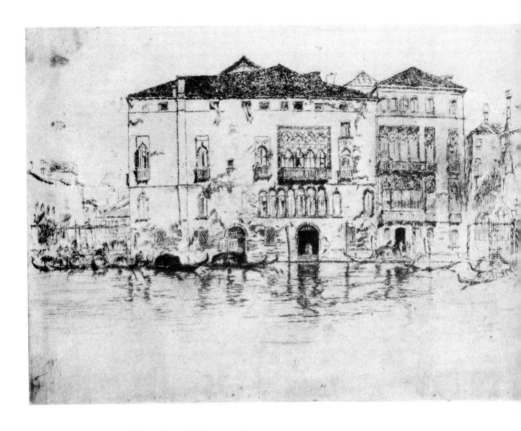

15. *The Palaces*, third state of
the etching, 1880. From
the *First Venice Set. Courtesy
of the Library of Congress.*

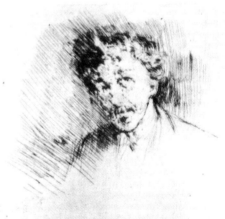

16. *Self-Portrait with White
Lock.* Etching. *Courtesy of the
Library of Congress.*

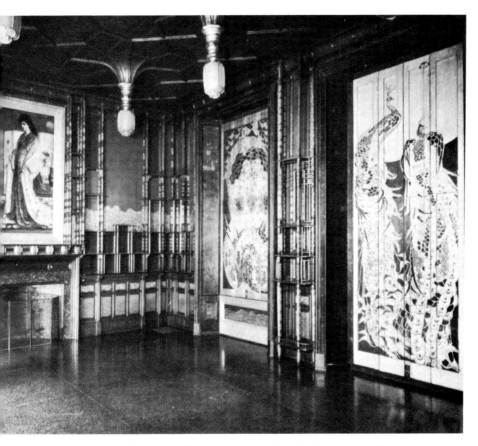

17. *The Peacock Room*, 1876–1877, showing Peacock panels and
La Princesse du Pays de la Porcelaine (1863–1864), as reconstructed in the
Freer Gallery. *Courtesy of the Smithsonian Institution,
Freer Gallery of Art, Washington, D.C.*

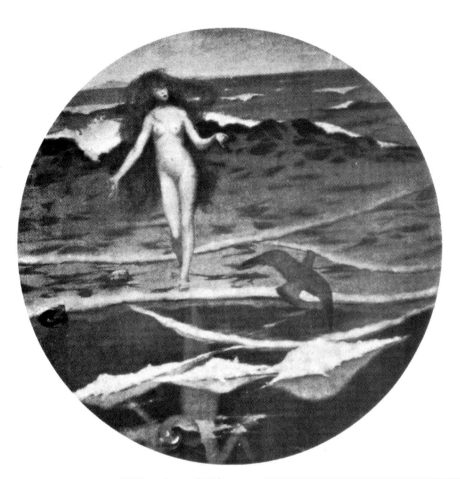

18. William Stott of Oldham:
Venus Rising from the Sea.
Oil on canvas. Exhibited at the
Royal Society of British Artists,
1887. Its present location
is unknown to the author.
The model is Maud.

19. *Maud Reading in Bed.* Pen and
watercolor on paper, $9\frac{7}{8}$ x $6\frac{7}{8}''$.
Probably drawn in France at the
home of George Lucas, 1887.
*Courtesy The Walters Art Gallery,
Baltimore, Maryland.*

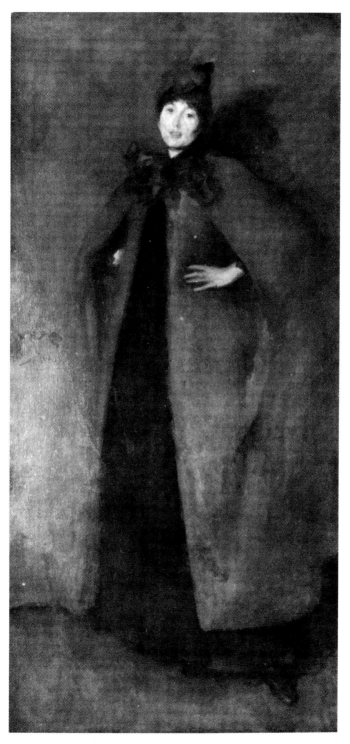

20. *Harmony in Red-Lamplight (Mrs Whistler).* Oil on canvas.
A portrait of "Trixie" painted in the mid-1880s before the marriage.
Courtesy of the University of Glasgow, Birnie Philip Bequest.

21. *By the Balcony.* Etching, 1896. The model is the dying Trixie
(Mrs Whistler), in her room at the Savoy, overlooking Westminster
Bridge and the Thames. *Courtesy of the Smithsonian Institution,
Freer Gallery of Art, Washington, D.C.*

For decoration (the "boys" had purchased Venetian rugs, draperies, and antiquities to embellish their rooms) Whistler brought two photographs, one of the coin-embellished peacock panel in Leyland's house, the other a photograph of himself with, said Bacher, "a most disagreeable sneer upon his face." The Master liked it, and told "Duveneck's boys" that it was "the way Whistler wants his enemies to see him." The bellicose new Whistler lived always in the shadow of his enemies, and his long Japanese bamboo walking stick, often used to punctuate a sentence, seemed part of his personality. One evening he found a scorpion in his room, and impaled it on his etching needle. The insect struck out helplessly in all directions, now and then hitting the handle of the needle with his barbed tail. "Look at the beggar now!" Whistler exclaimed to Bacher. "See him strike? Isn't he fine? Look at him! Look at him now! That's right—that's the way! Hit hard! And do you see the poison that comes out when he strikes? Isn't he superb?" He saw himself in the creature, and added the sting to his butterfly signature, especially when he wanted to emphasize a point. It was part of the changed Whistler, who realized that he had to get back to London but could only do so with an achievement which would both defy and silence his critics. With the months passing, every frustration was intolerable. As he kept telling Bacher and the others, "Whistler must get back to London as Whistler should. . . . Whistler must get back to the world again. You know Whistler can't remain out of it so long."

With the weather improving, Venice was the perfect subject, and he was especially pleased with the colorful shorthand of his pastels, although etching had brought him there. When he attempted a living subject he had less luck, a gondolier he was painting falling ill and being bled so profusely by local physicians that, Whistler's milk punch failing, he was too weak to sit again. But relieving his depression over the unfinished gondolier, Whistler wrote Nellie, were his pastels. "Just think, fifty—complete beauties—and something so new in art that everybody's mouth will I feel pretty sure water."

On good days Whistler went out with Cavaldoro, a gondolier whose services he had hired by the month, in search of the Venice tourists could not purchase on their postcards, deep shadowed doorways, bright squares and half-hidden courtyards, strange architectural or water effects, secluded shops and canals. On one trip early in the spring he confronted the past he was there to exorcise. He had heard from London that the despised Harry Quilter had completed the poetic justice of Whistler's punishment

for *hubris* by purchasing the White House. Suddenly, as Cavaldoro's gondola slowed to stop at an ornate doorway his employer had been etching, Whistler found the view blocked by another Englishman in another gondola. It was Harry Quilter.

> I had been drawing for about five days in one of the back canals a specially beautiful doorway, when one morning I heard a sort of war-whoop, and there was Whistler, in a gondola close by, shouting out, as nearly as I can remember, "Hi! hi! What, what! Here, I say, you've got *my* doorway." "Your doorway? Confound your doorway!" I replied. "It's my doorway. I've been here for the last week." "I don't care a straw. I found it out first. *I* got that grating put up." "Very much obliged to you, I'm sure; it's very nice. It was very good of you." And so for a few minutes we wrangled; but, seeing that the canal was very narrow, and that there was no room for two gondolas to be moored in front of the chosen spot, mine being already tied up exactly opposite, I asked him if he would not come and work in my gondola. He did so; and, I am bound to say, turned the tables on me cleverly. For, pretending not to know who I was, he described me to myself, and recounted the iniquities of the art-critic of the *Times*, one 'Arry Quilter—he always wrote my name 'Arry in his letters—and this at great length and with much gusto. So he sat and etched and chattered, and to the best of my remembrance I enjoyed the situation, and certainly bore him no ill will.

Because of what Quilter represented, Whistler was etching in Venice rather than painting in London, borrowing small sums of *lire* from Duveneck's boys and doing an occasional drypoint (pulled on Otto Bacher's press) to raise a few pounds quietly in London through an intermediary. With Bacher's help he printed his proofs, checking to see whether his weblike scratches retained sufficient ink; but when he wanted a large edition he went to an old man who kept a shop on a back street where his even older sister sold small madonnas. He had a primitive wooden press upon which Whistler insisted he used Bacher's imported ink, and while they operated the ancient press, Whistler doing most of the work, the elderly pair told stories of Napoleon's occupation of Venice, which they remembered. The inking was as important as the etching, for by incompletely wiping away the ink he secured variations in tonal effects which made each impression unique unto itself. His intentions would be

realized under better technical conditions in London, but the proofs he pulled in Venice were experiments in de-mechanizing the art of etching.

In order to find the kind of old Venetian paper which took the ink well he wandered through musty second-hand bookshops seeking volumes with blank leaves which, he said, would cost him a shilling a sheet in London; but before he had invested very much in this peculiar library Bacher located a bundle of old watermarked paper outside a junk shop, and paid a franc for it. Whistler was impressed, going upstairs to his room in the Casa and returning with a proof of one of his Venice etchings.

"Now, Bacher," he said, "I will trade you this very rare Whistler proof for your paper. Just look at the proof and see how beautiful it is. There were only six printed from that plate, and some day it will bring you a handsome price." Bacher examined the impression of Venice and its harbor and quickly agreed. It sufficed for Whistler's needs for a while, and although some sheets were written on in Italian script he used them anyway, happy with the rich mellow color of the paper.

When dissatisfied after pulling a proof on Bacher's own press he would try to improve the plate, in the case of *The Traghetto*, one of his finest etchings, spoiling it. "Whistler has decided to do *The Traghetto* all over again," he would announce, then explaining the procedure as if to a class. Duveneck's boys were often his informal *atelier,* and with them he was rejuvenated. He drank with them, painted with them, argued with them, even swam with them. But he was always "Whistler." After one dive from a gondola he remained out of sight so long that they were anxious about him, when suddenly his voice was heard from a location far from the trajectory of his plunge. "Was that a good dive? Were my knees all right? They didn't hit the water first this time, did they? It was a good dive, wasn't it? Not so high, perhaps, as it should be, but Whistler will do that by and by."

The mask seldom slipped. The public Whistler, however worn his clothes became in Venice, was carefully groomed from his curled white lock and polished monocle to his patent leather shoes, as he would take the "boys" in tow to show them how he would set up a scene or memorize it for drawing later. One day several of them called on him at work, and he invited them in. He was dressed in working clothes, and his hair showed no sign of comb or curling iron. And the monocle on the familiar thin black cord had been replaced by a pair of heavy iron-rimmed spectacles wrapped with cloth where they rested on his nose. One visitor,

finally finding his voice, wondered what had happened—"You seem so different."

"Oh," said Whistler, "I leave all gimracks outside the door."

He taught Duveneck's students a veritable volume of his aphorisms. "A tree should not be painted. . . . You cannot paint the sun. You cannot paint the moon. . . . Paint should not be applied thick. It should be like breath on the surface of a pane of glass. . . . A picture is finished when all trace of the means used to bring about the end has disappeared. . . ." His favorite themes were the old Venetian painters, and the simplicity of Canaletto's etchings, with their long, trembling lines, appealed to him most. "Canaletto could paint a white building against a white cloud. That was enough to make any man great." Bacher owned a Whistler *Thames Set* etching, *Boats at Mooring—Evening—Billingsgate*, which he had on the wall in his Casa Jankovitz room, and when the Master saw it his reaction was, "Whistler will do better with his Venetian plates." Confessing that he could not make out some of the details, Bacher asked about some of them, and Whistler pointed out the minute aspects that could only be verified with a magnifying glass, including a clock tower with every stone carefully defined. "Can't you see that he is smoking a pipe as he leans against the tall pile? The piles come up there quite well, don't they? . . . They prepare the eye to follow well the masts that come next. . . . See how sharp the ring is that is attached to the chain!"

In Venice, a generation older if not wiser, he had altered his etching strategy. Later he explained to Mortimer Menpes and Walter Sickert how, when he was drawing a bridge over a canal, the secret of drawing came to him as in a revelation. "I began first of all by seizing upon the chief point of interest—perhaps it might have been the extreme distance—the little palaces and shipping beneath the bridge. If so, I would begin drawing that distance in elaborately, and then would expand from it until I came to the bridge, which I would draw in one broad sweep. If by chance I did not see the whole bridge, I would not put it in. In this way, the picture must necessarily be a perfect thing from start to finish. Even if one were to be arrested in the middle of it, it would still be a fine and complete picture." But there was more to his Venetian technique than that. Just as he had simplified his painting through the art of omission, now—in James Laver's description—"he set about the simplification of his work on the copper. An interest in luminous shadow replaced his earlier interest in form, and instead of etching the roofs of Venice tile by tile, as he had

etched the warehouses of the lower Thames twenty years before, he lavished all his skill on dark doorways through which hardly anything could be seen, corners of unimportant canals barely indicated with a scratch of the needle, suggestions of shimmering light on water, and phantom outlines of churches and palaces seen in the dim light across the lagoons."

It was not that Whistler eschewed detail but that he now only sampled it, a few carefully drawn tile-like stones suggesting the way the Riva was paved, while he impressionistically allowed his scratches and hatchings on the plate to suggest objects as well as light and darkness through form and contrast. Still the older Thames style had not entirely vanished, and some Venice etchings—such as the opulent plate of the Renaissance doorway he had disputed with 'Arry Quilter—lovingly communicated in the weblike lines of the carving and fretwork the magic of past glory. Often delicate suggestion required more painstaking work than did accuracy and repetition, Whistler after one attempt to make a few lines represent a figure shouting excitedly over his success, "Look at this figure! See how well he stands?" It was the impressionistic technique of the nocturnes transplanted from London and oils to Venice and copper.

Whistler's insistence on linear economy in the Venice etchings emerged vividly when Sidney Starr happened to mention the published diaries of Benjamin Robert Haydon, who, debt-ridden and frustrated, had committed suicide in 1846 after his huge colorful canvases had failed to win him election to the Royal Academy. Whistler looked up from the copperplate of *The Traghetto*, which he was retouching with drypoint, and commented, cruelly (or perhaps in ignorance that Haydon eschewed bitumen, and berated artists who did), "Yes, Haydon, it seems, went into his studio, locked the door, and before beginning to work, prayed God to enable him to paint for the glory of England. Then, seizing a large brush, full of bitumen, he attacked his huge canvas, and of course—God fled."

The nocturnes themselves were not abandoned in Venice, and several survive which evoke the Lagoon and canals as Whistler had painted the harbor at Valparaiso or the Thames at Battersea, with hazy outlines of gondolas looming in the foreground through the blue-green dusk, lanterns flickering from ships and shore, and masts, roofs and campaniles dreamy and wraithlike against the darkening horizon. Memory-paintings, they were done from Whistler's room. He carried his pastels and his plates in the aged gondola, but rarely his oils. Usually he rose early and set out along the canals with Cavaldoro, his copperplates safely stowed

between the pages of an old book (once he removed the blank leaves of fine old paper for which he purchased it) and his pastel chalks in two boxes, one filled with little fragments of broken colors and another with newer materials, drawing on a supply of brown, red, and grey paper—depending upon what instant background he wanted—first with black crayon, to outline his subject, then carefully adding his pastel tones. Protecting the pastels from smearing, he placed them between leaves of silver-coated paper. The equipment was sufficiently substantial to make the gondola an efficient mobile studio; but there were places, even in water-veined Venice, where gondolas could not go, and old Cavaldoro would then carry a more limited stock of Whistler's drawing materials while they walked in search of subjects. Then they would take a single plate wrapped in paper to preserve the etching ground, etching needles (actually London dentists' tools) punched into corks to protect their points, a small oilstone to sharpen them, a drawing board and a supply of pastels and papers.

What Maud did with her time while Whistler was away is largely unknown. That she had at least one opportunity to model is known from Duveneck's *Girl with Book*, for which she posed sometime in 1880. Usually Whistler had coffee and rolls with her in their room while Duveneck's boys would repair to a neighboring café for breakfast; often he would bring some of them back for lunch, where Bacher recalled frequent servings of *"patate Américaine,"* Whistler always explaining, "These potatoes are very large and sweet, but the nice, golden yellow of the real American sweet potato is lacking. . . ." In season there were muskmelons, watermelons, and a variety of figs—from small and green to large, red, and coarse. For Maud, used to servants in Chelsea, shopping for daily necessities in a prerefrigeration age was time-consuming itself, especially when they lived a precarious existence and bargains had to be haggled for. What is known is that her clothes had become as shabby as Whistler's, and she longed for the ever-freshened supply of new dresses which were her own as a London model. In the evenings, with Whistler in his well-worn white duck, they could sit at Florian's listening to the music in the Piazza and observing the tourists observing other tourists; or they could stroll about listening to the Lagoon lap against the ever-crumbling buildings and slimy water steps, and to the cries of boatmen and vendors. And Whistler could point out the places Maud could only see mirror-imaged in his etchings, for when he struck a proof he reversed the topography he had drawn from nature on the plate.

Just as Maud could not go to the Consul's, she knew she was unwelcome at Mrs Bronson's Casa Alvisi, directly across the water from the baroque church of Santa Maria della Salute. But Whistler would often spend an evening on a crimson cushion on the stately balcony looking out on the Grand Canal, accepting the queenly Katherine De Kay Bronson's refreshments and cigarettes and calling her *Santa Cattarina Seconda.* Mrs Bronson, once of Newport and New York, maintained the unofficial salon for the Anglo-American cultural elite in Venice, her chief prize the regular attendance of Robert Browning, but on an evening when Whistler held forth on politics, art, and literature Browning would be more silent than usual. For Maud there was at least Sunday to look forward to, an entire day when Whistler would be at home, and would even invite guests for a noon-hour breakfast as he had done in London. Ever since Anna Whistler had blamed his bad fortune on his violating the Sabbath, Whistler had promised her that he would not work on Sundays; and even in Venice he kept his vow. In Hastings she was failing fast, as he heard from Nellie; and he wrote to his mother, "Do not let any anxiety for me at all interfere with your rapidly getting well." Reassuringly he described the new work he had done, predicting great success for it, and pledged that he would bring her samples as soon as he returned. He liked Venice best "after the wet," he told her, and his etchings and pastels often evoke the city just washed by the rain.

By the summer of 1880 he had amassed a great quantity of pastels and so many etchings—more than forty—that he began thinking about shows to follow the one committed to the Fine Art Society. As more plates were completed he would shift an etching from the proposed Fine Arts set to his own, replacing it with a new plate. As long as he was in Venice he kept rearranging the twelve which he wanted for the Society's exhibition. He knew the work he had allowed to survive was good, even if the admiration of Duveneck's boys was overdone. To Henry Woods, an English artist resident in Venice and a later R.A., the band of American art students who followed Whistler about was a cause of annoyance, and on behalf—he said—of a group of older members of the art colony he came to caution Whistler about the indecorous spectacle. The artist was busy at his easel, and Woods stood by his side for a time watching him work, for he was interested in how Whistler got his effects. Eventually he brought up the reason for his visit, Whistler working without pause or comment while Woods explained. "Waal, 'Arry," Whistler then remarked, "I needn't tell the boys. They've heard what you said. *There they*

are!" And with a sweep of his arm he indicated several of the acolytes sitting on a bench which a screen had hidden from view.

Through Woods, Whistler was introduced that summer to a Russian artist named Wolkoff, and, Woods wrote, "They are very happy together and I am glad." He was probably even happier when Wolkoff announced to a convivial group of artists in the courtyard restaurant of the Bauer Grünwald that Whistler's pastels were a sham and that he could easily knock off half a dozen which, if mixed with Whistler's, could not be told apart. An American artist bet a champagne dinner for all present that he could not, but Wolkoff hedged that he had to see a sampling of Whistler's output before he could begin. It was arranged, the reason unknown to Whistler, who took the group to his room and happily showed off his pastels, each pinned to a cardboard and then propped against the back of a chair. Six weeks later the Russian, who had dropped out of sight, emerged to declare that he could not go on because it was impossible to purchase in Venice the brilliant chalks with which Whistler obtained his effects. Stealthily these were lifted from Whistler's box, and Wolkoff promised results in a week.

Bacher remembered that six jurors were selected—an Austrian, a Dutchman, a Spaniard, Henry Woods, Frank Duveneck, and Bacher himself. By this time Whistler knew of the wager and was present, off in a dark corner of the long-windowed room off the Riva facing the lagoons. Wolkoff was conveniently sick in bed, but had sent his pastels, leaving Whistler the ordeal which for him the lark had become. "He was serious and wore a troubled look," Bacher recalled, "the truth being that he was nervous at the possibility that the jury might let one of the Russian's pastels slip by as one of his own." None did. Each *Wolkoff* was greeted with shouts of "Take it away!" Still, Whistler was struck by a quality about them which, however superficial, was still dexterous. "This," he said, "is obviously the work of a man who could work and smoke at the same time and call it a pleasing art."

By August 1880 Woods's attitude toward Whistler, with whom he had often eaten seemingly friendly Sunday breakfasts, had become almost pathological:

> Whistler, I hear, has been borrowing money from everybody, and from some who can ill afford to spare it. He shared a studio for five or six months with a young fellow named Jobbins. Jobbins never could work there with him in it. He (Whistler)

invited people there as to his own place, and has never paid a penny of rent. He used all the colours he could lay his hands upon; he uses a large flat brush which he calls "Matthew," and this brush is the terror of about a dozen young Americans he is with now. Matthew takes up a whole tube of cobalt at a lick; of course the colour is somebody else's property. . . . He is an epidemic, an old-man-of-the-sea. These young chaps were quite flattered at first when he joined them. It made me roar when I heard of his goings on amongst them, he evidently pays for nothing. There is no mistake that he is the cheekiest scoundrel out—a regular Ally Sloper. I am giving him a wide berth. It's really awful. There will be *Grande Festa* if he ever goes away.

There was a real Jobbins, W. H. Jobbins, but Whistler's few oils done in Venice as well as his actual practice of applying paint hardly suggest use of enormous brushes or wholesale quantities of cobalt, and his record of payment of his Venice debts was good. But Jobbins, too, had his emotional problems with Whistler. As a member of the staid old English art colony he was troubled by Whistler's irregular domestic establishment, and told other worried expatriates that really Whistler was going too far. He, for one, did not think he would know the fellow. But intensely curious about him and Maud and happening to be passing Whistler's lodgings a week or two later, he stopped and on the spur of the moment rang the bell at the street door. Whistler went out into the stairwell and leaned over the banister to see who the visitor was, then called back into the apartment, "Maud! Maud! Come here and look! It's little Jobbins. It isn't *true,* Maud; he *isn't* going to cut us!"

Woods, however, was right, but for the wrong reasons, about the last line of his letter: there *would* be a farewell *Grande Festa* for Whistler. As an American too he was earlier asked to the students' Fourth of July banquet, and even pressed to speak, which he did—at great length—on the virtues of his native land, its love of art, and other matters about which he knew little. Finally they had to clamor for him to stop. Toward the end of August, when several students were preparing to return home, and Whistler's own departure was expected, the group chartered an enormous open coal barge for a farewell party. Festooned with studio drapes, garlands of ripe fruit, hanging Chianti bottles and Chinese lanterns, and rowed clumsily into the current by oarsmen, it flew an American flag and was such a queer sight that curious Venetians followed

it in a flotilla. So did Whistler. He was late as usual, and caught the barge when it was far out in the lagoons opposite the Doge's Palace. His being piped aboard was the signal for beginning the drinking of toast after toast as they floated upward with the tide, the conviviality only falling off when it began to rain, when they rowed for shelter under the arch of the Rialto, where they remained until dawn. "The only incident that left a blot," Bacher recalled, "was when two men in light suits bunked in the forward cubby-hole, forgetting that it was a coal barge."

Whistler tried to do a study of the Grand Canal from a friend's window that day, but was too groggy to go on after he had set up his easel and begun to draw. When W. S. Adams returned to his flat he found a striking view on the easel as well as next to it. Whistler was asleep, and his brushes, charged with fresh paint, were resting in his lap. The white duck trousers were becoming an unanticipated Whistler *arrangement*.

Most of the students left with the onset of autumn, but shortly before Whistler packed up his belongings in November he gave a tea-dinner for his friends, using the opportunity to show his favorites from among his hoard of Venetian work, the six o'clock hour chosen so that Maud could prepare an appropriate repast which Whistler could afford. Over the sardines, hard-boiled eggs, fruit and coffee in the one-room apartment Whistler held forth about each etching or pastel he held up, pinned to a piece of cardboard, and conjectured sarcastically about the likely verdict of the London critics. To his friends packed in the tiny flat, who had made his stay rewarding and pleasurable, he announced a parting gift, and drew out a less-than-successful Venice etching. Then he counted the number of guests, took a scissors and cut the proof into the required number of pieces, solemnly distributing one to each.

To Henry Woods, Whistler communicated his concern, now that he was returning to London, about his expulsion for nonpayment from the Arts Club. Woods told him to write, humbly praying for reinstatement. The following day Woods wrote in his diary, "Went to Florian's. Saw Whistler. He paid me the 60 *lire* he borrowed some time ago. He goes away next Tuesday morning. Confidence, I believe, is restored to him in the Bond St Art Gallery, and they have sent him money." Another English artist then in Venice remembered Whistler's giving his remaining local currency to the loyal Cavaldoro to help replace his ancient

gondola, and the gondolier dutifully showing up before Whistler left to display the "better boat." As soon as Whistler and Maud had left, the old gondola reappeared.

XXIII

Exile's Return

AFTER fourteen months' absence Whistler arrived quietly in London early in November 1880, anxious that it should not be known he was back until he was prepared to make a public *entrée*. Selected friends were informed that he was lodging temporarily with his brother at 28 Wimpole Street, and soon a small luncheon in a Covent Garden restaurant celebrated the return over a bottle of '47 port, with Whistler furnishing his choicest tales of the Venice months. Then came the grand entrance, when the Fine Art Society was opening an exhibition, "Twelve Great Etchers," and the press was in the gallery. "Well, you know," he described it to the Pennells, "I was just home, nobody had seen me and I drove up in a hansom. Nobody expected me. In one hand I held my long cane; with the other, I led by a ribbon a beautiful little white Pomeranian dog—it too had turned up quite suddenly. As I walked in, I spoke to no one, but putting up my glass I looked at the prints on the walls: 'Dear me! Dear me!' I said. 'Still the same old sad work! Dear me!' And Haden was there talking hard to Brown and laying down the law, and as he said 'Rembrandt,' I said 'Ha ha!' and he vanished."

The Society rented two rooms at the corner of Air Street and Regent Street, over a stationer's shop, where Whistler could prove his twelve Venice plates. Young Tom Way came over from the South Kensington

School of Art to help damp the paper and press the proofs, and Mortimer Menpes, an Australian student of Poynter's at the school, came to watch, then took off his jacket and ground ink, afterwards eagerly slaving in the Master's service and never returning to classes. The informal Whistler *atelier* was re-forming.

The room was dim, despite a bay window, for the late autumn days were short and bleak; but they worked from early morning, neglecting the Pomeranian which accompanied Whistler every day to the studio, and usually stopping only long enough for lunch of tea and an egg. According to one tale, Whistler's affection for his dog was as extravagant as it was brief, and when it became ill he sent for the great Harley Street throat specialist, Sir Morrell Mackenzie. The doctor, discovering the nature of his patient, was clearly unhappy, but prescribed medication, pocketed a large fee, and drove away. The next day he sent urgently for Whistler, who dropped his work and rushed to Mackenzie's. On his arrival Sir Morrell said, gravely, "How do you do Mr Whistler? I wanted to see you about having my front door painted." For a while Whistler took the Pomeranian everywhere, even in cabs to the theatre, but once he left it alone for an evening in the Air Street studio, and when he came back it had chewed a pair of his trousers. He whipped it, called it a bad dog, and Whistler's first and only pet disappeared mysteriously.

On rare occasions when working at Air Street, for Whistler had little money other than what he could borrow, he and his helpers would cross to the Café Royal so that Whistler could order his favorite *croûte au pot,* which he ate between comments to the disciples about the etchings, still unsure which ones would constitute the most impressive twelve. Eager to complete the job, yet fastidious about each detail, he was angry with himself at delays necessitated by retouching any of the plates, for although he had received substantial advances on the promised £1200 he desperately needed the remainder. In the process he fell ill, and was kept at Wimpole Street for treatment, writing Way to urge him and his father to "watch a little over the proofs and let no prying spies come into the place. . . ." * Perhaps he meant Howell, for his ubiquitous old friend had come back into his life, Whistler encountering devious transactions of Howell's with his pictures everywhere he went in London, to the point that when he temporarily retrieved his *Carlyle* from dealer Henry Graves in February, 1881 he carefully instructed Graves to deliver the picture to Wimpole Street and to no one but himself.

* It was signed by "a very sick butterfly" over the usual symbol.

Way and Menpes kept the secret of the Air Street workshop close, and there were few observers. "His brother, the Doctor," Tom Way wrote, "occasionally came, and he, together with Maud Franklin (who was in very bad health, the result of the severe times they had had in Venice), and my father, who occasionally came to help with his papers, almost completed the list of visitors; but Howell found us out and came one evening. . . . Whistler would tell him nothing, but went on working, and occasionally spread a proof on the floor to look at, but at such a distance that Howell could not see it!" The fact of Maud's illness on arrival in London, created speculation. It was whispered that "her figure looked rather queer and she went away to Paris . . . and stayed away two months." * But Maud remained in London and helped Whistler set up housekeeping again, this time in Alderney Street, off Warwick Square.

As a result of his desire for secrecy about the Venice etchings rumors about them abounded. From London Luke Fildes, R.A., wrote to his brother-in-law Henry Woods, "I saw Whistler last night at the [Arts] Club, and he gives me a fearful account of the disagreeabilities of a winter in Venice. . . . I have not seen Whistler's etchings yet, but I hear on all sides that they are absurd fakes." Invitations to the private view were already out, but the speculation was almost all the public seemed likely to have when Whistler discovered that the Fine Art Society, thinking that a showing of twelve small plates was insufficient to draw an audience, decided to add to the interest with a display of how etchings were printed, with Frederick Goulding, a well-known printer, established in the middle of the gallery with a working press. Goulding, diplomatically writing about it to Whistler, could not have anticipated the outcry. According to Tom Way, "He threw down the plate on which he was working at the time and cussed and swore. . . . Very slowly, but at last, I got him to consent to reply to the letter, but only in the form of an ultimatum that he would not have any meerschaum pipe-making, or spun-glass works, or other foolery to take the people's attention from his etchings, and that if the Society would not undertake to do away with their proposed printing show, he would not go on with his proving." Way carried the message to Bond Street, and took back a promise which calmed Whistler into continuing his work.

* The Pennells reported that Miss Alice Chambers, a friend of Howell, told them of a daughter born to Maud in France; but scandal, especially from a source close to Howell, must be accepted with care.

A hundred complete sets were to be printed, but the work went too slowly, and the show opened before they were done. In fact, they were never done in Whistler's lifetime, Goulding finishing the work years later; but there was no need for them in December 1880. Few sets were ordered, and the critical consensus was that they were unfinished. According to the critic in *The World* (December 8, 1880) the etchings "were of unimportant dimensions, and of the slightest workmanship . . . , vague first intentions, or memoranda for future use, rather than designs completely carried out. . . . Venice has not deeply stirred Mr Whistler or his art." To editor Edmund Yates, who conducted a column under the name of "Atlas" for the paper, Whistler wrote in protest that "the private assassin you keep, for us" should be educated that "an etching does not depend, for its importance, upon its size. . . . As well speak of one of your own charming *mots* as unimportant in length! Look to it, Atlas. Be severe with your man. Tell him his 'job' should be 'neatly done.' I could cut my own throat better; and if need be, in case of his dismissal, I offer my services."

Such carping notwithstanding, the show enabled Whistler to pay some of his debts, for it was up to the Fine Art Society to dispose of the etchings after furnishing Whistler with his balance, less advances. As a result, when he was eager to exhibit his Venice pastels, with a commission on sales going to the Society, it was a chance for Ernest Brown to recoup. Early in January 1881 Whistler got ready a successor show. It was an economic necessity. As a young Irish painter named John Butler Yeats remembered, he visited the first exhibition, "remaining there for over two hours, and . . . during that time I was the only visitor."

The Master's idea of how to mount a show was very different from that of the Fine Art Society. There were no plans for a printing press for the gallery. Instead, there was an arrangement in brown and gold, designed by Whistler. The frames holding the fifty-three pastels were in yellow gold or green gold, with a background of pale reddish brown with green and yellow gold trim. The catalogue, written by Whistler and printed by the elder Way, was in brown paper. As an exercise in showmanship and salesmanship it was a triumph, and the private view on January 29 was crowded, Whistler rising to his cheekiest form in the excitement. Someone asked the price of a pastel and the artist overheard the answer: "Sixty guineas! That's enormous!" Remembering the Ruskin trial Whistler shouted back, "Ha! ha! Enormous! Why, not at all. I can

assure you it took me quite half an hour to do it." Sixty guineas was the top price: others ranged down to twenty.

For Maud the private view was a special sort of triumph. With some of the etching income she began a new wardrobe, her letter to Bacher about it indicating the pathetic state into which a once-sophisticated lady of fashion had fallen. "Whistler bought me a dress like this scrap I have pinned above to wear at the private view but the day was too dreadful—or it would have been lovely in that room." In a later letter she wrote, "I was sure you would like my dress. I've just been enjoying myself, I can tell you, and have managed to spend a hundred pounds on myself,—what do you think of that after the impecuniosity of Venice? Ah, well, I should like to go back there all the same. . . ." Both were signed "Maud Whistler."

Once in London, Whistler had found no time, the pressure on him to prepare his etchings and pastels shows so urgent, to visit his mother in Hastings. But at the end of the first day of the public exhibition of the pastels, January 31, 1881, there was a sudden summons to Hastings, where Anna Whistler had taken a turn for the worse, and Willie and Jimmy took a train for the coast. By the time they arrived it was too late. Willie, with a busy practice in London, left his brother and Nellie to make the funeral arrangements, but before he returned he tramped with his brother over the windy cliffs above the old town as they shared each other's remorse. Willie had visited her regularly and had cared for her, but had not been there at the end. Jimmy, ashamed of his failure, had not seen her since long before Venice and had not even written as often as he might have. Breaking down he reproached himself, "It would have been better had I been a parson as she wanted!" After the burial, in the Borough Cemetery at Hastings, the brothers had a white marble slab erected over the grave which set forth their mother's staunch faith:

> Blessed are they who have not seen
> And yet have believed.

By the end of the week Whistler was back, checking on his affairs at the Hanover Gallery.

Although the first day's receipts had been £400, and sales of pastels continued strong through the week, the Society's rules were that nothing would be paid until the end of the show. But Whistler had too many debts and needs to be that patient. "So the next Saturday afternoon," he recalled, "I came just when the crowd was thickest, and everything was

going beautifully, [Marcus] Huish and Brown taking people round and showing them and explaining the pastels, on the point of selling many, and I stood in the little central gallery, and I said in a loud gay voice, 'Well, the Show's over.' Huish and Brown came over to quiet me. Everybody was in a fearful agitation. But I said again, 'The Show's over. Ha! ha! They will not give me any money and the Show's over.' Finally, Huish promised to give me a checque on Monday. I had first asked for two hundred pounds; now I made it three hundred, and so I said, 'All right, the Show can go on.' And on Monday I had my checque."

At the private view John Millais had told Whistler how pleased he was with the pastels. Afterwards he wrote to him that he was "so *charmed* with your Venice work. . . . They gave me real pleasure. The gradations, tenderness and lovely tints of sunset, and the sea quite delighted me." Edward Godwin was particularly pleased, having felt that his friend's slapdash show of etchings had done nothing to rehabilitate his reputation. The pastels show had been arranged with more care, and had greater dimensions. "They are not as good as I supposed," Whistler told him; "they are selling!" But Godwin wrote in the *British Architect* (February 25, 1881), "As to the few bits of architecture he has drawn, he has given us—with what remains of the marble forms and details, which a knowledge of architecture would have tempted the eye to complete and restore and spoil—that most difficult of effects to render, its gradual decay. Of Venice as it is, in the dethroned, neglected, sad passing away of it, Whistler tells us with the hand of a master, who has sympathised with the noble city's sufferings and loss."

Maud had exaggerated on two counts when she wrote to Bacher that the Venice exhibitions were "as great a triumph as ever Jimmy could wish—but of course all the other artists were furious." Whistler's receipts were nevertheless better than his press: £1800 from the pastels show alone. It meant, at least, that he could reestablish his credit with his artistic public as well as with his grocer and wine merchant, and ebulliently, after Maud had penned her apologies to Bacher for Whistler's being too frightfully occupied to write, he added,

Bacher old chap you see the Madam has been trying to make it all right for me with you fellows—and I hope you will all be induced to forgive my apparent neglect, but ever since I got back here I have been so absolutely occupied, what with working and fighting!—and you know how I like both. I wish you could only

see the fun! Of course I managed to thrash them all around and the poor devils critics, and not a few of the painter chaps too are so dreadfully angry. . . . I enclose five pounds this ought to make something like 130 lire and I believe I owe you 68—but if you will let me buy one or two of your etchings for the remainder I shall be delighted. . . .

The psychological value of the offer on the part of the Master to purchase the work of the apprentice cannot be underestimated. Whistler's faults when it came to money were legion, but the instinct to buy a Bacher etching was an act of redemption.

The real joy of battle had come not during his own Venice shows, but from an April exhibition of the newly organized Society of Painter-Etchers at the Hanover Gallery, a group organized largely by the archvillain in Whistler's life, Seymour Haden—"the eminent barber-surgeon," his brother-in-law now called him. To the show Frank Duveneck had contributed three etchings of the Riva. Maud's breathless letter to Otto Bacher conveys the atmosphere and explains the comic-opera outcome:

Well—Seymour Haden, Legros, and some other man,—driven to madness almost by this [suspicion of a Whistler hoax]˙ and Jimmy's extraordinary success,—resolved to be avenged; so they go to the Fine Art Society and they ask to see the Whistler etchings of Venice. They are shown to them and after a good deal of talking amongst themselves—they say to the Secretary,—"Mr Whistler is bound by you to publish no more plates of Venice for a year, is he not?" "Certainly he is," says the man. "Oh, that's it, is it? Do you mind putting on your hat, Mr Brown, and coming over to the Hanover Gallery?" So, accordingly, they take Mr Brown over to the place and point out three etchings of more or less the same subjects by Mr Duveneck and declare them to be Whistler's. Mr Brown, on looking at them says at once, "They are not Whistler's"—at which remark they snort and still try to convince him that Jimmy is swindling the F.A.S. and is, in short, a scoundrel and a thief.

You can imagine Whistler when the man tells him all this. He, of course, explains that Mr Duveneck is a great personal friend of his who was in Venice at the same time—who was with all his "boys"—and was very much amongst all the etching

business and consequently any similarity of style could only have occurred from that. . . .*

The result was that Haden, making amends to Duveneck, offered to buy the three disputed etchings, and Whistler happily put together the correspondence on the affair into another pamphlet, *The Piker Papers* (afterwards renamed *The Painter-Etcher Papers*). For a painter-etcher, as he himself was, the publication was a waste of creative energy, but Whistler was still fighting the Ruskin case. Bitterness over his critical treatment had eaten into his soul, and although there would be flashes of the old Whistler again, and even sustained brilliance, he was busy fashioning a reputation. It would be his chief creative act of the Eighties.

Inevitably, when the Grosvenor show opened on the first day of May, not only did Whistler have nothing new he cared to exhibit—he borrowed and sent only the *Miss Alexander*—but was annoyed when *The Times* (Harry Quilter was now its anonymous critic, replacing Tom Taylor) praised Hubert von Herkomer's portrait of Ruskin, "the first oil portrait we have ever seen of our great art critic. . . ." Whistler hastened to his desk to suggest to *The World* that "surely, dear Atlas, when the art critic of the *Times*, suffering possibly from chronic catarrh, is wafted in at the Grosvenor without guide or compass, and cannot by mere sense of smell distinguish between oil and water colour, he ought, like Mark Twain, 'to inquire.' " Whistler's own contribution fared worse, the *Miss Alexander* described by the art critic of *Society* as "an arrangement in silver and bile," while *Punch* published a cruelly gruesome caricature of the portrait (signed by "H.F.") in which Cecily Alexander was given simian features and enormous feet, with the Whistlerian butterflies replaced by huge cockroaches. The returned exile could be pardoned his paranoia.

As security for loans he had made before Venice, Whistler had arranged to leave some of his pictures with Henry Graves in Pall Mall, the loans to acquire interest in the interim. As he was able he now bought them back, but in the process Graves remained his banker for years, for Whistler had quickly returned to his old extravagances, which included a ground floor studio at 13 Tite Street, "next door to myself," as he put it. It was as close as he could get to the White House, which to his distress Harry Quilter now occupied. When afterwards Quilter went beyond mere occupation, which was irony enough for its begetter, and set about improving the exterior, Whistler was unable to contain himself. Not only

* At least one of Duveneck's etchings was earlier than Whistler's of the same scene.

had the young upstart critic ordered Whistler's parting pearl of wit above the door to be chipped from the stone, but he had planned to alter the clean lines of the White House. "For, finding that there was little sleeping accommodation in the house," he explained with some hyperbole, "and certainly no means of washing, I altered the huge studio at the top, and made bed and bath rooms and other necessities, and in so doing changed slightly the front elevation—considerably for the better, I thought. But Whistler, who still seemed to imagine he had some seigniorial rights over the building, was more aggrieved than ever at this desecration, as he called it; and again the columns of the *World* bore witness to his wrath." It also bore witness to his confidence that he would be remembered.

To the Editor of the "World."

O Atlas! what of the "Society for the Preservation of Beautiful Buildings"?

Where is Ruskin? and what do Morris and Sir William Drake?

For behold! beside the Thames the work of desecration continues, and the "White House" swarms with the mason of contract.

The architectural *galbe* that was the joy of the few and the bedazement of "the Board" crumbles beneath the pick (as did the north side of St Mark's), and History is wiped from the face of Chelsea.

Shall no one interfere? Shall the interloper, even after his death, prevail?

Shall 'Arry, whom I have hewn down, still live among us by outrage of this kind, and impose his memory upon our pavement by the public perpetration of his posthumous Philistinism?

Shall the birthplace of Art become the tomb of its parasite in Tite Street? . . .

J. M'NEILL WHISTLER

TITE STREET, *Oct.* 14.

When he was asked to exhibit a picture at the Pennsylvania Academy of Fine Arts in Philadelphia in September 1881, he looked ahead to his future reputation by applying to Henry Graves for the loan of the *Mother*. The picture would be his first on public view in America, and the choice was obvious although his motives may have been more mixed than he

knew. Even by standards of usually hostile opinion it was his finest achievement, and it was the portrait of an American. Besides, however, he was paying the first installment of his posthumous debt to Anna Whistler.

Borrowing his own picture from the cooperative Graves—certainly one of the unsung heroes of art—was easier than recompensing him. It would be a decade before he could write to Algernon Graves that he was getting close to being able to pay off the remaining sums, and to again express his appreciation of the "delicacy in dealing with me" of the Graveses, father and son. "You have shown," he wrote in December, 1890, "that you understand how an artist whose work is without the pale of gross popularity, & whose purse is consequently not heavy with ill gotten gold, may be met with, . . . and hereafter in history this shall not be forgotten!"

At the suggestion of J. Alden Weir the Society of American Artists exhibited the *Mother* in New York after its sojourn in Philadelphia, and elected Whistler a member. It was his first recognition in America as a painter. Later *The White Girl* was shown at the Metropolitan, but no public gallery anywhere made any effort to purchase a Whistler. Still, Whistler's own sense of self-advertisement brought a great deal of publicity although fewer commissions and sales. He had boasted to Alan Cole in May 1881 that at his new studio in Tite Street he would "paint all the fashionables," and prophesied "crowds competing for sittings; carriages along the streets." To prepare he had the studio decorated in yellow. ("It makes me feel as if I were standing inside an egg," said Howell.) He refurbished his wardrobe with a long, fawn-colored frock coat and extraordinarily long cane, and pink bows blossomed on his patent leather shoes. Through letters to the editor, spoofs of him in the press and onstage, his ubiquitous laugh and defiant white lock above his curls, he was seldom out of the public eye.

One of the few who had admired the *Miss Alexander* was Louise Elder, a young American woman who later as Mrs Havemeyer spent her husband's fortune in amassing a great art collection. With her mother and a friend they called on Whistler at the Tite Street studio, not to commission an expensive portrait but to purchase a token Whistler. The artist, at first suspicious, quickly shifted moods at the act of homage.

Although we sat down, I do not recall any furniture in the room, not even chairs; I was so impressed with the lovely yellow

light that seemed to envelop us. . . . Two objects in the room arrested the eye: near the window stood a blue and white hawthorn jar which held one or two sprays of long reedy grass, and in the center of the room there was a huge Japanese bronze vase; it loomed up in that mellow light with the solemnity of an altar. . . . I made a direct statement of my errand. I said: "I have thirty pounds to spend and, Mr Whistler, oh! indeed I should like something of yours. Have you anything you would like me to have?"

He stood still just a second and looked at me, and I looked at the white lock in his intensely black hair. "Why do you want something of mine?" he asked.

"Because I have seen your exhibition and—because Miss Cassatt likes your etchings," I answered. . . . I have just thirty pounds—that is all I can spend, so please tell me if it is impossible."

"No, it is not impossible," he answered kindly, "let us go into the studio and I will see what I have. . . ."

Whistler went directly to one of the portfolios, and when we were seated he began taking out the pastels he had done in Venice. . . . I had to exclaim, "how fine!" as he drew out a pastel of a doorway.

"You like that?" he asked. . . .

"Oh, so much," I answered. "You have done so little and yet it is just Venice as I remember it."

Whistler placed it against the portfolio, and taking out another he said: "Don't you like that brown paper as a background? It has a value, hasn't it? But it sets the critics by the ears, you know they think I'm mad." He gave a little laugh and took out another pastel and I saw by his expression that it recalled something to him. He continued: "Do you know the critics hate me so they are using themselves up trying to get back at me?" . . .

Whistler finally selected five pastels for me. I put them in a row upon the floor and knelt down to admire them. I fumbled in my pocket until I found my pound notes and I deliberately shook them out and handed them to him saying: "Are you not ashamed to compare them with these?" and I gave a proud wave of possession over my lovely pastels.

Whistler appeared to be amused at my disdain of his mercenary instincts. He told me he had done those five in Venice and did not expect to sell them.

At £6 per pastel the future Mrs Havemeyer had acquired the best bargain in London; but these were unsold surplus from the Hanover Gallery show, and Whistler needed the money. He carefully put a title on the back of each, added his butterfly signature, and served the ladies tea. Something said over the cups about the *Miss Alexander* pleased him, and he explained, "Even when you begin, the portrait must be upon your palette and beware how you change it, or you will have to take another canvas and begin all over again." The theory sounded logical. In practice, however, it was trying the patience of his newest portrait subject.

When Valerie Meux, the beautiful and spirited young wife of a London brewer, commissioned a portrait in 1881, it was the first post-exile work of that kind to come to Whistler. In his Tite Street studio he had several widths of black velvet sewn together into a large square and hung from a crosstree as a background for his subjects, the equivalent of the black doorway against which he had painted Rosa Corder in Lindsey Row. There he painted Lady Meux (as she became two years later) with a sheaf of long-stemmed brushes at the ready in his left hand, while his right hand held the brush he was using and a large white handkerchief, giving the illusion—as he was dressed not in a smock but in a white shirt with ruffles at the wrists and down the front, tight-fitting black trousers and his usual black dancing pumps—of a matador stalking his prey. He ended by working on three canvases, a regal *Arrangement in Black*, a *Harmony in Pink and Grey*, and a third which was never completed, for Whistler became too demanding in the number of sittings he wanted, and Valerie Meux, in sable coat and muff, grew weary of the rubbing down and painting out of portions she thought already sufficiently close to being satisfactory. Equally exasperated, Whistler said something impertinent and Mrs Meux warned, "See here, Jimmy Whistler! You keep a civil tongue in that head of yours, or I will have in someone to *finish* those portraits you have made of me!" Harper Pennington, Whistler's young friend of Venice days, was in the studio and recalled that "Jimmy fairly danced with rage. He actually came up to Lady Meux, his long brush tightly grasped, and actually quivering in his hand. . . ." Finally he managed a "How dare you? How dare you?" * And Valerie Meux never

* According to Whistler's friend Count Montesquiou, a maid was actually sent to pose

sat again, nor did she ever see again the nearly completed portrait, which Whistler eventually destroyed, although Henry Meux had already paid for it. Still the concept of Whistler's doing all three simultaneously amused a *Punch* cartoonist and it turned up in print. It was good publicity, and Whistler was especially pleased with the first portrait, which he called his "beautiful Black Lady" and sent to the Paris Salon in 1882.

At the Grosvenor Gallery show, which opened the same day (May 1, 1882), Whistler exhibited the other completed portrait, the *Harmony in Flesh Colour and Pink*. The portrait was upstaged by the artist. According to the *World* of May 3, "Mr Whistler's wandlike walking stick was one of the most striking objects at the private view. . . . It was longer than himself, and even slimmer, and he balanced it delicately between finger and thumb. He explained that he intended it should become historical, and its appearance doubtless marks a new departure in the fashion of sticks." Lady Meux could not have been pleased.

With Lady Archibald Campbell, a friend, Whistler's relationship was far different. Although he may have hoped for a sale or a commission, he painted her because she was an attractive subject, and she sat to him in a variety of costumes and poses. Daughter-in-law of the Duke of Argyll, she was interested in the arts and put on amateur theatricals at Coombe, her country estate, Godwin designing the costumes and Whistler sketching a scene from one of them, when—in tights—she played Orlando in *As You Like It*. His first idea for a portrait was to paint her in court dress, with the Argyll coat of arms on a long train, but the fatigue of standing in it was too much at Whistler's tortoiselike brushwork speed. It was abandoned, as was another, *The Grey Lady*, which, nearly completed, had shown her descending a stair. When she next visited Tite Street he asked to paint her in the dress in which she had called, and stood her in an unusual pose, looking toward the artist from left profile, with a bright shoe emerging from beneath her long skirt. Again there were problems, Walter Sickert, one of the new group of Followers, remembering Whistler once standing on a chair holding a candle at the end of one sitting from "Lady Archie," scrutinizing the day's work and undecided whether to rub it all out. Putting out the candle, he started to dinner; then, once in the street, he hesitated, had second thoughts, and told Sickert, "Go back and take it all out." With a rag and benzine Sickert removed the agony of hours.

in Lady Meux' clothes. Since Whistler had sought substitute models himself in other cases, the cause for offense must have been the source of the suggestion.

Whistler stripped many a six-foot canvas, Sickert later said, because he "pitted his physical rapidity and endurance, not only against the unsleeping mobility of life, even in a north light, but against the laws of the very paint he knew and loved so well." The reason was that Whistler's paintings were not planned in "conscious stages . . . to form a steady progression to a foreseen end. They were a series of superimpositions of the same operation, based on a hope that the quality of each new operation might be an improvement on the last." Such repetition, "depending on nerve and skill and freshness," was "not likely to show an ascending curve of success." Not only did the paintings suffer from "the necessary simplification of their backgrounds" but also from "the fatigue of the sitters, and of their very clothes," and "from the fact that sittings approaching the rule of *de die in diem* necessitated the use of too tenuous a medium." Some of the rubbed-out canvases were never again worked over. "I cannot remember," Sickert wrote years later, "how many of these I helped him cut into ribbons on their stretchers."

It was Sickert, too, who told the story (one of the Campbell ladies may well have been the subject) of Whistler's once "yielding to the persuasion of a fair sitter" and allowing himself "to introduce, step by step, certain modifications in the scheme of a portrait that he was painting. As time went on he saw his own conception overlaid with an image that he had never intended. At last he stopped and put his brushes slowly down. Taking off his spectacles he said, 'Very well, that will do. This is *your* portrait: we will put it aside and finish it another day. Now, if you please,' he added, dragging out a new grey canvas, 'we will begin mine.' "

After one session Lady Archie's patience wore thin, and she was already in a hansom ready to leave when he sprang on the step and urged her to go back and rescue the portrait from the fate of so many Whistler canvases, which, having failed to meet the Master's intense desire for perfection, lingered unfinished until the painter destroyed them. She returned, and the *Arrangement in Black: the Lady in the Yellow Buskin* was exhibited at the Grosvenor in 1884; but neither sitter nor her husband were interested in buying it. When she had first sat for him, Lady Archie had warned Whistler that her husband appreciated the honor, but wished to be under no obligation to purchase the result. "Lord Archibald need give himself no uneasiness," Whistler said airily. "We are doing this for the pleasure there is in it." When it was ridiculed, and Lady Campbell's friends expressed surprise that she should have permitted so eccentric an

artist to paint so eccentric a portrait, she commented on its notoriety to Whistler, who placed his finger solemnly to his lips. "Sh–sh–sh!" he said. "So it has, my dear Lady Archibald; but every discretion has been observed that Lord Campbell could desire. Your name is not mentioned. The portrait is known as *The Yellow Buskin.*" It remained unsold until 1895.

Lady Colin Campbell, the estranged wife of the Duke's youngest son, was another favorite Whistler subject. As clever as she was beautiful, she earned her living as a journalist, writing a "Woman's Walks" column for *The World*; and Whistler wooed her as a potential subject via the kind of epistolary flattery Bernard Shaw would later utilize upon actresses he was interested in for his plays. She was Whistler's "lovely leopard," and when he rubbed out a day's sitting he would write her "heartstricken" that he had fatigued her while she had been "superbly standing" for a *Harmony in White and Ivory* that was never completed. Dozens of his letters about being her devoted slave survive; the canvas was displayed once unfinished, then done away with.

Theodore Duret, a French journalist and art critic, and friend of Manet, posed at the same time as Lady Archie, and managed the patience to sit through to completion. Whistler painted him, as he had Leyland, almost entirely in black, but this time in resplendent evening clothes, and with a lady's pink fan and pink domino over his arm. "Did he ever see Duret with a lady's opera cloak?" George Moore asked. ". . . Is Duret in the habit of going to the theatre with ladies? No; he is a *littérateur* who is always in men's society, rarely in ladies'. But these facts mattered nothing to Whistler [who] . . . took Duret out of his environment, dressed him up, thought out a scheme—in a word, painted his idea without concerning himself in the least with the model." To Moore it was further evidence that Whistler's art was "guided by his mind, and not by his eyes," and thus "severely classical"—in line with the dictum he had often heard from the Master himself: "Painting is absolutely scientific; it is an exact science."

During the ordeal Duret saw the portrait nearly completed, then rubbed out ten times before Whistler was satisfied. It was a matter of color and tone, he understood, for retouching was alien to the harmony Whistler sought.* To endure his method was more than most potential

* "A picture is finished when all trace of the means used to bring about the end has disappeared. . . . The work of the master reeks not of the sweat of the brow—suggests no effort—and is finished from the beginning." Whistler, in *Propositions—No. 2.*

subjects were willing to do especially when more fashionable portraitists abounded. But not only was Whistler's technique uncommercial. According to authoritative legend, a lady engaging him to do a portrait closed negotiations with "And if I don't like it when it is finished, Mr Whistler, I don't have to take it, do I?" To which the painter retorted, "Ah no, madam, that is not the case at all. Quite the contrary. If *I* don't like it, *you* can't have it." And to another, who proposed a commission and observed that the suggested picture be a "serious work," Whistler protested that he "could not break with the tradition of a lifetime." In both cases Whistler was being scrupulously honest. He would not give up, or even let stand unerased, a picture which dissatisfied him, and a serious work by Academy standards bore little relation to canvases signed with the Butterfly.

Among the most coveted original works signed with the Butterfly were Whistler's breakfast and dinner invitations. Art and society mingled easily in London, and a Lady Archie could be a dinner guest as well as model for a portrait, and could even sup from a menu also signed with the Butterfly which included *Potage à la Maud.* French artist Jacques-Émile Blanche wrote his mother about the "Lords and ladies" as well as the inevitable Americans at a buffet lunch in June 1882, when he entered the Tite Street house to find a Whistler disciple

arranging some yellow flowers which, placed in blue vases, made a harmony of blue and yellow. The servants were putting the last touches to the table, which was laid with fastidious care. In the middle of it was a blue-and-white Japanese bowl in which goldfish swam among water-lilies. In the centre of the room was a large table, in the corners small ones. At about one-thirty the guests arrived. All were lords and ladies, with the exception of some Americans. Everyone spoke French and was as familiar with Paris as with London. Opposite me was a lady in black and yellow; for all the ladies wore a little yellow or a little blue to match the colours of the dining-room. The dishes to which the guests helped themselves were as follows: Smoked fish; curried lobster; pressed beef; creamed chicken patties; polenta; saffron eggs; Italian cakes; and a Moselle cup (the favourite drink of the Prince of Wales). Things were said that entirely defied the imagination of a writer of vaudeville: people went into ecstasies over a flower; a particularly round pea was passed round the table

on a little plate. After the meal there was a big reception, with "all" London filing into the studio.

In one sense the Whistlerian revival began after Venice with the first sitters of social distinction; in another it followed the second exhibition of Venetian etchings, at the Fine Art Society in February 1883. This time fifty-one etchings were hung in a gallery decorated in white and yellow. The furniture was upholstered in yellow; yellow flowers sprouted from yellow pots; the attendant wore white and yellow livery; and at the private view Whistler wore yellow socks. White-and-yellow signed butterflies, intended to be worn at the opening, were mailed rather than formal invitations, and Whistler decorated other guests with butterflies at the gallery. It was flamboyant but effective advertisement, with the more serious business saved for the catalogue in the familiar brown paper cover.

No exhibition catalogue like it had ever been issued. Entitled *Mr Whistler and His Critics*, it opened with the title-page epigraph, "Out of their own mouths shall ye judge them," and Whistler followed each number and title with an unrelated extract from previous hostile criticism calculated to make the author appear small and foolish. The quotation appended to No. 1 was "Criticism is powerless here." It was exactly Whistler's intention. A later excerpt referred to "Another crop of Mr Whistler's little jokes." One quoted Frederick Wedmore as saying, "There is merit in them, and I do not wish to understand it," and Whistler approved of the printer's error for *understate*, although at the private view Wedmore complained about the unfairness of it all.

When the Prince and Princess of Wales appeared, the crowd was directed aside so that they could go round the gallery, the Prince chuckling at the catalogue as they went. "I say, Mr Whistler, what is this?" the Prince asked as he came to the *Nocturne–Palaces,* where the critic from *Literary World* was quoted as declaring that "Pictures in darkness are contradictions in terms." "I am afraid you are very malicious, Mr Whistler," said Princess Alexandra. He was, and now earned his bad press not by being *avant-garde* but by being insufferable to critics.

Signs of appreciation were beginning to emerge nevertheless, evidence that criticism could rise above *ad hominem* attacks. For the new Grosvenor show Whistler borrowed two nocturnes from Graves, and for the Salon sent the re-borrowed *Mother*, winning a third-class medal, which annoyed him yet was his first formal recognition in Paris.* In 1884

* Whistler sought first-class recognition for what he considered first-class work, writing to the Secretary of International Art Exhibition in Munich in 1888, "I beg to

the *Carlyle* was exhibited in a show of Scottish National Portraits in Edinburgh, and created enough of an impression (although described as "eccentric") for the critic of the *Scotsman* to urge its purchase for the Scottish National Gallery. When the subscription appeal included a disclaimer that it implied approval of Whistler's art and theories, Whistler was indignant, although Henry Graves saw a sale at the asking price of four hundred guineas as a way to recover the £250 still owed on it. Indignant, Whistler telegraphed, "The price of the *Carlyle* has advanced to one thousand guineas. Dinna ye hear the bagpipes?" The year, financially, he confessed to Algernon Graves, "has been notably a bad one for us all," but he would not have his artistic motives impugned by a purchaser. However abortive, the campaign indicated the progress Whistler had made since Venice, which was out of proportion to the work he had accomplished. Even the much-maligned Harry Quilter wrote in the *Spectator* of the *Lady Archibald Campbell,*

> Circumstances have rendered it difficult for us to write of Mr Whistler's work without considerable hesitation, but we shall at least not be suspected of any undue partiality in our admiration of this portrait. We do not find it possible to take the artist's point of view—we do not believe in his conception of what painting and portraiture is and should be—but if we accept this difference, if we judge this work from its own standpoint, it is difficult to see how it could have been better. The drawing is delicious throughout—easy and masterly as Mr Whistler's drawing can be when he takes the trouble; the tones of the black dress, and its colour and its relief against the dark background, are all good; the attitude and poise of the figure are natural and graceful, and the whole picture is fresh, powerful, and striking,—on the whole, a masterly piece of work, complete and good, full of distinct individuality and great artistic insight.

It earned Quilter no credit with his neighbor; for in an earlier letter to the *World* Whistler had insisted on "for me, O Atlas, the *succès d' exécration*—the only tribute possible from the Mob to the Master!" Eventually, Whistler sought for praise, but the time was not yet.

acknowledge the receipt of your letter, officially informing me that the Committee award me a second-class gold medal. Pray convey my sentiments of tempered and respectable joy to the gentlemen of the Committee, and my complete appreciation of the second-hand compliment paid me."

XXIV

Life among the Followers

To John Millais, R.A., Whistler was "a great power of mischief among younger men." In the sense that he created a school, or diverted large numbers of artistic Englishmen from the true faith of an academic painter, nothing could have been more off the mark. But he did work perceptible changes over the years in the way an artist or critic would view reality, on or off the canvas, while the force of his personality did alter the way some artistic lives were led. The authentic Followers were few, and before Venice had been even fewer. The artist who had been, perhaps, Whistler's earliest disciple (but for the Greaves brothers, who were more primitive than they were sophisticated painters), died, at thirty, in 1882. Cecil Lawson painted the crumbling, picturesque pre-Embankment Thames which Whistler had celebrated in *The Last of Old Westminster* and his early etchings, and in 1873 did a canvas, *Twilight Grey*, which was his attempt at a "moonlight," although he violated Whistler's dicta by inserting a Japanese full moon, vast and yellow, in his sky. After his 1878 Grosvenor Gallery show his landscapes and riverscapes, often Pre-Raphaelite in detail yet Whistlerian in mood, were so much in demand yet produced in such modest quantities that they brought great prices while still on the easel. In his formative years, Edmund Gosse, another friend, wrote in a memoir published the year

after Lawson's death, "It is evident that Mr Whistler and the Japanese were engaging his thoughts . . . and he was never so near becoming an impressionist. The same tendency is visible in an extremely fine composition which he never finished, a swan startled under old Battersea Bridge." For the book, Whistler made an etching from it, *The Swan and the Iris*. Preparing an etching from another man's canvas was for Whistler, who generally ignored other contemporaries' work, including that of his coterie, the rarest form of tribute. Then he went back to being Whistler.

The months in Venice with Frank Duveneck's boys had been the unanticipated preliminary to nearly a decade of close relationships with younger artists who would look upon Whistler as master. They were more than a small corps of missionaries who did his every whim and lauded his glories, yet less than a school of Whistler; for they could admire his technique without necessarily copying it, and accept his life style without, but for rare exceptions, copying that either. They saw his hair-trigger pugnacity and calculated eccentricity not as endearing traits but as reaction to academic conservatism in art, and his affection for Japanese decoration and ties to French painting as representing a larger tradition of art than the comfortable English one cultivated at Burlington House. Thus Tom Way and the Australian Mortimer Menpes left the South Kensington Museum, and E. J. Poynter, to help Whistler with his Venice etchings, and Walter Richard Sickert left the Slade School, and Alphonse Legros, to assist Whistler with his portrait painting.

Sometimes the Whistler tradition endured through his followers in spite of himself, for he taught them what he knew only by accident or example, and was often too selfish to be concerned with them as pupils, however slavishly they performed. "You must be occupied with the Master," he told them, "not with yourselves. There is plenty to be done." As James Laver put it, "They ran his errands, they helped print his plates, but (more important from Whistler's point of view) they formed a bodyguard when he walked abroad. In restaurants and on the streets they made him the center of a noisy crowd. They advertised him everywhere. They were terribly bad for him, and terribly necessary." Some were not even artists: a young art critic, whose wit and overdecorated dress amused Whistler, became part of the circle. Another Follower, Harper Pennington, was a Duveneck pupil, as had been Otto Bacher. Frank Miles, Julian and Waldo Story, Rennell Rodd, Sidney Starr, Anthony Ludovici and William Stott looked on Whistler as Master even when painting more in the tradition of Rossetti, Millais and Moore, and Philip Wilson Steer

remained in an outer orbit until he could no longer breathe in the courtier atmosphere.

For a Follower in the early 1880s any assistance given Whistler was ecstasy. When Menpes was summoned from grinding ink to try his hand at the press he was almost too overwhelmed to ink the plate of *The Palaces* (Venice) and pull the proof, and when Whistler adjusted his eyeglass and pronounced it "Amazing! Try another," Menpes was almost overcome with bliss, despite Whistler's cautioning, "Your hands, I know, Menpes, are doing the work, and your palm wipes the plate; but it is my mind, the mind of the Master, that is in the work, making it possible for you to do it. I have educated and trained you, and have created an atmosphere which enables you to carry out my intentions exactly as I myself should. You are but the medium translating the ideas of the Master."

When, in the winter of 1883–84, Menpes and Sickert accompanied Whistler to the Cornish coastal town of St Ives, "the very toenail of England," as Leslie Stephen would describe it, they were up at six because he wanted an early start, yet patiently waited to eat breakfast until he made his entrance and rang the bell. They prepared his panels, mixed his paints, cleaned his brushes. And they saw Whistler begin to experiment in new, less demanding techniques, and learned from them. In his fiftieth year (he was forty-six when he returned from Venice) he was tiring of the large-scale portraiture which his own exhausting demands often turned into rubbed-out or rejected canvases, doing fewer and fewer of them each year. From Cornwall he wrote to Paul Deschamps of the Society of French Artists that he was at St Ives "doing a lot of curious little 'games,'" by which he probably meant the seascapes, landscapes and townscapes on nine-inch or seven-inch panels which were easy to carry and upon which he painted a minimum of brush strokes to achieve the essentials of a scene. His shop fronts were nearer to total abstraction than anything else of the period, but it was the sea, he wrote to Godwin, which kept him there: "The country you know never lasts me long and if it had not been for the sea I should have been back before now."

At St Ives, Sickert purchased the devotion of their landlady with presents of fish, which he bought from local fishermen. Whistler was annoyed by the attention it got Sickert, and once when he was out painting his impression of a shop, Menpes saw him confronted by a potential gift that would outdo Sickert:

> Suddenly I heard a puffing and a blowing, and looking up I saw
> two men coming towards us carrying suspended from a pole an

enormous fish, a great flat thing about the size of a dining-room table. Whistler saw it, too, and . . . was inspired to buy the creature for the landlady. "Hey, stop!" he shouted. "How much for the fish? I'll give you half-a-crown." "Right you are," said the men, and they promptly laid the fish down on the ground, pocketed the money and went off. I pretended to ignore Whistler, the fish, and the whole transaction. "I say, Menpes," he shouted to me, "they have accepted it." It was all so sudden. Whistler had paid the half-crown, the fishermen had laid the fish down and disappeared all in the space of a few seconds. Whistler kept calling me to come, but I dared not approach him; I was convulsed with laughter. Here was this enormous flat fish and Whistler circling round and round, daintily probing it with his long cane and trying to find which way up it was, for the creature looked the same all round. And when I could steady myself a little, I asked him what he was doing. "Which, Menpes," he said—"which should you imagine was his chest?" It was impossible to tell; and I went on with my work and Whistler with his, and we left the fish on the pavement and never referred to it again.

Loyalty was essential to a Follower. To art dealer Walter Dowdeswell he once wrote, understanding the fickleness of loyalties, particularly his own, "I am staying with Sickert, of whom, for the moment, I approve—!" He did not always approve. When Sickert wrote a column praising Frederick Leighton's *Summer Moon*, at an exhibition in Manchester, Whistler telegraphed to his disciple in Hampstead, "The Summer Moon rises at Hampstead, and the cocks of Chelsea crow." He loved writing sharp notes to the press, or telegrams to his friends. "Often I was with Whistler when he thought of a brilliant phrase," Menpes remembered. "We might be in a hansom cab or at a Soho restaurant, and he would say, after telling the then latest quips, 'Now, who shall I tack it on to, Menpes?' If an opportunity did not occur, he very soon made one by writing a letter which called for answer." He could be stingingly cruel to the Followers too, but submission—and the pretense that it was just a joke, as was often true—was the price of remaining close. Thus when Sickert and Whistler were both printing etchings together and Sickert dropped a plate, Whistler observed, "How like you!" But a few minutes later he dropped one himself. "How unlike me!" he said.

It was unlike Whistler to be completely without pose, however he was sometimes trapped at it. Although visitors to the studio could be taken in by the calculated effects, Followers understood, however blind their initial adoration. He was uneasy about the continuing criticism of lack of finish in his work, sometimes defending his method and at other times pretending indifference. "Now, that is one of your good ones," a foreign artist exclaimed, pointing to a small picture in the studio.

"Don't look at it, dear boy," said Whistler; "it is not finished."

"Finished!" protested the visitor. "Why, it's the most carefully finished picture of yours that I have seen."

"Don't look at it," Whistler insisted. "You are doing an injustice to my picture—and you are doing an injustice to *me!*" And while the visitor continued to look bewildered, Whistler cried out dramatically, "Stop, I'll finish it now!" Then he located a small camel's hair brush, fixed it onto a long, slender handle, mixed a droplet of paint on his palette, tipped the brush into it and, standing off from the canvas lunged forward like a fencer and touched the picture in one almost imperceptible spot. "Now it's finished," he announced. "Now you may look at it!"

The next day the visitor, who had forgotten his umbrella, returned for it, and a servant let him in. While waiting he glanced at the canvas, looking for the touch of color he had seen so theatrically applied. It was gone. Whistler had carefully wiped it off.

The young artists who clustered about Whistler watched such scenes without disillusion. They knew that they benefited from being around him even when they were unable to capture what he could. "The magic of the mood," Sickert mused afterwards, "can be prolonged in the air, hung up, by an experienced magician for say, twenty-five minutes. (I have seen a wave that Whistler was painting, hang, dog-eared for him, for an incredible duration of seconds, while the foam curled and creamed under his brush . . .)." There was magic indoors as well. "We were allowed the intimacy of his studio," Menpes wrote; "we watched him paint day after day; we studied his methods, witnessed his failures and successes. He never placed us down as pupils and told us to paint such-and-such an object, nor did he ever [ask to] see our work when it was finished; but we felt his influence, nevertheless, and strongly. . . . We Followers saw things from Whistler's standpoint. If we etched a plate, we had to etch it almost exactly on Whistlerian lines. If Whistler kept his plates fair, ours were so fair that they could scarcely be seen. If Whistler adopted economy

of means, using the fewest possible lines, we became so nervous that we could scarcely touch the plate lest we should overelaborate."

Sometimes a Follower would work side by side with Whistler in his studio, using the same model. "I painted a small panel of Duret," Sickert wrote, "while W. painted his large portrait. . . . I painted a sketch of 'The Blue Girl' actually taking the mixtures off Whistler's palette. . . . I etched a plate of Stephen Manuel while he was sitting to Whistler." *
After Sickert's marriage to Ellen Cobden, he even commissioned portraits of his wife and himself from his Master, unwisely putting down the entire hundred guineas in advance for his own, and thirty guineas for the other. Whether an act of homage or an overly optimistic view of his prospects, the commissions in typical Whistler fashion were not only long in being completed but even in getting started, and Sickert even wrote for the return of the deposits, explaining that he was in financial difficulties and it was "becoming a question of shillings—for the moment." Eventually Whistler painted the pictures rather than search for the pounds to replace what he had long since spent, and Sickert acknowledged delivery of his wife's portrait with "Of course it is impossible to thank you at all for doing us such a work. We shall always look upon it as practically a magnificent present. . . . Now certainly the moneys are ridiculous and bear no sort of proportion to the value of the work." And he signed himself "W.S. (Pupil of Whistler)." †

Any request Whistler made to a Follower was *Important*, Menpes remembered:

> Invariably, every morning, I received a letter saying, "Come at once. Important." On rushing round to his studio I found another letter directing me to a certain spot on the Embankment at Chelsea, and there the master would be working at, perhaps, a little shop with a few soiled children in the foreground. . . . Perhaps, if one of them appealed to Whistler from the decorative standpoint he would say, "Not bad, Menpes, eh?" This was, perhaps, a very grubby little person indeed. But Whistler would take her kindly by the hand and the three of us would trot along to ask the mother if she might sit, the child with its upturned

* For the child-portrait *Master Stephen Manuel.* Whistler as he grew older became increasingly interested in, and effective at, painting children.

† One version of the Ellen Sickert portrait (*Violet and Pink*) was exhibited and apparently later destroyed for reasons unknown; another survives (Fogg Museum) as *Green and Violet.*

face gazing with perfect confidence at Whistler. And the master would talk to that little gutter-snipe in such a charming intimate way about his work and aspirations! "Now we are going to do great things together," he would say, and the little dirty-faced child blinking up at him seemed almost to understand. For Whistler never failed with children; no one understood them quite like the master, and no one depicted child-life better than he. Whistler's children were never little old ladies; they were real children, with all the grace and ingenuousness of childhood apparent in every line. He would explain to this child his entire scheme for the work, and together we would go back to the studio where, perhaps, the little one would help to set the table for lunch, settling down at once to full responsibility, for Whistler in some ways was very helpless. Then she would sit, and Whistler would paint—sometimes a life-sized oil-colour, sometimes a little pastel. But from the moment his brush touched the canvas, the child as a child was forgotten, and she might droop and faint before Whistler would come down to earth again and understand that this was a living, breathing mortal. Sometimes after a long afternoon the little girl began to bellow, something was hurting her or she was stiff with standing so long, and Whistler, looking up with a start, would say, "Pshaw! What's it all about? Can't you give it something, Menpes—can't you buy it something?" And the child eventually left the studio laden with toys, and perfectly happy once more.

American artists frequented the studio, some on their way to or from the Continent, others resident in London. Whistler, who had no idea of the distaste for him Julian Alden Weir in the late seventies had confessed to in letters home, once came upon the son of his old West Point teacher copying the Velasquez *Philip IV* in the National Gallery. Looking over the younger artist's shoulder he murmured, "Not bad," and Weir, annoyed at the patronizing comment turned around, saying, "To whom am I indebted for this compliment?" Unwithered, Whistler mentioned his name, and when Weir, overcome with confusion, identified himself, Whistler insisted that he go off to dine with him that evening. Weir protested that he would not be presentable in his working clothes, but the objection was brushed aside. Outside the gallery they hailed a hansom and started off. First they stopped at one of Whistler's clubs, Whistler going

in but soon emerging to report that he disapproved of the dinner menu; then they tried another club, this time Whistler finding it impossible because some bore he disliked showed no signs of leaving. They would try potluck in Chelsea, Whistler said, and sent the driver on to his home, where Weir was told to wait in the parlor while his host bathed and dressed. The room was quiet, but beyond Weir could hear people talking gaily. After what seemed—and probably was—a long time, Whistler reappeared and escorted Weir into a dining room full of guests who had all been previously and properly invited—and were accoutered, unlike Weir, in evening dress. But Weir found it difficult to react sourly: the occasion was too gay and festive. Later he enjoyed telling the story on himself.

Whistler's dinner habits as a guest were equally disconcerting. Punctuality had a low position in his priorities. Asked to dinner by a punctilious host, he had made no entrance by a point late in the evening, and the party sat down to dinner. Soup and fish were served, and still no Whistler appeared. When at last he arrived, his host's ill-concealed displeasure made no impression as he grasped the limp hand and rattled into the grim face, "Don't apologize for having begun without me. I shan't be offended in the very least." And he took his seat and became the life of the party.

William Chase arrived from America to study painting, and among other things wanted to study Whistler's art and paint the Master's portrait. Whistler agreed to pose while painting a canvas himself, until another American offered to buy a selection of Whistler's etchings and Chase urged Whistler to close the deal, for their work had been interrupted by tradesmen with their bills, and the Master had made no attempt to conceal the fact that he was again deep in debt. "Poor fellow," Whistler would say of a would-be caller with an obviously large bill, "I really must do something for him! So sorry I'm not in."

Still Whistler stalled about meeting the prospective purchaser at a bank in Queen Street to receive his check, claiming the needs of a particular canvas in progress; but Chase was insistent. "Very well," he said finally, laying down his brushes. "Now we'll go."

"Why *we?*" I replied. "I don't want to go," I protested firmly. . . .

"Oh, but you must," he said calmly, bringing my coat and hat; and presently we stood in front of the house signaling a cab.

One came up readily enough, but, after one scrutinizing look upon the "cabby's" part, drove swiftly by; another went through the same strange proceeding. I looked questioningly at Whistler . . . but Whistler was calmly signaling. At length a cabby took us in.

Whistler always carried as a walking-stick a long, slender wand, a sort of a mahlstick, nearly three quarters his own height. We were no sooner seated than he began poking his stick at the horse's hindquarters. The animal reared, plunged wildly, and started down the street at a breakneck gallop, while the astonished cabby swore freely and tugged desperately at the reins. Whistler looked calmly ahead, and kept poking.

Butcher-boys and grocer-boys made wild leaps for safety; outraged cabbies whipped their horses out of the way just in time, burly draymen bawled curses after us, and still we went merrily on. Little wonder, thought I, in the midst of my amazement and resentment, that Whistler never gets the same cab twice.

Suddenly he began waving his cane and screaming "Whoa!" He took the astonished cabby severely to task for driving so fast upon the public highway, and ordered him back to a corner we had just passed.

Here a greengrocer's shop, with its orderly and colorful array of fruits and vegetables, had caught Whistler's eye as we whirled by. He surveyed it critically now from two different positions, the cabby meekly obeying his orders, under the belief, I presume, that it was policy to humor an insane person.

"Isn't it beautiful!" exclaimed Whistler. He pointed his long cane at one corner. "I believe I'll have that crate of oranges moved over there—against that background of green. Yes, that's better," he added contentedly.

We drove on to the bank, where we found the American pacing up and down in no pleasant frame of mind; but Whistler soon had him pacified, and we left him waving and smiling adieus at us.

The incident at the greengrocer's shop reads like an arrant affectation. It was not, however. Whistler, as usual, was merely most natural. The following morning he posted his easel at the corner and painted the shop.

The casual behavior was so meticulously planned to impress the Followers as well as the public at large that it became, over the years, face as well as mask. That he could be unselfish, uncombative, unassuming, uncynical—even unobjectionable—seemed impossible. Yet with the Followers there were moments when he tired of playing the game, as when he took Harper Pennington to the Royal Academy, introduced him everywhere, calling him "pupil," and even praised an R.A.'s work. It was before an interior scene by Sir William Orchardson, who painted thinly and in low tones as did Whistler, but used his canvases to tell the melodramatic anecdotes Whistler despised. "Well," Pennington recalled to the Pennells, "he stood in front of the canvas, his hat almost on his nose . . . , and presently a long forefinger went out and circled round a bit of yellow drapery. 'It would have been nice to have painted that,' he said, as if he thought aloud."

One veteran Follower who was never seen with Whistler if the Master could help it was Walter Greaves. The boatman was too unsophisticated, too much an artistic primitive to fit in the new circle, although he was available for odd jobs. When in 1885 Whistler moved Maud and his studio to 454A Fulham Road, Greaves helped paint the shabby house which Whistler called the "Pink Palace." It was far removed from palace standards, but the move from Tite Street (Sargent took over the lease) was necessary: he was painting a great deal but selling little and living extravagantly. In Fulham Whistler painted Lady Archie, Walter Sickert, and Theodore Duret, who would come to dinner bringing bottles, fruit, and cake. The whitewashed walls and wooden rafters (useful as a loft for storing canvases) gave the studio a bohemian look, but the effect was not one of prosperity. Soon afterward he and Maud established living quarters closer to their old Chelsea haunts in a house with an overgrown garden in The Vale, a *cul-de-sac* off the King's Road. In the eighties The Vale was guarded from the noisy traffic of the King's Road by a rickety wooden gate across from Paulton Square, beyond which one entered a short stretch of quiet country land and creeper-shrouded trees which were all that remained of an ancient deer park. In the other two houses lived the mild and mediocre poet Alfred Austin* and the minor novelist William de Morgan. It was no Bohemia. Each move isolated Maud more from Whistler's circle, while the public

* Who would become Poet Laureate after Tennyson, because he was a Conservative and had no embarrassing personal idiosyncrasies.

Whistler still frequented fashionable London (and his six clubs) as well as the arty triangle formed by Tite Street, the Queen's Road and Cheyne Walk, and the Embankment.

The public Whistler was a work more "finished," his critics might have said, than his art. Menpes recalled going with him to his hairdresser in Regent Street, where all other activity stopped as everyone turned to watch Whistler direct the trimming of every lock, then plunge his head into a basin of water, half-dry it into matted curls, then carefully pick out the white lock just above his forehead, which he wrapped in a towel and walked about drying separately. Then he would beat the rest of his hair into ringlets, call for a comb to feather the white tuft, and sail out in search of a four-wheeler. In dress he sought out white duck trousers and overlong black frock coats, to create a harmony in black and white, modified it with yellow gloves, and elongated his person with the thin wand that could not have supported him had he used it for a walking stick. His unconventional dress, his outrageous behavior and flair for self-advertisement, his cultivation of a corps of Followers, critics could have said, were devices to divert attention from his artistic failure—the props of pride. But for Whistler the manner was a calculated risk: the only way to make the most of his special genius was to create an audience for it. "Fame, even if artificial, is not only a balm, it is a tonic. . . . An artist must have some kind of fame during his lifetime if he is to do his best work," James Laver suggested in defense of the public Whistler. "If that is so, then the artist is justified in organizing his own fame if he can, . . . [for] publicity is an essential part of his business." So was something else, Whistler observed to Starr one evening, leaning forward in their hansom as they rode along rain-glistened Piccadilly past Green Park on their way to the Café Royal. "I have not dined, as you know, so you need not think I say this in anything but a cold and careful spirit: it is better to live on bread and cheese and paint beautiful things than to live like Dives and paint potboilers. But a painter really should not have to worry. . . . Poverty may induce industry, but it does not produce the fine flower of painting. The test is not poverty; it's money. Give a painter money and see what he'll do. If he does not paint, his work is well lost to the world. If I had, say, three thousand pounds a year, what beautiful things I could have done!"

The insecure Whistler who preferred not to be alone, even in his studio or on a walk along Bond Street, could not help turning on his effrontery or charm—or both—at the dinners at which he arrived late, the

galleries at which his more staid rivals exhibited, the clubs which kept him more and more away from Maud. He belonged to the Arts, the Arundel, the Beefsteak, the Chelsea Arts, the Hogarth and the Beaufort Grill Club, and often conducted his business from them. Inevitably, as he became a more public person, Maud was withdrawn more from his artistic as well as his public life. A flaunted irregular union had a negative social and commercial impact. In accord with proper Victorian hypocrisy the invitations he received excluded her, however often Chelsea tradesmen called her "Mrs Whistler." And Maud modeled less and less for the Master, although she modeled now and then for a Follower, for portrait commissions came complete to subject, and even when no commissions came, a titled or socially acceptable lady was a better business risk for a great new canvas—especially if she were beautiful.

Whistler nevertheless continued to paint men as well, including several Followers, and the affair of Chase's portrait of Whistler and Whistler's portrait of Chase (equally unfinished but with an advance paid) provides a look at the private Whistler. The public Whistler, although exhilarating as a role, proved tiring to play without let-up, and after a museum-hopping trip to Holland the two took before Chase returned to America, the Master wrote to thank him for the good companionship:

> No! *Noo* NOO—Your stay here was charming for me and it is with a sort of self-reproach that I think of the impression of intolerance and disputatiousness you must carry as characteristic of my own gentle self—which also I suppose it will be hopeless for me to attempt to efface by even the mildest behavior when I return your visit in New York. Our little trip to Holland was charming and I only wish I could have stayed longer. Indeed if I had but gone with you to the gallery in Haarlem I might have done something toward rehabilitating myself in your eyes for I had meant to be quite sweet about the pictures as after all "there is nothing mean or modest about me." . . .
>
> Meanwhile our two pictures. By the way the world will have to wait, for yet a little while longer. You see colonel we rather handicapped each other I fancy and neither master is really quite fit for public presentation as he stands on canvas at this moment. So we must reserve them, screening them from the eye of jealous mortals on both sides of the Atlantic until they burst upon the painters in the swagger of completeness.

This is a disappointment, though only a temporary one, to me most certainly so far as your portrait goes for I should have liked you to have taken it over with you and shown it on your arrival. But in these matters I never deceive myself and I saw at once on my return from abroad that the work is not in its perfect condition and Whistler cannot allow any canvas stamped with the butterfly to leave his studio until he is thoroughly satisfied with it *himself*. . . . Under the circumstances I send you back the thirty pounds you had given me on your portrait—trust me it is better so—it would only make me nervous and unhappy were I to keep it before my work pleased me. . . .

Inevitably there was a rift with Chase, as with most Followers, Whistler annoyed that the American, on the basis of the brief intimacy, should give lectures on art which stressed his relationship with the Master as if it had been the friendship of a lifetime. Neither he nor his portrait of Chase ever came to the United States. With Sickert there was a rupture in the Nineties, while the break with Menpes came more quickly. Whistler had been so close to Mortimer Menpes that he became the godfather of his daughter, who was named Dorothy Whistler Menpes, and in the mid-Eighties painted her portrait as a gift to the family (*Note in Flesh Colour and Grey: Dorothy Menpes*). But Menpes committed several unpardonable offences, the first of them a voyage to Japan, which he took without telling Whistler first, knowing that he would be indignant about a mere Follower voyaging to the nation whose heritage the Master had transmitted to England. Letters that were "pin-pricks" followed, but the real tiff came at the Hogarth Club, their first encounter after Menpes' return.

When he saw me he laughed his marvelous laugh, and said, "Ha, ha! amazing!" All round the room one heard faint echoes,* "Ha ha! amazing!" "Well, sir," he said, "excuse yourself." I found it difficult, for I earnestly felt that from his standpoint there really was no excuse for my conduct. I could discover nothing with which I could plead extenuating circumstances. At the same time, filled with remorse and shame though I was, I could not resist telling him that I had met, in Japan, another master. "What!" screamed Whistler. "How dare you call this Japanese a

* From other Followers.

master on your own responsibility? Give me your reasons. What do you mean by it?" Then and there, in the Hogarth Club before Whistler and his followers, I began to explain Kyôsai's method of painting. So engrossed did I become in my topic that I talked on and on far into the night, forgetting all antagonism, forgetting everything, except that I was a student, and was describing to one master the methods of another. . . .

He forgot his anger against me for going to Japan, forgot everything, save his intense interest and desire to hear more of the Japanese painter who also was a master. The feeble followers he dismissed. Treating me as a friend and pupil once more, Whistler took me by the arm, and we walked home together to the "Vale." We sat up talking until the small hours of the morning; or rather I talked, for once, and Whistler sat drinking in every word. I described Kyosai's methods in detail, even to the mixing of his pigment and the preparing of his silk panels, for Whistler in some ways was a faddist and revelled in detail. When he was bidding me good-by on the doorstep, Whistler's last words were, "These Japanese are marvellous people, and this man Kyôsai must be a very great painter; but,—do you know?—his methods and mine are absolutely similar!"

Not long afterward Menpes had an exhibition of his Japanesque pictures, and Whistler appeared in the gallery, scowling and carrying an open copy of the *Pall Mall Gazette*, which contained a laudatory notice of the show. "You have stolen my ideas," he raged. "The eccentric hanging of this gallery brings ridicule upon the Master. Now, what do you propose to do? Your only hope of salvation is to walk up and down Bond Street with *Pupil of Whistler* printed in large letters on a sandwich board at your back, so that the world may know that it is I, Whistler, who have created you. You will also write to *The Pall Mall Gazette*, and tell them that you have stolen my ideas; also you will call yourself a robber."

Later Whistler encountered Menpes making a sketch on the Thames Embankment, and railed, "How dare you sketch in my Chelsea?" Still later Menpes made the mistake when redecorating his house in Fulham of using Whistler's favorite lemon-yellow color for the walls, and newspaper articles described "The Home of Taste." The Master was enraged, planting an imaginary and derogatory interview with Menpes in a Philadelphia newspaper and writing to *The World* claiming the color as

his own invention, but doing so, he said, "at the risk of advertising an Australian immigrant of Fulham—who, like the Kangaroo of his country, is born with a pocket and puts everything into it."

From that time on, when Menpes' name was mentioned in the presence of Whistler he would say, "Eh, what? Meneps—who's Meneps?" And the Followers about him would echo, "Meneps? Who's Meneps?" But Menpes was not quite dead, turning up with Justin McCarthy unexpectedly at a dinner where Whistler was a guest. Immediately the betrayed Master recalled Father Damien, who had died after ministering courageously to a leper colony. "Ha-ha!" he called out to McCarthy to warn him about contagion from Menpes. "Have you forgotten? Damien died!"

Despite the seeming brutality of the remark, Whistler relished the quip more than the grudge. Only toward one former Follower did the banter become enduringly bitter—a Tite Street neighbor named Oscar Fingal O'Flaherty Wills Wilde.

XXV

Jimmy and Oscar

"**M**Y nature needs enemies," Whistler once confessed. He had the compounded combativeness of the alien and the undersized, and often turned friendship into "a stage on the way to a quarrel," but too often the scorpion sting of the Whistler butterfly was wasted on trivial antagonists. In Oscar Wilde he met his match even before he knew he had a quarrel.

"I wish my full remarks on Mr Whistler to be put in (as per margin)," Wilde had written to Keningale Cook, the editor of the *Dublin University Review*, in returning his galley proof. "I know he will take them in good part, and besides they are really clever and amusing." What he had written, to the editor's uneasiness, had been aimed at *The Falling Rocket* and a companion nocturne: "These pictures are certainly worth looking at for about as long as one looks at a real rocket, that is, for something less than a quarter of a minute." His review of the first (1877) Grosvenor Gallery exhibition was his *entrée* into published journalism. But because it ran in a small-circulation journal distributed mostly in Ireland, Whistler may never have seen it.

Still more than a year from his Oxford B.A., Wilde, who had been at Trinity College, Dublin, was completing his education in a leisurely way. Although he visited the theatres and galleries more than most undergrad-

uates, and almost certainly was more visible than most of them, he was little known in London. After taking his B.A. in 1878, he identified himself as an art critic and poet (he had won the prestigious Newdigate prize at Oxford), lived mostly on a small inheritance from his father and moved with an effete artist friend, Frank Miles, first to rooms in Salisbury Street, off the Strand, then in August 1880 to 1 Tite Street, at just about the time Whistler was settling into his Tite Street studio.

It would have been difficult for either not to notice the other. During Whistler's exile in Venice Wilde had blossomed into a London personality. In his bulk and extravagant clothes he appeared to be Whistler grotesquely magnified, while his deliberately absurd talk seemed to be Whistler outrageously reduced to nonsense. Wilde was a walking advertisement for himself, and was not surprised when he heard a passerby comment, "There goes that bloody fool, Oscar Wilde," although he remarked to his companion, "It's extraordinary how soon one gets well known in London!"

Only a Follower could have withstood Whistler's barbs and remained for more, and Wilde was more than that. He understood the value of the prickly and prolonged initiation. Whistler after Venice was not accumulating riches, but he was accumulating newsprint. Wilde bided his time, and—almost always—knew when he had said enough. To answer the Master required courage, and a nimble tongue. "I remember a breakfast," Rennell Rodd told the Pennells, "which Waldo Story gave. . . . Everyone there had painted a picture, or written a book, or in some way outraged the Philistine, with the exception of one young gentleman, whose *raison d'être* there was not so apparent as were the height of his collars and the glory of his attire. He nevertheless ventured to lay down the law on certain matters which seemed beyond his province, and even went so far as to combat some dictum of the master's, who, readjusting his eye-glass, looked pleasantly at him, and said, 'And whose son are you?' "

Wilde's gaudy dress rankled Whistler more in retrospect, when he wrote of Oscar as a man "with no more sense of a picture than of the fit of a coat," and early in their association, seeing Wilde on Tite Street "in Polish cap and green overcoat, befrogged and wonderfully befurred," Whistler sent him a mocking message over the Butterfly:

Oscar—How dare you! What means this unseemly carnival in my Chelsea?

Restore those things to Nathan's, and never again let me see you masquerading the streets in the combined characters of a degraded Kossuth & Mr Mantalini! *

Whistler took the appearance of an exaggeration of himself in good humor, for the young poet and critic had little real claim to attention, even though by early 1880 George Du Maurier had been caricaturing Wilde in *Punch*, usually as Jellaby Postlethwaite the aesthetic poet. At one Whistler exhibition Du Maurier even brought the two face to face, taking each by the arm and inquiring, "I say, which one of you two invented the other, eh?"

Oscar's high compliment of imitation went beyond the verbal to Whistler's portraits and nocturnes. In his verses dawn rose "Like a white lady from her bed," wharves were "shadowy" in thick fog, and an omnibus crawled across a bridge "like a yellow butterfly." A poem entitled "In the Gold Room: A Harmony" devoted stanzas to ivory, gold and red, and had as subject a girl in a music room, recalling *The Music Room* and *At the Piano*. And in "Impression du Matin":

> The Thames nocturne of blue and gold
> Changed to a Harmony in Gray:
> A barge with ochre-coloured hay
> Dropt from the wharf: and chill and cold
> The yellow fog came creeping down
> The bridges, till the houses' walls
> Seemed changed to shadows. . . .

If Wilde had not yet found his own style, he had found others', in painting as well as poetry, which were there for the taking. His lectures on aesthetics would have sounded familiar too, had Whistler heard them, for Wilde had an ear for re-usable conversation as well as an eye for a translatable brushstroke; and Jimmy Whistler's pontifications and *bons mots* eventually returned to him, attributed to Oscar, in press cuttings from the Atlantic to the Pacific.

From America, where he toured for more than a year, going from Boston and New York to mining towns in the West and New Orleans in the South, appearing on the platform at the promoter's behest in

* Nathan's was the theatrical costumier; Lajos Kossuth (1802–94) was a Hungarian patriot and revolutionary often pictured in befrogged coats, while Mr Mantalini in Dickens's *Nicholas Nickleby* dressed like a dandy.

plum-colored velvet knee breeches, Wilde saw to it that newspapers reporting his lectures reached a dozen or two of his London friends, including Whistler. The Americans, he wrote Whistler, "are 'considering me seriously.' Isn't it dreadful? What would you do if it happened to you?" Whistler responded with a letter which reached Wilde in Chicago:

> Oscar! We of Tite Street and Beaufort Gardens joy in your triumphs, and delight in your success, but—we think that, with the exceptions of your epigrams, you talk like Sidney Colvin in the Provinces, and that, with the exception of your knee-breeches, you dress like 'Arry Quilter.

The language was pure Jimmy Whistler, but it was signed also by "Janey [Lady Archie] Campbell, Mat Elden and Rennell Rodd." * Leaving nothing to chance, Whistler published a version of the letter in the *World* (Feb. 15, 1882). Wilde was quick to respond, sending Whistler a telegram, "I ADMIT KNEE-BREECHES, AND ACKNOWLEDGE EPIGRAMS, BUT REJECT QUILTER AND REPUDIATE COLVIN." Their at-first friendly feud was on.

Wilde sailed home on December 27, 1882, and spent several weeks in London before going to Paris for three months to spend what was left of his American earnings. From the Hôtel Continental he wrote to American sculptor Waldo Story—also a friend of Whistler's—that he had seen "a great deal of Jimmy in London *en passant*. He has just finished a second series of Venice etchings—such water-painting as the gods never beheld. His exhibition opens in a fortnight in a yellow and white room (decorated by a master of colour) and with a catalogue which is amazing. He spoke of your art with more enthusiasm than I ever heard him speak of any modern work. For which accept my warm congratulations: praise from him is something."

By all evidence Wilde was still a convinced Follower. The verbal sparring, he understood, was the best publicity he could have. The feeling

* Sidney Colvin was a literary critic and Slade Professor of Fine Arts at Cambridge; Rennell Rodd was a poet and Oxford friend of Wilde's who became a diplomat and as Lord Rennell of Rodd was Ambassador to Italy, 1908–19; Mat Elden may be the "Mr Eldon" whose portrait, once owned by Walter Sickert, was attributed to Whistler, who lent Whistler money in pre-Venice days, and who was described by Thomas Way as "a mysterious man named Eldon [who] was constantly around him. What he did exactly, or even how he lived, I don't know, but he was entertaining, and seemed generally to make himself useful to Whistler—but, alas! . . . Eldon went out of his mind and died in an asylum."

was mutual. Whistler needed an ally among the critics. Wilde seemed the most brilliant new voice in criticism to have come along in years; and if that voice seemed to be at times an echo of Jimmy Whistler, that was all to the good. Thus visitors to the studio often found Oscar among the guests, entertaining the Master as he worked, and when Jimmy went to Paris in the spring for the Salon exhibition at which the *Mother* was shown, he was seen with Oscar, as the prim Mary Cassatt wrote to her sister-in-law in Philadelphia. "Whistler has been awarded a third class medal at the Salon, he asked for one and the jury were determined to punish him for his nonsense by putting him in the 3rd class, he behaved like a fool here, he and Oscar Wilde together." Wilde apparently brought out the silliness in him more outrageously than his other Followers. When he visited Edgar Degas, Eddie Cassatt (Mary's nephew) reported, Degas—perhaps reacting to Whistler's dapper dress and "cane about three and a half feet high"—asked him with the bluntness only possible between old friends how old he was,* and "Oscar Wilde and another satellite that was there burst out laughing. Whistler answered, 'Twenty-two' . . . Oh he is an idiot. Oscar Wilde and he together are just as crazy a pair of men as can be found on the face of the earth. . . .'"

In the first years of their friendship Oscar may have been ambitious, but he was loyal. After one dining at the Café Royal with young Robert Sherard, when Whistler had again joined them and again carefully ordered "the very cheapest claret to take with his frugal grill" while dominating the talk with a catalogue of grievances against his usual targets, Sherard exasperatedly told Wilde that conversation with Whistler before a meal "was an excellent substitute for bitters as an *apéritif.*" But to Wilde then, Whistler was "a grand Virginian gentleman," and he promptly warned Sherard, "One does not criticize a James McNeill Whistler."

In London *Punch* kept the two together in the public eye, publishing words allegedly overheard at the annual business meeting of the Hogarth Club. "I was standing," reported *Punch*'s correspondent, "at the buffet, when I suddenly heard the voice of Mr Oscar Wilde discussing with Mr Whistler and others the attributes of two well-known actresses. The criticism is at least expressive. 'Sarah Bernhardt,' he said, 'is all moonlight

* Degas and Whistler were both born in 1834 and had known each other since student days in Paris.

and sunlight combined, exceedingly terrible, magnificently glorious. Miss [Mary] Anderson is pure and fearless as a mountain daisy. Full of change as a river. Tender, fresh, sparkling, brilliant, superb, placid.' " On reading it Oscar—away lecturing in Exeter on "The House Beautiful"—rushed off a telegram to Jimmy:

> PUNCH TOO RIDICULOUS. WHEN YOU AND I ARE TOGETHER WE NEVER TALK ABOUT ANYTHING EXCEPT *OURSELVES*.

Whistler quickly responded:

> NO, NO, OSCAR, YOU FORGET. WHEN YOU AND I ARE TOGETHER, WE NEVER TALK ABOUT ANYTHING EXCEPT *ME*.

And he quickly sent copies of the exchange to "Atlas," who published them in the *World* on November 14, 1883, although not an alleged* Wilde reply, "It is true, Jimmy, we were talking about you, but I was thinking of myself."

Such raillery could only have been exchanged between friends, and the quality of the friendship as it existed late in 1883 was indicated by Whistler's last Sunday breakfast of the year. As "Atlas" on December 26 reported the event in a column certainly planted by Whistler, it was given

> in honour of two happy couples, Lord Garmoyle and his fairy queen,† and Oscar and the lady whom he has chosen to be the *châtelaine* of the House Beautiful. . . .

The House Beautiful would be 13 Tite Street, a three-story red brick structure across the street from Whistler's studio, the decoration of which would be supervised by Jimmy and Ned Godwin, as befit a Whistler Follower. The bride was the daughter of the late Horace Lloyd, Q.C. "Her name is Constance and she is quite young, very grave, and mystical, with wonderful eyes, and dark brown coils of hair," Oscar wrote to "Waldino" Story, "quite perfect except that she does not think Jimmy the only painter that ever really existed: she would like to bring Titian or somebody in by the back door: however, she knows I am the greatest poet, so in literature she is all right: and I have explained to her that you are the greatest sculptor: art instruction can go no further."

* Reported by Wilde biographer Hesketh Pearson (1946) but not included in Rupert Hart-Davis's *The Letters of Oscar Wilde* (1962).

† "The "fairy queen," Miss Fortescue, several months later sued Lord Garmoyle for £30,000 for breach of promise. Garmoyle by then had slipped off to India.

The wedding took place at St James's Church, Paddington, on May 29, 1884. Among the telegrams received was one from Whistler: "AM DETAINED. DON'T WAIT."

Among the couple's wedding presents were Venetian etchings from Whistler, which Constance wrote her brother Otho were beautiful. But Whistler, with the usual harsh license he appropriated for Followers, made public fun of the furniture in a punning letter to Godwin he had published in the *World* on October 17, 1884:

> I hear you have been dressing our Oscar in plush!—why? That I
> thought, ceased with the breeches—you know:
> "Knee plush ultra!"

The going would get even more rough. As long as Wilde gracefully acted as though he considered Whistler his master as raconteur and critic there were no problems between mentor and disciple. But Wilde was listening and learning, and had a genius for absorbing not only the brightest ripostes he heard but for repeating them, often subtly turned, as his own. At one dinner party Wilde's talk appeared to Whistler to be leading up to some carefully prepared witticism, and almost everyone was listening, especially Whistler, who was certain the performance would end in a line borrowed from him. But in the midst of it the lady whom Wilde had been assigned to take in to dinner, apparently lost on another level of consciousness, turned to Wilde as if he had been totally silent and asked, brightly, "And how did you leave the weather in London, Mr Wilde?" The dramatic build-up ceased, and farther down the table actor-manager George Alexander, who would later produce Wilde's plays, heard a familiar "Ha! ha!" and Whistler, leaning over him, whispered, "Truly a most valuable lady!"

Whistler, who labored to create the effect of spontaneous wit, had nothing of Wilde's fecundity and tenaciously hoarded his own stories and sayings. Nevertheless, when Oscar had asked him for a few tips for a lecture he would be giving to the students' club of the Royal Academy, Jimmy provided some material and Oscar automatically borrowed even more. "In the presence of Mr Waldo Story did Oscar make his prayer for preparation," Whistler set the scene; "and at his table was he entrusted with the materials for his crime." As Jimmy recalled it, "at his earnest prayer I had, in good fellowship, crammed him, that he might not add deplorable failure to foolish appearance, in his anomalous position as art expounder, before his clear-headed audience. He went forth on that

occasion, as my St John—but forgetting that humility should be his chief characteristic, and unable to withstand the unaccustomed respect with which his utterances were received, he not only trifled with my shoe, but bolted with the latchet!"

"Oscar has a memory like one of Mr Edison's phonographs," a newspaper afterwards reported. . . . "[He] was invited to a large dinner party and pelted with questions, across the full length of the table, with reference to the [Academy] lecture. 'Now, Oscar, tell us what you said to them,' the host would repeat inflexibly, and the poor fellow had to trot out all his points again. As each was enunciated, Whistler got up and made a solemn bow, with his hand across his breast to show his sense of the compliment paid to him by the reproduction of his theories. It was at this party that Whistler's famous *mot* first saw the light. . . ." The *mal mot* followed a Whistler epigram not offered to Wilde for his lecture, and Oscar gushed, "Jimmy, I wish I had said that." "You will, Oscar," said Whistler, "you will."

The problem for Whistler was that Wilde did, and what was more infuriating for the Master, after at first enjoying hearing his own lines, was that it became more and more difficult for him to claim ownership of his own ideas. The answer was to put them unmistakably into a lecture of his own. But he had never given a lecture, had a nasal voice unsuited to the platform, and a terror of making a fool of himself in public. With trepidation he went with a friend to the Savoy Theatre to discuss the possibility with the Gilbert and Sullivan impressario, Mrs Richard D'Oyly Carte, who was then rehearsing *The Mikado*. He had been accumulating material for years, having enjoyed producing his post-trial pamphlet against the critics and later pamphlets, catalogues and letters-to-the-editor; however this had to be different: he wanted to elucidate his artistic credo in appropriate style, from setting to language. It had to be his most significant arrangement.

Whistler chose the old St James's Hall, in Piccadilly, as the site for the lecture, and arrangements were made for the evening of February 20, 1885. A chronic latecomer himself, he ensured that his audience would come unhurried from the dinner table by scheduling his remarks for ten o'clock. Nothing of social or artistic importance had ever been scheduled so late into the evening, a move that had the effect of getting the *Ten O'Clock*—as it was quickly known—talked about even before it was written. And it would even be talked about on the evening of the

performance, as gentlemen lingered over their port waiting for their carriages, and ladies gossipped over their coffee.

W. C. Alexander told the Pennells that when he listened to Whistler's lecture nothing in it was new to him: he had heard it for years over the dinner table. Still, Whistler honed his words meticulously. As early as October 24, 1884 Alan Cole was writing in his diary, "Whistler to dine. We passed the evening writing out his views on Ruskin, art, etc.," and three days later, "Jimmy to dinner, continuing notes as to himself and art." He would visit Chelsea neighbor G. A. Holmes to try out a page or two, and when sick and abed at his brother's house in Wimpole Street he would sit up, propped by pillows, reading passages to Willie and Nellie Whistler. "Scores of times—I might say hundreds of times—" Mortimer Menpes recalled, "he paced up and down the Embankment repeating to me sentences from the marvellous lecture. He feared lest his voice should not carry, and certainly his performance at Prince's Hall never equalled those nightly ones by the side of the Thames."

As he worked over each word he changed his tactics. First he thought of offering the text to Comyns Carr's *English Illustrated Magazine*; then he decided that if the results warranted it he would publish it himself. He designed the ticket; he had it enlarged into a poster. He was in the vicinity of Mrs D'Oyly Carte's tiny office so often that he made two etchings there, *Savoy Scaffolding* and *Miss Lenoir* (the producer's name before her marriage). He memorized his speech, and did little else, apologizing to art dealer Walter Dowdeswell for asking for an advance although the gallery had been taking nothing in and getting no finished work from Whistler. "The air is just teeming with success—and the lecture is growing apace—and will be," he closed, "I need not deny Amazing!"

Never fluent as those of his literary contemporaries for whom writing was a profession, and never facile as those of his friends with more sophisticated formal education, Whistler would offer a text as artificial as Art. In its polished, epigrammatical portions it was a prose etching; in its efforts at explaining the mysterious effect of art on the onlooker it became a prose nocturne.

Newspaper prophecy centered on whether "the eccentric artist was going to sketch, to pose, to sing, or to rhapsodize," and whether, too, anyone would pay the steep price to listen. As the *Morning Advertiser* commented, "Mr McNeill Whistler, an artist with a certain kind of

reputation, has for some weeks or months past advertised a 'Ten O'Clock' at Prince's Hall, Piccadilly, and speculation has been rife amongst the curious as to what kind of an entertainment a 'Ten O'Clock' was likely to be, but having regard to the fact that the price of tickets was half a guinea, there could be little doubt that, whether it was to be dramatic, musical, or artistic, it would be eminently select." Encountering Val Prinsep and Frederick Leighton—*Sir Frederick* now that he was President of the Royal Academy—Whistler asked his two old but estranged friends to come to listen to his lecture, then a few days away. "What's the use of my coming?" said Leighton. "You know I should not agree with what you said, my dear Whistler." "Oh," Whistler appealed, "come all the same; nobody takes me seriously, don't ye know!" But complimentary tickets could not have induced the P.R.A. to give the *Ten O'Clock* his implicit imprimatur.

On Thursday, February 19, 1885 there was a rehearsal at Prince's Hall, with Mrs D'Oyly Carte and several of the Followers present to check whether his voice carried. The next evening the Hall was nearly full when, at 10:15, Whistler walked out, alone, put aside his hat and cane, removed his gloves, checked for the pitcher and water tumbler—and manuscript—on the small table, then, unintroduced, launched into his manifesto.

It is with great hesitation and much misgiving that I appear before you, in the character of The Preacher.

. . . I will not conceal from you that I mean to talk about Art. . . .

The people have been harassed with Art in every guise, and vexed with many methods as to its endurance. They have been told how they shall love Art, and live with it. Their homes have been invaded, their walls covered with paper, their very dress taken to task—until, roused at last, bewildered and filled with the doubts and discomforts of senseless suggestion, they resent such intrusion, and cast forth the false prophets, who have brought the very name of the beautiful into disrepute, and derision upon themselves.

Alas! ladies and gentlemen, Art has been maligned. She has naught in common with such practices . . . purposing in no way to better others.

She is, withal, selfishly occupied with her own perfection

only—having no desire to teach—seeking and finding the beautiful in all conditions and in all times, as did her high priest Rembrandt, when he saw picturesque grandeur and noble dignity in the Jews' quarter of Amsterdam, and lamented not that its inhabitants were not Greeks. . . .

Hence it is that nobility of action, in this life, is hopelessly linked with the merit of the work that portrays it; and thus the people have acquired the habit of looking, as who should say, not *at* a picture, but *through* it, at some human fact, that shall, or shall not, from a social point of view, better their mental or moral state. So we have come to hear of the painting that elevates, and of the duty of the painter—of the picture that is full of thought, and of the panel that merely decorates. . . .

That Nature is always right, is an assertion, artistically, as untrue as it is one whose truth is universally taken for granted. Nature is very rarely right, to such an extent even, that it might almost be said that Nature is usually wrong: that is to say, the condition of things that shall bring about the perfection of harmony worthy a picture is rare, and not common at all.

This would seem, to even the most intelligent, a doctrine almost blasphemous. . . . Still, seldom does Nature succeed in producing a picture. . . .

How little this is understood, and how dutifully the casual in Nature is accepted as sublime, may be gathered from the unlimited admiration daily produced by a very foolish sunset. . . .

And when the evening mist clothes the riverside with poetry, as with a veil, and the poor buildings lose themselves in the dim sky, and the tall chimneys become campanili, and the warehouses are palaces in the night, and the whole city hangs in the heavens, and fairy-land is before us—then the wayfarer hastens home; the working man and the cultured one, the wise man and the one of pleasure, cease to understand, as they have ceased to see, and Nature, who, for once, has sung in tune, sings her exquisite song to the artist alone, her son and her master—her son in that he loves her, her master in that he knows her.

To him her secrets are unfolded . . . , and *thus* is Nature ever his resource and always at his service, and to him is naught refused.

Through his brain, as through the last alembic, is distilled the refined essence of that thought which began with the Gods, and which they left him to carry out.

Set apart by them to complete their works, he produces that wondrous thing called the masterpiece, which surpasses in perfection all that they have contrived in what is called Nature. . . .

The master stands in no relation to the moment at which he occurs—a monument of isolation—hinting at sadness—having no part in the progress of his fellow men.

He is also no more the product of civilisation than is the scientific truth asserted, dependent upon the wisdom of a period. The assertion itself requires the *man* to make it. The truth was from the beginning.

So Art is limited to the infinite, and beginning there cannot progress.

A silent indication of its wayward independence from all extraneous advance, is in the absolutely unchanged condition and form of implement since the beginning of things.

The painter has but the same pencil—the sculptor the chisel of centuries.

Colours are not more since the heavy hangings of night were first drawn aside, and the loveliness of light revealed. . . .

We have then but to wait—until, with the mark of the gods upon him—there come among us again the chosen—who shall continue what has gone before. Satisfied that, even were he never to appear, the story of the beautiful is already complete—hewn in the marbles of the Parthenon—and broidered, with the birds, upon the fan of Hokusai—at the foot of Fusiyama.

Despite its mannerisms, which included sufficient Old Testament cadences to suggest that Anna Whistler had done her job well, Whistler had formulated the doctrine of the artist as exile and outsider. He was both. Hacks would continue to produce mercantile art. The artist would survive in a world which did not need him, and produce art for its own sake. He was anticipating a concept of the artist's role in society which would reverberate for generations.

The critics reviewed the *Ten O'Clock* as if it were an exhibition of

Whistler etchings, pastels, and canvases. One paper registered surprise, "little expecting to hear a closely reasoned and lucid exposition of the relations between the artist, his work, and the people in general." Another in a more predictable reaction reported that "the audience, hoping for an hour's amusement from the eccentric genius of the artist, were not disappointed." A popular success, it elicited invitations the next month from Oxford (where Whistler went with Dr Willie and Sidney Starr), the Royal Academy Students' Club, the Fine Art Society and Cambridge, where he was the most unlikely of guests at the home of Sidney Colvin. "I accept with pleasure the flattering invitation you have conveyed to me from the gentlemen at Cambridge," he wrote to the Slade Professor who had been the butt of so many of his jokes. "Therefore I will arrange to come to you on the 11th March—and deliver the address that I have here in Prince's Hall. With many thanks for the courteous hospitality you offer me. . . ."

The rapprochement with Sidney Colvin, and the academic respectability enforced by *Ten O'Clock*, completed the circle, for the *Ten O'Clock* had also begun the inevitable break with Oscar Wilde. In the *Pall Mall Gazette* the day after the lecture Wilde had been amusing at Whistler's expense, although he praised Whistler's "really marvellous eloquence," described him as "a miniature Mephistopheles, mocking the majority," and the lecture as a "masterpiece." There were, Wilde added, "some arrows, barbed and brilliant, shot off, with all the speed and splendour of fireworks, at the archeologists, who spend their lives in verifying the birthplaces of nobodies, and estimate the value of a work of art by its date or its decay, and the art critics who always treat a picture as if it were a novel, and try and find out the plot; at dilettanti in general, and amateurs in particular, and (*O mea culpa!*) at dress reformers most of all." After objecting to Whistler's elitist principles he went on to what, despite the tongue-in-cheek defiance, Whistler should have recognized as the honest praise of a disciple finding his own voice:

> Mr Whistler's lecture last night was, like everything else that he does, a masterpiece. Not merely for its clever satire and amusing jests will it be remembered, but for the pure and perfect beauty of many of its passages—passages delivered with an earnestness which seemed to amaze those who had looked on Mr Whistler as a master of persiflage merely, and had not known him, as we do, as a master of painting also. For that he is indeed one of the very

greatest masters of painting, is my opinion. And I may add that in this opinion Mr Whistler himself entirely concurs.

That the gratuitous but irresistibly clever last line would have enraged Whistler, Wilde certainly knew. And that his intention was not venomous was made obvious by a second essay in the *Gazette* a week later, in which Wilde praised the Master even more:

> Mr Whistler in pointing out that the power of the painter is to be found in his powers of vision, not in his cleverness of hand, has expressed a truth which needed expression, and which, coming from the lord of form and colour, cannot fail to have its influence. His lecture, the Apocrypha though it be for the people, yet remains from this time as the Bible for the painter, the masterpiece of masterpieces, the song of songs. It is true he has pronounced the panegyric of the Philistine,* but I can fancy Ariel praising Caliban for a jest: and in that he has read the Commination Service † over the critics, let all men thank him, the critics themselves indeed most of all, for he has now relieved them from the necessity of a tedious existence.

By the time Wilde's graceful (and perceptive) tribute had been published in the *Gazette* for February 28, Whistler had begun reading a special Commination Service for the unsuspecting Oscar. In his original *Ten O'Clock* review Wilde had mildly scolded Whistler for ascribing unnatural perceptive powers to the painter. Not every painter is an artist, Wilde wrote, and "as long as a painter is a painter merely," he is not privy to the secrets of artistic creation. "But the poet is the supreme artist, for he is the master of colour and of form, and the real musician besides, and is lord over all life and the arts; and so to the poet beyond all others are these mysteries known; to Edgar Allan Poe and to Baudelaire, not to Benjamin West and Paul Delaroche." The names were apparently carefully chosen: Whistler read and admired Poe and Baudelaire, and could not have appreciated the painting of West or Delaroche. But he wrote to Wilde after reading the *Gazette* review that he found it "exquisite" although he was disappointed in "the naïveté of 'the Poet,' in the choice of his Painters. . . ." The choice may not have been meant to

* In his anti-Ruskinian dictum that art was elitist, that any attempt to reach the multitude reached the lowest common denominator.
† A service to denounce sinners.

be a trap for the unwary, but it was, and since Whistler sent his letter to the *World*, there Wilde published his response:

> Dear Butterfly,
>
> By the aid of a biographical dictionary I discovered that there were once two painters, called Benjamin West and Paul Delaroche, who recklessly took to lecturing on Art. As of their works nothing at all remains, I conclude that they explained themselves away. Be warned in time, James; and remain, as I do, incomprehensible: to be great is to be misunderstood.

A chill descended over Chelsea, and hostesses took care that Oscar and Jimmy were not on the same invitation list. After Wilde was caricatured in a number of *Punch* in soldier's uniform Whistler even felt it necessary to growl to Walter Sickert that [picturing] "that ass Oscar as a French pioupiou" lacked imagination. "Funny about Oscar, though, isn't it," he mused: "that it should be his fate—in *everything* to be *after* me!" Jimmy had been a cadet and Oscar soldiered only in the pages of *Punch*, but Oscar was still hawking his Whistlerisms, newly minted, in increasingly popular lectures, essays and reviews.

Matters came to an acrimonious boil late in 1886, when Whistler was asked to help organize a reformist, anti-Academy National Art Exhibition, and he discovered that not only artists, but critics, were involved, and among them Harry Quilter and Oscar Wilde. Rejecting his invitation, he sent his customary copy to the *World*.

> Gentlemen,
>
> I am naturally interested in any effort made among Painters to prove that they are alive—but when I find, thrust in the van of your leaders, the body of my dead 'Arry, I know that putrefaction alone can result. When, following 'Arry, there comes on Oscar, you end in farce, and bring upon yourselves the scorn and ridicule of your *confrères* in Europe.
>
> What has Oscar in common with Art? Except that he dines at our tables, and picks from our platters the plums for the pudding he peddles in the Provinces.
>
> Oscar—the amiable, irresponsible, esurient Oscar—with no more sense of a picture, than the fit of a coat—has the "courage of the opinions"—of others!

With 'Arry and Oscar you have avenged the Academy!
I am, Gentlemen,
Your obedient servant,
J. McNeill Whistler

There was no libel suit. "Atlas," Wilde blandly replied for publication (November 24, 1886), "this is very sad! With our James, vulgarity begins at home, and should be allowed to stay there." Whistler kept his further thoughts to himself until he published the exchange on his own: "A poor thing, Oscar, but for once, I suppose, your own." Privately he produced, for his own satisfaction, several unfriendly pen-and-ink caricatures of Oscar, one as a pig and another as jockey. A third was more revealing: it was Oscar with Whistlerian top hat and stick.

For some months there was silence, but neither could leave the other with the last word. When Walter Dowdeswell published a short biography of Whistler in *Art Journal* the following year, Wilde reviewed it as if it were a full-length biography, for it gave him the opportunity to comment that "Mr Dowdeswell displays a really remarkable power, not merely of writing, but of writing from dictation, especially in his very generous and appreciative estimate of Mr Whistler's genius." The domain of the painter, he insisted yet again, was remote from the broad domain of the poet except in rare cases such as that of Mr Whistler. "Some of his arrangements in colour . . . have all the delicate loveliness of lyrics. The silver silences of his nocturnes seem at times almost passing into music. He has done etchings with the brilliancy of epigrams, and pastels with the charm of paradoxes, and many of his portraits are pure fiction." But, unhappily, Oscar was not yet through, pointing out "that it would be ungracious to criticize with too much severity an article that shows so much memory on the part of the writer, and such journalistic ability on the part of the subject."

Whistler publicly kept his peace, even later after Wilde, reviewing someone else's book in 1889, felt compelled to observe that "Mr Whistler always spelt art, we believe still spells it, with a capital 'I'." That he was still very much alive, however, was proved by his reaction to a newspaper cutting sent to him by Henry Romeike, who operated a press cutting service. He had been mentioned in Herbert Vivian's *Reminiscences*, not only via the story about the famous dinner at which Oscar had wished he had fathered a Whistler *mot*, but in a follow-up story which suggested

that Oscar indeed had borrowed again, in his "Decay of Lying" dialogue which had recently (January, 1889) appeared in the *Nineteenth Century*. The master consulted a copy and recognized himself in a parody of (or parallel to) the already famous *Ten O'Clock* ode to the brooding London fogs which created beauty where none existed, and in general in the essay's thesis of the superiority of art to nature. Even Wilde's central paradox, "Nature imitates Art," was Whistlerian, while borrowed also was one of the Master's most deeply felt and long-practiced precepts, that raw nature had no value for artists, and that art was the prism through which nature could best be perceived. (The only countryside that Whistler did not find detestable was that of Holland, where "the trunks of the trees are painted white, [and] the cows wear quilts.") But he was particularly annoyed by the borrowed *mot* in Wilde's suggestion that the popular realistic novelist "has not even the courage of other people's ideas. . . ." It was what he called in a letter in Henry Labouchere's *Truth* (January 16, 1890) "the other appropriated property, slily stowed away, in an article on 'The Decay of Lying'—though why Decay!"

For *Truth* he supplied a letter he had sent to "the detected plagiarist": "I had forgotten you—and so . . . , while I looked the other way, you have stolen *your own scalp!* and potted it in more of your own pudding."

Oscar reacted with the languid but righteous outrage of the successful. Whistler's "shrill shrieks" came from "silly vanity or incompetent mediocrity," were nothing but "venom and vulgarity," and were "as deliberately untrue as they are deliberately offensive." It was troublesome "for any gentlemen to have to notice the lucubrations of so ill-bred and ignorant a person," but he had no option:

> The definition of a disciple as one who has the courage of the opinions of his master is really too old even for Mr Whistler to be allowed to claim it, and as for borrowing Mr Whistler's ideas about art, the only thoroughly original ideas I have ever heard him express have had reference to his own superiority as a painter over painters greater than himself.

Whistler's response in *Truth* was to hope that "the gods may perhaps forgive and forget" Oscar in time, and then to make sure no one in England did so by reprinting the correspondence himself later in the year. In public, at least, Jimmy was left with the last word, and Londoners in both their orbits found it hazardous to maintain dual loyalties. Parisians had similar problems, for Oscar was often in the salons and cafés, and

Whistler once in 1891 excused his sudden return to Chelsea with a note to poet Stephane Mallarmé that he knew it was ungrateful of him "not to stay and denounce Oscar in front of your disciples tomorrow evening! It is a favor I owe you—I well know it—and it might have added some charm to your Evening!" But Mallarmé's "historic" Tuesday evenings, he added to his friend, should be "reserved to honest artists—admission is a privilege and proof of value. . . . And the Master's door should not be forced open by any practical joker crossing the Channel and imposing himself. . . ." After Mallarmé wrote (December 23, 1891) of the *"réclame prodigieuse"* stirred up about Oscar, Whistler responded that he was furious that Parisians had been taken in by someone who "pushes ingratitude as far as indecency. And all his old, worn out stories—he dares offer them to Paris as something new!—the tales of the sunflower—his promenades in the lilies—his trousers—his pink shirt-fronts—what else! And then 'Art' here—'Art' there—It is really obscene—and will come to no good."

He remained convinced that Wilde would continue to pick other brains to meet his writing deadlines as well as refill his fund of repartee, expressing the fear, to publisher William Heinemann in 1892, that Wilde would steal from Mallarmé's new book of poems. But his curiosity about the disciple who had outgrown him remained intense, and when the Wilde scandal erupted in 1895 he wrote to Heinemann from France, "What of Oscar? Did you go to the court? What does he look like now?" When Wilde was approaching the end of his sentence, Frank Harris, dining in London with Whistler, mentioned that he had heard that Oscar was working, in Reading Gaol, on "a new work, a very important drama." Whistler's response was cynical. "Oscar writing a new work, a great romantic drama? We must find a name for it. I have it; it must be known as *The Bugger's Opera.*"

Nearly a year after Wilde completed his two years in prison and, gaunt yet still strangely fleshy, stalked old Paris haunts, he saw Whistler for the last time, and described him to Robert Ross in terms of the half-crazy gypsy woman in Walter Scott's *Guy Mannering*: "Whistler and I met face to face the other night, as I was entering Pousset's. . . . How old and weird he looks! Like Meg Merrilies."

The end of foolishness? It was too painful a collision for that, and had been too influential. Wilde had learned a lot from Whistler, and had assimilated even more, both in matter and in style. And Whistler might

never have been provoked to the production of his *Ten O'Clock* credo had he not felt that Wilde was poaching dangerously upon his own intellectual preserve. The Follower outgrowing any need for the Master is a story as old as literature. Oscar and Jimmy had played it out in life.

XXVI

The British
and the Artists

I F any artistic organization in England commanded less respect from Whistler than the Royal Academy, it was the venerable but somnolent Society of British Artists, a collection of commercial hacks and well-intentioned dilettantes whose building on narrow Suffolk Street, between the National Gallery on Trafalgar Square and the Haymarket, was passed by more often than passed through. Still, Whistler was flattered when a deputation from the Society (after first discreetly checking to see whether it would be received or humiliated) visited his studio to invite his membership. It was a calculated risk for the Society, which could never be the same with a Whistler in it, but it was a chance at rejuvenation, for with Whistler would certainly come his corps of Followers, and following Whistler for better or worse would certainly be the corps of London critics. On November 21, 1884 at the S.B.A. half-yearly general meeting it was proposed "that Mr Whistler be invited to join the Society as a member," and the minutes further recorded that in the eagerness to receive him "it was proposed by Mr Bayliss, [and] seconded by Mr Cauty, that the law relating to the election of members be suspended" so that Whistler could be elected immediately. Thus at fifty he finally acquired professional status as an artist in England, and as the *Times* reported (December 3, 1884), certainly accurately, "Artistic

society was startled by the news that this most wayward, most un-English of painters had found a home among the men of Suffolk Street, of all people in the world."

On December 1, 1884 he attended his first meeting, after which he promptly invited the President of the Society and other leaders to a Sunday breakfast, and agreed to send to the Winter Exhibition a portrait and a watercolor. At the Summer Exhibition he showed his *Sarasate* for the first time, the *Pall Mall Gazette* observing that "the eccentric Mr Whistler" would probably bring "the neglected little gallery" in Suffolk Street into fashion. He could not be active in anything without dominating it, and the British Artists were soon receiving applications from such of his Followers as who were not already members, were holding Sunday receptions because he liked them, and were selling photographs of pictures on exhibit in the gallery because he had always encouraged recording his own work on film.* For the next Winter Exhibition he was ready with his *Portrait of Mrs Cassatt* and a small pastel of a nude, the *Note in Green and Violet*, which created a sensation out of all proportion to its significance, and did what Whistler's proposals for serious innovations had failed to do—call public attention to Suffolk Street.

The highlight of the Winter show was a small label attached to Whistler's *Note in Green and Violet*, and then removed, but not before it had been seen. Sixty-eight-year-old John Callcott Horsley, a stuffy Royal Academician who had painted anecdotes for two generations, had inveighed so frequently against the temptations the public was put to by artists who depraved models and onlookers alike by painting nudes that he had earned the nickname "Clothes Horsley."

The chaste, slight nude beneath which Whistler had affixed his response was as much a reply as the punning "Horsley *soit qui mal y pense*." † "This is not," Whistler told the critic of the *Pall Mall Gazette*, what people are sure to call it, " 'Whistler's little joke.' " On the contrary, it is an indignant protest against the idea that there is any immorality in the nude." That his prediction was accurate was seen in a London press cutting he sent to Lucas:

"*Le Prince de Papillon,*" otherwise the Undefeated Butterfly, otherwise "Our James," received a goodly crowd of social and

* Whistler's destruction of so many of his canvases made the camera even more important with respect to his own work, as some pictures now exist only via their photographs.

† Whistler was punning on the motto of the Order of the Garter, *Honi soit qui mal y pense:* "Evil be to him who thinks evil."

artistic celebrities in Suffolk Street, on Saturday afternoon. The function was nominally the private view of the British Artists, and it was true that other works by other hands than those of James McNeill Whistler hung on the walls, but the interest centered on the painting and the sayings of the ever-delightful little "Master" (here I bar all references to a *petit maître*). Escorted by fair dames and appreciative and critical listeners, the Butterfly flitted round the rooms, delicately alighting at intervals on some novel arrangement of his own or his disciples to murmur a critical "note," the works of all others being ignored with royal scorn. The said disciples, with dutiful affection, place the mystic sentence, "Pupil of Whistler," after their names in the catalogue, and as far as I can judge, these young catalogued caterpillars will, in the fulness of time, become butterflies. They show much promise. Few of them are comprehensible.

As for Whistler's nude, it was robed in little else save its, or hers, own suffusing blushes, and yet has no reason to be ashamed, and concerning the said caprice the Great Boss Butterfly adventured but one characteristic criticism—"Horsley *soit qui mal y pense*"! The *mot* is better than all the elaborate scribblings on the subject with which we were recently afflicted. The punning spirit was obviously contagious, for when the gallery became unbearably hot and close, a lady audaciously observed that it was "Suffolk-ating." There were nice people about, and gratefully do I acknowledge that "private-viewing" is not so desperately serious an affair after all, thanks to the Butterfly.

The Butterfly did not restrict his exhibitions to Suffolk Street, although there was a falling off in his submissions to the Grosvenor. In 1885 and again in 1886 he exhibited nothing at the Grosvenor, but was exhibited without his permission being needed at Christie's, when the property of the late William Graham came up for auction. Among Graham's pictures had been the *Nocturne in Blue and Silver: Old Battersea Bridge*. When it was brought forward for bids, "there was a slight attempt at an ironical cheer, which being mistaken for serious applause, was instantly suppressed by an angry hiss all round." It was bought for sixty pounds by R. H. C. Harrison. Whistler, reading of the effect of his work, acknowledged through the *Observer* (April 11, 1886) "the distinguished, though I fear unconscious, compliment so publicly paid."

At Dowdeswell's, where his "Set of Twenty-Six Etchings" (all of them of Venice) had been issued in April, there was a one-man show of small oils, watercolors, pastels and drawings which Whistler arranged himself. When the works were chosen Whistler gave a dinner for his friends (including Walter Dowdeswell) at the Arts Club, ostensibly to gather them for assistance in pricing the pictures. After dinner the pictures were called for as well as more of the cheap sparkling red wine that had already left them in a merry mood. With each bottle enthusiasm for the pictures mounted and the prices were adjusted upwards. As Menpes recalled it:

A picture of a shop painted in St Ives, called "The Blue Band," was held out for our inspection. We gazed at it for some time in silence. Dowdeswell said boldly, "£40," and then looked uncertainly round the table with a scared expression as if to say, "What have I said?" Whistler put on his eyeglass, and surveyed him critically. After more sipping I suggested £50. The Master received the remark quite calmly. He seemed now to be indifferent, and left all discussion to his followers. But the colder he grew, the more enthusiastic we waxed, until at last Dowdeswell said, in a burst of enthusiasm, "Well, if the public doesn't care to give £60 for the picture, far better would it be to live with it."—"Quite right, Walter," said Whistler, approvingly, "quite right. I see you have appreciation. It is, as you say, a supremely fine work." Then I became excited. "I should make it £80," I cried in a nervous, spasmodic way, as though I were taking a header into a cold pool. Whistler looked at me benignly. "I like these bush instincts, Menpes," he said. "Yes: I distinctly like them." He himself did not drink much; and never was he calmer, cooler, more collected. Somehow his coolness spurred us on to fresh efforts. Our enthusiasm mounted to fever heat. In the end "The Blue Band" was priced at £120.

So we continued throughout the evening. The pictures were priced at what seemed to be fabulous sums. None of us, of course, realised that under the influence of drink we had really become prophetic: that we were placing Whistler on a plane where he should be. To outsiders the prices seemed ridiculously extravagant. . . .

When the catalogue was printed and they were away from the wine, all had misgivings, and on Press Day the Followers looked as solemn as Dowdeswell. "Now," said Whistler, "I can't have this. You must smile." But the smiles were mechanical, and the Master noticed. "There is only one thing lacking, gentlemen," he said, "to complete the picture which this gallery should create. And that is the butterfly—a large painted butterfly on the wall." Calling for paints and a ladder, he stood on the bobbing topmost rungs and quickly produced the familiar signature nearly ceiling high. Then he was satisfied. But the Press was not, even sympathetic critics like G.B.S., who—more amused than impressed—felt that Whistler was not showing work up to his abilities:

Mr. Whistler's Notes, Harmonies, and Nocturnes are arranged in brown and gold, in a brown and gold room, beneath a brown and gold velarium, in charge of a brown and gold porter. It cannot be said of Mr. Whistler, as of Mr. Sparkler's ideal mistress,* that he has no nonsense about him. He has the public about him; and he not only humours their nonsense, but keeps it in countenance by a dash of nonsensical eccentricity on his own part, and by not standing too stiffly on his dignity as an artist, which is saved finally by the fact that his "Notes" are well framed, well hung, well lighted, suitably set forth, and exquisitely right so far as they go, except a failure or two which he unblushingly amuses himself by exhibiting as gravely as he might his very masterpieces. The "Chelsea Fish Shop," the Hoxton street scene, the Dutch seaside sketch (No. 47), are a few out of many examples of accurate and methodical note-taking, which is just the reverse of what the rasher spectators suppose them to be. As Mr Whistler presumably takes notes with a view to subsequent pictures, it is to be hoped that something will soon come of them.

When it came to answering really hostile criticism Whistler held his fire unless he thought his onslaught would educate his critics or their audience. After the exhibition Walter Dowdeswell offered to answer one vicious attack for Whistler, who thanked him for his warm feelings but felt that the piece was too foolish to merit rebuttal. "Among sportsmen," he wrote him, "there is a certain sense of the ridiculous that prevents them [from] firing at a skunk—and I, who count my trophies of the

* Edmund Sparkler appears in Dickens's *Little Dorrit*.

chase, could not possibly pin upon my wall the poor pecked feathers of the twittering tomtit, who struggles in the street with the stray straws from the scavenger's cart, that his starving family may feed on the filth and thrive. . . ."

But the pictures did not sell. Dowdeswell finally forwarded a check for £50 and reported that the show had been an absolute loss. He had no idea that he was "Jonah on the ship," Whistler confessed: he thought that times were bad all over London. And the mid-Eighties were bad times for painters, the Society of British Artists having seen their sales of several years before halved. At Suffolk Street the Society's President, John Burr, decided not to stand for reelection.

When Burr's decision became known, the younger and Whistlerite faction of the S.B.A., pledging each other to secrecy, held meetings in the studio of George Jacomb-Hood to plot a take-over, arranging to vote solidly for Whistler as President and for sympathetic non-Followers as Treasurer and Secretary. The meeting, on June 1, 1886, was full of excitement, as other groups, unprepared and unhappy, were divided and Whistler prevailed, the victors then adjourning to the Hogarth Club, from which the new President telegraphed to Dr Willie, *"J'y suis, j'y reste."* The press registered its astonishment, and although Whistler kept talking of going to America on a visit, and wrote the papers that "one cannot continually disappoint a Continent," he postponed the voyage and began planning for his new role.

But first he crossed the Channel. In the interim between election and assumption of office he went off to Brussels and Paris, showing 50 small oils, pastels and watercolors in June at the International Exhibition which included Monet, Pissarro, Renoir and Rodin. At the Salon he exhibited the *Sarasate*, then brought it to Belgium, to be shown at the *Société des XX*. Two years earlier he had been the first foreign painter invited to the club's opening exhibition, and had sent several major works, but had not come himself. This time he came, and met Fernand Knopff, leader of the group, who took him on a walking tour of Brussels, Whistler as badly equipped for walking as usual in his thin patent leather shoes and slender cane. It began to rain heavily, and he began walking gingerly on tiptoe to keep the water out of his shoes. Soon Knopff pulled him into the nearest public shelter, a church in which Mass was being celebrated. Instinctively taking from his pocket a small sketchbook, Whistler quickly filled a leaf with lines, then turned to Knopff to announce, "There's no room for my butterfly." A little later, at the elevation of the Host, he turned again to

Knopff, untouched by the ritual, and whispered, "Yes, there *is* room for my butterfly," and he made a few additional marks with his pencil.

Although he was not quite clear on how to preside, or what his duties or powers were, Whistler gaveled the Society to order for the first time on December 10. Rather than recognize speakers, he sat in the President's chair and talked himself. And he refused to accept the Society's "rule and tradition" that when the President spoke on an issue he would step down from the chair and stand up in the body of the meeting. Further, he would pack the meeting with his supporters, knowing that business meetings of any society were usually poorly attended—which was the case with the British Artists until Whistler began remaking the organization. His chief antagonist became Wyke Bayliss, a minor painter whom Whistler insisted on calling "Mr Bailey," until Bayliss began referring to "Mr Whistle," explaining that if the President insisted on dropping the end of his name, he would do the same. *"Touché!"* said Whistler amid the laughter—about the only occasion when the rival factions were in joint good humor. It was, the *Times* declared afterwards, "like electing a sparrow-hawk to rule a community of bats. Some of the bats moved out, some followers of the sparrow-hawk came in; but the interesting new community did not last long." While it did, Suffolk Street was a less stuffy place.

For the Winter Exhibition he redecorated the gallery, and would allow no crowding of pictures merely to represent every contributor, however poor his work. Gathering his cohorts at his studio, he told Mortimer Menpes, whom he had appointed to the Hanging Committee, to be ruthless in rejecting pictures, impressing upon him the necessity of saying, "Out, damned spot! . . . Never weary, Menpes, of saying 'Out,' " he went on. "If you are uncertain for a moment, say 'Out.' You need never be afraid of rejecting a masterpiece. We want clean spaces round our pictures. We want them to be seen. The British Artists must cease to be a shop."

The pictures were hung in faultless taste, but there were too few of them to please the many contributors of rejected canvases. Members of long standing were not pleased either when he redesigned the Society's official stationery and added a small red British lion. "I write on the official sheet, O dear and most respectful one," he penned joyously to Menpes, "because I am in love with the look of it. Isn't it really brilliant and fascinating as a picture? And my little red lion—isn't he splendid and well-placed?" Members could not complain when he exhibited his new

and brilliant *Harmony in Red: Lamplight—Mrs Godwin*, but when he sent in on varnishing day his *Harmony in White and Ivory: Lady Colin Campbell*, which he had never finished, and which despite some attractive features, looked unfinished, the exasperation reached the floor of the next meeting, when a motion to define the rights of the President was carried.

Undeterred, Whistler borrowed £500 on his own to pay off the Society's debts, even pawning his large gold Salon medal. He moved to increase the Society's prestige through encouraging artists he admired to join, contributed velvet curtains for the doorways, and invited the Prince of Wales to the next opening, staying up late the night before to paint the doors and dadoes yellow for the occasion. Elder members were incensed, but deaf to the protests Whistler went off to the Hogarth Club, remaining until it was time for the Royal visit. "I went downstairs to meet the Prince," he recalled to the Pennells. "As we were walking up, I a little in front with the Princess, the Prince, who always liked to be well informed in these matters, asked what the Society was—Was it an old institution? What was its history? 'Sir, it has none, its history dates from today!' I said."

Having the Prince of Wales at the preview was a feat of sorts, but it failed to answer the dissatisfaction of the painters whose pictures the Prince could not have seen because the new rules permitted only a fraction of those shown before to be exhibited. A motion was brought and passed "that the experiment of hanging pictures in an isolated manner be discontinued," and that enough works be accepted to cover the vacant space above and below the lines. Whistler ignored all resolutions and continued to make over the British Artists as he pleased. In place of the cluttered walls there were two lines of works with ample space between, and there were Sunday afternoon receptions, with tea and brown bread and butter arranged on long tables and served by young ladies in yellow beneath a gauzy velarium.

Two members of the Society had resigned long before the opening, both clearly concerned about the presidential policies of Whistler. One belatedly announced his withdrawal in a letter in the *Daily News* which concluded,

> It will be for the patrons of the Suffolk-Street Gallery to decide whether the more than half-uncovered walls which will be offered to their view next week are more interesting than the work of many artists of more than average merit which will be

conspicuous by its absence, owing to the selfish policy inaugu-
rated.

A BRITISH ARTIST

Whistler, always keen for battle, leaped at the suggestion that patrons
of the gallery might have a consumers' interest in well-populated walls:

> Now it will be for the patrons to decide absolutely nothing.
> It is, and will always be, for the gentlemen of the hanging
> committee alone, duly chosen, to decide whether empty space be
> preferable to poor pictures—whether, in short, it be their duty to
> cover walls, merely that walls may be covered—no matter with
> what quality of work. . . .

Punctuated by petty acrimony, the first year of Whistler's presidency
nevertheless included new prestige for Suffolk Street that could hardly
have come without Whistler. The glory came not with the patronage of
the Prince of Wales, whose blessing benefited few exhibitors, but with
the Golden Jubilee of Victoria's reign, the occasion for societies of every
description to offer ceremonious addresses to the Queen. When Whistler
discovered that the Royal Academy was in the process of preparing one,
he consulted with no one and rushed out his own in the name of the
British Artists. Instead of what he called the "illuminated performances"
traditional on such occasions,

> I took a dozen sheets of my old Dutch paper. I had them bound
> by Zaensdorf. Amazing! First came this beautiful binding in
> yellow morocco, and the inscription to Her Majesty, every word
> just in the right place, most wonderful. You opened it, and on the
> first page you found a beautiful little drawing of the royal arms
> that I made myself; the second page, an etching of Windsor, as
> though, "here's where you live." On the third page, the address
> began. I made decorations all round the text in watercolour—at
> the top, the towers of Windsor, down one side, a great battleship,
> plunging through the waves, and below the sun that never sets
> on the British Empire—What? The following pages were not
> decorated, just the most wonderful address, explaining the age
> and dignity of the Society, its devotion to Her Glorious, Gracious
> Majesty, and suggesting the honour it would be if this could be
> recognized by a title that would show the Society to belong
> especially to Her. Then the last page. You turned, and there was

a little etching of my house in Chelsea—"And now here's where I live!" And then you closed it, and on the back of the cover was the Butterfly.

When it was already on its way to Windsor the Council of the Society, unaware of its President's action, asked for a meeting to consult on an appropriate address to the Queen, since other societies were sending them. Bringing them together, Whistler asked the members what they proposed spending, and shocked them by explaining that the single guinea recommended might not meet a twentieth of the expenses he had already incurred. By the time a stormy protest meeting was held Whistler had received an acknowledgement from the Queen "and Her command that the Society should be called Royal." Withholding the news, he first permitted members to complain of his high-handedness in sending his own message for them, one arising to declare his intention to resign. "You had better make a note of it, Mr Secretary," Whistler said.

And then I got up with great solemnity and I announced the honour conferred upon them by Her Gracious Majesty. They jumped up and rushed toward me with outstretched hands. . . . I waved them all back. . . . But, the meeting over, I sent for champagne.

Delighted with the impact of his address to the Queen both on Victoria and the stunned—and now Royal—Society of British Artists, Whistler took down the venerable old signboard which announced, in white lettering on blue enamel, that the exhibition of the Incorporated Society of British Artists was held above, and that for the price of one shilling the public might enter. It was sent to his studio, where, he said afterwards, "I treated it as I should a most distinguished sitter—as a picture or an etching—throwing my artistic soul into the Board." He mixed a ground of royal vermillion, upon which he put the new title of the Society in gold letters, with the date of its "new birth." Then he added a gold lion and a gold butterfly. "The lion lay with the butterfly—a harmony in gold and red, with which I had taken as much trouble as I did with the best picture I ever painted." It failed to meet with universal approval at Suffolk Street. The Butterfly was more than a signature: there on the cherished old notice board was Whistler's symbol of his dominance over the Society he had remade and renamed.

As President of a Royal Society he was invited to the Jubilee

ceremonies in Westminster Abbey, to the Jubilee garden party at Buckingham Palace and to the Naval Review off Spithead, where he made several etchings and a watercolor of the occasion. The precipitous rise in prestige of the Society encouraged several Followers to revive the idea of a special Suffolk Street retrospective show of the President's work, but opposition to his continuing arrogance was strong. The Royal Society of British Artists was talked about and written about, but the membership objected to being the tail to Whistler's comet. "Just at present," Shaw wrote in the *World* (November 30, 1887), "Mr Whistler must be at least as well satisfied as any propagandist in London. The defeat of his opponents is decisive. It is not so much that the new school (or the young school, the French school, the Parisian-American school, the naturalistic school, the impressionist school, the atmospheric school, the 'New English Art' School, the Whistleristic school, or whatever you are in the habit of calling it) displays the best pictures, as that it puts the old school so hopelessly out of countenance." * But the old school at the British Artists had the votes, if they could put them together.

The crisis came over the decorations for the Summer Exhibition of 1888. At a meeting on May 7 a letter signed by eight members called for a special meeting to ask Whistler to resign his post. He duly called the meeting, made a speech, and refused to let the opposition reply. According to Mortimer Menpes he answered allegations that his eccentricities impaired the dignity of the Society and kept members' pictures from selling. Putting on his eyeglass and surveying the irate band, he spoke softly but with no effort to mollify his critics:

> You know, you people are not well! You remind me of a ship-load of passengers living on an antiquated boat which has been anchored to a rock for many years. Suddenly this old tub, which hitherto has been disabled and incapable of putting out to sea, to face the storm and stress of the waves, is boarded by a pirate. (I am the pirate.) He patches up the ship and makes her not only weather-tight, but a perfect vessel, and boldly puts out, running down less ably captained ships, and bearing a stream of wreckage in her wake. But lo and behold! her triumphant passage

* Earlier, reviewing the Spring Exhibition, he had objected to sheer imitation on the part of some Whistler disciples—"not a half-crown's worth of successful or even honest effort in some of the works conspicuously hung in the vinegar and brown paper bower he has made for his followers in Suffolk Street. These gentlemen are painting short-sightedly in more senses than one . . . (*World*, April 13, 1887).

is stopped, and by the passengers themselves. Unused to this strange and unaccustomed movement, they are each and every one of them sick—ill. But, good people, you will e'en live to thank your captain. But then you talk of my eccentricities. Now, you members invited me into your midst as President because of these same so-called eccentricities which you now condemn. You elected me because I was much talked about and because you imagined I would bring notoriety to your gallery. Did you then also imagine that when I entered your building I should leave my individuality on the doormat? If so, you are mistaken. No, British Artists: I am still the same eccentric Whistler whom you invited into your midst.

There were other special meetings, at which motions for censure or expulsion were advanced, but Whistler held on until the annual meeting on June 4. Two months earlier Menpes had prudently resigned, leading to Whistler's comment about "the early rat who leaves the sinking ship." Now Wyke Bayliss was elected President, and Whistler and his minority reacted by resigning from the Royal Society of British Artists. "I am taking with me the Artists," he announced, "and I leave the British." Whistler's favorite publication, the *World*, comparing the achievements of the expelled President and the new one, commented, "And so departs . . . the Master, of whom it has been written, '*Il est deja dans l'histoire*,'—and in his stead reigns Mr Bayliss of Clapham, Director of the School Board of his parish. The sarcasm of Fate is complete, the eternal fitness of things is satisfied, and History withdraws from Suffolk Street."

Immediately after the news of his unseating reached the press he submitted to an interview from the *Pall Mall Gazette*. Everything was just as it should be, he said:

> A new government has come in, and as I told the members the other night, I congratulate the Society on the result of their vote, for no longer can it be said that the right man is in the wrong place. No doubt their pristine sense of undisturbed somnolence will again settle upon them after the exasperated mental condition arising from the unnatural strain recently put upon the old ship. Eh? What? Ha! ha! . . .
>
> I wanted to make it an art centre . . . ; they wanted it to remain a shop, although I said to them, "Gentlemen, don't you perceive that as shopmen you have already failed . . . ?

Their only chance lay in the art tone of the place, for the old-fashioned pictures had ceased to become saleable wares— buyers simply wouldn't buy them. But members' work I *couldn't*, by the rules, eliminate—only the bad outsiders were choked off. . . .

Wyke Bayliss was quick to respond to the *Gazette* with statistics which demonstrated that during the years of "Mr Whistler's rule" sales of pictures at Suffolk Street dropped to all-time lows; but Whistler fired back that the new President's figures showed that the decline had set in years before 1887—the first year in office of the new regime.

The acrimony at Suffolk Street continued throughout 1888, for according to the constitution of the Society, Whistler remained President after his unseating until the December meeting. It was an awkward period, for he had no intention of stepping down from his chair a day early, while Wyke Bayliss was a formidable antagonist although little known as a painter. He was not only a school board director but a lecturer and writer, a lay church official, a Fellow of the Society of Cyclists and a Fellow of the Society of Antiquarians, the latter of which Whistler would have felt appropriate for the Presidency of the relapsed British Artists. At the first exhibition after his unseating he ostentatiously visited the Suffolk Street Gallery with a corps of Followers and observed a picture by a well-known Royal Academician. "Ah," he said, as he stood gazing at it through his eyeglass, "it is like a diamond in the sty."

One of the first acts of Wyke Bayliss was to take down the panel at the entrance to the Suffolk Street gallery to repaint the lion and remove the butterfly. To the Council of the Society Whistler telegraphed ironically, "CONGRATULATIONS UPON DIGNITY MAINTAINED AS ARTISTS LEFT IN CHARGE OF A BROTHER ARTIST'S WORK, AND UPON GRACEFUL BEARING AS OFFICERS TOWARD THEIR LATE PRESIDENT." It was, he told the *Pall Mall Gazette*, "an act of villainous vandalism." His golden lion had been clothed in "a dirty coat of black," his butterfly gone, and other decorative elements expunged. "They should have taken the board down, . . . returned it to me, and got another Board of their own to practise on. . . . You say they *only* painted out my butterfly. It is as if you were condoling with a man who had been robbed and stripped, and said to him, 'Never mind. It is well it is no worse. You have escaped easily. Why, you might have had your throat cut.'"

To the *Morning Post*, which had printed a Whistler letter of protest,

Bayliss responded from Clapham that the title of the Society, "being in pure gold," was untarnished, but "Mr Whistler's designs, being executed in spurious metals, had nearly disappeared, and what little remained of them was of a dirty brown. The board could not be put up in that state. The lion, however, was not so badly drawn as to make it necessary to do anything more than restore it to permanent colour, and that has accordingly been done. But as the notice board was no longer the actual work of Mr Whistler, it would manifestly have been improper to have left the butterfly (his well-known signature) attached to it, even if it had not appeared in so crushed a state. The soiled butterfly was therefore effaced."

To the *Post* Whistler confessed that he had been "disarmed," and punned dangerously, "I feel the folly of kicking against the parish pricks. These things are right in Clapham, by the common." Of Whistler's tenure with the British Artists not even the signboard remained.

XXVII

Venus Eclipsed

WHILE Whistler played his charade with Oscar Wilde, reigned at the Royal British Artists, and rehabilitated his reputation if not his bank account, his domestic arrangements with Maud were approaching collapse. Although after Venice she continued to call herself Mrs Whistler and even had the name engraved on her cards, Whistler carefully called her *Madame*. She was seen only occasionally with him socially, but went to British Artists' functions with him and was hostess at his breakfasts and dinners. George Lucas, with whom she had become friendly on her Parisian stopover en route to Venice, and whose guest she had often been since, also had a *Madame,* and although loyal to her had no more intention of making the arrangement legal than did Whistler. The parallel was her best hope, for Whistler used her less and less as a model, and more often than not appeared without her, as proper Victorian hostesses could neither have accepted "Mrs Whistler's" card nor "Mrs Whistler."

In early August, 1886 Whistler and Maud visited Lucas together at his country house near Boisserie, and to while the time away Whistler did a sensitive watercolor of Maud, her hair pinned up, reading in bed, and began a portrait of Lucas, who—although he had been the recipient of Whistler etchings as gifts for favors done—had never bought a Whistler

painting. After two sittings the portrait of Lucas was left unfinished: Whistler had had all of the country he could stand, and returned to London, while Maud remained at Boisserie until the end of September. It was a bad time for her to be away from London, for when Whistler returned he found his old friend Godwin ill with what even Godwin realized was his final illness. To Louise Jopling, for whom he was designing a new house and studio, he had closed a letter gloomily, "The next move I make is to St Peter's Hospital, where I have bespoken a ward all to myself; then the next ward may be 6 x 4 x 2. I feel completely done with life." Beatrice Godwin, who had been amicably separated from her compulsively philandering husband since the year before, was called home from Paris. And while Maud breathed the country air of Boisserie and Godwin was breathing his last, Whistler visited the hospital every day and soon held more than one hand.

Over the years since Godwin's marriage to the daughter of Scotch sculptor John Birnie Philip, Whistler had become so close to the couple that he escorted "Trixie" (as he called her) when Godwin was busy professionally or otherwise. That Whistler saw so much of her had awakened Maud's jealousy years before. Trixie was French in appearance, dark, and with a tendency to plumpness. At thirty-one (in 1886) she was at the opposite end of her thirties from Maud, active and artistic, and Whistler eagerly gave her painting lessons; while Maud, who modeled little and had lost the elegance which had attracted Whistler a dozen years earlier, was often ill—ascribed to privations in Venice she had never got over—and often away from London. In December 1885 she had even been ordered by Dr Willie to spend the entire winter in the sun at Mentone. It meant even more time for Trixie—already then living apart from Godwin—to be together with Whistler, who had painted a radiant full-length portrait of her, *Harmony in Red: Lamplight*. It was one of the rare portraits over which Whistler had no struggle, perhaps indicative of the atmosphere in which it was painted. The broad cape Beatrice Godwin wore shrewdly concealed the plumpness that stays could not restrain, while her face concealed nothing.

When Maud returned from France she launched into Whistler's professional life as seldom before. "We are both working like niggers," she wrote Lucas. "I am printing etchings." But more important was the laconic postscript. "Mrs Godwin is now a widow. He died two weeks ago."

With Godwin at the end had been his wife, Lady Archibald

Campbell, and Whistler. The funeral was even more unusual than Godwin's life. He wanted to be buried at Northleigh, near Witney, in Oxfordshire, without any ceremony. Mrs Godwin, Lady Archie, and Whistler accompanied the coffin from London to the nearest railroad station. There it was placed in an open farm wagon, onto which the three mourners clambered; and when they were ready for the picnic lunch they had brought with them they put a cloth on the coffin and used it for a table, while the wagon jolted along toward Godwin's last resting place.

After that life became more stormy at the house in The Vale. Mrs Godwin moved to Chelsea and to Maud's annoyance became an habitué of Whistler's studio. Whistler was then painting Lady Colin Campbell, who was peeved by the daily interruptions and the subsequent rubbings-out, for Trixie's arrival was often a signal for the work to stop, and Lady Colin complained aloud about the constant presence of "the little widdie." ("Trixie is my luck," he explained to Lady Colin.) Maud objected even more, for Trixie soon was also an habitué of The Vale, where once a quarrel erupted that was so violent that Whistler ordered both women out of the house to settle their differences in the street. The *cul-de-sac* off the King's Road was almost as private as the little square house with the iron railings itself, but Maud, Tinnie Greaves told the Pennells, in her anger burst a blood vessel and Whistler rushed off to the chemist in the King's Road to ask him to do something. The chemist said he was no doctor and refused to come. What happened after that Miss Greaves did not know, but one can assume that Dr Willie was quietly sent for. After that a deep chill descended over The Vale, although Whistler and Maud continued together.

Before Godwin's death Whistler had been planning a new home and studio, one which would revive the dreams shattered by the bankruptcy and the loss of the White House. Godwin's design had even been deposited with the London authorities for approval. Whistler had become so excited over it that, writing from Godwin's office in Westminster, on Godwin's own notepaper, he had urged Louise Jopling to look at the drawings "and you will immediately construct something for yourself." With the death of the architect and the altered circumstances of his life, Whistler abandoned any thoughts of building anew.

Left more and more alone by Whistler, Maud sought something to do, and returned briefly to modeling. A Follower "who only dreams of Whistler" (as Belgian critic Octave Maus described him in 1883), William Stott of Oldham, had been exhibiting at Suffolk Street, often

showing canvases of nudes with such mythological titles as *Diana*,
Twilight and Dawn, and at the spring (1887) show had produced yet
another, on which he put a price tag of one thousand guineas, and of
which G.B.S. said in the *World*, "Mr William Stott exhibits a nymph; and
she, basking in the sun on a couch formed by her own red hair, exhibits
herself freely and not gracefully. The red hair is ill painted." Stott, who
preferred auburn-tressed nudes, decided to replace his model. This time he
planned a canvas on the traditional theme of Venus rising from the sea,
and asked Maud to pose. It had been her profession, and she had the
figure, although more full-blown than before, for a Venus.

At·Stott's studio Maud posed in nothing but her lush auburn·hair,
cascading down her shoulders and back, and Stott afterwards painted
around her—literally around, as the canvas was circular—a sea flecked
with silver foam, a large sea bird, and colorful shells on a beach in the
foreground. It was ready in time for the winter show of the Royal British
Artists, which was primarily an exhibition of the work of the President's
Followers. As the *Times* reported, there was a *Bathers* by Theodore
Roussel "in which Mr Whistler's influence is evident; . . . Mr Alfred
Stevens sends five good examples of his knowledge of morning, evening,
misty and foggy effects; . . ." There was also a Roussel portrait of Mrs
Menpes which might have been called an *Arrangement in Red and Black*, a
Sidney Starr full-length portrait of veteran melodrama actor E. S. Willard
in black on a black background in characteristic Whistler fashion, and a
Sickert seascape from Holland which suggested the Master. And there
was an impressionist Brittany seascape by Whistler's friend Claude
Monet.

Whistler's own submissions were minor ones, as if he were reserving
the center of the stage for his school. But the "Mrs Whistler" was
noticed—especially by Whistler. The *Times*'s critic diplomatically reserved
his attention for the appropriate Follower:

> At one end of the room is the "Birth of Venus" (341), by Mr
> William-Stott, of Oldham. We failed to admire Mr William-
> Stott's work last year, and candour again compels us to say that
> his ambition exceeds his ability. It is a large, round picture, in
> which the naked goddess, amid waves whose foam and broken
> waters dispose themselves rhythmically at her feet, steps forth
> upon the sand. The foam is hard and strange, but the treatment of
> the sea, in which there is good colour, is not unsuitable to the

poetry of the subject. But the goddess herself—who that has ever advanced beyond Lemprière will think her either Greek or divine! She is graceful, but not noble; and if she is Venus at all, she is merely Venus Pandemos. It is a great pity that the merits and the high aims of the work should thus be brought to failure. . . .
The contributions of Mr Whistler, the president of the society, will naturally be looked for, but they are this year less important than usual. . . .

G.B.S. agreed about the *Venus*, maintaining "that a painter who sees nothing in a woman but an idiotic doll, sees too little, whatever his school may be." Fortunately overlooked in most critics' columns was a portrait of the same model by Whistler, in fur hat and jacket, lent by Mrs Walter Sickert. "The lady in her right clothing," the gossip went.

Whistler raged righteously over what he considered a scandal. It was the affair of Jo Hiffernan and Courbet all over again. He had never painted Maud in the nude, and no one else should have. He spent more time in his Fulham Road studio, and less at The Vale, and finally abandoned Maud and The Vale altogether to return to a studio flat in Tite Street. Pointedly he wrote to the Stotts, with whom his relations had always been good, explaining that *Madame* was unwell and needed some days away from London. Accepting temporary refuge with the Stotts at 81 Windsor Road, Oldham, Maud had no idea that it would mean the end of her role as "Mrs Whistler." There had been arguments before, but they had been together for more than fourteen years, and each time before mutual need as well as the habit of half a generation had kept the relationship going. The need had gone. And there was someone else. At The Vale the shutters were drawn and the door locked.

By early 1888 Maud's role in Whistler's life had diminished, and the flare-up over her *Venus* became a convenient excuse for disposing of her. He almost always had kept two domiciles anyway, his studio doubling as alternative residence; thus if she had elected to remain stubbornly at The Vale he then had his replacement for the discarded Pink Palace in Fulham Road, the far more fashionable and convenient Tower House at 26 Tite Street. Somehow Tite Street magnetized him: he was always drawn back, regardless of the number of times he had left for good. There he shifted his servants William, John and Lizzie, and there—regardless of where he had spent the night—he would have his usual breakfast of two raw eggs beaten in a tumbler with pepper, salt and vinegar; bread and coffee. Even

in the days with Maud he had a bedroom to himself and usually used it, and would sit up late with tea and biscuits, reading a French novel or rereading his favorite Poe piece, while arrayed in a sleeping robe of Japanese silk, getting up occasionally to tend the fire which burned nearly all the year round.

To handle his private business affairs and act as secretary he again no longer had need of Maud, for his son John Charles was out of school and had already been—as Charles Hanson—handling some of the day-to-day affairs connected with the Royal British Artists and with Whistler exhibitions. Dependent on his father's support, he was more obsequious than the average city clerk. Whistler took great advantage of him, and although he left him with all the Master's petty responsibilities, he nagged him about each one, from arranging with Lizzie for a "small dinner" of soup and leg of lamb to purchasing a copy of the *World*; and not trusting him to write a proper letter usually sent him the texts, to be rewritten as "I am directed by Mr Whistler to say. . . ."

Beatrice Godwin had long been a permanent feature of Whistler's social life. Now he even had Lizzie taking orders from her about preparations for his Sunday breakfasts. In the summer of 1888 he was seen with her everywhere, and it was an open secret that she had vanquished Maud. Trixie did not even discourage rumors, since both were now free, that there was an understanding, perhaps even an engagement. At the Welcome Club in Earl's Court, at dinner with Louise Jopling and her new husband George Rowe, and Henry Labouchere and his wife, the subject came up, Louise Jopling in her memoirs owning to have asked the crucial question, while "Labby" alleged the same.

"Jimmy," Labouchere claimed to have asked, "will you marry Mrs Godwin?"

"Certainly," said Whistler.

"Mrs Godwin, will you marry Jimmy?"

"Certainly."

"When?"

"Oh, some day."

"That won't do," Labby insisted. "We must have a date."

"I wish," said Mrs Jopling-Rowe, "that you would be married before I leave town."

"When is that?" Jimmy asked.

"On Saturday."

"But this is already Tuesday!"

"That's easily managed," said Rowe, a solicitor. "You have only to come up to Lincoln's Inn Fields, and get a special license, and there you are!"

They agreed that Labouchere should choose the date, the church and the minister—and that for his services he would have earned the right to give the bride away, leaving Rowe to be the best man. As an M. P., Labouchere supplied the Chaplain to the House of Commons, Francis Byng. Rowe arranged to go with Mrs Godwin to secure the marriage license, while his wife went with Whistler to discuss arrangements with Byng.

The day before the marriage Labby happened to meet the bride and said, in passing, "Don't forget tomorrow."

"No," said Trixie, "I am just going to buy my trousseau."

"A little late for that, is it not?"

"No, for I am only going to buy a new tooth-brush and a new sponge, as one ought to have new ones when one marries."

Although part of Labouchere's reason for haste was to keep the secret so that there would be no chance of interruption from what was assumed would be a furious Maud Franklin, the small wedding party on Saturday, August 11, 1888 included an uninvited reporter from the *Pall Mall Gazette*, who wrote afterwards that the event was "not a 'ten o'clock' after all but an 'eleven o'clock.' "

At twenty minutes after ten this morning, if you happened to be passing the fashionable church at St Mary Abbott's, Kensington, you might have been tempted by the strains of the organ to step inside for a few minutes, but you would never have thought that a wedding in which all artistic London is interested was about to take place. There was no crowd at the gates, no curious and sympathetic ladies anxious to catch a glimpse of bride and bridegroom. As they say on the turf, I have had the "straight tip," and walked boldly into the church. . . . The church seemed to be in the possession of a young lady in blue, who was playing the organ, and the pew opener, who was sweeping the floor. "There is to be a wedding this morning, I believe?" I said to her with assumed suavity. "Kindly ask the verger, sir." The verger desired me to step into the vestry, where I found the Rev Mr Byng, the Speaker's Chaplain, a handsome, greyhaired ecclesiastic. "Good morning, good sirs; would you be kind enough to inform me

when Mr Whistler is expected." . . . At that moment I heard the sound of a light and dapper footstep outside the vestry door, and . . . resonant laughter. . . . The door opened and enter Mr Whistler, charmingly attired in an admirably made blue frock coat, fitting like a glove, a shining new hat with a broad brim, the same canary coloured gloves, spotless, of course, the square-toed boots, and the long thin wand of the Master.

"Good morning, Mr Whistler," said the interviewer, shaking hands and addressing a few congratulatory words suitable to the occasion. "I hope I don't intrude." "Disturber of the peace," cried he, "who gave you the news which I had finally thought was enveloped in Whistlerian mists?" "No matter, Mr Whistler, here I am. May I remain?" Without recording more of the conversation, it is sufficient to say that I remained. Mr Whistler was in great spirits, . . . just a little chastened by the thought that he had been discovered but after the first shock was over all went as merrily as the morning blues. . . . At twenty minutes to eleven or twenty minutes before the hour appointed for the ceremony, the arrival of Mrs Godwin, the bride, with her party was announced. Mr Byng was ready, Mr Whistler put on his boldest air, he bade "his little fluttering heart be still," at least he laid his left hand on the place where it should be. . . . Mrs Godwin was dressed in a gown of some blue stuff, and wore a shapely hat of the same colour. . . . On her left was Mr Labouchere, in a grey frock coat who when the time came gave the bride away. . . . Mrs Whistler . . . was about to march down the aisle when she was gently reminded by her husband that the entry in the registrar's book had to be signed. . . . The happy pair and their friends then drove to take breakfast at the Tower House, Tite Street. Tonight he and his newly-made wife will go to Paris. . . .

After the ceremony the party adjourned to Whistler's studio flat in Tite Street, which had not been fitted out for entertaining and lacked sufficient chairs, although there was a table, loaded with a wedding breakfast ordered from the Café Royal. Some celebrants had to sit on packing cases. The former Mrs Godwin had insisted on a tiered wedding cake. When it was brought from Buszard's, Whistler refused on aesthetic grounds to sit at the table with it. He had no interest in what it tasted like—it was just too ugly. It was put on a chair.

The *Sunday Times* reported that "The Butterfly is captive at last," and the *Pall Mall Gazette* "The Butterfly chained at last!" Other newspapers followed suit. Maud was still in a perilous emotional state after the succession of shocks to what had been a well-ordered life. There was no redress. Whistler had breached no promise and committed no bigamy. After six years with Jo and fourteen with Maud, he was still technically a bachelor; and the press never referred to his earlier domestic arrangements. Still, fearing some public reaction from Maud, the newlyweds left for France.

Life with Trixie did not begin as an uninterrupted idyll. Whistler was in love, perhaps for the first time, his previous domestic arrangements having been accommodations which ripened into near-permanency but with none of the affection he clearly felt for his formidable new wife. Still, with the former mate near at hand, as well as her friends (often his as well), some embittered by the callous desertion, Whistler was left on the defensive, and it showed in his reactions in the first months of his marriage. "If I died before Jimmy," Trixie predicted, "he would not have a friend left in a week." But she could not protect him from himself in such bastions of a man's world as his clubs, and there Whistler would pen his diatribes or confront his detractors. Just before the marriage, at the time of his separation from Maud, his *Ten O'Clock* lecture had been published by Chatto and Windus, and had become the occasion for some Whistlerian invective. In fact the stormy behavior of the first months following his break with Maud paralleled the aggressiveness which had followed his estrangement from Jo more than twenty years before.

Through Theodore Watts, who was still carefully managing Swinburne in Putney, Whistler had let it be known that he would be very glad indeed if his old friend Algernon Charles Swinburne would publish a piece giving wider recognition to the *Ten O'Clock*. Coming from the most important poet of his generation it would have been helpful publicity, and Swinburne, in days when Whistler needed encouragement, had written favorably of his art. Faithfully, Swinburne produced his piece, and "Mr Whistler's Lecture on Art" appeared in the June, 1888 *Fortnightly Review*. But it was no favor to Whistler to have produced what was as candid a critique as ever friend penned of friend. To the poet, Whistler was "a brilliant amateur" over his head in aesthetics but even so it was "impossible" that he should not "once and again touch upon some point worth notice if not exploration." Whistler was "an artist of skill so consummate, of tact so refined, of so sensitive an instinct and so delicate

an eccentricity," yet, Swinburne wrote, "I cannot bring myself to descend to flattery so gross and insincere" as to praise "the apparently serious propositions or assertions. . . . It is a cruel but an inevitable Nemesis which reduces even a man of real genius, keen-witted and sharp-sighted, . . . to the level of the dotard and the dunce, when paradox is discoloured by personality and merriment is distorted by malevolence."

The problem was that Swinburne could not accept his old painter friend as a wordsmith, and "more or less respectfully" declined to accept Whistler as preacher or prophet, although at the close of his essay he managed to find one satirical shaft "of good sense and sound reasoning" which he hastened to praise with "Nothing can be truer, and nothing could be more happily expressed." But the total impact was devastating: Swinburne could not now stomach Whistler's praise of the Japanesque, which he denigrated as "Asiatic aestheticism," nor could he find "matter or meaning . . . to support so elaborate a structure of paradoxical rhetoric."

Beset by domestic difficulties at The Vale and discord and rebellion at Suffolk Street, Whistler—who in the best of moods would not have felt indulgent toward the patronizing calumny of his old friend—ripped off a painful letter to Swinburne. Watts, intercepting it at The Pines, hesitated to show it to his companion, dashing off instead to Chelsea on a Sunday morning to ask Whistler to withdraw the unopened but—he was sure—offending letter. Whistler refused. Watts returned to Putney without waiting for the ritual breakfast, and Swinburne read the letter the same day, livid with rage, and swearing he would never again speak to Whistler. The rest of London read it soon after, for Whistler had it printed in the *World* on June 3, 1888:

> . . . Cannot the man who wrote *Atalanta* and the *Ballads Beautiful*—can he not be content to spend his life with *his* work, which should be his love, and has for him no misleading doubt and darkness, that he should stray about blindly in his brother's flower beds and bruise himself! . . .
>
> How have I offended! and how shall you in the midst of your poisoned page hurl with impunity your boomerang rebuke? . . . Who are you, deserting your Muse, that you should insult my Goddess with familiarity . . . ? Do we not speak the same language? Are we strangers, then, or, in our Father's house are there so many mansions that you lose your way, my brother, and cannot recognize your own kin? . . .

You have been misled. . . . For me—why should I refuse myself the grim joy of this grotesque tragedy. . . . Bravo! Bard! and exquisitely written, I suppose, as becomes your state. . . . I have lost a *confrère;* but, then, I have gained an acquaintance—one Algernon Swinburne—"outsider"—Putney.

Swinburne replied in a poem he published before the year was out—lines which shut the door on a friendship which could weather anything but words:

Fly away, butterfly, back to Japan,
Tempt not a pinch at the hand of a man,
And strive not to sting ere you die away.
So pert and so painted, so proud and so pretty,
To brush the bright down from your wings were a pity—
Fly away, butterfly, fly away!

By August Whistler had flown—to France—but everything had happened so quickly that he had left much business undone, even his feuds, and had to conduct his affairs by mail. He had flown from The Vale leaving behind some paintings and his beloved screen with the painted riverscape, but not leaving behind the quarter's rent. The water was cut off, and he appealed to his factotum to take care of that and other matters. The Royal British Artists were on his mind, and Charles Hanson was ordered to go to the meeting of its Council to see that a preliminary agenda for the next general meeting was posted to him in Paris. "Then," he instructed Charles in Whistlerian behavior, "you can gracefully bow to the lot and bid them goodnight and shoot open your opera hat with a bang! and disappear."

For the most part he spent the late summer and early autumn in Boulogne and Paris. He and Trixie visited the beaches and Casino, and Jimmy did a watercolor of a Boulogne shop. Then it was on to Touraine, Chartres, Tours, Loches and Bourges, and finally Paris, by which time Whistler had done about thirty etchings as well as several watercolor landscapes on silk, some of them worked on while a newly acquired magpie sat on his shoulder and spoke mischievous French phrases. His revived passion for the copperplate was no sign of disenchantment with Trixie: rather, she encouraged his art, and he liked to have her about while he worked, and even indicated the position in his life she had acquired by accepting her suggestions for modifying what he had done. But after all, had she not been a Pupil of Whistler?

On Thursday, October 18 they re-crossed the Channel, reaching London at six in the morning on Friday. Whistler had written ahead to Charles to pay his overdue bill for coals so that there would be a fire going, and to have William sleep at Tower House that night so that the place would be in readiness. He was not only planning on settling in with Trixie, but wanted William to have the studio set up for printing "directly I return."

In London Whistler resumed his business affairs with the hope that Maud would not materialize, although he and Trixie had heard that she was still about, and still calling herself Mrs Whistler. Two Mrs Whistlers were more than an annoyance. So, too, were two homes, one of them unpleasant with associations of Maud; and Whistler set about getting The Vale repaired because its neglected appearance might dissuade a prospective tenant. Before long two young artists he knew from Suffolk Street, Charles Ricketts and Charles Shannon, had moved in, and Whistler was visiting them as if nothing had ever happened to him there.

Another battle now erupted. William Stott of Oldham, whom Whistler was grateful not to have encountered since his return from France, had been elected in the Master's absence to membership in the Hogarth Club. Early that winter he walked in, discovered Whistler there, and told him in a very few words what he thought of his old friend's behavior toward a lady whose name neither had to mention. As Stott afterwards explained in a letter to the Paris *Herald*, "The feelings with which I hope the very sight of Mr Whistler will always inspire me, for the moment overpowered my self-control." But he left the cause obscure, referring only to "a private matter." The gossip columns of the less staid newspapers less delicately handled the morsel. "Jim the Whistler, it appears," said one, "was wont before he wedded the architect's widow, to take such hints as he might require about the construction of the human form as a basis for his smudgy oddities from that young lady who posed latterly for that extraordinary personage, William of Oldham. Why, I cannot say; but this caused Wonderful Will to stalk down to the artists' club to give the little American a bit of his mind. One would have thought, judging from the Oldhamite's pictures, the whole of it would have been no overpowering burden." Whistler responded—he claimed—without a word, but leaving Stott on the floor. At the Club there was quiet consternation. A gentleman might bed down with a woman, and he might desert her as soon afterwards as he pleased, especially if she were

not a lady. But no gentleman would berate another gentleman for the deed, especially in the sanctum of his club. Clearly Stott had committed an outrage. Whistler felt obliged to explain innocently in a letter to the Committee of the Hogarth Club:

> I have the honour to express to you my deep regret for an incident that happened last evening in the Hogarth Club rooms.
> Mr Stott, a newly elected member of the club, entered the club rooms about midnight, walked straight up to me, and without one word of explanation addressed me in these terms:—
> "You are a liar and a coward." . . .
> I immediately rose from my seat and slapped his face.
> This act, I assure you, gentlemen, was a spontaneous act, and the inevitable consequences of this gross insult.
> It is also my painful duty to add that this first slap in the face was followed by another slap in the face.
> I regret also to add that this painful incident terminated with a kick applied by me to a portion of Mr Stott's person that he had finally turned towards me, and which I leave to you, gentlemen, to divine. . . .

Pleased with himself, the Master sent a note to Deborah Haden to provide her with the true facts about the "latest scalp" he had taken, and enclosed a cutting from the *Sporting & Dramatic News*, which he claimed had—appropriately—the greatest authority. And he invited her to come to Tite Street to meet Trixie, contending that the two women could not help but like each other. Since Trixie was a lawful wife, the invitation was in order; but the gossip papers had not yet forgotten the other woman. *The Hawk*, run by George Moore's younger brother Augustus, had earned deserved notoriety by its quarrelsomeness, and three weeks after the Hogarth Club contretemps ran a story in which it claimed it had "quite got hold of the right end of the stick":

> . . . Whistler having at present no regard or interest in the fair young lady whose face has been seen so often in his pictures, Stott has bestowed his gracious patronage upon her; and feeling a sense of irritation at old memories, he went down to the Hogarth intent on dire deeds of daring. Whistler was at the time talking to a friend, and Stott approached him and said, "Whistler, you are a coward and a liar." But the painter kept very cool, and answered,

"Though I can't prove at the moment that I am not a liar, I will show you that I am not a coward," whereon he knocked the Oldham man onto the carpet with a well-directed blow between the eyes. Stott is in reality a bigger man than his opponent, but the facer half stunned him, and he could do nothing. Whistler, on the contrary, is full of the affair, and will henceforth pose as a champion in the fistic art in addition to the other professions which fit him so curiously.

His pugnacity again provoked, Whistler determined on a rebuke to the author of the story, whom he did not know well enough to recognize. It took some time, while the Master brooded over the insult; but finally a friend pointed out editor Augustus Moore in the foyer of the Drury Lane Theatre. Whistler ran at him from behind, wand uplifted and announcing, "This is the way a hawk strikes!" He rapped the surprised culprit's face, with each blow shouting, "Hawk! Hawk! Hawk!" Then he missed his footing and fell. Moore, a much larger man, claimed afterwards that he had knocked the Butterfly down, but Whistler dismissed the allegation. "What difference does it make whether he knocked me down or whether I slipped?" he asked. "The fact is [that] he was publicly caned, and what happened afterwards could not offset the publicity and nature of this chastisement. . . ."

Maud would have been amused, if she knew; but by then she was living in Paris, at 12 Rue Jacob, surviving by selling the few Whistler etchings she had through such of her French connections as Duret and Lucas. To Mary Cassatt she appealed that with the experience she had in modeling and in printing Whistler's etchings she could support herself, if friends would send business her way.

Years afterward, Maud dropped the "Mrs Whistler" from her cards, having refused to efface her former self until she had acquired a new one. In Paris, Louise Havemeyer recalled, she, her husband and Mary Cassatt had attended a concert; "the first piece had already been played, when Miss Cassatt suddenly called my attention to a lady and gentleman entering the box next to ours. I looked and saw a beautiful woman, exquisitely dressed, elegant and dignified. I noticed her furtively during the concert, and I saw she was a little uneasy and avoided looking in our direction, and she and the gentleman left before the end of the concert." As she departed Miss Cassatt leaned toward Mrs Havemeyer and whispered, "That was Maud. She has married a rich man and lives in

luxury on the Champs Elysées." Widowed later, Maud had a country house near l'Étoile, and a motor car, and politely refused to see people who were seeking facts about her life with Whistler. As she told Lucas, "I cannot search back into the past for things that no longer concern me. I feel sure you will understand why. . . ."

XXVIII

Collecting the Quarrels

F OR Whistler the only thing more gratifying than coining a *mot* was
publishing it. When Walter Sickert fathered one, and wanted to
ensure its publication, he attributed it to Whistler, which gained it
the front page of the *Westminster Gazette*, directly under the leading article.
"Very nice of you, very proper, to invent *mots* for me," the Master said.
" 'The Whistler *Mots* Propagation Bureau!' I know! Charming! Only
when they are in languages I don't know, you had better advise me in
good time, and send me a translation. Otherwise I am congratulated on
them at dinner parties, and it is awkward."

People noted Whistler's *mots* in their diaries, one such entry by
Thomas Sergeant Perry in 1888 reporting, "Whistler is mistaken for a
hatter's clerk and addressed, 'This hat doesn't fit.' 'True, and your coat is
damnably ill cut, and I don't like the set of your trousers.' Going to
Collinses he finds an obviously unfinished picture in Whistler's style, a
frame like his own. C. asks for advice. 'Leave it as it is.' C. apologizes for
the frame, a copy of one of Whistler's, saying, 'You see, I took a leaf out
of your book.' At the foot of the steps W. says, 'It must have been a
flyleaf.' " The squibs and polemics by which Whistler advertised himself
were indispensable to his existence. Much as the artistic Establishment
would have had it otherwise, he would not be ignored. "I have seen

Whistler," Sickert once wrote, "spend mornings of precious daylight showing Nocturne after Nocturne to the football correspondent of a Fulham local paper."

Among the Americans in London whom Whistler knew in the late Eighties was Sheridan Ford, who wrote for the New York *Herald* and the Irving Bacheller Syndicate. Having written on Whistler, Ford had occasion to root through the newspaper files in which the record of the artist's jousts with his contemporaries had appeared, and came up with the idea that the correspondence was worth preserving as a book. It meant a second wind for the old antagonisms, and possible income, which Whistler was willing to share with Ford if Ford did the work; and as he searched newspaper files in the British Museum, Whistler went through boxes of correspondence and clippings, often taking an already printed letter and repolishing the text in order to sharpen a barb or improve his own position in an old controversy.

Originally the collection bore the commonplace title of *The Correspondence of James McNeill Whistler*, and the type was already set up by Messrs Field and Tuer of the Leadenhall Press when the author, urged on by his wife, decided to cancel the agreement, pay off the editor with a pittance of £10, and order him to proceed no farther with the publication. The printers, receiving early in 1890 a similar notice from Whistler's solicitor, George Lewis, obeyed; and it may have been preliminary to that action that Lewis, at his office in Ely Place, asked, "But, my dear Jimmy, would it be quite just—?" "My dear George," Whistler interrupted, "when I pay you six-and-eightpence, I pay you six-and-eightpence for *law*, not justice."

The law was on Whistler's side. He owned the rights to his own writing, although he had instructed Ford earlier to secure permissions in his own name from the newspapers involved, which Ford had accomplished. Despairing of publication in England, and unwilling to waste the work he had done, Ford took his copy to Belgium after having returned Whistler's £10 check, and had the book printed in Antwerp. There the printer, aware of the interest of the work, objected to the unimaginative title, and Ford invited him to pick a better one. He did, pointing to a paragraph in the introduction, where the compiler had written, "This collection of letters and miscellany covers something over a quarter of a century, from 1862 to the present year. It illustrates the gentle art of making enemies, and is in part the record of some unpleasantness between

the Brush and Pen." "There's your title," said the printer. "Don't use this other thing."

Put into type once more as *The Gentle Art of Making Enemies*, two thousand copies were printed and ready for delivery when George Lewis appeared in Brussels and had the *Procureur du Roi* confiscate the copies and the type. Still determined not to be thwarted, Ford then pawned his watch and his wife's jewelry and found another English printer, in Ghent, who printed the title page as "Paris: Delabrosse & Cie, 1890." Ford added an amiable dedication: "To all good comrades who like a fair field and no quarter these pages are peacefully inscribed." Even the introductory note was free from rancor, Ford denying the existence of any "soulful intimacy between Mr Whistler and myself," and commending the book "to Mr Whistler's enemies, with the soothing assurance that should each of them purchase a copy the edition will be exhausted in a week."

Four thousand copies were printed, those with a grey-green paper cover for European distribution, and those with a similar cover imprinted in red, bound from sheets by the firm of Frederick Stokes and Brother in New York, which later disclaimed involvement with the book. Most of the Stokes edition was destroyed by a warehouse fire, and few of the "Delabrosse" edition were sold over the counter, for Whistler persisted in his suit to ban any distribution of his book, and had gone ahead with preparation of his own edition, even to adopting Ford's title and device of butterfly silhouettes to mark each Whistler note. Prudently Ford remained in Paris when Lewis took the matter to the Belgian courts in October 1891. Whistler and M. Kohler, the Antwerp printer, were the only witnesses. "What religion do you profess?" asked the presiding judge before the administration of the customary oath. There was silence, while the artist pondered the unexpected question. "You are, perhaps, a Protestant?" pursued the judge, hoping to relieve the awkward situation. Whistler shrugged his shoulders, as if to leave it up to the judge, and when he was asked his age he objected and was upheld. But he did deliver his testimony, and Judge Moureau condemned Ford—in absentia—to a fine of 500 francs (then £20) and an indemnity of 3000 francs (£120), to be paid, with costs, or three years' imprisonment in default of payment. Since Ford never appeared in Belgium afterwards, only his confiscated books remained imprisoned, mildewing in the damp cellars of the Palais de Justice.

In Paris, too, Ford was checkmated, the American ambassador,

Whitelaw Reid, introducing Whistler to the *Procureur de la République*
who saw to it that the book was suppressed. When what Whistler called
"the true book" appeared he sent an inscribed copy to the ambassador, "a
souvenir of flattering courtesies, and most effective aid in pursuit of The
Pirate." As George Smalley put it in one of his dispatches from London,
"Nowhere was there rest for the sole of Mr Ford's publishing foot."
Unrepentant, Whistler wrote of Ford to a friend, "The horse pond is for
him a mild sentence."

While Ford was being treated badly, and reacting accordingly,
Whistler, having appropriated Ford's title and ideas, set about creating his
own edition. He had become close to the young publisher William
Heinemann, whom he called his "publisher, philosopher, and friend," and
together they planned the book, Whistler driving to Heinemann's office
almost daily at eleven, to extricate him from his morning's work and to
breakfast at the Savoy, where on the balcony overlooking the Embank-
ment, deserted between the customary dining hours, they would go over
such tiny details as the arranging of a single butterfly on a page. That
Heinemann might have other business or might already have had
breakfast was a preposterous idea to Whistler, and if the publisher
thought otherwise he concealed it with real enthusiasm for the project.

The Ballantyne Press was entrusted with the printing, but Whistler
chose the type, spaced the text, designed an asymmetrical title page and
drew expressive butterflies for each entry which laughed, mocked, stung,
drooped over the famous farthing damages or triumphed in gay flight. A
"publisher's note" prefaced the book, explaining it as the result of "a
continued attempt to issue a spurious and garbled version of Mr
Whistler's writings," with only the Heinemann version as under
Whistler's "own immediate care and supervision." Following were six
pages of extracts from the London and Paris press about the "extraordi-
nary piratical plot" of a carefully unnamed villain. Then came Whistler's
title page:

THE GENTLE ART

OF

MAKING ENEMIES

AS PLEASINGLY EXEMPLIFIED

IN MANY INSTANCES, WHEREIN THE SERIOUS ONES

OF THIS EARTH, CAREFULLY EXASPERATED, HAVE

BEEN PRETTILY SPURRED ON TO UNSEEMLINESS

AND INDISCRETION, WHILE OVERCOME BY AN
UNDUE SENSE OF RIGHT

The dedication was in the same spirit: "To the rare Few, who, early in Life, have rid Themselves of the Friendship of the Many, these pathetic Papers are inscribed." It was Whistler's artistic autobiography and testament. It included his carefully edited condensation of the Ruskin trial, his *Piker Papers*, his *Ten O'Clock*, his favorite catalogue texts, and interviews and newspaper encounters with the critics, from 'Arry to Oscar. As a piece of book design it became a leader in the Art Nouveau movement for the idiosyncratic disposition of black and white on a page, rather than the slavish centering of print, and the combining of simplicity with elegance and taste with economy. Through the examples of his catalogues and pamphlets, and especially through his *Gentle Art*, Whistler prodded book designers into producing striking effects with the simplest means at the disposal of any print shop. He required only ordinary type and ordinary paper, and inexpensive binding and lettering, but a distinctively unconventional product resulted, and one within the means of the ordinary book buyer—a book to be read as well as looked at.

The *Gentle Art* project was, to Whistler, as much of a work of art as his most ambitious canvas, and the pains he took over each page were paralleled by the time he ostentatiously took over the proof. To Frederick Keppel, visiting the studio, he had happily read aloud from the proof sheets for two hours when a servant announced the arrival of a great lady in the English peerage. "Where is she?" "In her carriage at the door, sir." For ten more minutes he continued reading aloud, ignoring the waiting servant, until Keppel, realizing how cold a day in March it was, reminded him of the lady.

"Oh," said Whistler, "let her wait—I'm *mobbed* with these people." Then he read on for fifteen more minutes before ordering the servant to let "her shivering ladyship" in. The book—or the pose—was more important.

Neither Whistler's pose nor his prose could have been deduced from the tranquil *Mother* or *Carlyle*, the fastidious yet simple later portrait arrangements, the evanescent nocturnes, the impressionistic etchings, the lyrical pastels. The bitterness of the maker of paradoxes and the belligerence of the maker of enemies materialized in Whistler's art only in the waspish sting in the tail of the butterfly signature. To George Moore the contents of *The Gentle Art* would never have existed had they

not been Whistler's "safety-valve by which his strained nerves found relief from the intolerable tension of the masterpiece," while the public at large probably agreed with the *McClure's Magazine* parody of the sublimely arrogant Whistler who chortled while hurling his scissors through a studio window one morning, "Ha, not yet nine o'clock and another enemy made!" To Max Beerbohm the book was the rare product of a "good talker who could write as well as he talked," and was as cosmopolitan and eccentric as the author:

> Read any page of *The Gentle Art of Making Enemies*, and you will hear a voice in it, and see a face in it, and see gestures in it. And none of these is quite like any other known to you. It matters not that you never knew Whistler, never even set eyes on him. You see him and know him here. The voice drawls slowly, quickening to a kind of snap at the end of every sentence, and sometimes rising to a sudden screech of laughter; and, all the while, the fine fierce eyes of the talker are flashing out at you and his long nervous fingers are tracing extravagant arabesques in the air. No! you need never have seen Whistler to know what he was like. He projected through printed words the clear-cut image and clear-ringing echo of himself. He was a born writer, achieving perfection through pains which must have been infinite for that we see at first sight no trace of them at all. . . .

G. K. Chesterton could not understand anyone thinking that there was any laughter in the *Gentle Art*. "His wit is a torture to him. He twists himself into arabesques of verbal felicity; he is full of a fierce carefulness; he is inspired with the complete seriousness of sincere malice. He hurts himself to hurt his opponent." He was not sufficiently objective to be a great satirist, yet his satire survives. "No man," Chesterton wrote, finding the reason, "ever preached the impersonality of art so well; no man ever preached the impersonality of art so personally." Perhaps in the contradiction lies the success of his satirical writing, although it may still stand as much for its historic value as its histrionic value. The battles Whistler fought, D. B. Wyndham Lewis thought, were collectively not merely Whistler versus the art critics of England but Whistler versus "the Island Race." He was "extremely fortunate in his period" for there was a cultivated, leisured newspaper-reading public and a press which strove to meet its taste without serious concern for the laws of libel.

Heinemann published *The Gentle Art* in 1890, a few months after the

last pirated version, and Whistler ornamented a pile of presentation copies with inscriptions in the spirit of the book, offering one to George Moore with what was, for the Master, lavish praise for his recipient. "For furtive reading," he wrote, "which means that anything George Moore writes—anything good he writes about painting—was plagiarised from me, James McNeill Whistler." Two years later a second edition appeared, enlarged with more recent missives to the press, but before it emerged Whistler, in a second-hand bookshop, came upon a copy of the first edition which he had given to an acquaintance after blandly inscribing, "With the regards of the author." He bought the book, penned in an additional word above the line and sent it again to the ungrateful friend. The amended inscription read, "With the renewed regards of the author." At work was the sting in the tail of the butterfly, the animating force behind the collected quarrels; for the butterfly was not born with his sting, but had to develop it and perfect it in self-defense. At the end of his second edition he included an *envoi* to "Atlas." "These things we like to remember, Atlas, you and I," he wrote, "—the bright things, the droll things, the charming things of this pleasant life—and here, too, in this lovely land they are understood—and keenly appreciated. As to those others—alas! I am afraid we have done with them. It was our amusement to convict—though they thought we cared to convince! *Allons!* They have served our wicked purpose—Atlas, we 'collect' no more."

XXIX

The Conquest of Paris

B Y the time Whistler and Trixie had crossed the Channel in the summer of 1888 his frustrations with France were diminishing. Even London had been more hospitable to his work than Paris, although by the 1880s critics and artists of his own generation were creating shifts in French tastes, and the words *impressionist* and *symbolist* were gaining respectability. Whistler's own work had spurred the change in attitude. In 1882 he had shown his *Lady Meux* (*Arrangement in Black, No. 5*) at the Salon, and in 1883 had submitted the *Mother*, with Walter Sickert taking charge of it and remembering for years afterward "the vision of the little deal case swinging from a crane against the star-lit night and the sleeping houses of the Pollet de Dieppe."

Whistler had given Sickert letters of introduction to his old friends Degas and Manet, copies of the brown-paper catalogue of his etchings to present to them, and instructions that when they asked politely after the health of their old Left Bank comrade he was to say that Whistler was "amazing." Manet was too ill to see him, but Sickert heard him through the open door ask his brother to show Whistler's friend the studio. Sickert then went to visit Degas, who received him early one morning with his head tied up in a flannel comforter. "Sir," said Degas politely, "I am unable to receive you. I have a devilish case of bronchitis. I'm sorry."

"It doesn't matter," said Sickert blandly. "I dislike conversation. I've come to see your pictures. I am a pupil of Whistler. Let me present you with my master's catalogue." Silently then, and with great deliberation, Sickert proceeded to examine all the pictures on view in the flat, as well as the wax statuettes under their glass cases, keeping the puzzled invalid standing all the while. Whistler would have been amused. But he was not amused by Degas's own wit when it was directed at him. Once, irritated by Whistler's vanity, he exploded at him, "You behave as if you have no talent." Whistler feared his tongue and said nothing. The situation was not lost on Francophile George Moore, who wrote art criticism friendly to Whistler, but who could not resist an unfriendly epigram: "When Degas is present, Mr Whistler's conversation is distinguished by brilliant flashes of Silence."

Degas, who cared little about his own dress, was irritated by Whistler's caring overmuch, and in the years when his friend still affected his broad, flat-brimmed hat and made sure that it was noticed, Degas grumbled, "Indeed, it suits you very well, but it does not return to us Alsace and Lorraine." Later, when Whistler, dressed befitting his role as master, with tall cane and gleaming monocle fixed at their appropriate angles, and frock-coated and top-hatted, strode into a restaurant where Degas was sitting, the Frenchman called out, "Whistler, you have forgotten your muff!" Rejecting his friend's life-style he once blurted, "Whistler, if you were not a genius, you would be the most ridiculous man in Paris. It must be very tiring to keep up the role of butterfly. Better to be an old bull like me."

Of Whistler's art Degas said, "He draws by distances, not thicknesses." And of the stylish *Lady Archibald Campbell*, with its unusual, half-turned figure against a black background, he observed, "She is going back into Watteau's cavern." The *Ten O'Clock* was scorned by Degas as an exercise in showmanship—"art scorned by society in evening dress." What Whistler wants, he told Ludovic Halevy, "is quite simple. He wants you to talk about him according to his own lights." To young Frank Harris he observed of Whistler, "What a pity! He should paint with his tongue: then he might be a genius." Yet Whistler had sent the *Ten O'Clock* to him with the warm inscription, "To Degas: Charming enemy—best friend!"

In truth the old combatants found much to admire in each other, and had been working along similar lines.* As Degas had told Paul Poujaud,

* Degas, whose early work showed clear Whistlerian influences, appears in his *Interior* (*le Viol*) to have been inspired by the "tense and ambiguous eroticism" of *The White*

he and Whistler had been working along the "same road . . . from Holland" in their first canvases; and of an early *scène de toilette* by Fantin in eighteenth-century Dutch style he suggested, "We [both] could have signed it, Whistler and I." And later Whistler assured a young Austrian gallery representative who had come to Paris to choose works for a Viennese exhibition, "As far as painting is concerned, there is only Degas and myself." Yet always unsure of his technical skill and aware that Degas was at no such disadvantage, Whistler was never his cocky self in Degas's presence. Elsewhere he could be closer to center stage. With Claude Monet he was on terms of easier familiarity. Monet had not known Whistler quite as long, yet had painted with him as early as 1865, when they joined Courbet at Trouville; and it was Monet's 1874 painting *Impression: Sunrise* which had suggested a name for the new movement for which Whistler was London exemplar. At his friend's invitation Monet had later exhibited at Suffolk Street among riverscapes of Whistler's which were impressionistic in ways other than his own. They corresponded about showing their wares together, and Monet visited Whistler in London and reciprocated the hospitality in Paris, where his low-ceilinged dining room, painted a startling yellow and sparely furnished with cane-bottom chairs and Japanese prints might have been Whistler's own. On the other hand, Edouard Manet, who had exhibited with Whistler as early as the Salon of 1861 and the *Salon des Refusés* in 1863, had remained only in faint contact with Whistler, yet even this was more than Renoir, Cezanne and others of the Impressionist group.

Whistler's closest ties with France as he passed fifty—but for his contemporary Camille Pissarro—were with younger writers and painters. Pissarro pressed the study of Whistler on his son Lucien, pointing out how the delicacy of Whistler's etchings was often derived from the artist's own inking—"no professional printer could substitute for him, for inking is an art in itself and completes the etched line." Every Paris exhibition in which a Whistler work appeared furnished the text for another lesson to Lucien, from the use of black to "the mode of presentation." Whistler, Pissarro assured his son in 1887, "is a showman, but nevertheless an artist."

Among the more unlikely but genuine admirers of Whistler in Paris

Girl (*Symphony in White, No 1*), while he even copied in his notebook Whistler's *Symphony in White, No 3*, which in the handling of the figure and subtlety of tone directly affected his *Mlle Fiocre dans le Ballet de la Source*. (Theodore Reff, "Degas's 'Tableau de Genre,' " *Art Bulletin*, LIV (Sept., 1972).

was Henri de Toulouse-Lautrec, whose portraits, especially of poet Georges-Henri Manuel, both sitting and standing in profile, with coat, hat, and gloves, are composed in the manner of the *Mother* and the *Carlyle.* His trips to London, usually with his friend Maurice Joyant, included visits to Whistler's studio, and they saw each other in Paris as well, Lautrec being interested in discussing with Whistler his Europeanization of Japanese techniques. One result was evidenced in Lautrec's posters, especially his *Loïe Fuller* (reproduced in the *Echo de Paris*) and subsequent designs.

In London Whistler once invited Lautrec and Joyant to dine at the Café Royal, and after a lengthy conference there with the *maître d'hôtel* selected a menu almost exclusively French. Each dish was worse than the preceding one, and Whistler, chagrined, cursed English cooks and cookery. Returning the hospitality, Lautrec invited Whistler to luncheon in the grill-room of the Criterion and ordered nothing but typically English dishes. The English cooks, knowing what they were doing, produced an edible meal, and Lautrec was triumphant. Back in Whistler's studio Lautrec made two pencil sketches of his friend, one in straw hat, the other in top hat and with cane.

A much closer friend since the early 1880s, and as much an exotic as Lautrec, was Count Robert de Montesquiou, the eccentric and dandy who had been the inspiration for the depraved sybarite Des Esseintes in Huysmans' *À Rebours.* Montesquiou was the archetype of the future Decadence, and in fact epitomized the outer limits it could reach when one was allied, as he claimed, to "the greater part of the European aristocracy" and had the wealth to indulge a life of stylized pleasure. He cultivated upward-pointed waxed mustaches, improved his complexion with makeup, and spent much of each day with his tailor, hairdresser and manicurist. But he was also a poet and a wit, a connoisseur of art and a man who knew everyone in Paris worth knowing. Through John Singer Sargent he met Henry James in London, Sargent having described his acquaintance to James accurately as "unique" and "extra-human." The Count had been travelling with Prince Edmond de Polignac, and James invited both to dinner to meet Whistler. Montesquiou was beside himself with desire to see the Peacock Room, which Whistler himself was the very last in London to be able to enter; but James agreed to make the arrangements, and Whistler offered to give lunch to the Frenchmen prior to the visit. It began a period of close friendship with Montesquiou, who

wrote a poem, "The Dying Peacock," and afterwards posed for a Whistler portrait.

Marcel Proust later praised the poem, and put the Count, as the Baron de Charlus, into his *À la recherche du temps perdu*. After Proust, who had become interested in Ruskin, met Whistler at the *salon* of Méry Laurent, the artist assured him that Ruskin knew nothing whatever about painting; yet Whistler was cajoled by his new admirer* to say a few favorable words about his *bête noire,* and in confusion left his grey kid gloves behind. Proust appropriated them as a souvenir and appropriated Whistler's personality in part for the character of yet another figure in the *Remembrance,* the painter Elstir. Montesquiou had given Proust a specially bound copy of *The Gentle Art,* awakening the young writer to Whistler's religion of art as well as his raffish behavior, and Proust had been enchanted, afterwards putting the famous trial into his early novel, *Jean Santeuil.* "I will walk with your Majesty," says the Duke of Brittany to the King of Portugal at the Opéra. "No, Brittany," the King responds affably but firmly; "I'd rather go with my young friend Jean; he can finish telling me about the libel suit between Ruskin and Whistler, which fascinates me. . . ."

In the *Remembrance,* the gothic-drunk Bergotte is Ruskin; and Elstir, although he paints pictures attributable to several artists—Monet, Moreau, Renoir, Degas and even Turner—does both impressionist seascapes and firework nocturnes, and has much in him of Whistler, even to the suggestive name.

The villa of Méry Laurent at 9 Boulevard Lannes, where Proust first encountered Whistler, was the establishment to which Stéphane Mallarmé repaired regularly when the dreariness of domesticity became oppressive, but never on Tuesday evenings. Unlike Paul Verlaine, who—it has been said—"spared himself, whenever possible, the fatigue of logical thought," yet did suggest to his fellow Symbolists that poetry should have hazy contours, like a Whistler nocturne, and through his influence helped liberate French verse from literalism, Mallarmé was an intellectual who cultivated intellectuals, both at the *salon* of his "belle amie" and at his more modest official residence. *"Le symbole du Symbolisme,"* he was the poet to whom all literary people gravitated as soon as they were in Paris, and invitations to his Tuesday literary evenings at his home in the Rue de Rome, *Les Mardis,* became a coveted

* Proust kept a lithograph of Whistler's *Carlyle* on his bedroom wall.

token of artistic worth. Whistler missed few *Mardis* when he was in Paris, and a warm friendship grew between the two men, beginning after Monet had brought the two men together at the *Café de la Paix,* and Mallarmé had quickly offered to translate the *Ten O'Clock* into French.

The stocky Mallarmé, who dressed in a schoolmasterly black which befit his occupation, on the surface could not have been less like his great new friend. A family man, his wife and daughter were to all appearances the most important people in his life. He dwelt in a frugal and bourgeois manner, kept no servant and answered the door himself, shepherding visitors to the dining room, where a china stove ineffectively warmed the room from a corner, and an ugly gas chandelier hung from the ceiling over a bulky table on which the only visible cheer was a large bowl of tobacco from which guests filled their pipes. On the walls were arranged modestly the work of his friends—a Monet, a Whistler, a Gauguin; and on a small table stood a Rodin. It was a world away from *Les Talus,* Méry's countrified little house with its low ceilings and rustic furniture covered in flowered cretonne. She was as old as Whistler (and a year younger than Mallarmé), and had been model and mistress to Manet. A year after Manet's death in 1883 Mallarmé had become her lover; and all the while she had actually been kept in the style she appreciated by Dr Thomas Evans, who had been Napoleon III's American dentist. Evans, as Proust's biographer George Painter has described him, "was wealthy, generous, and free from jealousy"; he installed Méry—"Mistress Mary" in Whistler's pun—"in an apartment near his own consulting room in the Rue de Rome, but had no objection to her also indulging her passion for painters and poets, so long as they were out of the way when he called, as he did every day, for lunch."

In Whistler's description, Evans was "en plein Buffalo Bill" or "our dentist," and Méry and Mallarmé were useful contacts with him because, among his other activities in Paris, Evans published the *American Register,* to which Whistler fed publicity about himself through his friends. Among the pieces passed on to Méry Laurent was an article by Théodore Duret, who for nearly a decade had been one of Whistler's most successful exponents in France. After Venice, Duret had devoted an article in the *Gazette des Beaux-Arts* to Whistler's new work, praising the nocturnes as akin to "those Wagnerian compositions in which the harmonic sound, separated from all melodic design and any accented cadence, remains a kind of abstraction and conveys only a very indefinite musical impression." Without having changed his style, Whistler had

found himself related to a new intellectual movement about which he knew little. Wagner was the rallying cry of the latest *avant-garde*.

Through Mallarmé Whistler found yet another entry into the French consciousness. Charmed with the *Ten O'Clock,* Mallarmé in 1888 had offered to translate it for publication in Paris,* and through the *Mardis* Whistler began meeting the new generation of artists and critics. He needed the help. Although he had been exhibiting regularly at the *Salon,* as he described the situation to Mallarmé, "For years I have been sending my etchings to Paris shows, and they are hidden around the gardens and the buffets while my prize medals are regularly awarded to others." (One of the "others" was Seymour Haden.) Their correspondence over the translation was a miracle of tact. Whistler sent proposed corrections with a note that he was touched by "the sympathy shown in every line for my work," and Mallarmé responded that he found the changes easy to make as "I sympathize entirely with your artistic vision." It was easy to see why. One evening Mallarmé read a sonnet to his guests. They were obviously pleased. He was displeased. "They understood immediately," he told a friend. "I have failed. I must rewrite the sonnet and veil the thought so that it is accessible only to superior intelligence." The veiled concept. It was a mutual aim.

On occasion the *Mardis* drew a stocky, goateed young composer, Claude-Achille Debussy, who would in 1894 musically illustrate Mallarmé's *L'Après-midi d'un faune.* Literature had been important in his life from the earliest years of his education, as at ten he had been "discovered" and taught piano by Mme Mauté de Fleurville, the mother-in-law of poet Paul Verlaine, before he went to the *Conservatoire.* At the *Mardis* he met artists as well, and was attracted by tendencies in some of their work which encouraged his own. The *Académie des Beaux-Arts* had already discovered in his symphonic suite *Printemps* alarming traces of "that vague impressionism which is one of the most dangerous enemies of artistic truth." Inevitably Whistler and his work appealed to him, as did the poetry of the quintessential Pre-Raphaelite, Rossetti, whose *Blessed Damozel* he set to music, and Poe, for whose *Fall of the House of Usher*—a Whistler favorite—he began a setting but left it unfinished. When he turned to Henri de Régnier's *Scènes au crépuscule,* which from 1892 through 1899 he developed into the *Nocturnes for Orchestra,* two favorite Whistler labels for his pictures seemed involved, and Debussy's

* It was published in 1891.

biographer saw as a "strong" and "lasting" influence "that of Whistler, who often borrowed words from the musical vocabulary for the titles of his pictures, just as Debussy was to choose terms used by painters for the titles of his symphonies." Despite his aversion to explanations of his compositions he did define the nocturnes in language reminiscent of Whistler:

> The title "Nocturnes" is to be interpreted here in a general and, more particularly, in a decorative sense. Therefore, it is not meant to designate the usual form of the Nocturne, but rather all the various impressions and the special effects of light that the word suggests. "Nuages" renders the immutable aspect of the sky and the slow, solemn motion of the clouds, fading away in grey tones lightly tinged with white. "Fêtes" gives us the vibrating, dancing rhythm of the atmosphere with sudden flashes of light. . . .

"The painter," wrote Debussy's biographer, "was a favorite with Debussy, and their art has often been compared . . . , for in the work of both these artists the lines seem to resolve themselves into an atmosphere, luminous or sonorous, colored or harmonic, that seems more essential to the composition than either the subject or the landscape." Alfred Bruneau and Paul Dukas (of *Sorcerer's Apprentice* fame), friends of the composer and composers themselves, agreed that Debussy's music recalled "the strange, delicate vibrating 'Nocturnes' of Whistler, and like the canvases of the great American painter, they are full of a deep and poignant poetry." That such a relationship was intended is evident from such letters as that of Debussy to the violinist Eugène Ysaÿe, in which he wrote of the Nocturnes he was composing, "It is in fact an experiment in the different combinations that can be achieved with one color—what a study in grey would be in painting." Hardly a Follower, Claude Debussy was one of Whistler's better students.

A faithful *mardiste,* Whistler nevertheless violated all the rules but his own by always dressing in tails. No Frenchman found such sartorial elegance necessary in the Rue de Rome. Reciprocating Mallarmé's work on the *Ten O'Clock,* he did a frontispiece portrait lithograph for a new collection of his friend's poems, and urged him to send verse to the editor of the *National Observer,* W. E. Henley, whom he knew well. There was also another minor collaboration. For a London periodical, *The Whirlwind,*

a self-styled Legitimist weekly which came out only occasionally and had little to do with Jacobite aspirations* but was run by friends of Whistler, Mallarmé contributed a sonnet, a *"Billet à Whistler,"* which was published in November, 1890 along with a lithograph by the Master, a coup which enchanted the artist but did nothing for either's reputation. But Mallarmé's greatest service involved a plan hatched among Whistler's friends in Paris in 1891 to have the *Mother* purchased for the nation.

After March, 1891 their task was made easier, for the Corporation of the City of Glasgow had finally, after protracted negotiations, purchased the *Carlyle*. The movement to do so had begun after its showing at the Glasgow Institute in 1888, when a group of ninety influential residents petitioned the Corporation to buy the work. But the price asked in 1891 was a thousand guineas, six hundred more than before, when Whistler was desperate for funds. There was Scots' resistance to the extravagance, yet Whistler had remained adamant, telling Graves that he was weary about the prices of his paintings being damaged by allegations of their eccentricity. The *Carlyle* would have its "real worth" established by its price—"since in no other way can it be understood."

He was hard up as usual, and sorely tempted to take less than his asking price; but his marketplace reputation had to be recognized, and this was the opportunity. Quietly, however, he turned to Otto Goldschmidt, who had been manager and accompanist for Jenny Lind (and who also became her husband), and whom Whistler knew as pianist and manager for Pablo Sarasate. "At that moment," Goldschmidt recalled, Whistler "had no money to live on, and he came one night at 11 o'clock, asking me for £200." In exchange, Whistler urged, "You come tomorrow to my studio and you choose some pictures." Goldschmidt went, and took what Whistler offered him—two nocturnes and a Venice etching. It kept Whistler going.

Despite the fact that the *Carlyle* would no longer be what its painter called a cheap and easy acquisition, local pressure in Glasgow continued, with the result that two representatives of the Corporation were delegated to discuss the price with Whistler, one the chairman of the galleries committee, Robert Crawford, the other a conservative colleague expected to keep the negotiations on a sound fiscal level.

Receiving the ambassadors cordially, Whistler, in velveteen jacket

* Whistler however did belong to the Order of the White Rose and attended a number of its meetings in the early Nineties.

and loose necktie, offered them "Vienna tea" (with lemon and rum) and talked about everything but business. When they pressed Whistler about the picture, he professed eagerness to see the *Carlyle* in the philosopher's home country. But when they suggested compromising at eight hundred guineas, Whistler apologized that he wished, rather, that he could bestow it as a gift upon the good people of Glasgow "in appreciation of their good judgment in desiring to possess it." But, he confessed, he could not.

The next day the men from Glasgow returned, with the hope that the Master had thought the better of their offer. Whistler offered them cigarettes and tea, but no reduction in price. The picture was displayed on an easel, and the two negotiators looked at it long and critically, hoping to come up with something which might alter Whistler's mind. Several tries were quickly countered; then one Glaswegian observed, "The tones of this portrait are rather dull, are they not? Not very brilliant, are they?"

"Not brilliant?" Whistler asked. "No; why should they be? We are not 'highly colored,' are we? We are very ordinary-looking people. The picture says that, and no more."

Whistler got his thousand guineas, nearly half of which (£462.13.2) was owed to Graves for principal and interest on loans which the *Carlyle*, the *Mother*, the *Miss Franklin* and two nocturnes had secured. But it was the selling price which was news on both sides of the Channel. First he was made a Chevalier in the Legion of Honor, which made him respectable enough for the government to deal with. Then Maurice Joyant and Roger Marx, then Inspector of Fine Arts, with Georges Clemenceau's backing (which was important since he was leader of the Radical deputies and publisher of *La Justice*), suggested purchase of the *Mother* to Léon Bourgeois, Minister of Public Instruction and Fine Arts. Mallarmé was the middleman in the negotiations. Whistler at first held out for a sum equivalent to that paid for the *Carlyle*—about twenty-five thousand francs. He did not want to make any difficulties about the amount, but would be embarrassed by an undignified low price. A diplomatic maneuver finally suggested itself to Whistler—that it be reported that a token amount was paid at the government's insistence. But then another problem arose. The purchase would go to the Luxembourg Museum, which was in some ways a corridor to the Louvre, but Whistler insisted on "an official promise that, later on, the painting would go to the Louvre." Mallarmé was commissioned to handle that matter delicately, and to quash any suggestion that a public subscription might be required to raise funds beyond what the government would offer. "You

know only too well," he confided to his friend, "how pleasing this artistic triumph would be [to me] right now in the capital of the arts! All the sufferings of the past years in that country—of insult and ribald misunderstanding—would seem insignificant, and I might even find a poetic justice in the severe test the artist endures before he dares hope for such reward in his lifetime."

On the evening of November 19, 1891 "the great letter with the beautifully imposing seal of the armorial bearings of France, "floating in a lake of red wax," arrived at Whistler's home in Chelsea. No sum was mentioned, this being beneath the dignity of the occasion, but Whistler wrote back that he was flattered by the sympathy and gracious honor. Soon Roger Marx reported that the price would be four thousand francs, a fraction of the amount brought by the *Carlyle*. Whistler happily telegraphed, *"ACCEPTE LA SOMME DICTÉE,"* and to Mallarmé suggested that he would be spending more time now across the Channel, "because since France has permanently taken the 'Mother' it seems to me that she also has to adopt the son a little!" (In one sense she immediately did, as Whistler was simultaneously elevated from Chevalier to Officer in the Legion of Honor, entitling him to wear the rosette of an Officer, rather than the red ribbon of a Chevalier, in his lapel.)

The *Mother* purchase electrified artistic London and set critics in England and America to bemoaning the loss to France of a painting either nation could have had at any time over the years. An English newspaper lamented, losing sight of Whistler's nationality in the process, "Modern British art will now be represented in the National Gallery of the Luxembourg by one of the finest paintings due to the brush of an English artist." From America there were newspaper reports of a commission for Whistler to paint a picture in commemoration of the Chicago International Exposition, the added reason being given that it was believed his grandfather had first selected the site of the city.

In Paris the *Chronique des Beaux-Arts* declared, *"Au musée du Luxembourg, vient d'être placé, de M. Whistler, le splendide* Portrait de Mme Whistler mère *une oeuvre destinée à l'éternité des admirations, une oeuvre sur laquelle la consécration des siècles semble avoir mis la patine d'un Rembrandt, d'un Titien ou d'un Velasquez."*

Rather than exult publicly, Whistler busied himself with a new commission destined for France. "You do know," he wrote Mallarmé, "that Montesquiou is here—and I work every day until nighttime on the portrait." Count Robert had written to Whistler in 1889 that he wished

he had a portrait of himself to lend to the *Exposition universelle* but not until February 1891 did he propose that his friend should do it. In November, while the *Mother* negotiations were going on, he arrived in London to pose, although Whistler was far too emotionally involved in the Luxembourg transaction to keep his mind on the new portrait, Montesquiou claiming even to have been in the studio when the letter from the French government arrived to seal the purchase. The pose, Sickert afterwards complained, was "limp, weak, 'gone at the knees,' giving no hint of Robert's nervous alertness." It was not a good time to be sitting to the Master.

That it took Whistler well into the next year to complete the canvas may be due to his recognition of its failure, but his subject did not see it that way at the start, sitting enthusiastically to Whistler seventeen times during his month's stay in London, and reporting to Edmond de Goncourt what it was like, the diarist recording the experience as "a mad rush at the canvas, one or two hours of feverish frenzy, from which the thing emerges all wrapped up in its covering. Then there are long, long sittings, during which most of the time the painter brings his brush up to the canvas, does not touch it, throws the brush away and takes another—with the result that in three hours he will add about fifty touches to the painting, each touch, in his words, removing one veil from the sketch's covering. Sittings in which it seemed to Montesquiou that Whistler with his fixed attention was emptying him for life, was 'pumping away' something of his individuality."

Regaled at length as he sat with the Master's brilliant talk, Montesquiou became, even more than before, a kind of belated Follower. At the beginning of 1892, soon after work on the picture had been begun, with the Frenchman holding the furred black cape which caused Whistler to refer to him as "Bat," Whistler, Mallarmé, the Countess Greffuhle, the Countess Potocka, and others famous—in Count Robert's opinion—for their genius or their beauty, each received a box wrapped in silk on which bats had been embroidered. Inside was a privately printed book of poetry by the sender, with bats, in grey on mauve, on the flyleaves, and vignettes by artists the poet knew, like Whistler.

The bat was Montesquiou's equivalent of Whistler's butterfly, and in the hiatus between renewed sittings, Whistler wrote to "Dear Bat" to excuse the delays. "It is always humiliating to recognize in life," he explained to him, "that there are circumstances over which one has not got absolute power." Perhaps it was also distressing to him that he no

longer had—if he had ever had—absolute power over his brush, for in his later fifties he felt more and more comfortable with smaller pictures; and while his completion record for full-length portraits was never good, in the nineties it was even worse. But while Montesquiou bore the delays impatiently, he nevertheless promoted Whistler's work in Paris so effusively that Jean Lorrain suggested in a novel that the painter's influence was baleful indeed, his fictional M. de Phocas (Montesquiou) being under a spell cast by the satanic sculptor Ethal (Whistler).

Eventually, at Montesquiou's urging, the canvas was brought to Paris, where he had secured a room in a second floor studio at 22, Rue Monsieur le Prince, the Count having decided that Whistler could paint him there with least interference with the many Montesquiou social obligations. Whistler even came to Paris with the canvas and continued work at the temporary studio, leaving Trixie behind as he expected a short stay, but Montesquiou's social obligations and a trip Whistler had to take to Antwerp delayed the new sittings. Finally he wrote to Trixie that he hoped "to manage it in three or four days if I don't get demoralized." But he *was* being demoralized—by the Count's hospitality, gifts, and friends—and would find himself with the Prince de Polignac, the Countess Greffuhle and Madame de Montebello at the Vaudeville when he should have been at his easel. Desperate measures were needed, and Whistler suddenly and perhaps diplomatically perceived the need to touch up parts of it which had long dissatisfied him. "Now," he wrote Count Robert, "I have seen what was missing in your picture. Again, just at the right moment, so that I could give it the dash and the perfect finesse which it must have before its future is sure." He pressed Montesquiou to let artist Antonio de la Gandara stand in the required pose, which he did until the Count appeared, while Whistler went on without interruption. Finally it was done, and Whistler wrote Trixie that the Count was "enchanted" with the result and "childlike in his joy." Interpreting his portrait Montesquiou solemnly told Whistler, "It is the acme of pride, untainted with vanity." Madame de Montebello, whom the Count had brought to the studio, said *"C'est noble"*—"with a sort of religious intonation," Whistler reported to his wife, "—and there they were really worshipping before a sort of monument of their blue blood!"

Even Whistler was impressed by the reaction, agreeing that "certainly in the flattering light of the evening our Montesquiou *poète et grand seigneur* did look stupendous." He was sorry to see the portrait in blacks and grays, which he privately thought of as the *Chevalier Noir*, leave his

hands; but Montesquiou rushed it off before Whistler could change his mind, afterwards lending it to the *Société Nationale des Beaux Arts*, on the Champ de Mars, in 1894. The portrait gone, Whistler's mood changed. "How right you are, dear poet!" he confessed. "How mad I was! It is splendid, a true d'Artagnan. I shall never forgive myself for my unworthy modesty and fear. But what an inspiration to have sent for it—and just in time!" With clients rather than friends, there was less modesty. Once when Count Robert took Whistler to have tea with Mme de Casa-Fuerte and Mme de Montebello, one of the women asked how much one paid the painter for a portrait, and Montesquiou replied, "One must give him more than one is able to!" It was true. At long last he was fashionable.

Within a year after the purchase of the *Mother*, Whistler had made good his threat to adopt France, acquiring the lease on a flat in the Rue du Bac, where he had workmen altering the premises to his taste. Scheduled for installation, too, was the Louis XVI bedstead which Montesquiou had given him in part payment for his portrait, a piece of furniture which had been presented to an ancestress by Napoleon I when she was governess to the young King of Rome. Whistler had it shipped off to M. de Petiteville in the Rue des Martyrs to be relaquered, and Beatrix wrote to Montesquiou that the great curved, carved Empire bed with swan's heads at each corner was "straight from fairyland"—and so beautiful that the room in which it would be placed "will really—I believe—have to be begun all over again to make it at all worthy of it." *

There would also be a studio in Paris—in the Rue Notre Dame des Champs, where in his student days his friends Poynter, Lamont, and Armstrong had lived and painted, and in which he and Du Maurier had spent so many leisure hours. Thirty-six years had passed since then. The eccentric young American had become a Paris celebrity, and his long-scorned masterwork was en route to the Louvre.

* The bedstead is now in the Victoria and Albert Museum, London.

XXX

London with Trixie

WHISTLER mellowed after his marriage—or so tradition has it. If so, the change was far from an abrupt one, as his settling a score with "Hawk" Moore occurred after his wedding journey to France, and so did his contretemps with General Rush C. Hawkins. Hawkins—an American cavalry officer—administered the United States section of the Universal Exhibition in Paris, which was to open in the spring of 1889, and invited fellow West Pointer Whistler to contribute some of his work. Overly generous, Whistler sent a large portrait and twenty-seven etchings, more than could be displayed by a single artist, and the General shortly afterwards sent Whistler a brusque note—a form letter sent in all similar cases. "Sir—" it went, "Ten of your exhibits have not received the approval of the jury. Will you kindly remove them?" Not taking kindly to the letter, the Master went to Paris, asked for Hawkins and announced, "I am Mr Whistler, and I believe this note is from you. I have come to remove my etchings."

"Ah!" said the General, "We were very sorry not to have had space enough for all your etchings, but we are glad to have seventeen and the portrait."

"You are too kind," Whistler countered, "but really I will not trouble you." And he insisted on removing all his work, not telling Hawkins that

he had already arranged—however much he had insisted until then on his American identity—to hang them in the English section. Hawkins, embarrassed, urged Whistler to reconsider, but it was too late. Whistler had not objected to trimming down his contribution, but to the allegedly discourteous way in which it was done; and the *Paris Herald* quoted Hawkins as retorting, "What in heaven's name is he crowing about? . . . The truth is that while we rejected only *ten* of his etchings, the English department rejected *eighteen* of them, and of the nine accepted hung only two on the line. Had Mr Whistler been the possessor of a more even temper and a little more common sense, he would have had five or six works on the line in the American department, and nearly twice as many on exhibition than is actually the case. Really, I fail to see what he gained by the exchange, unless it was a valuable experience."

The controversy failed to fade with the seasons, Whistler writing to the *Herald* from Amsterdam in October that the etchings hung in the English section—"and perfect is their hanging"—were the only ones he sent. Had he been advised by the Americans, as he had by the English, how limited their space was, he would have refrained from abusing it. It was "part of the good form of a West Point man" to have remembered, he added, ". . . that a drum-head court martial . . . should be presided at with grave and softened demeanour." With that he resumed his American identity.

After receiving a first-class medal at Paris (in the English section), Whistler had been to Amsterdam for a show of his work. In Holland his *Mother*, the *Fur Jacket*, and the *Effie Deans* (*Arrangement in Yellow and Grey*) received another gold medal. Even before, while the Paris Exhibition was going on, he was elected an Honorary Member of the Bavarian Royal Academy and given a first-class medal as well as the Cross of St Michael. The rush of honors pleased him, but none more than the dinner his friends gave him on May 1, 1889 at the Criterion Restaurant to celebrate the Bavarian decorations. Even two Royal Academicians were present—Sir William Orchardson and sculptor Alfred Gilbert—as well as Sir Coutts Lindsay, the loyal "Atlas" (Edmund Yates) and Stuart Wortley, who said in a speech that Whistler had influenced every artist in England. After the toast the guest of honor rose to his feet to respond to the first such occurrence to him in his life:

> You must feel that, for me, it is no easy task to reply under
> conditions of which I have so little habit. We are all even too

conscious that mine has hitherto, I fear, been the gentle answer that sometimes turneth not away wrath.

Gentlemen, this is an age of rapid results, when remedies insist upon their diseases, that science shall triumph and no time be lost; and so have we also rewards that bring with them their virtue. It would ill become me to question my fitness for the position it has pleased this distinguished company to thrust upon me.

It has before now been borne in upon me, that in surroundings of antagonism, I may have wrapped myself, for protection, in a species of misunderstanding—as that other traveller drew closer about him the folds of the cloak the more bitterly the winds and the storm assailed him on his way. But, as with him, when the sun shone upon him in his path, his cloak fell from his shoulders, so I, in the warm glow of your friendship, throw from me all former disguise, and making no further attempt to hide my true feeling, disclose to you my deep emotion at such unwonted testimony of affection and faith.

Whistler in 1889–90 was a London celebrity. The newspapers quoted his remarks, interviewed him at length at his studio and at his newest home, at 21 Cheyne Walk, and reviewed *The Gentle Art*, already notorious in advance, when it came out, three months later, in June, 1890. Typically for Whistler, the Cheyne Walk house was partially furnished and partially cluttered with packing cases. The dining room was painted lemon-yellow, and the appropriately never-finished *Six Projects* canvases hung prominently. On a white cloth on the table was a cherished piece of blue china, and a peat fire burned year-round in the blue-tiled hearth. Elsewhere one was more likely to find sitting space available on unpacked crates rather than chairs, and the stairs up to the bare drawing rooms used as studio space were correspondingly uncarpeted. Two tall windows looked out on the Thames, and glimpses of incomplete pictures were revealed on stretchers stacked against the walls.

That the house included a wife and official hostess added to Whistler's new respectability. Now his Sunday breakfasts were replaced in fair weather by an outdoors equivalent, as a magazine reported:

All through the summer Mr Whistler holds a kind of reception every Sunday afternoon in the garden at the back of his house. You meet all sorts of conditions of people there—men of

light and leading in the world of art and literature; tenth-rate
daubers who adulate him, and whom he takes pleasure in
constantly snubbing; eccentric people who have taken his fancy;
theatrical people—in fact, the sort of menagerie that could but
rarely congregate at the same time anywhere else. He is the life
and soul of the party, strolling about with a little child's straw hat
on the back of his head, and a bit of ribbon in place of a necktie,
and chattering away unceasingly wherever he can get the largest
audience. He has a habit, when he is talking to anyone, of gazing
searchingly into his eyes, and literally buttonholing him; that is,
holding him firmly by the buttonhole so that he cannot escape.
His face is a remarkable one. It is covered with countless
wrinkles, but is clear of complexion, and evidently very well
groomed. He wears a well-curled gray mustache and slight
imperial. His eyebrows are unusually bushy, and his glistening
brown eyes peer out from underneath them like snakes in the
grass. His hair is the most "amazing" part of his get-up. It is all
arranged in separate curls, most artistically put together. They are
all dyed black, with the exception of one, which remains quite
white. . . .

Despite his press clippings, Whistler's fame was not translated into
pounds and guineas. His etchings had a ready market and he could sell his
lithographs to the magazines; but he could not sell his canvases and
although he retained his standard of living he also retained a decade of
post-Venice debts. Still, he was gaining on his critics, who were shifting
ground while he remained essentially the same.

In the newest generation paying him a homage about which Whistler
as yet knew nothing was a tubercular twenty-year-old London insurance
clerk who had been taking night lessons from Frederick Brown at the
Westminster School of Art. In the summer of 1891 Aubrey Beardsley
visited 49 Prince's Gate to see the Peacock Room, coming away impressed
by the marriage of wit to art and of English to Japanese style, and awed by
the peacock shutters and the "gorgeously painted" central portrait. Back
home he filled a long letter to his Brighton friend Scotson Clark with
detailed sketches of what he had seen. One depicted him reverently
walking through an art-filled room. Another showed a large Whistler
portrait of a woman in Japanese dress—the *Princess from the Land of
Porcelain*—flanked by pairs of peacocks. As added information he included

drawings of other Whistlers. The *Miss Alexander* was "a truly glorious, indescribable, mysterious and evasive picture. My impression almost amounts to an exact reproduction in black and white of Whistler's Study in Grey and Green." Then there was Whistler's portrait of his mother, in a thumbnail reproduction, but in Beardsley's accompanying description, "the curtain marvellously painted, the border shining with wonderful silver notes. The accompanying sketch is a *vile* libel."

At one of the bookshops in Queen Street which Beardsley had been visiting regularly in lieu of lunch, and where he sometimes bartered his own drawings for books, he was also acquiring the beginnings of a personal collection of art. Inevitably his newest acquisition had to be "a gem in the shape of an etching by Whistler." It was an 1859 *Thames Set* etching—not in the Master's later Japanese style, but nonetheless a Whistler. And as Beardsley's own style developed, traces of Whistler and of Japan began to emerge. Inspired by the patterns in the Peacock Room, Beardsley began to seek out Japanese art, and when he received one of his earliest commissions as an illustrator—the *Salomé* of Oscar Wilde—he produced a series of fantastic decorations with the peacock as the central image and the Whistler atmosphere palpable.

Followers and imitators of all kinds had sprung up in London, all showing Whistler's increased influence. A certain Moffat P. Lindner was known in art circles (according to the *Whirlwind*) as "the moonlighter" because of his coarse pastiches of Whistlerian nocturnes, but others, directly or indirectly Whistlerian in approach, were better signs of the winds of change in English painting. As early as December 1889 there was a *London Impressionists* group exhibition which reinforced Whistler's improving reputation in part by the massive implicit display of his impact and in part by the tendency of critics to conclude that whatever the younger artists had done, Whistler had done it better. All the old terms of abuse of Whistler were hauled out—*daub, smudge, eccentric, foggy-spectacled*—but the implication was that Whistler was a serious artist. "*The Bridge*," complained the *Manchester Guardian* critic of Philip Wilson Steer's painting, is "a clever piece of blague, a pasticcio on Whistler without the sense of decoration that Whistler never loses. . . ." Others represented in the Goupil Gallery exhibition organized by Walter Sickert, were Sidney Starr, George Thomson, Francis James, Theodore Roussel, Fred Brown and Paul Maitland, the latter who utilized Whistler's concepts of tonality in his studies of the Thames and London parks. According to the *Saturday Review*, one of the beachscape paintings in the exhibition, "if you

stand back far enough from it, is almost beautiful." Whatever the extent French impressionism came to London through Whistler, or the young painters had gone directly to French sources, not all of the new tonal methods were necessarily French if they came via Whistler. He had learned a great deal from his cross-Channel peers but he had also learned from Dutch, Italian, Spanish and Japanese predecessors. And he was also still his own eccentric self, an unreformed original whom time was making respectable.

Of the younger painters, Steer seemed to follow Whistler in more ways than any other, and with more success. His Walberswick sketches harked back to Whistler's Venice etchings and pastels, and his *Yachts Lying off Cowes—Evening* was a nocturne according to the Whistler formula, as were his Thames scenes on small wood panels, a technique Whistler had found useful as he reduced his scale. Even his portraits echoed the Master, the *Illustrated London News* writing nastily of Steer's full-length *Lady in Grey*, exhibited at the Grosvenor several years earlier, "A fair specimen of the Whistler school, but very properly placed in an obscure corner." And he had also painted a *Japanese Gown* portrait. In another way, too, young Wilson Steer followed the Master. He wooed away Whistler's youngest and newest London model.

When Rose Pettigrew was eight years old she posed for a Millais painting exhibited at the Royal Academy in 1884. Before Whistler's break with Maud she had visited her at The Vale and had been painted by Whistler in Tite Street. When Trixie came on the scene Rose was overjoyed. "The wife I really loved," she remembered when she was in her seventies, "was the real one. . . . I adored and admired her very much; she was exceedingly pretty, a bit on the plump side, and much taller than Whistler; she adored her dear Jimmy. She sang beautifully, and gave me my first singing lessons; I . . . knew all the old songs, which we would sing together." At first all three Pettigrew sisters sat for Whistler. To the young girls Whistler "was very clever and cynical, loving to say smart things, even if they hurt; my sister Hetty was a perfect match for him; he admired her and was very amused by her cleverly cruel sayings, even when it was against himself. He was an exceedingly mean man, paying his accounts as rarely as he dared, and cutting down as much as he could: he hadn't paid Hetty for some time, so she waited until he was in the middle of an important picture he was painting of her, and demanded her money. We never, never posed under half a guinea a day, which was a big sum in those days. . . . So she handed him an account

for the month. 'Oh! Hetty dear, that is much too much,' Whistler said. Hetty looked at him with a little sneer and said, 'I'm so sorry, I'd quite forgotten you were one of the seven and sixpenny men.' Hetty said that his white lock shook but from that day she got her half guinea."

In the first, London, years of Whistler's marriage to Trixie, Rosie Pettigrew, who was fatherless and whose widowed mother depended on the children's earnings as models, practically lived with the Whistlers. She went on errands as a young daughter might, going with overly large check to the fishmonger so that Whistler could have the resulting cash, watching their heavy-drinking Irish cook prepare dinner, taking a telegram to the post office. (One to Sickert, she recalled, read, "Come along to lunch, gumbo soup.") When she posed, often for a pastel, she would stay to lunch, and to her great joy Trixie was also often in the studio when she sat. "Mrs Whistler loved me as much as I loved her; she wanted to adopt me, but mother wouldn't hear of it; she made me lovely little frocks; she was so clever and artistic; she had the prettiest little nose and mouth I've ever seen, and a perfectly charming speaking voice: she wore the most marvellous antique jewellery, usually composed of garnets, pearls, or rubies and diamonds, and were nearly all figures or animals."

Since Rosie was with Whistler so often she saw him in all seasons. Once "he was in a perfect tantrum, dancing all over the place in his rage, like a small boy; he had piles of delicate pastels on the large glass table, where he mixed his colours, and in his rage began to quickly throw [them] on the floor; Mrs Whistler was smiling, but I was in tears, trying to pick them up as fast as he threw them down; Mrs Whistler said, 'Don't cry, darling, they are all the bad ones.' "

Trixie remained the heroine in Rosie's life, but a new hero intruded in the Chelsea pattern. The slim, mustached Wilson Steer was the handsomest man she had ever seen, and the desire to be painted by him gave her the courage to put on the prettiest dress Trixie had made for her, and knock on Steer's studio door in Addison Road. "I asked him if he'd like to paint me, as I was disengaged, but that, as I posed to all the really big artists, he'd have to make up his mind at once; he looked very surprised but amused, asking who was the great [one] that was waiting for me that morning; I said Whistler, and that Mrs Whistler had made the lovely frock I was wearing, and that he'd better paint me in it, as it would please Mrs Whistler. He said, 'I think it's horrible, and doesn't suit [you] a bit; I don't want to paint a picture of Mrs Whistler's frock and call it a study in pink; it's exactly the colour of your face.' "

Steer agreed to have her pose two days a week, but since she had been posing five days a week for Whistler, it meant cutting back there. Whistler was upset, additionally so because she refused to identify her new employer. But soon Trixie found out and asked her, "Why do you pose for Steer for so many days? Are you in love with him? Does he know how young you are? He's old enough to be your father, and will never make a name." Rosie insisted otherwise, and gradually drifted away from the Whistlers as she posed more for Steer, whom she adored sufficiently to pose for nothing. But Steer was not the marrying kind, although for a time she wore his ring. Before she was seventeen she had ceased modeling for Steer as well as Whistler, and was playing the music halls. For Whistler there were other surrogate daughters close at hand. His wife had two younger sisters. Both modeled for him. And one later married the author of a "Modern Man" essay on Whistler, Charles Whibley, who wrote for W. E. Henley's paper, the *National Observer*.

Whistler was, to Whibley, "the Yankee with the methods of Barnum." "Your Jimmy is first-chop," Henley congratulated the author. And both Whibley's and Henley's relationships with Whistler grew apace, although Whistler's first letter to Henley landed him in trouble. He had finished with a "regret that the ridiculous 'Romeike' had not hitherto sent me your agreeable literature." The search for an alliterative adjective to characterize the press-cutting firm resulted in a curt letter from Romeike and Curtis with a demand for an apology. "This statement," Romeike observed, "had it been true, was spiteful and injurious, but being untrue (entirely) it becomes malicious, and I must ask you at once to apologize. And at the same time to draw your attention to the fact that we have supplied you with 807 cuttings."

Whistler bowed with faint grace. "Sir— If it be not actionable," he wrote, "permit me to say that you *really are delightful!* . . . Who, in Heaven's name, ever dreamed of you as an actual person? Or one whom one would mean to insult? My good Sir, no such intention—believe me—did I, in my wildest of moments, ever entertain." It marked the end of the affair, but Henley, who published Whistler's reply, was enchanted. Burly and hearty, he was physically an opposite to Whistler, but both shared a love for combativeness, and when the *Observer* made its offices in London (it began in Edinburgh) Whistler often attended the staff dinners at Solferino's, with Rudyard Kipling, R. A. M. (Bob) Stevenson, Arthur Morrison, Charles Whibley, J. M. Barrie, Kenneth Grahame, G. W. Steevens and Marriott Watson. When Whibley involved himself and the

Observer in a squabble with Slade Professor Hubert von Herkomer over the difference between a drypoint and an etching, Whistler contributed his advice. After all, the paper had championed him and his work, Henley describing the "enchanting *Ten O'Clock*" as "an indigestion of strawberries, a feast for the high Gods, which I fear . . . has not had anything like the effect to which its art and brilliancy, let alone its rightness, entitle it." Defending Whistlerian theories he declared, "To render the facts . . . grain by grain, or hair by hair, or petal by petal, is to play a losing game with the camera," and his own poetic practice suggested Whistler's canvases, one evocation of river and "old skeleton bridge" written in 1891 even entitled "To James McNeill Whistler." Whistler's promise to paint him, "And at once," Henley crowed to Whibley, was "better than a dukedom," but all that resulted in the end was a portrait lithograph (1896). The Master found it unsatisfactory, and only six impressions were pulled.

Whistler's London literary friendships were many in the early 1890s. A regular visitor to 21 Cheyne Walk was Brandon Thomas, author of *Charley's Aunt*, and Henry Harland, novelist and later the editor of the *Yellow Book*. Henry James sent Whistler and Trixie tickets for "the two best stalls in the house" for a performance of *The American*, and Whistler sent his fellow expatriate an etching. *The Gentle Art* and the *Ten O'Clock* had made Whistler a peer among writers, and he gloried in his new distinction. Off the paper his wit was even more stinging, so that a group of Englishmen and Americans discussing the versatility of the Royal Academy President waited for Whistler's barbed contribution, knowing of his Paris friendship, and London falling out, with Frederick Leighton.

"Exquisite musician," said one. "Plays the violin like a professional."

"Brilliant speaker," said another.

"Amazing linguist."

"Superb essayist."

"Charming host."

"Dresses to perfection."

"Dances divinely."

"Paints, too," said Whistler.*

After the sale of the *Mother* and the *Carlyle* in 1891 Whistler had less need to be concerned about finding purchasers for his own paintings,

* The remark is generally dated after Leighton's death in 1896, and put in the past tense; but Bernard Shaw quotes it in an unsigned review in the *Daily Chronicle* on February 18, 1893.

although rankled by continued exclusion from Lord Leighton's Royal Academy. The passage of the *Arrangement in Grey and Black* to France even inspired a reception in his honor at the Chelsea Arts Club on December 19, 1891, where he was presented with a parchment signed by a hundred members as "a record of their high appreciation of the distinguished honour that has come to him by the placing of his mother's portrait in the national collection of France." In reply Whistler said that he was gratified by the gesture from his brother artists: "It is right at such a time of peace, after the struggle, to bury the hatchet—in the side of the enemy—and leave it there. The congratulations usher in the beginning of my career, for an artist's career always begins tomorrow."

It *was* the beginning of a new career, for Whistler already knew that his next exhibition would be an event—an "heroic kick in Bond Street," as he called it, when David Croal Thomson proposed a show at the Goupil Gallery, which he managed. Thomson had shown the *Carlyle* there, which because it had been bought for Glasgow drew large crowds. With the *Mother* having also made news, the time had come for a big exhibition, he concluded. "Of what?" Whistler asked. "You know what I mean," said Thomson. "We can't do anything with pastels and water colors. We have got [to go] beyond etchings and lithographs which have often been exhibited. It must be pictures." In the first months of 1892 Whistler supervised every detail, shifting the accent from portraits to the fullest possible retrospective. *Nocturnes, Marines, and Chevalet Pieces*, Whistler described his show, but it was more representative than that for the *chevalet* (easel) pieces encompassed his painting almost from his student days, and he strove mightily to convince wary owners to lend them. Finally, forty-three pictures were chosen, plus a photograph of a forty-fourth to cap the exhibition: the *Mother* was now the property of France.

In his search for appropriate paintings he sometimes had to find their new owners, but he had always been careful to check the whereabouts of the children of his fancy. Howell, for example, long estranged from Whistler, had died in 1890 and his possessions sold at auction. When the event occurred, Graham Robertson, a well-to-do young pupil of Albert Moore, received a hurried scrawl from Ellen Terry: "Howell is *really* dead *this* time! Do go to Christie's and see what turns up." The sale was poorly attended, as people had forgotten the ubiquitous Portugee, and the collection fetched low prices, Robertson acquiring the *Rosa Corder* (for

£241.10*) and the *Crepuscule in Flesh Colour and Green—Valparaiso* ("that dream of opaline dusk falling on phantom ships becalmed in an enchanted sea"). Whistler found out, and a letter to Robertson followed. "I am told that you have acquired the two paintings of mine that were offered at the Howell sale the other day. This being the case, you will perhaps pardon my curiosity to see them hanging on your walls and my desire to know the collector who so far ventures to brave popular prejudice in this country."

He was invited for lunch, and in a yellow fog which might have deterred him from less important missions, Whistler arrived, dapper and restlessly eager to see the old canvases, lamp-lit in the mid-afternoon dimness. The meeting between painter and portrait, Robertson remembered, "was quite touching. He hung over her, he breathed softly upon her surface and gently stroked her with his handkerchief, he dusted her delicately and lovingly."

"Isn't she beautiful?" he asked no one in particular. Robertson knew better than to say anything at all, and Whistler went on to inquire about other items in the Howell sale, for his old friend had accumulated a hoard of other friends' property, from Whistler's black lacquer bed to more portable objects. "I never *could* remember where that bed was. He would never *let* you remember where your things were. What else?" Robertson described some of the auctioned items he remembered, Whistler categorizing them as "That was Rossetti's—that's mine—that's Swinburne's. . . ." Memories of Howell welled up. "He was really wonderful, you know. You couldn't keep anything from him and you always did exactly as he told you."

Happily, Whistler took Robertson after lunch through the fog to the Royal Academy, to visit the enemy within its gates and create a minor stir, for it was impossible for him not to be recognized, and he preferred it that way. Then it was on to the fledgling New English Art Club, which Whistler described, omitting Sickert, as the "Steer-y-Starr-y-Stott-y lot." It had been a good day.

Mentally docketing Robertson's two choice Whistlers, he remembered them when planning his retrospective, and they were duly borrowed. Not all the canvases he wanted were so readily available. There were no paintings from the collection of F. R. Leyland in the Goupil show. It had been years since he had communicated with Whistler, and

* Ten years later he sold it for £2000.

he bore toward him a not unreasonable enmity. But he had kept his Whistlers, and the Prince's Gate mansion with its Peacock Room was still intact and open to special visitors; and he continued to buy paintings by Burne-Jones. Whether anyone, including Frances Leyland, could have induced him to lend a Whistler is doubtful, but the test never came, for on January 4, 1892 he died suddenly in an underground train between the Blackfriars and Mansion House stations. When the Goupil exhibition opened, the Leyland estate—it would amount to more than £700,000—was in process of settlement. Yet there was a Leyland-owned Whistler in the show, the *Nocturne: Blue and Silver*. It had been a gift to Mrs Leyland from Whistler in the days of their friendship, and was her own to dispose of.

Florence Leyland had never quarrelled with Whistler, and afterwards they visited each other a number of times until her oldest daughter had cautioned her. With Leyland gone, she sent a message through Mrs Alan Cole that Whistler was now free to visit, and to bring his wife; but Trixie objected with apparent protective jealousy, remembering what she had heard of the old relationship, and asked Mrs Cole whether she intended to disrupt the peace of a happy home. In the end only the picture passed between Florence Leyland and Whistler, and a letter shortly after protesting against the inclusion in the Leyland sale of sketches of her and her children. They were hers and not Leyland's, Whistler declared. He had given them to her, and Leyland had not bought them. But they never saw each other again.

Two hundred and fifty copies of the exhibition catalogue, designed by Whistler, were printed by Thomas Way, but it was an error in the second printing which made it briefly the talk of London. The *by* was omitted from the title page description of the "small collection kindly lent by their owners." It was unintentional, and Whistler had the word restored in later printings, although there were many who accepted the statement as correctly reflecting the artist's attitude toward ownership of his works. Because of the furor, when Whistler later produced an augmented edition of the *Gentle Art*, and included the Goupil catalogue, he sardonically re-removed the controversial preposition. That he included the catalogue at all had nothing to do with the title page, for what he had done inside was again to expose his critics by maliciously placing extracts from the most wrong-headed reviews under the titles of his works. Time had made them even more ridiculous than before. Now the second and third *Symphonies in White, Chelsea in Ice, Battersea Bridge*, the *Lange Lijzen*, the *Fur Jacket*, the Valparaiso nocturnes, the *Blue Wave—Biarritz*, the *Rosa*

Corder, the *Miss Alexander*, the *Yellow Buskin* and others lent by their owners were contemporary classics. And one Whistler had never been able to sell, and which had prompted the Ruskin suit and precipitated his bankruptcy—the *Falling Rocket*—was there above the notorious libel. After the Goupil show Whistler sold it for eight hundred guineas—or, as he put it, "four pots of paint."

At the private view neither he nor Trixie were visible. As Croal Thomson explained later, Whistler "knew that many people would expect to see him and talk enthusiastic nonsense, and he rightly decided he was better away. . . . Crowds thronged the galleries all day, and it is impossible to describe the excitement." About five in the afternoon Whistler and Trixie arrived, but remained off the exhibition floor, in a curtained-off part of the Gallery. From there he could observe his triumph, and that evening he told a gathering of friends that it needed only the presence of Ruskin to make the day perfect. "I do not think I am exaggerating," said Croal Thomson afterwards, "when I say that the exhibition marked a revolution in the public feeling towards Whistler. His artistic powers were hitherto disputed on every hand, but when it was possible for lovers of art to see for themselves what the painter had accomplished, the whole position was changed. I will be pardoned, I hope, in stating that whereas up to that time the pictures of Mr Whistler commanded only a small sum of money, after the exhibition a great number of connoisseurs desired to acquire his works, and therefore their money value immediately increased."

Without the impetus of the publicity surrounding the *Carlyle* and *Mother* sales, the Goupil exhibition would not have happened, let alone become Whistler's watershed. But it was unquestionably true that the real index of the show's success was in the increased prices owners of his paintings asked when offers came to buy their Whistlers, in offers Whistler received himself for unsold canvases, and in tenders of new commissions. He began to touch up and restore some of the old pictures in expectation of sale, and even to plan a new canvas on a grand scale, for the Duke of Marlborough approached him after the Goupil exhibition to commission a state portrait. The terms appeared generous—two thousand guineas for a large full-length, or, if Whistler would also paint the Duchess, three thousand for the pair of portraits. But the Duke was concerned that Whistler complete the work and not get involved in petty diversions. "You must stick to painting," he cautioned, "and give up writing letters about R.A.'s and A.R.A.'s." Whistler replied that he would

undertake the assignment, essayed a pen-and-ink preliminary sketch, and prepared to go to Blenheim. Then the Duke died suddenly. "Now I shall never know," Whistler complained, "whether my letter killed him, or whether he died before he got it. Well, they all want to be painted because of these [Goupil] pictures, but why wouldn't they be painted years ago when I wanted to paint them, and could have painted them just as well?"

As the late Duke had observed, one of the minor controversies which emerged as a result of the Goupil catalogue was Whistler's labeling a quotation from a Ruskin witness at the libel trial as by "Mr Jones, R.A." Sir Edward Coley Burne-Jones had been plain Mr Jones before the days of his greatest fame, and Whistler, who bore his grudges lustily, explained to "Atlas," "R.A. or A.R.A., and in my opinion he deserves to be both, I personally owe Mr Jones a friendly gratitude which I am pleased to acknowledge; for rare indeed is the courage with which, on the first public occasion, he sacrificed himself, in the face of . . . future possible ridicule, in order to help write the history of another." When he was collecting pictures for the Goupil show, he became friendly with Graham Robertson, whose two Whistlers he had borrowed. Together, with Trixie, they visited Albert Moore, and, on departure, Robertson prepared to say good-bye also, and turn towards Hammersmith.

"What are you going down there for?" Whistler asked suspiciously.

Robertson braced himself. "I'm going to see Burne-Jones."

"Who?"

"Burne-Jones."

"Oh—Mister Jones. But what on earth are you going to see him for?"

"I suppose because I like him."

"*Like* him? But what on earth do you like him *for*? *Why* do you like him?" And Whistler turned round, in effect barring the way, his thin cane tapping angrily on the sidewalk.

"I suppose—because he amuses me," said Robertson feebly.

"Amuses you? Good heavens—and you like him because he amuses you? I suppose—I suppose *I* amuse you!" And Whistler rapped his cane again, and glared at Robertson, who pondered whether it would be worse to say *yes* or to say *no*.

"Don't tease him, Jimmy," said Trixie. "Surely he may choose his own friends." The irascible Whistler personality had become too hard a shell to soften at a word, but Trixie worked at it.

After the Goupil show one of the commissions offered to Whistler

came from America via a fellow expatriate American, John Singer Sargent, who had been asked to supervise the decoration of the new Boston Public Library. Sargent asked Whistler to undertake the large panel at the top of the stairs, and Whistler met with Sargent, Charles McKim, the architect, and Samuel Abbot, a Library trustee, at Foyot's in Paris for dinner and discussion of the project. "Now one of three things will happen," Sargent had warned the others, "and I don't know which. Either he will be as silent as the grave, or outrageously vituperative, or the most charming dinner companion you've ever met." Whistler turned out to be in good humor, and flattered by the deference paid him, was anxious to find out what location in the building he would be offered. The dinner was so great a success that the men never settled anything; but a second dinner was arranged, after which, when the table was cleared, Whistler enthusiastically drew on the white tablecloth a tentative idea for a great peacock fifteen feet high. His companions watched, and departed literally and figuratively in the greatest good spirits. Then the personnel at Foyot's put the cloth in the wash, and nothing further came of the mural. When Whistler returned to London he became occupied with other and easier things, chief among them the acquisition of American gold for work already accomplished.

Americans, Whistler observed happily, were determined "to pour California into my lap," and not long afterwards he was writing to Tom Way that "now I fancy I see fortune looming on the horizon!—and I might really be rich! Who knows!" Chief reason from America was a magnificently mustached and fortyish bachelor from Detroit. Charles L. Freer was a manufacturer of railroad cars who had made sufficient millions to be able to leave much of his day-to-day work to others and indulge a passion for travel and for oriental art. Things oriental led eventually to Whistler, especially after Freer read of the prestigious sales to the Corporation of Glasgow and the government of France, and he wrote to Whistler congratulating him on the sale of the *Mother* portrait. By early 1893 Freer was attempting to acquire every etching and lithograph Whistler had done, and had arranged to buy a copy—at least one—of every new etching Whistler turned out, at an average (for the new ones) of four guineas each. And as a careful businessman Freer made sure that he had had the import duty on each exempted by a consular invoice upon which Whistler attested that he was an American artist "residing temporarily abroad."

Before long Freer also purchased a *Harmony in Blue and Gold* and

three pastels and watercolors—for the staggering price of thirteen thousand guineas. It was worth taking the trouble to complete Freer's consular invoices. For Whistler they meant freedom from care for the first time in his life, and as such prospects mounted, Trixie suggested a house in Paris. Away from the press of increasing London publicity, perhaps he could return to serious work. Selling it could be left to the dealers.

XXXI

An American in Paris

"Our address is as you see, Paris," Whistler wrote Sidney Starr, "—and I must say I am delighted with the place. The dreariness and dullness of London was at last too depressing for anything—and after the exhibition there was really nothing to stay for. . . . No further fighting necessary—I could at last come to this land of light and joy where honors are heaped upon me, and Peace threatens to take up her abode in the garden of our pretty pavilion. However, I do not promise that I shall not, from time to time, run over to London, in order that too great a sense of security may not come upon the people!" The house and garden at 110 Rue du Bac, undergoing renovation and full of the inevitable Whistler packing crates, was uninhabitable in the spring of 1892, and Whistler and Trixie oversaw the work from rooms in the Hôtel du Bon Lafontaine, an establishment, he told the visiting Joseph Pennell, "full of bishops, cardinals, and *monsignori,* and altogether most correct." It was also more placid than the Foyot, occupied largely by Senators, from which the Whistlers had moved after a bomb placed in a kitchen window had exploded.

Eager to establish a pattern of work, Whistler began a lithograph of Mallarmé (published as frontispiece to *Vers et Prose* in 1893) in his cramped hotel bedroom, drawing on thin Japanese tracing paper with a

rough book cover beneath to establish a grain. Painting there was obviously impossible, and he began a search for a studio, discovering what he thought he wanted high up in a building at 86 Rue Notre Dame des Champs, with a view of the Luxembourg Gardens. It was a choice dictated more by nostalgia than practicality. It was necessary to climb six flights of steep oak stairs to get there, and Whistler, fifty-eight that summer, found it necessary to rest on a strategically placed bench, on a landing half-way up. Wheezing en route, forced to wear his heavy spectacles more and more as he worked (although he switched to the familiar but largely useless monocle in public), and tinting his hair and his grey-flecked mustache less and less as the pretense became silly, he may have pondered that Trixie, twenty years younger, could soon be nursing an invalid older than his years.

Young Will Rothenstein often visited them early in their days in France. Whistler brought out a picture or two shipped from London, "the privileged occasion . . . not without its embarrassment," Rothenstein recalled, because the artist's comments on his own canvases "were so loving, so caressing, that to find superlative expressions of praise to cap his own became, as one canvas or panel after another was slipped into the frame on the easel, increasingly difficult and exhausting." After dinner at the Bon Lafontaine Whistler proposed a return visit to his pictures. They walked to the Rue Notre Dame des Champs, and climbed the many stairs to the darkened studio. There Whistler lit a single candle. Suddenly his dinner table gaiety disappeared, and he became quiet and intent, almost forgetting his companion or the reason for their being there. "Turning a canvas that faced the wall, he examined it carefully up and down, with the candle held near it, and then did the like with some others, peering closely into each. There was something tragic, almost frightening, as I stood and waited, in watching Whistler; he looked suddenly old, as he held the candle with trembling hands, and stared at his work, while our shapes threw restless, fantastic shadows, all around us. As I followed him silently down the stairs I realised that even Whistler must often have felt his heart heavy with the sense of failure."

His public face was far different, as a reporter for the *Westminster Budget* discovered on being taken on a tour of the studio.

Underneath the gallery, and screened off, a press for the printing of etchings, behind it a table with a litter and paraphernalia of the craft, and the only commercial-looking thing in all the place, a

wooden thing with a screw, which is used, I believe, for keeping papers on which are etchings straight and smooth and clean. But of work other than that behind the screen, no sign. No easel visible, not one palette, none of the charming litter of the art. Against the wall, indeed, a number of frames, but with their faces turned away.

"And we have terraces and hothouses and things," said Mr Whistler, and led me right across the immense room and opened doors, and drew aside draperies, and brought me out on a broad terrace, with trellis-work and venetian-blinds, from which the whole of Paris was to be seen, and there was a sheer precipice at one's feet. A terrace which ran round the whole front, and turned off at angles and still continued, and was as unexpected as all the rest. To the left, on issuing forth from the studio, was a hothouse, in which already a heating apparatus was at work, and "where we shall grow flowers, and grapes, perhaps, and charming things."

"There will be little *dejeuners,* and so on, given here," said Mr Whistler. . . .

I had seen it announced in an American paper that he was engaged on some decorations for the Boston Library, and asked him about this.

"Mon Dieu, yes. I was approached on the subject in the most delightful way. Most courteous approaches and so on were made, and everything that was flattering and polite was said about it. Possibly something may be done. Sargent, I suppose you know, is doing some work for this library." . . .

"Are you going to exhibit anything this year at the Salon?"

"I am very busy, and things are under way, and doubtless efforts will be made, and so on."

"I suppose you go out a great deal?"

"There are numerous engagements, and one has little time to oneself, and everybody is very hospitable and charming."

Life was generally too busy in Paris for Whistler to dwell on what he had not done. There were the renovations to the Rue du Bac house to supervise, and the business of moving and selling pictures, as well as other affairs that transplantation to France could not cause to disappear. One of them was John Charles Hanson, much less now his father's private secretary because Trixie had taken on that task, but still

Whistler's London legs. Romeike had been dropped and Messrs. Durrant now furnished his press cuttings, and no believer in art for art's sake was more assiduous in scrutinizing his press than Whistler, which meant trips by Hanson to Holborn Viaduct to their offices. Charles also carried Whistler's checks and collected his bills, conveyed (on instruction) London gossip and conducted (also on instruction) his London artistic business. And now and then Whistler in fatherly fashion condemned his habits and inquired after his health, all the while addressing him as "Dear Mr Hanson" and signing his letters "J. McN. Whistler." On a fifty guinea yearly allowance, Charles was then a university student above the average in age but below it in ambition and assiduity, as Whistler complained when he received notice that his son was at the bottom of the class. But he sent a £4 cheque. Later he found Charles's name on a printed list of successful students and sent another £4. Charles meekly accepted both the prods and the pounds, eventually married and broke free.

Some artistic business barely waited for Whistler's arrival in France. John L. and "Mrs Jack" Gardner, as soon as they themselves had arrived in Paris, hurried to find the Whistlers in order to ask them to dinner. Whistler invited them instead, and soon the Gardners found themselves in the Rue Notre Dame des Champs studio, where Mrs Jack saw a painting she wanted. It was the *Harmony in Blue and Silver*, the beach at Trouville, with Courbet the small silhouetted figure in the foreground. It was not for sale. But that autumn she returned to Paris, and to Whistler's studio, and decided that she had to own it. Legend has it that she asked the American Minister to France, T. Jefferson Coolidge, to accompany her to Whistler's studio, and on the way told him that his mission would be "to take a certain picture down to the carriage." He was to "pick it up and take it without any fuss" while she distracted the artist's attention. According to the story, "Mr Coolidge was somewhat disturbed but obeyed." Whistler, a variation of the tale has it, followed them down the six flights of stairs and had the picture brought back—so that he could sign it. The only certainty is that a cheque changed hands and that the receipt was for "six hundred guineas for picture: Harmony in Blue and Silver, Trouville."

For Trixie such visitors from abroad meant more than money in the Whistler purse. In Paris her husband visited his French artistic and literary friends without her, although in London she had long been part of Chelsea artistic life. Upper Bohemia in Paris was mostly a man's world, and Trixie, besides, knew little French and had no interest in learning

more than was necessary, even employing English servants. While work on their house went on, she absorbed herself in its decoration. As far as both were concerned, it was to be their residence for the rest of their lives. For Christmas, as he told Mallarmé, "we return to the fogs." He had been invited to show a work at the opening exhibition of the Grafton Galleries, and had secured the *Arrangement in Black, No. 5* from a now contrite Lady Meux for the purpose. A London newspaper featured a drawing of the top-hatted gentlemen and gowned ladies entering the "Large Room" for the private view, while off to one side was an inset drawing of two ladies and another top-hatted gentleman carefully scrutinizing a full-length portrait of a woman. The caption was "Looking at the Whistler." It was an index of how far he had come.

Early in 1893 the move to what Mallarmé called the "Rue antique du Bac" finally took place. It was a ground floor apartment in a seventeenth-century house, reached from the street through an unpromising archway between two shops, where it fronted on a small brick-paved court with an old bronze fountain which no longer worked. High on the walls above the several doors was a sculptured frieze worn nearly smooth. Whistler's entrance door was painted blue-green, with a brass knocker. Inside one went down several steps to a landing and then to a reception room, painted blue and white and with a carpeting of blue matting, furnished with a few Empire chairs, a couch, a grand piano and a table usually littered with newspapers. On a wall was an early Whistler. Near the fireplace was a writing table with inkwell, paper and pens, where Whistler would often sit with a cup of coffee and a cigarette while he pondered a barbed note to an editor. The dining room, to one side, and also in blue, displayed the blue and white china, flowers in porcelain bowls, and a Japanese birdcage which housed a white parrot until it flew into the garden and up a tree where, to Whistler's grief, it starved to death, rather than come down.

The "*bijou* of a garden" was their greatest joy. One reached it through the sitting room, through a glass door through which one could see that it was thickly treed and shaded. But for an American rocking chair sometimes brought out from the house for Whistler, a few decrepit stone seats were its entire furnishings. Beyond was a high stone wall, reached by winding gravelled walks. On the other side was the Séminaire des Missions Étrangères. Morning and evening its bells could be heard, and in the evenings, when the chanting of a choir sometimes carried over the wall, Whistler would stop talking and listen. There, too, Whistler held

court, more happily than ever before because his reputation seemed established and his income promised to be secure.

While he visited his Parisian literary and artistic acquaintances, most of his own visitors—but for very close French friends like Helleu, Gandara, Montesquiou and Mallarmé—were Englishmen and Americans. The younger generation of painters, and the older generation of collectors, sought him out on his Sundays; but almost never Frenchmen, who traditionally cultivated massive disinterest in foreigners, however prestigious. Among the younger artists were the American Joseph Pennell and the English Aubrey Beardsley, who, coming away from the opera in May, 1893, noticed Whistler in the Café de la Paix. Although he knew Pennell, he greeted them coolly, and the hero-worshipping Beardsley, frail and needing his sleep anyway, took the hint and went back to his hotel. Then Whistler sniffed to Pennell, "What do you make of that young thing? He has hairs on his hands, hairs on his finger ends, hairs in his ears, hairs on his toes, hairs all over him. And what shoes he wears—hairs growing out of them!"

"You don't know him," said Pennell. "Do you mind my bringing him to your place this Sunday afternoon?" Whistler loved to show off his new garden, and was unable to say no. That Sunday the two went to the Rue du Bac, Beardsley in a little straw hat similar to one he had seen Whistler wearing. The Master was in the garden with a number of his admirers, including Mallarmé, and when most had drifted away, a wealthy English dilettante who had lingered on asked the Whistlers, Pennell, and Beardsley to join him for dinner at one of the cafes in the Champs-Élysées. Everyone agreed, but as they left to dress for the occasion, Pennell was whispered to urgently by Whistler, "Those hairs—hairs everywhere!"

"But you were very nice," Pennell appealed, "and of course you'll come to dinner." The Whistlers never appeared, and Beardsley took it as a personal affront. Before the day was over he had worked out an acidulous caricature of the Master, and handed it to Pennell, but somehow Walter Sickert got hold of it—afterwards losing it in a cab, he claimed*—before it could do any further damage. The snub from the man he admired more than any other living artist continued to rankle, and Beardsley later tried to even the score by drawing a gratuitously nasty

* It turned up much later, and was published. Beardsley caricatured Whistler several times, once as a faun on a settee, in a panel for the title page of one of John Lane's *Keynotes Series* novels, *The Dancing Faun*, by actress Florence Farr (1894).

caricature of Trixie. When he proposed using it in the inaugural issue of *The Yellow Book* early the next year, publisher John Lane recognized the resemblance, and, having no desire to provoke Whistler's explosive hostility, demurred. Beardsley reacted with a letter illustrated by a self-portrait of the tearful artist contemplating a noose suspended from a gallows. "Yes, my dear Lane," he wrote, "I shall most assuredly commit suicide if the fat woman does not appear. . . . Really I am sure you have nothing to fear. . . . The picture shall be called, 'A Study in Major Lines.' " Far from being innocuous, the title called attention to Whistler's method of titling his pictures, and Lane was unmoved. Rather than press the issue further, Beardsley offered "The Fat Woman"—he abandoned the overly clever original title—to another magazine, where it was printed within weeks of the first *Yellow Book*. Whistler recognized who had inadvertently sat for the portrait. He was offended, and Beardsley was glad.

A memory of the visit to Whistler's garden lingered. Beardsley drew a small (8″ × 4½″) sketch of the Master sitting on a frail garden seat, wearing an oversized Wildean carnation in his buttonhole and a straw hat over outrageously bushy hair, and pointing his finger at (and possibly hectoring) a butterfly. It was, he confided to André Raffalovich, "a very malicious caricature of Whistler." For a while Beardsley privately savored his joke, but in 1894 he and his sister Mabel hung it on their Christmas tree. The season of good will toward all men—at least for Beardsley—excluded Whistler.

The garden at 110 Rue de Bac continued as a mecca for visiting Americans, Henry James going to tea with the Whistlers "in their queer little garden-house . . . where the only furniture is the paint on the walls and the smile on the lady's broad face." A later gathering of Americans there—early in 1894—would put literature in its debt. William Dean Howells was there, and crippled, but cheerful, Jonathan Sturges. Howells had come to visit his son, who was at the École des Beaux Arts, and in Whistler's garden seemed untouched by the gaiety. Sensing his brooding, but not realizing the reason—that Howells had just been summoned home from Paris, beautiful in the spring, by news that his father was dying—young Sturges came over to commiserate, and Howells, having been affected by Europe in a way he could hardly express, put his hand on Sturges's shoulder and said, "Oh, you are young, you are young—be glad of it: be glad of it and *live*. Live all you can: it's a mistake not to. It doesn't so much matter what you do—but live. This place makes it all

come over me. I see it now. I haven't done so—and now I'm old. It's too late. It has gone past me—I've lost it. You have time. You are young. Live!" *

Sturges first kept the incident to himself; then, when deeply unhappy over his own unlived life, he emotionally confided in Henry James. James recorded it in his notebook, adding, "I amplify and improve a bit, but that was the tone. It touches me—I can see him—I can hear him. Immediately . . . it suggests a little situation." Eventually the drama of the aging American in Paris, called home to reluctant duty and foregoing a life he might have preferred, became *The Ambassadors*.

Although the artist-figure in the novel, the American sculptor Gloriani, had appeared earlier in James's *Roderick Hudson*, and was based largely on William Wetmore Story, in the new novel, born in the Rue du Bac, he takes on aspects of Whistler. Lambert Strether, who turns to Little Bilham in Gloriani's garden and passionately urges him not to miss life, sees in Gloriani's own artistic, worldly, even sexual success the "terrible life" he had quietly envied. The "great Gloriani" is "at home on Sunday afternoons," and there "fewer bores were to be met than elsewhere." He has "a queer old garden" in Paris in Whistler's district, the Faubourg St Germain, attached to "an old noble house" and "of decoration delicate and rare." As James later wrote his publisher, he "could easily focus the setting" in the "charming old garden attached to the house of a friend." He did.

Distance from London improved Whistler's prices as well as his reputation. It was clear to the knowledgeable that although he painted a great deal, and talked about it a great deal more, he now finished very little. It made the stock of unsold or resellable Whistlers go up in price, enriching early collectors or their estates. Even Sir Frederick Leighton indicated interest in Whistler, inviting him to contribute to the British section of the Chicago Exposition of 1893. Whistler supplied *The Yellow Buskin*, *La Princesse du Pays de la Porcelaine*, and *The Fur Jacket*, although the request, he confessed, "filled me with the bewilderment of Thackeray's little boy in the street, to whom he had abruptly given a penny, and whose surprise was more ready than his gratitude." After Chicago the

* "Perhaps it was as well I called home," Howells wrote his son (who had remained in Paris). "The poison of Europe was getting into my soul. You must look out for that. They live much more fully than we do. Life here is still for the future,—it is a land of Emersons—and I like a little present moment in mine. When I think of the Whistler garden!"

three were exhibited in Philadelphia, where John G. Johnson bought *The Fur Jacket* for the Wilstach Collection through Alexander Reid.

"Whistlers are daily looking up," Whistler wrote Reid after another sale of two oils for £1400, accomplished by dealer Gerald Potter. And when Reid suggested that Whistler might be offended by the sale of his work for high prices by previous owners who had paid little, he was still too new to fame as measured in pounds and guineas to profess being anything but pleased. If a dealer or owner purchased a picture for £5 and sold it for £5000, he explained, the price for all his work went up, including his own unsold canvases and even his yet-to-be-painted ones.

But Whistler soon developed mixed emotions about the new prices of his old canvases, remembering how little he received for them, as he told an interviewer in Paris.

He tells you a story of a collector who bought certain pictures for trifling sums, who has just sold them hastily for fully ten times as much. "Did he put the money, the couple of thousand pounds, say, on a cushion, and bring it to me?" says Mr Whistler; "did he kneel and beg me to accept at last the value he would have given at the time could he have afforded it? No!" . . .

"I asked one man," Mr Whistler says, "I did it to test him, if he would send me here a picture of mine for which he had given eighty pounds. I think I told him I could easily get him eight hundred guineas now, if he wanted to part with it. He wrote back instantly that he would, and that he would give me a commission of 5 per cent on the transaction!" The humorous side of this business strikes the artist as he recounts it. He feels evidently that an offer of 5 per cent as a reward for a life of fighting for artistic principles is a thing that deserves more than personal recognition. . . .

These little anecdotes he tells you with the keen interest of a sympathetic onlooker at the game; not with the moody disappointment of an injured man; lightly, and with airy scorn, but with a grim delight in the humour of the sordid joke.

By 1894, Whistler seemed well settled in the Rue du Bac. Only business would take him to England, and in the summer of 1893 he had vacationed with Trixie in Brittany, returning to begin a number of small portraits and to turn more and more to lithography. Edward Eddy of Chicago came to commission a portrait of himself, for which he sat nearly

every day for six weeks, Whistler painting on into the twilight until it was impossible to distinguish what was on the canvas. Still Eddy could not take the picture home with him: it was completed and sent the following year. J. J. Cowan gave sixty sittings of three to four hours, finally giving up and permitting a model to pose in his clothes. Three years later it was finished to Whistler's satisfaction, after he had pleaded for one last sitting to get the head right. Even as he retreated to smaller portraits he could not find the confidence in his own hand which would have prevented such agonies. Yet when he finally finished a work his enthusiasm had no false modesty about it. If he had declared it finished it was worth being seen. If not, it remained turned to the wall. It had been the case with the *Montesquiou*, which was exhibited at the Salon in 1894, and of which Whistler attempted a lithographic version to cash in on the publicity. The painting had been an agony, but when he saw a proof of the lithograph he wrote to Tom Way that it was to be destroyed and done over, for it had failed to capture the essence of the "superb original."

Lithography was his newest passion. The profits were less, but the medium took less concentration and energy than portraiture, and Whistler even planned a book of them, to be called, after Mallarmé's term for the lithograph, *Songs on Stone*, and published by Heinemann. When the Parisian printer, Belfont, failed, many of the stones vanished, and the project with them. But he continued experimenting in the medium, often publishing the results in English and French art journals. An interviewer asked him about rumors of an impending London show.

> "Ah! people always say that," Mr Whistler rejoins. "It is a long time since I stopped the traffic of Bond Street, mounted policemen, and all that sort of thing. But not yet! I may by-and-by. I am only beginning lithography. There is a lot to be done yet. Presently we shall have something worth showing." Yet, as you persist, Mr Whistler fetches you a print of one of his latest songs on stone, and as he sets it in a chair before you, you notice—as sharply as if the same irresistible conviction had not struck you a hundred times before, both in his etchings and paintings—that the insight into beauty for its own sake, the love of lovely things because they are lovely, is his ruling passion, as evident in the lithographs as in any previous method. . . .
>
> Mr Whistler . . . shows you other prints. The *Rue de Faustinbourg* and *La Blanchisseuse*; one a wonderful street scene,

the other a most delicate group. Then a marvellously decorative panel—*La Forge de la Place de Dragon*, a thing as realistic as a photograph, and yet by subtle selection as purely decorative as the work of an Italian primitive; . . . *La Belle Dame Paresseuse*—a most beautiful figure, in an easy-chair; then a delightful nude study, and so on, until your praise is exhausted and your appreciation rising to indecently open comments. Then he shows you the portrait of Mallarmé the poet, and it astounds, captivates and bewitches you, to the point of purloining a copy when Mr Whistler's back is turned; but you leave it, as fresh proofs appear of other things, yet . . . long afterwards you wonder if it be not the best of all—this poem of a poet. It would be no use to catalogue these things in dull words. The chalk has been coaxed to new feats, the despised art of the stone long in commercial bondage is again set free for the artist's service, a craft that had gone into trade takes its place again among the aristocracy of the portfolio. You try to say something like this, but he laughs it aside, and you know that he knows, and you hope that he knows that you know, that it is not the material but the treatment of it that has bewitched you. . . .

"I want to make lithographs just as important as etchings," he says; "there should be no difference in their rank." "Certain things can be done in etching, others in lithography."

Happy with the medium, Whistler did several dozen prints of Paris subjects in the Rue du Bac period, experimenting with various ways to transfer his impressions to the stone. One subject, *The Duet*, harked back to his early days with Deborah and Annie Haden, as it showed Trixie and her sister at a grand piano, with deep evening shadows on the wall behind. The shadows were almost symbolic. His life had not been one of utter contentment in Paris—there were tiffs with the printers of his lithographs, and with new patrons and old enemies. And he had reduced his work in scale and intensity, finding it increasingly difficult to imitate his earlier style. But the newest shadow had fallen over Trixie. She had become wan and ill, and received unsatisfactory diagnoses and unsuccessful medication from Parisian physicians. In December, 1894 Whistler locked the studio at the Rue Notre Dame des Champs and the house and garden off the Rue du Bac, and took Trixie to London.

XXXII

L'Affaire Trilby

ALTHOUGH Whistler's corps of admirers had increased during his two years in France, and he had become the most famous American in Paris, Englishmen had been less susceptible than their transatlantic counterparts. Englishwomen too, "Vernon Lee" * writing home, "I have . . . seen Whistler, whom I do not like: a mean, nagging, spiteful sniggling little black thing, giving no indication of genius. . . ." An old friend of student days in Paris clearly agreed, for in January 1894 the first installment of his novel *Trilby* had appeared in *Harper's New Monthly Magazine*, with characters, whatever their names, out of the *atelier Gleyre* of the late 1850s. A description of the young model whose name gave the novel its title suggested that George Du Maurier, who illustrated as well as wrote his exercise in nostalgia, had inadvertently succumbed to the impact of Whistler, for Trilby, virginal and seventeen, is "a true inspiration of shape and colour, all made up of delicate lengths and subtly-modulated curves and noble straightnesses and happy little dimpled arrangements in innocent young pink and white." Arrangement or not, the reading public took to her like no other heroine since Dickens's Little Nell, even Henry James writing to the author as monthly

* Violet Paget (1856–1935), English novelist and essayist.

chapters followed, "Trilby goes on with a life and charm and loveability that gild the whole day one reads her. It's most delightfully and vividly talked! And then drawn!—no it isn't fair."

Also drawn as well as written about were characters recognizable as Poynter, Armstrong, Ionides, Prinsep, Lamont—and Whistler, the March installment including a chapter, "The Two Apprentices," which opposed the virtues of Lorrimer, "the industrious apprentice," and Joe Sibley, "the idle apprentice, the king of Bohemia," ". . . always in debt . . . and also eccentric in his attire. . . ." The accompanying illustration left no doubt that Du Maurier was describing Poynter and Whistler, but describing less the Whistler of 1859 than the Whistler since. More than a hint of envy and bitterness at their respective fates emerged in the writing, Du Maurier concealing Whistler only by the flimsy touches of increasing his height and altering the famous white lock to an entire head of white hair. While one artist had married respectably, lived respectably, and earned a respectable income as illustrator for *Punch* and author of a modestly successful recent novel, *Peter Ibbetson*, his friends of Paris days had become successful painters—even Academicians. Worse still, the most conceited and obnoxious of the lot, having tasted infuriatingly early success and then decades of failure, had nevertheless emerged from professional frustration into international fame. It was too much. As Joe Sibley, Whistler was

now perched on such a topping pinnacle (of fame and notoriety combined) that people can stare at him from two hemispheres at once; and so famous as a wit that when he jokes (and he is always joking) people laugh first, and then ask what it was he was joking about. And you can even make your own mild funniment raise a roar by merely prefacing them, "As Joe Sibley once said."

. . . He was a monotheist. . . . He is so still—and his god is still the same—no stodgy old master this divinity, but a modern of the moderns! For forty years the cosmopolite Joe has been singing his one god's praise in every tongue he knows and every country—and also his contempt for all rivals to this godhead—whether quite sincerely or not, who can say? Men's motives are so mixed! But so eloquently, so wittily, so prettily, that he almost persuades you to be a fellow-worshipper—*almost*, only!—for if he did *quite,* you (being a capitalist) would buy nothing but "Sibleys" (which you don't). For Sibley was the god

of Joe's worship, and none other! and he would hear of no other genius in the world!

Whistler was furious. Refusing to concede that the damage might have been done in friendly fun, he fired off a letter to the *Pall Mall Gazette*. On May 15, 1894 it was published, and battle was joined:

> Sir,—It would seem, notwithstanding my boastful declaration, that after all, I had not, before leaving England, completely rid myself of that abomination—the "friend"!
> One solitary unheeded one—Mr George Du Maurier—still remained hidden in Hampstead. . . .
> Now that my back is turned, the old *marmite* of our *pot-a-feu* he fills with the picric acid of thirty years' spite, and, in an American Magazine, fires off his bomb of mendacious recollection and poisoned rancune.
> The lie with which it is loaded, *à mon intention,* he proposes for my possible "future biographer"—but I fancy it explodes, as is usual, in his own waistcoat, and he furnishes, in his present unseemly state, an excellent example of all those others who, like himself, have thought a foul friend a finer fellow than an open enemy.

Another letter, dated May 7, went to the President of the Beefsteak Club, of which both men were members. Whistler did not intend to let that situation continue, bluntly calling the committee's attention to the club rules:

> As good faith and good fellowship are your essentials it becomes plain that Mr Du Maurier & I cannot both continue as members. Either I am a coward, or he is a liar—*That* is the issue.

Whistler also demanded that a copy of his letter be hung in the club's supper room, but the committee turned him down, pointing out that Du Maurier had already resigned from the club. Stuart Wortley, another member, reported to him that "while most of them thought you did D.M. too much honour by taking any notice at all, the matter evoked expressions of sympathy & regard for you all round." Du Maurier sought sympathy also, writing to Tom Armstrong, "J.W. seems to me to have gone quite crazy—however there's nothing I can do now—and I don't see what he's aiming at unless it's notoriety. . . . Nor can I, after all this

virulence on his part, attempt anything in the shape of an apology." But he suggested, perhaps hoping that Armstrong might be an intermediary, that he would "delete Joe Sibley in the coming volume" if Whistler were to write him "a decent letter." The situation left him puzzled, he explained. Perhaps Whistler wanted to "have it out with fisticuffs! *à notre age, et dans notre position!!!* I suppose he does mean to come and 'hit me in the eye' as he always called it. . . ."

Since the prospect of a scandal existed, the *Pall Mall Gazette* assigned a reporter to interview Du Maurier, his story appearing on May 19. At first the author of *Trilby* had refused to explain his side of the matter: "If a bargee insults one in the street, one can only pass on. One cannot stop and argue it out." Then he confessed that "certain lines" in the character of Joe Sibley had been drawn "with Mr Whistler in my mind. I thought that reference to these matters would have recalled some of the good times we used to have in Paris in the old days. . . . But he has taken the matter so terribly seriously. It is so unlike him."

Du Maurier anticipated some reaction, but not the reaction he did get, he admitted. "I thought it might have drawn from him something funny, something droll, to which I could have replied in kind. . . ." When the interviewer asked whether he harbored any hostile feelings, Du Maurier replied very carefully:

> I am neither his friend nor his enemy. I am a great admirer of his genius and his wit, but I cannot say that I could call myself his friend, for thirty years past. We were intimate in the old days, but that is all. . . . He talks of my pent-up envy and malice. I must ask you to believe that I am not such a beast as that. I have no occasion either for malice or envy. . . .

That Du Maurier had not nursed his envy for years was less than honest, but his response did leave the way open for a truce. The reporter's question—whether the author of *Trilby* would be willing to withdraw the offending character for volume publication—received the same answer he had privately given Tom Armstrong. "If I had a word or sign of regret from Mr Whistler for the savage things he says in his letter I might consider that. . . . A man so sensitive as Mr. Whistler . . . should beware how he goes about joking of others. . . ." Whistler immediately wrote to *Harper's* London agent. Letters went also to Edward Poynter and to Henry Stacy Marks, the latter who had been parodied meanly as "Macey Sparks," a critic who had few lucid intervals, too much to drink,

and hoarse hiccups. Marks offered to join battle, and asked the Arts Club for Du Maurier's resignation, although Du Maurier had been a founding member. "I thought how he would laugh at this old reminiscence about him & be much amused!" Du Maurier wrote to Tom Armstrong. "*Mais pas du tout*—He was *furious*; & I in despair—so I . . . wired to New York to suppress the whole passage relating to him. . . . I then went home & wrote all my sincere & heartfelt penitence to him, and he wrote me a very nice letter back—and I have since spent a whole day with him. . . . He hiccupped more than ever as we came home. . . ."

Whistler's application to Marks had been a failure. Du Maurier was apparently more adamant than ever, for he could have telegraphed to Harper's to suppress the Sibley passage as well in the future book. Poynter was even less satisfactory. "I have a general idea," he wrote Whistler coldly, "that Du Maurier has been making a story out of our old Paris life, but I have not read anything of it. . . ." He could not credit the idea that Du Maurier would write something "personally objectionable to any of us. . . . I see very little of Du Maurier now, but we are always good friends." Whistler forwarded a copy of the *Pall Mall Gazette* interview, but Poynter refused "to quarrel with Du Maurier—altho' your letter is so seductive, that you almost persuade me to take a side. I know you will say this is just like me; but there is not time in this life to go into these things."

Although Du Maurier had told the *Pall Mall Gazette* reporter that Whistler's rude letter had been worse than his own *Trilby* caricature, and that he would now withdraw Joe Sibley, toward the end of May—perhaps prodded by Poynter—he wrote to his publisher, "Is there still time, do you think, to make a small alteration in parts 3 & 4 of *Trilby* for the American volume form? As I wish to replace the character of 'Joe Sibley' by another (& better one), Joe Sibley as you may have seen, has given dire offence to J. Whistler, deeply to my regret." Du Maurier did not know that Whistler had already begun legal action to sue for libel, not so much to extract damages for professional harm caused him as to force the removal of the offending passages and humiliate the author. His first thought was to bypass his usual attorney, William Webb, and engage the great trial lawyer of the day, his old friend Sir George Lewis. But Sir George had also known the author of *Trilby* for years, and wrote to Whistler that not only did he know nothing of the offending publication but that "naturally it is impossible for me to act against him. I hope however that no proceedings will be taken."

Replying to Lewis—clearly the *Trilby* affair was taking much of his active hours—Whistler listed at length the injuries he felt he had already suffered from the book "to make clear to you in its full light the infamous conduct of Du Maurier." There was no hope that Lewis would undertake the case, however, and Whistler returned to the Webb brothers, who handled his day-to-day legal matters. To William Webb—"a little man, a thorough Englishman in big spectacles, with a curious sniff," according to Joseph Pennell—Whistler mailed long letters of procedural advice from Paris urging that Du Maurier and *Harper's* be sued for substantial damages. Cautiously and diplomatically Webb suggested that his client's likelihood of receiving significant damages was remote, for his artistic reputation was too strong to have suffered from *Trilby*. Instead, Webb recommended seeking a retraction and an apology, and on May 29, 1894 the firm wrote in such a vein to Harper's:

> Mr Whistler instructs us that proceedings will be commenced against you for an injunction unless you comply with the following requirements:—
>
> Mr Du Maurier's work containing the libel must be stopped. The March number of the Magazine must be destroyed and a satisfactory apology must be published wherever reasonably required, and an understanding [given] not to repeat the libel when the work is published in book form.
>
> As to the damage done to Mr Whistler's reputation by the libel which has been circulated over the civilized world, this will have to be dealt with and provided for by you if proceedings are to be stayed. . . .

Replying, Clarence McIlvaine of the London office regretted what had happened, and pointed out that any action he might take would have to have the consent of the New York headquarters of Harper's. While he awaited instructions he sent the Webbs' letter to Messrs Frere, Forster & Co., solicitors. Immediately, Arthur Stirling of Frere, Forster rushed a cable to New York: "WHISTLER THREATENS INJUNCTION MARCH TRILBY. SUGGEST DEFERRING COMPOSITION BOOK." The London office had never informed New York that any trouble had arisen, and in puzzlement Harper's cabled McIlvaine for information. In early June cables began crossing each other in confusion, for Stirling's opinion on reading the alleged libel was that Whistler was right—that it had to be altered, and an apology tendered in hopes it would be accepted as sufficient settlement.

McIlvaine took the opinion and cabled New York himself, "ADVISED MARCH NUMBER LIBELLOUS PROPOSE SETTLING EXPRESS REGRETS STOP MARCH CIRCULATION MODIFY BOOK CABLE SANCTION." Since the next month's issue, with another portion of *Trilby*, was in press, with more to come, and the book version expected to make large profits on the basis of the *Trilby* boom already underway, Harper's telegraphed back, "CABLE PROPOSED TERMS TRILBY SETTLEMENT." McIlvaine specified, "COUNSEL ADVISES TRY STOP INJUNCTION BY APOLOGY STOPPING SALE MARCH NUMBER AND PROMISING BOOK REVISION NO MONEY PAYMENT PROPOSED."

But although Du Maurier had been working on substitute passages, he was unwilling to apologize, convinced that Whistler's letter abusing him in the *Pall Mall Gazette* was sufficient grounds to make that unnecessary. Whistler, on the other hand, felt that the apology was essential, for as the negotiations between attorneys dragged on it became clear that no pecuniary loss could be proven to extract compensatory damages. "But let us throw away nothing," he urged William Webb. "If after what we exact from them in the way of amends we can still hold over their head the possibility of further action why not take it in some equivalent further *giving away* of Du Maurier in the very humble letter they are to publish for us?"

Meanwhile, Du Maurier's feelings about Whistler spilled over into an issue of *Punch*, in an anonymous piece presumably by another staff member, in which a *Punch* reporter rushes across the Channel to see Whistler's portrait of Montesquiou, then on exhibit at the New Salon.

LE CHEF-D'OEUVRE DE VISTLAIRE.

Wednesday.—Fired by the enthusiasm of some English critics, resolve to run over to Paris to see the wonderful WHISTLER in the New Salon. Understand that it excels anything done by VELASQUEZ or TITIAN. As for such old-fashioned men as REYNOLDS or GAINSBOROUGH, they are simply forgotten. True art is so elevating. Therefore run over.

Thursday.—Delightful in Paris. Brilliant blue sky, glorious sunshine; animation, movement everywhere. Glorious sunshine a trifle hot. Can't possibly go to see the WHISTLER to-day in that great greenhouse on the Champ de Mars. Sit in the Avenue du Bois and look at all the pretty Parisiennes. By chance meet that charming little Comtesse, who is so gay and delightful. Shall do the New Salon to-morrow.

Friday.—Sky bluer. Sunshine brighter and warmer. Unfortunate. Did really want to see the *chef-d'oeuvre* of modern times. Art is so ennobling! But on a day like this, and in a greenhouse! Stroll along the Avenue des Acacias and watch the pretty little *dames bicyclistes* in their knickerbockers. Meet the Comtesse again. WHISTLER must wait.

Saturday.—Sky if possible bluer. Sunshine decidedly warmer. Begin to get anxious about that Salon. Must do it somehow. But *ars longa* in a conservatory in this weather would make *vita* very *brevis* indeed. Can't do it. Take one of those comfortable little *fiacres* and drive to the Bois, and have *déjeuner* in the open air with the Comtesse and some friends. Resolve firmly that, whatever the weather may be, will do the New Salon to-morrow.

Sunday.—Last day here. By Jove, it is warm! How delightful it will be to go out to St Germain, or somewhere, and—Oh, hang it! There's that sublime WHISTLER. Must really see it. Give up trip to country air and in frock coat and top hat, drive to New Salon. Roasted on the way. But at least in fresh air. Inside Salon, baked—without fresh air. Sun blazing on glass roof. Crowds of *bourgeois endimanchés.* Pull myself together and, in the interests of immortal art, resolve to find that WHISTLER. These alphabetical catalogues maddening. Never know what room anything is in. Walk round gasping. That's a funny figure anyhow. No. 1186. Look it out. Hullo! What? Stagger to a seat. "1186. *Noir et argent—portrait du comte Robert de Montesquiou-Fézensac.*"

Sandwiched into the piece was a caricature of the portrait, with Montesquiou appearing so limp that he would have had to have been suspended from his crooked collar by a butcher's hook.

To Harper's in June Du Maurier proposed two alternative characters, the first not an artist—"Mr Kretsch, a Swiss Jew," an anti-semitic caricature hardly needed when Svengali, the evil influence over Trilby, had already accomplished all that seemed worthwhile in that direction. The other pleased the New York office more—"Bald Anthony," based upon a Swiss painter named Huniker with whom Du Maurier had once shared a studio in Düsseldorf. The replacement text was sent to Whistler, who telegraphed from Paris on July 19, "COMPLIMENTS AND COMPLETE APPROVAL OF AUTHOR'S NEW AND OBSCURE FRIEND BALD ANTHONY."

Whistler still insisted on a published apology, and wrote to Webb

that he wanted the humiliation of Du Maurier made clear, but since Du Maurier continued to drag his feet, Whistler approved of the widest possible circulation of his cable.* "Fancy when it becomes known that he has had, not only to rewrite his manuscript, but to *submit it to me for approval!!* And to think that he should have consented to do it!!! Why nothing so absolutely abject was ever heard of! And then *think* of the TELEGRAM!!"

An agreement between Whistler and Harper's was drawn up that July which stipulated that the March issue of the European edition of their magazine would be withdrawn from sale, an empty gesture since it was sold out. Also, Harper's agreed to publish a public letter of apology in the September or October issue, it being too late to put it into the August number which concluded the run of *Trilby*. Further, Harper's would alter the book version as previously arranged, and as a token, pay Whistler's legal costs not exceeding ten guineas, costs Whistler had long exceeded. Publication of the August number almost exploded the agreement, for an illustration of Trilby's death-bed included in the crowd of concerned friends an overlooked reappearance of Joe Sibley. For the book version, Whistler was assured, the face would be altered, disguised by a beard; and in actuality Bald Anthony himself never appeared as described, for he became "the yellow-haired Antony, a Swiss—the idle apprentice . . . ," still always in debt and eccentric in attire.

More than slight annoyance must have been sustained by Whistler as a result of the second and even greater triumph of *Trilby*, on publication that September as a book. Some thirty thousand subscribers had canceled in disapproval of Trilby O'Ferrall's bohemian life, while a hundred thousand new subscribers were gained because of it; and although it had hardly needed any additional promotion, Whistler's legal action had provided it. In New York, the "This Busy World" column of *Harper's Weekly* noted on October 13, 1894 that "Thanks to thousands of readers who delighted in it as it appeared in serial form, to some dozens of readers who disapproved of its morals, and to Mr Whistler, who disliked some of its allusions, it is by very much the best-advertised book of the year." And in London the publication of the apology by *Harper's Monthly*, forced upon them by Whistler, provided his critics with a new reason to attack the surprising sensitivity of the author of the *Gentle Art of Making Enemies*, whom, the *Speaker* observed on October 27, "nobody has ever

* It appeared in *The Star*, October 30, 1894.

approached . . . in the candour of his personalities and his contempt for the ordinary observances of society; but when a candid portrait of himself appears in a work of fiction, nothing will satisfy him except an apology from the publishers and an alteration of the offensive passage."

In its public relations impact, the *Trilby* affair damaged Whistler. The butterfly with the notorious sting was expected to receive as he gave. Yet the affair seemed to trouble Du Maurier more after it was over than before, and with his lone and ailing eye handicapping him (he had been blind in the other since student days, and now drew at three times publication size), he drafted a letter to Whistler's lawyers and several to Whistler. If Whistler had "only let me know by a line or a word" that he wished the reference expunged, he proposed writing the Webbs, he would have "thus spared himself both trouble and expense." To Whistler he tried out regretting "having written the unfortunate paragraphs that have given you so much offence, & of which I now see and admit the carelessness and indiscretion. . . . The whole thing has been to me a matter of much painful preoccupation, not indeed from any fear of what you & your lawyers might do—but that I should so needlessly and so deeply have offended you without ever wishing to do so." The regrets were insincere. He was very likely still worried about whether he needed to head off a suit against himself. Privately he reveled in reports that Whistler had been cutting a poor figure in France, and that Degas had managed to intimidate him "& sits on him like anything." To Armstrong he wrote, "I shall tell Jimmy in the most abjectly fulsome terms of adulation I can invent that he's the damndest ass & squirt I ever met." There is no evidence that he sent Whistler anything.

In November 1894 Whistler proposed to put his arrangement of the documents in the *Trilby* affair into a third edition of the *Gentle Art*, writing to William Heinemann, "I fancy I have wiped up Hampstead and manured the Heath with Du Maurier! . . . It will be time soon to begin preparations for a new edition. Meanwhile I think I must put together all the Du Maurier campaign and let you have it set up that we may see how it looks! We can then get it into pretty shape." Perhaps it looked less good than he pictured. Certainly his new personal problems made *l'affaire Trilby* in retrospect less funny. There was no new edition.

XXXIII

Lyme Regis and London

D<small>R</small> Willie's diagnosis shattered Whistler's life. Trixie had cancer. Whistler would not believe the worst and took Trixie to London specialists, staying at Wimpole Street with Willie while she underwent tests at a physician's in Holles Street. The results, which confirmed Dr Willie's pessimism, were kept from Trixie, and Whistler took her back to Paris, where a French surgeon proposed an exploratory operation. Guessing that his brother would accept the advice of anyone who promised a cure, Willie rushed across the Channel just in time to prevent Trixie from going under the knife, declaring frankly that it would only add to her agony. Whistler exploded with indignation. He could not accept the idea of incurable illness, and told Trixie nothing. But she now knew, and Whistler was even angry with her for telling others the truth. A violent quarrel erupted between the brothers, Whistler afterwards refusing to see Willie further, as if the tragedy had been his fault.

The Whistlers took rooms at Long's Hotel, in Bond Street, as if their stay would be brief, and 110 Rue du Bac reopened. He was flailing about in disorganized anguish about what to do next, for Trixie was not bedridden, however uncomfortable, and decisions had to be made. More physicians were consulted, with results Whistler accepted hopefully as inconclusive, and on December 9, 1895 he wrote to the dealer E. G.

Kennedy in New York that it was possible that he and his wife would be coming to America immediately, in order to consult certain doctors recommended to them. But he ruled out, because of the nature of the visit, any hospitality or festivities, public meetings, exhibitions or receptions, and urged him to keep the matter secret until further notice. To cross the North Atlantic in winter was a daunting prospect for Trixie, however, and nothing came of the idea. They remained in London, where Trixie's mother and sisters could be with her, and Whistler worked on lithographs of Deborah Haden, and of London scenes, visiting almost daily at Tom Way's, where the drawings were being transferred to the stone and printed. "It was madness on my part," he later told Way, for he could not work effectively under the strain, yet he felt that he had to keep busy doing what he could do best.

Worry over Trixie fed his litigiousness as well, a petty argument over the price of a commissioned portrait to have been delivered the year before having burgeoned into an international legal matter, with the case pending in the Civil Tribunal of the Seine. Dozens of lengthy letters passed between Whistler and his lawyer, Paul Beurdeley, and between Whistler and Mallarmé, keeping him not only from his work but from his worries, perhaps the subconscious reason he pursued the case with such tenacity. On March 6, 1895, he had to return to Paris for the trial, and when the judgment went against him he appealed the case with a relentlessness beyond its merits. The newspapers reported the affair as a huge joke, unable to understand what lay behind it. Mrs Whistler's ill health was still a very private matter.

To maintain the pretense, both Whistlers returned briefly to the Rue du Bac early in the summer, and Whistler conducted some artistic business, sending *The Little White Girl* to the International Exhibition at Venice, a portrait of Mrs Sickert to an exhibition at the Glasgow Institute, six lithographs for a centenary exhibition of the development of the art in Paris, and a head of his model, Carmen Rossi, to the Portrait Painters show in London. It was the appearance of activity. Then the house in Paris was again closed, and the Whistlers went off to test the medicinal properties of the sea air at Lyme Regis, in Dorsetshire.

At the Royal Lion Hotel, where they had taken the best room, with a bay window overlooking Broad Street, Trixie was unimproved, "far from well," as Whistler confessed to Way. It was impossible for him to think of anything else, he added, but he was going to do some lithographs, and had started six to get his hand in. Working on them became easier when

Trixie determined to return to London, where her sisters could again be with her, for she encouraged her husband to remain. His French servant Constant stayed with him.

Whistler was in agonies of self-doubt about his work—the old inspiration failed to come and could not be forced, and she felt that he needed to be left where he could paint without the problems of her care. The picturesque fishing village, with its thatched-roofed houses with white walls, and the rugged Dorset coast, were ideal subjects to reawaken what he called his "Goddess," but once Trixie left, his letters to her poured out almost daily confessions of uncertainty and futile struggle. Much of it was owed to his concern for Trixie, and the crisis he passed through without her was more emotional than artistic. He was failing in health, and his hand failing with it; but she was living in pain and Whistler knew that soon she would take to her bed for the last time and leave him alone.

From London Trixie returned letters of encouragement and optimism, and provided a useful diversion in the form of an on-the-scene report of the artistic activities of the Greaves brothers. Since 1890 they had walked, almost daily, the five miles from Chelsea, across Battersea Bridge through Clapham to Streatham, wearing shabby silk hats and frock coats, and pink-and-yellow ties, to decorate the new Town Hall with Whistleresque murals. It was a Peacock Room concept grotesquely magnified and completely beyond their capacity; and the dark, damp corridors were thoroughly unsuited for the hundred-or-more murals now nearly done, most of them imitations of Whistler which bordered upon travesty.

Whistler had learned of the project, and was disturbed; but he was still far away in Dorset. Trixie, though ill, was closer by in London. A fierce guardian of her husband's reputation, she managed to get to the Streatham High Road to examine what the ageing brothers, who still identified themselves as "Pupils of Whistler," had been doing to eke out a living. Confronting the murals was a shock which turned her from any concern about herself, and she wrote to Lyme Regis to report her impressions:

> You have no idea how dreadful it all is!! . . . you enter at the side into a narrow stone passage, as dark and damp as possible. I think it was painted grey with a dado and pictures above in panels—in fact, it is all alike, horrors in panels above a dado and there is no attempt at anything original. . . . They have

remembered anything and everything you ever did, even to the Japanese panels in your drawing-room, your brown paper sketches, the balcony, Battersea Bridge. . . . They have painted the frames on the walls with yellow paint, with shadows and with the blossom pattern, the shells . . . etc., etc.!!

. . . Two or three classic ladies with pots, flowers on the floor, a travesty of *The Balcony*—two or three recollections of your peacocks. Another room with an imitation of *The Fire Wheel, Chelsea in Ice.* There! I can't go on—it was like a sort of hideous Whistlerian chaos, I felt quite mad and sick—I laughed out loud at last. I couldn't help it and turned round to find the man who showed us round was laughing too. It's frantic. My God, I could kill them—conceited, ignorant, miserable, gutter-born wretches. Don't write—write to them if you like and insist that they wipe out the pupil business. Don't, don't, my own dear darling love, draw any attention to them—besides the place will be rotten in ten years, it is running with damp and beginning to peel off. They have been at it for four years!!!!

. . . My darling, don't write to the papers. You must go and see yourself. I cannot give you any idea.

Whistler had no desire to involve himself in any legal contest to enjoin the brothers from completing their work. It would only call attention to something upon which papers like *Punch* would seize with glee. Besides, the brothers had been his earliest followers, and Whistler felt too guilty about his conduct toward them to want to rob them of their livelihood. Let the tax shillings of innocent Streatham support his least successful disciples.

Now, this matter of the Greaves is, Chinkie, of a certain *importance.* Very important, I consider. The situation may be made vexatious if I appear at all backward or disturbed—You see the letter [to a newspaper] is a public challenge—the two Greaves are not only held up to ridicule, but are accused of imposition and falsehood. . . .

I have written a charming letter, which I shall first send you, there is time, though none too much. . . . The thing is making a stir—

As to the work in the Hall itself—it may not be all that good. It may be absolutely wild and uncultivated as decoration—the

work of peasants perhaps, but, take my word for it, there must be some stuff in all that. *To have done it* . . . what others have *done* anything? Besides they were very intelligent and nice boys—and it would be a graceful act on my part—I feel kindly about them after all—Chinkie dear!

A tactful letter to Walter Greaves followed but it was not meant to cancel the project. That was done, quickly enough, by time.

In Lyme Regis, Whistler pressed on with his work, knowing that with the onset of bad weather he would have to return to London and—possibly—the end of his work for an indefinite time. From his window looking out on Broad Street he saw a girl of about ten, with beautiful auburn hair, pass by on her way to school. Soon after he stationed himself on the sidewalk across from her path, and when she approached, he dashed across the street and asked her if she were willing to be painted. The idea was as terrifying as was being accosted. She thought the strange old man literally meant to paint *her,* and ran home.

Whistler discovered that she was Rose, the daughter of G. J. Rendell, an alderman who twice had been mayor. After some persuasion her parents permitted her to model, and after school she would pose for *The Little Rose of Lyme Regis,* one of his best smaller-scale (20″ × 21¼″) later portraits, in the room he had rented for a studio behind Number 51, Broad Street. The house agent, the local coal merchant as well, was astonished by being asked to sell Whistler coal by the pound, French style, for the studio, but Constant came regularly for his ration, and Rose Rendell posed in a room warmed to Whistler's needs.

The sittings were wearying to the child, who fidgeted and even cried when kept from her dinner. "Rosy, Rosy, Rosy," Whistler would appeal, "just another minute." But it was always a good deal longer. Before they were done Whistler gave her a splendid box of sweets in the shape of a tambourine, which he had ordered from Paris, and later sent her a doll from Paris. She saved the box and the doll all her life.

Another person who attracted him as a painting subject was Samuel Govier, a blacksmith, who came for sittings right from the forge, and when he had not been at work had to dirty himself in order to pose. Again it was a small portrait—the size of the *Little Rose*—and Whistler felt it was so successful that he also painted Govier's eleven-year-old daughter Ada, in a small full-length he called *The Dorsetshire Daisy.* (The next year he sold the *Little Rose* and *The Master Smith of Lyme Regis* to the

Boston Museum of Fine Arts.) He worked in all his familiar media, doing an oil he called "a sketch of skies and tops of houses," a gentle canvas in broadly brushed browns, grays and greens which had a bucolic serenity he could not have felt. Just over two feet in width, it was the largest of his few landscapes. (It would be purchased by Charles Freer.) Just as he looked out toward the Dorsetshire countryside, he also found a more familiar subject by the sea, doing among his Lyme Regis water colors a curving sweep of beach, water and promenade into which, in the middle distance, the town was tucked.

His concern over his loss of mastery over his art, entangled as it was with his concern over the deterioration in his wife's health, could not have been alleviated entirely by the completion of new work which satisfied him. Yet he told Trixie that he had achieved new freshness in his art, that "ease comes where was toil, and all is simple and clear where once was vexation and doubt."

Before he left Lyme Regis for London, his worry about Trixie boiled over in a furious note to his son, who had written to ask for money to keep him from starvation while he worked on a patent which he thought had the potential to bring him out of economic difficulties. Faced with a return to Trixie's irreversible problems, the severity of which he could not even admit to himself, he lashed out at Charles, who was innocent of any knowledge of them. "You have had what seems to you a very hard time, but your trials are really nothing. They only concern yourself. . . . What does it matter that you sometimes eat little—and are not so comfortably lodged as you might like to be? You have no other cares but your own, & what are they? Bye & bye they will be remembered even with pleasure, as proofs of something like pluck and self respect." Then Whistler softened, and added, "I don't complain of your conduct. I have no reason to do so. Frankly I believe you behave well, and are persevering in your work, and I doubt not it will come out all right. . . ." And he enclosed a check for £20.

A month later, in December 1895, there was an exhibition of seventy Whistler lithographs at the Fine Art Society, with the artist back from Lyme Regis to receive what were now the predictable plaudits of the press. Since the medium was relatively new to him, most of the lithographs were the product of the past few years, evidence of his continuing although unserene activity; but the usual efforts to set the exhibition in characteristic Whistler style were missing. He was too preoccupied with Trixie, who was now clearly failing, although he wrote

to Deborah Haden, "We are pretty well, and I think Trixie better than when you saw her." He thought again about consulting specialists in New York, but "the vast far-offness" of America dissuaded him. Instead, to "please" Trixie he took a studio at 8 Fitzroy Street, after first trying to work at Sickert's, then at Sargent's, studio. It was one flight up a ramshackle glass-roofed passage at the back of the house, and large enough for any conceivable need; but he was too busy shifting living quarters and tending Trixie to spend many hours there, going from Garlant's Hotel to rooms in Half-Moon Street, and thence to the De Vere Gardens Hotel.

After the De Vere Gardens Hotel it was the new Savoy, which Whistler had etched when under construction in the 1880s, from the windows of the D'Oyly Carte offices when he was planning his *Ten O'Clock* lecture, observing that he "must draw it now, for it would never look so well again." The Savoy was the acme of Victorian opulence, both in appointments and cuisine, but neither meant much to the failing Trixie, for whom Whistler sought rooms high up and overlooking the Thames. Again a column of porters carried in cases of little-used clothing and personal effects, with special attention given a birdcage housing an exotic Asian magpie with long, brilliant tail feathers—a gift to Trixie from Charles Freer, who had been travelling again in the East to add to his collection of Orientalia.

From each new address there was evidence of Whistler's continuing efforts to work amidst the disorganization and chaos. There was a lithograph of Kensington Gardens from the De Vere Hotel, an etching of Clare Market and others of Fitzroy Square, and eight lithographs done at the Savoy, six of them remarkable views of London from his Hotel room window, as Whistler spent more and more time with his wife, who by the end of winter seldom left her bed. The other two were of Trixie, titled *By the Balcony* and *The Siesta*, in a pathetic attempt to convince himself that Trixie was merely resting. What he drew belied his captions. *By the Balcony* showed a wasted Trixie asleep on a day bed under a coverlet, in the background an open door onto a balcony beyond which was a glimpse of Waterloo Bridge and the Thames. In *The Siesta* she sinks back into the sheets, her head held up by a pillow, her left hand dangling limply, a book abandoned open on the bed. Whistler made only thirty-one proofs, none for sale.

Sometimes so exhausted with watching by Trixie's bed that he would

fall asleep over the lithographic stone, he was still too restless to sleep himself, finally dozing by mid-morning, then going out on artistic business. He would visit the Pennells, who lived on tiny Buckingham Street, below the Strand and near his hotel, on one afternoon drawing four portraits of Joseph Pennell and one of Elizabeth Pennell; and he told them of plans to paint a full-length of Joseph Pennell in a Russian cloak, as a preliminary to doing a lithograph, *The Russian Schube*. When Pennell told him there was no time for the sittings required, as he had to be off for an illustrating assignment in Italy, Whistler explained, "Well, I thought some gallery—the Pennsylvania Academy, what?—would have bought it and you and I might have been remembered by it."

Once when Whistler was at the Pennells, Aubrey Beardsley arrived, wan and tired, but as usual carrying his drawing portfolio under his arm. He had some new things to show them, and with Whistler about might have hesitated exposing himself to ridicule. But by early 1896 he was no longer a diffident boy. At twenty-four he was already the sacked and notorious former art editor of *The Yellow Book* (fired for his nonexistent association with Oscar Wilde, whom he disliked, after Wilde's arrest and trial the year before) and the current editor of *The Savoy*, which, brilliant experiment in magazine publishing as he and Arthur Symons had made it, lasted out only the year, Beardsley surviving it little longer. In Pennell's parlor he opened the portfolio to show his newest drawings, illustrations of Pope's satire *The Rape of the Lock*. Whistler looked at them indifferently; then as the gaunt visitor turned from one of the nine pen-and-ink masterpieces to another, Whistler's attitude shifted to interest and then delight. "Aubrey," he said slowly, "I have made a very great mistake—you are a great artist." Beardsley began to cry, leaving Whistler speechless. Finally he added, "I mean it—I mean it." Then he went back to the Savoy to sit by Trixie's bedside.

Some afternoons were spent elsewhere in London, often at Way's, where drawings made in Paris, Lyme Regis and London were transferred to stone for printing, Whistler working until dark, then sometimes accepting a drink with Way before returning to the Victoria Embankment and the Savoy. Even there he conducted his affairs when he could, writing a long letter on March 28 to the editor of *Scribner's Magazine* in New York listing twelve works he would be willing to have reproduced, and going into the details of how they could be seen through E. G. Kennedy, at the Wunderlich Gallery at 868 Broadway. He was particularly loyal to his old paintings, as when on Wednesday night April 2 he followed up a

hurried trip to Chelsea, writing to Stephen Richards from the Savoy to instruct him how to re-varnish a Cremorne canvas hanging appropriately in the home of Arthur Studd, who lived in the Lindsey Row house in which Whistler had dwelt in impecunious but happier days. "I want you to take with you the materials for varnishing a picture of mine that is hanging in his drawing room. You doubtless will remember it—having varnished it a few years ago at the time of the [Chicago] Exhibition—a nocturne 'The Firewheel.' The picture has just come back from America, and though perfectly clean, I washed it myself this afternoon, is in a very dull state. The varnish is quite chilled and much sunken in. It is ready to have another coat of varnish—your very best! So give it a thin coat tomorrow morning. . . . I want you to make a beautiful job of this. . . ."

At the Savoy there was never any hope, although Whistler and Trixie pretended otherwise to each other. G. P. Jacomb-Hood remembered "the misery and pathos of his sitting beside his wife's sofa, holding her hand, while she bravely tried to cheer him with banter and gossip." To J. J. Cowan, whose portrait, *The Grey Man*, had been untouched for fifteen months, Whistler almost confessed the worst on April 4, writing from the hotel that Trixie's illness had made his life "one long anxiety and terror," and that for nearly two years he had hidden the fact although his "one thought" had been her care. "And so we have wandered from home and work—going from town to country, and from doctor to doctor. Living in hotels, and leaving behind us the beautiful place you know so well in Paris—and the studio in which we both passed so many hours!" The "pilgrimage for health" had canceled all else, and Whistler could not speak in the first person singular about it—"all sense of time and ambition was lost—we were ill—and the sun had gone out of our sky!" Yet he still clutched at the impossible. "At last however there is hope . . . [that] all will be well. . . ."

Rather than hope, there was only another pilgrimage, this time to rugged Hampstead Heath, where Whistler had rented a cottage from Canon Barnett, a local clergyman. He was able to joke about the hilly surroundings that it was "like living on the top of a landscape," but to Walter Sickert he wrote, again eschewing the first person singular, "We are very, very bad." Soon he was seen wearing one black and one brown shoe, the ultimate citadel—his fastidiousness—breaking down. On May 10, 1896, Sydney Pawling met him running across the Heath, a wild expression on his face. Alarmed, Pawling stopped Whistler, who cried

out, "Don't speak! Don't speak! It is terrible." And he raced on. Trixie had died.

Whistler would not tell Dr Willie, who found out about his sister-in-law's death accidentally. The break with his brother had affected him so profoundly that he had taken to drink, and was soon in financial difficulties. Whistler then, unasked, came to his aid through "Sis"—their half-sister Deborah. Letters with black mourning borders arrived afterwards from Jimmy, with the cause for the breach never mentioned in them. But the old relationship was gone. Dr Willie died soon after.

Trixie's burial was at Chiswick Cemetery. The morning after the funeral, Whistler went off automatically to his Fitzroy Street studio, then remembered, and wandered dazedly off with a friend who painted nearby, traversing Fitzroy Square and Tottenham Court Road until they were tired and found a pub in which to sit down. On the wall directly above them, the friend noticed, was an engraving of W. P. Frith's famous *Life at the Seaside* (*Ramsgate Sands*), crowded with dozens of people and with a backdrop of photographically accurate buildings—the antithesis of a Whistler beachscape. Whistler smiled when his attention was called to it, and then talked of retiring to a monastery or the top of a mountain. But he disliked mountains and had all the monastery he could want adjacent to his own abandoned home in the Rue du Bac. The Sunday afternoon following the funeral he appeared at Buckingham Street to ask Elizabeth Pennell to go with him to the National Gallery, where he showed her the canvases Trixie loved, standing through a long silence before Tintoretto's *Milky Way*, which had been her favorite. There was none of the usual talk about pictures, and Trixie's name was never mentioned.

Hearing the news in Venice, Sickert—who understood the Whistler-Trixie relationship with great sensitivity and could write as well as he painted—sent a letter which couched advice in condolence:

My dearest Jimmy.
You must always remember now how you made her life, from the moment you took it up, absolutely perfect and happy. Your love has been as perfect and whole as your work and that is the utmost that can be achieved. Nor has her exquisite comprehension of you, and companionship of you ceased now. Never let yourself forget that her spirit is at your side now, and will always be, for sanity, and gaiety, and work; and you must not fail her now either in your hardest peril.

Sickert had gently pressed the idea that only by continued work could Whistler keep the faith. It was easier urged than done. For months Whistler's letters were despairing. "You—understand everything," he wrote to Mallarmé, "—you understand the one who has left—and you understand, no doubt, why I remain. As for me—I do not understand anything. . . ." In another letter he told Mallarmé that he now felt "always alone—alone as Edgar Poe must have been, who you found to have a certain resemblance to me." * To Charles Freer nearly a year later he wrote of his "forlorn destruction," and described a scene he could not forget.

> . . . She loved the wonderful bird you sent her with such happy care from the distant land! And when she went—alone, because I was unfit to go too—the strange dainty creature stood uplifted on the topmost perch and sang and sang—as if it had never sung before! . . . Peal after peal until it became a marvel [that] the tiny beast, torn by such glorious voice, should live!
>
> And suddenly it was made known to me that in this mysterious magpie waif from beyond the temples of India the spirit of my beautiful lady had lingered on its way—and the song was *her* song of love, and courage, and command that the work, in which she had taken part, should be complete—and so was her farewell.
>
> I have kept her house in Paris—in its fondness and rare beauty as she had made it—and from time to time, I will go to miss her in it.

Confronting Whistler were unfinished pictures and unfulfilled promises, one of which, at least, he was still determined to leave undone, however many French lawyers it took to make his resistance stick. To Freer, however, he vowed completion of a long-delayed portrait. "I write to you many letters on your canvas! And one of these days you will, by degrees, read them all, as you sit before your picture."

* Poe, the favorite American writer among Frenchmen since Baudelaire, when twenty-seven married a young wife, Virginia Clemm, who at thirteen was hardly more than a child. She died of tuberculosis eleven years later.

XXXIV

Eden v. Whistler

WHISTLER, the Pennells relate, could imitate two men fighting outside a door so cleverly that people inside never ceased to be astonished when the painter walked into the room alone, unruffled and unhurt. It was almost symbolic of his public quarrels. Visiting The Pines, Putney for the first time, William Rothenstein was introduced to Swinburne's keeper, the stubby, walrus-mustached Theodore Watts. "Ah, I hear you know Whistler," said Watts. "Dear Jimmy, how clever he is; indeed the most brilliant of men. I have known him intimately these twenty years. What genius! Latterly, owing to his quarrelsome nature—though I myself have no difference with him—still, owing to his misunderstanding with my friend, I have ceased to see him. But what a talker! Is he doing well now? Some say yes, some no. Surely he was in the wrong over Sir William Eden. George Moore I am rather prejudiced against; but of course I don't know him, and I have not read his books. But I trust Jimmy always for being in the wrong; he loves a quarrel."

Whistler quarrelled compulsively, and the Eden affair was no exception. "One really can't live in London," he once said, "without a lawyer." In his case it had been true almost since his arrival in London, for he attracted suits even more than he went to law himself, for reasons

varying from his inability to pay his bills to his inability to live harmoniously in the same city with his brother-in-law, his critics, and his patrons. His litigiousness might have been attributed to his lack of size, his insecurity about his art, his chronic financial problems, his reaction to maternal dominance or other factors not directly connected with the incident which would trigger the suit. The Eden case arose from such a complex of motives, yet seemed simple on the surface. In 1894, Whistler had accepted a commission, painted the portrait, cashed the check—and refused to deliver the picture. And the suit against him, and his own appeals, dragged on through Trixie's illness and after her death, not even the greatest tragedy in Whistler's life sufficient reason for him to drop the matter of a check for one hundred guineas. Very likely her illness was even an encouragement to continue the case, an unconscious diversion from its agony and its aftermath.

Whistler's claim was always that the Eden case was based on principles vital to the maker of art, not on personalities or pounds. Few, even among his friends, believed him; yet he had been seeking for years to affirm certain artist's rights which had no legal precedent in England. The idea belonged to the creative mind from which it had come: only an object was sold or transferred. Whistler's opinions on ownership and copyright of art were uncommon. "People imagine that just because they've paid £200 for a picture, it becomes their property. Absurd!" Although he had once given his early Paris portrait *La Mère Gerard* to Swinburne, he later decided that "Time has changed the condition of the gift, and therefore of course, as will be understood among gentlemen, the gift must be returned." He even hated parting with his work for a price. Money seemed poor consolation for its loss. "He was in this respect," Mortimer Menpes wrote, "a mere child," and he went through agonies which on the surface seemed either selfishness or malice.

> Once he had to select an etching to give as a present to his physician. He first laid eight or ten proofs out carefully on a sheet of white paper and placed them upon the table. "Now, Menpes," he said, "if you were me, which one would you choose to give the doctor?" Naturally, knowing the ways of the Master, I pointed to the one I thought least successful. Looking at me with affectionate approbation, Whistler murmured: "What instinct! Of course that is the only one—we must give him that proof." But even when it was chosen, and the finest proofs remained, he hated

parting with it. From that moment it possessed for him new beauties. He placed it apart on white paper, isolated it, and raved about it. "Why should I give it to the doctor?" I heard him mutter. By and by I saw him wrap it up, and put it away with the others. He looked curiously sheepish when he met my eye. This would occur over and over again, until at length Whistler consented to part with the proof. . . .

One night, Menpes recalled, Whistler dined at the house of a lady who owned one of his early canvases. It hung in the dining room itself, which ended all chance of his entertaining the other guests with any other subject.

He spent the evening talking about his pictures, springing up now and then to peer into this one and caress it with his handkerchief. He loved it, and felt that it was not in sufficiently sympathetic hands. Towards the end of the evening he implored his hostess to send it round to his studio the next morning to be revarnished and cared for, and generally put into proper condition. The lady, in a trusting way, complied, and sent it to him. For years she wrote innumerable letters begging Whistler to send back her picture; but still it remained in the studio being cared for. He showed me the last letter he received, a charmingly sympathetic note, in which the lady said, "I can live no longer without my beautiful picture, and I am sending to have it taken away."—"Isn't it appalling?" he cried. "And she is presumably a woman of the world and of great habits!" I saw nothing appalling about it; but I murmured, "Extraordinary," thinking that that would more or less cover the situation. "Just think of it, Menpes!" Whistler continued in an excited voice. "Ten years ago this woman bought my picture for a ridiculously small sum, a mere bagatelle, a few pounds; she has had the privilege of living with this masterpiece for ten whole years; and now she has the presumption to ask for it back again. Pshaw! The thing's unspeakable!"

One owner took a philosophical view of Whistler's behavior. Henry Labouchere had bought the Connie Gilchrist portrait *The Gold Girl* at the Sotheby bankruptcy sale in 1880, and returned it at the artist's request for some alteration. "That is ten years ago," said Labby. "He is still not

sufficiently satisfied with it to return my picture and I don't expect ever to see it again." Eventually it was returned, but while in Whistler's hands it was never exhibited. The artist was sincerely dissatisfied with it.

It was a result of the Goupil exhibition of 1892 that Sir William Eden wrote to the Galleries to ask how much Mr Whistler would charge to paint a head of his attractive wife. A fox-hunting squire and certified English eccentric, he loved both money and art, and although he also loved Lady Eden, he hesitated from commissioning what might be a far more expensive full-length portrait. "If one could have that little head of hers," he inquired, "painted upon a background of pale gold. . . ." The answer was disappointing.

> Thank you for your letter about Mr Whistler's charges for a portrait of Lady Eden.
>
> I fully recognise and appreciate Mr Whistler's merits, but I hoped his charge for a head only would have been much less than £525. I cannot therefore at that price think of it. . . . If you would kindly send me Mr Whistler's address in Paris *I would try and call on him on my way through.*

Sir William sent an intermediary instead, George Moore, a mutual acquaintance, and Whistler told Moore that he had read his last book, and his recent article, and would be delighted to see him. According to Whistler, Moore came right to the point. "We know quite well your prices," he said, "but as a friendliness, you might set aside your usual considerations and just do a bit of a pastel or watercolor, the slightest little thing, for just nothing at all—say from a hundred to a hundred and fifty pounds. It is for a friend of mine, on the one hand; and on the other you will have to paint a very lovely and very elegant woman, whose portrait you will be delighted to undertake. Under the circumstances, I think you might make very liberal concessions." Eden followed up Moore's approach, and on January 6, 1894 Whistler responded warmly.

> . . . It is quite understood as to the little sketch, and I think there will be no difficulty about the sum. The only really important point is that I should be able to produce the charming picture, and, with the aid of Lady Eden, that is to be expected. Once undertaken, whether it is a sketch or anything else, and however modest its pretensions might be, for me one work is important as another. . . . As for the amount, that which you

have in mind will suffice. I think Moore spoke of 100 or 150 pounds.

When Whistler later compiled the materials relating to the controversy into a book, he subtly altered a number of lines in various documents, to put his case in a more favorable light. Here he altered the "100 or 150" to "100 to 150"—and it would make a difference, for hardly more than a month later, when the picture was all but finished, Eden turned up at the studio in Paris. There Whistler was working on a small oil, about twelve inches by eight, in which Lady Eden was shown at full length seated in the corner of a sofa in a golden brown dress against a brown background. He could not have been surprised at the size or the medium, for he had accompanied his wife regularly, sitting at the other end of the sofa and watching the little panel take shape. But on February 14—Valentine's Day—he came alone, took the painter by the lapel of his coat and thrust an envelope into his pocket, "in a burst of English heartiness" (according to Whistler) saying, "There is your Valentine! Don't open it until you get home!"

With the check was a letter:

> Dear Mr Whistler—Herewith your valentine—cheque value one hundred guineas. The picture will always be of inestimable value to me, and will be handed down as an heirloom as long as heirlooms last! . . .

Whistler opened the envelope as soon as his client had gone, and was astonished. The Master had been paid little more than the minimum, and in a fashion seemingly calculated to have him expect the maximum. He did not yet know how annoyed he should feel, and answered in a note straddling the extremes:

> My Dear Sir William—I have your valentine. You really are magnificent!—and have scored all round.
> I can only hope that the little picture will prove even slightly worthy of all of us, and I rely on Lady Eden's amiable promise to let me add the few last touches we know of. She has been so courageous and kind all along in doing her part. . . .

The baronet understood, and before leaving on a shooting trip to India, decided to have it out with Whistler:

Eden: "I have received a letter that I do not understand."

Whistler: "Like many others."

Eden: "A very rude letter."

Whistler: "Impossible—I never write them."

Eden: "But I don't understand."

Whistler: "There are those who pass their lives in not understanding my letters."

Eden: "You have written this: *'My dear Sir William, I have your valuation'*—"

Whistler: "*Valentine,* you mean—*valuation,* ha! ha! is your accident!—You send me your valentine; I send you my graceful acknowledgment."

Eden: "But you say: *'You really are magnificent'*—"

Whistler: "Well, are you not?"

Eden: " *'And you have scored all round'*—I had no desire to score."

Whistler: "But as a sportsman, my dear Sir William, that's your luck!"

Eden: "You seem to wish to insinuate, sir, that I have been mean in my dealing with you. If you tear up that cheque I will give you this one for one hundred and fifty guineas."

Whistler: "Put up your papers, my dear man, I can't be wearied with more business details. The time has gone by."

Eden: "Well, I know that the picture is a beautiful one, and that I am lucky in having it. But *a man is a d——d fool who pays a larger price for anything he can get for a smaller one.*"

Whistler: ! !

Lady Eden, apparently knowing nothing of any quarrel, but only of Whistler's desire to add "the few last touches," remained in Paris and, having heard nothing, wrote to him on March 30, "When shall I come for my last sitting? Any day after Monday will suit me." But there was no sitting, and no delivery. Instead, Whistler exhibited the picture at the 1894 Champ de Mars as *Brown and Gold. Portrait of Lady E. . . .* When he fetched it away, he reinstalled it in his studio. There it remained until November, when Eden, back from India, had his solicitors instruct Whistler, in a letter to 110 Rue du Bac, "to give up to the claimant, within twenty-four hours, the portrait of his wife, Lady Eden, ordered by him, and paid for at a price of £105; as can be proved; and the claimant declares that, in default of such immediate delivery, he shall take such proceedings as may be necessary."

Acting through his solicitor in London, and the French advocate Maître Ratier, Whistler sent Eden a check for £105 and considered himself relieved of obligation although Eden refused the check. Lady Eden had posed some seven or eight times over a month, and Sir William had ordered the picture and paid for it by a check which had been cashed, but Whistler ignored the inferences and the summons. By then Trixie was ill, and Whistler distraught—and Eden had taken his charges to the Civil Tribunal of the Seine.

The case quickly became a cause on both sides of the Channel. The *Pall Mall Gazette* published almost daily letters on the subject, including an anonymous one (from Joseph Pennell) proposing a defense fund for Whistler. Only two contributions were received, however, for a total of eight guineas, an omen reminiscent of the even less successful subscription after the Ruskin trial. But since controversy sold newspapers, the *Gazette* fueled it further by publishing an authoritative defense of Eden, then editorializing in behalf of Whistler.

> "Q.C.," who to-day takes up the cudgels for Sir William Eden in the now famous case of Eden *v.* Whistler, falls into the error from which the purely legal mind seems unable to extricate itself. . . . He can see no difference between the artist and the cobbler. The artist undertakes to deliver you a picture and the cobbler undertakes to supply you with a pair of boots—both for a specified sum—and there is an end of it. But that is only the beginning of it. A man who goes into a bootmaker's shop knows exactly what he wants and what he is likely to get. The bootmaker knows what he is expected to supply and what it will cost him to supply it. But a picture in the hands of an artist may develop into a priceless masterpiece, or it may be virtually worthless. Therein lies the difference. . . . If "Q.C." cannot see that, then the dusty purlieus of the law must have dulled his natural intelligence.

Whistler claimed a perverse agreement with the lawyer's reasoning:

> —I find no objection to "Q.C.'s" theory, that the law for painters and cobblers should be the same. He may be quite right, only he doesn't get far enough and misses the point!
>
> If a pair of slightest slippers be ordered, through wheedling of friend, on the understanding that they shall cost from half a

sovereign to fifteen shillings, it is the *cobbler only who shall determine* when, in his own folly, and under the approving eye of the appreciative customer, the flimsy slippers have grown into elaborately dandy boots, and are off the last, whether half a sovereign or fifteen shillings, or, according to his sense of their beauty, any sum between shall pay for them.

And if, before his natural gentleness has allowed him to make out his bill, the very smart customer cuts the ground from under him, and, in the sly form of affectionate "Valentine," forces the meaner sum upon him, hoping to make the situation of a delicacy beyond his tackling, he has every right, as noble cobbler, to be indignant, and send his pitiful client about his business!

. . . *"Pourquoi, Monsieur"*—I was prepared for the question —*"pourquoi, si vous n'aviez pas l'intention de livrer le tableau, aviez vous accepté le chèque?"*

"Pour qu'il vienne me le réclamer ici—devant tout Paris!"

Now, this is what has happened. His story is told!—and the whine of it remains in the ears, and the odour of it in the nostrils, of my confreres—and I doubt if the insinuating amateur, [will] again unhook in a hurry any picture, humbly cozened for as sketch, from easel in any studio at home or abroad.—Yours, &c.,

To Mallarmé the Master boasted of a "plan of battle" that had "become a masterpiece." Gleefully, Whistler had prepared a surprise. "Under no circumstances must one find out the condition of the painting! . . . No one must see the painting until the last moment of the trial so that we may have our grand finale!!" The day before the trial was to begin, late in March, 1895, he informed the prosecutor that he had painted out Lady Eden's head and substituted that of another sitter. As the *Westminster Gazette* had commented, "Mr Whistler has really surpassed himself in the gentle art of making enemies."

Eden's attorneys pointed out in court that "the plaintiff, on examining the picture, formally recognised it as his property, identifying it not only by the tonality of the face, but also by all the accessories, the furniture, the hangings, even the dress worn by Lady Eden when she sat. . . ." The Tribunal was unimpressed by Beurdeley's arguments for Whistler, which included the flagrant untruth that "He went on with his picture, it is true, but without the help he had originally hoped for from the sitter." Whistler was ordered to hand over the portrait, to refund the hundred

guineas, and pay damages of a thousand francs (£40). As the London *Times* viewed the verdict, "the Court showed that every artist, however eminent, must respect his engagements."

Despite—or perhaps because of—his trials with Trixie, Whistler fought back through his attorneys and through the newspapers. He vowed resistance, and predicted redress in a higher court. Meanwhile his behavior became almost insanely vindictive. Everyone who sided—or was seen with—Eden became the enemy of Whistler. George Moore, who had received a letter which exceeded reasonable controversy, replied in kind, and incensed Whistler even more by sending it to the *Pall Mall Gazette,* which published it on March 12, before the original had arrived at the addressee's door in the Rue du Bac.

> Dear Whistler,
> I . . . have no time to consider the senile squalls which you address to the papers and are obliging enough to send me. There is so much else in life to interest one. Yesterday I was touched by the spectacle of an elderly eccentric hopping about on the edge of the pavement; his hat was in the gutter, and his clothes were covered with mud. The pity of the whole thing was that the poor old chap fancied that everyone was admiring him.
>
> <div align="right">Very truly yours,
George Moore</div>
>
> P.S. If a man sent me a cheque for a Ms., and I cashed the cheque, I should consider myself bound to deliver the Ms., and if I declined to deliver the Ms. I should consider that I was acting dishonourably. But, then, everyone has his own code of honour.

Whistler was nearly apoplectic with fury. In a country where bureaucrats and journalists still settled their differences with pistols at fifty paces, he challenged Moore to a duel, and the timid, flabby Moore wisely remained out of sight. After a week of Moore's silence, letters from Whistler's seconds and the challenger himself were published in French newspapers on Sunday, March 24, 1895:

> Paris, 23rd March. To Mr Whistler.—CHER AMI,—In consequence of a letter deemed offensive to you, addressed and published elsewhere by Mr George Moore, you have charged us to demand of him either a formal retraction or reparation by arms.

Mr Moore, having preferred silence to the answer for which we have waited eight days, we consider our mission terminated.— FRANCIS VIELE-GRIFFIN, OCTAVE MIRBEAU.

CHERS AMIS,—I beg to acknowledge the receipt of your letter. I deeply regret that I have placed you *en rapport*, even imperfectly, with Mr George Moore, and you see me quite humbled at having wasted your precious time by the immoral contemplation of this poor personage. . . .
Paris, March 23. J. McNEILL WHISTLER.

Whether it was West Point or some other code which had moved Whistler, his behavior in the matter remained absurd. As Trixie failed, Whistler shifted abodes in search of medical miracles but refused to shift his position regarding a painting the size of a sheet of note paper. Whistler, Eden knew, was dependent upon the indiscretions of his opponent to keep the pot boiling pending an appeal, and he remained silent but for a brief interview in the Paris edition of the New York *Herald*, which was enough to spur Whistler into characterizing Eden as a "Bunko Baronet"—a "thrifty Maecenas, who, through life, surely never gave away anything, [but] now . . . gives away . . . himself!" The letter in the *Pall Mall Gazette* drew an answer from Frederick Eden, a cousin of Sir William, equating the artist (whom he called no gentleman) with a tailor who deliberately cut a hole in his customer's trousers. Whistler called him a "gallant kinsman," and had an excuse for another letter to the press, but Eden remained silent through Whistler's tantrums and then through Whistler's bereavement, the appeal not being heard until December, 1897. Then again the case was heard through counsel.

What he revolts against [declaimed Beurdeley on his behalf] in the name of personal freedom—of the freedom of all artists—of the independence and the sovereignty of art—is the judgment which condemns him to deliver the picture in its present state.

The right of refusal to deliver has always been recognised in jurisprudence. I could quote many precedents, gentlemen, but will restrict myself to one which sums up the respective positions of contracting parties in such cases in a few lines. It is the judgment of the First Chamber of the Court of Appeal in Paris on July 4, 1865, in a suit between Rosa Bonheur and a client who had given her a commission for some pictures she refused to deliver. I will

read the two clauses which define the nature of the contract, and the respective rights of painter and client:

"Seeing that nonexecution of an obligation to execute resolves itself into a question of damages, and that there are no grounds for fixing a certain period for the execution of the contract, with a pecuniary penalty for every day's delay, unless the seller himself agree to such terms;

"And seeing the special nature of the contract, and the formal refusal of Rosa Bonheur to fulfil her obligation, we have only to pronounce upon the question of damages."

The Court was, I think, misled by a special circumstance connected with the suit. I refer to the avowed cause of Mr Whistler's refusal, which he himself has never attempted to disavow. He refused because his self-respect had been wounded by Sir William Eden. He considered in execrable taste the methods of Sir William Eden, who sends him £100 when he might have sent him £150, when at least he might have consulted with him as to the sum between the £100 and the £150 he ought to send him.

As to the picture itself, Mr Whistler thought it excellent, and exhibited it publicly. The critic I have quoted pronounces it "a marvel of arrangement and tone." Mr Whistler himself, in an interview published in the *Figaro*, speaks of it as "the little masterpiece." The term is perfectly correct.

Mr Whistler's refusal, then, to hand over the picture is not due to any defect in the work itself, by which his reputation might suffer, but to the fact that he has a quarrel with Sir William—between man and man—*gentilhomme à gentilhomme*—gentleman and gentleman.

The Court thought this reason a bad one. As for myself, I feel that the Court herein made a mistake.

The artist is not even called upon to give any reason for refusing to fulfil his contract. He is within his rights if he refuses to carry out his undertaking, and elects to take his chance of having to pay damages. This right is absolute, and Mr Whistler simply affirmed his right when he refused to give up the picture.

Whistler called the judgment in the appeal a triumph for the artist. He could keep the picture as long as he made it unrecognizable as a

portrait of Lady Eden, but had to refund—as he was quite willing to do—the amount he had been paid, plus interest. Lady Eden had sat in vain, and the Court's protection of her rights in the painting was poor consolation.

In the French press Whistler became that rare figure, a victorious Don Quixote. Among Parisians he was briefly a hero, which he found "simply amazing!" Caught up in the enthusiasm the ever-loyal Jonathan Sturges exclaimed, "I really believe they love you!" *Love,* however, was not a word used by others once reckoned among the Followers, for while the Eden appeal had been pending, Whistler—still deranged by Trixie's long illness and death—did his unwitting best to divest himself of his old friends. His combativeness curdled into vindictiveness, and his wit into spite, when Eden was in any way involved with an artist in the Whistler orbit. In October 1896, several months after Trixie's death, Sickert turned up by coincidence at the same luncheon party as Sir William, and leaving at about the same time agreed casually to browse with him in a Bond Street gallery before parting. Since Sickert liked to sell his work, and Eden purchased art, it was good business. But Whistler happened by soon afterwards, and one of the gallery officials gossiped to him excitedly, "Who do you think has just left? Sir William Eden. You'll never guess who was with him—Mr Walter Sickert!"

To his younger sister-in-law Whistler wrote, "I will not hide from you that Walter Sickert has been in town for days. He has not presented himself to me, but has been seen parading Bond Street with Sir William Eden and George Moore." Afterwards Sickert did try to reach Whistler, but not finding him in at the Fitzroy Street studio, left his calling card. The sight of it revived the image of Eden with a Follower of the Master, and Whistler sent it back with a note:

> I feel I really *dare* not, Walter!—and doubtless I shall miss you. Benedict Arnold, they say, also was a pleasant desperate fellow, and our old friend of the "30 pieces," irresistible! I fancy you will have done it cheaper though, poor chap!
>
> Yet be careful—Remember!—and take nothing from the Baronet in an envelope!

Then came another incident. Sir William decided to sell part of his collection of modern paintings and drawings at Christie's. Included were paintings and drawings by Sickert, Steer, Conder and Rothenstein. Steer was worried by the effect on their prices if they fetched insignificant sums,

suggesting that they ask Eden to put modest reserve prices on their work. Eden agreed to consider the matter, and Steer and Rothenstein went to Christie's to meet him. While they were talking there with Sir William, Whistler entered, affixed his eyeglass, stared hard, and turned his back.

Soon Whistler felt even more paranoid, for the New English Art Club hung an Eden watercolor in its little gallery. When Whistler walked in one Monday evening and saw the "toad's" picture he blamed the Club's committee, which included Steer, Rothenstein, Sickert and Fred Brown. None of the "criminals" were there when the Master made his entrance, but Whistler thought he observed "stupefaction" among the members present when he complimented them upon their appetite for toad. At lunch the next day, Steer was asked, "How about the toad in the belly?" He was mystified, but quickly understood, for Rothenstein had been so accused in a letter, and wrote to Whistler unhappily that although he had nothing to do with the watercolor painted by the enemy, he was willing to "keep, then, officially, 'the toad in the belly.' "

The "Whistler raid on Chelsea," the perpetrator wrote to Rosalind Birnie Philip in France, "and the mopping up of the pavement with his few fine English friends still lingering on all so loyally!" had been great fun. It was hardly so to the friends, whose loyalty had been taxed too greatly, and who were neither children nor apprentices. The correspondence with Rothenstein became more acrimonious on Whistler's side, and Rothenstein wrote that although he had long admired the neat hand of *"cher maître"* with the foil, "to brandish a scythe, with intent to lop off my legs" in the other hand was too much. "There were limits to the price one should pay for Whistler's friendship," he later wrote, "I felt that [further] explanation would be useless and undignified. I never saw Whistler again."

But he did, for Whistler's litigiousness as the Eden appeal pended seemed insatiable, and he induced Joseph Pennell, who called his drawings made on transfer paper rather than worked directly onto the stone, lithographs and was attacked for it by the *Saturday Review* by Sickert, to sue their old friend for libel. Among Sickert's witnesses were William Rothenstein and—ironically—George Moore, who in the witness box proved he knew so little about lithography that he finally floundered about helplessly and stammered, "But I have known Degas." To Deborah, Whistler described Moore's intrusion as "monstrous," and an attempt "to mislead public opinion—so that it should be supposed that the whole affair was only the sequel to the Eden trial. . . ." On the stand

himself, Whistler, addressing the judge, asked, "May I be permitted to explain, my lord, to these gentlemen [of the jury] why we are all here?" "Certainly not," said Justice Matthew, exasperated by the case, "we do not want to hear about that; we are all here because we cannot help it." In cross-examination Sickert confessed to malice, but after the trial—which he then lost—transferred the malice with reason to Whistler.

Radiant with having won his adopted case, Whistler dined afterward with Rothenstein (whose affront he forgave), Helleu and Sturges; and returning homeward Jonathan Sturges bubbled over with his enthusiasm for the Master. "You never get to the end of his knowledge," he said. "Why, Jimmy never let on to me that he was a classical scholar; yet there he is, he knows everything; did you notice during dinner, he said *'hinc illae lachrymae'*? Amazing! Amazing!"

After the second Eden verdict, Whistler professed such delight with the decision that in a letter to Deborah he somewhat irrationally likened Eden's fate to that of the Biblical tyrant Haman, and set about making "a beautiful little book" of the case, spending months designing a companion work to *The Gentle Art* for William Heinemann, reminding him all the while, "Remember that as my publisher you must have *nothing to do* with the enemy," and that like foes of an earlier day, George Moore had "ceased to exist." But even the loyal Heinemann was soon scourged. To promote the book in advance of publication he released the Whistler-written front matter of the book to the New York *Critic*, and quotations from its story reappeared in London newspapers in October, 1898, complete to Whistler's declaration that because of the verdict a "new law is added to the Code Napoleon!" A month later Heinemann was shocked by a letter from his friend and author:

> My dear Publisher,—How am I to harden my heart and approach you with a proposal of—let us say momentary—divorce!
>
> Certainly neither of us would have supposed it possible that further developments of "The Gentle Art" could have brought complications suggesting even our separation! But what is to be done?
>
> This American impatience, and the smart method of announcement that distributes *pages of an unfinished book* to the newspapers—"of which there is no end"—has destroyed for the time the pleasure I looked forward to in presenting, with you, the pretty story of "The Baronet and the Butterfly" to my London people!

I must really change the *venue*—what do you think?

Your first feeling in this matter was so entirely with me, that I will at once abuse your sympathy, and frankly ask you to transfer your *camaraderie,* and the glory of aide-de-camp, to a Frenchman—whom I shall choose!

There is no mere easy ingratitude, on my part, as a friend! *
Of far greater magnitude is the villainy—I will not stop to dilate upon it. Suffice it to say that Napoleon and I do these things—*and France shall have the baronet first!* Indeed, the refusal should be hers—who has already presided at his *"toilette."*

<div align="right">J. McNEILL WHISTLER</div>

Courage, mon ami! a un de ces jours!
Paris, Nov. 29, 1898.

Eden versus Whistler. The Baronet and the Butterfly. A Valentine with a Verdict was published instead by Louis Henry May in Paris in April 1899. But in it the foil had become a scythe, although Whistler was unaware of the difference, writing to Charles Freer to ask him whether he thought it was "worthy of West Point." It had none of the appeal of the earlier book, confined as it was to several cantankerous letters in the press, two long speeches of the advocates in superior English translations, and Whistler's marginal comments and butterfly embellishments. The real aim may have been encapsulated in the book's motto—*"Noblesse Abuse!"* But Whistler read into the verdict the "prestige" of the work of art and the "privilege" of the artists:

> *Established: The ABSOLUTE RIGHT of the Artist to control the destiny of his handiwork—and, at all times, and in all circumstances, to refuse its delivery into unseemly and ridiculous keeping—*

> *The DIVINE RIGHT of the Artist to pay damages, and so rid himself cleanly of the carelessly incurred, and pertinaciously unbecoming company of this hereintofore completely discovered, penetrating—persevering—planning—devising—Valentine design-ing—pestilential, and entirely matagrabolising personage!—*

* The withdrawal of the book, strangely, did not affect the Whistler-Heinemann friendship, which persisted to the end of Whistler's life. In the end, not publishing the book saved Heinemann money.

Perhaps it was at least as much the triumph of spite. There was no Trixie at the time to soften the wrath of wounded pride. During the first trial she was dying. By the second she was dead.

XXXV

Alone

"**W**HAT is to become of me?" Whistler asked in a letter to his sister after the Eden case. The elation over the verdict was more public than private. He was nearly alone. In the weeks after Trixie's death he remained at Heath End, Hampstead, and brooded, while letters of condolence arrived. One came·from art dealer Frederick Keppel, who also sent Joseph Pennell and Ernest Brown a curious pamphlet he had received, a *Guide to the Study of Whistler* published the year before by the State Library of New York. Although primarily a bibliography of writings about the Master occasioned by his American background and newly established reputation, its biographical data was less than flattering, calling attention to Whistler's delight "in keeping up the mystery of his nativity," his academic and other deficiencies at West Point and his rejections by the Salon and the Academy, and ending with the comment that he had "now . . . deserted England as he did America, and spends most of his time in Paris, where he receives more attention and where his works are more favorably criticized." What followed were quotations from the press, many of them hostile and not a few inaccurate, among them the reference to him as "a harum scarum genius; keeps none of his works; makes no records; gives

no help to anyone who wants to help him . . ." and another which commented that his etchings "attract a good deal of attention, and differ from his paintings in meriting it. . . ."

Whistler was forwarded Brown's copy and in outrage wrote to the American institution "upon whose shelves is allowed to be officially catalogued this grotesque slander of a distinguished and absent countryman." Then, on black-bordered mourning stationery, he wrote to Keppel on June 7, 1896 to protest against "the circulation of one of the most malignant innuendoes in the way of scurrilous half-assertions, it has been my fate hitherto to meet. . . . Had you sent to *me direct,* and to *me alone,* the libellous little book, it would have been my pleasant duty to have thanked you for the kind courtesy—and to have recognised, in the warning given, the right impulse of an honorable man."

Keppel reacted by writing satiric verses on Whistler, which he had printed privately, in which he described him as a "Great artist—as self-advertiser" who blew his "tireless trumpet" and beset the public with his "flippant brag":

> . . . You pounce on all men, rend them, shake them;
> You give hard knocks—and you must take them!

Whistler was furious, and told friends that he would kill Keppel if he could. But he had too much to do in settling the problems created by his becoming a widower to worry overmuch about Keppel. How would his affairs be managed? And, looking ahead to his own demise, who would be his heir? To bring his illegitimate son back into the picture was out of the question, and he soon made Trixie's younger sister, Rosalind Birnie Philip, his ward, drawing up a new will which appointed her his heiress and executrix.

Briefly Miss Philip and Mrs Whibley remained with him in Hampstead; then in the autumn of 1896 he asked his new ward and her mother to reopen the Rue du Bac and maintain it for him. But he went instead to William Heinemann's flat in Whitehall Court, where he remained for much of the next two years, and only when the publisher was gone on business did he move temporarily elsewhere, going to Garlant's Hotel, or on drawing expeditions, or across the Channel to the Rue du Bac.

The much younger Heinemann was good medicine for Whistler. His fashionable flat overlooked the Embankment; his dinner parties over-

flowed with celebrities, gossip and good wine; his walls were soon hung with Whistlers, from the *Mère Gerard* * to the newest lithographs. To visitors Whistler would joke about "my guest Heinemann." A summer sketching journey soon after the depression following Trixie's death had worn off had taken him unproductively to Rochester and Canterbury with Mrs Whibley and Miss Philip. Then he and Joseph Pennell crossed to Havre and Honfleur, with Whistler seeking the big kitchen fires in the hotels, flattering each *Madame* in order to get closer to the warmth, while never removing his overcoat. Pennell thought it was funny, but Whistler was showing signs of circulatory failure, and was truly cold. He was happier back in London at Heinemann's.

At Whitehall Court dinners Arthur Symons saw a Whistler now ravaged by age, in his sixty-third year but looking much older. Whistler tried to make up for it in the illusion of activity:

> I never saw any one so feverishly alive as this little, old man, with his bright, withered cheeks, over which the skin was drawn tightly, his darting eyes, under their prickly bushes of eyebrow, his fantastically-creased black and white curls of hair, his bitter and subtle mouth, and, above all, his exquisite hands, never at rest. He had the most sensitive fingers I have ever seen, long, thin, bony, wrinkled, every finger alive to the tips, like the fingers of a mesmerist. He was proud of his hands, and they were never out of sight; they travelled to his moustache, crawled over the table, grimaced in little gestures. If ever a painter had painter's hands it was Whistler. And his voice, with its strange accent, part American, part deliberately French, part turned to the key of his wit, was not less personal or significant. There was scarcely a mannerism which he did not at one time or another adopt, always at least half in caricature of itself. He had a whole language of pauses, in the middle of a word or of a sentence, with all sorts of whimsical quotation-marks, setting a mocking emphasis on solemn follies. He had cultivated a manner of filling up gaps which did not exist; "and so forth and so on," thrown in purely for effect, and to prepare for what was coming. A laugh, deliberately artificial, came when it was wanted; it was meant to annoy, and annoyed, but needlessly.

* Once owned by Swinburne.

One Heinemann guest was not only not annoyed, but accepted an invitation in the autumn of 1896 to stay at Whitehall Court with Whistler while the publisher spent some weeks away. He was Henry Savage Landor, an artist and son of the poet, Walter Savage Landor. He had met Whistler and Trixie in Paris, and was then back from a trip to Japan and Korea. That Landor had seen the East, which had so affected Whistler's own early work, tantalized Whistler; but it was not Landor who did the talking when they were alone. The first night they had dinner together in Heinemann's absence; at eleven they were still sitting at the table as Whistler talked about his pictures and his controversies, amused that Landor had never heard of most of the bitter enemies who had made the Master's career a nearly endless quarrel.

> To me it always seemed a pity that a great man like Whistler should stoop to argue and discuss with any fourth-rate painter, or any ignorant art critic, or journalist who did not think as he did. He always had his pockets full of newspaper cuttings, many from disreputable halfpenny sheets, and with them invariably the caustic answers he had written. I told him on several occasions that in my opinion he attached much too much importance to what people said or wrote. . . . He did not seem to agree. Decidedly, my way of thinking would have deprived him of his greatest joy in life, quarrelling. Discussion was a real delight to him, because he always came out of it on top. His lightning rapidity of wit was almost incredible. He had a lash of the whip ready whenever anybody said anything. Once or twice I had previously dined with Whistler at Heinemann's flat, when the latter had asked friends to meet the great genius. They all arrived enthusiastic at so great an honour, and invariably departed detesting Whistler, for in conversation he never spared anyone so long as he could say something brilliant.

After leaving the table they adjourned to the drawing room, where Landor, drawn to a skull and a lamp on the Florentine grand piano, induced Whistler to try to capture the effect.

> Whistler enthusiastically agreed, produced from his pocket a large-sized visiting-card, on which, with a finely sharpened pencil, he began to draw that still-life. Whistler knew nothing of anatomy, which he confessed he had never studied. With pencil

and india-rubber he drew and re-drew and rubbed out a hundred times what he had drawn. A child could have drawn that skull more faithfully than Whistler did that evening. I was amazed. Was it really the great Whistler I saw drawing so infamously? He tore visiting-card after visiting-card on which he had worked, when the india-rubber had rendered the cardboard rebellious to pencil marks.

After over an hour of futile attempts, I asked Whistler's permission to let me have a try. He lent me his pencil and a clean card. In a few minutes I had drawn the skull with its shadows and its delicate tones around the base of the cranium and the eye-cavities and the zygomatic arch. Whistler, who had been busy lighting a cigarette, seized both my hands when I showed him the rapid sketch.

"Good God!" he exclaimed in rapture. "It is simply wonderful. . . . How on earth did you manage to get it so quickly and so correctly? It is beautiful—it is simply wonderful!" he repeated. "I am going to keep it. If I could only draw like that I would be a great painter. Did you see how difficult it is for me to draw?"

In so saying he produced a letter-case in which he kept papers precious to him and some of his own drawings. He shoved in my drawing, and with great care replaced the case in his pocket. It took Whistler several days to recover from the shock of my swiftness in drawing. From that moment he treated me with respect that almost amounted to reverence. While in conversation he barked at and bit everybody, he ever spoke tenderly, almost with fatherly affection, to me.

After that they were friends, and Whistler took Landor to Fitzroy Street to see the studio. The younger man was pressed for his opinions of the dozens of canvases—finished, unfinished, or barely begun. Obviously some of the "finished" ones were still there because Whistler felt that they were failures, and Landor was reluctant, but finally candid.

I told Whistler where I thought some of his unfinished figures were defective. He recognized that what I said was right, and set to work at once with his palette and brushes to make the suggested alterations. And here came the most remarkable thing in Whistler's work, which astonished me more than I can tell.

No man on earth has ever succeeded in getting more magnificent final results on a canvas than Whistler, but few realized that no man ever had so much difficulty in obtaining such superb results than Whistler. He gradually got to absolute perfection in his pictures after an immense amount of tentative labour, doing and undoing until every part of the picture was exactly as he wished. He knew quite well when things were wrong and had the strength of character to persevere until he had obtained the result he wanted. That is why, when he felt that his vision could not distinguish any more how defects could be remedied, he placed the pictures face to the wall for months before he would work on them again.

Landor became a regular observer in Fitzroy Street; sharer of Whistler's table at the Café Royal, where the Master would summon the chef to receive complex instructions for his special French dishes, while his companion would order a beefsteak; visitor with Whistler at the Pennells' home in Buckingham Street, where they talked about other painters. Whistler would not hang their work on his walls, but he was always intensely curious about what they were doing. A number of them, members of the Chelsea Arts Club with John Lavery as their spokesman, even invited Whistler to be their guest at a Café Royal dinner, and Whistler agreed, although insisting that Landor be asked as well. The afternoon prior to the event Whistler, prepared for adulation, rehearsed to Landor "a graceful and extraordinarily witty speech" in which there were the expected sarcastic attacks upon his enemies. But the hosts were so kind, lionized him so warmly, and applauded him with such sincere enthusiasm that Whistler was too deeply touched to go through with an artificial performance. His voice was as unsteady as his knees as he rose to acknowledge Lavery's introduction, and his remarks were out of character although greeted with great applause. It took him some time to recover, and his eyes were wet with tears.

With William Heinemann away, he saw much of Heinemann's brother Edmund, a stockbroker, who sat—in Whistler's description—"in a tangled web of telegraphs and telephones" and invested some of Whistler's money for him. Suddenly he had more than he needed, although he had several establishments—none of which he then lived in—to maintain. He ate little, and most of that at Whitehall Court or at Buckingham Street with the Pennells, the only place for which he did not

dress for dinner, sometimes not even warning of his coming, although he might arrive with an unsent wire in his pocket, or ahead of Heinemann's servant, Payne, whom he had instructed to announce him, or Constant, his own valet, model, and cook. Because he grumbled over Sunday supper served cold in English fashion, he would sometimes have Constant come to the Pennells to make onion soup or an omelette for him, since with Trixie gone his need for company was too urgent for him to want to eat alone, or drink alone. Although he would still mix a cocktail, he had his servant prepare the coffee, a pleasure soon ended when Whistler's doctor ordered him to give up both coffee and cigarettes, great sacrifices during the long days he would spend in Fitzroy Street, often until it was too dark to see.

Whistler's first appearance in public since his wife's death proved to be his last encounter with his brother-in-law. Haden, who had been knighted in 1894, was seventy-eight, and had retired from his medical practice nine years before to write a monograph on Rembrandt as an etcher. Long estranged, both were largely honorific vice-presidents of the Society of Illustrators, and Haden, who had been living at Woodcote Manor in Hampshire, a Tudor House in which William Rothenstein "had never seen such shining floors, such polished panelling and furniture, bright brass handles and sparkling silver," was not expected to attend the Society's dinner at the Holborn. But he came, a large and impressive figure, although to Whistler merely "the apothecary of Hants," and was placed at the high table to the right of the President, Sir James Linton. Then Whistler arrived. There was consternation. Over the years Whistler had been seeing and corresponding with Lady Haden, but had not been face-to-face with Sir Seymour since he had knocked him through a plate-glass window in Paris thirty years before. Quickly a small table was set up in the middle of the room with Whistler at its head, his back to Haden. Dinner was announced without any difficulty having arisen. Sitting down, Whistler produced, as usual, two or three monocles from his pocket to have them at the ready, but even that gesture, his signature, went unnoticed at the head table. Then the soup was served. Someone said something to Whistler, who reacted with a characteristic, high-pitched "Ha! ha!" Haden looked toward the laugh, dropped his spoon in his bowl, and left, as another "Ha! ha!" rang out. But even then Whistler had no idea of the disturbance he had caused,* only later, in

* The Pennells' biography asserts that Whistler recognized Haden and teased him into fleeing; their later *Journal* contradicts this.

Heinemann's rooms, raising a glass to his unintended expulsion of an unforgotten foe.

That winter Joseph Pennell urged Whistler farther out of his shell by having him join publisher T. Fisher Unwin and his wife, and the Pennells, on a Christmas trip to Dorsetshire, where one cold, cheerless afternoon they stopped at a small inn at Poole, near Bournemouth. The landlady watched Whistler sip his hot whisky-and-water, convinced by his manner that he was an important personage but unable to place him. "And who do you suppose I am?" he asked her when he understood her stare. "I can't exactly say, sir," she confessed, "but I should fancy you was from the 'Alls!" Nearby, at Boscombe, they knew, was Aubrey Beardsley, ravaged by tuberculosis and slowly dying, but Whistler shrank from the sight of more suffering. The Pennells went to Boscombe without him.

At Christmas dinner he kept the subject off Beardsley, lamenting instead over his poorly done turkey, "To think of my beautiful room in the Rue du Bac, and the rest of them there, eating their Christmas dinner, having up my wonderful old Pouilly from my cellar."

Still he did not return to Paris, but rather to Fitzroy Street, where he worked through the winter, while his neighbor, the watercolorist Charles Edward Holloway, whose seascapes Whistler admired, prepared for a Goupil exhibition in March in his large Fitzroy Street front-room studio. When he became seriously ill, and retired to his back room, Whistler, reversing his attitude at Poole, stayed with the bushy-bearded Holloway, keeping him busy by posing him for a portrait. As Tom Way recalled, the rooms were "most depressing, almost bare of furniture, and [Holloway] almost without means for the necessaries of life. . . ." Going there evenings to inquire after him, Way learned that Whistler was spending his afternoons with the dying artist, painting a small full-length he had already entitled, to the pleasure of the subject, *The Philosopher*, Holloway marveling "at the skill with which the whole of the little figure would be painted from head to foot at each sitting," and declaring to his friend, "Mr Whistler, you are a magician." The most magical part of the procedure was that Holloway was bedridden, and Whistler had painted him full-length, standing before his fireplace.

Holloway's daughter came in daily to care for him, but when the doctor decided that the case was beyond her nursing, Whistler and some other friends arranged for Holloway's transfer to a hospital in Fitzroy Square. His exhibition opened soon after, and Whistler lent the portrait.

"Oh, for one long day's painting," Holloway sighed to Way at the hospital. He died on March 5, 1897.

In the Fitzroy Street studio that winter Whistler had few visitors. He was still not ready for them. But there was one he did permit, an American then living at 23 Tedworth Square, Chelsea, whom almost no one knew as Samuel L. Clemens. "I was determined to get the better of him, if possible," Mark Twain recalled. He put on his "most hopelessly stupid air," and drew close to a canvas on which Whistler was working. "That ain't bad," he said. "It ain't bad; only here in this corner"—and he pointed to an area of the picture with his finger—"I'd do away with that cloud if I were you."

"Gad, sir," Whistler cried out, "be careful there. Don't you see the paint isn't dry?"

"Oh, that don't matter," said Twain. "I've got my gloves on." And after that they got along well together.

Another American in London managed to keep on better-than-quarrelsome terms with Whistler; but it would have been difficult in any case to be belligerent toward Henry James, whose manner defeated hostility. Seeking a way to return a favor, James sent Whistler his newest novel, apparently *The Spoils of Poynton*, and Whistler answered with lavish appreciation. Eager for good words about the book, James—who had turned to dictating everything, including his correspondence, to a typist—responded with initial apologies for his typewritten thanks, which were indelicate, he knew, but were at least over his own "hand and seal." Since the arts were inseparable, he thought, the good words from a fellow artist came to him "as from one who knows," and "To have pleased you, to have touched you, to have given you something of the impression of the decent little thing one attempted to do—this is for me, my dear Whistler, a rare and peculiar pleasure. . . . You have done too much of the exquisite not to have earned more despair than anything else; but don't doubt that something vibrates back when that Exquisite takes the form of recognition of a not utterly indelicate brother. . . ." And James signed it with a reference to "my dear Master," a term that would soon be used by others in reference to James himself.

In April, after the Pennell-Sickert libel trial was over, Whistler finally went to Paris, returning the next month. He had been working on several pictures for the Salon, but the time he had spent with the dying Holloway, and on Pennell's libel suit, left him with no finished new canvas, but for the portrait of Holloway on display at Goupil's as an act of

posthumous friendship. With no work on view, he lost interest in Paris and returned to London in a month. It was the summer of Victoria's Diamond Jubilee, and Whistler was living at Garlant's Hotel in Suffolk Street, near the home of the British Artists. A short walk away was poster-bedecked Trafalgar Square, buried high up the Nelson column in platforms and seats for official celebrations. Amused by the vulgarity of "the Island and the Islander" in its self-celebration, Whistler sketched the mountain of boards and placards, titling it

Trafalgar Square: the finest $\frac{site}{sight}$ in Europe!

"Admiral Nelson: 'Boarded at last.' " "England expects every man to be ridiculous."

On June 18, 1897 the drawing appeared in the *Daily Chronicle*, evidence after a year that Whistler's sense of humor was returning. There was further evidence of his return from hibernation: he accompanied Mr and Mrs George Vanderbilt—both of whom he was painting—on their yacht to the Royal Naval Review at Cowes. There he turned out twelve etchings of the Jubilee Review in a single day, and even began a painting on board, but kept altering it until it was completely unsatisfactory. It was obvious that he was restless, and the Pennells suggested that he cross the Channel with them as far as Dieppe, from whence they planned a bicycling tour. Whistler agreed. The next morning, the Pennells recalled, everyone but Whistler was on time for the boat train to Newhaven. "Even his baggage came, but not until we were reduced almost to nervous collapse, not till the train was starting, did he saunter unmoved—his straw hat over his eyes—down the platform, followed humbly by the pompous station-master and amazed porters, looking for our carriage."

Once in Dieppe, Whistler got out his box of watercolors and headed for a familiar shop-front; but first he had to find another kind of shop, where he could buy a replacement rosette of the Legion of Honor, for he had forgotten to wear his, and decided that it would be lacking in respect to appear in France without it. The shopkeeper to whom he explained his need was sceptical, saying, "All right, *monsieur*, here is the rosette, but I have heard that story before." Whistler suppressed his fury.

In Dieppe were two former adversaries. Beardsley, wasted and dying, was there, having seen England for the last time. They passed his window without realizing it, and he saw them. Afterwards the Pennells called on

Beardsley without Whistler. He had put aside his dread of the death-bed in the case of Holloway, but Beardsley was young, much younger even than Trixie. The other opponent would also never see England again—Oscar Wilde, out of Reading Gaol and beginning his foreshortened exile. Wilde saw him go by, but Whistler was unseeing. The next day Whistler had had enough of Dieppe, and returned across the Channel.

In London there was yet another score to settle, one of the sadder legacies of Whistler's combativeness. One Sunday afternoon he had called at the home of young Tom Way, where to his surprise he saw on the walls a Cremorne Gardens picture and an unfinished study of a nude Venus. "He forthwith thanked me for taking so much care of these works," Way later wrote, "but stated that the time had come for him to resume possession. I was amazed and said I thought there was a mistake, that my father had given them to me many years before. I knew their history, that they had come with the other [unauctionable] canvases, mostly portraits, which my father had bought after the bankruptcy, and moreover, I knew that he had offered to give these portraits back to Whistler as he did not think, for the sake of the sitters, they ought to be hawked about on sale. But the offer did not refer to other sorts of paintings."

Whistler insisted that the misunderstanding be cleared up, particularly, Way thought, because he wanted to retrieve the Cremorne canvas. He had forgotten that he had seen it, with many others that old Way held, after Venice, remarking that he "never expected to set eyes upon these old ghosts again." Most Whistler had deliberately defaced, and some unfinished ones Way felt were useful only as primed canvases to be painted upon. But they had been forgotten. Now, seventeen years later, Whistler went to Webb, his solicitor, to get advice on how to recover them, and also to have his eighteen-year-old lithographic account with the Ways settled, intending to sever that business relationship.

Webb heard the Ways' story and their offer of the return of the mutilated portrait canvases, and told Whistler, "I think you had better accept Mr Way's offer of these whilst it is still open." Tom Way understood that this was going to be unsatisfactory and asked Whistler "upon what principle he claimed the *Cremorne* and whether he also claimed the *Three Girls* and the other pictures, watercolours and pastels which my father had bought from him. . . ."

"Well," Whistler said, "your father gave me so much for them; it can be put on the bill."

Way was sure that Whistler had American customers in mind for them at his new prices, and refused to give up what he considered his legitimate property. That he was probably correct could be seen in the effusive letters from such clients as Freer, who had written Whistler from Detroit on July 18, in sending him a draft in partial payment for the nocturne *Southampton*, "I say partial payment because money cannot do more in connection with such a great work of art. I do hope you know how deeply grateful I am to you for entrusting to my care this wonderful interpretation of the true beauty and mystery of night." He had caught Whistler's philosophy perfectly: the purchaser was only entrusted with the care of the work of art. Old Way—as far as the Master was concerned—misunderstood. Hurt by Whistler's brushing aside the years of loyalty and the conventional legalities, he refused to settle personally with Whistler's lawyers, and sent his own, without withdrawing his decade-old offer. On August 10, 1897 Whistler's lithographic stones as well as the portrait canvases were handed over to a representative from Messrs Webb, after which Whistler wrote an unnecessary, bitter letter to old Way, who had long been one of his staunchest friends. If it were intended to make the break complete, it succeeded. Fifteen years later, Tom Way sold the *Cremorne Gardens* to the Metropolitan Museum in New York. One way or another, it had got to America.

In the autumn, before he returned to Paris for the hearing of the appeal against the Eden verdict, Whistler received a letter from Naples, addressed to him at "The Academy, London." Someone at the post office added "Burlington House" to expedite its handling, but although the address was correct for the Academy, it was as wrong as could be for Whistler, and a functionary returned it to the mails, endorsed, "Not known at the R.A." Eventually it reached Whistler, who sent the envelope, this time with more amusement than belligerence, to the *Daily Mail*. Under the heading, "Mr Whistler's Character," the newspaper speculated, "One can imagine the packet going over the different departments of the Royal Academy, and each room spurning it with remarks such as 'Whistler—Whistler—never heard of him'; or 'Whistler —that wouldn't be the husband of our charwoman, would it?—no, her name is Whisker'." Whistler had sent a note with the envelope, which the *Daily Mail* printed on October 12, 1897:

To the Editor of the Daily Mail.

Sir,—In these days of doubtful frequentations, it is my rare good fortune to be able to send you an unsolicited, official, and final certificate of character.

It would be as close as he would get to the Royal Academy in his lifetime.

A few days later he was in Paris, telegraphing Mallarmé, "Propose visiting you tomorrow." But he spent most of his time at the Rue du Bac thereafter in bed, his doctor, worried about his heart, prescribing "absolute calm." Heinemann had announced a third edition of *The Gentle Art*, which Whistler had not even begun, but which had prompted Max Beerbohm to write, "Oasis found in the desert of Mr William Heinemann's Autumn List!" Illness postponed, then ended, any plans for it. In the damp, chill Paris autumn he was plagued by colds, and, in bed with influenza after the Eden appeal was over on December 2, he wrote, early in 1898, to Mallarmé, that he had been "exiled from the Rue de Rome since a century ago." In London in the interim, he had been sporadically active. To sell his work himself, he had formed an agency called The Company of the Butterfly, with an office at 2 Hinde Street, Manchester Square. It failed to compete effectively with established dealers, and seldom had its doors open. Still, his reputation was such that when Mrs Watney, widow of the beer baron, bought the Leyland town house, intending to efface and redecorate the Peacock Room, public pressure caused her to change her mind.

In London, although intermittently ill, Whistler enjoyed some of the fruits of his belated fame. He was elected the first President of the International Society of Sculptors, Painters and Gravers, a largely honorific title since he permitted John Lavery, the Vice President, to do most of the work, although he was active in organizing its first two annual exhibitions. Because he traveled across the Channel on his own business at any opportunity, exhibition functionaries had to follow him, painter Anthony Ludovici once finding Whistler in Paris "laid up with an influenza cold, wrapped in flannel, inhaling eucalyptus from a steaming jug." Commuting between Paris and London, he kept the Rue Notre Dame des Champs studio, visiting it with Duret and Mallarmé in June; but most of his work was being done in Fitzroy Street, where he painted portraits of rich American men and poor Cockney girls, and harangued visitors about the brief American war with Spain, then in progress. It was "a wonderful and beautiful war," he said. "The Spanish were gentlemen." There was reciprocity too, he thought, describing to whomever would

listen his version of the aftermath of a sea battle when a Spanish admiral was fished up out of his sinking vessel and brought to the deck of an American warship looking like—like—and Whistler paused to probe for a suitable description—"well, for all the world like a clod of cotton-wool pulled out of an ink bottle, and was received by everyone on board with all the pomp and ceremony due to his position, as if he had just stepped on board to inspect his own ship." * His pockets were full of newspaper clippings about the battles, which he dragged out at London dinner parties and analyzed as "I, a West Point man." It was in London, too, that he received a telegram, on September 14, from Genevieve Mallarmé announcing the death of her father. To her and her mother he wrote, "I weep with you two. . . . I loved him so!" He lived in sadness now, he added, and begged forgiveness that he intervened in their sorrow. He may have even thought that Paris would no longer be a place to which he would want to go, but he would soon be drawn back, for unusual activities would be conducted under his name at 6, Passage Stanislas, just off the Rue Notre Dame des Champs.

* After a naval battle off Santiago, Cuba, on July 3, 1898, seamen on the sinking Spanish flagship, the *Infanta Maria Teresa*, were picked up by American craft, among the survivors Admiral Cervera. According to a [London] *Times* dispatch quoting Admiral Sampson, Cervera, who had been slightly wounded, "was received at the gangway of the *Gloucester* by Lt-Comm Richard Wainwright, who grasped his hand, and said, 'I congratulate you, Sir, on having made as gallant a fight as has ever been witnessed at sea.'"

XXXVI

The Académie Whistler

FOR years Whistler dreamed of his own *atelier*. The White House had even been built, in 1878, with that in mind, but bankruptcy intervened. For a while the corps of Followers around him in the 1880s satisfied the ambition, but the few disciples with whom Whistler had not quarreled had long outgrown the mentor-apprentice relationship when an announcement appeared in Paris of the imminent opening of the *Académie Whistler*. The school, according to the circular, would be managed by Madame Carmen Rossi, a large handsome woman with black hair and dark eyes whom Whistler had first painted as a child and who continued to model for him, the subject, in her maturity, of his *La Napolitaine, Rose et Or*. From Whitehall Court, where he was again staying with Heinemann, Whistler wrote to the newspapers on October 1, 1898:

. . . to correct an erroneous statement, or rather to modify an exaggeration, that an otherwise *bona fide* prospectus is circulating in Paris. An *atelier* is to be opened in the Passage Stanislas, and, in company with my friend, the distinguished sculptor, Mr [Frederick] MacMonnies, I have promised to attend its classes. The *patronne* has issued a document in which this new Arcadia is described as the *Académie Whistler*. . . . I would like it to be

understood that, having hitherto abstained from all plot of instruction, this is no sudden assertion . . . of my own. . . . I purpose only, then, to visit, as harmlessly as may be, in turn with Mr MacMonnies, the new academy which has my best wishes, and, if no other good comes out of it, at least to rigorously carry out my promise of never appearing anywhere else.

To initiate the school, despite his disclaimers, Whistler had advanced Madame Rossi from London two hundred pounds, which she took to the Crédit Lyonnais for deposit, steadfastly refusing, despite the entreaties of the cashier, to endorse the check by any other name than "Carmen." Then she signed a lease and bought herself a new silk gown.

No 6, Passage Stanislas was a two-story house in a small street off the Rue Notre Dame des Champs. Over the front door the sign *Académie Whistler* did appear, but it was soon taken down, and the *atelier* became informally known as the *Académie Carmen*. Still, the promise that Whistler would criticize the students' work was sufficient to crowd the premises, most of the early arrivals deserters from other *ateliers*.*

For several weeks Carmen Rossi's students were exasperated by her innocence of anything resembling teaching ability, and Whistler's nonappearance. For their tuition—and Carmen at first charged the women one hundred francs a week, twice as much as the men, until Whistler found out and protested—all they had was a letter in which he addressed them as "the distinguished pupils whom it is my pleasure to meet." The setting of a day of visitation galvanized the students into preparing samples of their art for scrutiny, and one student † remembered how the hush of work was broken by an exclamation from Carmen, "I hear wheels."

> The wheels of "M. Weeslaire" could not possibly be mistaken for the wheels of any ordinary mortal. Hastening off her paint-apron and stowing it in a dark corner, she flew out to meet him. Presently the door opened and she swept aside the curtain,

* Between 1898 and 1901 one American émigré divided her time between Rome and Paris, studying art, until her eccentric and wealthy mother died, leaving her free to dwell as artist and lesbian amidst the cultivated upper-bohemian milieu of England and the Continent. She was Romaine Goddard Brooks, whose style and palette suggest that whether or not she attended the *Académie Carmen* she drew her inspiration from the Master. When she died, in 1970 at ninety-six, she was probably the last surviving disciple of Whistler.

† Mary Augusta Millikin, in *The Studio*, February, 1905.

announcing, "Mr Whistler." And there he was, but much less extraordinary in appearance than our expectations had pictured him. He even looked healthy and acted like a human being.

In spite of carefully calculated clothing, he was evidently so small and so slight as to be really tiny. He wore his monocle, kept on one of his black kid gloves, and carried his high hat while he criticised. Nothing could be funnier than to see the little man picking his way around among the easels, the *massière* with an immaculate "paint-rag" in readiness, and the rest of us swinging after, like the tail of a comet. . . .

While many of his criticisms were direct, simple, and rational, he occasionally treated us to a picturesque *bon mot*. Coming up to the easel of a new pupil, he looked at the work in profound silence; then directing his monocle and his business eye towards the pupil, he began: "From New York?" "Yes." "Pupil of Chase?" "Yes." "Um-m! I thought so. Why did you paint a red elbow with green shadows?" The young lady protested, "I am sure I just paint what I see." He nodded his head in grave appreciation of the case, adding, "But the shock will come when you see what you paint."

Going round the crowded class, Whistler asked each pupil with whom he had studied before, and the stories about the inquiry agree only on how the questioning ended.

"With Julian," said one.

"Couldn't have done better, sir," said Whistler.

"With Bonnat," said another.

"Couldn't have done better, sir," said Whistler again.

"With Mowbray," said a third.

The litany was the same in each case, with Whistler complimenting the pupil on his previous training, until he came to one who confessed, "I have never studied with anyone, Mr Whistler."

"Couldn't have done better, sir," said Whistler, and went on down the rows.

He insisted on seriousness, he told the class afterward. There was to be no gossiping or smoking; the latter, he said, because it obscured the light. But one large Englishman went on discharging smoke into the classroom. "My dear sir," said Whistler gently, "I know you do not smoke to show disrespect for my request that students refrain from

smoking on the days I come to them, nor would you desire to infringe upon the rules of the *atelier,* but—it seems to me—that when you are painting—you might possibly become so absorbed in your work as to—let your cigar go out!"

To further probe their backgrounds he asked, "Do you know what I mean when I say *tone, value, light, shade, quality, movement, construction* and so on?"

"Oh, yes, Mr Whistler," they chorused.

"I'm glad," he said, "for it's more than I do myself!"

At first Whistler persevered with the enthusiastic yet untalented, telling one student who apologized for his drawing, "It is unnecessary—I really come to learn—feeling you are all much cleverer than I." But the idea of men and women crowded together to paint a nude model offended his ingrained puritanism, and he asked Carmen to provide "separate *ateliers* for the ladies and gentlemen and that the present habit of both working together should be discontinued." After that his other dicta seemed mild. There was a long Parisian tradition of charcoal-decorated *atelier* walls, but students were to confine their drawing to their easels. Instead Whistler commissioned Théodore Duret to translate his "Propositions" into French and had them posted.

During his second visit, he criticized student work in the perspective of his theories, declaring that "even the most unpretentious" picture "must be, in form and arrangement, a perfect harmony from the beginning." However authoritative, it was too demanding an idea for beginners. His third visit proved more useful. Carmen Rossi was utterly ineffective and disorganized as a teacher and had quickly become little more than proprietor, having appointed student monitors for each class and hoping for the best. Whistler appeared undisturbed but, observing that the infinite gradations of tone which he required were impossible with a badly organized palette, told the female students, "You ought to be so familiar with the location of the colors on your palette that you could paint in the dark," and picked one up to explain his practice of color arrangement:

On the outer rim of the palette the chosen colours were ranged in invariable order: white in the centre; to the right, vermilion, Venetian red, Indian red, and ivory black; to the left, yellow ochre, raw siena, raw umber, cobalt, and mineral blue. Then on the lower part of the palette these colours were mixed with the

palette-knife, so as to form in flesh tones a systematic transition from light to dark: quite as definite a sequence as an octave on the piano, and in his hands capable of every possible variation. The brushes—the flexible, round-end Whistler brushes—the manner of whose track through the wet paint I recognise with so much pleasure in his work, were carefully devoted each to its particular tone in the scale of colour. He laughingly suggested that the brushes should be named "Susan," "Maria," and so forth; and that we should be careful not to confuse their identities.

"You must see your picture on the palette," he used to say: meaning that on the palette we must find and test and be sure of exactly the tone that we needed for each individual brush-stroke throughout the picture. "Here, not on your canvas, is your field of experiment, the place where you make your choices."

His was not a drawing school, he told Carmen's pupils. "I do not teach art; I teach the scientific application of paints and brushes." No painting on a canvas was to be begun before the artist could see, on his palette, the harmony of model and background. One student protested that she did not wish to paint in such low tones as Whistler prescribed and practiced, but wanted to keep her colors pure and brilliant. "Then keep them in the tubes," he warned. "It is your only chance at first."

Sometimes he demonstrated his own painting technique for the students, baffling many close to the canvas who saw no perceptible difference as each new brushstroke was applied. Those at a farther remove could see the subtle changes worked, as the Master described it, "in painter's clay." His own early experience was cautionary, he said, for in his youth he found no useful artistic facts, and "fell in a pit and floundered. . . . All is so simple. It is based on proved scientific facts; follow this teaching and you *must* learn to paint; not necessarily learn art, but, at least, absolutely learn to paint what you see." He had known Rossetti for many years, he once said, "and had talked art many, many times, but *painting* only once."

Whistler taught that the subject "should be presented in a simple manner, without an attempt to obtain a thousand changes of color that there are in reality." The *visible* world, he stressed, was much lower in tone than artists normally painted it, ". . . that long accustoming oneself to seeing crude notes in Nature, spots of red, blue, and yellow in flesh where they are not, had harmed the eye, and the training to readjust the

real, quiet, subtle note of Nature required long and patient study." One indefatigable student, sure she had accomplished something according to the Master's formula, looked up smilingly as he passed. He paused behind her chair. "Scrape it out, madam, scrape it out!" he said, and passed on. In another case he disapproved of a red background behind a model, and attempted to remove it from a pupil's canvas, mixing and studying and scraping while surrounded by admiring students. Finally he remarked, "I suppose you know what I'm trying to do?"

"Oh, yes, sir," most of them chorused.

"Well," he said grimly, "it's more than I know myself."

Whistler often worked *with* his pupils. Anything they picked up in the process had to be acquired the way the apprentices of an earlier day learned their craft. The most praise he permitted himself was "Go right on," or *"Continuez, continuez."* But he was seldom encouraging. "If you possess superior faculties, so much the better, *allons,* develop them," he would say; but should you lack them, so much the worse, for despite all efforts you will never produce anything of interest." Good teaching methods required that each pupil be given some praise at some time, but this was not Whistler's method. "Distrust everything you have done without understanding it," he exhorted. "It is not sufficient to achieve a fine piece of painting. You *must* know how you did it, so that the next time you can do it again. . . . Remember which of the colors you employed, how you managed the turning of the shadow into the light, and if you do not remember, scrape out your work and do it all over again, for one fact is worth a thousand misty imaginings. You must be able to do every part equally well, for the greatness of a work of art lies in the perfect harmony of the whole, not in the fine painting of one or more details."

After some frustrating weeks, Whistler was sufficiently satisfied with the work of one young woman, Inez Bate, to entrust her with the overseeing of new pupils and the explaining to them of his principles. In the men's class Earl Stetson Crawford had become *massier,* and received small courtesies from Whistler, as when the Master would call on him to see what he was "up to outside the school." But Whistler spent more and more time nursing colds in the damp ground-floor Rue de Bac apartment, and Crawford would receive a note on black-bordered paper to come to consult about the class.

Only the first New Year to pass in the life of the school was a satisfactory one, as Whistler's health was still up to his interest in the

class. The students, one of them tipped him off, were planning on a New Year's (1899) call upon him, and Whistler excitedly protested that he never received callers in the morning—any morning. Instead, they came to his studio that afternoon, where he greeted them with champagne and fruit and cake, told stories of his work and his warfare in behalf of it, and showed them work of his he had never exhibited, including canvases from his allegorical period. One pupil asked how he arranged his subjects to capture the low tones so characteristic of his pictures, and Whistler posed a visitor, pulled down all the shades but at one window and produced a live "arrangement" ready to recede behind the frame as he thought all portraits should do.

In 1899 the *Académie Carmen* began to drift, mirroring Whistler's own situation. He was losing interest in the school, which had been for "poor little Carmen," found Paris now less attractive than London, and was distracted by other problems, among them the loss of a fixed English residence—more disturbing to an old man (he was now in his middle sixties) than a young one. Heinemann's losing *The Baronet and the Butterfly* had not separated Whistler from the publisher's fashionable flat in Whitehall Court, but Heinemann's sudden romance with Magda Sindici did. He had fallen in love with a beautiful Italian novelist whose book had been recommended to him by Gabriele d'Annunzio, and brought her to London to meet his closest friends, Landor and Whistler. At dinner Whistler was charmed, and when the authoress of *Via Lucis* departed, he was pressed for his opinion. "An angel just descended from heaven," Landor thought, "could hardly have received so much enthusiastic praise." Heinemann, who was desperately in love, was delighted. Landor was silent. He was sure Signorina Sindici was too overpowering for his cautious friend.

The marriage took place in Italy in February 1899, Whistler going to Porto d'Anzio for the wedding, and then to Rome, which he described without enthusiasm as "a bit of an old ruin alongside of a brand-new railway station. . . ." The marriage was not a success. Magda was a born bohemian and Heinemann a born bachelor. Eventually she consoled herself elsewhere and three years later Heinemann secured a divorce. By then Whistler had long understood his mistake, and when Heinemann confided to a mutual friend that he was grieved that Whistler had not written a word of sympathy when the marriage was dissolved, Whistler said, "Please tell Heinemann from me that if it had been the *right thing* to express sympathy on such an occasion, I should of course have done so."

During the brief marriage Heinemann's loyalties persisted, prompting him to suggest that Whistler permit an authorized biography which his friend would publish. First Heinemann suggested Henley as author, and then Whibley, but Whistler objected to each, finally agreeing to Pennell early in 1900. The Pennells then began recording the Master's table-talk openly, plumbing him for details of his life on each visit to Buckingham Street. But he was much more talkative about the Boer War, and about foreign intervention in China.

"Here are these people, thousands of years older in civilization than we," he said at a dinner party in July 1900, "with a religion thousands of years older than ours, and our missionaries go out there and tell them who God is! It is simply preposterous, you know, that for what Europe and America consider a question of honor, one blue pot should be risked." A guest at the table, Capt. Charles M. Hunter—a West Point man—brought Whistler up to date on the Academy, including the information that the cadets now played intercollegiate football. Whistler was disgusted. "They should hold themselves apart and not allow the other colleges and universities to dispute with them for a ball kicked round the field—it is beneath the dignity of officers of the United States."

Not forgetting his years of battle against what he considered to be British blindness and stupidity, and the admiration in which he basked on each visit to Holland, he was fervently pro-Boer, and applauded each dispatch which made the Empire seem blundering and foolish. General Buller's incompetence amused him, and he mused over the method of his selection.

"First of all," he would say in his whimsical way, "a Commander-in-Chief must be had. The authorities search the list. They find nothing in the A's. They come to the B's. Buller. Buller, now: what has Buller done? They refer back, and find that when Buller was at Eton he fought a butcher boy and licked him. Ha! ha! good muscle," and Whistler, in his dainty way, struck with his cane his forearm,—"muscle, muscle. This man had muscle; we English want muscle; so out goes Buller, the muscle man, without any regard to his fitness for the post, or to his local knowledge."

Whistler was amused by Buller's announcement that he had made the enemy respect his rear; and when he was told of the General's boast that on one occasion he had retreated without losing a man, a flag or a cannon,

he added, "Yes, or a minute." He enjoyed repeating the rejoinder to a man exhorting an audience that the cream of the British army had gone to South Africa—"Whipped cream." The Boers were defying the English: it was enough to win his praise. Englishwomen came in for equivalent sarcasm. At a dinner party, he told the Pennells, best-selling novelist Sarah Grand had declared in her feminist way how delightful it was to return to England after some weeks in France, for a Frenchman could never forget that women are women, while she liked to meet men as comrades, without thought of sex. "You are to be congratulated, madam," Whistler told her; "certainly the Englishwoman succeeds, as no other could, in obliging men to forget her sex." But the jests were fewer than ever before. As Joseph Pennell put it, Whistler was "suddenly grown old and thin and shrunken and sad."

On July 15, 1899 he had arrived at Buckingham Street to find Elizabeth Pennell alone, and chattered to her with forced gaiety about the school. "It is amazing. It grows more amazing with every day. No one knows what is being done there. Really, I am amazed myself when I see it all. And, you know, this is the proper moment to make the world see what is going on, and you surely are the person to do it. I have been thinking it over. I would not care to have it come from me—it would not answer. But it has occurred to me that Miss Bate is just now in London on her way from Paris; why should there not be a talk with Miss Bate?" He was overly eager to promote the *Académie Carmen* and may not even have confessed to himself that the reason was its faltering condition. He had lost almost all his students in the men's life class, which had a constantly changing enrollment as the men would not settle for the slow progress upon which he insisted, one of them writing in charcoal on a wall where Whistler would be sure to see it;

> I bought a palette just like his
> His colours and his brush.
> The devil of it is, you see,
> I did not buy his touch.

Although the men realized that no one could make them instant Masters, many nevertheless wanted to send their current work off to the annual Salon with the identification that they were Pupils of Whistler. He refused, explaining that a few months made no one ready for the Salon, and that he was like the chemist who put drugs into bottles: he would not send them out under his name unless he were satisfied with the

contents. The men dwindled to a handful, then to one, Clifford Addams—loyal more, perhaps, to Inez Bate, whom he later married, than to Whistler's apothegms.

On July 20, in London, Whistler signed a Deed of Apprenticeship with Miss Bate, a gesture which "bound herself to her Master to learn the Art and Craft of a painter, faithfully after the manner of an Apprentice for the full term of five years, his secrets keep and lawful commands obey. . . ." It looked back to a world that had passed. Afterwards they celebrated with lunch at the Café Royal, where Whistler vowed he would make her the greatest woman artist there had ever been—better than Rosa Bonheur. As *massière* more than as apprentice, however, Miss Bate opened the school for the second year that autumn. Each new candidate was to submit an example of his or her work to the *massière,* to weed out the untalented. There were objections that only the Master should have that privilege, and the *Académie Carmen* was disparaged in the *Quartier* as a school run by a student. Still, Elizabeth Pennell, loyally visiting the Passage Stanislas to prepare the promised article, saw—or reported—"the absorption in their work of the women in the life class, and the model, posing for the nude on the throne against quiet grey draperies, was exactly like a Whistler, needing but a frame to complete the illusion." But no article ever appeared, and Whistler, intermittently ill through the winter, seldom appeared at the *atelier.*

When the third year began the only pupils left were women. Whistler had refused to criticize in the second-year men's class at all, having come in, he said, on Sunday mornings to examine what had been done the previous week and finding only a "blankness" of inspiration he could not face. The third-year group shifted quarters to an old building on the Boulevard Montparnasse, but Whistler was unable to meet with them, his doctor having prescribed Mediterranean sun. Without the token presence of the Master or even the promise of his return, the empty easels began outnumbering the others, and the letters reaching Whistler early in 1900 suggested that the *atelier* was in danger of closing. Even Carmen had left the *Académie Carmen.*

An apologetic note Whistler had sent the class from Algiers many weeks before had never arrived. Discovering the fact he sent another letter "for the troubled and anxious Apprentice to read to her discontented company," hoping "in all kindliness, that the great & simple truths they have together been permitted to approach, may well occupy them during the longest absence." Privately he added to his *massière* that he thought

his address to the pupils might take its place on the walls with the "Propositions." Matters had gone too far for that. On January 27, Rosalind Birnie Philip had written to him that his apprentice seemed quite capable of managing the school on her own, and since Carmen, with nothing whatever to do, had become proprietress of a wine-shop, "this is a very excellent time to free yourself from the responsibilities of the school." But soon after that Whistler received word from the *massière* that the remaining students were bent on leaving, and at the beginning of April he sent his final address to the *Académie* from Corsica, regretting that any pupils had remained longer than was necessary out of politeness, suggesting that they forget the narrow principles imposed upon them (which were too strong for ordinary painters), and bidding them goodbye. On Saturday, April 6, 1901 the *Académie* was closed with the reading of the letter, after which *Mme la Massière* reported, in a telegram, "DOCUMENT READ YESTERDAY ASSEMBLAGE LARGE SAD STUPEFACTION EXISTS ALL SHALL BE AS YOU WISH." Whistler forwarded it to his sister-in-law with a note on it, "Last act! Curtain! How do you like my play?" And he signed it with his butterfly.

To Inez Bate—by then Mrs Addams—he suggested that she and her husband write an account of the *Académie,* "The beginning of it—the misunderstanding of it—the resenting of it—" and of "life in the pestiferous air of Carmen's first studio!—and the sadness of it! and the deep suspicion and disappointment that came of it." And he followed it up with instructions to William Webb to draw up a deed of apprenticeship for Clifford Addams, "the one man who remained a faithful student." None of the gestures obscured the fact that the *Académie Carmen* had failed. It had come too late.

Carmen herself had done very well indeed. Her share of the tuition had dwindled with the pupils, but she found other financial consolation, even beyond the wine-shop. All that Whistler had been aware of was that some of his canvases were mysteriously missing, but he was less and less able to check on the studio in the Rue Notre Dame des Champs, often verging on collapse on reaching the sixth floor. "Why don't you have a studio on the ground floor?" he was asked; and he answered stubbornly, "When I die I will." But the missing work had begun to turn up in Paris shops, and pupils in the *Académie* had even come upon Whistler lithographs which had not been placed for sale. What he called "the picture robbery" was on a substantial scale. He had La Napolitaine shadowed, although he felt too indulgent toward her to take any

precipitate action. She was always his child model, and possessed—or affected—a childlike delight in everything which Whistler enjoyed, although his oval *Violet and Rose* portrait of her in 1898 evidenced a buxom woman half again the fragile Whistler's weight. Even in London she was watched, and was discovered in conversation in Charing Cross Station with one of Whistler's Fitzroy Street servants. But a check of unfinished canvases there showed nothing missing.

Wherever Carmen concealed her Whistler pictures, they were available for sale as soon as his death made it possible. Freer unblinkingly bought several from her in Rome, and others were offered, along with a packet of Whistler letters, to the manager of the Hotel Drouot gallery, to whom she explained that Whistler gave her paintings and lithographs in payment of bills he owed her relating to the *Académie Carmen*. Still, the whole affair had been a mistake Whistler had to make. An *Académie Whistler* in Paris, where he had been the "idle apprentice," had been made even more necessary for him by *Trilby*. It was a price he was willing to pay in terms of diminished creative time, for it was easy to bank one's creative fires when they burned low in any case. Yet the price in nervous strain, as the cost mounted not in canvases undone but in canvases vanished, was something he had not counted on, although he joked to his old Parisian friend Charles Drouet that the futile detective work was *"la seule joie qui me reste."* It was almost true.

XXXVII

Twilight

H E was always cold now. In Paris he stayed at the Hotel Chatham, because the Rue de Bac house was too damp for his old bones. But he would not own up to his aging. "You know, Mr Whistler," said an American he met, "we were both born at Lowell, and at very much the same time. You are sixty-seven and I am sixty-eight."

"Very charming," said Whistler. "And so you are sixty-eight and were born at Lowell. Most interesting, no doubt, and as you please! But I shall be born when and where I want, and I do not choose to be born in Lowell and I refuse to be sixty-seven!"

His old friend Drouet at about the same time asked him how old he was, and fumbling with his eyeglass he said "about fifty-eight or fifty-nine, yes, that must be it," all the while looking out of the corner of his eye to see if Drouet took it in.

Paris and London were now too chill in most months for him, Sickert gossipping to Rothenstein, "Whistler's doctor has forbidden him to paint out of doors, has told him it is at the risk of his life. He gets such attacks of influenza. Poor old Jimmy. It was all such fun twenty years ago." Taking cabs—a vanity in earlier years—was now a necessity. Drouet thought it was the "little, tight shoes" that were the problem, but remembered, also, "You would see him in cabs, fast asleep. One night he

was going to dine with a friend. It was cold, and he took a cab, with a *chaufferette.** Got in, couldn't find it anywhere. Then he saw that the *cocher* had it under his own feet. When Whistler got out he paid his fare . . . —exactly thirty *sous* and no more, and the drive had been long. 'And the *pourboire?*' the *cocher* asked, and his language was awful. 'Inside on the *chaufferette,*' Whistler said, so pleased that he was in wonderful spirits all evening."

It was particularly true that each time he went to Paris on business he would return with a "cold" more severe than the previous one, but returning to London he would work more furiously than before, portrait-painting in Fitzroy Street until dark. His favorite models remained London children—Sophie and Edith Burkitt, who lived next door, and others he saw in the side streets. "At times," Edith remembered,

> instead of coming directly to the studio, he would make the cab driver take him through some of the poorer side streets while he looked for subjects suitable to his art. In this way he discovered the subject of his well-known picture, [*Brown and Gold:*] *Lillie in our Alley.* She had red hair, which he greatly admired. He asked where she lived and went with her to see her mother. He arranged for her mother to bring her to the studio, and when they arrived he was very disturbed to find that her mother had frizzed and curled her hair in a way that he considered frightful. He explained that he wanted her just as he had seen her playing in the street, with her long, straight hair, and got her mother to take her home and wash out the curls and frizzes.
>
> Whistler was making nude paintings at this time of a girl, Eva Carrington—or they might have been pastels. He discovered her also in one of the "alleys." She was quite brazen and when I went into his studio he had an understanding that his maid Marie should take her out of his studio to the kitchen—"while Miss Edith is here."

What the attraction to adolescent girls meant in his old age is speculated upon by critics, but Whistler had always—at least since Cecily Alexander—loved to paint children. Such pictures as his *Purple and Gold: Phryne the Superb* (1901) have evident erotic undertones, and prove, if nothing else, that he was not finished experimenting. But he was often

* Foot-warmer, usually heated with charcoal.

too ill in his rooms at Garlant's Hotel to go to Fitzroy Street, and on November 19, 1900, when he dragged himself from his sickbed to dinner at the Pennells, they recorded afterwards, with concern, that he "was worried about himself—his cough will not go, and he talks of Tangier." Yet he remained in London, Joseph Pennell recording on December 1, "Whistler came to dinner, was better but more depressed than I have ever seen him, ordered off at once by the Doctor, who wants him to go somewhere by sea." His heart, damaged as a child by the rheumatic fever he experienced in Russia, was less and less able to sustain his normal activities, and he was easy prey to every respiratory ailment that raced through the badly heated and poorly ventilated rooms. But the diagnosis, Whistler said, was that he was "lowered in tone: probably the result of living in the midst of English pictures."

Ronald Birnie Philip, his young brother-in-law, was pressed into service as companion. On December 14 Whistler left from Liverpool Street Station for the Tilbury docks, his affairs left in the hands of William Webb. The passage to Morocco was uneventful, but Tangier was unseasonably cold and its picturesqueness too "Eastern" to interest Whistler. Algiers, next, was "too cheap: and the Hôtel de L'Oasis no better, Whistler on January 3, 1901 summing up his holiday from Algiers as "two stupid hotels with bad dinners!" Yet, adding to the few drawings, in his distinctive shorthand, done on board ship, he produced a sketchbook full of pen-and-ink studies of Algiers, with its crowded streets and exotically garbed people. He fled to Marseilles, but it was no improvement. Snow was falling as he disembarked, making him long for the warmth of London. Too ill to return there, he put up at the Hôtel de la Canebiere and sent Ronald Birnie Philip for a doctor. The prescription was a stay on Corsica, in the sun, once he could travel, but only by the end of January was he able to sail for "Napoleon's island."

"This is a wonderful place!" he rejoiced in a letter to Rosalind. There were oranges and roses and he was ready to acquire a villa and remain awhile. From the Hotel Schweizerhof in Ajaccio, with its German proprietor and mostly German clientele, he wrote to Heinemann that although there was a good deal of toasting of the Kaiser, the food was "really good." He had been kept "so long away looking for this sun and warm Southern weather" that he was "tired with the wandering" and grateful to have found a place "fit to stay in." He should have realized, he confessed, that "there is nothing Southern but the South! and made a straight line for the West Indies!!"

Soon, however, the weather in Ajaccio turned cold, and, shivering, he complained to Freer that he should have remained in Paris. Every time he prepared to draw, "some Mistral" would blow in. But by mid-February his brother-in-law felt it was safe to leave him alone until Heinemann arrived in early March. The dreary loneliness gnawed at Whistler for although at first he found "beautiful things in uncanny corners" of the island, his wandering after sunset led to a new cold, and days of rain—even the sun was wet, he wrote—forced him further indoors. But when he recovered, he was lent "a corner" of a studio by the curator of the local museum, and began painting the head of a Corsican child—a little ragamuffin, he complained, who was "entirely too wild to sit!"

Isolated from his affairs, Whistler spent more time in letter-writing about petty matters of business than in painting or etching, although he experimented in both media. The overwhelming concern with trivia was another sign of age, but he had to be indulged, and Ronald Birnie Philip had to go to Paris to represent him in his least significant law suit. One of his tenants, Madame Saleron, in an apartment above his own ground-floor rooms in the Rue du Bac, persisted in shaking her carpet out of the window into his beloved garden. Her behavior filled him with disgust, but there seemed no way to stop her. According to the law he needed disinterested witnesses to the act from outside the family, which might have meant hiring a private detective to lie in wait. Then the unexpected happened: she dropped the carpet accidentally into his garden, and he refused to permit it to be returned. This time Mme Saleron went to law, and Whistler's lawyers advised return of the carpet. He refused, and the case dragged on while he was away, his servant Euphrasie and his lawyer Ratier reporting to him and forwarding his adversary's letters.

In Corsica in early March he heard from Ratier that the case had gone against him. He was to return the carpet and pay twenty-five francs damages. Overly miserable about the verdict, he instructed Ratier to enter an action for "wrongful damages," but the lawyer would not continue with it, and Whistler had to content himself with sending Mme Saleron, along with the money, a sarcastic letter regretting that his absence from Paris prevented him from hearing the presentation of her most imaginative case.

More important letters went to Rosalind. Almost daily Whistler expected to return to work in London, and instructed her to keep in touch with his models and to close the seldom-open "Company of the Butterfly" sales office at 2 Hinde Street. He had his property moved to 8 Fitzroy

Street, and asked that in his absence his work be sorted and listed, and his engraved plates listed and cleaned. But whether these activities meant that he expected, as he suggested, to return to painting, or whether he really intended to wind up his professional affairs, is best inferred from his other correspondence. He had not finished his portraits of the Vanderbilts, and felt too ill to be able to, although George Vanderbilt wrote from Dresden that they would like to meet Whistler in Paris in the spring so that he could give the pictures "those last touches" needed to complete them. Whistler knew they needed more than that, and wrote to Webb in March that if his lawyer would supply the £2000 Vanderbilt had advanced for his portrait the check could be returned "until I am well enough to finish his picture! . . . I might perhaps manage Mrs Vanderbilt's—and that would simplify the position, as nothing is advanced upon that." Through his London agent he had already confessed to Wünderlich and Company in New York, which had requested copies of lithographs which they did not have in stock, "We are getting very nearly out of proofs now, and I don't know *when* others will be printed!"

His productivity in Corsica was minimal. As he told Elizabeth Pennell, although he never went out without sketchbook or etching plate, "always meaning to work, always thinking I must," he accomplished little. The first afternoon he had used the corner of the studio he had been offered, the Curator had said to him, "Mr Whistler, . . . I have been watching. You are all nerves, you do nothing. You try to, but you cannot settle down to it. What you need is rest—to do nothing—not to try to do anything." Suddenly it struck Whistler, he confided, "that I had never rested, that I had never done nothing, that it was the one thing I needed. And I put myself down to doing nothing—amazing, you know. No more sketch-books, no more plates. I just sat in the sun and slept. I was cured. . . ."

On the first of May he left Corsica for Marseilles, on the P & O steamer *Egypt* to London. On May 8, when the vessel arrived in the Thames, a passenger recalled, "it might have been late November—a heavy fog, no wind, and a persistent downpour." Looking toward the riverbank Whistler said to him, "Now is that not far more beautiful than anything you see in the Mediterranean with their hard, crude colors—tell me what you see?"

"I see," said his chance companion, "two sailing barges in the foreground, and dimly through the fog a cement works with three kilns and two tall chimneys."

"Yes," said Whistler, "but what soft coloring!"

An hour later they arrived at the dock, and just as they were being moored, a seaman asked them to move aside for a mooring rope. Just as they did so another came by and pushed up an awning over their heads that contained a large pool of sooty water. Most of it came down on Whistler's head, after which his only slightly doused companion murmured, "Now I appreciate the soft coloring!"

Because Whistler had to unpack his trunk and change his clothes, they shouted their goodbyes through his closed cabin door. It was not his only disaster. The day before he left England he had sent about a dozen copperplates to Joseph Pennell to be grounded in readiness for use abroad. He packed them inside his shirts, although Pennell warned him that there had not been enough time for the plates to be cooled and fixed, and that the ground might come off. In Corsica the warning proved accurate. Only four etchings survived. But other work remained: watercolors, a landscape in oils and some drawings, as well as his capacious sketchbook. It was not a great haul, but he had survived well enough to work through the summer at Fitzroy Street; and determined now to spend the rest of his working days in London, he made plans to give up his expensive and redundant quarters in Paris.

In October, Whistler returned across the Channel to close the studio the stairs of which he could no longer climb, and to sell the house in which his ground-floor quarters were too damp for him to live. In London he moved from Garlant's Hotel to Tallant's Hotel, in North Audley Street, where he was ill again in the now-chronic way which made friends realize his deterioration, although he joked about it. "In this room, sir," the landlady had said as recommendation, "Lord Ralph Kerr died." "I told her," Whistler said, "what I wanted was a room to live in!"

Off and on, although he kept his historically distinguished room, he stayed with his mother-in-law and Rosalind in the house at 36 Tite Street he had acquired for them, in December going off to Bath with them to escape the London winter and look for shops to browse in and paint, finding old pieces of silver to send the doctor at Marseilles and the curator at Ajaccio. Through the months in Bath he regularly took the train back to London, to attend a meeting, go to a gallery or exhibition, visit the Heinemanns or the Pennells.

When spring came he returned to the Thames, leasing 72 Cheyne Walk from architect C. R. Ashbee, and having "the ladies" move in with him. The house stood on the site of a riverfront fish-shop which Whistler

had once lithographed, and had a ground-floor studio at the back. Two
flights up was the drawing room, where (in glass cases) Whistler
displayed his still-beloved blue-and-white. Except that it returned him to
his favorite part of London, the choice was a curious one. Almost all the
windows opening on the river were so small and high that little of the
Thames could be seen, and the bedrooms were three flights up, a struggle
for Whistler. Its decorative touches, too, were exactly what he and
Godwin, years before, had tried to eliminate. "The whole, you know," he
told the Pennells, "[is] a successful example of the disastrous effect of art
upon the British middle classes. When I look at the [beaten] copper front
door and all the little odd decorative touches throughout the house, I ask
myself what am I doing there, anyhow?"

He hardly went out anymore, but prospective patrons were eager to
visit him, one of them a New York gambler, Richard A. Canfield, whom
Whistler began painting in April and May, 1902, after two distant
Winans relatives had interceded. Like Freer, Canfield had no shortage of
cash, and had sent Whistler an advance of £500 on the portrait, adding to
it in April a further check "for pictures not completed," which was
returned by Whistler with a note, once he had begun sitting, "You have
seen that the work is all absorbing—and indeed I myself find the
difficulties in the brush quite sufficient in themselves, without allowing
them to become complicated with anything distantly resembling responsi-
bility of any kind!" He had accepted the check advanced for the unpainted
portrait, he confessed, but that was "as much of a link with business as I
can stand in the midst of incompleted work."

In May Whistler began a portrait of the long-faced, bearded Freer;
lunched with the visiting Rodin—who offended him by not asking to see
his pictures; and found a new cause for distress which made Mme
Saleron's carpet seem like no offence at all. Ashbee had started building a
new house next door to the one he had leased to Whistler. No doubt, he
now realized with resentment, the architect had himself left the house "to
get out of the annoyance. It is knock, knock, knock all day long." He
became nervous and irritable and when his new studio became impossible,
he referred the matter to the patient William Webb. The agitation, his
doctor warned him, was too much for his heart, and Freer, who dined
with him at Cheyne Walk on June 17, suggested relaxation in Holland.
But at the Hôtel des Indes in the Hague he became critically ill. Freer
called a local doctor, and summoned Miss Birnie Philip and Mrs

Whibley, remaining until they came; Whistler in the meantime insisted upon Freer's taking down a new will:

> I, James Abbott Whistler, also known as James McNeill Whistler, being of sound mind, hereby give and bequeath unto my ward and sister-in-law Rosalind Birnie Philip of 36 Tite Street, Chelsea, London, all of my real and personal property of every kind and nature wherever located. I declare this to be my last will and testament written briefly, fearing because of the great heart strain upon me the cord might at any moment snap. . . .

That July 2 Freer wrote to Webb to communicate his concern about the validity of the will, because it had been signed J. McNeill Whistler rather than the legal James Abbott Whistler. "As my mother's eldest son," Whistler had insisted, "I have the real right to bear her Highland name of which we are all very proud." Webb assured Freer it was all right. From the Hague also came belated reports of Whistler's illness to London papers, and the *Morning Post* on July 28 published a column about his condition which read like an obituary:

> The news from The Hague concerning Mr Whistler's health is encouraging, and artists will unite in wishing the eminent painter a recovery from his illness as speedy as the exigencies of the case permit. Mr Whistler is so young in spirit that his friends must have read with surprise the Dutch physician's pronouncement that the present illness is due to "advanced age." In England sixty-seven* is not exactly regarded as "advanced age," but even for the gay "butterfly" time does not stand still, and some who are unacquainted with the details of Mr Whistler's career, though they may know his work well, will be surprised to hear that he was exhibiting at the Academy forty-three years ago. His contributions to the exhibition of 1859 were "Two Etchings from Nature," and at intervals during the following fourteen or fifteen years Mr Whistler was represented at the Academy by a number of works, both paintings and etchings. In 1863 his contributions numbered seven in all, and in 1865 four. Among his Academy pictures of 1865 was the famous "Little White Girl," the painting that attracted so much attention at the Paris Exhibition of 1900. This picture—rejected at the Salon of

* He was 68 on July 11, 1902.

1863—was inspired, though the fact seems to have been forgotten of late, by the following lines of Swinburne. . . .

On August 6, 1902, appeared Whistler's response:

Sir,—I feel it no indiscretion to speak of my "convalescence," since you have given it official existence.

May I therefore acknowledge the tender little glow of health induced by reading, as I sat here in the morning sun, the flattering attention paid me by your gentleman of ready wreath and quick biography!

I cannot, as I look at my improving self with daily satisfaction, really believe it all—still it has helped to do me good! and it is with almost sorrow that I must beg you, perhaps, to put back into its pigeon-hole, for later on, this present summary, and replace it with something preparatory—which, doubtless, you have also ready.

This will give you time, moreover, for some correction—if really it be worth while—but certainly the "Little White Girl," which was not rejected at the Salon of '63, was, I am forced to say, not "inspired by the following lines of Swinburne," for the one simple reason that those lines were only written, in my studio, after the picture was painted. . . .

It is my marvellous privilege . . . to come back, as who should say, while the air is still warm with appreciation, affection, and regret, and to learn in how little I had offended!

The continuing to wear my own hair and eyebrows, after distinguished confreres and eminent persons had long ceased their habit, has, I gather, clearly given pain. This, I see, is much remarked on. It is even found inconsiderate and unseemly in me, as hinting at affectation.

I might beg you, sir, to find a pretty place for this, that I would make my "apology," containing also promise, in years to come, to lose these outer signs of vexing presumption. . . .

And I have, sir, the honour to be

J. McNEILL WHISTLER

In the same issue was a gracious leading article:

Who will venture to maintain that the art of letter-writing is dead or has even fallen into its "sere and yellow" when we are

able to take the delightful opportunity of printing the courteous and witty letter from Mr James McNeill Whistler that appears in our columns this morning? . . . He had small need to ask for "a pretty place" in these columns. The best we can offer is his, as the hymn says, by sovereign right, but even if an unexpected pressure on space had cast his letter into the Parliamentary columns they would have gained unwonted radiance from its proximity. Mr WHISTLER, as every reader of the *Morning Post* will be glad to learn, admits convalescence, but surely this letter cannot be taken as other than a sign of robust health—we had almost said rude health, but so heavy an epithet cannot be admitted, since he sets us right with such good humour and merry tact. . . .

The patient was delighted, as the *Morning Post* noted in printing the "latest bulletin from Mr Whistler":

THE HAGUE, August 7, 7.16 P.M.
Perfect! A bijou! A little masterpiece most delightful to me.
The gracious thing said, glistening in the daintiness of the saying of it.
Never has *amende* become by its courtliness more like knightly favour!
On n'est plus grand seigneur!
WHISTLER

In addition, because the news "was all over the place," he wrote to Nellie Whistler, his brother's widow, to ask her to take the newspaper columns "and read them to Sis"—Deborah Haden, who was now in her mid-seventies—"with my best love. I am sure she will like the letter, which I think one of my very best! and be pleased at what the paper has said about it, differing so greatly from the sort of thing we have always had." It had taken him until his sixty-ninth year to become a living legend in London, and he savored the feeling.

In Holland, too, he was a Very Important Person, and the Queen of the Netherlands sent her personal physician to check upon Whistler's recovery. When he was well enough, Dutch artists paid their respects, and he left his own calling cards at the residences of the Boer generals then being honored at the Hague. Then, with artist George Sauter and his wife, he visited the Haarlem Gallery to see its Franz Hals portraits. Renewed briefly by his recovery and the attendant publicity, he was

enraptured by the paintings, chattering about Hals' methods, then creeping under a railing to get a better look, until a guard saw him and ordered him back. Whistler crawled back obediently, then after other visitors in the vicinity were gone he went to the chief attendant to arrange matters. Pointing to the signature in the visitors' book the attendant asked Sauter, *"Is dat de groote schilder?"* Sauter confirmed it, and they were quickly left alone with the pictures. Whistler crawled under the railing again, calling to Sauter, "Now, *do* get me a chair." And then, *"And now, do* help me on the top of it." His enthusiasm temporarily took decades from his years. "Look at it—just look; look at the beautiful color—the flesh—look at the white—that black. . . . Oh, what a swell he was—can you see it all?—and the character—how he realized it. Oh, I must touch it—just for the fun of it"—and he moved his fingers tenderly over the face of an old woman.

When Whistler left Holland in mid-September it was to return to 74 Cheyne Walk, and to the continued sounds of hammering and sawing. The stairs to the bedroom at the top of the house were too much for him, and he was moved, along with his Empire bed, to a small ground-floor room adjoining the studio and looking out onto the street, where the clatter of traffic added to the noises of carpenters and bricklayers. He went out little, but received visitors in the studio, with the watchful Miss Birnie Philip or Mrs Whibley or Mrs Birnie Philip sitting apart but present to caution visitors when Whistler seemed overtired. It created an additional sense of strain and near-imprisonment, both in Whistler and his visitors, for there were things which could not be discussed before the ladies. Still his friends came—Luke Ionides, Nellie Whistler, George Sauter, John Lavery, Arthur Studd, Inez Bate Addams (now heavily pregnant), the Pennells, the Heinemanns, and—leaning on the walking stick Whistler had given him—crippled Jonathan Sturges. But Whistler spent much of his time sleeping in an easychair after sleepless nights, and often dozed, too, at the dinner table, or amid conversation with his guests. When his head drooped they dutifully waited, then withdrew.

The studio and bedroom were littered in the fashion of a sickroom, and often as Whistler dozed a calico cat slept in his lap, the companion of all his hours. The Pennells recalled that once he insisted to them that even in his most difficult days he was the dandy: "I, when if I had only an old rag to cover me I would wear it with such neatness and propriety and the utmost distinction!" Now he shuffled about forlornly in his substitute for the dressing gown he no longer owned. His clothes hung on him, and

because he was cold he often wore an old brown fur-lined overcoat, now gone shabby, over a white nightshirt, black trousers and short black coat, a far cry from his former dapper dress; while his hair, once primped and curled, was now thin and flat.

In October, he was working again. Joseph Pennell arrived to find a model about to leave, rolling up an abundance of red hair that may have reminded Whistler of Jo or Maud. It was Dorothy Seton, a slender Irish girl. "Most people," he told Pennell when she left, "think she isn't pretty, but I find hers a remarkable face." Once, painting her, he walked back and forth across the floor muttering, "You cannot do it—your day is done!" Then, recovering, he added, "You can do it—you must do it as long as you live," and returned to the easel. Seeing his model's concern, he patted her on the head and said, "Take no notice of me, child; I am growing an old man, and getting into the habit of talking to myself." And he worked on, longer than usual.

The next month his spirits rose briefly when a painting exhibited in London, but which had been seen first at the Salon the previous summer, was described by the critics as one that had often been around the galleries before and thus provided evidence of Whistler's lack of productivity. He wrote to the *Evening Standard* to attack one of his enemies of long standing, critic Frederick Wedmore, Graham Robertson calling soon afterwards and having it read to him aloud. "Well? Eh? Well? How's that, d'you think?" While Whistler chuckled, Robertson wondered what to say, having found it labored and too long; but Miss Birnie Philip, then whispered, "Don't tell him *now* if you don't like it. He's been over it all the morning and he's so tired." Then the Pennells arrived. "The letter is one of my best," he told them elatedly. "I describe Wedmore as Podsnap—an inspiration, isn't it? With the discovery of Podsnap in art criticism I almost feel the thump of Newton's apple on my head. . . . I do believe it has made me well again!"

On November 29 the Pennells returned to Cheyne Walk to discover a motor car at the door, and Heinemann in the studio with Whistler, who was dressed and animatedly discussing a possible third edition of the *Gentle Art*. The *Standard* had refused Whistler's second letter answering Wedmore, and now he thought of not only of a separate pamphlet, but of putting the unprinted letter, as well as much older correspondence, in the new edition. He was digging through old mail, and discovering threatening letters from bailiffs he hadn't remembered, and recalling the *Trilby* letters which he thought ought to go in. But the idea faded away

when Rosalind could not find the Du Maurier file, and the conversation turned to Clifford and Inez Addams and their new baby. "Was the baby an apprentice?" Elizabeth Pennell asked. "Oh, yes, of course," said Whistler. "It was born an apprentice."

By early December Heinemann had produced proofs of a projected Wedmore-Whistler pamphlet, but Whistler after initial enthusiasm was too ill to be concerned. It was not his heart, he told Elizabeth Pennell between coughs, but his tonsils. Finally he was forced to write down what he wanted to say. On the fourteenth she was back, to discover him still looking "frightful" and agitated over the news that Count Montesquiou had sold his portrait by Whistler for 75,000 francs. "I painted it for a mere nothing . . . and it was arranged between gentlemen." Worse still, it was bought by another friend, Richard Canfield, who eventually gambled his money on thirty-four Whistlers. The Master might have hoped that it would go eventually to the Louvre,* but it was nothing he could say publicly. He began a public statement for the newspapers about "the blush to the cheek of a great family of France," but decided instead to send a letter about his feeling of injury directly to the Count. In return came a wounded response from Montesquiou. It was their last exchange.

Now Whistler found a new source of indignation. In America Elbert Hubbard had published at his Roycroft Press a pamphlet, *A Little Journey to the Home of Whistler.* "Really," he told the Pennells, "with this book I can be amused—I have to laugh. I don't know how many people have taken my name in print, and, you know, usually I am furious. But the intimate tone of this is something quite new. What would my dear Mummy—don't you know, as you see her with her folded hands at the Luxembourg—have said to this story of my father's courtship? And our stay in Russia—our arrival in London—why, the account of my mother and me coming to Chelsea and finding lodgings makes you almost see us—wanderers—bundles at the end of long sticks over our shoulders—arriving footsore and weary at the hour of sunset. Amazing!" On January 2, 1903 he responded sarcastically, "I congratulate you. The book contains several things I never knew before." Other recognition was more acceptable. Late in the month D. S. MacColl came as an emissary from Glasgow University to inquire whether if Whistler were offered an honorary doctorate he would accept the honor. He agreed, and the official invitation came in March, but Whistler had to accept it *in absentia.* The

* Later it was bought by Henry Clay Frick of New York for his personal collection.

farthest he now traveled was a drive, heavily swathed in blankets, in Heinemann's auto along the Embankment, and even then the eyes which once sparkled at the sight of the Thames usually closed in sleep after ten minutes.

Through the autumn, Whistler had puttered about the studio on good days looking at the accumulations from his Paris studio and from the Rue de Bac, and when his strength permitted that winter, he went through his canvases and prints, sorting and destroying—preparing for the end, whether or not he consciously permitted himself the thought. John Lavery arrived one day to discover a stack of big canvases against a wall, their backs turned, and the fireplace full of ashes. Realizing that Lavery knew what had gone into the fire Whistler remarked, "To destroy is to exist, you know." While Lavery was still there Whistler had a "bad turn," and Lavery helped him to his bed, Whistler struggling for breath. When he was able to sit up again he said, understating the situation, "I don't like this at all, Lavery, not at all." They both understood.

While Whistler clearly was failing further, Freer and Canfield vied with each other for whatever of the Master's work appeared available. As Whistler was unwilling to sell flawed or unfinished works, and was too weak to do much more painting, it meant finding owners willing to part with their canvases, and Canfield, who had already pried away the *Montesquiou*, went to see Graham Robertson, offering him a thousand pounds for his *Rosa Corder*. Robertson said no, and Canfield doubled his offer. This time Robertson agreed, Canfield, telling the story to the Pennells, saying, "Damned fool! I would have offered five thousand. . . ." On the first of March Whistler telegraphed to the Pennells to come to see the *Rosa Corder* for the last time. He had cleaned it, and it was to be shipped to New York the next day, along with lesser work. Freer, who arrived again in London in the spring, quickly added to his Whistlers, buying from the Cheyne Walk stock nine lithographs, nine watercolors, two pastels, one oil, seven sketches in ink and two in pencil, for a total of £1363.7, the artist again signing the ironic customs declaration which freed the work from import duty:

> I, James McNeill Whistler, do hereby certify that I am a Citizen of the United States of America, and by profession an artist; that my place of permanent residence in the United States is []; and that I departed from the United States of America on or about the [] day of [], that I have not given up,

and that it is not my intention to give up, my residence in the
United States, and that it is my purpose to return ultimately to
the United States. . . .

Although the fires were burning lower as winter turned to spring in
London, something still remained of Whistler's epistolary urge. Will H.
Low, in New York, had sought to protect Whistler's interests in a loan
exhibition of the Society of American Artists by insisting that the newly
arrived *Rosa Corder* and two seascapes borrowed from Charles Freer be
hung "in a good position." The position selected did not suit him, and he
withdrew the pictures, as Whistler himself might have done years before.
But Whistler had mellowed, and, in his usual ornate prose, chastised
Low:

> I have just learned with distress that my canvases have been a
> trouble and a cause of thought to the gentlemen of the Hanging
> Committee!
> Pray present to them my compliments and my deep regrets.
> . . . And above all, do not allow a matter of colossal
> importance to ever interfere with the afternoon habit of peace and
> good will, and the leaf of the mint so pleasantly associated with
> this society.
> I could not be other than much affected by your warm and
> immediate demonstration, but I should never forgive myself were
> the consequences of lasting vexation to your distinguished
> confreres, and, believe me, dear Mr Low, very sincerely,
> J. McNEILL WHISTLER
> London, April 7, 1903.

In painting, too, there was still something left. One afternoon in
May, after Joseph Pennell had become used to seeing Whistler most often
in bed, with a vague look in his eyes, he found him dressed. Whistler
walked him across the studio where on the easel was a striking portrait of
Dorothy Seton, her coppery red hair hanging over her shoulders, an apple
in her hand. "Hm, hm, when do you think I did that?" he asked. Pennell
said he didn't know. "Oh, you never know. When did I do it?" he asked
Miss Birnie Philip. "This afternoon," she said. "And how long did I take?
About two hours?" "No, it was about an hour and three quarters." It
would be called *The Daughter of Eve*, the finest of his late small studies.

June came, and Freer continued to spend most of his hours at Cheyne

Walk, sometimes taking Whistler for a brief ride in his carriage, but the recurrent pneumonia, coupled with heart disease, made it even more difficult for him to shuffle about, even on the ground floor level of the house, which was now all of it he saw. Elizabeth Pennell called on July 1, and the maid let her in, but communicated Miss Birnie Philip's warning that the visit should be brief for Whistler was tired. "He was in bed, distinctly worse, with a curious vague look in his eyes, all the life gone out of them. He said nothing, and seemed almost in a stupor, though he must have been listening, for every now and then he interrupted to ask, 'What's that?'" Theodore Duret came from Paris, and found Whistler only able to stare at him dumbly. During a second visit Whistler struggled again to talk, showed him some of the etchings of recent years which had been lying about, and appeared glad to have his friend recall the old days. But speech came with difficulty. Duret was overcome with emotion and left, trying to blink his eyes clear. .

On the fourteenth Whistler appeared to have rallied. Mrs Pennell found him dressed, and although his cheeks were sunken, and his eyes hollow and vague, there was "a touch of gallantry" in his greeting: "I wish I felt as well as you look!" He asked about Henley, who had died a few days earlier, and to whose obsequies he had sent a spray of purple iris. Then, after some small talk, interrupted by Whistler's frequent dozing, she got up to go, because John Lavery had arrived.

On Friday July 17, Charles Freer lunched with Tom Way at the Carlton, then went off to Cheyne Walk to take Whistler for a drive, as he had done the day before, when Whistler had seemed better, in the midst of a new rally. But by the time Freer had arrived, at half past three, Whistler, who had taken a sudden turn for the worse after his own lunch, was dead. The doctor was also too late. He remained to sign the certificate, and Freer remained to handle the details which had to follow.

The next day, Freer later told Louise Havemeyer, "I was exhausted . . . and I thought that when finally the coffin was placed in the studio I could go and rest. But when a member of the family begged me to remain and receive those that might come during the afternoon, I could not refuse, and remained alone in the silent studio. Before long the bell rang and I opened the door. A woman's voice asked if she might be permitted to see Whistler's face. As she raised her veil and I saw the dark eyes and the thick, wavy hair, although it was streaked with gray, I knew at once it was Jo . . . , *'la belle Irlandaise'* that Courbet had painted with her wonderful hair and a mirror in her hand. . . ." Maud, too, Freer claimed,

came "all the way from Paris and was very much affected as I uncovered Whistler's face for her to see him. . . ." Whether they were really there remains buried with Freer. The scenes would have made characteristic mid-Victorian "story" canvases, inevitably to be hung "on the line" at the Academy. Whistler would have scorned them.

Epilogue:
After the Butterfly

"How much for the whole lot, Mr Whistler?" a rich American collector is reputed to have asked the Master one day in Fitzroy Street.

"Five millions."

"What?"

"My posthumous prices," he said. "Good morning."

Whistler left an estate valued at £10,602.16. Given the later prices of his paintings the estimate was modest. His *Harmony in Red: Lamplight* portrait of Trixie, which he would never sell, and which passed eventually through his sister-in-law's bequest to the University of Glasgow, could have commanded £10,000 by itself from a Freer or a Canfield, and much more since. And he left hundreds of works—from sketches to canvases—which never reached the marketplace, where Mammon made, or confirmed, reputations.

At the time of Whistler's death no public gallery in England held one of his pictures. In his last years, bitter at his long neglect, he would not have sold one to a public gallery in England. Yet the neglect was due only in part to the blindness of his contemporaries, for they were not blind to the Whistler *persona,* which grated against the smugness of late Victorian England. As John Butler Yeats put it a decade after Whistler's death, "All his life Whistler committed the unpardonable offense of being himself; sprung of a nation where the *vox populi* is the *vox dei,* he hated the *vox populi."* His old enemy Harry Quilter, in an obituary article, had used a similar argument *against* Whistler, that his work suffered from his social ambitions and his extravagance in money matters—his attempt "to serve those incompatible masters, Art and Society. Herein lay the secret of his life and art, this and not any special peculiarity of vision or mysterious aim; and this is why criticism enraged him beyond endurance. He had grown impatient, possibly incapable, of prolonged effort, of quietly considered work; . . . he thought whatever he chose to do was good enough because he did it. . . ."

But there *was* a peculiarity of vision, recognizable, at least, to those whose perspectives had been educated by the literal academic painting Whistler had rejected. As Yeats explained it in 1914:

> There are painters of such skill that what they paint seems more real than the things themselves, and we are dazzled by the closeness of the imitation; the water is so like water, the satiny sheen of the lady's dress so well rendered and the flesh tints so true. Scornfully Whistler drew away from all this kind of industry; what was positive, distinct and complete was to him meaningless. A true artist, he lived in a world where the truth fully expressed is a truth murdered; his function not to represent but always to suggest. . . .
>
> Whistler appears as one saying: "I understand myself, and others so far as they are artists understand; let the remainder continue to misunderstand." In the world of art we find our way about by the artistic sense, provided that such has been cultivated to the highest degree, and let the men of practical sense, and of intellect, men of science and of virtue, patriots and politicians keep aloof, for the ground is enchanted. You cannot explain pictures as you cannot explain music. People understand or they do not—that is all. His long fight with friends and enemies, and all his witty malice, was to establish this great, this elementary principle.

As Arthur Symons explained, Whistler "never stared at nature, and you must not stare at his pictures," and Symons celebrated in an essay, "On the Purchase of a Whistler for London," the acquisition by the National Art Collections Fund for the Tate Gallery "of a picture of Whistler which was once derided in a British law-court with Ruskin and Burne-Jones, each an honest man of genius, bearing false witness against it." The reason as Symons saw it was that

> the public was beginning to accustom itself to the minute religion of the eyes which the Pre-Raphaelites had brought in; and the public, though it may have many loves contemporaneously, can have but one creed at a time. Ruskin by much preaching had brought the public to its knees; it was not convinced that it liked Pre-Raphaelite pictures, but it was certain that its duty to its higher self condemned it to accept them as what it ought to like.

Imagine a poor public convinced that the manner of "The Awakened Conscience" was the manner of all great art, and then brought face to face with this particular *Battersea Bridge*, which seemed to it a wavering blue ghost, a trick of moonshine, the imposition of a juggler! Here was a choice of subject, a way of painting, which had no relation with those devout details of the older school; and if the one was religion, the other, certainly, must be heresy. So said the public, and so, alas! said Ruskin. And so Whistler had to wait for the new eyes of the new generation; and he had to train the sight of those eyes, to accustom them to take in new images of familiar objects; so every great original painter has had to do in every generation.

Painting was only one aspect of Whistler's art, and possibly the last to be recognized. "The past," Oswald Sickert observed, "scarcely affords a parallel to the sensibility of a hand which could find its own different and equally happy ways with the point of a needle, the point of a pencil, with the pastel stick, with the brush dipped in water colour and the brush which carried oil." But whatever the medium, his art was international. He handed on no American tradition although he called himself an American to the end. He drew no American scene other than his copperplates for the Coastal Survey, and after he left the United States for Europe he painted no Americans except those who sat for portraits in his London or Paris studios.

Without founding a school, Whistler had, if only by teaching artists how to see, an immense influence on art. But to the end, he was an outsider, aware of the directions in which art was moving and often spurring change himself. He had never thought of America as a place in which he could seriously practice his art, and resisted the temptations of Paris, realizing that France was seldom sympathetic to any but its own, and that England provided, even for an artist working at odds with his milieu, the best possibilities for his energy and tenacity. No Englishman, he nevertheless was the one great artist to emerge from Victorian England, an irony he would have appreciated. Not only did he lead the rebellion against anecdote and subject matter and toward abstraction through his painting: his *Ten O'Clock* lecture was the major manifesto of Aestheticism in England. And largely through Whistler the winds from France and Japan entered the stagnant artistic atmosphere across the Channel.

Aestheticism in Whistler, Roger Fry declared nevertheless, was his chief limitation, more apparent in his painting than in his etching, for on canvas he "almost sank the genius in the man of taste." In the asceticism and refinement of his method, according to Fry, he was an artistic Calvinist. Perhaps it was Whistler's mother at work in his subconscious, yet as a painter and as a personality he was a liberating force in the artist's continual battle against the Philistine. Still, the calculatedly eccentric personality intrudes—the undersized man, the oversized wand; the amalgam of arrogance, aggressiveness, isolation and insecurity; of perfectionist, poseur, poet and prophet. But he fostered the recognition that an arrangement of forms and colors could have an aesthetic satisfaction apart from any human interest, and thus helped art emerge renewed into the new century which had barely begun at his death.

Whether or not his work itself ranks him with the major creative figures of his time, he was, in Hilton Kramer's words, "in firm possession of the advanced esthetic materials out of which the major artists of his time were producing their masterworks." In John Dos Passos's novel *1919* two young women would leave wartime Paris "in the last faint mauve of twilight.... There were very few lights and they were blue and hooded with tin hats so that they couldn't be seen from above. The Seine, the old bridges, and the long bulk of the Louvre opposite looked faint and unreal; it was like walking through a Whistler." On location in Budapest a century after the first nocturnes were scorned in London, a famous actress looked down the Danube in the dusk from her hotel suite at the chunks of dirty ice drifting down the river, fascinated by what she described to a reporter as "the kind of Whistler beauty of that bridge." Controversies about the nature of greatness notwithstanding, Whistler's artistic vision had survived and become metaphor.

Sources

The major published sources for a life of Whistler remain the *Life of James McNeill Whistler* (1908) and the *Whistler Journal* (1921), by Joseph and Elizabeth Pennell. No chapter is without indebtedness to the conversations they recorded, or the letters and documents upon which they drew, now in the Pennell Collection of the Library of Congress (*LC*). An equivalent hoard of Whistleriana is the Edith Birnie Philip Bequest (hereafter referred to as *Glasgow*), the residue of the Whistler estate left to his sister-in-law (and ward), which passed to Glasgow University at her death minus those parts of it sold by her in her lifetime as guardian of Whistler's effects and reputation. Many of the important documents from it have now been published in a variety of scholarly journals, books and exhibition catalogues, these noted where of significance in a particular chapter. Most references sufficiently clear from the text itself are not repeated here.

PROLOGUE

The story of Sturges after the funeral appears in James Barnes, *From Then Till Now* (1934), 328–29; I am indebted to Leon Edel for calling it to my attention. The William Rothenstein account is in *Men and Memories 1900–1922* (1932), 51–52.

CHAPTER I

Whistler's holograph autobiographical fragment is at *Glasgow*. The early journal and letters of Mrs Anna Whistler appear in Elizabeth Mumford, *Whistler's Mother* (1939); additional details of the Whistlers' life in Russia are in Albert Parry, *Whistler's Father* (1939). The reference to the "blue dimness of the northern days" is from Parry. The drawn-in Russian grammar is at *Glasgow*. Jimmy's letters to his father are quoted from John Sandberg, "Whistler's Early Work in America, 1834–1855," *Art Quarterly* (1966).

CHAPTER II

The documents in Mumford remain an important source for Whistler's life in America, as do the Pennells' publications and papers. Whistler's performance at West Point is derived from Academy records as well. The Weir background is from the *Diary of George Templeton Strong 1835–1849*, ed. Allan Nevins and Milton H. Thomas (1952) and D. W. Young, *Life and Letters of J. Alden Weir* (1960). The Academy period is recorded also in Samuel J. Bayard, *The Life of George Dashiell Bayard* (1874); Gustave Kobbe, "Whistler at West Point," *Chap-Book*, VIII (1898); Thomas Wilson, "Whistler at West Point," *The Book-Buyer*, XVII (1898–99); Charles W. Larned, "Whistler, West Point Cadet and Artist: Early Sketches," *Illustrated London News*, Jan. 25, 1908; Joseph Pearson Farley, *Three Rivers* (1910), Chapter XVIII; H. M. Lazelle, "Whistler at West Point," *Century Magazine*, XC (1915). Other West Point-Whistler material has turned up in such auction catalogues as the Park-Bernet list for October 19, 1971 (illus. 448).

CHAPTER III

Whistler's Washington experience is recorded in Gustave Kobbe, "Whistler in the U.S. Coast Survey," *The Chap-Book*, VIII (1898); John Ross Key, "Recollections of Whistler while in the Office of the United States Coast Survey," *Century Magazine*, LXXV (1908); Charles E. Fairman, "Whistler in Washington," *The Lamp*, XXIX (1924); Walter Sickert, *A Free House* (1947); A. J. Wraight and Elliott B. Roberts, *The Coast and Geodetic Survey 1807–1957* (1957); John Sandberg, "Whistler's Early Work in America, 1834–1855," *Art Quarterly*, XXIX (1966); the Pennell papers; and Marlene A. Palmer, "Whistler and the U.S. Coast and Geodetic Survey," *Journal of the West*, VIII (1969).

CHAPTER IV

Henri Murger's *Scènes de la Vie de Bohème* (1848) was published in the English translation used here by John Van Horne in 1924. Much useful material about the artist in early America appears in Neil Harris, *The Artist in American Society* (1966). Whistler's correspondence with his mother in this period is in Mumford.

CHAPTER V

Whistler's Parisian experience is recorded in Du Maurier's novel *Trilby* (1894); by the Pennells, by Tom Armstrong in reminiscences published in L. M. Lamont, *Thomas Armstrong, C.B.: A Memoir* (1912), in Du Maurier's letters in Daphne Du Maurier, ed., *The Young George Du Maurier* (1951), and in Leonée Ormond, *George Du Maurier* (1969). The O'Leary and Aubert episodes are in Armstrong, as also the recollection of Whistler's Negro songs. The Whistler recollection of the Captain from Stonington is from the *Journal*. The stepladder episode at the Luxembourg is from J. W. McSpadden, *Famous Painters of America* (1907), quoting W. L. B. Jenney in *American Architect* (1898).

CHAPTER VI

Whistler's account of the trip to Germany comes from the *Life* and the *Journal* and from his undated (1858) letter to Deborah Haden (*LC*). His mother's letters are from "The Lady of the Portrait. Letters of Whistler's Mother," *The Atlantic Monthly*, CXXXVI (1925). The translation of Fumette's song (from Armstrong) is from James Laver's *Whistler* (1951). The Degas comment is from Marcel Guerin, ed., *Degas Letters* (1947).

CHAPTER VII

Whistler's early years in London are principally recorded in the *Life* and the *Journal*, in the Du Maurier letters and in Armstrong. Whistler's letters to Fantin-Latour are from Leonce Benedite, "Artistes Contemporains: Whistler," *Gazette des Beaux-Arts*, XXXIII (1905), where the correspondence is printed in its original French. Luke Ionides' reminiscences are from "Memories," *The Transatlantic Review*, I (1924). The reference to the Academy's Octagon Room is from Walter Crane's memoir, *William Morris to Whistler* (1911).

CHAPTER VIII

Again the *Life*, the *Journal*, Armstrong and the Fantin and Du Maurier letters are principal sources, as now—and through to 1888—become the letters to George A. Lucas in John A. Mahey, "The Letters of James McNeill Whistler to George A. Lucas," *Art Bulletin*, XLIX (1967); however the letter on *The White Girl* comes, rather, from the *LC*, dated 26 June [no year but 1862]. The "later critic writing on English illustration" is Gleeson White in

Sources

English Illustration. The Sixties: 1855–1870 (1897). White also prints Whistler's magazine illustrations of the period. Baudelaire's comments on Whistler appeared on April 2, 1862 and September 14, 1862. The Whistler remark to Fantin is in a letter in the *LC.* Arthur Severn's relationship to Whistler is described in Sheila Birkenhead, *Illustrious Friends: the story of John Severn and his son Arthur* (1965). The Ford Madox Brown recollection is from Ford Madox Hueffer [Ford], *Ancient Lights* (1911).

Chapter IX

The quotation from Zola's novel *L'Oeuvre* (*The Masterpiece*) is from the Thomas Walton translation (1950). The best account of the *Salon des Refusés* in English is in William Gaunt, *The Aesthetic Adventure* (1967). The Fantin letter to Whistler telling him that the *White Girl* was "well hung" is quoted in Denys Sutton, *Nocturne, The Art of James McNeill Whistler* (1961) from *Glasgow.*

Chapter X

Swinburne's letters to and about Whistler are in Cecil Y. Lang, ed., *The Swinburne Letters*, I (1959); Rossetti's in Oswald Doughty and John Robert Wahl, eds., *Letters of Dante Gabriel Rossetti*, I–II (1965). Both utilize *Glasgow* and the Rossetti letters also utilize *LC* material. Meredith's recollections of Whistler are from Clarence Cline, ed., *The Letters of George Meredith*, III (1970). Whistler's first meeting with Rossetti is discussed in Georges Lafourcade, *Swinburne* (1932), and in Alastair Grieve, "Whistler and the Pre-Raphaelites," *Art Quarterly*, Summer 1971. Whistler's assault upon, and break with, Legros, is discussed, utilizing William Michael Rossetti's papers, in Rosalie Glynn Grylls, *Portrait of Rossetti* (1964), and in Helen Rossetti Angeli, *Pre-Raphaelite Twilight* (1954), quoting her father W. M. Rossetti. Whistler's relationship with Rossetti is referred to by Whistler himself in his fragment of a memoir (*Glasgow*), in the *Journal*, and in the *Life*, and is supplemented by Du Maurier's letters and the memoirs of Armstrong and Ionides. The earlier collection of Rossetti correspondence, *Dante Gabriel Rossetti. His Family Letters* (1895) includes valuable notes about Whistler in W. M. Rossetti's editorial comments and personal memoir. Mrs Whistler's relationship with Swinburne is in Mumford. The earliest version of the Rossetti kleptomania episode is in Clement Shorter's *The Free Lance* for January 26, 1901. Swinburne's plea for drink rather than cigars comes from a British Museum manuscript on Swinburne by Edmund Gosse printed as an appendix to Lang, *Swinburne Letters*, VI. The table-rapping episode is reported by Mortimer Menpes, *Whistler As I Knew Him* (1904).

Chapter XI

The major source of information about Howell is Helen Rossetti's *Pre-Raphaelite Twilight* (1954). Whistler also talks about Howell at length in the *Journal*. Howell's stealing from Rossetti and Whistler is related in G. C. Williamson, *Murray Marks and His Friends* (1919). Whistler confirms it in the *Journal*. The letters about the Whistler cabinet are in Angeli as well as in Whistler's own *The Paddon Papers. The Owl and the Cabinet* (1882).

Chapter XII

Mrs Whistler's letters, primarily to James Gamble, are from the *Atlantic Monthly* (1926) and Mumford. Whistler's letters to Fantin appear in the Benedite article, but for the *LC* letter (undated) in which Whistler complains of his technical inadequacies. His Trouville episode with Courbet and Jo is described in the *Journal*, the *Life*, and in Sutton and in

Whistler and His World (catalogue of the New York and Philadelphia Exhibition of 1971 arranged by the Art History Department of Columbia University), the latter two utilizing *Glasgow* material, including letters from Courbet to Whistler. Whistler's comment about a distant ship as a tone is in Val Prinsep, "James A. McNeill Whistler, 1834–1903. Personal Recollections," *The Magazine of Art*, XXVII (1903). Swinburne's confusion in seeing Whistler off to America and his delight in a "Sapphic" sculpture come from the Lang *Letters*. The Valparaiso affair is described by Whistler in various places in the *Journal*. His pre-Valparaiso legal documents in behalf of Jo and her letters to Rose are in the Rose papers acquired by the Pennells for the *LC*. Jo's posing again for Courbet in 1866 is related in *World*, in Georges Boudaille, *Gustave Courbet. Painter in Protest* (1970), and in Pierre Borle, ed., *Lettres de Gustave Courbet à Alfred Bruyas* (1951). Whistler's boxing lessons are described in Armstrong.

CHAPTER XIII

Whistler's letters to Fantin are in Benedite, and his letters to Lucas are in Mahey. The material on Whistler's club expulsion is printed from *Glasgow* in Appendix F of Grylls, *Portrait of Rossetti*. Material on Albert Moore comes from Sutton; Du Maurier; Albert Baldry, *Albert Moore* (1894); Graham Robertson, *Life Was Worth Living* (1931); and John Sandberg, "Whistler Studies. Whistler and Albert Moore," *Art Bulletin*, L (1968). The latter utilizes *Glasgow* and *LC* material. Jameson's recollections are in the *Life*. The Ionides reminiscences are from *Transatlantic Review*. The anecdote about Moore's refusing a "subject-painting" commission is from John Hebb, letter to the editor of the *Pall Mall Gazette*, March 22, 1895.

CHAPTER XIV

The Dudley Gallery incident is from Armstrong. Whistler's comment to Starr on detail in the nocturnes is from Sidney Starr, "Personal Recollections of Whistler," *Atlantic Monthly*, CI (1908). The thank-you to Leyland for the *nocturne* name is from a letter quoted in *Murray Marks and His Friends*. The letter to Lucas on "picture pattern" is from Mahey. The Nov. 22, 1873 letter to Deschamps is from the Freer Gallery. Background on the Greaves family, especially the brothers, is from Tom Pocock, *Chelsea Reach. The Brutal Friendship of Whistler and Walter Greaves* (1970), while the Limerston Street story is told by George Moore in *Hail and Farewell* (*Vale*, 1911). The Sept. 30, 1868 letter to Fantin on color is translated from the *LC* original in Sutton. The letter to the *World* on plot in a picture is reprinted in *The Gentle Art*. The letter to Walter Greaves reproaching him for imitation of arrangements and harmonies is in the *LC*, and is reprinted in Pocock. Mrs Whistler's note to the Greaveses is from the *LC*. Whistler's comment, "As the light fades . . . ," is from Don Seitz, *Whistler Stories* (1913). The story about "finish" in a picture is from Frederic Keppel, *One Day with Whistler* (1904).

CHAPTER XV

The *Mother* portrait material is primarily from Mumford, the *Atlantic* letters and the *LC*. The Leyland material is from the *Journal*, the *Life*, the *LC*, and Peter Ferriday, "The Peacock Room," *Architectural Review*, (XCCV) (1959). The Maud Franklin material is from the *Journal* and the *LC*. The joint Jimmy Whistler-Anna Whistler letter to Leyland is from the *LC*. The Miss Alexander material is primarily from the *Life* and from Reginald Colby, "Whistler's Controversial Masterpiece," *Country Life*, August 2, 1962. The *Carlyle* material is from the *Life*, from Armstrong, and from the *Diary* (publ. 1967) of William Allingham. The Swinburne letter on the Whistler private view is Lang #521. The

Sources

Rossetti letter on the show is from Doughty and Wahl #1490. Whistler on hunting with Leyland is from the *Journal*. The Whistler menu is reproduced from a page in an unidentified auction catalogue. The Whistler recollection of Sir George Scharfe's comment on the *Carlyle* is from an 1892 holograph note in the *LC*.

CHAPTER XVI

The Rossetti letter to Madox Brown is from Doughty and Wahl #1515. The episode with Mrs Bateman is from Compton Mackenzie, *My Life and Times*, II (1963). The Irving episode is from Laurence Irving, *Sir Henry Irving* (1952). The Sir Henry Cole and Lord Redesdale material is from the *Life*. The Sickert comment on Whistler's unfinished canvases is from *A Free House*. Whistler's comment on "finish" and "labour" evident in a picture is from his "Propositions, No. 2," reprinted in the *Gentle Art*. The Rosa Corder material is from *Murray Marks and His Friends*; Angeli, *Pre-Raphaelite Twilight*; Robertson, *Time Was* (1931); and the *Journal*. The substitution of *Old Battersea Bridge* for an unfinished picture ordered by William Graham is from Andrew McLaren Young, *James McNeill Whistler* [exhibition catalogue of the Arts Council and the English-Speaking Union], #35 (1960). Whistler on self-portraiture is from Thomas R. Way, *Memories of James McNeill Whistler* (1912).

CHAPTER XVII

Mrs Whistler's letters are from Mumford, the *Atlantic* and the *LC*. The Peacock Room correspondence between Dante Gabriel Rossetti and his patron Leyland is from Val Prinsep, "A Collector's Correspondence," *The Art Journal*, London, n.s. (1892). Details of the Peacock Room are from Armstrong, Comyns Carr, Ferriday, Ionides, Laver, Moscheles, Sutton, Williamson and the Freer Gallery publication 4024, *The Whistler Peacock Room* (1965). Whistler's correspondence with Leyland is from Ferriday. Whistler's letter to his mother at Hastings is from Charles Van Doren, ed., *Letters to Mother. An Anthology* (1959). Whistler's correspondence with Mrs Leyland is in the *LC*. Also his letter to Theodore Child. His letter to Alan Cole on working "like a nigger" in the Peacock Room is from an unidentified auction catalogue page in the Alverthorpe Gallery. Additional details of the making of the Peacock Room are from the *Life* and *Journal*; Pocock; Menpes; *The Times* of February 15, 1877; and Louise Jopling-Rowe, *Twenty Years of My Life* (1925).

CHAPTER XVIII

Bernard Shaw on the Lawson family is from the Preface to *Immaturity* (written 1921) and the novel itself (written 1879, published with preface 1930). The letter from Leyland's son to Whistler is from Ferriday, as are Leyland's letters to Whistler and Whistler's countercharges. Whistler's letters to Watts are in the privately printed *Nine Letters to Th. Watts-Dunton*, ed. Albert Ehrmann (1922), in the British Museum. The encounter at the Grosvenor with Poynter is from Comyns Carr. Millais' comment to Wortley at the Grosvenor is from Sickert, *A Free House*. The "Mrs Jack" material is from Louise Hall Tharp, *Mrs Jack. A Biography of Isabella Stewart Gardner* (1965). Boughton's memories of the inspiration for the libel suit are from George Boughton, "A Few of the Various Whistlers I Have Known," *The Studio*, XXX (1903). The *La Cigale* episode is from Theodore Reff, "Degas and the Literature of His Time," *Burlington Magazine*, CXII (1970). Ruskin's draft defense against Whistler is from an appendix to the *Journal*. The Letters of Alden Weir to his father are from Dorothy Weir Young, *Life and Letters of J. Alden Weir* (1960).

CHAPTER XIX

The episode at Leyland's related by Crane is from Walter Crane, *An Artist's Reminiscences* (1907). Earlier cases of Whistler's litigiousness are from the Anderson Rose documents in the *LC*. Howell's confession to Whistler on his duplicity regarding Blott is from the *LC*. Whistler's letter to *The World* was published on 22 May 1878 and reprinted in *The Gentle Art*. Charles Keene's lack of eagerness to appear in Whistler's defense is in a letter to a Mr Stewart, 24 November 1878, in George Somes Layard, *Life and Letters of Charles Samuel Keene* (1892). The basic material on the trial is from the *Life*, the *Gentle Art* ("Whistler vs Ruskin" section), *The Times* and H. Montgomery Hyde, *Their Good Names* (1970). Arthur Severn's report of the reaction to the display of the Titian painting is from Birkenhead, *Illustrious Friends*; George Smalley's version is from G. W. Smalley, "A Tribute from One of His Old Friends," *The Times*, reprinted in the New York *Tribune*, August 19, 1903. Another Severn story, about the bumping of a nocturne being placed in evidence, and Whistler's response is from an undated *Boston Transcript* article by T. P. O'Connor in the *LC*. The "imperious autocrat" line of Ruskin's counsel, not in the trial transcript, is reported by Burne-Jones in a letter to Joan Severn, 27 November 1878, in Helen Gill Viljoen, ed., *The Brantwood Diary of John Ruskin* (1971). Shaw's view of the bungling of Whistler's case is from Hyde. The Smalley report of the aftermath is from "A Tribute. . . ." Rossetti's letter to William Davies is from Doughty and Wahl #1995.

CHAPTER XX

Whistler's letters to Rose are from the *LC*. Whistler's letters to Lazenby Liberty are from the Kenneth Rendell Catalogue 55 (1971). The extract from a letter on Chelsea people "in rags" is from another Rendell catalogue. The Severn report on the trial, and Burne-Jones's comments, are in the *Brantwood Diaries*. Burne-Jones's letter to Rossetti on the trial as "a hateful affair" is from Georgiana Burne-Jones, *Memorials of Edward Burne-Jones*, II (1904). The footnote on Captain Marryat's complaint about American resistance to prices of paintings is from Neil Harris. Whistler's financial problems are related in the *Life* and in Laver. The letter from Whistler to his mother in Hastings is from an undated copy in the *LC*. The Godwin material is primarily from Dudley Harbron, *The Conscious Stone, The Life of Edward William Godwin* (1949); however Godwin's accounts to Whistler on expenditures in building the White House are in the *LC*. Charles Dowdeswell's account of a White House visit is from a holograph manuscript in the Alverthorpe Gallery. The letters to Watts are from Ehrmann. The account by James of his White House breakfast is from Edel, *Henry James*, II. Martini's complaint about a White House breakfast is from Alice Comyns Carr, *Mrs J. Comyns Carr's Reminiscences* (1926).

CHAPTER XXI

Whistler's indebtednesses are recorded in the Anderson Rose papers in the *LC*. His and Maud's letters to Lucas are in Mahey; those to his mother in *LC* copies. His confession to St Gaudens is in Louise Hall Tharp, *Saint-Gaudens and the Gilded Era* (1969). The club episode with Swinburne is related in Julian Hawthorne, *Shapes that Pass, Memories of Old Days* (1928). The auction notice on the White House is in the *LC*. The incidents with the bailiffs are in the *Life*, the *Journal*, and contemporary newspaper accounts. The bankruptcy papers are (via Freer Gallery copies made by H. H. Hammond of the Bankruptcy Court) File No. 103240 in the London Bankruptcy Court. The autograph note to Charles Dilke is Add. Ms. 43910, folio 299, British Museum, ca. 20 May 1879. The comment of an unknown lady on *The Loves of the Lobsters* is from the *Life*. The Rossetti letter to Watts-Dunton is Doughty and Wahl, #2090. The results of the bankruptcy auction are

from Hammond. The story of Whistler's lintel inscription is from Armstrong. The breakfast attended by Mrs Langtry is reported by Phoebe Garnaut Smalley in *The Lamp*, XXVII (1903). The costume ball reminiscence is from a letter to the editor by Arthur Lumley in the *New York Times Saturday Review of Books*, July 21, 1903, and Walter Crane, *An Artist's Reminiscences*.

CHAPTER XXII

The major source of information about Whistler in Venice (even more so than the *Life* and the *Journal*) is Otto H. Bacher, *With Whistler in Venice* (1908), which contains Bacher's own account as well as post-Venice letters to him from Whistler and Maud; also useful is W. Scott, "Reminiscences of Whistler Continued. Some Venice Recollections," *The Studio*, XXX (1903). Maud's letters to Lucas are from Mahey. The letter from Whistler to Nellie Whistler is from a copy at the Alverthorpe Gallery: the letter to Deborah Haden is from an LC copy. Whistler's comment that a darn was "premeditated poverty" is from Way, *Memories of Whistler*. The acid-spilling incident is from the *Journal*. His unhappiness with Italian and early preference for London cabs over gondolas is from Jean Adehmar, "Concerning the Venetian Exhibition: Venice, Whistler and the Esthetes of 1900," *Revue de l'Université de Bruxelles*, July–August 1954. Harry Quilter's gondola encounter with Whistler is from Quilter, "J. A. McNeill Whistler, a Memory and a Criticism," *Chambers's Journal*, VI (1903). Whistler's replacement of monocle by spectacles and comment on "gimracks" are from Katharine Metcalf Roof, *The Life and Art of William Merritt Chase* (1971). His encounters with Henry Woods are from Luke V. Fildes, *A Victorian Painter. Luke Fildes, R.A.* (1968). The reference to "a man who could work and smoke at the same time" is from Menpes. Whistler's uncharitable reference to Benjamin Haydon is from Sidney Starr, "Personal Recollections of Whistler," *Atlantic Monthly*, CI (1908).

CHAPTER XXIII

Whistler on routing Haden is from the *Journal*. Way's reminiscences are from his *Memories* and Menpes' from his *Whistler*. The story of the dog and Sir Morrell Mackenzie is from Seitz and the *Journal*. Whistler's letters to Edmund Yates ("Atlas") in the *World* are from their reprinting in *The Gentle Art*. Maud's and Whistler's letters to Bacher are from *With Whistler in Venice*, and from other copies in Freer. Whistler's memories of his post-Venice shows are from the *Journal*. The John Millais comment is recorded in Sutton (1961). The John Butler Yeats comment on the Fine Arts show is from his preface to the Knoedler (New York) exhibition catalogue of 1914. Material on the burial of Anna Whistler is from Mumford. Fildes's comment on Whistler's etching show is from *A Victorian Painter*. Whistler's letters to *The Times* (May 2 and May 18, 1880) are reprinted in *The Gentle Art*. Whistler's letters to Henry and Algernon Graves are from the Houghton Library (Harvard). His comments to Alan Cole, from Cole's diaries, are in the *Life*. His method of painting Lady Meux, as if he were stalking her, is from Julian Hawthorne, *Shapes*. His tiff with her is from the *Life*. His painting Lady Colin Campbell is from the *Journal*, from Sickert, from Duret, and from his letters to her in the Freer. The letter to the Secretary of the Munich Exhibition is from the *Life*. His description of the Prince and Princess of Wales at his Fine Art Society exhibition is from the *Journal*. Harry Quilter's comment on the Lady Archie portrait is from his *Preferences in Art, Life and Literature* (1892). Moore on Duret and his portrait is from *Confessions of a Young Man* (1888). Whistler's "If *I* don't like it *you* can't have it" is quoted in K. Roof, *Life and Art of William Merritt Chase*; his refusal to "break with the tradition of a lifetime" is from

Evan Charteris, *John Sargent* (1927). Harry Quilter's rationalizations for his renovations are from his "Memory and a Criticism" in *Chambers's Journal*; Whistler's response of October 17, 1883 in the *World* is in the *Gentle Art*. His encounter with Louise Havemeyer is in her *Sixteen to Sixty: Memories of a Collector* (1961). Sickert's explanation of Whistler's difficulties with full-length portraits is in *A Free House*. Jacques-Émile Blanche's letter to his mother is quoted in Philippe Jullian (trans. by John Haylock and Francis King), *Prince of Aesthetes* (1968). Whistler's relationship with Lady Archie Campbell is from the *Life*, from Sickert, and from Arthur Jerome Eddy, *Recollections and Impressions of James A. McNeill Whistler* (1903).

<h2 style="text-align:center">CHAPTER XXIV</h2>

The Millais "power of mischief" comment about Whistler is from Charteris, *Sargent*. The Cecil Lawson material is from Edmund Gosse, *Cecil Lawson. A Memoir* (1883), in the British Museum. The Whistler letter to Paul Deschamps is quoted from *Glasgow* by Sutton. The Sickert comment on his painting side-by-side with Whistler is from Lillian Browse, *Sickert* (1960). The stormy side of the Sickert-Whistler relationship, including the correspondence, is from Andrew Dempsey, "Whistler and Sickert: A Friendship and Its End," *Apollo*, LXXXIII (1966). Menpes' recollection of Whistler painting children is from his "Reminiscences of Whistler" (recorded by Dorothy Menpes), *The Studio*, XXIX (1903). Weir's adventure is from D. W. Young. Chase's is from Roof. The Starr reminiscence of the Fine Art Society show ("someone of no importance") is from Sidney Starr, "Personal Recollections . . . ," as is the "Dives" comment; both are reprinted by Seitz. Chase's letters from Whistler are in Roof. Whistler's planted interview with Menpes was in the Philadelphia *Daily News*; his rebuttal in *The World* was reprinted in *The Gentle Art*.

<h2 style="text-align:center">CHAPTER XXV</h2>

Wilde's letters to Whistler and some of Whistler's replies are in Rupert Hart-Davis, ed., *Letters of Oscar Wilde* (1962), while all of Whistler's letters are reprinted, some altered, in *The Gentle Art*. The Wilde retort to Robert Sherard that Whistler was "a grand Virginia gentleman" is quoted from Sherard's *Oscar Wilde: the Story of an Unhappy Friendship* (1909). The Cassatt remarks are from Sweet. Oscar's lecture to the students' club of the Royal Academy was on June 30, 1883. Whistler's report of how Wilde plagiarized from Whistlerian dinner table conversation is in *Truth*, January 2 and January 16, 1890, reprinted in *The Gentle Art*. Whistler's vain entreaty to Leighton to listen to the *Ten O'Clock* is from Prinsep, "Personal Recollections," *Magazine of Art*, XXVII (1903). Whistler's correspondence with Mallarmé is from C. P. Barbier, ed., *Mallarmé-Whistler Correspondence* (1964) where the letters appear in the original French; the translation is by Jacqueline Wengrovitz. Whistler's query about Wilde to Heinemann is from the *LC* letter. The "Bugger's Opera" remark is from Frank Harris, *My Life and Loves*, IV (repr. 1962).

<h2 style="text-align:center">CHAPTER XXVI</h2>

The British Artists period is well documented in the *Life* and in the *Journal* (where pages of Whistler's address to the Queen are reproduced) and in Menpes. The letter to Dowdeswell about answering abuse is from the *LC*. The cutting sent to Chase is from the typed copy in the *LC*. Bernard Shaw's review of the "brown and gold" exhibition is in "The Picture Galleries," *The World*, May 5, 1886. The withdrawal letter of "A British Artist" and Whistler's response are reprinted in Sadakichi Hartman, *The Whistler Book*

(1910). Whistler's sketching while the Mass was being celebrated is from Walter S. Sparrow, *Memories of Life and Art* (1925). The letters to the editor battle over Whistler's signboard is reproduced in *The Gentle Art* as is his *Pall Mall Gazette* interview on his being voted out of office. His speech to the Society using the ship metaphor is most fully reported in Menpes.

CHAPTER XXVII

The Lucas material is from Mahey and *LC* copies. Godwin's letters to Mrs Jopling are from Harbron. Godwin's funeral is from Harbron and the *Journal*. Shaw's comments on Stott's paintings are from *The World* of April 13 and November 30, 1887. The *Times* review is November 29, 1887. Biographical details on Stott are from R. A. M. Stevenson, "William Stott, of Oldham," *The Studio*, IV (1894), where the *Venus* for which Maud posed is reproduced. "The lady in her right clothing" is from the *Journal*. Whistler's letters to John Charles Hanson are from the *LC*. The report of Whistler's proposal to Trixie and subsequent wedding preparations is from Henry Labouchere in *Truth*, July 23, 1903 and Louise Jopling Rowe, *Twenty Years of My Life* (1925). Whistler's refusal to sit at the same table with his wedding cake is from Luke Ionides. His "Trixie is my luck" comment to Lady Colin Campbell is in a letter in the Freer. The reports on the Stott-Whistler altercation are from *Land and Water*, January 26, 1889 ("Jim the Whistler . . ."); the *Glasgow Evening Citizen*, January 12, 1889 (the text of Whistler's letter to the Hogarth Club committee); and *Hawk*, January 23, 1889 (the Augustus Moore report which ended in his caning by Whistler). Whistler's note to Deborah Haden is from the Freer. Mary Cassatt's encounter with Maud is from Louise Havemeyer; the aftermath is from Mahey.

CHAPTER XXVIII

The "hatter's clerk" episode is from the manuscript European diary of Thomas Sergeant Perry, entry for August 15, 1888, in the Colby College Library. Sickert's "*Mots* Propagation Bureau" remark is from a letter to the editor of *Art News* dated 21 April 1910, published in Richard Friedenthal, ed., *Letters of the Great Artists* (1963); his recollection of Whistler's showing nocturnes "to the football correspondent of a Fulham local paper" is from *A Free House*. The editions of *The Gentle Art* used in this chapter are the suppressed Sheridan Ford, ed., *The Gentle Art of Making Enemies* (1890) and James Abbott McNeill Whistler, *The Gentle Art of Making Enemies*, 2nd edition (1892). The *Life* has most of the details about Whistler's pursuit of Ford and is supplemented by Octave Maus, "Whistler in Belgium," *The Studio*, XXXII (1904), on the Antwerp trial. George Smalley's remark on Ford and Whitelaw Reid's role are from Royal Cortissoz, ed., *Life of Whitelaw Reid*, II (1921). George Moore's remarks are from his *Modern Painting* (1893). Max Beerbohm's are from *Yet Again* (1928); G. K. Chesterton's from *Heretics* (1909); D. B. Wyndham Lewis's from "Whistler" in Leonard Russell, ed., *English Wits* (1940). The inscription to George Moore is quoted by Moore in *Avowals* (1936), while his amended "With the renewed regards of the author" is from Frank Harris, "Whistler: Artist and Fighter" in *Contemporary Portraits* (1915). The Heinemann material is from the *Life* and Frederic Whyte, *William Heinemann: A Memoir* (1929). Frederic Keppel's reminiscence is from Keppel, *One Day with Whistler* (1904).

CHAPTER XXIX

Sickert's memories of Degas are from *A Free House*. Whistler's correspondence with Mallarmé is from the Barbier edition (as trans. by Jacqueline Wengrovitz). Degas'

comments about Whistler are also from Frank Harris, "Whistler: Artist and Fighter" and Daniel Halevy (ed. and trans. by Mina Curtiss), *My Friend Degas* (1964) and R. H. Ives Gammell, *The Shop-Talk of Edgar Degas* (1961). The Monet material is from Charles Merrill Mount, *Monet. A Biography* (1967). Camille Pissarro's letters are from John Rewald, ed. (with the assistance of Lucien Pissarro), *Camille Pissarro: Letters to his Son Lucien* (1943). The Lautrec material is from Gerstle Mack, *Toulouse-Lautrec* (1938) and Jean Bouret, *The Life and Work of Toulouse-Lautrec* (1966). Proust's involvement with Whistler is from George Painter, *Proust. The Early Years* (1959) and Marcel Proust, *Jean Santeuil*, III (1956), and the *Remembrance of Things Past* (1913–27). The impact upon Debussy is from Victor I. Seroff, *Debussy* (1956) and Edward Lockspeiser, *Debussy: His Life and Mind*, I & II (1962–65). Whistler's sale of pictures to Otto Goldschmidt is recorded in Goldschmidt's pencilled notes in a copy of Way's and Dennis's *The Art of James McNeill Whistler* (1904), recorded in Thomas B. Brumbaugh, "A Whistler Footnote," *Art Journal*, XXXI (1972). The Carlyle sale is detailed in the *Life*, the Mallarmé *Correspondence*, a letter to Graves (undated) in the *LC*, and Graves's bills and documents in the *LC*. Whistler's (footnoted) membership in the Order of the White Rose is chronicled in R. F. Francillon, *Mid-Victorian Memories* (1914). The Montesquiou relationship is detailed—mainly from *Glasgow* documents—in Jullian, *Prince of Aesthetes*; Edgar Munhall, "Whistler's Portrait of Robert de Montesquiou," *Gazette de Beaux-Arts*, LXXI (1968); Kerrison Preston, ed., *Letters from Graham Robertson* (1953); and Leon Edel, *Henry James. The Middle Years* (1962).

<div align="center">CHAPTER XXX</div>

Whistler's encounter with General Hawkins is in *The Gentle Art*, as is his response to the toast at the Criterion. The report on Whistler's Chelsea garden Sunday receptions is from the anonymously written "Whistler, Painter and Comedian," *McClure's Magazine*, VII (1896). The Beardsley material is from Stanley Weintraub, *Beardsley* (1967; rev. 1972). The Moffat P. Lindner reference, and the Wilson Steer material, is from Bruce Laughton, *Philip Wilson Steer* (1972). The Rose Pettigrew memoir is an appendix to Laughton. The Whibley-Henley reference is from John Connell [Robertson], *W. E. Henley* (1949). The Romeike correspondence is from *The Gentle Art*. Whistler's letters to David Croal Thomson are in the *LC*. His speech at the Chelsea Arts Club is reported in the *Life*. The encounter with Graham Robertson, the new owner of the *Rosa Corder*, is related by Robertson in *Life Was Worth Living* (1931); also their later visit to Albert Moore. The story of Florence Leyland's last relationship with Whistler is from the *Journal*. The Goupil exhibition is described in the *Life* and the *Journal*; and the abortive Marlborough commission in the *Journal*. The abortive commission from the Boston Public Library is related most fully in Mount, *John Singer Sargent*, in Laver and in the *Life*. The "California" boast is from the *Life*, and the "fortune" prediction to Way is quoted by Sutton.

<div align="center">CHAPTER XXXI</div>

Whistler's life in Paris with Trixie is described in the *Life*, the *Journal* and Arthur J. Eddy's *Recollections and Impressions of James A. McNeill Whistler* (1903). William Rothenstein's reminiscence is from his *Men and Memories*, I. The *Westminster Budget* interview appeared on March 3, 1893. The letters to Hanson are in the *LC*. The Mrs Jack purchase is related in Tharp. The Beardsley material is from Weintraub. The Henry James material is from Edel and from F. O. Matthiessen and K. B. Murdock, eds., *The Notebooks of Henry James* (1947). Howells' footnoted letter to his son John is from Mildred Howells, ed., *W. D. Howells, Letters*, II (1928). The letters to Alexander Reid are at the Freer. The

Sources

discussion with an interviewer in Paris about his prices, and about his new interest in lithography, is from the anonymous "Afternoons in Studios: A Chat with Mr Whistler," *The Studio*, IV (1895).

CHAPTER XXXII

The "Vernon Lee" remark is from a privately printed edition of her letters at the Colby College Library; the letter to her mother is dated June 12 [1894]. The *Harper's Magazine* references to "Joe Sibley" are from the March 1894 serial segment of *Trilby*. Henry James's letter to Du Maurier and Whistler's letter to the President of the Beefsteak Club are from Ormond, *George Du Maurier*, as is the correspondence between Du Maurier and various Harper's representatives in London and New York, and Whistler and his lawyers to Harper's. The *Punch* parody on Whistler's *Montesquiou* is from the issue of May 26, 1894. Whistler's telegram of approval to Webb is from a copy in the Alverthorpe Library. His letter to Heinemann is in the *LC*.

CHAPTER XXXIII

Details of Trixie's illness are in the *Life* and the *Journal*, and Whistler's letters in the *LC*, Freer and *Glasgow*. The letter to Kennedy on the abortive New York trip is in the *LC*. The Lyme Regis period is additionally recorded in Way, Pocock, Sutton, McLaren Young catalogue entries and Whistleriana in the Philpot Museum, Lyme Regis, Dorset. Whistler's instructions to Hanson from Lyme Regis are in autograph letters in the *LC*. Trixie's letter to Whistler on the Greaves brothers murals, and his response to her, are quoted from *Glasgow* by Pocock. The Beardsley incident is from the *Life*. Whistler's letter to Stephen Richards is no. 32 in the Paul Richards catalogue no. 70 (1972). Jacomb-Hood's reminiscence is from his *With Brush and Pencil* (1925). The letter to the editor of *Scribner's Magazine* is no. 98 in the Richards catalogue no. 67 (1971). The autograph letter to J. J. Cowan is in the *LC*. The death of Trixie is described in the *Journal* and the *Life*. Sickert's letter to Whistler is in Sutton. Whistler's to Mallarmé is in their *Correspondence*. Whistler's to Charles Freer, March 24, 1897, about the "wonderful bird," is in manuscript in the Freer and quoted almost in its entirety in Lawrence Williams's novel, *I, James McNeill Whistler* (1972).

CHAPTER XXXIV

The Rothenstein recollection is from *Men and Memories*, I. The Menpes anecdotes are from his memoir. The letter to Croal Thomson on art copyright is in the *LC*. Hesketh Pearson's comment on art ownership is from his *The Man Whistler*, which is also the source of the Labouchere remark on *The Gold Girl*. The Eden-Whistler trial testimony, letters, and conversations are (except where otherwise noted) from James A. McNeill Whistler, *Eden versus Whistler. The Baronet and the Butterfly. A Valentine with a Verdict* (1899). Some of the same material, probably more accurately transcribed, appears in Timothy Eden, *The Tribulations of a Baronet* (1933), from whence the Eden letter dated February 14, 1894 is quoted. Whistler's letter to Heinemann on Moore, warning him to have nothing to do with the enemy is from an *LC* copy. The *Pall Mall Gazette* editorial is dated March 26, 1895. The Sturges remark is from Rothenstein. The Sickert material is from Andrew Dempsey, "Whistler and Sickert." The New English Art Club incident is from Rothenstein, Dempsey, and the *Life*. The original letters to Rothenstein or the incident are in the Houghton Library, Harvard. Whistler's letter to Deborah Haden is from the Freer, and his inscription to her in a presentation copy of *Eden versus Whistler* is no. 481 in the Winifred A. Myers catalogue no. 8 (1972). The worthy of "West Point" remark to Freer is in a letter dated July 29, 1899, in the Freer Gallery.

CHAPTER XXXV

The Whistler plaint to Lady Haden is from a letter on mourning stationery at the Freer. The Keppel fracas is from Keppel, *One Day with Whistler*, and its sequel, *The Gentle Art of Resenting Injuries* (privately printed, 1904), both in the Alverthorpe Gallery. The publication in question was Walter Greenwood Forsyth and Joseph LeRoy Harrison, *A Guide to the Study of Whistler* (State Library [of New York] Bulletin. Bibliography No. 1, May, 1895). Arthur Symons's description of Whistler is from his "Whistler and Manet," in *From Toulouse-Lautrec to Rodin* (1968). Landor's reminiscences are from A. Henry Savage Landor, *Everywhere* (1924). The Beerbohm "Oasis" remark is from A. E. Gallatin, "Mr Whistler's Art Dicta," *The Lamp*, XXVIII (1904). The Rothenstein reminiscence of Haden is from *Men and Memories*, I. The Holloway relationship is from Way, McLaren Young and the Pennells. The Mark Twain incident is from an unidentified newspaper cutting in the *LC*, reprinted by Seitz. The extracts from a letter from Henry James, 25 February 1897, are from a copy in the possession of Leon Edel. The "Admiral Nelson" drawing, with caption, is reproduced in the *Journal*. The quarrel with Way is from Way. The letter from Freer offering "partial payment" for a nocturne is from the Freer. The "Not known at the R.A." correspondence is reproduced in the *Journal*. The London *Daily Mail* comment and Whistler's letter to the editor of October 12, 1897 are from a cutting in the *LC*. The letters to Mallarmé and Genevieve Mallarmé are from Barbier. The Ludovici quotation is from Laver. The comment on the rescue of Admiral Cervera is from Menpes.

CHAPTER XXXVI

Whistler's letter to the press on the *Académie* is from the *Life*. The footnote on Romaine Goddard Brooks is from Hilton Kramer, "Revival of Romaine Brooks," *New York Times*, Sunday, April 23, 1971. The basic information on the *Académie*, other than in the *Life* and *Journal*, and sources noted in the text, is from E. S. Crawford, "The Gentler Side of Mr Whistler," *The Reader*, II (1903); C. Cuneo, "Whistler's Academy of Painting," *The Century*, LXXIII (1906); and Margaret F. MacInnes, "Whistler's Last Years: Spring 1901—Algiers and Corsica," *Gazette des Beaux-Arts*, LXXIII (1969)—which utilizes *Glasgow* material. (Inez Bate Addams's memoir of the *Académie* is printed in the *Life*.) Additional material on Carmen Rossi appears in the *Journal* and in McLaren Young. Whistler's exhortation to his pupils ("Continuez . . .") appears in Hartman. The red paint incident, the "scrape it out" incident and the New Year's morning incident are from unidentified *LC* newspaper cuttings. The Heinemann material is from "Mrs Pennell's Memories" in Whyte; Heinemann; Landor; and Ella Hepworth Dixon, *"As I Knew Them,"* (1930). The General Buller tale is from Menpes. The China ("blue pot") and West Point football references are from the *Journal*.

CHAPTER XXXVII

The most detailed accounts of Whistler's last years are in the *Life* and *Journal*. The Rothenstein report of Sickert's comment is in *Men and Memories*, I. The memoir by Whistler's child model Edith Burkitt is from Edith Shaw (introduced by Margaret F. MacInnes), "Four Years with Whistler," *Apollo*, LXXXXII (1968). The Mediterranean voyage is described also by MacInnes, "Whistler's Last Days . . ." and in letters to Heinemann and Freer in the *LC* and Freer, respectively. The recollection of the return to London by the chance companion is from an unidentified letter to the editor cutting in the *LC*. Whistler's new will is from Freer's copy in the Freer. The letter from Webb to Freer, July 2, 1902, is in the Freer. Whistler's letter to Nellie is at the Freer. The Dorothy Seton

Sources

story appears in many places but here is taken from Pearson. The Wedmore-"Podsnap" story is also from Pearson. The Montesquiou reference is from Munhall. The Elbert Hubbard story is in an undated cutting from *The Idler* in the *LC*. The U.S. Customs import declaration is in the *LC*, dated May 18, 1903. The letter to W. H. Low is from an undated cutting in the *LC*. The report by Freer of the visits by Maud and Jo is quoted in Havemeyer.

Epilogue

The "Posthumous prices" remark is from Pearson. The size of the estate is from *The [London] Times*. The J. B. Yeats comment is from his preface to the Knoedler catalogue (1914). The Quilter comment is from his "James Abbott McNeill Whistler. A Memory and a Criticism," *Chambers's Journal*, VI (1903). The Symons comment is from his "A Whistler for London," in *Studies on Modern Painters* (1967). The Hilton Kramer observation is from "The Art Institute of Chicago Mounts a Major Survey of Whistler," *New York Times*, Sunday, January 13, 1968. The actress describing the "Whistler beauty" of a Budapest bridge is Elizabeth Taylor in Thomas Thompson, "Liz Taylor is 40!" in *Life*, February 25, 1972.

Acknowledgments

My colleagues at Penn State have been extraordinarily helpful, from detective work at home to legwork abroad—Hugh Chapman, Ralph Condee, Shirley Rader, Stephen Grecco, Lois and Francis Hyslop, George Mauner, William Hauptman and, especially, Charles Mann. My wife—and colleague—Rodelle has also aided in research. I am indebted, too, to Richard Cary, Curator of Rare Books, Colby College Library; H. Chessell, Honorary Curator, Philpot Museum, Lyme Regis, Dorset; Harry P. Clark; Leon Edel; Alan Fern, Assistant Chief, Prints and Photographs Division, Library of Congress; Chadwick W. Hansen; Dan H. Laurence; Kinley E. Roby; Gordon N. Ray; Lessing J. Rosenwald and the Alverthorpe Gallery; and Jacqueline Wengrovitz.

For the opportunity to utilize Whistler material at the University of Glasgow I am especially grateful to Alexander O. MacKenna, Librarian, and Andrew McLaren Young of the Department of Fine Art, whose forthcoming *catalogue raisonné* of Whistler's paintings will provide details and subtleties this already lengthy life of Whistler cannot possibly furnish. My debt is great, also, to the staffs of the Library of Congress and the Freer Gallery for making my work in the great Pennell and Freer collections of Whistler possible, and to the librarians and libraries at the Pennsylvania State University, the New York Public Library, the British Museum, Harvard University and Yale University. For authority to utilize Henry James material I am grateful to Mr Alexander James.

With respect to recently published work I am indebted, in particular, to Andrew Dempsey's "Whistler and Sickert: A Friendship and Its End," *Apollo*, 83 (1966); Peter Ferriday's "Peacock Room," *Architectural Review*, #749 (1959); Alastair Grieve's "Whistler and the Pre-Raphaelites," *Art Quarterly* (1971); Bruce Laughton's *Philip Wilson Steer*, in the *Oxford Studies in the History of Art and Architecture* (Oxford: Clarendon Press, 1972); Margaret MacInnes's "Whistler's Last Years: Spring 1901—Algiers and Corsica," *Gazette des Beaux-Arts*, 73 (1969); John Mahey's "The

Letters of James McNeill Whistler to George A. Lucas," *Art Bulletin*, 49 (1967); Edgar Munhall's "Whistler's Portrait of Robert de Montesquiou," *Gazette des Beaux-Arts*, 71 (1968); Leonée Ormond's *George Du Maurier* (London: Routledge and Kegan Paul; Pittsburgh: University of Pittsburgh Press, 1969); Tom Pocock's *Chelsea Reach. The Brutal Friendship of Whistler and Walter Greaves* (London: Hodder and Stoughton, 1970); John Sandberg's "Whistler's Early Work in America 1834–1855," *Art Quarterly*, 39 (1966); and Denys Sutton's *Nocturne. The Art of James McNeill Whistler* (London: Country Life Press, 1963). Whistler scholarship is especially rich for their work here and elsewhere.

For permission to reproduce Whistler art—acknowledgements noted more fully with the descriptions of individual illustrations—I am indebted to the Smithsonian Institution (Freer Gallery), the Library of Congress, the Art Institute of Chicago, the National Gallery of Art, the New York Public Library, the Walters Art Gallery, the Frick Collection, the Tate Gallery, the Musée du Louvre and the Musée du Petit Palais.

S. W.

Index